Digital Photography

ALL-IN-ONE DESK REFERENCE

FOR

DUMMIES®

2ND EDITION

Digital Photography
ALL-IN-ONE DESK REFERENCE
FOR
DUMMIES®
2ND EDITION

by David D. Busch

WILEY

Wiley Publishing, Inc.

Digital Photography All-in-One Desk Reference For Dummies,® 2nd Edition

Published by
Wiley Publishing, Inc.
111 River Street
Hoboken, NJ 07030-5774

WILEY

About the Author

David D. Busch has demystified imaging and computer technology since 1980 through more than 75 books and several thousand articles on digital imaging, photography, and computer technology for leading photography and computer media, including *Popular Photography and Imaging, Petersen's PhotoGraphic, The Professional Photographer, The Rangefinder, Computer Shopper,* and CNet Networks. A two-time winner of Computer Press Awards, Busch has also operated his own commercial photo studio and lab, worked as a newspaper photographer, and taught photo posing at a New York modeling agency.

Contributing author **Dan Simon** has spent the past 25 years as a journalist and photographer. He began his career as a Navy journalist with assignments aboard several ships, and in Norfolk, Va., Dededo, Guam, and McMurdo Station, Antarctica. After leaving the service in 1990, Dan worked as a river guide and photographer on Pennsylvania's Lehigh River. During the past ten years, he has worked as a writer/photographer for several Pennsylvania and New Jersey newspapers including the *Wilkes-Barre/Hazleton Times Leader* and *Allentown Morning Call.* Simon's writing and photography have appeared in numerous books, magazines, Web sites, and newspapers including *The New York Times* and ESPN.

Contributor **Laurie Anne Ulrich**'s books include *Photoshop Elements 2 Restoration and Retouching, Photoshop Elements 2 Bible,* and *Photoshop 7: The Complete Reference.*

Contributor **Michael Meadhra** has authored, co-authored, and contributed to dozens of books, including *How to Do Everything with Dreamweaver MX 2004, Lotus SmartSuite Millennium Edition for Windows For Dummies , Lego Mindstorms For Dummies, StarOffice 5.2 For Linux For Dummies, KDE For Dummies,* and *Windows 2000 Professional Bible.* While a member of the Cobb Group, Michael served as editor-in-chief of several newsletters covering topics such as PageMaker, QuarkXPress, Freehand, Illustrator, CorelDraw, Illustrator, and Photoshop.

Technical Editor **Michael D. Sullivan** added a great deal to this book in addition to checking all the text for technical accuracy. A veteran photographer (in the military sense of the word!), he began his photo career in high school where he first learned the craft and amazed his classmates by having Monday morning coverage of Saturday's big game pictured on the school bulletin board. Sullivan pursed his interest in photography into the U.S. Navy, graduating in the top ten of his photo school class. Following Navy photo assignments in Bermuda and Arizona, he earned a BA degree from West Virginia Wesleyan College.

He became publicity coordinator for Eastman Kodak Company's largest division, where he directed the press introduction of the company's major consumer products and guided their continuing promotion. Following a 25-year stint with Kodak, Sullivan pursued a second career with a PR agency as a writer-photographer covering technical imaging subjects and producing articles that appeared in leading trade publications. In recent years, Sullivan has used his imaging expertise as a technical editor, specializing in digital imaging and photographic subjects for top selling books.

Dedication

I dedicate this book, as always, to Cathy.

Author's Acknowledgments

Thanks to my compatriots who helped me put together the first edition of this book. They include contributing author Dan Simon for his help on some of the difficult "hard-core" photography chapters on travel, sports, people photography, and shooting for publication, as well as his overview of equipment and those great photographs, including many of the best shots in the color section. More thanks to contributor Laurie Ulrich for her work on the chapters on image editing, and to contributor Mike Meadhra for his overview of image acquisition options and concise comparison of image editing software. Also, kudos to the multitudes at Wiley for keeping this project moving ahead with due speed and precision, and technical editor Michael D. Sullivan, whose knowledge of digital photography is unsurpassed.

Publisher's Acknowledgments

We're proud of this book; please send us your comments through our online registration form located at www.dummies.com/register/.

Some of the people who helped bring this book to market include the following:

Acquisitions, Editorial, and Media Development

Project Editor: Nicole Sholly

Sr. Acquisitions Editor: Steven H. Hayes

Sr. Copy Editor: Teresa Artman

Technical Editor: Michael D. Sullivan

Editorial Manager: Kevin Kirschner

Media Development Manager: Laura Carpenter VanWinkle

Media Development Supervisor: Richard Graves

Editorial Assistant: Amanda Foxworth

Cartoons: Rich Tennant (www.the5thwave.com)

Production

Project Coordinator: Courtney MacIntyre, Nancee Reeves

Layout and Graphics: Karl Brandt, Andrea Dahl, Brian Drumm, Lauren Goddard, Joyce Haughey, Michael Kruzil, Jacque Roth, Heather Ryan, Julie Trippetti

Special Help: Jacque Roth

Proofreaders: John Greenough, Carl William Pierce, Sossity R. Smith

Indexer: Steve Rath

Publishing and Editorial for Technology Dummies

 Richard Swadley, Vice President and Executive Group Publisher

 Andy Cummings, Vice President and Publisher

 Mary Bednarek, Executive Acquisitions Director

 Mary C. Corder, Editorial Director

Publishing for Consumer Dummies

 Diane Graves Steele, Vice President and Publisher

 Joyce Pepple, Acquisitions Director

Composition Services

 Gerry Fahey, Vice President of Production Services

 Debbie Stailey, Director of Composition Services

Contents at a Glance

Table of Contents

Chapter 2: Close-Up Photography225

Chapter 3: Photographing People249

Introduction

The future of photography is in your hands, and it's becoming all digital! Not since the 19th century, when photographers had to be artisan, craftsperson, artist, chemist, and public relations expert rolled into one, has so much of the photographic process been entirely in the control of the person taking the picture. Now you can compose and view the exact picture you're going to take, using your camera's full liquid crystal display (LCD) screen. Review the picture an instant after pressing the shutter. If your computer is nearby, you can upload it seconds later, view a super-large version on your display, crop, enhance, and then make your own sparkling full-color print — all within minutes!

When you go digital, you never need to buy film or wait while your photos are processed in a lab. You decide which images to print and how large to make them. You can display your digital photographic work framed on your wall or displayed proudly over your fireplace. You can make wallet-size photos, send copies to friends in e-mail, or create an online gallery that can be viewed by relatives and colleagues over the Web.

And if alchemy is in your blood, you can transform the simplest picture into a digital masterpiece using an image editor. Correct your photos, delete your ex-brother-in-law from a family portrait, or transplant the Eiffel Tower to the seashore.

Digital photography gives you the power to take pictures on a whim, or to create careful professional quality work that others might be willing to pay for. The choices are all yours, and digital photography puts all the power in your hands. All you need is a little information on how to choose and use your tools, and how to put them to work. That's what you'll find within the pages of this thick, comprehensive All-in-One guidebook.

The most exciting thing is how rapidly the technology is changing to bring you new capabilities and features that you can use to improve your pictures. Today, 2 megapixel (MP) cameras are difficult to find unless you're shopping for a photo-capable cellphone. Even the leanest digital camera you're likely to find in stores will have 3.3–4MP of resolution. I've tested models in this range that cost less than $150! You'll find 5MP and 6MP

cameras for $500 or so, and even 8MP models are widely available for less than $1,000. Digital single lens reflex cameras (SLRs) with interchangeable lenses are available from companies like Nikon, Canon, and Minolta.

Adobe Photoshop cs has bumped up the image editing ante with lots of new capabilities of interest to digital photographers, and even inexpensive applications like Adobe Photoshop Elements 3.0 have more features than you could find in the most powerful image editor four or five years ago. Your new hardware and software tools make working with digital images easier while giving you important new capabilities.

About This Book

This book is written for the person who has a good grasp of using a computer, navigating an operating system, and at least a cursory knowledge of the operation of a digital camera. It would help if you have some familiarity with an image editor, such as Paint Shop Pro, Corel PhotoPaint, or Adobe's Photoshop or Photoshop Elements. It is intended to be a comprehensive reference book that you can read cover to cover or reach for when you're looking for specific information about a particular task.

Wherever I can, I sneak in a useful tip or an interesting technique to help you put digital photography to work for your project needs.

If you have some knowledge of conventional photography, too, this book will help you fine-tune your capabilities. If you know very little about photography, there's help for you here, too. One large chunk of the book is devoted to tips on the most popular genres of photography, from close-up and sports photography to travel photography and shooting for publication. Check out the helpful section on getting the best composition. If you're puzzled over what equipment to buy, look to the sections on choosing cameras, photo accessories, and related equipment such as printers and scanners.

What's in This Book

This book is broken down into mini-books, each covering a general topic. Each mini-book comprises chapters, each covering a more specific topic under the general one. Each chapter is then divided into sections, and some of those sections have subsections. I'm sure you get the picture.

You can read the book from front to back, or you can dive right into the mini-book or chapter of your choice. Either way works just fine. Anytime a concept is mentioned that isn't covered in depth in that chapter, you'll find a

cross-reference to another book and chapter where you'll find all the details. If you're looking for something specific, check out either the Table of Contents or the index.

The Cheat Sheet at the beginning of the book is a quick guide to file formats and lingo. Tear it out, tape it to your monitor, and don't forget to say, "Thanks." (You're welcome.)

The glossary at the back of the book provides a comprehensive listing of digital photography terminology.

And finally, I've got pictures. Lots of them. Many of these pictures illustrate good photo techniques as well as traps to avoid. You'll find examples of the kinds of pictures you can take right away and maybe a few that you'll want to strive to equal or exceed.

This book contains seven mini-books. The following sections offer a quick synopsis of what each book contains.

Book 1: Digital Photography Overview

This section is your digital photography short course, providing all the information on a variety of topics that you really need to get started. Each of the six chapters is an overview of topics covered in depth later in the book. You'll find the essentials of good digital photography, the basics of equipment, and how to acquire digital pictures. Buzz through the quickie introduction into some of the ways you can edit or restore a photo electronically, and take a look at how you can store and organize your digital photos. Then, if you're interested in what's involved in selecting a printer or scanner, you'll find all the basic information summarized for you in an easy-to-understand way.

Book 11: Building Your Digital Photography Studio

This book helps you choose the right camera, whether it's your first digital camera or the one you're dreaming about as a replacement for your current model. You'll read all the facts on resolution, lens settings, storage, and accessories. One chapter shows you the requirements for setting up a PC for digital photography. The good news is that you probably already have everything you need in your computer. I'll give you some advice on some recommended upgrades that can make your system work even better with digital images.

You'll also discover your options for getting pictures from your camera into your digital darkroom. And, if you want to get the most from your pictures, you'll want to read up on how to add a scanner and printer, too.

Book III: Taking Great Pictures

This is the meat of the book for veteran and aspiring photographers alike. Each of the six chapters is devoted to a different kind of photography. You'll see the basic rules for composing great photos — and when to break them. You'll discover the secrets of close-up photography and how to make pleasing portraits of individuals and groups.

Whether shooting for publication is part of your job description or just a goal, you'll find tips on how to take publishable photos and how to market them. I also include chapters on sports and action photography as well tips on travel photography.

Book IV: Basics of Image Editing

This book is your introduction to image editing, providing general tips on what you can — and can't — do with popular image editors such as Paint Shop Pro, Corel PhotoPaint, PhotoImpact, or Adobe Photoshop and Photoshop Elements. You'll see the capabilities of these programs, discovering the full range of tools at your disposal.

The book winds up with a chapter that compares and contrasts the most popular image editors, so you can choose which image editing program you really need (or whether you might even benefit from owning two).

Book V: Editing with Adobe Photoshop and Photoshop Elements

This book goes into a little more detail on the use of the two favorite image editing programs: Adobe Photoshop CS (favored by professionals) and Adobe Photoshop Elements 3.0 (an inexpensive younger sibling with lots of power yet easy to use). You discover the power of making selections, brush away problems with your digital photos, correct your colors, and apply special effects with filters.

Although this book is not a complete guide to Photoshop, you'll find lots of good information you can use right away to try out your digital photo editing muscles. For tons of in-depth coverage, read *Photoshop CS All-in-One Desk Reference For Dummies,* by Barbara Obermeier (Wiley).

Book VI: Restoring Old Photos

Continue your study of Photoshop and Photoshop Elements with this mini-book, which shows you how to restore old photos and make some common repairs to your digital images. See chapters on scanning in print images, tips

for working with slides and negatives, and some common fixes for vintage photos.

Book VII: Printing and Sharing Your Digital Images

Your digital photos are going to be so good that you won't be able to keep them to yourself. This mini-book provides more information on printing your photos, showing you ways to share your pictures over the Internet. You'll become more comfortable with your printer's capabilities, discovering all the things that you can do with photos online, whether it's showcasing your pictures among your friends and colleagues, or making photo greeting cards, T-shirts, or other gift items.

Color insert

Trying to illustrate the powers of digital photography without showing some images in full, living color would be about as useful as if I handed you a broken umbrella on a rainy day. The 16-page color insert does just that, so don't miss it.

Conventions Used in This Book

Digital photography knows no operating system limits. All digital cameras and many software applications work equally well on a PC as on a Macintosh. To that end, this book is cross-platform. Understandably, some differences do crop up, however, particularly in the chapters that deal with image editing. In these, Windows commands are given first, followed by Mac commands, like this:

Press Enter (or Return on the Mac) to begin a new line.

Occasionally, text will be specific to one platform or another. Commands listed often involve using the keyboard along with the mouse: for example, "Press Shift while dragging with the Rectangular Marquee tool to create a square," or "Alt+click (Option+click) the eyeball to redisplay all layers."

When you see a command arrow (⇨) in the text, it indicates that you should select a command from the menu bar. For example, "Choose Edit⇨ Define Custom Shape" means to click the Edit menu and then choose the Define Custom Shape option.

Although this book has been written using the latest digital cameras and the newest software (such as Paint Shop Pro 8 and Photoshop CS), if you're still bouncing around with earlier versions, you can still glean valuable info. You

might just have to poke around a little more to find a tool or option that's moved — and of course, the topics covering new features won't be applicable. But hey, seeing the cool new features might just be the impetus you need to go out and upgrade!

Icons Used in This Book

While perusing this book, you'll notice some icons in the margins beckoning you for your attention. Don't ignore them; embrace them! These icons point out fun, useful, and memorable tidbits about Photoshop, plus facts you'd be unwise to ignore.

This icon indicates information that will make your digital photography experience easier. It also gives you an icebreaker at your next cocktail party. Whipping out, "Did you know that many digital cameras can focus down to within an inch of an object?" is bound to make you the center of conversation.

This icon is a reminder of things that I want to *gently* re-emphasize. Or I might be pointing out things that I want you to take note of in your future digital photography excursions.

The little bomb icon is a red flag. Heed these warnings, or else your camera or image editor might show its ugly side.

This icon points out info you don't necessarily need to know. If you're interested in getting more technical, however, you'll find such information interesting.

Where To Go From Here

If you want your voice to be heard, you can contact the publisher or authors of the *For Dummies* books by visiting the publisher's Web site at www.dummies.com, sending an e-mail to customer@wiley.com, or sending snail mail to Wiley Publishing, Inc., 10475 Crosspoint Boulevard, Indianapolis, IN 46256.

And, of course, the very next place to go is to the section of this book that covers your favorite topic. Go ahead and dive right in.

Book I

Digital Photography Overview

The 5th Wave By Rich Tennant

"THAT'S A LOVELY SCANNED IMAGE OF YOUR SISTER'S PORTRAIT. NOW TAKE IT OFF THE BODY OF THAT PIT VIPER BEFORE SHE COMES IN THE ROOM."

Contents at a Glance

Chapter 1: The Essentials of Good Digital Photography

*I*n 1888, George Eastman began promoting the first hand-held Kodak camera with the slogan, "You press the button, we do the rest." His idea was to make the camera as ubiquitous as the pencil. However, the film king's dream didn't really come true until the invention of the digital camera.

Certainly, conventional photography has long been as simple as pressing a button, but the "we do the rest" part — taking the film to a photo lab, deciding what size and kind of prints to make, and then waiting for the results — is a lot less convenient than using a pencil.

Digital photography has finally put the entire process of making pictures in the hands of the person holding the camera. You compose the picture through the viewfinder (as always), but now you can preview the exact photograph that you're going to take with a bright liquid crystal display (LCD) screen on the back of your camera, or through an electronic viewfinder inside. Then, after snapping a shot, you can instantly review the photos you've taken and erase the bad pictures on the spot.

Even better, you don't need to remember to stop and buy film; digital "film" (storage memory) is almost infinitely reusable. And you don't have to drop off film for finishing any more: It's "processed" instantly, ready for viewing or printing from your own inexpensive color printer. Wow, no more sifting through stacks of prints of marginal images. You decide which images to print up and whether to make them 4 x 6 inches or 5 x 7 inches or some other size.

You also don't need to fret if your images aren't exactly right or could benefit from a little cropping. With an image editor, such as Photoshop cs or Photoshop Elements 3.0, you can fix bad color, remove your ex-brother-in-law from a family photo, or adjust the borders of an image to focus on the most interesting subject matter.

Digital photography puts everything in your hands: You press the button, and you can do as much of the rest yourself as you're comfortable with. If all you want to do is point and shoot, you can do that. Taking photos and making prints can be as simple as snapping a picture and then slipping your digital film card (also referred to as a *memory card*) into a slot in your color printer to crank out selected snapshots. Or, you can take your memory card to a kiosk or digital workstation at your local retailer and make prints there. On the other hand, if you want to have full control over your photos, digital photography gives you that, too, to a degree that has never before been possible.

This chapter provides an overview of the sort of things you can find out how to do in this book. I cover each topic in more detail in a mini-book and chapter of its own.

Knowing What Equipment You Need

I realize that not all of you are curled up with this book in one hand and a digital camera in the other. You might already have a digital camera and have just purchased this book to find out exactly what you can do with it. However, I'm guessing that quite a few of you haven't taken the plunge yet. You bought this book to find out more about digital photography before expending your hard-earned money on the equipment you need. You have questions that need answered first: Can a camera that I can afford do the things I need it to do? Can a computer fumble-fingers like me really do digital photography? What's the best camera to buy? Others of you are digital camera veterans who are already thinking of upgrading. You, too, need some advice about equipment, which you can find in this book.

Choosing a digital camera that's right for you can be tricky because a lot more goes into your selection than simply the specifications. Two cameras with identical specs can perform quite differently. One can exceed your expectations while the other one frustrates the heck out of you. I explore some of the subtleties of camera selection in Chapter 2 of this mini-book.

However, if you want to get the most from this book, your digital camera should have certain minimal features and capabilities. For example, if your digital camera is one of those Web cams that can capture stills measuring 320 x 200 pixels, or maybe 640 x 480 pixels, you probably don't have what you need to take serious or semi-serious digital photos.

One of those $79 digicams with a lens that can't be focused, no exposure controls, and no removable storage probably won't do the job for you, either, other than as a fun toy. If you believe the adage, "Any camera is better than no camera," go ahead and slip one in your pocket and be ready to take a snapshot anytime, anyplace (as long as there is enough light, your subject holds still, and a wallet-size print will suffice). Such a minimalist digital photo system, however, won't enable you to do much.

Any digital camera costing a couple hundred dollars or more will probably do a fine job for you. Even the least-expensive, true digital cameras today boast resolutions of at least 2 megapixels (MP). (That is, at least two million pixels of information, usually 1600 x 1200 pixels or more.) Typical digital cameras have automatic exposure, a color LCD viewing screen for previewing or reviewing your photos, and removable storage so you can take out your digital film card when it's full and replace it with a new one and keep shooting. Most have a zoom lens so that you can magnify an image without moving forward, which is invaluable when you want to take pictures of different subjects from one spot.

Those minimum specs give you everything you need to take great photos. After all, it's the photographer, not the camera, that produces the best images. I once wrote an article for *Petersen's PHOTOGraphic* magazine, in which I presented photos of the same subjects, side-by-side, taken with an inexpensive point-and-shoot camera and a full-blown professional system that cost 100 times as much. After both sets of photos had been subjected to the vagaries of halftone reproduction, it was difficult to tell them apart.

Spending a lot on a digital camera buys you a few new capabilities from better zooms, enhanced resolution, interchangeable lenses, or a more sophisticated built-in flash. If you have a full-featured model, you can find lots of information in this book on how to get the most from your camera's capabilities. But this book also contains workarounds for those owning more modest equipment.

You can find digital cameras suitable for the most exotic of photographic pursuits, such as the underwater set-up shown in Figure 1-1. It's a Canon WP-DC300 waterproof case for the Canon PowerShot S50 digital camera. It provides full access to all your camera's controls while letting you photograph those colorful coral reefs in Tahiti at depths down to 100 feet!

Figure 1-1:
Even underwater photography is possible with modern digital cameras.

Minimum and Maximum Specs

For most of this book, I assume that you have a digital camera with at least 2MP of resolution. (If you don't understand resolution right now, see Chapter 2 of this mini-book for an explanation.) A camera with a 2MP sensor corresponds to about 1600 x 1200 pixels, which is enough detail to give you decent 6 x 8" prints or larger at 200 dots per inch (dpi) printer resolution. A 2MP camera also can capture enough information to allow some cropping, especially if you plan to use the image on a Web page, where high resolution isn't necessary. A 5MP resolution was a standard midrange spec as I wrote this book.

However, if you have an older 1.0–1.3MP camera, you can still do plenty of things, even though such cameras are becoming rare. You can prepare images for dynamite Web pages and make sparkling 4 x 5" prints. I still use an ancient Epson digital camera that maxes out at 1024 x 768 resolution to take pictures for eBay auctions; most of the time, the snaps are taken at a lower 640 x 480 setting that's plenty sharp enough for photos shown at small sizes.

Cameras with up to 8MP of resolution have dipped into the $1,000 range and will probably become common during the life of this book. If you own one of these babies, you can do even more. You can make tack-sharp 8 x 10" prints (and even larger prints if your printer supports them), crop out the center of an image, and still have sharpness to spare. Your camera will have loads of automated features, such as automatic *bracketing* (taking several exposures at different settings to make sure one is ideal) or a very long zoom lens (to reach way out and capture distant objects).

Although I seem to focus on the number of pixels a camera has, other considerations, such as the zoom lens that I just mentioned, might also be important to you. Even the least expensive cameras can have a 2:1 to 3:1 zoom, which can magnify an image 2X and 3X (respectively). Better cameras have 4:1 or longer zooms, up to 12:1 or more. Your camera probably has *macro,* or close-up, capability, which lets you grab images from inches away from your subject. Book III, Chapter 2 is devoted to close-up techniques.

Most of the other components (such as amount and type of memory storage, manual/automatic exposure and focusing options, built-in flash capability, and so on) can vary widely. You can find discussions of these in Chapter 2 of this mini-book.

Although I've been using single lens reflex (SLR) cameras (both digital and conventional) for more years than I care to think about, very little in this book actually requires a digital SLR to achieve. However, now that digital SLRs from Canon, Nikon, and Minolta are available for about $1,000, I expect a much larger percentage of readers will own a camera with what were until

recently considered high-end capabilities. Those of you with these sophisti-
cated cameras should still find lots to like in this book because one of my
goals has been to present pro-level techniques in ways that can help begin-
ners, too. If you have a digital SLR like the one shown in Figure 1-2, you'll find
these techniques even more useful.

One thing that I avoid in this book is mentioning specific camera models
except as a matter of interest from time to time. My oldest digital camera
in regular use is a half-decade-old (plus) Epson PhotoPC 600. When camera
model matters, I might mention 6MP or 4MP or 2MP models in a generic
sense. You won't find any discussion in this book about the relative merits
of the latest Nikon or Canon cameras or other references that will be hope-
lessly outdated in a few months. (Those of you reading this in the year 2006
with your $400 12MP cameras should refrain from laughing.)

Figure 1-2:
Digital SLRs
are less
expensive
now and
well within
the reach of
the serious
amateur
photo-
grapher.

Taking Great Digital Shots

So, when you have a camera in hand, what do you need to know to take great digital photos? In this section, I discuss the knowledge that needs to reside in your brain (or be otherwise available) to take great pictures.

Understand how your camera works

No digital photography book can tell you how to turn on your camera, how to adjust the autoexposure settings, or how to use your model's self-timer to take a picture with you in it. Those are things found only in your camera's instruction manual. Read it. I promise that the information you seek is in there; it just might be hard to find. The instructions for my own Nikon digital camera are so cryptic that I found myself creating a cheat sheet with lists of steps, such as, "To turn off the autosharpening feature, press the Menu button, then. . . ."

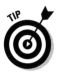

Some of the techniques in this book call for using a specific exposure mode or lens setting. I might ask you to switch to your camera's close-up mode to take photos a few inches from your subject. You might need to use your camera's built-in flash. Learn how to do these now so that you can add some simple but effective tools to your shooting repertoire.

Know some photography fundamentals

Certainly, you can point your camera and snap off a picture that might turn out great. Some prize-winning shots were taken in an instant as a fast-breaking news event unfolded without warning. Amateur photographers took more than a few of those photos, such as the famous Pulitzer Prize winner of a woman falling from a burning hotel captured by a 26-year-old Georgia Tech student. However, whatever part instinct and luck take in the production of great pictures, a little knowledge can be much more important.

✦ **Composition:** If you know a little about composition, you can nudge your images into a more pleasing arrangement. (See Book III, Chapter 1, for a full course in photographic composition.)

✦ **Focus:** Understanding how focus can make parts of your image sharp or blurry gives you the freedom to use focus selectively to isolate or emphasize subjects (see Book III, Chapter 2).

✦ **Shutter speeds:** Some background in how shutter speeds can freeze action can improve your sports photography (see Book III, Chapter 5).

✦ **Lighting:** Although you don't need to become an expert in lighting effects, understanding how light works can improve your people pictures (see Book III, Chapter 3).

Find out how to use an image editor

In digital photography, the pseudo-snap of an electronic shutter is only the beginning. With an image editor, you can do lots of things after the shot to improve your photo or even transform it into an entirely new one. Simple image editors enable you to crop pictures, fix bad color, or remove defects such as those glaring red eyes found in many flash photos. However, you can find even more creative freedom in more advanced image editors that let you do anything from eliminating trees that appear to be growing out of your subject's head to bringing seriously damaged photos back to life. If you want to polish your reputation as an all-around digital photographer, plan on developing at least a modicum of skill with a decent image editing program. You'll find general information on a broad range of image editors in Book IV as well as specifics on Adobe Photoshop CS and Photoshop Elements 3.0 in Book V.

Master a scanner

Digital photographers don't *have* to own a scanner, but you don't *have* to own a camera bag or an extra digital film card, either. Like other digital accessories, a scanner provides you with some supplemental techniques that let your scanner complement or substitute for your digital camera. For example, a scanner can be used for producing close-up images of relatively flat three-dimensional (3-D) objects, such as coins. A scanner can grab pictures of very small objects (less than 1 x 1 inch) that are difficult to capture with a digital camera.

The exact kind of scanner you have isn't important as long as it's a flatbed model, like the one shown in Figure 1-3. I explain the differences between the major types of flatbeds and how their capabilities diverge (that is, some scanners can be used to scan 3-D objects, whereas others can't) in Book II, Chapter 4.

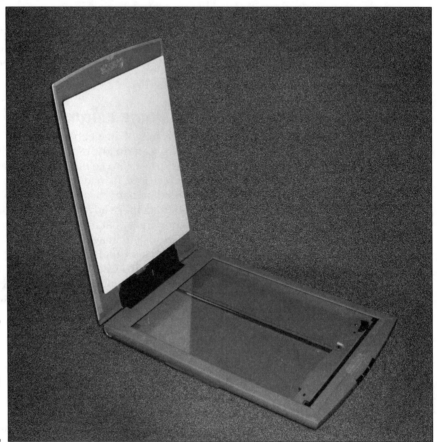

Figure 1-3:
Flatbed
scanners
can turn any
print into a
digital
image.

Making Any Photo Digital

In this book, you can also find out how to transform any photo you happen
to have into a digital image. Scanners are one way to do this: Slap an existing
photo down on the scanning bed, scan it into your image editor, and you have
a digital image that's the equal of anything you might capture with your digi-
tal camera — except it's likely to have dust spots!

Or, drop off your film at your local photo lab and request a Picture CD along
with (or instead of) your prints. Picture CDs and their cousin Photo CDs can
be produced from slide film, too, or even stacks of existing prints. What you
receive for your money is a high-resolution scan of your images, perfect for
manipulating in your image editor and printing on your own color printer. You
don't even need to own a scanner: Your photo lab does all the work for you.

Another option is using a local or mail-order service that processes your film and puts the finished images on the Internet. You can download your photos to your computer or make them available for viewing by family, friends, and colleagues on a Web page. What could be easier? You can find more information on this topic in Book VII, Chapter 2.

Printing Your Final Pictures

The final piece of the digital photography puzzle is the hard-copy print. You can create photos electronically, view them on your computer, post them on your Web site, and send them to others as e-mail, but nothing beats having a stack of prints to pass around or an enlargement to hang over the fireplace.

In Chapter 6 of this mini-book, you can find basic information on making prints, and you can find more advanced advice in Book VII. The good news is that the equipment you need is inexpensive and easy to use. A photo-quality inkjet printer can set you back $100 or so. It probably plugs directly into a USB port on your computer and requires little or no setup. Making the prints can be a point-and-click operation. A variety of printers can do the job for you. The one shown in Figure 1-4 has slots for your camera's memory cards and an LCD display that shows each photo you took, so it can produce prints directly from your digital film, with no computer required at all!

Figure 1-4:
Producing sparkling prints is fast and easy.

The bad news, if it can be called that, is that the cost of materials can seem a little high. You can pay $1 or more just for the paper and ink for a single 8 x 10" print. However, I show you some money-saving tips in Book VII, Chapter 1. The best news is that unlike a photofinishing lab, you don't make a print of every single photo you take. You can view your prints on your computer display and make hard copies of only the very best. From that angle, making your own prints isn't expensive at all. You're printing only the pictures you want — and in the long run, probably paying a lot less overall than you used to spend on those prints that end up in a shoebox.

Chapter 2: Basics of Equipment

In This Chapter

✔ **Choosing the best camera**

✔ **Looking at resolution**

✔ **Examining camera categories**

✔ **Checking out basic camera features**

C hoosing a digital camera isn't a once-in-a-lifetime thing any more than buying a car, choosing a computer system, or purchasing a television is. Your goal should be to select the digital camera that can do the job you want today and for the foreseeable future but not for the rest of your life. Odds are that you'll be making the decision all over again two or three years down the road when prices have dropped even further and new features are available.

You want to choose wisely now while planning to make future upgrades. In that sense, purchasing a digital camera is more like buying a television than a computer system. Most computers can be easily upgraded to add features or improve performance. You can increase the amount of memory, substitute a DVD drive for an older CD-ROM drive, and perhaps even double or triple the speed with a new processor.

Comparatively, digital cameras aren't easily overhauled. Except for models with interchangeable lenses, you're pretty much stuck with the lens, sensor, and storage system built in to the camera when you purchased it. You can certainly enhance your camera with add-ons, such as lens attachments, additional removable storage, or a better external electronic flash unit. But essentially, no matter how much digital cameras improve over the next few years, yours will stay the same. Just like you wouldn't purchase a 45-inch conventional projection TV now if you're going to need a 42-inch HDTV set next year, you want a digital camera that's ready for everything you plan to throw at it.

This chapter is an overview of what to look for when choosing a digital camera that's best for you, whether you're a well-heeled amateur who changes cameras as often as many of us change clothes or a frugal buyer who wants a camera that will do the job for two or three years. You find out the basics of the features that you need to evaluate before you lay down your cash. In Book II, I go into more detail as you learn to build your digital studio, starting with a detailed look at cameras and features in Book II, Chapter 1.

Deciding What You Need

What's the best car on the market? That's hard to say without knowing your driving plans, isn't it? Will you be making a 40-mile commute on crowded freeways every day? You might find that a 40 miles-per-gallon econobox suits your needs. Do you have six kids to transport? Plan on driving off-road? Need to impress the country club set? Will you be running in road rallies during the weekends? You can see why the automotive world has so many options.

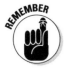 The same holds true in the digital camera realm. Some kinds of cameras do some kinds of things better or more easily. Although you can use workarounds to get great sports photos or close-ups with cameras that aren't particularly suited to those situations, you're better off carefully defining your expectations before you purchase a camera.

Unfortunately, price isn't the best indicator. If you want to take lots of different kinds of pictures, you can't just buy the most expensive camera and figure that it has every feature you can possibly need. You'll probably end up with a camera so complicated that you'll spend more time trying to figure out how to access a feature than actually taking the photo. I've used digital cameras that force you to access a menu, press several buttons, and then turn a dial just to be able to manually focus.

In the following sections, I discuss some of the things that you need to consider before you begin to narrow your choice to a particular category or brand of digital camera.

How much resolution do you need?

Digital cameras are often categorized simply by the amount of detail they can capture — *resolution* — which is measured by the number of pixels available in the sensor, regardless of their other features. Although the resolution of the camera might be 1600 x 1200 pixels (or some other figure), it's advertised only by the total number of pixels that it can grab. Thus, it's classified as a 2 megapixel (MP), 4MP, or 6MP camera, as if that resolution figure is the only measure of the camera's value. I can almost visualize digital cameras on shelves with unit pricing stickers like you find at a supermarket. Hmmm . . . one camera offers 4000 pixels per $1 whereas this other one gives you 6600 pixels per $1. Clearly a better deal!

 In practice, the resolution that you require depends a lot on what you plan to do with the photos you take. Do you plan on making excellent 8 x 10" or larger prints? If so, you need a camera with a minimum of 3.3–6MP. Is it likely that you'll crop a small section out of the center of an image and make a 5 x 7" print out of that? You'll need one of those high-resolution cameras, too. You can probably see the difference between the top photo in Figure 2-1, taken with a 4MP camera, and the one below it, taken with a 1.3MP camera and enlarged to the same size.

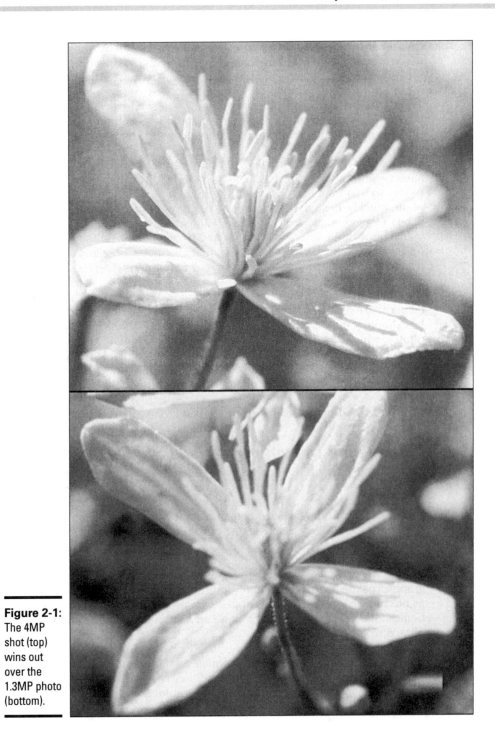

Figure 2-1:
The 4MP
shot (top)
wins out
over the
1.3MP photo
(bottom).

On the other hand, do most of the photos you take end up in digital presentations viewed on your computer screen? Are you creating newsletters or other desktop publications? Will you rarely make prints larger than 4" x 6"? A camera with 2–4MP will probably do the job for you and will probably also exceed your expectations. With the money you would have spent on pixels, you can invest in a camera with a better zoom lens or more digital film (so that you can take more vacation pictures).

Perhaps you'll be taking pictures of things you plan to sell at eBay. Figure 2-2 shows a photo that I took for an eBay auction. It was resized to 550 pixels (wide) so that people who viewed the auction page could download the photo quickly. In such situations, you rarely want images wider than 600 pixels. Or, you might be setting up a Web page of your own with lots of individual photos. A camera with as few as 2MP might be best for you. You can find tiny digital cameras in this range that slip in a pocket and are always available for a quick snapshot. There really are times when less is more.

As you decide the amount of resolution you need, remember that digital cameras are downwardly compatible. That is, a higher resolution camera has shooting modes at lower resolutions, so your 4MP camera can take 2MP photos, which saves space on your digital film and hard drive when the extra resolution isn't needed. If 90 percent of your photos require only 2MP of resolution but a solid 10 percent could benefit from a bit more pixel-grabbing capability, seriously consider getting a higher-res model.

I look at resolution in more depth in Book II, Chapter 1.

Do you plan to manipulate your photos?

Many digital photographers don't want to mess with image editing programs. All they want to do is take pictures and either make prints or view them in digital albums onscreen. They see the need to spend extra time with an image as a drawback, finding tasks (such as cropping or correcting colors) to be a needless waste of time. Such snapshooters fall into two broad categories. Many are amateurs with little interest in photography itself: Their interest is in the pictures that capture memories of vacations or document their little ones as they grow up. Others are business professionals who use photographs as a means to an end and want the process to be as fast and simple as possible. If you were a real estate agent preparing an online database of homes for sale, would you want to spend a lot of time editing hundreds of photos of your listings?

On the other hand, photography enthusiasts take great joy in the ability to edit their photos, using image manipulation as a creative outlet or, at the very least, a means to perfect their photographic vision as they tweak the image to look exactly as they planned.

Figure 2-2:
This image
was resized
to a 550-
pixel width
for display
on eBay.

If you belong in the latter camp, you'll want a camera with lots of features
and lots of options so that you can get sharp images worthy of your image
editing efforts. But if all you want are pictures, consider a basic point-and-
shoot digital camera.

Are you a photo hobbyist?

If photography was in your life long before you considered buying a digital
camera, you'll want all the manual features you can get, a powerful zoom
lens to give you a variety of perspectives, and compatibility with as many
add-on gadgets as possible. Dedicated photo hobbyists talk about the impor-
tance of composition, darkroom skills, and the photographer's eye. But I
haven't met one yet who didn't think that a bit of technology, properly
applied, couldn't make a good photo even better.

Photo hobbyists tend to spend a lot on their pastime and understand and
value all those features that others seldom use. If you're an avid amateur
photographer, don't try to scrimp when the time comes to buy your digital
camera. You'll regret it later.

How often do you plan to upgrade?

If you don't intend to replace your digital camera for a long time, consider spending a little more now on a camera that will avoid the shadow of obsolescence a little longer. On the other hand, if you know you'll buy a new camera next year, go ahead and buy one that suits your needs today. Tomorrow will take care of itself.

Believe it or not, you can purchase a digital camera for the long term if you opt for more than a basic model. For example, you can use a 4MP digital camera with a zoom lens and a standard removable storage system, such as CompactFlash, for most applications for a long time to come. Such a camera has enough resolution for good-looking, 5 x 7" photos and is versatile enough to take a broad range of pictures. Unless your needs change drastically, a good digital camera in that range can serve you well for two or more years. In fact, two of my favorite and most-used film cameras are a 120 roll-film SLR (single lens reflex) and a 35mm SLR that are each almost 30 years old. They still do the job, even if batteries for them have become hard to come by.

If you find yourself yearning to take different kinds of photos and constantly upgrading your expectations, however, you'll probably want to upgrade cameras more frequently. Digital cameras are adding features at reduced prices at an amazing rate. When I wrote my first digital photography book in 1995, a 2MP SLR digital camera cost up to $30,000. By the turn of the century, 6MP SLRs were available for $5,000; today, they cost $1,000 or less.

If you can afford it, you might want to upgrade every year or so. Even if you can do that, it's wise to take your upgrade plans into account when buying today. You'll want to use the accessories that you buy now with your new camera. Or if your pocketbook has restrictions, you might want to scale back your expectations today so that you can afford to dump your current camera when you upgrade.

Defining Categories

Digital cameras fall into several overlapping categories, which are usually defined by the number of pixels that they can capture, plus some other features, such as lens type, availability of manual controls, add-on accessories, and other features. Specifications that define a category change over time. Point-and-shoot cameras once had 640 x 480 to 1024 x 768 resolution (less than a megapixel). Today, even the most basic cameras have 2MP of resolution or more. However, the categories themselves have remained fairly constant in terms of types of snapshooters or photographers they attract.

Web cams

This book more or less ignores Web cams. They're not toys, but they're not digital cameras within the scope of this book. Web cams are low-cost (less than $100) TV cameras that can supply low-resolution (640 x 480 or 320 x 200/240 pixel), full-motion images that can be transmitted over the Internet, put on Web pages, or attached to e-mails. Most can also capture low-resolution still images.

These cameras frequently lack removable storage or controls, have lenses that don't zoom, and might not even have a facility for changing focus. A good first camera for kids or a spare digital camera, they're useful for note-taking (say, to document the various steps of a science project experiment). However, most Web cams aren't flexible enough for serious digital photography. Moreover, in a pinch, most conventional digital cameras can grab motion clips. My advice: Unless you really need a Web cam, don't consider buying one.

Point-and-shoot models

Point-and-shoot digital cameras cost about $200 and can do anything that a simple film camera can do. Most will have 2–3.2MP resolution; a built-in flash; some sort of removable storage; and either a fixed focal length, nonzooming lens (in the ultracompact models) or a modest 3:1 to 5:1 zoom that provides a little magnification. Expect automatic exposure and no manual controls. Figure 2-3 shows a typical point-and-shoot model.

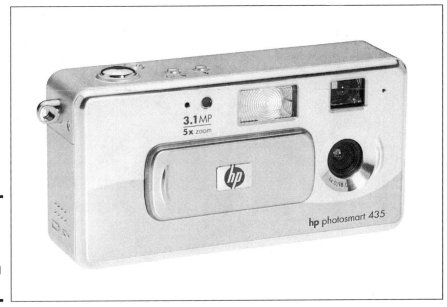

Figure 2-3:
This is a typical point-and-shoot digital camera.

Intermediate models

Intermediate digital cameras, priced in the $200–$500 range, are the most widely used. As such, they have the best compromise of features to suit most consumer needs. Look for 3.2–5MP resolution; a 3:1 to 4:1 zoom lens; either CompactFlash or Secure Digital (SD) storage; and at least a few special options, such as different exposure modes, close-up focusing, or manual controls. Figure 2-4 shows a popular, intermediate-level digital camera.

Advanced consumer models

In the $500–$600 price range, you can find digital cameras aimed at those who want some special features, extra resolution, or a longer zoom lens. These are 4–6MP models with 4:1 to 10:1 zooms (or better) and plenty of add-on accessories, such as wide-angle and telephoto attachments, filters, external flash units, and more. You can also find lots of optional exposure modes, customizable settings, and other (potentially confusing) features. Advanced consumer cameras usually require a session or two with the instruction manual to master all their capabilities, but they have few limitations. Figure 2-5 shows an advanced digital camera.

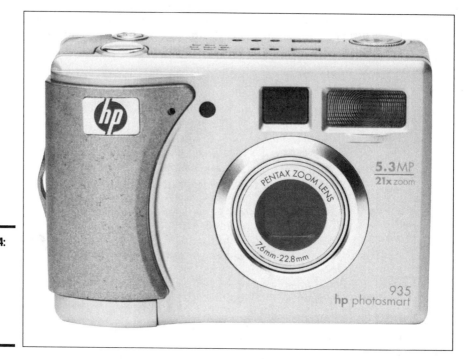

Figure 2-4:
This is a popular intermediate-level camera.

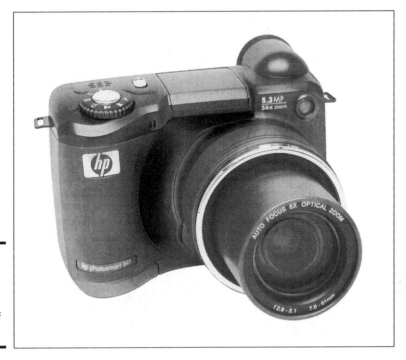

Figure 2-5:
Advanced
digital
cameras
have lots of
features.

Prosumer models

Prosumer (falling between consumer- and professional-level) digital cameras
are the models that photo buffs and even a few professional photographers
favor. The avid photographer doesn't countenance much in the way of com-
promises and is willing to spend the $1,000–$3,000 tariff for these cameras in
order to get the advanced features. Pros find them useful as backup cameras,
even if most aren't quite rugged enough to take the beating that professional
equipment is subjected to.

Prosumer cameras feature an electronic or optical through-the-lens
viewfinder that lets you evaluate and focus through the same lens used to
take the picture. These cameras either have a good-quality, fixed zoom lens
(in the 8:1 to 10:1 magnification range) or, in some cases, take the same
interchangeable lenses that film camera stablemates from the same vendor
accept. (The latest Canon, Minolta, and Nikon prosumer cameras belong in
this category.)

Expect a minimum of 5–6 million pixels to shoot with, plus a lot of extra
weight to lug around, particularly if your model is not built from the ground
up as a digital camera but is based on an existing 35mm SLR.

All other controls on a prosumer digital match or beat those found on conventional film cameras. You get automatic and manual focus as well as multiple automated exposure modes, plus manual shutter speed and lens opening settings if you want them. About the only difference between high-priced prosumer digital cameras and professional digital cameras is the speed (pro cameras can usually snap off digital pictures at a 5 pictures-per-second clip; prosumer models might be limited to 2–3 pictures per second) and ruggedness. Figure 2-6 shows a prosumer camera with an electronic viewfinder.

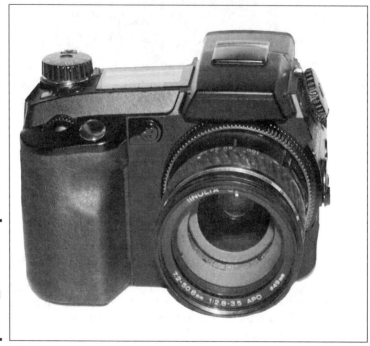

Figure 2-6:
Prosumer
cameras
rival
professional
cameras in
features.

Professional models

Pro digital SLR cameras still cost $3,000–$30,000 and have both the pedigree and features to match. These high-end models are the equals of their film camera counterparts in almost every way. If you can't do it with one of these, it can't be done.

You'll find 6–14MP sensors in these cameras, and you can fit standard interchangeable lenses to them while retaining all the sophisticated autoexposure and autofocus modes of their film camera mates. One feature that pros demand is speed. If you use a pro camera, you'll see just how this speed is applied: Lesser cameras are often hampered by a time lag between the time

you press the shutter button and the instant when the picture is actually taken. Then you might have to wait a second or two while the photo is saved to the storage media. Although some prosumer and advanced amateur digital cameras let you take another shot or two immediately, you're limited to two or three before you have to stop and wait for the storage to catch up.

On the other hand, with a pro camera (such as the one shown in Figure 2-7), you can usually snap off pictures as quickly as you can press the shutter release or trigger the motor drive (continuous shot) mode. (History lesson: *Motor drives* are used with film cameras. They're battery-powered, super-fast film-advance mechanisms that pull the film quickly after exposure, allowing you to grab several quick shots in succession — faster than your winder thumb and shooting pointer-finger can wrangle.) You might be able to snap off 5 pictures per second for as long as you like — or at least until the storage media fills up. That can be a long time because pro digital cameras usually accept humongous storage options, such as 1GB (or larger) mini hard drives.

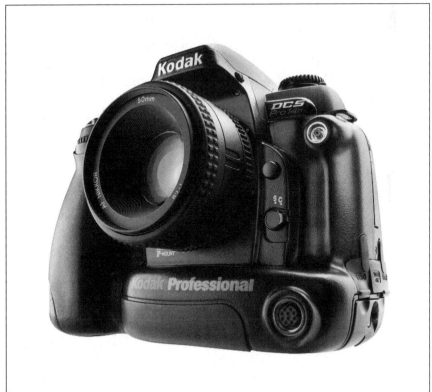

Figure 2-7:
Professional
digital
cameras
cost a lot,
but they can
do a lot!

Pro cameras (as well as prosumer models) with interchangeable lenses often boost the effective magnification of your lenses as well because the sensors on many models are smaller than the nominal 24 x 36mm 35mm film frame. A 35mm lens or zoom setting might have the same field of view as a normal lens on a film camera. A 105mm portrait lens can become a longer telephoto. However, some of the latest cameras have a true 24 x 36mm sensor and can use lenses at their marked focal lengths.

Checking for Key Camera Features

Check out Book II, Chapter 1, for a close look at all the features to consider for your digital camera. In this overview chapter, I provide a list of the key features that you should think about. I discuss resolution earlier in this chapter (because resolution is one of the key ways of categorizing cameras), but thus far I've only touched briefly on other features. Here's a summary of what to look for:

✦ **Resolution:** Again, resolution determines how sharp your image will be, how much you can enlarge a photo before the pixels start to become distracting, and how much you can crop a photo and still be left with a decent image that you can enlarge and manipulate.

✦ **Lens:** The lens is the eye of your digital camera. Look for the following in your lens:

 • You'll want good, quality optics that focus a sharp image on your camera's solid-state sensor. The best way to gauge the quality of the lens is to take a test photo or two. A vendor's reputation or lab tests in magazines are other ways to evaluate a lens.

 • The lens also needs enough light-gathering power to let you shoot in reduced light levels. A camera's light-gathering capabilities are measured in *f-stops,* which I explain in more detail in Book II, Chapter 1.

 • The magnification power of the lens (how large or small an image appears to be from a particular shooting position) is another factor. A digital camera's lens magnification can usually be varied by zooming in and out to make the image larger or smaller.

 • A related factor, the zoom range, is another key characteristic to look at. Whereas magnification tells you only how large or small the image can be made to appear, the zoom range tells you the difference between the two. As I mention under the discussion of general camera categories, some lenses have only a small zoom range, say 2:1, whereas others have a longer range of up to 12:1 or more (which means the image size can be varied up to 12X).

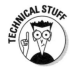

What's the difference between magnification and zoom range? Magnification deals purely with how large or small an image appears to be. For example, one lens might extend from a 28mm (35mm equivalent) to 85mm (35mm equivalent) magnifications, which is a 3:1 zoom range. Another lens might go from 50mm to 150mm (both 35mm equivalents) and also qualify as a 3:1 zoom range optic. However, the second lens would provide more magnification.

✦ **Storage:** The kind and amount of removable storage is another key feature. The more storage space you have for photos, the more pictures you can take before "reloading" your digital camera. Most cameras use CompactFlash, Secure Digital, or other electronic pseudo-film media. You can find more on this topic in Book II, Chapter 1.

✦ **Exposure controls:** Except for the least expensive models, all digital cameras include automatic exposure controls that adjust the amount of light reaching the sensor based on the lighting conditions of your subject. If the illumination is low, an autoexposure system uses a wider lens f-stop or exposes the sensor for a longer period of time. If there is a lot of light, the exposure system reduces the amount of light reaching the sensor. Cameras with more versatile automatic exposure controls let you specify what type of exposure to use.

For example, when shooting action, it's often preferable to use the shortest shutter speed possible to freeze the motion and adjust the size of the lens opening instead. Conversely, if you want a lot of your image to be in sharp focus (say, objects both very close to the camera and very far are both important), you might be able to choose an exposure mode that favors maximum *depth-of-field*. You probably want a digital camera that can handle several different exposure modes and lets you set exposure yourself. I explain more about these modes in Book II, Chapter 1. If you want the maximum control over your pictures, you want a camera that allows manual control of exposure, too.

✦ **Focus controls:** Most digital cameras also have an automated system for sharply focusing your images. Some are more versatile than others, and many cameras also let you focus manually to ensure that the subject matter that you want to emphasize is the sharpest.

✦ **Viewfinders:** Digital cameras generally have several ways to let you preview and compose your images prior to exposure. The color LCD panel on the back of the camera shows you the same image that the sensor is capturing. Because the LCD is often hard to view in bright light, digital cameras also have optical viewfinders that let you see a nonelectronic version of the frame. Another option is the so-called *electronic viewfinder* or EVF, which replaces the optical viewfinder's window with a peephole used to view an LCD similar to the one on the back of the camera but

more protected from extraneous light. High-end cameras (SLRs) let you see an optical version of the picture through the same lens used to take the photo. I explain more about your viewfinder options in Book II, Chapter 1.

✦ **Other equipment, other features:** Finally, as you choose your digital photography gear, think about accessories, such as tripods, filters, add-on lenses, external electronic flash units, scanners, printers, and additional stuff. Even the storage media you use to archive your photos, such as Zip drives, CD-ROMs, or DVDs, can all be important.

I reveal the mysteries of these extra pieces of equipment in various parts of Book II. This overview has given you enough to think about.

Chapter 3: Acquiring Your Digital Pictures

In This Chapter

✓ Transferring from your camera to your computer

✓ Scanning images

✓ Getting photos online or on a Photo CD from a photo lab

How do you acquire digital photos? The quick answer is, "With a digital camera!" However, the digital photography process involves more than simply snapping a picture. Indeed, you can use other ways of acquiring a digital picture that don't even involve a digital camera. Scanners, for example, can convert any printed image into a digital image. Some scanners, such as those with slide scanning attachments or dedicated slide scanners, can even capture color transparencies or negatives.

In this chapter, I provide you with an overview of all the ways you can acquire digital pictures. I also point you to other chapters in this book that explore these topics in more detail.

From Camera to PC

The first challenge that you have to face is getting your digital images from your camera into your computer so that you can edit them (if necessary), store them on some archival medium (such as a CD-R or DVD), and make prints. Today, transferring images to your computer is a fairly painless process. It wasn't always so.

My first digital camera had no removable storage. It was bad enough that when the camera's internal storage was full, I had to stop taking photos. Even worse, it often took 10–20 minutes to move those photos from the camera to my computer. The only option was an old-fashioned serial cable that moved an image one bit at a time, like a line of soldiers, from the camera to the serial port on my computer at about 64 kilobits per second (Kbps).

Even at a prehistoric resolution of 640 x 480 pixels, I had roughly 2.5 million bits (307K, or kilobytes) to move per picture. So at best, I spent a minimum of 40 seconds transferring *one* photo. It seemed longer.

To make things worse, this was back in the days when PCs didn't share peripheral ports very well, so my computer really had only two functional serial ports. I used one for my mouse and the other for both a modem and my camera's serial cord. I had to unplug one to use the other. This might seem bizarre today, when a computer's serial ports might not be used at all, with the USB (Universal Serial Bus) ports used to connect a mouse and dozens of other peripherals at once. And of course, the broadband connections that are available today have sent my modem to the dustbin, although I still have a USB port modem to plug in during emergencies. But, that's the way it was then.

Today, you have multiple options for transferring your images. I plug a USB cable directly into my favorite camera and transfer 5-megapixel (MP) images in a few seconds. I also have a *card reader* (a USB device with slots for different kinds of memory cards) that accepts seven different varieties and also lets me move images between the card and my hard disk as if the memory card were another disk drive. A card reader is shown in Figure 3-1. Your camera might feature an IEEE 1394 (FireWire) connection, write its images onto a miniature CD-R, or transfer images wirelessly. The latest innovation is to have multiple digital camera memory card slots built right into computers and printers so you don't even need a separate card reader.

Figure 3-1:
A card reader lets you transfer images from a memory card directly to your computer.

I outline all the options and explain the pros and cons of each type of camera-to-PC transfer in Book II, Chapter 3. You can find everything you need to know about transferring images from camera to PC or Mac there.

Grabbing Images of Hard Copies

Another way to create a digital image is to capture an existing print or slide with a scanner. As far as your image editor or printer is concerned, these kinds of digital images are just as digital as those that began their life in digital form in the sensor of a digital camera.

Indeed, before digital photography became common, the only way most of us who worked with images could acquire a digital picture was with a scanner. Scanners remain a valuable tool for anyone who needs digitized graphics. The good news is twofold: The price of scanners has come down since the late 1980s, and the features have also improved. Whereas my first "real" scanner (forgetting about toys such as the ThunderScan, available for the Macintosh in the mid-1980s) captured a whopping 16 levels of gray at 300 samples per inch (spi), my latest has a true resolution of 2,400 spi and can grab a few billion different colors. It's about ten times faster and includes a capable transparency scanner. My first scanner cost me about $2,500; the list price of my latest is about $200. A typical scanner is shown in Figure 3-2.

You can find a lot of information on scanners in Book II, Chapter 4, but I can summarize a lot of what you need to know here in this overview.

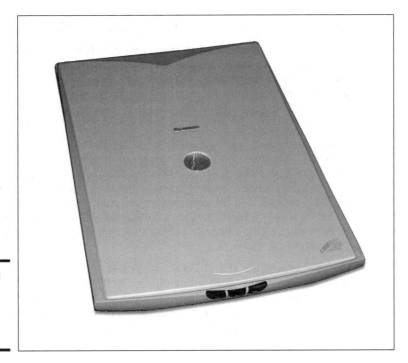

Figure 3-2:
This is a
typical
flatbed
scanner.

Kinds of scanners

Over the years, a variety of nonprofessional scanners has drifted off into the fog of history. My first scanner was a ThunderScan unit that replaced the ink ribbon in an Apple ImageWriter and captured an image on a photo or piece of paper as it fed through the roller. Other scanners have included the hand scanner, which looked like an overgrown mouse. You used your hand to move the sensor and light source. Another kind mounted the sensor above the original on a mounting arm and looked something like a photographic enlarger.

Yesterday's sheet-fed scanners live on in the form of dedicated fax machines that suck your documents past a stationary sensor. The flatbed scanner, which looks and works a little like a photocopier, has become today's standard.

Today, unlike times past, it's not necessary to agonize over what category of scanner to buy. That should be obvious from the kind of scanning you want to do:

+ **Flatbed scanners** are used for scanning reflective copy, such as docu-
 ments, photographs, articles torn from magazines, and other similar
 material. You simply place the original face down on the scanner's glass,
 and a moving bar with a light source and a sensor (or a mirror that reflects
 the light to a sensor located elsewhere in the scanner) captures the image
 a line at a time when you close the lid and activate the scanning software.

 Some flatbed scanners have a light source built into the lid (or another
 component), as shown in Figure 3-3. This light source can transillumi-
 nate a negative, slide, or transparency so that you can use the flatbed to
 grab images from transparent originals. These scanners can do a good
 job in noncritical applications, where you decide you can get by with
 less than the best, fastest, and sharpest.

+ **Slide scanners** are specialized units designed to scan slides and trans-
 parencies. They often have the higher resolution needed for scanning
 the 24mm x 36mm area of 35mm slides. They often cost quite a bit more
 than flatbed scanners although you'll find some models for as little as
 $299. Largely used in the past by professional graphics workers, slide
 scanners today in their low-cost configurations are popular among
 all consumers with lots of film and slides that they want to convert
 to digital form.

+ **Photo scanners** are simplified devices used to convert snapshots to
 digital format. Deposit your standard-sized photo in the scanner, and it
 grabs an image for you to edit. Photo scanners are sometimes mated
 with color printers so that you can make copies of prints as quickly as
 you can feed them into the scanner.

Figure 3-3:
Some
flatbed
scanners
have a light
source built
into the lid
for scanning
slides.

What to look for in a scanner

When shopping for a scanner, you'll want to look for a few important things. Here's a quick summary:

✦ **Resolution:** Scanners generally have a lot more resolution than you need, measured in samples per inch (spi). You'll also see the terms *dots per inch* (dpi) and *pixels per inch* (ppi) applied to scanners even though scanners don't have dots (printers do) or pixels (monitors do). Scanner resolution varies from 600 x 600 spi for older scanners to 2400 x 2400 spi

or higher for the latest models. Unless you're scanning tiny, very high-resolution originals (such as postage stamps), anything more than 300–600 spi is overkill. I explain why in Book II, Chapter 4. The difference between 300 spi and 2400 spi resolution is shown in Figure 3-4.

+ **Color depth:** This is the number of colors that a scanner can capture. The color depth is measured using something called *bit depth*. For example, a 24-bit scanner can capture 16.8 million different colors, a 30-bit scanner can grab a billion colors, and a 36-bit or 48-bit scanner can differentiate between . . . well, zillions of colors. You'll never have an original with that many different hues, however. In practice, the extra colors simply provide the scanner with an extended range *(dynamic range)* so that the scanner can capture detail in very dark areas of the image as well as in very light areas.

+ **Speed:** Some scanners are faster than others. If you're scanning a lot of photos, you'll want one that works quickly.

+ **Convenience:** So-called "one-touch" scanners have buttons mounted on the front panel so that you can trigger the scanner to make a copy (that's sent to your printer), scan to a file, route a scan to e-mail, capture text with optical character recognition, or perform other functions.

+ **Bundled software:** The best scanners are furnished with an easy stand-alone software interface plus a more professional scanning program that gives you total control over every scanning function. You also get drivers that let you access these interfaces from within programs, such as Photoshop. You might even get Adobe Photoshop Elements bundled with the scanner, plus software to create panoramas, build Web pages, manage documents, and do other fun stuff.

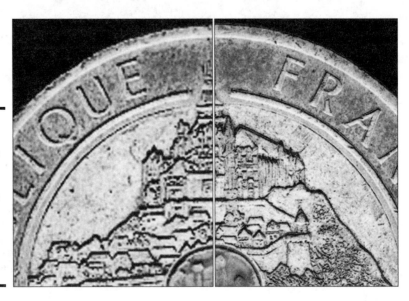

Figure 3-4:
Lower resolutions like 300 spi (left) don't provide the detail of 2400 spi scans like the one at right.

✦ **Accessories:** Some scanners include sheet feeders (for scanning a stack of documents) or can be fitted with them as an option. Others have slide-scanning attachments or built-in slide-scanning tools. Depending on the kind of work you do, these accessories can be a perk or a necessity.

To find out the details about the scanner features covered here, see Book II, Chapter 4.

Letting the Other Guy Do It

Sometimes you don't need to convert an image to digital format yourself. Professional services can do that for you. These range from standalone kiosks at your local retailer (with a built-in scanner and printer) to services that your local photofinisher offers.

When you take in your film for processing, your local lab can give you the same set of prints or slides that you always have received or return your images already scanned onto a Kodak Picture CD. Some mail-order firms offer the same service.

As long as your images are being scanned anyway, your professional service might post them on the Internet for you, either as Web pages or as files that you can download directly to your computer.

You can find more about these options in Book VII.

Chapter 4: Electronically Editing or Restoring a Photo

In This Chapter

✔ Deciding how to restore and improve digital photos

✔ Choosing which repairs to make first

✔ Picking the right software for your image editing needs

✔ Solving common photo problems quickly and easily

*R*emember when getting free double prints of your photos was a big deal? It was so convenient to have a spare copy of every photo on the roll. With the advent of digital cameras and scanners, however, the excitement of double prints has worn off. Why get doubles made when you can simply print as many copies of a given photo as you want? Why use traditional film and then have to get it developed when you can take the pictures with a digital camera and have them immediately? And why put up with damaged images or photos that are too dark or too light when you can fix them electronically?

With digital photography and a good image editor, you have the power to reproduce and repair your own photos as well as photos others have taken. This chapter is an overview of what's possible with photo editing software, which applications do the best job for the money, and how to make some quick corrections of common photographic problems, such as fixing red-eye and removing dust spots.

In this chapter, I also explain how you can improve the image quality and content of your digital photos by removing the telltale signs of age, poor photography, or bad lighting. (I even show you how to remove unwanted people or things — ex-boyfriends/girlfriends and the like — from the picture.) And if the last remaining photo of a long-departed relative is looking shabby or has faded with time, there's no need for alarm or regret: Just open your favorite image editing application (some programs to consider are discussed later in this chapter) and add color, remove spots, improve contrast, and in general make the image look like new. For example, Figure 4-1 shows before and after versions that illustrate how you can spruce up an old photo.

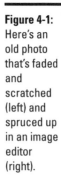

Figure 4-1:
Here's an old photo that's faded and scratched (left) and spruced up in an image editor (right).

You can also remove unwanted content — like that dumpster that nobody noticed when the picture was taken or the brother-in-law you really don't miss — and replace it with more desirable stuff, such as a hedge, a pet, or an extension of the background (any of which are likely to be more desirable than your ex-brother-in-law). You can make the photo look as though the item were never there in the first place.

Choosing an Image Editing Program

In a digital photograph, you can fix just about anything as long as your image editing program has the tools you need. You don't want a program to limit what you can do, but you also don't want to spend $600 when you could pay just $100. This section helps you figure out what type of editor meets your needs, and I offer you a guide to some of the different programs on the market.

Determining your needs

If you're using a powerful application, such as Photoshop Elements, the repairs and improvements that you can make are almost unlimited:

✦ **Selection tools:** You can use a flexible and powerful set of selection tools to control where the edits and repairs take place, thus eliminating changes to areas of the photo that are just fine as they are.

✦ **Brush tools:** You have access to a nearly unlimited set of brush tools for painting, drawing, and erasing anything you want, like the Photoshop Elements 3.0 Brush Tool set shown in Figure 4-2.

Figure 4-2:
A good
assortment
of brush
styles and
effects is
the mark of
a great
image
editing
program.

+ **Filters:** You can use filters to blur and sharpen images.

+ **Adjustment tools:** You can work with a vast assortment of color, brightness, and contrast adjustment tools (see Figure 4-3) to fix the results of an overachieving flash, a cloudy day, or old photo paper whose images faded and colors changed with time.

Figure 4-3:
Tinker with
color,
brightness,
and contrast
to bring
images
back to life.

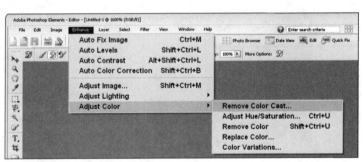

If you're using Photoshop Elements, the tools at your disposal are virtually the same set of tools found in the full version of Photoshop. Some of the features that only hardcore professional photographers use have been weeded

out in Elements, but the basic set of tools and features is still there. On the opposite end of the image editing power spectrum are simpler applications like ArcSoft PhotoImpression. The retouching tools for these applications are much more limited but are adequate for simple resizing, cropping, and brightness/contrast adjustments (see Figure 4-4).

Checking out different applications

So how do you know which application to use? Your needs are your most effective guide, but of course, your budget will have some impact as well. After you start pricing these applications, you'll notice that the prices vary from over $500 to less than $5. How can that be? Is the least expensive software terrible? Is the priciest application great? Well . . . no and yes. It all depends on what you want to be able to do, how intuitive you are with software, and how much photo editing you'll be doing.

Table 4-1 gives you an overview of what various applications have to offer. I discuss these and other applications in more detail in the following sections. You can find a more detailed comparison of the various software packages in Book 4, Chapter 3. Each of these applications is easy to use except for Corel PhotoPaint.

Figure 4-4: ArcSoft Photo-Impression has simple tools for simple editing.

Table 4-1	Overview of Image Editing Applications		
Product Name	*Expensive?*	*Mac or PC?*	*Editing Capabilities*
Adobe Photoshop cs www.adobe.com/ products/ photoshop	Yes (Over $600)	Both	Professionals prefer this program hands-down. You can do quick fixes, restoration, or just about anything.
Photoshop Elements 3.0 www.adobe.com/ products/ photoshopel	No ($99 retail)	Both	Great for the home user. Also good for quick fixes and more substantial editing. Has a Red Eye tool that Photoshop does not.
Jasc Paint Shop Pro www.jasc.com/ products/ paintshoppro	No (about $99)	PC	Similar to Photoshop Elements.
Microsoft Publisher http://office. microsoft. com/home	Yes (Usually sold as part of Office; $159 if sold separately)	PC	Photo retouching is not Publisher's main purpose, but if you use it for other things, the retouching tools can be convenient.
ArcSoft PhotoImpression www.arcsoft.com/ en/products/ photoimpression	No (Less than $99)	PC	Very easy to learn; automated features with plenty of templates.
Ulead Photo Express www.ulead.com/pe	No (Under $20)	PC	A simple, somewhat limited set of tools.
Ulead PhotoImpact www.ulead.com/pi	No (Around $99)	PC	Good, basic tools for photo retouching.
Corel PhotoPaint www.corel.com	Yes (Part of the CorelDRAW suite; over $500)	PC	A fairly comprehensive set of retouching tools but not quite as rich as Photoshop or Elements.
Corel Painter www.corel.com	No (Costs $499; $199 for upgrades)	PC	Consider as a companion to whatever other retouching software you buy; it has painting features not available elsewhere.

Adobe Photoshop cs and Photoshop Elements

Photoshop cs is the photo editing software for professional photographers, graphic artists, Web designers, and the like. Photoshop Elements was designed to put a good number of Photoshop's tools in the home and small business user's price range. The interface for these two products was similar

until Elements 3.0 came out dressed in a spiffy new interface. Neither are sit-down-and-use-it applications. You'll want to read the guide that comes with either editor or buy a book about the software (or use the portions of this book that specifically discuss these applications).

The top-of-the-line software (Photoshop) costs as much as $600 for a full version, but it does offer the most powerful set of image creation, editing, and retouching tools that you can lay your hands on. Photoshop Elements, which has functions similar to Photoshop for the average person's photo editing needs, is only $99 and even has some tools that Photoshop doesn't, such as an instant red-eye removal tool. Considering that, it's a steal at the price, and both Photoshop and Photoshop Elements are available for the Mac or Windows PCs. You might even find Photoshop Elements bundled with your digital camera for free!

Paint Shop Pro

Jasc's Paint Shop Pro is inexpensive (on a par with Elements), and it's power-ful. The interface is pretty intuitive, and it allows you to do all the standard stuff (resizing, cropping, rotating, color and contrast adjustments, and adding textures). It has some quick and useful tools for eliminating red-eye, scratches, tears, and so forth. If you feel intimidated by Photoshop or aren't big on using Help and figuring out stuff, you'll like Paint Shop Pro. It was designed for reg-ular folks, but it has photographer-quality tools included.

Corel PhotoPaint and Ulead PhotoImpact

Applications such as Corel PhotoPaint and Ulead PhotoImpact are intended as true competitors to Photoshop although neither does everything that Photoshop can do.

Corel Painter

Many serious digital photographers and artists own both Photoshop and Painter because Painter's natural media tools let you paint on image can-vases in ways that are completely different from what you can do with Adobe's flagship image editor.

Lower-end products, shareware, and freeware

The lower-end products — such as Photo Express, PhotoImpression, and others that you can find by searching the Web — are great for quick adjust-ments to size, rotation, and even simple color and contrast changes. If all you want to do is capture images from your digital camera and make minor adjustments to their size and general quality before sending them to friends via e-mail, these packages might be just what you need. If you really want to

restore and edit photographs for prints or Web pages, you'll probably be happier with one of the more powerful (and pricier) applications.

Some cameras and scanners come with basic image editing software, such as PhotoImpression or Photoshop Elements, and both Mac OS and Windows come with simple image editors that can perform some basic tasks. If you have very simple needs, you can use these free programs and pay nothing at all.

To find freeware and shareware for photo editing, search for "*Photo Editing*" at www.hotfiles.com or www.tucows.com. A search of either site's software libraries will yield a long list of downloadable freeware and shareware applications. *Note:* Shareware is not free: If you keep and use the product, be sure to pay its author or manufacturer — it's the right (and legal) thing to do.

Performing Photographic Triage

How do you decide what needs to be done to a given image? Well, some problems are obvious. A torn photo (where the tear shows in the scanned version) is in definite need of plastic surgery. A photo with a row of red-eye-plagued children needn't look like a lineup of demons. You can remove the red-eye and return the little darlings to their normal state.

Some photos, however, have several problems, and you might not be sure which problems to tackle first. There might be fading from age, scratches and scuffs from improper storage, yellowing, or stains. Maybe the picture was too dark or too light from the start. If your photo suffers from two or more problems, solving one might solve another if you attack them in the right order. Here's a series of tips to help you do a little image triage:

✦ **Handle structural problems first.** If there's a torn corner or a rip or hole in the photo, scan the image and repair the tear first in your image editor so that you're working with an intact "canvas" while you continue to fix other problems.

✦ **Adjust light and dark problems before tinkering with color.** If you add color to an image and then adjust brightness and contrast, the color added with the software can become too bright or too dark — or change to a color you don't want.

✦ **Determine whether content removal/replacement will solve other problems.** For example, as shown in Figure 4-1, the missing left edge of the photo was fixed by removing the person standing behind the boy on the bicycle. If you need to get rid of a person's hand or shoulder — or some other content that was inadvertently included in a shot — maybe replacing that content with something else will also get rid of a torn corner or a big scratch on that part of the photo as well.

Making Quick Fixes

For the purposes of this portion of the book, I use Photoshop Elements to demonstrate some quick fixes: simple, fast techniques for solving the most common photographic problems. You can find similar techniques in other applications, assuming that the applications can perform these tasks to begin with. If you're still up in the air about which photo editing program to use, the inability to perform some of these quick fixes is a good reason to take one or more of your alternatives out of the running!

Fixing red-eye

Red-eye results from the camera flash reflecting off a retina. We've all had it happen, especially when taking pictures of children who get too close to the camera, and with pets, whose pupils are quite large (letting in a lot more light). So what do you do when your dog looks like Satan's best friend or your niece's eyes look like two red marbles? You can use tools designed specifically to get rid of red-eye (see Figure 4-5), or you can use conventional editing tools to exorcise the demons that have possessed your image.

The Red Eye tool

Figure 4-5:
Get the
red out!

To use the Photoshop Elements 3.0 new and improved Red Eye tool, follow these steps:

1. **Click the Red Eye tool (refer to Figure 4-5) or press Ctrl+Y (⌘+Y) to select it.**

2. **Go to the Options bar that runs just above the document window and make sure the Radius Fraction percentage is set to 50 percent and the Darken Amount to 50 percent, both of which are average settings that work well for most photos.**

3. **Drag a rectangle around one eye, as shown in Figure 4-6.**

You don't have to be too precise. When you release the mouse button, the Red Eye tool locates the red pupil, removes the red coloration, and darkens it.

Note: This works only with red pupils; the yellow or green pupils found in animals are not affected.

4. **If the pupil is too dark, press Ctrl+Z (⌘+Z) to reverse the action. Then change the Darken Amount to a lower value and try again.**

Your results should look like Figure 4-7.

5. **Select the other eye or try clicking inside the pupil.**

The Red Eye tool works either way.

Figure 4-6:
Drag a rectangle around the eye. You don't have to be too precise.

If your image editing software doesn't have a specific red-eye tool, you can still get rid of red eyes. Doing so just requires a few more steps and tools:

1. **Set your application's Paintbrush tool to a size that matches the diameter of the red eye.**

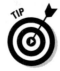

2. **Manually choose a color to replace the red.**

 Choose a color that's darker than the person's real eye color so that the colorization looks natural.

3. **Zoom in tightly on the eye to apply the color to the right spot.**

4. **Click with the brush to fill the red area.**

 This step should require just one click if your brush is set to the right size.

Figure 4-7:
The Red
Eye tool
removes
the red
coloration
from the
pupil.

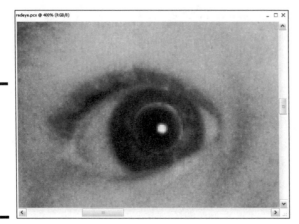

Removing dust spots

Dust spots and scratches are common problems for photos that are old and/or that have been stored in desk drawers and shoe boxes or tucked inside a book or a wallet. If the front of a photo has been rubbing up against other stuff — other photos, papers, or pens and pencils in a drawer — chances are that the photo has highly visible scratches. Dust can collect in these scratches, compounding the problem, or you might simply have scanned the photo without dusting it off first. Mold, things spilled on the photo, or just places where the emulsion has cracked and come off the photo can also create small, unpleasant blemishes.

Any image editing program provides the basic tools to clean up this sort of stuff. Although the Clone or Rubber Stamp tool (discussed later in this chapter) is useful for touching up dust spots, if the background is a solid color, you can use your software's Paintbrush tool instead — along with color selection tools — to correct the problem by following these steps:

1. **Use your program's Eye Dropper tool to sample the color near the scratch, spot, or stain.**

 If you're using Photoshop Elements 3.0, you don't need the Eye Dropper tool; just skip to Step 2.

Most applications have an Eye Dropper tool for selecting a color in the image and setting it as the paint color. You'll use the color you choose to paint over your blemish.

2. **Click the Paintbrush in the Tool palette to activate it; if possible, set the size of the brush so that you control how much color is applied.**

 If you're using Elements, hold down the Alt/Option key while clicking near the dust spot to sample the color; you don't need an Eye Dropper tool.

 Be sure to use a very small brush so you don't paint over nonblemished areas — to do so can leave obvious signs of the touchup.

3. **Zoom in on the area you want to touch up. Then, by clicking in the image and dragging your mouse, paint that color over the blemish, as shown in Figure 4-8.**

If your image editing software has filters or other similar tools specifically for cleaning up an image, you can use them instead of repairing the spot or scratch manually. Photoshop Elements has a Dust & Scratches filter that allows you to select the portion of the photo to repair, and it provides settings so that you can control to what degree the photo is cleaned up. Figure 4-9 shows the Dust & Scratches dialog box, which you open by choosing Filter➪Noise➪Dust & Scratches.

Figure 4-8:
The Paintbrush tool can touch up dust spots on a solid color background.

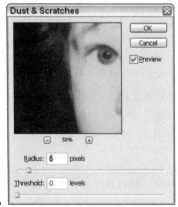

Figure 4-9:
The preview
window
shows how
the settings
affect the
final results.

To use the Photoshop Elements Dust & Scratches filter, follow these steps:

1. **Select the area to be repaired with any of Photoshop Elements' selection tools (Marquee or Lasso).**

2. **Open the Dust & Scratches dialog box by choosing Filter⇨Noise⇨Dust & Scratches.**

3. **Adjust the sliders by dragging both the Radius and the Threshold sliders to the far left.**

4. **Ease back the Radius slider, dragging it slowly to the right until you see the scratches and spots in the preview area disappear.**

You might have to tinker with the sliders until you like the result.

5. **When you like how the preview looks, click OK to apply the repairs to the selected area in your photo.**

If the entire surface of your photo is damaged, you can select the whole thing or repeat the filter procedure on several different selected areas. This latter approach is probably best unless the damage is absolutely uniform over the entire image. If it's not, you'll benefit from applying different levels of Dust & Scratches removal to the different areas of the image.

Don't go too far when removing scratches and dust because you could end up with a blurry image or a portion thereof that looks obviously smoothed out. If the photo is old or clearly an amateur photo, nobody expects absolute perfection, and going too far in removing every little tiny blemish can have an undesirable effect overall. However, Photoshop and Photoshop Elements share a handy feature under the Edit menu from which you can revert back to a previous version of your image. You can do this in steps if you go too far in the correction process.

Correcting color

Colors on printed photos can fade, and scanning a photo can magnify this problem. If you take a picture with a digital camera, you can lose color accuracy and depth, depending on the quality of the camera, the lighting at the time, and the file format and quality you choose when you save the captured image to your computer. No matter what the cause, though, your image editing software should offer at least one or two options for fixing the color in a photo. These options are usually automatic correction tools that do an allover sweep for bad color or manually controlled tools that allow you to increase or decrease tones in your image.

In Photoshop Elements, the quickest fix is the Auto Levels command, which you can employ with the following steps:

1. **Issue the Auto Levels command by choosing Enhance⇨Auto Levels.**

The Auto Levels command goes over your entire image (or a portion thereof if you made a selection first) and adjusts the color levels.

2. **You can repeat the process for further adjustments or press Ctrl+Z (⌘+D on a Mac) to undo it if you don't like the results.**

Figures 4-10 and 4-11 show Before and After views of the same photo.

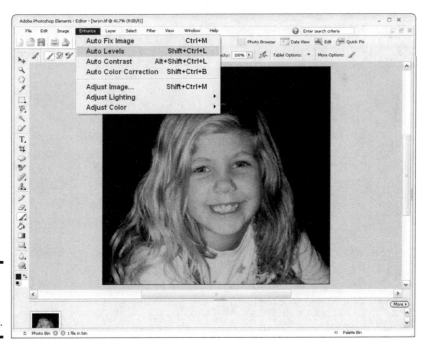

Figure 4-10:
Auto Levels
can correct
this photo . . .

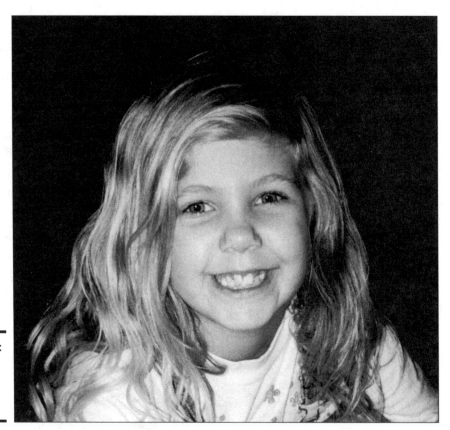

Figure 4-11:
. . . produc-
ing results
that look
like this.

Typically, even the lower-end image editing applications offer a similar tool for correcting color quickly. If your application doesn't offer this tool or doesn't do what you want, you can switch to a more effective application.

Photoshop Elements offers a handful of commands (each with its own dialog box) that allow you to adjust brightness, contrast, tones, hues, and color casts. You can find these tools on the Enhance menu, under the Color and Brightness and Contrast submenus. Figure 4-12 shows the dialog box that appears if you choose Enhance➪Adjust Color➪Hue/Saturation. The box's three sliders are for adjusting hue (color), saturation (amount of color), and lightness (amount of white in the colors). To use this and similar dialog boxes, simply drag the sliders for whatever levels you are able to adjust (Hue, Saturation, and Lightness in this case) and watch the preview (select the Preview check box). When you like what you see, click OK to apply the changes to your image. You can find out more about these specific tools in various chapters in Book V, which focuses on Photoshop and Photoshop Elements.

Figure 4-12:
Adjust
multiple
color
attributes all
in the same
dialog box.

Restoring, Replacing, and Removing Photographic Content

When my aunt was a child, she liked to draw on photos, especially those that included pictures of my mom. Consequently, we have a lot of old pictures with crayon and pencil strokes on them, and many of those strokes run through people's faces and parts of the picture that you couldn't crop away without losing the charm of the image. Other photos in our family's collection are torn or ripped, bear deep scratches, and generally look tattered. I've salvaged many battered photos by using Photoshop and Photoshop Elements to replace the missing content. Various tools in these applications enable you to take content from another spot in the photo and use that content to rebuild what's missing. For example, in the photo shown in Figure 4-13, rough handling resulted in a tear, and an unfortunate fold cost this photo its corner. Figure 4-14 shows the image after I repaired it.

Figure 4-13:
A photo with
tears and
lost content.

Figure 4-14:
I restored
the missing
parts using
other
content in
the image.

Another problem that you might encounter is unwanted content. Perhaps a truck is parked in front of the house you're trying to sell, and you can't take the picture without including the truck. Never fear — if you have the right software, you can easily get rid of the truck and replace it with a curb, grass, and even a few shrubs that might not really exist. You can do the same thing to get rid of people in a picture or to add people (or pets!) to a photo when they weren't there the day the picture was taken. How do you think the tabloids make it look like two people who haven't really even met went to a party together? Is that really Elvis in the background of Lisa Marie's wedding? It's all a matter of taking existing content, placing it in the image, and leaving unwanted or unimportant content in its wake.

Replacing missing or unwanted content

Suppose you want to replace the missing corner or some image content lost to a big rip or deep scratch. Perhaps you want to cover up something that's undesirable in the photo. You can use a variety of tools, and most of the more powerful image editing applications enable you to take content from one spot in the image and repeat it in another spot. To finish the job, you might need tools to make the pasted content blend in, and those tools are normally available even in midrange image editing applications.

The tools that you use to replace the missing content or cover up the unwanted content depend on the size of the area being filled. To cover a thin seam (such as a deep scratch) or to fix a tiny corner, you can use the Clone Stamp in Photoshop or Photoshop Elements (other higher-end applications have their own versions). If the missing or unwanted content represents a

large area of the image, I recommend copying and pasting content from one part of the photo to another. I explain both techniques in this section.

Figure 4-15 shows a shot of two gargoyles perched on the Cathedral of Notre Dame in Paris. Unfortunately, a guardrail protrudes on the image. The Clone Stamp tool is the best bet for getting rid of that rail.

If you use the Clone Stamp, you can paint other content into the area that's lacking, filling as much or as little as you want. If you use the copy-and-paste technique, you might have to paste repeatedly to fill in the missing content.

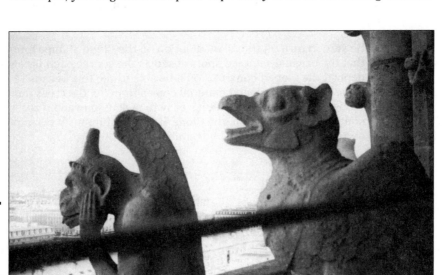

Figure 4-15: Cloning can remove the guardrail.

Fixing small areas

To replace content in a small area with the Clone Stamp tool, follow these steps:

1. **Click the Clone Stamp in the Tool palette to activate it.**

2. **Choose an appropriately sized brush, as shown in Figure 4-16.**

3. **Find the spot that contains the content you want to use to cover something else.**

 If necessary, zoom in to zero in on the spot.

4. **Press and hold the Alt key (or the Option key, if you're on a Mac) and click to *sample* (clone from) that spot.**

The software now knows that this is the area you want to clone and use elsewhere. The size of your brush dictates the size of the sampled area. You can set the brush size on the Options bar while the Clone Stamp is active.

5. **Go to the spot that you want to cover and then click to deposit the cloned content, as shown in Figure 4-17.**

You can click over and over, and the cloned content appears wherever you click.

Be sure to turn off the Aligned option on the Clone Stamp Options bar so that the original sampled spot is used as the source each time you click to deposit the cloned content. You'll be able to see this because a small cross shows where the cloned material comes from. As the cross moves (when Clone Aligned is turned on), it's easy to pick up unwanted areas as cloning sources. If Aligned is on, the Clone Stamp continuously resamples content, and you can end up with undesirable results.

Figure 4-16:
Choose a brush to "paint" your cloning strokes.

Figure 4-17:
Your copied
content is
painted
over the
guardrail.

Fixing larger areas

To replace larger areas with the Edit, Copy, and Paste commands, follow these steps:

1. **With the Marquee or Lasso tools, select the area that you want to use to cover up something else in the image, as shown in Figure 4-18.**

You can find more information about these selection tools in Book V, Chapter 2.

2. **Choose Edit⇨Copy from the main menu.**

You can press Ctrl+C on a Windows computer or ⌘+C on your Mac to do the same thing.

This places a duplicate of the selected area in your computer's memory, and it waits there until you tell your software where to place the copied content.

Figure 4-18:
Select the area you want to use to cover up something else.

3. **Paste the content to the desired area by choosing Edit⇨Paste from the main menu.**

 The keyboard shortcut for this is Ctrl+V for Windows/⌘+V for Macs.

4. **Click the Move tool in the Tool palette to activate it and then drag the pasted content into the desired position.**

 After you position your content, you can use the Blur tool to blend any obvious sharp edges.

5. **Blur the edges of the added content so that it blends with the rest of the photo.**

 If you're not sure how, read on.

Adding the finishing touches

After you position your cloned or pasted content, you can use the Blur tool to blend any obvious sharp edges. To do so, follow these steps:

1. **Click the Blur tool to select it.**

2. **With a small brush size, scrub (brush) over the edges of the pasted content to make the edges disappear.**

 The content should look as though it were always there, as shown in Figure 4-19.

If you merge the layers of your image (Layer⇨Merge Visible), the photo becomes one layer again, and you can blur both the pasted content and the surrounding content, too, all with one stroke.

Rearranging parts of the picture

Moving part of your image requires selecting it with the Marquee or the Lasso tool (or the equivalent tools in the software you've chosen to use). After you select the content, you activate the Move tool and then drag the selection to a new spot.

Figure 4-19: The guardrail and overlapping gargoyle are gone!

One caveat to moving is that it leaves a hole where the content was originally. The hole is filled with the current background color, which is normally white. If you want to move content and also leave it in place, press and hold the Alt key (or Option key if you're using a Mac) as you drag. The content is duplicated and moved at the same time, as shown in Figure 4-20.

If you're wondering whether you can move content between images, the answer is yes — if you're using the higher-end image editing applications. Some of the lower-end applications don't allow more than one image to be open at a time, making it impossible to drag content from one image onto another. In other lower-end applications, you can't easily use the standard Edit⇔Copy command in one image and then use the Edit⇔Paste command in another image.

Figure 4-20:
Holding down the Alt/Option key while you drag a selection creates a duplicate of the selection.

Original Duplicate

Getting rid of unwanted content

After you select an area of your image by using any of the selection tools, you can press the Delete key to get rid of it. Doing so leaves a hole, and the background color shows through. You can then use any tool you want — such as the Paintbrush tool or the Paint Bucket tool (which fills the area with a solid color or a pattern) — to occupy the hole where the content used to be. You can also use the Clone Stamp or the Edit⇨Copy and Edit⇨Paste commands to fill the hole with content from elsewhere in the image.

Another way to get rid of content in one place — but to not lose the content altogether — is to use the Edit⇨Cut command. This command removes content; however, instead of simply deleting it forever, the content is placed in the computer's memory (in a space called the *Clipboard*), where it waits for you to paste it somewhere. This is similar to the copy-and-paste process except that the Cut command deletes the selected content where it currently is. The Paste portion of the process is the same, whether you use Cut or Copy. Remember that when you cut content to the Clipboard, anything that has been copied there is replaced. So, you can't copy something, cut something else, and then paste anything except the last content that was cut.

Chapter 5: Storing and Organizing Your Digital Photos

In This Chapter

✔ Understanding your organizational options

✔ Choosing the right tools to organize and store your photos

✔ Keeping your treasured photos safe

We all have at least one box or drawer that's full of photos that we've never had the time to put in an album — vacation photos, pictures of the family at holiday dinners for the last ten years, even collections of vintage photos — all waiting for someone to take them out of their envelopes and put them in a book so that people can actually look at them. What about your digital photos? They might not be languishing in a drawer, but if they're in different folders scattered all over your hard drive, they might as well be in a shoebox under the bed.

The most important things that you can do with your digital images is first to organize them and then to store them in a way that keeps them safe from accidental erasure; unwanted changes; or loss because of fire, flood, or a computer meltdown. You can easily achieve the proper organization and reliable storage of your digital images, and plenty of tools are at your disposal to make it all happen. The key, however, is to do it — so don't put it off any longer!

Organizing Your Photos

When it comes to taking control of the organization of your photos, you have a few different approaches to choose from. Your personality, your computer, and your access to the Web all dictate your choice. Some approaches to consider include

✦ Setting up a file structure on your computer

✦ Working with software that makes it easy to organize and store your images and view them through a special interface

✦ Organizing and storing your images in an online gallery

What do I mean about your personality influencing your choice of organization tools? If you're a very organized person who enjoys straightening out closets and dresser drawers, always knows where the remotes are, and always puts things away after using them, using the file management tools already on your computer might appeal to you.

If, on the other hand, you don't tend to be too tidy and often forget where you left your glasses or your keys, you might prefer using software that organizes things for you or posting your images to an online gallery. The tidy person might like these latter approaches as well.

Using your computer's file-management tools

You already have some great tools for organizing your images, and the tools have been on your computer all along. If you're running Windows, you have My Computer and Windows Explorer right there at your fingertips. If you're using a Mac, you can use the file management tools that you've already been using to create folders on your Desktop or hard drive.

Using these tools requires devising some sort of filing system — one or more folders that will help you categorize your images. You might start with one called Photos and then create subfolders such as Family Photos, Vacation Pictures, and Scanned Vintage Photos. You can create folders on your computer for whatever groupings fit the pool of images you have. After you create the folders, all you have to do is move your images into the appropriate folders and remember the folder names when you store new images in the future.

Using Windows Explorer to store and organize your photos

Working with folders under Windows is pretty basic but deserves a review in the context of organizing your digital image files. To create folders to store your images by using Windows Explorer, follow these simple steps:

1. **Choose Start⇨Programs⇨Windows Explorer.**

You can also right-click the Start button and choose Explore from the contextual menu.

2. **When the Windows Explorer opens, click the C: drive icon.**

If there's a plus sign next to the icon, click that plus sign to display the folders currently on the drive. If there's a minus sign next to the icon, that means you can already see all the folders.

The Windows Explorer window is divided into two panes: the Folders pane on the left and the Content pane on the right (see Figure 5-1). When you click a drive or folder in the Folders pane, that drive's or folder's content is displayed in the Content pane. This two-sided display makes

it possible to drag items from one folder to another simply by displaying the source (where the content is now) and target (where you want the content to be) folders in the separate panes.

3. **If there's a My Pictures or other folder that you want to use as the basis for your image organization, click it. If you want to start a new folder for your photos, choose File⇨New⇨Folder from the main menu.**

If you go the New Folder route, a New Folder appears in the Content pane, with its temporary name highlighted, awaiting your typing its real name (see Figure 5-2).

Figure 5-1:
Navigate
your hard
disk to
locate the
folder you
want to use.

Figure 5-2:
Create a
new folder if
necessary.

4. **Again, if you go the New Folder route, give your new folder a name and then press Enter to confirm it.**

With a folder created to house some or all of your photos, you can begin to place them in a single location. You can also make subfolders in that main folder to categorize your photos. For example, if you have a Photos folder, you can create a Vacation Photos subfolder and a Baby Pictures subfolder to keep those two, distinct photo subjects separate. Figure 5-3 shows just such a folder system.

Figure 5-3: Here's a typical folder system for organizing images.

To create subfolders of the main folder, simply click the main folder to select it (on the left side of the screen, in the Folders pane), and repeat Steps 3 and 4 from the preceding steps. You're going to use the File➪New➪Folder command to create a new folder, but because you're in an existing folder when you do it, the new folder appears inside the active folder.

The process is like taking one of those green, hanging file-drawer folders and putting one or more manila folders in it. The green folder represents the main Photos folder, and each of the manila folders is the same as the subfolders you create to categorize your photos. You can create as many subfolders as you want and even create subfolders within subfolders. The folder hierarchy can become as complex as you want or need it to be, but be careful to not make managing files so cumbersome that the process becomes confusing when you need to place an image in the right folder.

If you don't need to categorize your photos by subject, consider creating folders that separate your photos by date. You can have a separate folder for individual years, months, or weeks, depending on how prolific of a photographer you are.

Working with My Computer

You can also use the My Computer program on your Windows-based computer, and it works much like Windows Explorer. Instead of a two-paned window, however, you'll have separate windows for each drive and folder on your computer. The commands for creating new folders are the same (File➪New➪Folder), but you have a visually different environment in which to work when creating and using your folders. Figure 5-4 shows the main My Computer window, showing the C drive and other computer components. In addition, a folder window is displayed, and you can see that that folder contains subfolders that will help categorize your photos.

Figure 5-4:
You can also use My Computer to navigate your hard disk.

Organizing your photo images on a Mac

Whether you're using Mac OS 9 (or an earlier version of the operating system) or the new OS X, you can easily create folders to store your photos and other digital images. You can choose to store them on your hard drive or make them quickly accessible from your ever-visible Desktop.

To create a new folder in OS 9 and previous OS versions, follow these steps:

1. Choose File➪New Folder from the menu bar.

A folder named Untitled Folder appears on the desktop. You can also press ⌘+N or Ctrl+click the Desktop and choose New Folder from the contextual menu that appears.

2. **Give your folder a short, yet relevant name that will make it easy to find the folder in the future.**

3. **You can leave the folder on the Desktop or open your hard disk and drag the folder there.**

If you store the folder on the Desktop, the folder is quickly available at any time, but you also make it quickly available to anyone using your computer. If you don't want people poking around in your photos, store the new folder on your hard drive instead.

4. **If you want folders within the folder you just created, open the folder and then repeat Steps 1–3 to create the subfolders.**

If you're using OS X, the procedure is nearly identical except for the keyboard shortcut. Instead of ⌘+N, you press Shift+⌘+N to create a new folder.

You can duplicate an existing folder by using the File⇨Duplicate command. Alternatively, drag the existing folder to a new location while holding down the Option button; this approach makes a copy of the original folder, and leaves that original where it was.

Using photo album software

Setting up a series of folders to store and categorize your images is easy enough. To view them after they're stored, however, you either have to open them in the software you used to edit/retouch them or use the generic software (such as Microsoft Photo Editor) that came with your computer to see the images. If you find that inconvenient (and you probably will, especially if you like to look at and work with your images frequently or to view them side by side), you'll probably be glad to know that several great photo album applications are on the market. Two of the most popular are Adobe Photoshop Album for Windows and iPhoto for Macintosh. These applications enable you to view one, two, or several of your images at the same time, all in one easily navigated workspace, and include very simple image editing features. Figure 5-5 shows a group of photos viewed through Adobe Photoshop Album. Similar programs are often furnished with cameras from various vendors.

Some photo album products to consider are listed in Table 5-1.

Figure 5-5:
Groups of
photos
can be
viewed as
thumbnails.

Table 5-1		Photo Album Software	
Product Name	*Purchase Information*	*Platform*	*Description/Comments*
Photoshop Album	$49.95 www.adobe.com	Windows	Connects to online services such as Shutterfly so you can order prints directly from your albums. Great for Photoshop and Photoshop Elements users.
Virtual Album	$29.95 (Download or on CD) www. radar-software. com/valbum/	Windows	Organize, protect, and share photographs with this product as well as add messages, captions, and create slideshows for the Web. It's a powerful package for less than $30.

(continued)

Table 5-1 *(continued)*

Product Name	Purchase Information	Platform	Description/Comments
3D-Album (several versions)	$29.95 and up `www.3d-album.com/product.html`	Windows	Choose from a series of presentation styles for your images. You can put the final presentations on CD, on the Web, in an e-mail, or in a screensaver slideshow. The program isn't much of an organizational tool but has interesting ways to view images.
FlipAlbum (several versions)	$19.95 and up `www.flipalbum.com/`	Windows and Macintosh	Like 3D-Album, this program allows you to create onscreen photo albums with predesigned styles. It allows you to see all the photos in a folder in an onscreen book that you can flip through (thus the product name).
ThumbsPlus	$49.95 `www.cerious.com`	Windows	Includes image editing and viewing features. Use it to manage images, fonts, and multimedia files. It can also help build Web pages.
My Photo Album	Free `www.x-industries.com/mpa/`	Macintosh	Features an easy-to-use wizard that leads you step-by-step through creating albums with headings and captions. Also does slideshows.

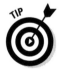

Want more? Do a search at your favorite search site for *"Photo Album Software"* — remember to use the quotation marks to make sure that the search engine uses the full phrase. You can also check Web sites, such as `www.buy.com` and `www.amazon.com`, where you can do similar searches for the photo album software each site has to offer.

Your criteria for selecting photo album software are a personal thing. You might prefer ease of use and not care whether you don't get a lot of fancy functionality. If you want a lot of bells and whistles, you might not mind it if the product is a little more complicated to use. Some photo album software serves as both an organizational tool and a vehicle for creative display of your photos; some just do the latter. If you've already got a system for organizing your images, you might not need software that does double duty.

The Mac solution

You won't find many album applications for the Macintosh (Adobe doesn't even offer Photoshop Album on the Mac platform) because the best solution for the average amateur photographer was originally included in a basic version free as part of Mac OS X. The latest editions are part of the iLife '04 suite (which is not free). iPhoto will do just about anything you want, whether you're working with a dozen photos or a dozillion (actually, the application is limited to 25,000 pictures). It lets you organize, edit, and share your photos, resize them, and perform very simple edits such as red-eye removal.

iPhoto can create "smart albums" that collect only photos that meet criteria you set up, automatically, and offers features for sharing them over your home network. You can also create books, slideshows, burn DVDs or CDs, and order prints directly from Kodak.

My biggest beef with iPhoto is the current limitation on the number of photos that you can organize with it. 25,000 images might sound like a lot, but — because you're not paying for your digital "film" — it's easy to take 200-300 photos over a weekend (I do!). Plus, as you edit photos and save different versions or as you build your image library by scanning your old pictures, the number of photos you have on hand will increase dramatically. I have *way* more than 25,000 pictures in my own collection. The accompanying figure shows iPhoto's album view, using the e-mail option to send a resized version of an image.

You can download and test many photo-album products for free (with a time or number-of-uses limitation), making it possible to test-drive two or more products before plunking down any cash and making a final commitment. It pays to shop around if you plan to use this software frequently. ThumbsPlus, available for evaluation at `www.cerious.com/download.shtml`, is shown in Figure 5-6.

Here are some features to look for in photo album software:

+ Ability to categorize and classify each photo using built-in or custom-designed categories.

+ Provision for adding your own captions and other annotations.

+ Search capabilities with which you can locate certain images — say, classified as Vacation pictures, using keywords such as *beach* or *2002.*

+ Sorting abilities with which you can permanently or temporarily arrange your photos by filename or other criteria. (These features go hand-in-hand with search capabilities.)

+ Features for uploading from your local album to your own Web space or sharing services.

+ Viewing capabilities that include looking at single photos and arranging them into slideshows.

+ Simple image editing features, such as cropping, resizing, and rotating, so that you can make small changes to your pictures without firing up your image editor.

Using online galleries

You probably already e-mail photos to friends, sending the images as message attachments that the recipients must open and view. Your recipients can save any images that they want to keep on their hard drives. There might be a better way to share your images — assuming that you don't mind having your images posted on the Internet — namely, using *online galleries* to display your photos. You'll find a complete look at this valuable tool, including a discussion of all the leading gallery providers, in Book VII.

The online approach to image distribution has some great advantages and some drawbacks. First, the advantages are that you can

+ **Avoid the hassle of having to e-mail photos to lots of different individuals.** Because you're placing all your photos on one Web site, all you have to do is let people know to check the site for your images. This makes it possible to share images that are larger than some e-mail services can handle (2MB for many services).

+ **Share more images with more people.** Anyone with an Internet connection can view the images without owning any special software other than a browser, which people need to surf the Web anyway.

+ **Enjoy yet another relatively protected repository for your images.** If you lose the original files, you can download them from the online gallery.

Two possible disadvantages (and only you can decide whether they are real disadvantages) are that

+ **Your photos are on the Web, and anyone can view them.** This can expose you and your family to people with whom you would not normally share your vacation, holiday, and otherwise personal photos. You have to be careful about posting photos that show your house number, last name, or any other identifying information.

+ **Most online galleries charge a fee for providing space on their site for your photos.** The fees are usually reasonable, but compared with e-mailing photos, which is free (you're already paying to have e-mail anyway), the cost might be more than you're willing to pay.

Figure 5-6:
ThumbsPlus is a popular album software application with tons of features and a reasonable price.

To find an online gallery to post your photos, do a search online for *"Online Galleries."* You'll see quite a few that are devoted to actual artists (and this might be of interest if you are an artist) and some that are for the general public to use. If you add *"+free"* to the search criteria, you'll ferret out those sites that offer the space for free or that will let you test their services for free or for a limited time.

Obviously, the cost for an average person's online images is quite reasonable, and many sites are free. There's no reason, therefore, not to try posting your images in an online gallery. If you are fearful of the exposure that posting your images on the Internet creates, post only those images that are completely anonymous. You can find a more complete list of services in Book VII.

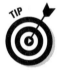

If you're an America Online subscriber, you can share your photos online through the You've Got Pictures feature (see Figure 5-7). You can upload digital images, add fun backgrounds, and even post your images to topic-specific galleries. You've Got Pictures is also discussed in Book VII, along with .Mac for Macintosh owners.

Figure 5-7: AOL users have access to the You've Got Pictures feature offered in partnership with Kodak.

Archiving and Backing Up Photos

Not all your photos will require instant, easy access. Vacation photos from the past, certainly if you visited a not-too-exciting place, could be a waste of valuable, hard drive real estate. But what if you don't want to delete these infrequently viewed images? You don't have to make rash decisions — you can simply archive the ones you don't need to access quickly or frequently. If a photo is valuable to you on some level in the long run but you don't imagine wanting to look at or print it within the foreseeable future, just save

it to disk — a floppy disk, a Zip disk, a CD, or a DVD. You have several archiving options, many of which might be on your computer right now. If they're not, they're easily acquired.

Backing up your best shots

First, because you've already organized your photos (assuming that you've read the beginning of this chapter), you should already have your photos categorized and know which ones are so dear to you that, if anything happened to them, your family would have to take your shoelaces lest you do anything foolish. These cherished shots need to be backed up — stored in some way in order to protect them from anything that can happen to your computer or your photo albums (printed or electronic).

Your backup options are simple:

+ **Store the photos on disk.** Use a floppy disk if they're small in terms of file size (less than 1.44MB.) Of course, your computer must include a floppy disk drive, which is disappearing from some Windows PCs and has already vanished from the Mac platform. Although not as popular as they once were, Zip disks can be a good choice if your files are over 2MB individually and if you have more than 100MB of large images altogether. To use an Iomega Zip disk (they come in 100MB, 250MB, and 750MB varieties), you need a Zip drive, too.

+ **Write them to a disc via a CD or DVD burner.** This method enables you to store up to 700MB on a single CD or several gigabytes on a DVD. If your computer already has a burner (external or internal), all you need is a package of writeable CDs or DVDs.

+ **Store them online.** Web sharing sites provide you with a sort of backup for your images. Its best to use these as a secondary backup (sort of as a backup to your backup) because there's no way to guarantee how long these services will be around!

Using CD-R and CD-RW

Until just a few years ago, most computers came with a CD-ROM drive, and all you could do was read or install software from the content of a CD-ROM. (In case you're curious, ROM stands for read only memory.) After CD burners hit the market, now virtually every new computer comes with one (or perhaps with a DVD drive or a combo drive that's compatible with both CDs and DVDs instead) as standard equipment. If your computer has only CD-ROM capability, you can easily add a CD burner for under $50 (usually well under, after rebates and discounts). Actually, CD-only burners are becoming an endangered species. The last DVD/CD burner I bought cost less than $60. At that price, who needs a CD-only drive?

With the ability to write to a CD, you now can save up to 700MB of data on a very reliable medium. Unlike floppy and Zip disks that can be ruined by exposure to magnets, heat, cold, sunlight, water, and rough handling, CDs are pretty stable. Other than breaking or scratching them or subjecting them to serious mistreatment, you can't really hurt them.

Before you run out and buy a CD burner and CDs to burn, consider these writeable CD facts:

✦ Writeable CDs come in two types: CD-R and CD-RW. CD-Rs can be written to (the R stands for *recordable*) but only once. CD-RWs can be written to, erased, and written to again, over and over.

✦ You can use a CD-R or a CD-RW just like a floppy or Zip disk, using a mode called Packet Writing. In that mode, you can copy files or groups thereof to the CD. However, you can't interrupt the writing process like you can with a floppy or Zip disk, and the process takes a bit longer.

✦ CDs are pressed from a mold. CD-Rs and CD-RWs are marked with a laser, creating spots that represent data (in binary form). CDs are virtually indestructible (unless you crack, break, or severely scratch them) and can withstand a sunny day in the car or night below freezing in that same glove box. Even so, CD-Rs and CD-RWs shouldn't be exposed to direct sunlight or extreme heat although they are less vulnerable to such conditions than floppy or Zip disks.

Using DVD storage

As commonplace as DVD (digital video disc) players have become in many households and on many computers, are they a reasonable tool for saving data? In the past few months, a DVD player that also writes to writeable DVDs has become relatively inexpensive, often available for around $100. The trend is to include a DVD burner in the newest computers (instead of a CD burner) because they cost very little more and can burn CDs as well as DVDs.

DVDs do hold more data than a CD-R or CD-RW can — 4.6–8GB (gigabytes) or more. The price of DVD burners (DVD drives that write DVDs) has come down so that they're easily within the reach of most consumers. Like CD burners, DVD burners also come in more than one type:

✦ DVDs (the prerecorded kind) come with stuff prewritten to them. You can view what's on them, but you can't erase and then rewrite to them.

✦ DVD+Rs (note the use of the plus sign) can be written to only once.

✦ DVD+RW discs can be written to, erased, and written to again.

✦ DVD-Rs (note the use of the minus sign) can be written to only once.

+ DVD-RW discs can be written to, erased, and written to again.

+ DVD+RW burner/players can play DVDs, DVD+Rs, and DVD+RWs, but DVD-RW burners/players can work with DVDs plus the -R and -RW type disks. Happily, most new devices introduced recently can read and record both +R/+RW and -R/-RW discs.

+ Computers with a DVD player can generally play all forms of DVDs.

+ Computers must have a DVD writing device to write to a DVD+R/DVD+RW or a DVD-R/DVD-RW.

Offsite storage for maximum safety

If your photos are so precious that you'd just die if anything happened to them, or if they're important for legal, financial, or other compelling reasons, don't risk losing them to a fire or burglary or other disaster. You can store your archives offsite in one of three ways:

+ Use a bank safe deposit box.

+ Use a safe located in a secure storage facility.

+ Arrange to keep one of two archive copies with a friend or family member.

If you save your precious images to a CD, DVD, or Zip disk, you can make two sets and store one set offsite, selecting one of the aforementioned places based on the level of security you need. The bank could burn down, but the safe deposit boxes are usually in or near the vault and are protected from very high temperatures, even in the event of a fire. If you keep a safe in a paid offsite storage space, the place is likely to be fireproof or well-protected by sprinklers and video cameras, so it's probably more secure than your home. If neither of these are an option, find a friend or relative whom you trust and give the extra set to him or her. If you're really, really worried, make more than one backup copy and store each in a different location.

Chapter 6: Printing and Sharing Your Pictures

In This Chapter

✔ Making prints while you wait

✔ Choosing among printer categories

✔ Recommended print sizes

✔ Sharing the wealth (of pictures you've taken)

*U*ntil the cost of those huge, flat-panel digital displays that hang on the wall like a picture frame dip below their current $6,000-plus level, you'll probably want to use hard copy prints of your best digital pictures to decorate your home or office. You'll also find that prints are more fun to pass around when you're sharing your vacation with co-workers. And have you ever tried to tuck an electronic image of a loved one in your wallet?

No, prints are here to stay. Digital technology is just making prints easier for anyone to produce. Instead of stacks of photos of every single picture you've ever taken (plus shoeboxes full of "lost" negatives), you can have great-looking enlargements of the photos you want to keep, perfectly cropped and carefully corrected in your image editing program. The ability to make prints is one of the best things about digital photography.

An alternative to sharing prints is sharing your pictures online through commercial sharing services or your own personal Web space. Such options let friends and colleagues view your photos even if they aren't close by.

In this chapter, I provide a quick overview of printing, printers, and picture sharing services. You can find a lot more detail in Book VII.

Creating Prints on Demand

One of the reasons why you'll want a printer for your digital camera is the sheer joy of being able to produce your own prints, any time, in only a few minutes. If you're used to dropping off film at a local photofinishing outlet and then waiting hours or even overnight to get sparkling 4 x 6" prints, you'll love your color printer.

For example, on the day I began this chapter, I was called over to my daughter's school to take a picture of her science class performing the infamous Egg Drop experiment. I snapped off a couple shots of carefully cushioned eggs surviving (hopefully) a two-story plummet and then ran home and made two 5 x 7" enlargements (one for the class and one for our local newspaper). It actually took longer to write the caption for the newspaper than it did to print the photo. Less than 30 minutes after the last egg fell to an untimely end, I returned to the school with prints in hand. Try *that* with a film camera sometime!

Color printers have never been cheaper or more ubiquitous. My local supermarket sells $50 inkjet printers in the school and office supplies aisle, just across from the microwave ovens. It's a 24/7 market, too, so if I'm ever stuck in the middle of a project at 3 a.m., I can dash out and pick up some ink or even a whole new printer before sunrise.

Here are your main options for making prints from digital cameras:

✦ **Use your local MegaMart's print kiosk.** These typically accept a broad range of digital media, from CompactFlash and Secure Digital film cards to floppy disks and CD-ROMs. They let you choose a photo, crop, rotate, or resize your pictures, maybe add some text, and perform other simple manipulations using a touch-screen video display. When you're happy with your picture, press a button and wait a few minutes until your photo emerges. If you don't make many prints, this can be a viable option. The quality will be equal to or better than the prints you can make at home. Many retailers also have in-store digital minilabs, which can accept your digital film or which link directly to their kiosk, and produce prints while you wait.

✦ **Make do with your laser printer.** Even a black-and-white laser printer can serve in a pinch if you need some posters for the utility poles in your neighborhood to promote the goodies at your garage sale. You might even have access to a color laser printer at your job or at a local copy shop.

✦ **Go whole-hog with an inkjet printer.** Inkjet printers can produce prints that look almost exactly like photographs, on glossy or matte paper, at a cost of about $1–$2 per print. Most digital photographers own an inkjet printer, and unless you are *very* fussy, they'll do the job for you.

✦ **Try an alternative technology.** Although no longer as popular as they once were (and they never were extremely popular), alternative technologies still exist. These other types of printers, such as dye-sublimation printers, thermal wax printers, and solid wax printers, have become specialized devices for special niches, such as snapshot-only printing, but they all do a great job with color photos. Some, such as dye-sub printers, can't be used for anything else. You can find more information about all these printers in Book II, Chapter 4.

Getting the Most from Your Printer and Supplies

If you want to get the best from any of these printers, just follow a few simple tips:

✦ Calibrate your monitor so that what you see is what you get in your prints. Check the manual that came with your image editing software for instructions on calibrating your monitor to your application. Macs have calibration facilities built into Mac OS.

✦ Use the best quality, glossy photographic paper that you can afford. You can't go wrong using the paper recommended by your printer manufacturer. You might also be able to get good results with some of the newer, matte finish papers, as well.

✦ To avoid visible lines or blurry prints, clean your inkjet's print heads from time to time and keep the paper path clean.

✦ Wait until your prints are completely dry before you touch them. Most kinds of wet ink can smear easily, which spoils a $1–$2 investment.

✦ Have fun with those special printing media offered to let you make transparencies and T-shirt transfers, print on fabrics, or create greeting cards.

✦ Don't ruin a perfectly good sheet of paper by making a print that's too large for your digital camera's resolution (and thus comes out a bit fuzzy looking). Table 6-1 shows good sizes and maximum sizes for typical digital camera resolutions.

Table 6-1	Recommended Print Sizes	
Camera Resolution	*Good Size*	*Maximum Size*
640 x 480 pixels (.3MP)	2½ x 3½"	3½ x 5"
1024 x 768 pixels (.75MP)	3½ x 5"	5 x 7"
1280 x 960 pixels (1MP)	4 x 6"	8 x 10"
1600 x 1200 pixels (2MP)	5 x 7"	11 x 14"
3600 x 2400 pixels (8MP)	8 x 10"	20 x 30"

Sharing Your Photos

You can always e-mail your photos to friends and colleagues, but there's a better way to share your pictures. You can post them to your own Web site or use one of the commercial photo sharing services. You can share your vacation photos, pictures from school, brag shots of your new house or car, or create an online holiday newsletter.

Your ISP (Internet service provider) probably provides some free Web space you can use to create pages for your pictures. Check with your provider for instructions on how to use this space. Even easier is using the services provided by companies like America Online and Eastman Kodak Company. Their Web sites lead you hand-in-hand through the process.

If you use an online sharing system or online gallery to display your images, you'll find that many of them offer some space for free. In the case of an online community such as America Online, your monthly fee to AOL includes access to the company's You've Got Pictures feature (provided in teamwork with Kodak), which enables you and others to view your images online. You get free Web space, too, which you can use to store and display your photos.

Other commercial sharing services are known as *online galleries,* which allow you to post your images for free in exchange for posting a few ads on your Web pages. Other sites make their money through software they sell, such as image editing or photo album applications.

Some sites, like Kodak's PhotoNet Online or Ofoto (available to non-AOL subscribers), let you upload your photos for viewing and also offer the ability to send picture postcards, order prints, enlargements, mugs, T-shirts, and other related items.

Sound intriguing? Check out Book VII for more on sharing your photographic treasures online.

Book II

Building Your Digital Photography Studio

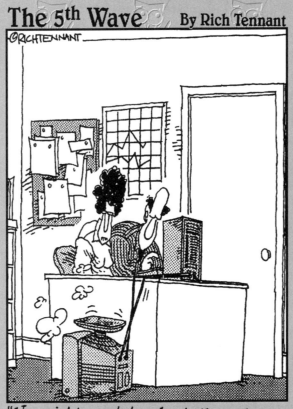

The 5th Wave By Rich Tennant

"You might want to adjust the value of your 'Nudge' function."

Contents at a Glance

Chapter 1: Choosing the Right Camera

In This Chapter

✔ Selecting a camera category

✔ Key components of digital cameras

✔ Evaluating lens requirements

✔ Understanding sensors and resolution

✔ Choosing exposure controls

✔ Selecting exposure options

✔ The digital SLR advantage

✔ Exotic digital camera capabilities

✔ Finding a camera that's easy to use

Choosing the right digital camera has gotten a lot more exciting recently! Digital single lens reflex (SLR) cameras — the ones that have interchangeable lenses and show you an optical (not electronic) preview image through the same lens that takes the picture — have dipped under the $1,000 price point, making them a reasonable choice for many more serious amateur photographers. Affordable 8MP (and up) cameras provide sharper, better pictures without busting your wallet. Digital cameras are becoming smaller, easier to use, and packed with special features we never dreamed were possible as recently as a year ago. This is a great time to be choosing a digital camera, whether you're a snapshooter or a dedicated photo hobbyist.

Yet, selecting the right digital camera isn't as daunting a task as it might appear to be on the surface, even with the increased features and options to choose from. Most of the leading vendors of digital equipment produce fine products that take great pictures. It's really hard to go wrong. All you need to do is a little homework so that you're aware, when you make your purchase, of the features you need — and features you don't need. The vendors write their brochures and ad copy so that those who don't sort out features and benefits ahead of time might think that *every* feature is essential.

Trust me: They're not. The ability to shoot several pictures consecutively, each using different color settings to make sure that one picture is perfectly color-balanced, might sound cool, but it's not something many people need

every day. But if you find yourself constantly taking pictures under varied lighting conditions and color accuracy is very important to you, a feature like that might be a lifesaver. Only you can decide for sure.

The key is having the upfront information you need to wisely choose/buy the camera that has the largest number of your must-have features — and a nice sprinkling of nice-to-have features — at a price you can afford. In Book I, Chapter 2, you can find an overview of the choices you need to make. There, you can find an introduction to the chief things to consider, which are

- ✦ Lens requirements
- ✦ Viewfinder options
- ✦ Sensor resolution
- ✦ Exposure controls
- ✦ Storage options
- ✦ Ease of use

This chapter looks at each of these considerations, plus others, in more detail, with special emphasis on the newest digital SLR cameras. Although much of the information can help you select a camera, you can also find some basic explanations of digital camera nuts and bolts that will be helpful as you take pictures. If you ever wanted to know what shutter speeds and lens openings do, this is your chance.

Choosing a Camera Category

Digital cameras fall into several different categories, each aimed at a particular audience of buyers, as well as particular kinds of applications for them. You can find an extended discussion of camera categories in Book I, Chapter 2. However, as a recap, the major types include

- ✦ **Web cams:** *Web cams* are cheap TV cameras that also offer low-resolution, full-motion images and still images. They're fun to use and essential for things like videoconferencing. They aren't covered in this book because most don't have the kind of image quality and capabilities required for serious photography.

- ✦ **Camera-phones:** Camera-phones are those multipurpose cellphones that also have photographic capabilities built in. Some have 2MP or better resolution that exceeds the picture quality available from some $500 digital cameras only a few years ago. In Japan, cellphones with cameras built in have already cut heavily into the market for one-time-use film cameras. Folks who sometimes forget to take their digital camera with them wouldn't be caught dead without their cellphone, so they're

always ready for the kind of spur-of-the-moment photography that single-use cameras have traditionally served. I'm not covering these useful (but specialized) devices in this book, nor cameras built into other products, such as personal digital assistants (PDAs), either. None of them are intended for use as a primary camera.

✦ **Point-and-shoot models:** These entry-level digital cameras, priced at $100–$200, offer 1.3–4MP of resolution (although it's becoming very difficult to find a 1.3 or 2MP camera in stores), simple lenses (frequently with zoom), and autoexposure. I recently tested a 4MP camera with a 3X zoom lens and 16MB of built-in memory (a memory card was optional) that could be purchased for $169! Clearly, even the most basic point-and-shoot cameras are gaining resolution and features almost faster than we can keep track. This kind of camera is an excellent choice for someone looking for a basic camera with few manual adjustments, and for casual shots that will be enlarged no more than about 5 x 7 inches.

✦ **Intermediate models:** Priced in the $200–$400 slot, intermediate digital cameras have 3–5MP resolution, a 3:1 or better zoom lens, and Secure Digital (SD), xD, or CompactFlash storage. Many have close-up focusing, burst modes that can snap off seven or more frames in a few seconds, and some manual controls. The average snapshooter would be very happy with a camera in this category and would be satisfied with the few tweaks that can be made to add a little creativity to selected photos.

✦ **Advanced consumer models:** In the $400–$800 range, you can find deluxe digital cameras with roughly 5–6MP of resolution, decent 4:1 to 8:1 zoom lenses, lots of accessories, optional exposure modes, and a steep learning curve. These cameras are easy enough to use that the average snapshooter can use them with a little training and practice, yet versatile enough with features like electronic viewfinders and manual settings, that serious photographers can invoke for those special picture-taking situations.

✦ **Prosumer non-SLR models:** Serious amateurs and some professional photographers use these. They cost $800–$1,200 and have all the features you could want, including 6–8MP or more of resolution, the highest quality lenses, an electronic viewfinder (EVF), and every accessory you can dream of. Expect automatic and manual focus, multiple automated exposure modes, and motor drive multishot capabilities. (Read more about motor drive capability in Book I, Chapter 2.)

✦ **Prosumer SLR models:** The prosumer SLR is very nearly a whole new category of camera, created in the last year or so when Canon introduced the Digital Rebel at $999 (with lens), and other vendors, including Nikon and Konica Minolta followed. In price, there is some overlap with the prosumer non-SLR cameras. However, the true SLR type offers interchangeable lenses and other features found in the traditional advanced-amateur favorite. Later in this chapter, I describe these features and why you might want them.

**Book II
Chapter 1**

Choosing the Right Camera

✦ **Professional models:** Professional quality digital cameras used to cost $5,000 and up and have 6–14 million pixels of resolution. Today, you can still pay around $5,000 or more for a pro camera, but some very fine professional-worthy models are available for a few thousand dollars less, too. The top-end cameras are feeling the pressure of competition from the sub-$1,000 digital SLRs, so you can expect prices to drop even further as features proliferate. However, professional photographers will continue to pay a premium for these cameras because they frequently operate more quickly, allowing the pro to grab shot after shot without pausing for breath. They're rugged, too, which means they can withstand the harsh treatment pros often subject their equipment to (not because they're mean, but because they're *working*).

You can find some general tips in Book I, Chapter 2 that can help you determine what category of camera you should look for. Read here, though, for the lowdown on everything you need to decide.

Parts of a Digital Camera

If you're very new to digital cameras, you might be wondering what all those buttons, LEDs, and windows are for. Here's a quick introduction to the key components of the average non-SLR digital camera. Not every camera will have all these features, and some will have additional features not shown in Figures 1-1 and 1-2.

✦ **Shutter release:** Depressing this button halfway locks exposure and focus; press all the way to take a picture.

✦ **Control buttons:** Miscellaneous control buttons might turn on/off close-up mode, automatic flash, or other features; set picture quality; or activate self-timer.

✦ **Shooting mode dial:** Most cameras use this button for changing among different scene modes (such as Night, Portrait, or Sports), adjust automatic or manual exposure choices, select Movie mode, or switch into close-up mode.

✦ **Microphone:** This captures audio for movie clips and voice annotations; it can even activate a sound-triggered self-timer.

✦ **Focus-assist light:** This is an auxiliary illumination source that helps the camera focus in dim lighting conditions.

✦ **Electronic flash:** This provides light under dim conditions or helps fill in dark shadows.

✦ **Optical viewfinder:** This window is for framing and composing your picture.

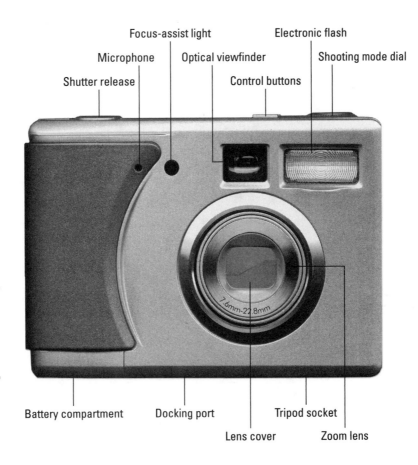

Focus-assist light

Microphone

Shutter release

Optical viewfinder

Control buttons

Electronic flash

Shooting mode dial

Figure 1-1:
The front of
a typical
digital
camera.

7.6mm-22.8mm

Battery compartment Docking port Tripod socket

Lens cover Zoom lens

✦ **Zoom lens:** This magnifies and reduces the size of the image, taking you closer or moving you farther away.

✦ **Lens cover:** This protects the lens when the digital camera is turned off.

✦ **Tripod socket:** This allows you to attach the camera to a firm support, such as a tripod or monopod, plus other accessories, such as an external flash bracket.

✦ **Docking port:** Some cameras have a special dock that can be used to transfer photos, recharge the batteries, make prints, or other functions.

✦ **Battery compartment:** This contains the cells that power the camera.

✦ **Power switch:** Here is where you turn the camera on or off.

✦ **Indicator LEDs:** These lights show status, such as focus and exposure, often with green and red go/no go LEDs (light-emitting diodes).

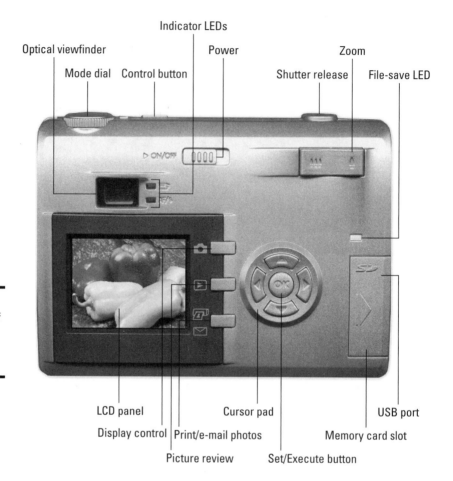

Figure 1-2:
The back of
a typical
digital
camera.

- ✦ **LCD (liquid crystal display) panel:** This shows the sensor's view of an image before exposure, previews images after exposure, displays status, photo information, and menus.

- ✦ **Display control/Menu button:** This is used to control the amount of information shown in LCD display and to produce menus. Some digital cameras have multiple buttons for recording menus, setup menus, and special functions.

- ✦ **Picture review:** Press this button to review the pictures you've already taken.

- ✦ **Print/e-mail photos:** Some digital cameras allow printing directly from the camera to compatible printers, or marking pictures for printing or e-mailing later.

✦ **Cursor pad:** Use this to navigate menu choices. Many digital cameras use the cursor buttons to activate frequently accessed features, such as flash options, macro mode, exposure value adjustments, and self-timer.

✦ **Set/Execute button:** Press this to activate a feature or set a menu choice to the current selection.

✦ **Memory card slot:** This accepts digital memory cards.

✦ **USB port:** Use this to connect your camera directly to your computer or a printer via a USB cable.

✦ **File-save LED:** This light usually flashes or lights up to indicate that an image is currently being saved to the memory card.

✦ **Power zoom control:** Press this to zoom the lens in and out.

Evaluating Your Lens Requirements

The lens and the sensor (or film, in the case of a conventional camera) are the two most important parts of any photographic system. The lens gathers the light from your scene and focuses it onto the capture medium, digital or analog. The sensor or film transforms the light into something that can be stored permanently and viewed as a picture after digital or chemical processing.

Sharp lenses and high-quality sensors (or film) lead to technically good images; poor lenses and bad sensors lead to poor photos. Indeed, in one sense, most of the other components of a camera are for your convenience. Theoretically, you could mount a simple lens on one end of an oatmeal box, focus it on a piece of film or a sensor affixed to the inside of the other end of the box, and make an exposure by covering and uncovering the lens with a dark cloth. Of course, the digital version of this science fair project would require some additional electronics to handle the captured signal, but such a system could work.

When you're choosing a digital camera, the first thing to concentrate on is the lens furnished with it. You probably don't need to go into as much detail as I'm going to provide, but understanding the components of a camera lens does help you use your optics as much as it helps you choose them. The major things you need to know fall into four simple categories:

✦ **The optical quality of the lens itself:** Just how sharp is the piece of glass (or, these days, plastic)? The better the lens, the better it can capture — *resolve* — fine details. In most cases, the optical quality of digital camera lenses marches in lockstep with the price of the camera and the resolution of the sensor. Even at the low and medium ends of the price spectrum, digital cameras have good quality lenses that usually can resolve a lot more detail than the 2–4MP sensor can capture.

Camera vendors have been mass-producing lenses like these for film cameras for decades, and any film camera can capture a lot more detail than an inexpensive digital camera. At higher price levels, lenses have better quality optics, which are necessary to keep up with the detail-capturing capabilities of 6–8MP (and higher) sensors.

✦ **The amount of light the lens can transmit:** Some lenses can capture larger amounts of light than others, generally because they have a greater diameter that can transmit more light. This factor, called *lens speed,* is a bit more complicated than that. Think of a 1"-diameter pipe and a 2"-diameter pipe and visualize how much more water (or light) the wider pipe can conduct; now you're thinking in the right direction. Lens speed, in part, controls how low of a light level you can take pictures in. If you take many pictures in dim light, you'll want a *faster* lens. I look at this factor in greater detail, later in this chapter.

✦ **The focusing range of the lens:** Some lenses can focus closer than others. The ability to get up-close and personal with your subject matter can be very important if your hobbies include things such as stamp or coin collecting or if you want to take pictures of flowers or bugs. Indeed, close-focusing can open whole new worlds of photography for you, worlds you can explore in more detail in Book III, Chapter 2.

✦ **The magnification range of the lens:** Most digital cameras, except for the least expensive, have a zoom lens, which allows you to vary the amount of magnification of the image. You might be able to take your basic image and double it in size (a 2:1 zoom ratio), triple it (a 3:1 zoom) or magnify it 10X or more (a 10:1 zoom). The zoom range determines how much or how little of a particular subject you can include in an image from a particular shooting distance. As you might expect, the ability to zoom enhances your creative options significantly. At the widest settings (*wide-angle* settings), you can take in broad sweeps of landscape, whereas in the narrowest view *(telephoto),* you can reach out and bring a distant object much closer.

Understanding How Lenses Work

You don't need to have a degree in optical science to use a digital camera, but understanding how lens openings *(f-stops)* and some other components work can help you use those components more effectively.

Lenses consist of several optical elements, made of glass or plastic, that focus light in precise ways, much like you focus light with a magnifying glass or with a telescope or binoculars. The very simplest lenses, like those used on the least expensive digital cameras, are *fixed focal length* lenses, usually comprising just three or four pieces of glass. That is, the elements can produce an image only at a single magnification. You find these in the simplest point-and-shoot cameras that have no zooming capabilities. There aren't

many of these around, but I did run into a camera with no "real" zoom recently: an extra compact model that used a 3:1 digital zoom as a substitute for optical zooming capabilities.

Most digital cameras have zoom lenses, which have very complex optical systems with 8, 10, 20, or more elements that move in precise ways to produce a continuous range of magnifications. Zoom lenses must be carefully designed to avoid bad things, such as stray beams of light that degrade the image bouncing around inside the lens. For that reason, when choosing a digital camera with a zoom lens, you need to pay attention to the quality of the image. All 4:1 zooms are not created equal; one vendor might produce an excellent lens with this range, whereas another might offer a lens that is less sharp. Among digital cameras with similar or identical sensors, lens quality can make the biggest difference in the final quality of an image. You'll discover how to select the best lens for your needs as we go along.

You can get a top-quality lens and still save some money if you know how to interpret digital camera specifications. Many vendors share lenses and sensors among similar models in their product lines. I tested two cameras from the same manufacturer that had identical resolution and lens specifications, but one model was more compact, was outfitted with a rechargeable battery, and included rubber gaskets that made it water resistant. (It also cost more than $100 more!) A penny-pinching photographer who didn't mind a tiny bit more bulk, was willing to use AA batteries, and didn't plan any photography in rain showers could buy the less expensive version and save enough money to buy some extra memory cards or other accessories.

Magnifications and focal lengths

Comparing zoom ranges of digital cameras can be confusing because the exact same lens can produce different magnifications on different cameras. That's why you usually see the zoom range of a digital camera either presented as absolute magnifications or in the equivalents of the 35mm camera lenses that the zoom settings correspond to.

Zoom range doesn't relate to lens quality. You'll find excellent 4:1 zooms and other 4:1 zooms that are only average in quality. However, the longer the zoom range, the more difficult it is to produce a lens that makes good pictures at all zoom settings. You should be especially careful in choosing a lens with a longer zoom range (8:1 or above); test the camera and its lens before you buy. However, lenses from the major manufacturers (Canon, Konica Minolta, Sony, Nikon, Fuji, and so forth) are all generally quite good.

Until the advent of digital cameras, figuring the magnification of consumer camera lenses was relatively easy because in recent years, most consumer (and the workhorse professional) film cameras used a standard film size — the 35mm film frame — which measures a nominal 24mm x 36mm. Some cameras also used Kodak's now-discontinued Advanced Photo System (APS) film format, which produced images in three different configurations. The

Optical zoom versus digital zoom

Digital cameras have two kinds of zooming capabilities: optical and digital. *Optical zoom* uses the arrangement of the lens elements to control the amount of magnification. Usually, optical zoom is the specification mentioned first in the camera's list of features. *Digital zoom* is a supplementary magnification system, in which the center pixels of an image are enlarged using a mathematical algorithm to fill the entire image area with the information contained in those center pixels.

Digital zoom doesn't really provide much in the way of extra information; you could zoom in on an image in your image editor if you like. However, digital zoom is a way of turning a 4:1 zoom into an 8:1 (or better) zoom lens even if the results aren't as good as those you'd obtain with a true optical 8:1 zoom. I tend to discount digital zoom capabilities when buying a camera because I want the sharpest picture possible, and many of the digital zoom pictures I've taken have looked fuzzy and pixilated, like the examples shown in the following figures. (The first is a wide-angle shot, and the other is an 8X digital zoom that cropped and enlarged the center of the photo.) The feature doesn't cost you anything, and you can usually switch it off so you won't accidentally grab a digital zoom picture by mistake.

magnification of any particular lens with a standard film size is easily calculated by measuring the distance from the film the lens must be positioned to focus a sharp image on the film. (This is the *focal length* of the lens.)

By convention, in 35mm photography, a lens with a 45–50mm focal length is considered a *normal* lens. (The figure was arrived at by measuring the diagonal of the film frame; you can calculate the focal length of a normal lens for any size film or digital camera sensor by measuring that diagonal.)

Lenses with a shorter focal length, such as 35mm, 28mm, 20mm, or less, are described as *wide-angle* lenses. Those with longer focal lengths (such as 85mm, 105mm, or 200mm) are described as *telephoto* lenses. We've lived happily with that nomenclature for more than 75 years, since the first 35mm camera was introduced. Wide-angle and telephoto images are shown in Figure 1-3.

Then came the digital camera, and all the simple conventions about focal lengths and magnifications went out the window. For good and valid technical reasons, most digital camera sensors do not measure 24mm x 36mm. You wouldn't want a sensor that large (roughly 1" x 1½") anyway in a compact digital camera because the camera would have to be large enough to accommodate it. In addition, as with all solid-state devices, the larger a device such as a sensor becomes, the more expensive it is to manufacture. Sensors that are as large as the full 35mm film frame are available for an increasing number of digital SLR cameras, which means the magnification effect I'm about to describe doesn't apply for those models.

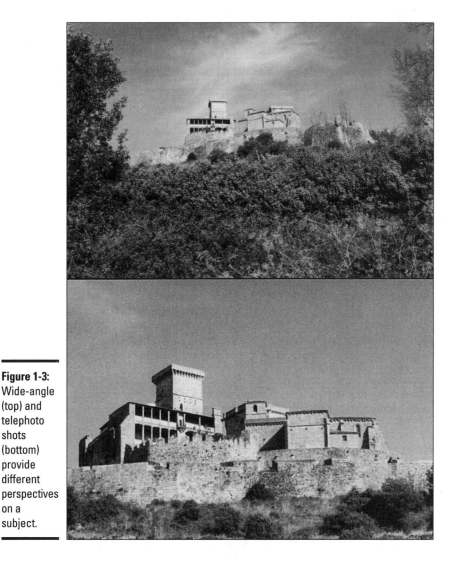

Figure 1-3: Wide-angle (top) and telephoto shots (bottom) provide different perspectives on a subject.

Most sensors are more likely to measure, say, 16mm x 24mm or less. Even the larger digital camera sensors might be no bigger than about 38mm x 38mm. So, a normal lens on one digital camera might be 8mm whereas another normal lens on another camera might be 6mm. A 4:1 zoom lens can range from 8mm–32mm or 5.5mm–22mm. What a mess! How can you compare lenses and zoom ranges under those conditions?

Camera vendors have solved the problem by quoting digital camera lens focal lengths according to their 35mm equivalents. If you're already familiar

with 35mm camera lenses, that's great. If you're not, at least you have a standard measurement to compare to. That's why you often see digital camera zoom ranges expressed as *35mm–135mm equivalent* (roughly 4:1) or some similar expression. You can safely use these figures to compare lenses in your quest for the perfect digital camera.

Because digital camera lenses have such short focal lengths in the first place, most models tend to be deficient in the wide-angle department. Expect to see most digital cameras with no better than a 35mm–28mm wide-angle equivalent. That's barely acceptable because 35mm isn't very wide. If you really need a wide field of view, consider a wide-angle attachment that fits on the front of your lens.

What focal length (equivalents) do you look for? Your preferred range will depend on what kind of photos you want to take. If you shoot architecture or indoor photos, you'll want the shortest focal length possible. An alarming number of digital cameras seem to have settled on a 38–39mm (equivalent) focal length as their widest setting. There are several reasons for that. First, a lens with that meager wide-angle field of view is easier to design (and usually more compact) than one with a broader perspective.

In addition, a lens with a particular magnification will have a longer telephoto effect if you're starting from a base focal length that's less wide to begin with. Consumers tend to get more excited about long telephotos than they do about wider wide-angles, even though both perspectives have an important place. Table 1-1 shows how a 4:1 zoom lens gains a more impressive telephoto "look" when the vendor snips millimeters from the wide-angle portion of the range.

Table 1-1	4X Zoom Lenses (35mm Equivalents)
Minimum Focal Length	*Maximum Focal Length*
28mm	112mm
32mm	128mm
35mm	140mm
38mm	152mm

Hey, wouldn't you prefer a 152mm medium telephoto over a 112mm short telephoto? You would until you found yourself with your back up against the wall trying to take a picture of an entire (albeit moderately small) room and discovered that your 4X zoom lens would give you no more than the field of view of a 38mm lens. You might be happier with the lens that has a wider minimum focal length but which accepts a telephoto attachment for those times when you really need to reach out and touch something.

Wide angles and digital SLRs

A digital SLR with interchangeable lenses doesn't make the wide-angle problem go away. Remember that if your SLR has a sensor that's smaller than what is called *full-frame size,* the focal length of any lens you attach will be magnified. If your camera's magnification factor is 1.6, a super-wide 18mm lens (or zoom setting) is instantly transformed into a moderately wide 28mm lens. Extreme wide angles can be expensive in the first place, so you might be crushed when you discover that your expensive piece of glass that qualifies as an ultra-wide angle on a 35mm camera provides you with a rather ordinary wide-angle view when mounted on a digital camera.

If wide-angle photography is important to you, look for a digital SLR with a full-frame sensor or purchase a lens that has been designed specifically for digital photography. A wide lens for a 35mm camera costs as much as it does because it must cover a full 24mm x 36mm film frame evenly. When a lens designer is creating optics that will be used with sensors that are smaller than the traditional film frame, the lens can have a wider view, be more compact, and still provide an image that is sharp over the entire surface of the sensor.

Although one of the attractions of digital SLRs is the ability to recycle a photographer's existing stable of lenses, the major vendors are all introducing lenses specifically for digital cameras that do a better job, cost less, and provide improved fields of view.

Lens apertures

The *lens aperture* is an adjustable control that determines the width of the opening that admits light to the sensor. The wider the aperture, the more light that can reach the sensor, making it possible to take pictures in dimmer light. You can think of an aperture as the pupil of your eye. When it's bright outside, your pupils contract (and you squint), letting in less light. When it's dim, your pupils dilate.

A narrow aperture reduces the amount of light that can reach the sensor, letting you avoid overloading the imaging device in very bright light. These lens openings are used in tandem with *shutter speed* (the amount of time the sensor is exposed to the light) to control the exposure. (I explain more about exposure later in this chapter.) Your digital camera needs a selection of lens apertures *(f-stops)* so that you can take pictures in a broad range of lighting conditions.

f-stops aren't absolute values; they're calculated by measuring the actual size of the lens opening as it relates to the focal length of the lens using a formula that I won't repeat here. The easiest way to visualize how f-stops work is to imagine them as the denominators of fractions. Just like ½ is larger than ¼ or ⅛, f/2 is larger than f/4 or f/8. The relationship is such that as the amount

of light reaching the sensor is doubled, the f-stop increases using an odd-looking series of numbers: f/2 is twice as large as f/2.8, which is twice as large as f/4, and so on through f/5.6, f/8, f/11, f/16, and f/22 (which is just about the smallest f-stop you'll encounter in the digital realm, which tends to "stop" stops at around f/8). Figure 1-4 shows lens openings of various sizes.

Figure 1-4:
Left to right, f/4, f/8, and f/11 lens openings.

If you're taking photos in automatic mode, you don't need to know what f-stop you're using because the camera selects it for you automatically. Your digital camera probably displays the f-stop being used, however, either in the viewfinder or on an LCD panel, and the information can be helpful. Just remember these things:

✦ The larger the f-stop (and the smaller the number), the more light is admitted *(faster)*. An f/2 lens (small number, large f-stop) is a fast lens whereas one with a maximum aperture of f/8 (larger number, smaller f-stop) is *slow*. If you need to take photos in dim light, you want to buy a camera with a fast lens.

✦ The smaller the f-stop (larger the number), the more of your image that is in sharp focus. (More on this later.)

✦ As the f-stops get smaller (larger number), exposure time must be increased to let in the same amount of light. For example, if you take a photo at f/2 for one-half second, you need to double the exposure time to one full second if you *stop down* (reduce the aperture) to f/4. I look at exposure a little later, too.

Typically, you'll find that among non-SLR digital cameras, the *speed* or maximum aperture of camera lenses is smaller than is common among 35mm film cameras, and the range of available apertures is more limited, too. For example, even an inexpensive snapshooter 35mm film camera might have an f/1.9 lens (pretty fast), and serious photographers with 35mm SLRs probably own f/1.4 or faster normal and wide-angle lenses. Although zoom lenses usually have smaller maximum apertures, in the 35mm film world, f/2.8–f/3.5 are common numbers.

In the digital camera realm, things are a bit different primarily because the very short focal lengths of the lenses are more difficult to design with large lens openings. So don't be alarmed if your favored digital camera has an f/4 or f/5.6 maximum aperture. You might even find that the lens is labeled f/4–f/5.6 because the effective widest opening can vary as a lens is zoomed in and out. A lens might have an f/4 opening when zoomed out to 38mm but only f/5.6 at its maximum telephoto setting of 152mm. (In most cases, as the focal length increases, the lens opening itself moves along with the optical glass, so the opening is farther away from the sensor and looks smaller.)

To make things really interesting, your digital camera lens might have only a limited number of different f-stops available, perhaps f/4, f/5.6, and f/8, or maybe none at all. You won't miss the lack of f-stops: Modern electronic shutters are fast enough to provide the proper exposure without smaller lens openings. Further, in 35mm photography, smaller lens openings have been used to increase the range of sharpness (called *depth-of-field*). As you can read in Book III, Chapter 2, though, the short focal length of digital camera lenses usually means that just about everything is sharp, anyway.

**Book II
Chapter 1**

Choosing the Right Camera

Focus range

The focus range of a digital camera is simply how close it can be from a subject and still create a sharp image. Digital cameras vary in their close-focusing (also called *macro*) capabilities. If you want to photograph flowers, hobby collections, items for sale on eBay, or anything else up-close, you want to make sure that your camera is up to it. Close focus can vary from model to model. Some vendors deem anything less than about a foot as macro capability. Other cameras take you down to one-half inch from your subject. Here are some things to consider when evaluating focus range.

✦ **There's such a thing as *too* close.** When you get to within a few inches of your subject, you'll find that the subject is difficult to light. The camera itself can cast shadows and keep sufficient light from reaching your subject. You'll find more about lighting close-ups in Book III, Chapter 2.

✦ **Some lenses don't allow close focus at all zoom settings.** You might want to step back a foot and zoom in to get the best view of your subject. However, some lenses don't allow automatic (or even manual focus) at longer zoom settings. Some restrict macro capabilities to midrange or wide zoom settings.

✦ **Close focusing is tricky.** You want to make sure your digital camera includes automatic macro-focusing capabilities so that you don't have to focus manually when shooting up tight to the subject.

✦ **Keep attachment friendliness in mind.** If your favored digital model doesn't have sufficient built-in macro options, see whether you can attach close-up lenses to the front of your lens. Not all digital cameras can accept screw-on attachments of this type.

Exposure controls

Because light levels vary, digital cameras must vary the amount of light reaching the sensor. One way to do that is to change the f-stop, as described earlier in this chapter. The second way is to alter the amount of time that the sensor is exposed to the light. This is done either electronically or with an actual mechanical device — a shutter — which opens and closes quickly to expose the sensor for a set period — *shutter speed.*

Like f-stops, shutter speeds are the denominators of fractions. The larger the number, the less light that reaches the sensor. Typical shutter speeds include $\frac{1}{60}$, $\frac{1}{125}$, $\frac{1}{250}$, $\frac{1}{500}$, and $\frac{1}{1000}$ of a second. Your digital camera readout might show them as 60, 125, 250, 500, or 1000 because the numerator is always 1. However, a recent trend has been to include the numerator anyway to avoid confusion with longer shutter speeds, which are whole numbers. Otherwise, you'd have no way of telling whether an 8 in the viewfinder means $\frac{1}{8}$ second or 8 seconds.

Cameras (chiefly film models) using mechanical shutters might have only exact intervals like those available although most film cameras have electronic shutters these days. Electronic shutters aren't limited to those values and can provide you with any actual interval from a few seconds through $\frac{1}{2000}$ (or sometimes even $\frac{1}{4000}$) of a second. The traditional shutter speed values are useful only when calculating equivalent exposures.

For example, suppose a basic exposure were $\frac{1}{250}$ of a second at f/16 (which is a typical exposure for a digital camera in bright daylight). If you wanted to stop some fast-moving action, you might want your camera to switch to $\frac{1}{500}$ of a second to freeze the movement with the shorter exposure time. (You can find out more about stopping action in Book III, Chapter 5.)

Because you've cut the amount of light in half by reducing the shutter speed from $\frac{1}{250}$ to $\frac{1}{500}$ of a second, your camera needs to compensate by doubling the amount of light admitted through the lens. In this example, the lens is opened up from f/16 to f/11, which lets in twice as much illumination.

Usually, all this happens automatically thanks to your digital camera's handy autoexposure modes, but you can set these controls manually on some models if you want. It's probably a better idea to choose a different autoexposure mode (described later) that gives you the flexibility you need. Sometimes, you'll look at an image on your LCD review screen and decide that the picture is too dark or too light. A digital camera's autoexposure modes can take care of this, too. When shopping for a digital camera, you'll want to look for the following exposure options.

Plus/minus or over/under exposure

With these modes, you can specify a little more or a little less exposure than the ideal exposure that your camera's light-measuring system determines.

These adjustments are called *exposure values* (EV for short), and most digital cameras let you fine-tune exposure +/– about 2EV, using half- or third-stop increments. The most conveniently designed cameras have the EV adjustment available from one of the main buttons on the camera, such as the Up-cursor key. Beware of cameras that make you wend your way into the menu system to make an EV adjustment. Fortunately, after it's set, the EV setting "sticks" so that you can continue to take pictures in the same environment with the modified setting.

Full autoexposure

With this option, your digital camera selects the shutter speed and lens opening for you by using built-in algorithms, called *programs,* that allow it to make some intelligent guesses about the best combination of settings. For example, on bright days outdoors, the camera probably chooses a short shutter speed and small f-stop to give you the best sharpness. Outdoors in dimmer light, the camera might select a wider lens opening while keeping the shutter speed the same until it decides to drop down to a slower speed to keep more of your image in sharp focus.

Some digital cameras have several autoexposure program modes (sometimes called *scene settings)* to select from, so if you're taking action pictures and have chosen an action-stopping mode, the camera tries to use brief, action-stopping shutter speeds under as many conditions as possible. These program modes are different from the aperture/shutter-preferred modes described next because they frequently include other factors in their adjustments. They might have names like Sports, Night, Night Portrait, Landscape, Fireworks, or Portrait. I used a camera with a scene setting called Cuisine (I kid you not), which (after a little digging) I discovered also increased the sharpness and color richness of the picture to supposedly make food pictures look better. Some cameras have both an Auto (A) and Program (P) setting.

Aperture-preferred/shutter-preferred exposure

These options let you choose a lens opening (aperture-preferred) or shutter speed (shutter-preferred) and then set the other control to match. These settings might be indicated by A or S markings — commonly, Av and Tv (Time value). For example, by choosing shutter-preferred, you can select a short shutter speed, such as $\frac{1}{1000}$ of a second, and the camera locks that in, varying only the f-stop.

Unlike programmed modes described in the preceding section, if your camera finds that the selected shutter speed, for example, can't be mated with an appropriate aperture (it's too dark or too light out), it might not take a photo at all. I've run into this at soccer games when I've set my camera to an action-stopping shutter speed, but clouds dim the field so much that even the largest lens opening isn't enough to take a picture. Figure 1-5 shows an action shot taken with the camera set on shutter-priority.

Book II
Chapter 1

Choosing the Right Camera

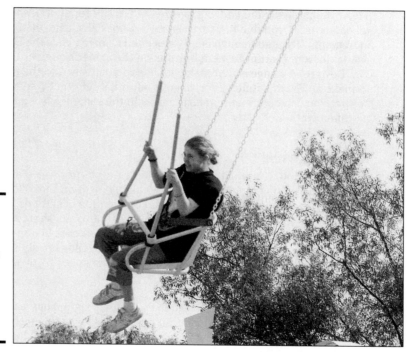

Figure 1-5:
Choosing shutter priority lets you select an action-stopping shutter speed.

Full manual control

With this option, you can set any shutter speed or aperture combination you like, giving you complete control over the exposure of your photo. That means you can also completely ruin the picture by making it way too dark or much too light. However, complete control is good for creative reasons because seriously underexposing (say, to produce a silhouette effect) might be exactly what you want.

Other factors to consider

In addition to exposure options themselves, you must consider other factors when evaluating the exposure controls of your dream digital camera. Here is a quick checklist of those you should look out for:

✦ **Sensor sensitivity:** Like film, sensors have varying degrees of sensitivity to light. (For film, this is its *speed*.) The more sensitive the sensor is, the better it can capture images in low light levels. Most digital cameras have a sensitivity that corresponds roughly to that of ISO 50 to ISO 100 film (so-called *slow* film), and the specs often use that terminology. Many cameras let you specify the sensitivity, increasing from the default value of, say, ISO 100 to ISO 400 or even ISO 800 (fast) to give you a "faster" camera. Unfortunately, upping the ISO rating usually increases the

amount of random fuzziness — *noise* — in the image. It's like turning your radio up really loud when you're driving a convertible with the top down. The wind flying past your ears tends to cancel out some of the audio information that your too-loud radio is producing. Increasing the ISO boosts image information while increasing background noise in the image. If you plan to shoot many pictures in very dim light, any camera you buy should be tested first to see whether ISO settings could be set manually. Then check how noisy the pictures become when you increase the sensitivity.

✦ **Measurement mode:** Just how does your digital camera's exposure system measure the light? Sometimes it measures only the center of the picture (which is probably your subject anyway); sometimes, it might measure the entire frame and average out the light that the sensor sees. You don't always want the camera to measure the light the same way. Measuring a center spot sometimes produces the most accurate reading. Other times, such as when the scene is evenly lit, an averaging system works best. On still other occasions, say, when there is a lot of sky in the photo, you might want the camera to measure only the light in the lower half of the picture. Many cameras have multiple exposure modes that allow you to choose what part of the image is measured. One clever exposure system I've used works in conjunction with the camera's automatic focus, selecting the part of the image that is in sharpest focus to calculate the exposure.

✦ **Compensation systems:** Many exposure systems can sense when a picture is *backlit* (most of the light is coming from behind the subject) and add exposure to make the subject brighter. Sophisticated cameras can analyze your scene and choose an exposure mode that best fits each individual picture, compensating for potential trouble spots in the photograph. Or the camera might have an override to the exposure system, allowing the sensor to receive more light from backlit subjects when you choose to activate it.

✦ **Manual exposure:** If you're seriously interested in photography, you'll want at least the option of setting exposure manually (both f-stop and shutter speed) so you can custom-tailor your exposure to the artistic effect you're trying to achieve.

Choosing Your Resolution

The best lens can't produce any more sharpness than the sensor used to capture its information. For that reason, the resolution of most digital cameras is the specification most people use to choose their equipment. They want a 4MP camera or a 5MP model or maybe a 6–8MP camera. They figure (with some justification) that the more pixels they have, the more features the vendor packs into the camera. After all, you can expect a 6MP camera to

have a decent zoom lens, lots of exposure control choices, close focusing, and all the other goodies, right?

Most of the time, that's true. The sensor is usually the most expensive part of any digital camera, so if you're building a camera that's going to cost $800 anyway, you might as well load on the other goodies to justify the price. However, as sensors get less expensive, I'm seeing cameras with (supposedly) equivalent sharpness with widely varying feature sets. For example, I've used cameras in the 4–5MP range that cost as little as $169 (and had sparse lists of features to match) and others with the same nominal resolution that cost $1,100 and were chock-full of advanced capabilities.

And, even when dealing with sensors, all pixels are not created equal. For one thing, the *true* resolution of a sensor is likely to be somewhat less than you might think. Take a sensor measuring 2048 x 1536 pixels. You'd think that such a sensor could image about 3.1 million different details. Bzzzt. Wrong answer! That would be possible only if the image were captured in black and white.

In practice, the sensor has to capture red, green, and blue pixels. With current sensors, each pixel can capture only one particular color, so those 3.1 million pixels are actually divided up into red-sensitive pixels, green-sensitive pixels, and blue-sensitive pixels. If the pixels were divided up evenly, you'd wind up with three 1MP sensors — one each for red, green, and blue, rather than the 3.1MP sensor you thought you had.

However, the pixels aren't divvied up in that way. Because our eyes are more sensitive to green light than to the other colors, sensors typically divide up their pixels unevenly: 50 percent are green, 25 percent are red, and 25 percent are blue. That's done by alternating red and green on one line, and green and blue on the next, as shown here and also in Figure 1-6:

RGRGRGRGRGRGRGRG

GBGBGBGBGBGBGBGB

RGRGRGRGRGRGRGRG

Figure 1-6:
The typical sensor pixel is sensitive to red, green, and blue light.

Your camera's brain examines the picture and calculates (or *interpolates*) what the red and blue values probably are for each green-sensitive pixel position, what the green and blue values are for each red-sensitive pixel position, and the likely green and red values for each blue-sensitive pixel.

Other digital cameras use technologies that are a little different — or a lot different. For example, Sony offers a sensor that captures what it calls RGB+E (for emerald) light, producing what it describes as color fidelity that is closer to human color perception, with more life-like rendering of blue, blue-green, and red hues. Another vendor, Foveon, produces a sensor that has separate layers for red, green, and blue light, as shown in Figure 1-7, so that each pixel is capable of capturing any color light without interpolation.

Beyond the capture scheme used, other factors affect sensors. Some sensors are more sensitive than others, and other factors make a particular sensor not perform as well as another one with the same number of pixels. For example, some sensors don't register some colors well or have pixels that bright light can easily overwhelm.

Red light absorbed by red-sensitive layer

Green light absorbed by green-sensitive layer

Blue light absorbed by blue-sensitive layer

Figure 1-7:
The Foveon sensor has separate layers for each color of light.

When choosing a digital camera, you want to choose one with the resolution you want. If possible, compare the pictures taken with each camera under consideration to see whether that resolution is being put to good use.

When it comes to megapixels, you can estimate the resolution you require with these guidelines:

+ **Low *res* (short for resolution):** If you're shooting pictures intended for Web display, for online auctions, or for pictures that either won't be cropped or enlarged much, you can get by with a lower-resolution camera in the 1–2MP range.

+ **Medium res:** If you often need to crop your photos, want to make larger prints, or need lots of detail, you want at least a 3.3–5MP camera.

+ **High res:** If you want to extract small portions of an image, make 8 x 10" prints or larger, or do a lot of manipulation in an image editor, you want a 5–14MP (or more) camera.

Keep in mind that most digital cameras allow shooting in a reduced mode, so if you own a high-resolution camera, you can still shoot in low resolution to pack more images on your digital film or to reduce file sizes on your hard disk. Resizing images is rarely a good idea, even with a good image editing program, so you usually want to shoot at the resolution you intend for your finished photo. Resize later, if you want, but keep your full-size version for printing, just in case.

The mode in which your camera stores the image on your digital film can affect the final resolution of your image, too. Digital cameras usually store photos in a compressed, space-saving format known as *JPEG* (Joint Photographic Experts Group). JPEG format offers reduced file sizes by discarding some information. In most cases, a JPEG file is still plenty good, but if you want to preserve all the quality of your original image, you might want to set your camera to store in a *lossless* image format (that is, one that doesn't discard any image information when compressing the file), such as TIFF, RAW, or EXIF. You might be able to choose from different JPEG quality levels, too.

Expect these alternate formats to eat up your exposures quickly. One of my digital cameras can store 32 images on a particular digital film card in JPEG format but only 5 in TIFF. TIFF and RAW also take more time to store on the film card, too, so they're not a good choice when you're shooting sports or other sequence-type photos.

Some cameras generally label their resolution choices with names such as Standard, Fine, Superfine, Ultrafine, and so forth. These terms can vary from vendor to vendor.

Choosing Your View

Generally, you want what you see to be what you get, but that's not always the case with digital cameras. That's because the viewfinders available are usually a compromise between what works best and what can economically be provided at a particular price level. In the digital photography realm, the solution has long been to provide you with two viewfinders per camera, each with its own advantages and disadvantages. You usually find

✦ A **color LCD display screen** on the back of the camera, which you can use to preview and review your electronic images.

✦ An **optical viewfinder,** which you can peer through to frame and compose your image.

Some cameras have two LCDs: one on the back in the traditional location, and a second one inside the camera and visible through an optical system. This variety is an *electronic viewfinder.* None of these are ideal for every type of picture-taking application.

LCD viewfinders

The liquid crystal display, usually measuring from 1.5–2.5 inches diagonally, shows an electronic image of the scene as viewed by the sensor. On the one hand, that's good because you can view more or less the exact image that will be captured. It's also not so good because the LCD display is likely to be difficult to view, washed out by surrounding light, and so small that it doesn't really show what you need to see. Moreover, the backlit LCD display eats up battery power. I've used digital cameras that died after 20 minutes when the LCD had depleted their rechargeable batteries. Luckily, some digital cameras let you specify that the LCD is turned on only when composing a picture or only for a few seconds after a picture is taken (so that you can quickly review the shot).

Although often not usable in bright daylight, LCDs, such as the one shown in Figure 1-8, are better in more dimly lit conditions. Some third parties offer LCD hoods that fit over the back panel of the camera to shield the LCD from direct illumination. If you mount your camera on a tripod and make sure all the light is directed on your subject, an LCD is entirely practical for framing, focusing, and evaluating a digital image (even outdoors, if you use one of those protective hoods.) As you shop for a digital camera, check out the LCD display under a variety of conditions to make sure it passes muster. Here are some things to look for:

✦ **Brightness controls:** Many cameras include a brightness control that allows increasing the brightness of the LCD to make it easier to view in full sunlight or decreasing the brightness indoors to use less battery juice.

✦ **Swivel mount:** The LCD doesn't have to remain fixed rigidly to the back of the camera. Some swivel and rotate, allowing you to point the camera in one direction and move the LCD so that you can easily view it at an angle. (Alternatively, the part of the camera with the lens can swivel while the part with the LCD remains in place.)

✦ **Resolution and size:** Ultracompact digital cameras often have tiny LCD displays, on the order of 1½ " (measured diagonally), and others have more generous 2" LCDs. The size of the LCD and the number of pixels it contains will partially determine how easy it is to preview your image.

✦ **Display rate:** Some digital cameras update their LCD images more efficiently, so the view is smooth even when the camera or your subject is moving. Others offer up blurry images or ghost trails that make it difficult to view images in motion.

✦ **Vanishing images:** What happens when you press the shutter release? Does the image instantly freeze as soon as you start to press the button but before you actually take the picture? If so, what you saw might not be what you get because your subject matter might have changed in the time between the initial press and the actual photo. Or, does the LCD go completely blank, leaving you with no clue about what you're shooting? Ideally, the LCD should display a real-time image right up until the instant before the picture is taken.

✦ **Accurate viewpoint:** Believe it or not, even though an LCD viewfinder's display is derived from the same sensor used to make the exposure, the LCD might not display 100 percent of the sensor's view. Instead, it might trim a little off the sides, top, and bottom, and show you 80–90 percent of the actual picture. That's not good when you're carefully composing a photo to make the most of your pixels, particularly with lower-resolution cameras that don't have pixels to spare.

✦ **Realtime corrections:** Some cameras have live *histograms* — graphs that show the distribution of the tones in the image — that can be viewed on the LCD and used to correct exposure manually while you shoot.

✦ **Accurate rendition:** I've found that some LCDs don't let you evaluate just how good (or bad) your picture is because they provide an image that's more contrasty, or brighter, or with more muted colors than the actual digital picture. You don't want to reshoot a picture because you *think* it looked bad on the LCD. Or worse, make a manual exposure or other adjustment to correct a defect that appears only on the LCD and not in the finished photo.

Figure 1-8:
LCD
displays
work fine in
dim light.

Optical viewfinders

Most of the time, you use an optical viewfinder, which is bright and clear, uses no power, and lets you compose your image quickly. However, optical viewfinders have problems of their own, most notably *parallax.* Parallax is caused by the difference in viewpoint between your camera's lens and the optical viewfinder. They don't show the same thing.

If the optical viewfinder happens to be mounted directly above the camera lens, its view will be a little higher than that of the lens itself. This becomes a problem chiefly when shooting pictures from relatively close distances (3 feet or less). Such a viewfinder tends to chop off the top of any subject that is close to the camera. Optical viewfinders usually have a set of visible lines, called *parallax correction lines,* which you can use to frame the picture. If you keep the subject matter below the correction lines, you can avoid chopping off heads. Of course, you get *more* of the lower part of your subject than you can view.

Parallax becomes worse when the optical viewfinder is located above and to one side of the lens, as shown in Figure 1-9. In that case, a double set of parallax correction lines is needed to help you avoid chopping off both the top and the side of your subject. Yuk! Here are some things to look for in optical viewfinders:

+ **Magnification:** I get to use dozens of digital cameras in a year, and one of the first things I notice is the difference in magnification of the optical viewfinders. Put the camera up to your eye, and you might see a tiny image floating off in the distance, with the details of your scene barely discernible. Other cameras provide a big view that makes it easy to frame and compose your photo.

+ **Zoom:** Believe it or not, some digital cameras with zoom lenses have optical viewfinders that don't zoom! Ideally, the image should match the view of your LCD display and lens, but some cameras keep a fixed view and use indicator marks to show the picture area.

+ **Parallax correction:** As I mention earlier, optical viewfinders might not accurately frame the image when you move in close to your subject. The position of the viewfinder window can have an effect: If the viewfinder is directly above the lens, the side-to-side view will be accurate, but you might cut off the top of your subject if the camera doesn't provide parallax correction. If the viewfinder is immediately to the side of the lens, your problems will involve accidentally cutting off the side of your subject. Some viewfinders are both above the lens and to one side, which can produce parallax problems in both directions.

+ **Accurate viewpoint:** As with LCD displays, the optical viewfinder might not show everything you're framing, with some image area clipped off the top, bottom, or sides.

+ **Diopter adjustment:** Eyeglass wearers will want an optical viewfinder that offers adjustment for common prescriptions so the camera can be used without wearing glasses.

+ **Extended eyepoint:** The *eyepoint* is the distance your eye can be from the viewfinder's window and still see the entire view. Some viewfinders mandate pressing your eye up tightly against the windows. Others let you back off a few millimeters, which is handy when you want to be able to see *around* the camera to monitor the whole scene (and not just what appears in the viewfinder) or need to wear your glasses while using the camera (and are thus not able to get close to the window because the glasses get in the way.)

+ **Readouts:** What information is available within and around the optical viewfinder? Some cameras show nothing but the unadorned image. Others have framing or parallax correction lines or perhaps a faint grid to help you line up the image. Perhaps some camera status indicators appear in the viewfinder, too, such as a flash-ready LED, within the field of view or located just outside the viewfinder window where it can be detected by the eye.

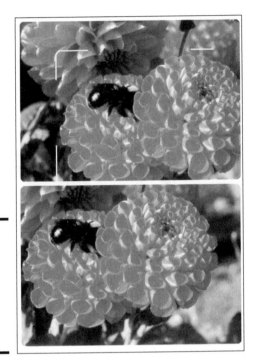

Figure 1-9:
Parallax
correction
lines help
you avoid
chopping
off heads
or worse.

Electronic viewfinders

Recently, some affordable cameras have been introduced with hybrid viewfinders that work like optical viewfinders (that is, you put your eye up to a window to view your subject) but that use an electronic display to show you the image. These LCDs are much like the LCDs found on the backs of cameras, but because they are automatically shielded from extraneous light, are much easier to view. Because they form an image using the signal from the sensor, when compared with optical viewfinders, they offer a potentially more accurate and SLR-like picture taking experience.

However, poorly designed EVFs can be a pain to use, so you'll want to examine the view through any camera so-equipped before you sink your money into one. Here are some of the considerations to think about:

✦ **Magnification:** EVFs can suffer from viewfinder magnification issues, the same as optical viewfinders. Because you'll be composing, and (in some cases) focusing manually via the internal LCD, make sure your view is as large and sharp as possible.

✦ **Extended eyepoint:** Just as with optical viewfinders, you might not be able to (or want to) press your eyeball up to the viewfinder window, so an EVF with an extended eyepoint is a plus.

✦ **Readouts:** Compared with optical viewfinders, EVFs usually contain a lot of information, including status readouts, grids, focus and exposure area indicators, and so forth, as shown in Figure 1-10. Make sure you can turn off these distracting elements when you don't want to see them.

✦ **Swivel mount:** Some eyepieces for EVFs can swivel 90 degrees to allow taking pictures from especially low or high angles. I find this capability handy when I have the camera mounted on a tripod at about waist level and I don't want to crouch down to look through the viewfinder.

✦ **Resolution and size:** The LCDs in EVFs typically are larger than their camera-back counterparts and have more detail. Vendors have raised the bar on EVF resolution, with at least one offering a full megapixel display on its top-of-the-line camera. These high-resolution electronic viewfinders are easier to see to discern detail and more reliable when used for focusing.

✦ **Display rate:** EVFs can have ghost images, too. A brand-new feature on some models is so-called *smooth mode,* which refreshes the EVF image 60 times a second (about twice as fast as normal), providing an especially good preview of your photo.

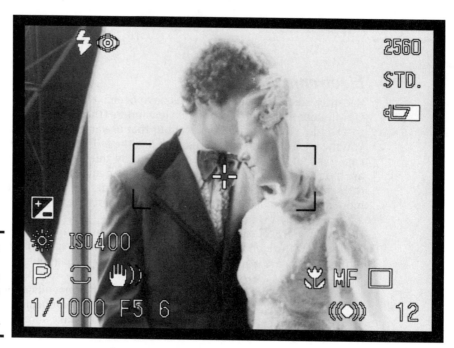

Figure 1-10:
Electronic
viewfinders
can contain
a lot of
information.

✦ **Vanishing images:** Obviously, the EVF can't provide a continuous image because the sensor's view must be collected and captured at the instant the photo is taken. During that interval, the image might freeze onscreen or vanish entirely. Some cameras switch into *high-gain mode* under dim lighting conditions, in which the image signal is amplified to provide better viewing, sometimes offering only a fuzzy or black-and-white view in that mode. Better cameras give you an accurate, full-color preview up until the exact moment the photograph is taken.

✦ **Accurate viewpoint:** EVFs don't always display 100 percent of the sensor's view, either. The best show at least 92–99 percent of the actual picture area in the viewfinder.

✦ **Accurate rendition:** As with any LCD, the image you see might not be exactly like your final photograph, but the results should be close.

SLR viewfinders

And there's always the single-lens reflex camera, which shows you (more or less) the exact image the sensor sees through the taking lens via an optical system. It's done with mirrors (really). In the most common configuration, you view the subject through the lens using an image bounced off mirrors and (sometimes) a glass prism. When you take the picture, the mirror moves out of the way to expose the sensor. You lose sight of the image for a fraction of a second, but film SLR users have been tolerating that inconvenience for decades.

Both general types of SLR viewfinders use a mirror to bounce light upward, where it then reflects off a series of surfaces until the final image (erect and nonreversed from left-to-right) is viewed through an optical window. Less-expensive cameras use a series of mirrors (often called a *pentamirror* because of the five total surfaces in the structure), and more costly models use a solid glass prism, called a *pentaprism*. The latter provides a brighter, higher-contrast image that looks better and is easier to use for viewing and focusing. However, pentamirror viewfinders can also be very good, particularly if you don't compare them directly with models using a pentaprism. The light path for an image viewed by a pentamirror/pentaprism viewing system is shown in Figure 1-11.

Because the number of digital SLRs is still rather limited, you probably won't be shopping around for a camera based on viewfinder specifications. However, some of the same parameters I describe earlier, including eyepoint, accurate viewpoint, and magnification, apply.

Regardless of what optical or SLR viewing system you use, you want to make sure your camera either has built-in eyesight (diopter) correction to adjust for your near/far-sightedness or can be fitted with corrective lenses matched to your prescription. This vision correction enables you to get your eye

close enough to the viewfinder to see the whole image. Some viewfinders make it difficult for those wearing glasses to see through the optical system because a bezel or other part of the viewfinder prevents the glasses from getting close enough.

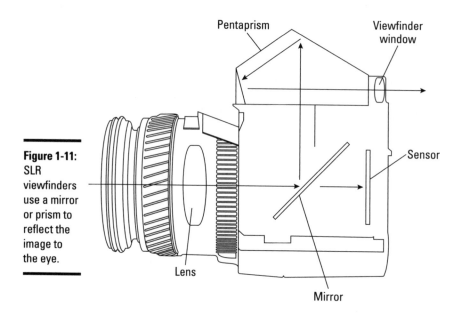

Figure 1-11: SLR viewfinders use a mirror or prism to reflect the image to the eye.

Considering Your Storage Options

The kind of storage your digital dream camera uses will never be a factor in making your selection (unless it's a truly odious choice, and that's a matter of personal taste). The days of the digital cameras that used floppy disks and other oddball media are long gone. Today, all digital cameras use one (or more) of the following options:

✦ **Secure Digital (SD):** In early 2004, the SD format overtook CompactFlash as the most popular memory card format. These postage-stamp-size cards allow designing smaller cameras, are available in roughly the same capacities as CompactFlash, and cost about the same. The chief drawback (to date) is that there are no mini hard drives in the SD format. If you want to use a mini hard disk, you'll need a camera with a CompactFlash slot. Some digital cameras can also use the similar (but slower) MultiMediaCard (MMC).

✦ **CompactFlash (CF):** CompactFlash is the second most-favored format in the United States. Although larger in size than SD, CompactFlash cards are still very small and convenient to carry and use. As larger capacities

are introduced, they usually appear in CF format first. As a bonus, the CompactFlash slot can also be used for mini hard drives, such as those from IBM, with capacities of a gigabyte or more.

+ **xD and mini-xD:** The xD and mini-xD formats are new, smaller than Secure Digital, and supported by fewer vendors (currently only Olympus and Fuji.) Although it's wise to avoid getting stuck using a Betamax format when everyone else has converted to VHS, you're safe in choosing a camera using an xD variant. The vendors are important enough that even if the format fails, you should be able to purchase memory cards for as long as your camera works. Indeed, because memory cards are typically used over and over forever, the cards you purchase with your camera or shortly thereafter are likely to serve you throughout your camera's useful life.

+ **Sony Memory Stick:** About the size of a stick of gum, Sony's Memory Sticks are useful because you can also use them with other devices, such as MP3 players. They're not going to replace CompactFlash, though.

+ **SmartMedia:** These digital film cards were always more popular in Japan than in other countries, chiefly because of their very small size. Because so many digital cameras are made in Japan, lots of cameras used SmartMedia. However, because SmartMedia cost more than its chief competitor (CompactFlash) and had lower capacity to boot, these cards have fallen from favor, and no new cameras introduced in the past year or so have used them.

+ **Mini hard drives:** For a long time, mini hard drives were your only option when you needed more than a gigabyte of storage. If you're using a 6MP or better camera and like to save your images as TIFF files or in another lossless format, you need more than a gigabyte of storage. However, with CompactFlash cards now available in 4–8GB sizes, the mini hard drive is losing its capacity edge, and they have always cost more than the equivalent silicon memory card. Although not excessively prone to failure, mini hard drives do have moving parts and must be handled with more care than memory cards.

+ **CD-R/R:** Sony, in its never-ending quest to change its digital camera media options annually, seems to have abandoned floppy storage in favor of mini CD-R and CD-RW discs. Although not really a bad idea, because the media is relatively inexpensive (a 240MB mini CD-R is a lot cheaper than a 256MB CompactFlash card), this option hasn't caught on yet.

Digital memory cards might be offered in various speeds, such as *standard, high-speed, 40X, Ultra, or Extreme,* depending on the nomenclature used by the vendor. The faster, more expensive media are able to store images more quickly. Unless you're shooting sequences and don't want to wait even a short time between pictures, standard media will probably do the job for you. Some newer digital cameras that provide a high-speed burst-photo mode require these higher performance digital cards to function as advertised, however.

No Flash in the Pan: Determining Your Lighting Needs

Your digital dream camera's electronic flash capabilities (or lack of them) should be on your list of things to evaluate before you make a purchase decision. Not every photo is possible using existing light. Even if there is plenty of light, you might still want to fill in those inky shadows with an electronic flash. Your camera's built-in flash features are definitely something to consider.

Most digital cameras have a built-in flash unit that can be turned on or flipped up or swung out or otherwise activated when you want to use flash — or when the camera decides for you that flash is required. (Usually, a tip-off is a flashing red light in your viewfinder. Time to flip up that flash!)

You should be aware that most flash units are good only over a particular range. If you've ever seen a fan stand up in the balcony at a Bruce Springsteen concert and take a flash picture of the Boss from 100 feet away, you'll understand just how limited flash is at long distances. Some units are so feeble that they can only illuminate subjects 2–12 feet away. Others have special settings to spread the flash illumination for wide-angle shots or tighten it up for telephoto pictures.

Here are some features to look for in electronic flash:

✦ **Auto-on:** It's useful to have a flash that can be set to flash only when it's needed. Some cameras require you to flip up the flash to use it. Others build the flash into the body of the camera in such a way that the flash can be used anytime.

✦ **Autoexposure:** An electronic flash can sense the amount of light reflected back from the subject and turn itself off when the exposure is sufficient. See whether your camera's electronic flash uses a sensor built into the body of the camera or whether the sensor measures the light actually being used to take the photo.

✦ **Red-eye prevention:** Some flashes can be set to produce a short preflash just before the picture is taken. That causes the subjects' irises to contract, reducing the possibility of the dreaded red-eye effect. Alternatively, the preflash can fool your subjects into thinking that their ordeal is over and produce some priceless weird expressions.

✦ **External flash capabilities:** At times, you want to use an external flash, either in concert with or instead of your camera's built-in flash. See whether your camera has either a built-in flash-sync socket or a *hot shoe* that you can use to mount an external flash and connect the camera to the flash. Keep in mind that many digital cameras require that you use only a particular brand of flash to retain the automated exposure features or (in some cases) to avoid frying your camera's flash triggering circuit with too much voltage. If you're thinking of using a slave, make sure that it can be used with your camera. The preflash of some cameras will set off the slave unit.

The Digital SLR Revolution

As this chapter has unfolded, I've been referencing the special needs and advantages of the digital SLR in each of the sections dealing with lenses, exposure capabilities, and other features. However, the current digital SLR (dSLR) revolution is such a great leap forward for the serious amateur photographer that I wanted to include a special section that goes into more detail about the nature of this particular beast.

After all, high-end cameras in the $1,000 price range use electronic viewfinders. (Their vendors often refer to them as *SLR-type* or *SLR-like* cameras.) An increasing number of true SLR cameras are also available at the same price. Which should you choose? First, consider the coolness factor.

**Book II
Chapter 1**

Choosing the Right
Camera

Ten reasons why digital SLRs are cool

Of the many reasons why so many digital photographers are turning to dSLRs, here are ten of my favorites (some of them a little facetious):

1. **Interchangeable lenses let you change viewpoints dramatically.**

2. **You can manually focus them in the same way you focus "real" cameras.**

3. **Their longer lenses make it easier to use depth-of-field creatively.**

4. **What you see is pretty much what you get.**

5. **A bigger, brighter viewfinder makes it easier to compose photos.**

6. **Reduced shutter lag and faster storage speeds (with many models) let you shoot sports and fast-moving subjects.**

7. **Many dSLRs can use readily available lenses, filters, flash, and accessories from the film camera realm.**

8. **They're less painful when it comes time for an upgrade.**

 Your lenses and gadgets can be used with your next camera. One digital camera vendor even announced a program for replacing an older camera's sensor with the sensor provided in the latest model.

9. **You can sneak onto the field at a sports event more easily because you look like a pro.**

10. **Your digital photographer friends will turn green (and not red-eyed) with envy.**

Some digital SLR considerations

The decision to buy a dSLR is not as easy as you might think. Anyone who has lusted after a dSLR for years (but who couldn't afford the $2,000 or more

required to purchase a decent model with lens) might jump at the chance. Here are some factors to take into account:

Do you need interchangeable lenses?

This isn't as outrageous a suggestion as it might appear to be. My favorite camera with an EVF viewfinder has a 28mm–200mm (equivalent) zoom lens. I find that those focal lengths suffice for 99 percent of my photographs. The wide view is wide enough for most architectural photos, and the long end has enough telephoto effect for most sports photography.

In contrast, one popular dSLR can be purchased with an 18–55mm f/3.5– f/5.6 zoom lens for less than $1,000, and the vendor describes the true focal length of the included lens rather than the prevalent 35mm-equivalent value. That's because the true equivalent focal lengths, 29mm at f/3.5 to 88mm at f/5.6, aren't very impressive. A dedicated 35mm photographer probably wouldn't consider such a lens for a film camera, but that's what budget-minded dSLR buyers will probably end up with as their initial lens choice.

Personally, I'd rather have a good-quality 28–200mm zoom lens on an EVF camera than be stuck with a puny 29–88mm zoom on a dSLR. If you choose a dSLR, you'll be glad you have interchangeable lenses because you'll need that capability rather quickly. (Remember, not all digital SLRs have interchangeable lenses; a few have fixed lenses, usually with an extra-wide zoom range to compensate.)

And, if you need wider lenses or longer telephotos frequently and don't want to use add-on wide-angle or tele attachments, a dSLR is the only camera box that will do the job for you.

One advantage of interchangeable lenses is that after you've invested in a collection of optics, you can transport them from camera to camera. If you and a friend have the same brand camera (even if one is a film camera and the other a digital camera), you can loan each other compatible lenses as required. Or, you might own a film camera and some lenses that will fit your new digital model. You could own two digital cameras and use the same lenses on both. In the future, you could upgrade to the latest model and use your old lenses with the new camera. Veteran photographers will be familiar with the phenomenon of being locked into a particular Nikon, Canon, Minolta, or Olympus camera system because a given set of lenses and accessories can often be used only with one vendor's line of gear.

Can you afford interchangeable lenses?

Some photographers are stretching their resources simply to acquire a $1,000 camera. Expanding beyond that 29–88mm zoom (equivalent) by purchasing an additional interchangeable lens might be out of the question. The really cool lenses for dSLRs can easily cost as much or more than the

camera itself. If you think you won't be able to afford the interchangeable lenses your camera can use, you might as well have a camera with an EVF.

Do you need a very compact camera?

Digital SLRs are not exactly small, with most of them weighing 19–24 ounces or more. If you want the advantages of a dSLR but also need a compact camera at times, consider buying a second camera as a backup and as a "spy" camera for clandestine or candid photography.

How rugged must your camera be?

You'll find dSLRs with bodies made of plastic and others of a more rugged magnesium alloy or other material. These larger cameras seem to attract knocks and dings. If you shoot outdoors a lot, tote your camera along on trips, or like to photograph extreme sports, you'll want the most rugged camera available.

How much control do you need?

Several vendors offer $999 dSLRs in competition with their own $1,500–$2,000 (and up) cameras. Often, they use the same sensor, can be outfitted with the same lenses, and share much of their electronic innards. (Indeed, the newer, cheaper models might in fact have more sophisticated electronics.)

So how do the vendors keep from killing off their more expensive models? The less-expensive cameras are built into cheaper, less-rugged plastic bodies. In many cases, the answer has been to reduce the number of customizable controls and settings in the cheaper camera. Some manufacturers actually achieve this goal by crippling their cameras' permanent software: *firmware*. Two cameras might be very, very similar internally but with some features turned off deliberately in the less-expensive model.

One particular pair of cameras that I've used has the same basic design. The flagship model can save files in space-saving JPEG format and also by using a loss-free TIFF format. The cheaper version doesn't have the TIFF option. The expensive version lets you vary the points used to determine autofocus; the low-end version does not. The advanced camera offers several sophisticated flash options, lets you customize autoexposure, manually choose exposure compensation values in finer increments, redefine the functions of certain buttons, and retain in memory sets of customized functions. Most of these could be enabled in the entry-level camera with a simple programming change, but you need to purchase the upscale version to get them.

If you want the maximum control over your dSLR's features, see exactly how much control your camera gives you over the features you plan to use most.

A Dozen Exotic Digital Camera Features

After automobile manufacturers introduced heated seats and Global Positioning System (GPS) for their luxury cars, everyone wanted them, so the designers had to come up with other high-end features, like holographic rearview mirrors and rocket-powered ejection seats. Digital camera vendors are in a similar race to develop features that are similarly too-cool-for-school. Here are some of my favorite features that are exotic now but probably won't be exotic by the time you purchase your next camera:

✦ **Sound activated self-timers:** I had a ball playing with a new camera that could be triggered by sound. Just set the audio sensitivity, go get in the picture yourself, and shout, "Cheese!" No more racing to beat the self timer or ending up with a photo showing you holding your camera's infrared (IR) remote control.

✦ **Ultra-fast shutter speeds:** At least one camera has a shutter speed of 1/16,000th of a second. You might need a super-nova as your illumination source, but you can stop the fastest action with this baby.

✦ **Image stabilizers:** Several cameras offer internal stabilization that cancels the effects of shaky hands or the blur induced by the high magnification of telephoto lens. My favorite is the camera that automatically moves the sensor in time with your camera jiggles.

✦ **Night shot capabilities:** Digital camera sensors are inherently sensitive to IR illumination, so vendors like Sony provide enhanced night photography capabilities by taking advantage of this sensitivity.

✦ **Infrared photography:** Speaking of infrared imaging. . . . Many cameras have a device called a *hot mirror* to filter out infrared light, but allow flipping this filter out of the way or have enough remaining IR sensitivity left over to allow you to take interesting weird-tonal infrared pictures.

✦ **Predictive focus:** Slow autofocus is the bane of digital cameras, which is why I was glad to see the introduction of high-end models smart enough to figure out where focus *should* be set ahead of time when you're photographing subjects where the focus changes rapidly.

✦ **Enhanced movies:** Traditionally, digital cameras have been able to shoot only short video clips (perhaps 15–30 seconds) at abysmal resolutions (some no better than 320 x 240 pixels) and not necessarily with sound. Some recent digital cameras are virtual camcorders, letting you grab VHS-quality clips for as long as your digital memory card holds out. Make sure your card is a capacious one because digital video can eat up a megabyte a second!

✦ **Unlimited burst mode:** I loved using an advanced digital camera that uses a technique called *pipelining* to keep the images flowing onto the memory card at high speed (when used with a high-speed card.) I managed to take more than 150 3.3MP resolution photos in a row at around

4 frames per second (fps) before my 256MB memory card filled up. Set to a lower resolution, I took 1,500 shots in a little more than five minutes. My finger got tired before this ultra-fast camera started slowing down. Think how well you can analyze your golf swing with a camera like this!

✦ **Panorama photography:** A growing number of digital cameras have cool panorama capabilities that make it easy to shoot a series of pictures that can be automatically stitched together in your computer. You'll find out more about panorama photography in Book III, Chapter 6.

✦ **Two-in-one shot:** No tripod, but you want to get in the photo yourself? Some cameras let you take a picture of the background, have someone else take a picture of you, and then merge the two shots automatically.

✦ **Underwater photography:** I once purchased a Nikonos underwater camera specifically so I could take surfing photos at Huntington Beach, California. (I wasn't surfing; I was *photographing* surfers.) Now, anyone with a digital camera and an inexpensive underwater housing offered for Canon and other models can take pictures in, around, and under the sea. Digital cameras are much better than my old Nikonos: You get to see exactly what you shot right away, so you can jump back in and do it over until you get it right.

✦ **Time-lapse photography:** Thirty or 40 years ago, the big thing was time-lapse photos of flowers opening and paint drying. Today, every television show includes a sunset-to-sunrise time-lapse sequence to demonstrate that time marches on. Whether you have some flowers you want to watch opening or need to document a construction project, digital cameras with time-lapse capabilities can snap off a picture every few seconds or every few hours, depending on how you set them. This is a great feature that's fun to play with.

Checking Out Ease of Use

I've saved the most important for last because I want this topic to sink firmly into your mind as you put this book down and continue to think about what you're looking for in a digital camera. *Usability* is one of the most important factors to keep in mind when choosing a camera. The sharpest lens, the most sophisticated sensor, and the most advanced features are all useless if you can't figure out how to operate the stupid camera! I've owned digital cameras that absolutely could not be used without having the manual at hand. Even common features were so hard to access that I sometimes avoided taking certain kinds of pictures because activating the feature took too long.

Ease of use is not limited to digital cameras, of course. Difficult-to-operate cameras have been creeping up for 15 or 20 years. This was not always so. When I began my photographic career as a newspaper photographer, film cameras had a limited number of controls. There was a shutter speed dial,

f-stops to set on the lens, focusing, and maybe a rewind knob to move the film back into the cassette when the roll was finished. Over the years, electronic exposure controls were joined by exposure modes and a ton of other features as film cameras became more and more computer-like.

Today, even digital cameras that most resemble their film counterparts bristle with buttons, command dials, mode controls, menus, and icons. That's not necessarily a bad thing. What is evil is an interface that's so convoluted that even advanced users might have problems. You might have to wade through nested menus to change the autofocus or exposure control mode. Switching from aperture-priority to shutter-priority can be a pain. Something as simple as changing from automatic focus to manual focus can be difficult, particularly if you don't make the switch very often and forget which combination of buttons to press.

Ease of use varies greatly, depending on which sets of features are most important to you. A camera that one person might find a breeze to use might be impossible for another person to manage simply because a particular must-have feature is hard to access.

I urge you to try out any digital camera that you're seriously considering buying before you plunk down your money. A camera's feature set, the vendor's reputation, or recommendations of a friend won't tell you how the camera will work for you. Hold the camera in your hand. Make sure it feels right — that its weight and heft are comfortable to you. Be certain your fingers aren't too large or too small to handle the controls. Can you see through the viewfinder?

If possible, take the camera for a test drive, borrow a similar camera from a friend or colleague, or at least shoot some photos in the store. Can you find the features you use most? Can you figure out the menus and buttons? Is the camera rugged enough to hold up under the kind of treatment you'll subject it to?

As much as I like buying by mail order or over the Internet, a digital camera is too personal a tool to buy from specifications lists and photos. If you're reading this book, you're probably serious enough about digital photography that you'll be spending a lot of time with your camera — and probably will spend more than you expected to get the camera you really want. Make sure it really is the one you want by giving it a thorough workout.

Chapter 2: Setting Up a Computer for Digital Photography

In This Chapter

✔ Choosing between a Mac and a PC

✔ Understanding your memory and storage needs

✔ Selecting a microprocessor

✔ Doubling your display pleasure

✔ Pointing with a pen

You might be ready for digital photography, but is your computer up to the task? The good news is that virtually any computer of recent vintage probably has the horsepower and features needed to work with the digital images that you capture with a camera or scanner. A Windows PC that operates at 800 MHz or faster or any 500 MHz or faster G3 or G4 Macintosh has what it takes to import, process, and output digital images. I know that's true because those are the exact specs of the Windows and Macs I used until very recently, when I finally engineered a long-overdue upgrade.

Even so, the differences between a computer that's good and one that's good enough can be significant. Your system might be exceptional, or it might be the exception. You probably don't want to be working with the minimal system possible even if you'd rather invest your money in a better digital camera. (I know if faced with the choice of a new, 3 GHz computer and a digital single lens reflex, I'd choose the camera every time.)

This chapter helps you develop your own checklist of recommended hardware, shows you how to upgrade to make your work even easier, and offers tips on setting up your computer to make working with digital images a breeze.

I cover only the main equipment options for setting up a computer for digital photography editing and storage in this chapter. You can find information on equipment used to transfer images between your camera and computer in Book I, Chapter 3.

Hardware Wars Revisited

Macs versus PCs. Why are we even having this conversation?

Digital photography, graphics work in general, and multimedia production are the key arenas in which the Macintosh versus PC battle is still being waged. In most other areas, Windows-based systems have taken over the desktop, with Macs relegated to specialized or oddball applications. Apple keeps coming up with compelling hardware, interesting computer designs, and lots of quirky but cool applications, but those solidly camped in the Windows realm take notice of what's going on only when those cute Macintosh commercials interrupt prime-time TV viewing.

Not so in the digital photography world. Visit any newspaper or magazine relying on digital cameras, and you'll find Macs. Drop in to any professional digital photographer's studio, and you'll see a brawny Macintosh perched on the desktop. Talk to the top Photoshop users in the country. Most of them are using Macintoshes, too, either exclusively or in tandem with a Windows box.

Indeed, for a long period of time, the only logical choice for most photographers has been the Macintosh. The decision was along the lines of selecting a 35mm Nikon or Canon SLR for photojournalism or a Sinar view camera for studio work: a no-brainer. Although I don't have hard figures, my gut feeling is that Macs outnumber PCs in imaging environments by at least 8 to 1. In the rest of the business world, the figures are reversed.

By and large, the latest G5 Macintoshes provide enough muscle for virtually any still image work, particularly when equipped with dual processor chips (which provide extra speed with applications designed to work with multiple CPUs) and gigabytes of memory. No photographer need be ashamed of driving a properly equipped Mac.

In the digital photography world, Macs are not only viable but often the system of choice. However, in some cases, you might not have a choice because you already own a computer or need to use a particular system to remain compatible with friends and colleagues.

Yet, if you aren't locked into a particular platform and operating system, should you be using a Macintosh or a Windows computer? If you want a definitive answer, I'd say, "It depends." (Which isn't very definitive, is it?) Each platform has its pros and cons. Here is a summary of some of the things you should consider:

+ **The bandwagon effect:** If you plan to make your living (at least in part) from digital photography, you need to learn two things: how to use a

Mac and how to perform image magic with Photoshop. Both skills are expected to be part of your *résumé.* Jump on the bandwagon while you can. On the other hand, Windows proficiency is expected for most jobs outside imaging. Unless you're a full-time graphics professional, you might have to learn to wear two hats.

✦ **Ease of use:** The Macintosh is generally acknowledged to be a bit easier to learn and somewhat easier to use for many tasks. Of course, the Macintosh system's vaunted ease of use has been subverted over the years as Apple tried to catch up with Windows systems. (For example, the Mac's sublimely simple single-button mouse must be augmented by holding down the Control key while clicking to reproduce the Windows two-button mouse's right-click option. You can also reprogram certain Macintosh mice to provide the same results.) If you're just starting out in computing and don't want to climb a steep learning curve, the Mac is your computer.

✦ **Software compatibility:** Not all applications are available for both Mac and PC. Most key applications are offered for both, including the Photoshop CS image editor, shown in Figure 2-1 in both Mac and Windows incarnations; the StuffIt archiving tool; browsers such as Netscape and Internet Explorer; and word processing applications such as Microsoft Word. Plus, Microsoft is now offering Virtual PC for the Macintosh, making it possible to run Windows XP and Windows applications under Mac OS X. But if you must be totally compatible with Windows, you still need Windows.

✦ **The cost factor:** Macs have generally been more expensive than PCs although the cost difference has decreased over the years. Even so, with powerful Pentium 4 systems available in barebones configurations for $500 or so, even the least expensive Mac still costs a bit more. In the Mac's favor, however, most peripherals and add-ons such as memory, hard drives, DVD devices, monitors, and so forth cost the same whether you're purchasing them for a Mac or a PC.

✦ **Hardware reliability:** Reliability is a two-edged sword. Macs are wonderfully crafted machines, a beauty to behold when you dismantle one, and filled with high-quality components. The insides of some of the assembly-line-built PCs have a decided industrial look, and if you examine the parts, you might find a mixture of known brand-name pieces and *what's this?* components. On the other hand, if something does break on your PC, you can run down to the local MegaMart and buy a new floppy drive, a CD burner, and maybe some memory off the shelf next to the cellphone batteries. My local *grocery store* carries these items. Parts for your Mac might be harder to come by, and it's unlikely you'll know how to replace them anyway. So, even assuming the Mac is more reliable than the average PC, is that always an advantage?

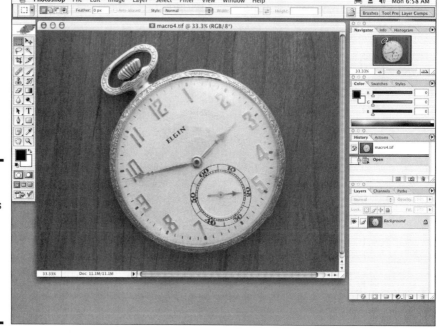

Figure 2-1:
Many
applications
operate
almost
identically
in Mac
(bottom)
and PC
versions.

✦ **Operating system reliability:** Trust me, Macs do crash, especially when Apple is making a transition as it did from Mac OS 9.*x* to OS X. Early versions of a Mac OS can crash and burn as spectacularly as any Windows release. On the other hand, Mac users don't add hardware or new applications at the same clip as Windows users, who seem to be constantly trying this new utility or that, applying the daily patches Microsoft issues for its software and OS, and doing other fiddling that can lead directly to the Blue Screen of Death (BSOD).

Anyone who swears his or her Windows installation never crashes is probably using Windows 2000 or Windows XP, never runs more than two or three applications at once, and avoids installing new software more often than once every six months. By any measure, Windows has to be considered inherently less stable than Mac OS. And let's not get into the frequent horrifying discoveries that things such as the Windows Help system have bugs that let a hostile user invade your system. (I'm not making that up.) If no-crashing is on your holiday gift list, the Mac still has the edge.

✦ **Technological superiority and coolness:** If owning a computer that looks like a Tensor lamp is your cup of tea and you like the idea of having cool stuff before anyone else, you really, really need a Macintosh. The most exotic hard disk interfaces (from SCSI in the '80s to FireWire in the '90s) came to the Mac first, along with flat-panel displays, DVD burners, and other radical innovations that turned out to be a little (or a lot) before their time.

Hardware differences aside, the most visible differences between Macs and PCs (after you get past transparent, multicolored cases and eye-catching design tricks) stem from the two competing operating systems. Only a year or two ago, a dual-barbed joke was circulating, implying that the current version of Windows was almost identical to the Macintosh operating system of 1984. But of course, the same observer noted, the current Mac OS was also almost identical to the Macintosh operating system of 1984. The more things change, the more they stay the same.

The gibe is no longer true. Windows has been transformed into Windows XP, which is the most stable, easiest-to-use operating system Microsoft has ever offered, even if it does still resemble some of the older versions of Mac OS. At the same time, Mac OS is completely different, too. Mac OS X is now a thinly disguised version of Unix, which is both good news and bad news. Unix is more stable than the System 9.*x* and earlier versions that preceded it, but Mac-Unix has some underlying complexities (including—horrors—a command line interface if you want it) that didn't intrude themselves on Macintosh users in the past.

Windows has its advantages and disadvantages. One advantage is that it's almost universally available and has the broadest range of widely used applications written for it. One disadvantage is that Windows still forces you to do things the Microsoft way when you'd really rather do them your own way. For example, Windows XP is fond of setting up your network the way it likes, bludgeons you into using Internet Explorer even if you prefer Netscape, and has a tendency to coerce you into using the Windows Media Player for everything and anything.

Mac OS, on the other hand, lets you do things your own way quite easily. Would you prefer that your digital camera application be installed on your secondary hard disk rather than the one you first installed it on? Just drag it to the new hard drive; there's no need to uninstall it and reinstall it as you must do with Windows.

Although you probably won't choose a computer based on the operating system, these things are nice to know.

What Equipment Do You Need?

Digital cameras themselves make few demands on a computer system, of course. The real drain on your system is running your image editing program and storing your images for editing or archival purposes. Make no mistake, image editing is among the most demanding types of work you can lay on a computer, so before you start down this road, you'll want to know about the minefields that lie along the way. If you want the flying short-course, the ten most important things you'll need to consider are

+ Memory
+ More memory
+ Even more memory
+ Adequate local storage (a fast, big hard disk)
+ A fast microprocessor
+ Archival storage
+ Advanced video display capabilities
+ Other peripherals, such as digitizing tablet and pen devices
+ A little more memory
+ More RAM than you thought you'd ever need

The rest of this chapter examines each of these needs thoroughly.

Determining How Much Memory You Need

If you noticed that I've listed memory five times on my top ten list, there's a reason for that. Memory makes everything else possible. A fast, big hard disk is also important because it gives you room to work with your current project's files and can substitute for RAM (memory) when you finally do run out. But nothing can replace memory when decent performance is your goal.

I can't emphasize this point enough: When you're working with images, you must have, as a bare minimum, at least six to ten times as much RAM as the largest image file you plan to work with on a regular basis. With inexpensive 8MP cameras now available for less than $1,000, many digital photos can amount to 18–60MB, which translates into 180–600MB of RAM for *each* image you want open at once. If you're working with more reasonably sized 4MB images but need to have ten of them open at one time, you still need tons of memory to do the job.

Book II
Chapter 2

Setting Up a
Computer for Digital
Photography

Without sufficient RAM, all the bucks you spend on a super-speedy microprocessor are totally wasted. Your other heavy-duty hardware is going to come to a screeching halt every time you scroll, apply a filter, or perform any of a number of simple functions. That's because without enough RAM to keep the entire image in memory at once — plus your image editor's Undo files (basically copies of the image in its most recent states) — your computer is forced to write some or all of the image to your hard disk to make room for the next portion it needs to work with.

Digital photography can produce some large images, too, especially if you're working with a serious camera in the 8MP range and choose to save your files in the highest-quality mode. An 18MB image is fairly common these days, so you should be prepared with as much RAM as you can cram into your computer.

Most systems have three to four memory slots, which can each hold a 256–512MB memory stick. Loading your computer with 2GB of memory is not at all outlandish and relatively inexpensive. You can purchase that much memory for a few hundred dollars. Any Mac or PC with 512MB or less of RAM is hopelessly underequipped for digital photography. Beefing up your memory can be the least expensive and most dramatic speed enhancement you can make.

Indeed, when I upgraded from my ancient 800 MHz Windows computer to a spiffy new 2.8 GHz Pentium 4 model, I was annoyed to find that my new computer seemed to be significantly slower than my old one. It didn't take long to discover the reason. My older computer had 1GB of RAM, but my new "faster" one was initially equipped with a mere 512MB of memory. When I worked with large digital photos, Photoshop CS didn't have enough RAM to keep more than one or two images in memory at one time. It was forced to

continually swap image information out to the hard disk to make room for the changes I made. Having a processor that was more than three times faster made no difference: lack of memory was slowing everything down through a poky hard drive bottleneck.

Within a week, I upgraded the Pentium 4 to 1.5GB of RAM, and guess what? It really flew! If you feel your current computer is slow, try adding memory before upgrading to a faster processor. You might be surprised.

Choosing Local Storage

Your graphics powerhouse is only as fast as its narrowest bottleneck, so you should pay special attention to that looming potential roadblock I just mentioned: your mass storage subsystems. You need one or more big hard disks for several reasons:

+ **To keep as many images as possible available for near-instant access:** A large hard disk enables you to store all your current projects — plus many from recent months — all in one place for quick reference or reuse. With a large hard drive, you can store a vast library of your own photographic clip art, too, and avoid having to sort through stacks of archive CDs.

+ **To provide working space for your current projects:** You'll want *scratch space* — space on your hard drive — to store images that you probably won't need but want to have on hand just in case. Alternate versions of images eat up more space as you refine your project. Image editors such as Photoshop also need spare hard disk space to keep multiple copies of each image you're editing.

+ **To let you store additional applications:** Good bets here would be panorama-generating programs, a second or third image editor for specialized needs, utility programs, extra plug-in programs, and so forth.

In the recent past, your hard disk storage options were limited to internal hard disks in one of two categories: fast, expensive hard disks using a Small Computer System Interface (SCSI; *SKUZ-zee*) interface or inexpensive, slow hard disks using the Enhanced Integrated Drive Electronics (EIDE) interface. Today, the technologies have converged. SCSI drives no longer cost that much more than EIDE disks, and EIDE drives have gotten much, much faster. Moreover, new options have appeared, chiefly in the form of external hard disk drives that link to your computer via FireWire or Universal Serial Bus (USB) and a new kind of internal serial drive.

SCSI and EIDE hard disks

You don't see SCSI disks used much outside server environments these days. Their chief advantage is that your computer can transfer information to and from several SCSI disks simultaneously. That's because SCSI is a system-level

interface that conveys information in logical terms: Multiple devices can use the same connection in parallel fashion, although more intelligence is required to decode requests from the computer. Other kinds of hard disks, particularly EIDE drives, might have to take turns in talking to your computer, which can reduce performance. Peripherals are so fast these days that the difference in performance between SCSI and other systems is seldom important outside the server environment.

The chief advantage of drives in the EIDE/SuperATA and the very latest serial ATA (SATA) categories is that they are almost free. As I was writing this book, 320GB Maxtor hard drives could be purchased for a lot less than $1 per gigabyte, and I expect the cost per byte will drop even more dramatically during the life of this book. However, even at $1 per gigabyte, hard drives aren't that much more expensive than CD-R media.

External hard disks

With external hard disks, you're no longer limited to the number of disk drives you can cram into your computer's housing. These disks link to your computer using an IEEE 1394 (FireWire) or USB 2.0 interface, such as the one shown in Figure 2-2.

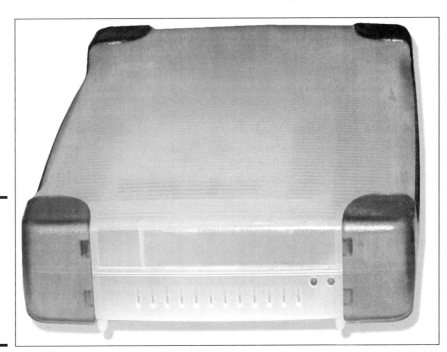

Figure 2-2:
You can
use this
FireWire
drive with
both
Windows
and Mac
platforms.

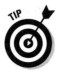 The advantage of external storage is that you can install and remove FireWire and USB 2.0 drives without opening your computer's tower, and you don't need to worry about how to fit them in the case. You can also easily move such an external drive from computer to computer.

Archiving and Backing Up

Digital photos can fill even the largest hard disk faster than Yankee Stadium on Bat Day. Your graphics powerhouse needs open-ended storage that is relatively cheap and reliable and that provides near-on-line (permanent storage) access speeds.

Zip disks

For a while, Iomega's Zip drives, which were initially available in 100MB and 250MB capacities, seemed to be the answer. However, as file sizes and hard disks grew, a mere 250MB hardly seemed practical as a serious storage and backup option. Can you really back up an 80GB hard drive on 320 Zip disks? Not when the disks cost $5–$15 each! Even extending the capacity of the Zip drive to 750MB in late 2002 didn't help. Zip drives have become the floppy disk of the new millennium: useful for transferring files from one computer to another but not a serious consideration as an archival or backup medium. Although Zip drives are not nearly as common as they used to be, they can still be useful. I have a portable Zip drive I carry around with me when I make troubleshooting visits to friends' homes. I can plug it in, copy files from one computer to a new one, install utility programs, and perform back-ups without worrying whether or not my friend has a CD burner.

CD-Rs and CD-RWs

CD-R and CD-RW discs have a bit more credibility in this arena because you can cram a healthy 700MB on a CD that can cost as little as a nickel. You still wouldn't want to back up your 160GB drive to 200 CD-RW discs (even though the media itself might cost you only $20), but it's entirely practical to archive your digital photos on this media.

DVDs

More likely to emerge as a long-term storage medium is one of the various versions of DVD. Depending on how many layers are used, DVDs can store up to 8GB or more each. The cost of the DVD burners is coming down, and this medium should become more popular when the industry settles on a single, standard format. In a world where DVD-ROM, DVD-RAM, DVD+RW, DVD-RW, the best plan is to buy a DVD burner that supports them all. Things might become more complicated in the future when the newer, extra-high capacity DVDs (including the blue-laser Blu-ray discs) become available.

Kodak Photo CD

Although mostly supplanted by the Kodak Picture CD (available from photo-finishers with your picture order), the Kodak Photo CD is still a viable alternative for storing digital images although the writers for this media are not within the budgets of the average digital photographer, and the number of labs offering them is diminishing. However, you can have your images transferred to Photo CD and take advantage of the unique features of the format.

Photo CDs, originated by the Eastman Kodak Company, are a form of write-once CD-ROM with some special advantages for photographers. Photo CDs store each image in five compressed versions called Image Pacs, each with a different resolution:

Base	*Resolution*	*Size*
Basic, or Base	512 x 768	1MB
Base/4	256 x 384	300K
Base/16	128 x 192	74K
Base * 4	1024 x 1536	5MB
Base * 16	Full-resolution, 2048 x 3072	18MB

Book II
Chapter 2

Setting Up a
Computer for Digital
Photography

The Pro CD version adds a sixth: Base * 64, 4096 x 6144, 74MB version.

Some of the advantages of Photo CDs include

✦ Compatible, image editing software can choose which resolution to work with. You can preview the tiny Base/16 images, use the Base version for comps (layouts), edit and release the Base * 4 image for noncritical work, or unleash the full-resolution Base * 16 or Base * 64 images for full-page layouts, posters, or what have you.

✦ You don't need a high-resolution scanner to produce Photo CDs. Photofinishers and pro labs can convert your images to Photo CD format using their own Photo CD equipment.

✦ You can specify

• *Photo CD Master Discs:* Designed for 35mm photography, these hold up to 100 images at the five basic resolutions

• *Pro Photo CD Master Discs:* These can store images in 35mm, 120/220, 70mm, or 4 x 5" format.

Up to 25 images can be included with the sixth Base * 64 resolution added.

✦ Also available is the Photo CD Portfolio II disc, which you can create yourself by using Kodak Portfolio II authoring software. The Portfolio

disc can include photos, stereo audio, graphics, text, and other material. If you have a Photo CD writer ($3,000 and up), you can create your own business presentations, trade show displays, or educational programs.

✦ You can encrypt images on Photo CDs, enabling photographers to use a disc as a portfolio and a stock-photo distribution tool. Send out sample discs to clients. They can retrieve the unencrypted Base version to see what your work looks like on their own computer screens. *Note:* No one has access to the high-resolution versions needed for reproduction until you supply a password.

Avoiding Microprocessor No-brainers

Several times in this book, I've noted that the very fastest microprocessor is no longer essential for most digital photography and image editing applications. If you have a system operating at 800 MHz or faster, you can do just fine. Microprocessor speeds have greatly outpaced the requirements of most applications, even for processor-intensive applications such as image editors. As I mention earlier, I got along quite well with an 800 MHz Windows computer until that venerable machine finally went up in smoke after an unfortunate accident. If you're serious about digital photography, there's no need to rush right out and buy a new computer if your old one suffices. Spend the money on a better digital camera or some accessories instead!

However, if you're buying a new machine, there's no reason not to buy one with the fastest microprocessor available, within reason. The microprocessor is what processes many of your program instructions — everything that isn't handled by a separate digital signal processing chip. So the faster the microprocessor runs, the faster your image editing software will work, generally speaking.

Each individual element of an image involves from 1–4 or more bytes of information. An RGB (red/green/blue) image requires 3 bytes per pixel, a CMYK (cyan/magenta/yellow/black) image needs 4, and additional alpha (selection) channels take up 1 byte each. Even a relatively small 640 x 480, 24-bit image can involve nearly 1MB of data.

If you ask your image editor to apply an image-processing filter to an entire image, your microprocessor must calculate the effects of that filter on each and every one of those million bytes. That can take a second or two with a very fast system or as long as a minute or much more with very slow computers.

And although there are other constraints (such as memory or hard disk speed), the speed of the microprocessor affects nearly everything you do on

your system. As you might guess, a fast CPU should be a major consideration when assembling a graphics workstation from scratch. You might not need the very fastest microprocessor available, but then again, you never hear anyone complaining that a computer is just too darn fast.

Determining What's Most Important

Even though I went three years between new computers, I generally buy a new system more often than that, and upgrade most other components more frequently than that. However, I keep three pieces of equipment for years and years. I lavish all available funds on the original purchases and hang onto them as long as possible. Those three items are my display screen, my keyboard, and my mouse.

This trio comprises the components you interface directly with all day, every day, usually for long periods of time. For efficiency and sanity's sake, you should insist that these pieces of equipment be only the very best available and don't change them capriciously. I liked the IBM keyboard that was furnished with my IBM PS/2 in 1987 so much that I am still using it a decade and a half later (even on my Macintosh, thanks to a keyboard/video/monitor switch). My ball-less infrared mouse has been serving me well for several years, and I can't recall exactly how long my beloved 19-inch monitor has been a fixture on my desk. I look at or touch these components all day, every day, and they're worth every penny I spent.

For digital photographers, your display and video card are two of the most important components in your system. You need a video card with 64–128MB of fast memory (or more) so that you can view 24-bit images with 16.8 million colors at resolutions of up to 2048 x 1536 (or more) on a 19- to 24-inch monitor. A combination like that enables you to examine your photos closely, array several large images side-by-side, and view pictures at a size very close to their printed size. Here are some specific recommendations:

✦ Unless you also play computer games, you don't need to spend hundreds of dollars on video cards with video accelerators so powerful that they require their own fans. Instead, sink your funds into a video card with enough RAM to display images at high resolution. Think 2-D instead of 3-D.

✦ Consider buying a dual-head video card capable of displaying separate images on two different monitors. You'll find most serious Photoshop users and digital photographers are working with two monitors (at least). One monitor can contain your image editor, and another can display a Web browser or another application. Or, you can move Photoshop's palettes to the second monitor to make more room for your images.

Another trick is to use different resolutions for each monitor, say 1920 x 1440 on one for a high-res display, and 1024 x 768 for a larger view on the second monitor. If a Web page is hard to read on my main display, I often just slide it over to the second monitor at 1024 x 768 for a closer view. Figure 2-3 shows a dual monitor setup.

✦ Two video cards can also give you dual monitor capabilities. When I upgraded, I purchased an "obsolete" 64MB PCI video card for about $40 and installed it in tandem with my system's original AGP card. I then purchased a 17-inch monitor with multiple rebates for a net cost of $49. For less than a C-note, I was in dual monitor heaven.

✦ Check out the monitor you buy in the store before you purchase it. You'll be staring at it all day, so you want a sharp image that you can live with.

✦ Until the cost and quality of LCD monitors drops further, don't buy one of these as your primary monitor unless you're really cramped for desk space. An LCD monitor can make a good second monitor, but the models worthy of your image editing workstation are still quite expensive. I know Mac fans with their slick LCD monitors will argue with me, but for now, the CRT is still your best choice for image editing. It provides the best image quality and most versatility for the buck. Most CRT displays have better color fidelity than higher-priced LCDs but are larger and require calibration on a regular basis.

Of course, on the plus side for LCDs, you can tuck one of these flat beauties into the most confined desktop or even hang one on the wall. And they don't require geometry (shape), convergence (alignment of the electron guns), or focus adjustments. They're easier on the eye, emit no radiation, use as little as ten percent of the power of a tube-based display, and are not affected by electromagnetic fields.

However, LCD displays might not be as bright as your trusty CRT monitor, and most have a rather limited viewing angle, making it difficult for more than one person to see the screen clearly. Most LCDs also have a narrower color gamut than a CRT and are more difficult to calibrate. But if you are able to do so, they rarely need to be recalibrated.

You must consider a few monitor specifications and controls. For example, sharpness is often measured in terms of *dot pitch,* which is a supposed indicator that's supposed to be the distance, measured diagonally, between the centers of two RGB phosphor dot triads (found on a CRT). Some vendors, however, measure horizontally, yielding a smaller dot pitch figure that doesn't reflect the true sharpness of the image (anything between .22–.27mm is considered acceptable).

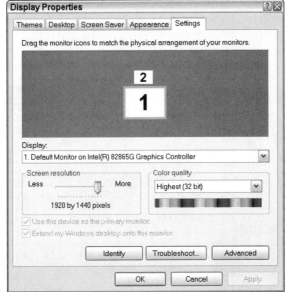

Figure 2-3:
Dual
monitors
offer a lot of
flexibility in
arranging
applications
on your
screens.

Other specs, such as color *convergence* (how accurately the electron guns
are aimed); video bandwidth (measured in megahertz; determines how well
an analog signal is displayed onscreen without ghosting or the loss of bright-
ness in thin lines); or refresh rate (the number of times per second an image
is renewed) affect your viewing experience. Of these three, the refresh rate is
the most important. Most people perceive a 75 Hz refresh rate at most reso-
lutions as flicker-free, compared with, say, a 60–68 Hz refresh rate. The less
flicker, the longer you can stare at your monitor without going blind (or at
least getting a whopping headache). When buying a monitor, your best bet
is to try one out in the store and purchase the one that looks good to you.

Choosing Pointing Devices

Can you sign your name with a bar of soap? No? Can you sign your name with
a pen? If so, you probably would be more comfortable doing graphics work
with a pen-based graphics tablet rather than a clunky old mouse. Pressure-
sensitive tablets with cordless pens are especially cool. Used with applica-
tions that support pressure-sensitive pads, such as Photoshop, they enable
you to draw thicker lines just by pressing harder. Tablets and pens are a very

natural way of working with graphics; if you can draw, you can use one faster and more accurately than you can sketch with a mouse. Trackballs and alternate mice are also choices if you prefer them. A typical pressure-sensitive pad and stylus are shown in Figure 2-4.

Figure 2-4:
Digital photographs can be edited more easily with a pressure-sensitive pen.

Chapter 3: Getting Your Picture from the Camera to the Digital Darkroom

In This Chapter

✔ Connecting the camera to the computer

✔ Using various connections and memory cards or disks

✔ Moving your images from camera to digital darkroom

*W*hen you take pictures with a conventional film camera, you end up with a roll of exposed film that must go to a photo lab (or the minilab at your local drug store) for processing and printing using special chemicals and darkroom equipment. When you get the prints back a few hours or days later, you get to see how your pictures turned out. Often, a fair number of pictures end up in the trash, and you keep the rest. If you want extra prints or enlargements of the good shots, it's back to the lab to order reprints.

One of the great things about digital photography is that you don't have to process and print every single image you shoot. Most digital cameras let you preview your images right in the camera, so you know immediately how you did. And you can discard the obvious blunders and bloopers before anyone else sees them. What remains are the pictures you want to print.

With digital photography, there's no need to go to a photo lab to get prints from your pictures. The darkroom and lab are as close and convenient as your own computer. But unlike conventional photography, there's no roll of exposed film to send off for processing. Instead, you move your digital pictures from your camera to your computer by copying the image files from one device to the other.

How you do that depends on the features of your camera (and to a lesser extent, your computer). This chapter first addresses the various camera-to-computer connections you're likely to encounter and then describes the process of transferring images from camera to computer.

Making the Connection between Camera and Computer

Before you can use your computer as a digital darkroom to process and print pictures from your digital camera, you must get your picture files out of the camera and into the computer. After you save the images as files on your computer's hard disk, you can manipulate them with the image editing software of your choice and print them on your printer. Parts IV and V describe the basics of editing images and working with Photoshop products to do so.

Some printers are capable of accepting images directly from a digital camera and printing them without going through an image editing program or other software on your computer. These use the new PictBridge standard, which was created for printing from digital cameras to printers, using a direct connection without the need of a PC. The camera and printer can be made by different vendors; all devices that support the new PictBridge specification (and the number is growing all the time; check your camera manual) should work fine with any other device that conforms to the standard.

Several technologies for transferring pictures from your camera to your computer are available. The range of options might seem confusing, but you don't need to worry about most of them because a given camera rarely supports more than one or two options.

In general, the image-transfer technologies fall into three broad categories:

✦ **Wired connections:** A cable, wire, or other connection enables you to transfer picture information from the camera to the computer. Some vendors offer printer docks with a niche for certain model cameras, allowing direct transfer between the camera and the printer and/or your computer. The communication between your computer and your camera is similar to that between your computer and other peripheral devices, such as printers, scanners, or external modems. I discuss wired connections in the following section.

✦ **Wireless connections:** In the future, more digital cameras will be using wireless transfer to beam pictures directly to a computer or printer. At present, these are still too slow to be very popular.

✦ **Removable media:** The camera stores picture data on a disk or memory card that you can remove from the camera and then insert into a drive, slot, or reader on your computer. This process is much like saving files to a floppy disk and then moving the disk to another computer and accessing the files there. For information about different types of removable media, see the later section, "Memory cards and disks."

Getting wired

When you look at the back of a typical computer, you see a variety of sockets and ports in different shapes and sizes. Some of them probably have cables attached that lead to assorted peripheral devices, such as your mouse and your printer. Camera manufacturers can choose from several of these ports in order to connect the camera to the computer. However, you rarely find any one camera with more than one type of wired connection.

Serial cable

The serial port is the old standby for connecting miscellaneous peripheral devices to a computer. It's used for everything from external modems to pointing devices, and of course, it was used in the past for many digital cameras. Nowadays, most digital camera manufacturers are using a USB connection instead of the older serial connection, but plenty of cameras still in use rely on a serial cable. (To show you how far we've come, the most recent modem I purchased uses the USB connection instead of the serial port; another dial-up modem I looked at uses the Ethernet connection. It's no longer necessary to use the serial port for much of anything!)

A typical desktop computer has two serial ports on the back, like those shown in Figure 3-1. Look for a flattened D-shaped connector containing nine small pins. It's often labeled COM1 or COM2. Occasionally, the serial port of an older computer might be a larger, D-shaped connector containing 25 pins. Regardless of the number of pins, however, it's always a male connector. (The male connector contains pins arranged to fit into holes in the female plug at the end of a serial cable.) If the serial cable that came with your camera has a plug for the 9-pin connector but your computer has a 25-pin port, you can use an adapter (available in most computer supplies stores) to make the connection.

Figure 3-1:
Standard serial ports come in 9-pin (top) and 25-pin (bottom) varieties.

For best results, always shut off your computer before adding or removing cables from the serial, parallel, or PS/2 ports on the back of the computer. On the other hand, USB and FireWire connections are designed to be *hot swappable,* which means that you can plug them in and unplug them while the computer is running.

After you identify the serial port on your computer, you can use the cable that came with your camera to connect the camera to your computer by following these steps (with your computer turned off):

1. Plug one end of the cable into the serial port on your computer.

If two or more serial ports are available, always use the lowest numbered port first.

2. Plug the other end of the cable into your camera.

The plug on the camera end of the cable might look like a small telephone plug or some other special connector. It's a safe bet that there's only one place on the camera where that particular plug fits. (The socket might be hidden behind a small door.)

3. Turn on the camera and the computer.

Check your camera manual to see whether your camera should be turned on before you boot the computer. That will often be the case.

4. Use the camera manufacturer's software to transfer image files from the camera to the computer.

Use your camera's AC power adapter to run the camera while you have it hooked up to your computer, transferring files. That way, you don't run down your camera's batteries. Most importantly, you don't want the camera to die while you're doing something like erasing files on the memory card that have already been copied to your computer. That can corrupt your memory card or possibly damage it.

Parallel port

The parallel port is normally used to send information from the computer to a printer; in fact, it's often called the printer port. (Today, most printers use a USB port, so the parallel port is falling into as much disuse as the serial connection.) However, the parallel port itself isn't restricted to printing duty, and it sometimes gets pressed into service to handle data transfers for other devices, such as scanners, external drives, and (rarely) cameras. Nowadays, an external device is more likely to connect to your computer via USB than the parallel port, but you might still find the odd scanner or camera that requires a parallel port connection.

The parallel port is a D-shaped, 25-pin, female connector. (The connector on your computer has two rows of small holes, and the plug on the end of the corresponding cable has two rows of small pins.) The port might be labeled with LPT1 or a printer icon.

After you identify the parallel port on your computer, you can use the cable that came with your camera to connect the camera to your computer by following these steps (with your computer turned off):

1. Plug one end of the cable into the parallel port on your computer.

You might need to unplug your printer in order to make room for the cable from the camera. Often, the cable from the camera includes an extra plug into which you can plug the printer cable. This enables both devices to share the same port.

2. Plug the other end of the cable into your camera.

The plug on the camera end of the cable might look like a small telephone plug or some other special connector. It's a safe bet that there's only one place on the camera where that particular plug fits. However, the socket might be hidden behind a small door.

3. Turn on the camera and the computer.

Again, check your camera's manual to see whether the vendor recommends turning on the camera before you boot the computer.

4. Use the camera manufacturer's software to transfer image files from the camera to the computer.

USB

The USB (Universal Serial Bus) port is the all-purpose connection that was supposed to replace the older serial, parallel, and PS/2 (mouse/keyboard) ports. The older alternatives haven't gone away completely yet, but USB is increasingly becoming the connection of choice for many computer devices, including digital cameras. The original USB 1.1 port has already been replaced by the faster USB 2.0 version now found on most new computers. Cameras and other peripherals will work with either type, although at a slower speed when connected to a USB 1.1 port.

USB connections are capable of moving data faster than the older serial and parallel connections. Because USB connections are also hot swappable, you can safely plug in and unplug USB cables without shutting down your computer. You can also expand the number of USB ports available by adding a *hub* (a small box containing multiple USB ports) or a device, such as a keyboard or monitor, that has extra USB ports built in. Then, you can plug your

camera or other USB device in to the added ports, just as you can the USB ports on the back of your computer. Your USB hub may need a power adapter to run some equipment. Some gear works from the unadorned port, drawing power from your computer, but others require more juice.

Some older computers might not have USB ports built in. You can upgrade most of those computers with a relatively inexpensive add-in card to provide the needed USB ports. Another potential problem is that older versions of Windows (Windows 95 and Windows NT 4) or Mac OS (prior to Version 8.5) don't support USB. Upgrading to a newer operating system that does support USB is usually possible, but it's likely to be more expensive than a simple hardware upgrade.

The USB port is a small, flat, rectangular socket approximately ⁵⁄₁₆ x ½ inch. You usually find at least two of them on the back of your computer, clearly marked with a special symbol. USB ports might also be available on the front of the computer, on a USB hub (like the one shown in Figure 3-2), or on a keyboard or other device that has a built-in hub.

Figure 3-2:
USB hubs
provide
additional
USB ports.

You can use any of these ports to connect your camera to the computer. Just follow these steps (with your computer turned on):

1. **Plug one end of the cable into the USB port on your camera.**

The USB connector is often hidden behind a small door on your camera. It's usually a squared-off, D-shaped socket, approximately ¼ x ⁵⁄₁₆ inch. If your camera includes a standard USB port, you can use a standard USB cable, which has a rectangular plug on one end and a square plug on the other. However, some cameras use a smaller mini-USB connection to save space. In that case, you need to use the special cable supplied with your camera.

2. **Plug the other end of the cable into the USB port on your computer or USB hub.**

3. **Insert the camera manufacturer's disc into your computer if prompted to do so.**

Windows automatically recognizes when a new device is added to a USB port. The first time you connect your camera to the computer, Windows might need to load drivers supplied by the camera manufacturer in order to access the camera.

4. **Use the camera manufacturer's software (or other file-management software) to transfer image files from the camera to the computer.**

FireWire

FireWire connections (formally known as IEEE 1394) are an alternative to USB connections. Like USB, FireWire transfers data faster than serial and parallel ports and is hot-swappable. You can also connect multiple FireWire-equipped devices to the computer. FireWire connections are a standard feature on all Macintosh computers built in the last few years. FireWire is also available for PCs, but built-in FireWire on a PC is unusual. You probably need to purchase and install an add-in card for your PC if your camera needs a FireWire connection.

FireWire isn't common on digital still cameras; you encounter it more frequently on digital video cameras. But because some digital video cameras can capture still images as well as digital video, I guess that qualifies them as digital photography devices.

The FireWire port (shown in Figure 3-3) is a small, rectangular socket that looks somewhat similar to a USB port. The FireWire port is a little fatter than a USB port, however, so there's no chance of mistakenly plugging a FireWire cable into a USB port or vice versa.

Figure 3-3:
The 6-pin FireWire connector (top) is on your computer. The 4-pin version (bottom), or a special connector for a particular add-on, is found on the external device connected to the computer.

Follow these steps to connect your camera to your computer via a FireWire port:

1. **Plug one end of the cable into the FireWire port on your camera.**

The FireWire connector is often hidden behind a small door on your camera. If your camera includes a standard FireWire port like the one on your computer, you can use a standard FireWire cable, which has identical plugs on each end. However, if your camera uses a special cable configuration to save space, you need to use the special cable that came with your camera.

2. **Plug the other end of the cable into the FireWire port on your computer.**

3. **Insert the camera manufacturer's disc into your computer if prompted to do so.**

Like USB, Windows and the Mac automatically recognize when a new device is added to a FireWire port and will prompt you for a disc if it needs to load drivers supplied by the camera manufacturer in order to access the camera.

4. **Use the camera manufacturer's software (or other file management software) to transfer image files from the camera to the computer.**

Riding the (infrared) light wave

An IrDA (Infrared Data Association) port enables you to transfer computer data from one device to another using pulses of infrared light instead of a physical wire. The process is similar to how most TV remote controls send channel and volume adjustment instructions to the TV. Infrared connections are slow and not very reliable, but those drawbacks are countered by the convenience of not having to poke around the back of your computer every time you want to make a connection or deal with wires that get tangled and lost.

An IrDA port looks like a small, dark red (nearly black) lens or window. You find them on some digital camera models from Kodak and Hewlett-Packard, and on a few printers and laptop computers, but rarely as standard equipment on a desktop computer. If your computer doesn't have an IrDA port, you can purchase an adapter that will probably connect to your computer via a cable to one of the standard serial or USB ports.

To use an IrDA port to transfer pictures to your computer, follow these steps (with your computer turned on):

1. **Turn on your camera and set it for infrared data transfer.**

Use the camera's controls to select the infrared data transfer mode. Each camera model is different, so refer to your camera's instructions for details.

2. **Position the camera's infrared port so that it points toward the infrared port on your computer.**

Although it's possible to make an infrared connection from several feet away, you generally get better results when the two infrared ports are close together (just a few inches apart). Ensure that no obstructions are between the two IrDA ports and that no bright lights (such as sunlight from a nearby window) are shining on the infrared sensors.

3. **Use the camera manufacturer's software on your computer to start transferring picture data.**

Memory cards and disks

All digital cameras have some form of built-in memory to store the pictures you shoot. In many cases, the memory medium that the camera uses is a card or disk that you can remove from the camera. Using removable media to store image data has a couple of advantages over fixed, built-in memory.

First, you can swap out a full memory card (sometimes referred to as a digital film card) or disk and insert another to increase the number of digital photos you can take without erasing some from memory. It's like putting a fresh roll of film in a conventional camera.

Second, you can use the removable memory media to transfer images to your computer for processing and printing. All you need is a suitable disk drive or card reader on your computer, and you can read the image files directly from the disk or memory card without attaching the camera to the computer.

Manufacturers use several kinds of removable memory devices in digital cameras. They range from the standard 3½" floppy disk to solid state memory cards, such as Secure Digital or CompactFlash cards, that are scarcely bigger than a postage stamp.

The following points give you some insight on inserting, removing, and accessing files on cards (which can be a trickier endeavor than you might think):

✦ To remove a memory card of any type from your digital camera (or computer), just press the eject button next to the card slot (for some kinds of cards) to pop the card loose from its connection. Then you can grab the end of the card and pull it out of its slot. Other kinds of cards pop out automatically when you press them.

✦ To insert a memory card into a laptop computer, a card reader, or digital camera, insert the card connector-edge first into the slot. Slide the card all the way in, and then press it firmly but gently to seat the connectors along the edge of the card. If the card won't go all the way into the slot, you've probably got it in upside down. Flip it over and try again.

✦ After you insert the memory card into your computer, you should be able to access it as a virtual disk drive. You can use your normal file-management techniques to copy and move image files from the PC card to your computer's hard drive. See Book I, Chapter 5, for more on managing your digital photo files.

Windows XP and Mac OS X will usually recognize your digital memory card in a card reader or when you connect your camera and will pop up a dialog box like the one shown in Figure 3-4. You can choose one of the actions available, including copying the files to your computer and erasing them from the memory card when finished.

CompactFlash cards

CompactFlash cards, like the one shown in Figure 3-5, are used as removable memory in a few other devices, but their primary application is for image storage in digital cameras. They provide a much smaller and more efficient form of removable memory than PC cards.

Figure 3-4:
Windows
XP
recognizes
your digital
memory
card and
offers to
perform one
of the
available
actions.

Figure 3-5:
Compact-
Flash cards
are a
common
storage
option.

At about 1½" square, a CompactFlash card isn't much larger than a postage stamp, and it's just a little thicker than a credit card. Still, there's room for two rows of holes for connector pins along one edge. All CompactFlash cards are physically the same size, but they can have various memory capacities ranging from 4MB to 4GB or more. (A higher-capacity version seems to come out every few months.)

Card-reader attachments are available for your computer. These attachments enable you to read and manipulate the contents of a CompactFlash card. The card reader is usually a small, external device that attaches to your computer via a FireWire, USB, or serial cable. Sometimes, a card reader for your computer comes with the camera. If not, you can purchase one from most computer supply stores for less than $50. PC card adapters are also available. The adapters enable you to access your CompactFlash cards via a PC card slot in a laptop computer.

For tips on removing, inserting, and accessing files on CompactFlash cards, see the bulleted list in the preceding section.

Secure Digital/MMC cards

Secure Digital cards and the identically sized but less flexible MultiMediaCard (MMC) are yet another memory card format similar to CompactFlash. Secure Digital cards are a newer format that has swept the industry in a relatively short period of time because the smaller size (roughly ⅞ x ¼") of the SD card allows designing smaller cameras. One key difference between MMC and SD cards is that the Secure Digital version allows encryption of the files to prevent tampering. They also offer higher performance and thus are preferred over MMC cards for digital cameras.

Using a Secure Digital card for image storage is essentially the same as using a CompactFlash card except that the card itself is slightly smaller, which means that the sockets in the camera and the card reader must be made to fit the Secure Digital card. The Secure Digital format is not interchangeable with the other formats.

Memory Stick

The Sony Memory Stick is one more form of memory card, functionally similar to the CompactFlash and Secure Digital cards. Sony uses the Memory Stick in several of its high-end digital cameras and also in digital video cameras, music players, and so on, which means that you can move your Memory Sticks around between devices and use them for storing pictures, music, and other files.

The Memory Stick is about the size of a stick of chewing gum and comes in capacities of 32–128MB. The newer Memory Stick Pro offers higher capacity

but is not backward-compatible with earlier devices that used the original Memory Stick. There is also the half-sized Memory Stick Pro Duo.

Several models of Sony laptop computers include a built-in Memory Stick slot so that you can use the laptop computer to access the contents of your Memory Sticks. You can also use a card reader similar to the card readers for CompactFlash and SmartMedia cards to access Memory Sticks from your desktop computer. The card reader is usually supplied with your camera and attaches to your computer via USB cable.

Here are some pointers for removing, inserting, and accessing files on a Memory Stick:

✦ To remove a Memory Stick from your digital camera (or card reader), press the eject button next to the slot to pop the stick loose, grasp the exposed end of the stick, and slide it out of its slot.

✦ To insert a Memory Stick into the camera (or card reader), insert the stick into the slot in the direction of the arrow marked on the surface of the stick. The arrow and a clipped corner help you orient the stick properly. The stick goes into its slot in only one way. Push the stick in firmly but gently to seat it properly.

✦ Like the other memory cards, after you insert a Memory Stick into the card reader attached to your computer, you can access and manipulate the files on the stick as if they were located on a virtual disk drive. Copy, move, and erase the files using your normal file management tools.

The Memory Stick includes an Erasure Prevention Switch that lets you protect the contents from accidental erasure. Make sure the switch is in the Off position when you want to record images onto the stick in your camera or erase files in the card reader.

CompactFlash cards, Secure Digital cards, Memory Sticks, and the like are often called digital film because inserting a memory card into a digital camera is analogous to loading a conventional camera with a fresh roll of film.

SmartMedia cards

SmartMedia cards have faded almost completely from the scene and exist today only as memory options for older digital cameras that use them. They are similar to CompactFlash cards but in an even smaller package, and they are limited to only 128MB capacity. A SmartMedia card is slightly smaller than a CompactFlash card in height and width, and it's much thinner — only about the thickness of a business card. Like a CompactFlash card, a SmartMedia card has connectors along one edge, but the connectors are metallic foil strips instead of rows of tiny holes. SmartMedia cards come in varying capacities, from 4–128MB or more.

You use a card reader attachment — very similar to the one you would use to read a CompactFlash or SD card — to access the contents of a SmartMedia card. The only difference is that the slot in the card reader is made to fit a SmartMedia card. Card readers with slots for SD, CompactFlash, SmartMedia, and Memory Stick cards are available.

Following is the lowdown on removing, inserting, and accessing files on a SmartMedia card:

✦ The SmartMedia card slot on your digital camera is often hidden behind a small flip-up door. To remove the SmartMedia card from your camera, open that door, press the edge of the card to activate a spring-loaded eject mechanism, and then release. When the card pops out part way, grab the exposed edge of the card and slide it out of its slot.

✦ To insert a SmartMedia card into the camera (or card reader), insert the card into the slot, connector-edge first. Slide the card all the way in, and then press it firmly but gently to seat the card into the slot. If the card won't go all the way into the slot, you've probably got it in upside down. Flip it over and try again. If it pops out part way, try pressing in the edge of the card again and then release the pressure slowly and gently so as not to activate the ejection mechanism.

✦ When you insert a SmartMedia card into the card reader attached to your computer, it functions like a virtual disk drive. You copy, move, and erase image files on the SmartMedia card using the same tools you would use to work with files on a floppy disk.

PC Cards

The oldest format for a memory card still in use is the PC Card, also known as ATA Type II PC Cards or PCMCIA cards. PC Cards come in many different forms and are not limited to memory configurations. They are typically used to provide plug-in components, such as modems or network interface cards, for laptop computers equipped with a PC Card slot. Memory cards and miniature hard disks also are furnished in the PC Card form factor. It's these hard disks and memory cards that are used in a very few older digital cameras.

A PC Card is roughly the height and width of a credit card — and about four times as thick — with holes for tiny connector pins in one edge. Just about every laptop computer has at least one socket designed to accept a PC Card. You can also get add-on PC Card sockets that fit into a drive bay in a desktop computer, but finding a desktop computer that comes with a PC card socket preinstalled is rare. Attaching a card reader through the USB or FireWire port to read PC Cards is a more common practice.

Floppy disk

When it comes to removable storage, what could more familiar than the plain old 3½" floppy disk? For years, Sony built a line of digital cameras that use the ubiquitous floppy disk to store and transfer images. A floppy disk drive is actually built into the camera.

At only 1.44MB, the capacity of a floppy disk is puny compared with even the lowest capacity CompactFlash and SD cards, and the size of a floppy disk makes it an inefficient storage medium. However, the disks are cheap and readily available, and everyone knows how to use them. Because floppy disk drives are standard equipment on almost all computers, you can generally count on being able to access your images from any computer without worrying about cables, card readers, drivers, or special software.

The exceptions to the universal availability of floppy disk drives are the recent Macintosh computers, such as the Apple iMacs, as well as some extremely lightweight laptop computers. These computers are about the only ones that don't come with built-in floppy disk drives. However, even for these machines, add-on external drives that read floppy disks are available.

Here's how to remove and insert floppies:

✦ To remove a floppy disk from your camera, press the eject button next to the floppy disk slot. When the disk pops out part way, you can slide the disk out of the drive.

✦ To insert a floppy disk into your camera or the disk drive in your computer, slide the disk into the drive, metal-slide-edge first with the label facing up. Push in the disk until it clicks in place and the eject button pops out.

Mini-CD

To combat the problem of the limited capacity of floppy disk drives, Sony builds some digital cameras with a mini-CD drive in place of the floppy disk drive. The camera actually includes a CD burner to record picture data onto mini-CDs, which are smaller diameter versions of standard CDs. A standard CD-ROM drive can read the mini-CDs, and because CD drives are standard equipment on almost all computers, the mini-CD enjoys the same universal accessibility as floppy disks. The downside is that the mini-CDs aren't readily available for purchase like floppy disks or even memory cards.

Microdrive

The Hitachi (formerly IBM) Microdrive is a tiny hard disk drive that's a little thicker than the standard CompactFlash card but otherwise the same. If

**Book II
Chapter 3**

Getting Your Picture from the Camera to the Digital Darkroom

your camera is equipped with a CompactFlash+ Type II slot, you can use the Microdrive. The Microdrive is a bit pricey, but it provides a lot of storage space for your images. It's available in sizes up to 1–4GB or more. Using the Microdrive is just like using a standard CompactFlash card except that because it is actually a miniature hard drive, it must be handled with more TLC than a CompactFlash card.

Transferring Images from Camera to Computer

As the previous section shows, different digital cameras offer different tools for connecting the camera to your computer. It might be a direct connection such as a cable from the camera to a port on your computer, or it might be an indirect connection such as a memory card or disk that you can remove from the camera and then insert into a reader or drive attached to your computer.

After you make the connection between your camera and your computer, you might have a few more options available regarding what software you use to transfer pictures from the camera connection to your computer. Most digital camera manufacturers supply a software program with the camera that is designed to handle the task, but you might also have the option of transferring pictures to your computer via image editing software or your computer's normal file management utilities.

Transferring pictures using camera utility software

Windows XP and Mac OS X can recognize memory cards or cameras and offer to transfer your photos for you. However, you'll often prefer to use the utility software provided with your digital camera because such software frequently has additional features, such as the ability to edit your photos after you transfer them.

Just about every digital camera on the market today ships with a disc containing a software program designed specifically to transfer pictures from the camera to your computer. Often, the software has a number of other features as well, but its main purpose is to allow you to use your computer to access the pictures you shot with your camera.

The details of the installation and use of the software accompanying the various digital cameras vary as much as the cameras themselves. Covering all the different programs in detail in this book is not possible, but the general process goes something like this:

1. **Make sure the camera (or card reader) is connected to the computer and is turned on.**

This ensures that the software can find the camera/card reader connection if the installation searches for it.

2. Insert the disc that came with your camera into your computer's disc drive and launch the installation utility (if it doesn't start automatically).

The software disc is usually a CD, and the installation routine usually starts automatically a minute or so after you insert the disc into your computer. However, if the installation doesn't start automatically, you can usually get things going by using Windows Explorer to double-click a file icon labeled Setup or Install. You can probably find the file in the root folder of the drive where you inserted the disc. With Macs, click the program's icon on the Desktop.

3. Follow the onscreen instructions to install the software.

A couple of mouse clicks to accept defaults are all it usually takes.

4. Start the camera utility software.

Sometimes the utility software sits in the background and waits for your camera to be connected. Then it pops up automatically and goes to work. If not, double-click the Desktop icon that the installation program added or look for the new addition to your Windows Start menu. If the camera or card reader is connected and turned on when you start the program, it will usually find your camera automatically. In some cases, you might need to help the program locate the camera by choosing a command such as File⇨Connect and selecting the appropriate location in a dialog box.

5. Click an icon or menu command to view the image files on the camera (or removable media).

Here's where the different software programs really go their own way. There is usually an icon or menu command that you can use to display a list of picture files on your computer. You might even be able to preview the pictures as *thumbnail* (small) images.

6. Select the picture files you want to transfer and click an icon or menu command to begin moving the files to your computer.

Again, the details vary greatly in the different programs, but there is usually a prominent icon that you can click to start the transfer process. If you don't see an obvious icon, check the File menu for a command, such as Import.

The same utility program that enables you to transfer pictures from your camera to your computer often includes features that enable you to edit or manage your image files. You can also erase pictures from your camera's memory after transferring them to your computer so that you have room to shoot more pictures with the camera.

After you transfer the images to your computer, you can view, edit, and print them using any appropriate program on your computer. Windows' and

**Book II
Chapter 3**

**Getting Your Picture
from the Camera to
the Digital Darkroom**

Mac OS X's built-in utilities are sufficient for basic viewing and printing, but you'll undoubtedly want to use more capable programs for most image editing tasks.

Copying files to your hard drive

Perhaps the simplest and most straightforward way to move pictures from your camera to your computer is to treat them like any other computer file. In other words, you simply use your standard file-handling utilities to copy, move, and delete the image files. This is the technique you use with most forms of removable media, and you can often use it with direct camera connections via USB or FireWire as well.

The biggest advantage of this approach is that you don't need to deal with a specialized program in order to access your pictures. Instead, you use familiar tools, such as Windows Explorer and the Open dialog boxes, in your favorite programs.

In order for this technique to work, your computer operating system (Windows or Mac) must be able to access your camera or card reader adapter as part of the computer's file system. Fortunately, that's exactly how most memory card readers and many cameras (most cameras that connect via USB or FireWire) work. They appear to your computer as virtual disk drives, and you can read, write, and erase the files on those devices just like you can files on your hard drive or floppy disk.

Many digital cameras have a setting that let you choose whether the camera, when linked to your computer by cable, appears to the computer as a digital camera or as just another storage device. The chief advantage of choosing the storage device option is that you can copy files back and forth just as if the camera were a hard disk drive, with no extra software required other than your operating system itself. Choose to appear as a digital camera, and you'll be able to use your camera's utility software to make the transfer.

To transfer pictures from your camera to your computer, you can use any of the same techniques you would use to move files from one disk drive to another. The only exception is the extra steps needed to connect a virtual disk (your camera or card reader) to the computer. The following steps summarize the process for the Windows environment (similar techniques work for Mac OS):

1. **Connect the camera (or card reader) to your computer and turn it on.**

After a moment or so, Windows displays a message box saying that it has found new hardware and is installing the necessary software drivers. An icon appears in the system tray portion of the taskbar next to the clock.

2. **If prompted to do so, insert the manufacturer's disc containing drivers for your camera or memory card reader.**

 You only need to do this the first time you attach your camera or card reader to the computer.

3. **Open Windows Explorer and navigate to the virtual disk drive representing your camera or card reader.**

 You can double-click the My Computer icon on your desktop to open an Explorer window and then double-click the appropriate drive icon to display the contents of the camera memory or the memory card in your card reader. Look for a new drive letter that doesn't correspond to one of the standard disk drives installed in your system.

 The name of the drive might be the brand name of your computer or card reader.

4. **Open another Windows Explorer window and navigate to the folder where you want to store the picture files from your camera.**

 Be sure to position the two Explorer windows on your desktop so that you can drag and drop between them.

5. **Drag and drop one or more files from the first Explorer window onto the second window.**

 That's all it takes to copy pictures from your camera to your computer. If you copy them in this way, you'll need to delete them from the memory card if you no longer want them there.

Of course, after you connect your camera (or the memory card from your camera) to your computer as a virtual disk drive, you can use all the standard Windows tools and techniques to manage your picture files. The default action for a drag and drop is to copy the files to their new location. However, if you click and drag with the right mouse button instead of the normal left button, Windows displays a contextual menu that gives you the option to move the files instead of copying them. The Move command lets you copy the files to their new location and erase them from the old location in one step. You can also return to the first Explorer window and erase the picture files from your camera memory in a separate operation.

You can even copy files from your computer to your camera memory so that you can view them in the camera. You're not likely to do that very often, but it's possible. One reason you might want to do this is to load your camera with images that can then be shown as a presentation by using the camera's built-in slide show capabilities. Because most digital cameras can be connected to an external TV monitor, this mode lets you use the camera as a portable presentation machine!

Book II
Chapter 3

Getting Your Picture
from the Camera to
the Digital Darkroom

After you finish transferring pictures from the camera to your computer, don't forget to disconnect the camera properly. To do so, you need to right-click the device icon in the system tray and choose Unplug or Eject Hardware from the contextual menu that appears. Then, select the camera from the list in the dialog box that appears next and click the Stop button to tell Windows that you want to disconnect the device. Windows displays a confirmation message, after which you can physically disconnect the camera and its cable from the computer. With a Mac, you should drag the camera's icon to the Trash before disconnecting your camera.

Importing images into image editing software

The normal sequence of events is to use your camera's utility software to transfer one or more picture files from your camera to your computer. Next, you launch your favorite image editing software and open the image file to make some adjustments before finally saving or printing the picture. However, several image editing programs can do the transferring for you, which shortens the whole process.

If Windows recognizes your camera or card reader as a mass storage device (and most such devices that connect to the computer via USB and FireWire are), the device and all the files on it appear to Windows just like any other disk drive. Consequently, you can open a picture for editing in your image editing program by simply selecting it in the program's Open dialog box. The only thing you have to do is make sure the camera is connected and turned on (and recognized by Windows) before you attempt to open files in the photo editor.

Macs operate in the same way, recognizing your camera or card reader and offering to open the photos in iPhoto.

In some cases, the image editing software actually uses the camera manufacturer's software to access images on your camera. You still save time by having the option to access that software with a menu command or button in the image editing software instead of opening the camera software separately. The process is very similar to the way you acquire images from a scanner directly into your image editing software.

The advantage of this technique is that it not only streamlines and automates the process of using the camera access software, but it often brings the images directly into the image editing program without making an intermediate stop as a file saved on your computer's hard disk. As a result, you get to view and edit each image before saving it.

To transfer images from your camera directly to your image editing software, you first need to tell the program what camera you use and where to find it. Make sure that the camera manufacturer's software has been installed and is

operating properly on your computer, and then configure your image editing software to access images from the camera. The setup process varies in the different programs, but the following steps are typical:

1. **Connect your camera to the computer and turn it on.**

2. **Choose File⇨Import⇨Digital Camera⇨Configure (or an equivalent command) in your image editing program.**

The program usually opens a dialog box, but it might also present a sub-menu instead.

3. **Select your camera and (if necessary) the port where it's connected; then click OK to close the dialog box.**

After you configure your image editing software, you can use it to access images from your camera. Here's how:

1. **Connect your computer to the camera and turn it on.**

2. **Choose File⇨Import⇨Digital Camera⇨Access (or an equivalent command) in your image editing program.**

A dialog box appears, giving you access to the images stored on your camera. This is usually a subset of the camera manufacturer's access software.

3. **Select the image or images you want to open in the image editing program and then click the button or choose the command to begin the transfer.**

The software transfers the selected pictures from your camera to the image editing software.

4. **If the image editing software doesn't return to the foreground automatically, click its taskbar button.**

The selected images appear in the image editing program window, ready for you to begin working with them.

Chapter 4: Adding a Printer and Scanner

*N*othing shows us more dramatically how digital technology has changed the face of photography as the ways in which we use prints. We've gone from the days of the daguerreotype (in which every photographic image was a unique and original hard copy) to the digital age in which (if we wish) a photograph can exist entirely and solely in electronic form and never be transferred to a piece of paper or film that we can hold in our hands. The photographic print has gone from being the normal and expected result of taking a picture to nothing more than an option.

In the digital age, prints have taken on an additional role as a source for digital images. If you have a scanner, the photographic fodder for your image editing software can come as easily from a hard-copy photograph that you've scanned as from your digital camera. Indeed, some of the happiest marriages of imagery come from mixing and matching photos that originate in digital form with pictures that have been created on film, printed on paper, and then scanned.

Even when you have the choice of viewing your finished photographs on a computer screen, there are so many good reasons for making prints. A better color printer is probably the first accessory that a digital photographer purchases after upgrading to a digital camera. And a scanner used to convert existing prints and slides into pixels is probably the second accessory considered.

This chapter looks into the factors that you need to take into account when choosing a printer and a scanner for your digital photography outfit.

Why You Want Prints

Digital pictures are great when you want to show them on your computer screen, project them on a screen during a presentation, or incorporate them into your Web page. Even old-fashioned color slides have their uses. Professional photographers like prints for their unsurpassed reproduction capabilities. Amateurs have long used slides as a tool for lulling neighbors to sleep during a discussion of their last vacation.

Yet, when it comes time to share your photographic efforts seriously, nothing beats a print. You can hang a print in a frame over your fireplace. You can pass around a stack of photos of your kids without worrying whether your captive audience has the right viewing hardware or software. Photo prints are used as proofs submitted for approval or as samples in a portfolio. When you open an old shoebox of memories tucked away in your closet, you hope to find a slew of old prints inside, not a stack of CDs or DVDs.

Indeed, students of photography have already noticed a dramatic change in how the work of the very best photographers can be studied and evaluated since digital photography became common. The photographic masters of illustration and photojournalism of the past worked with prints and often made proof copies, called *contact sheets,* that contained a rough, uncropped and uncorrected version of every picture they took. We can look at those old prints and see how photographic ideas evolved into the famous photos we know today.

With digital photography, though, test shots, alternative angles that didn't work out, and other material can be erased and forgotten. A digital camera's Quick Erase feature can obliterate unwanted photos before they ever reach a computer. Only the best images survive, and only the best of the best make it to print form.

That doesn't mean that prints are an endangered species. The same digital technology that has eliminated some of the need for prints has given us whole new capabilities that make them more useful than ever. For example, when shooting pictures on film, you probably let your photofinisher make a print of every single shot on the roll, so that you can see which ones are the good ones. (In these days of double prints, you probably get at least two copies of every shot, including the blurry ones and the pictures of your shoes.)

With digital photography and inexpensive color printers, you don't need to accumulate stacks of 4 x 6" prints that you don't want. Not only can you print just the pictures you like, but you can also easily crop them the way you want to see them, fix the color, sharpen the blurry parts, and print them as glorious 5 x7s or 8 x 10s. Digital photographers might not end up with more prints, but they do have better prints and like them better, too.

Choosing a Printer for Digital Photography

The good news is that printers capable of producing photo-quality images are inexpensive, and printers from all the vendors are comparable in quality, ruggedness, and image quality. If all you want are a few photos now and then, it's hard to go wrong. All the well-known printer manufacturers and many of the companies that sell cameras are hard at work building faster, better, and less expensive printers for you to choose from.

The bad news is that the vendors have a nefarious purpose behind their industrious efforts. Those who sell printers these days want to make their devices so easy to use and produce hard copies that are so pleasing to the eye that you'll be tempted to make more and more prints. And that's where the money is: The cost alone of special photo papers and inks used during the first few months can easily exceed the price you paid for a color printer. As you read the descriptions of your printing options that follow, you need to keep foremost in your mind not how much the equipment costs to buy, but how much it costs to use. I provide some guidelines and tips as you go along.

Here are your primary options:

✦ **Let somebody else do it.** If you don't need many prints, you can probably get by quite well without owning any color printer at all. Color ink cartridges tend to dry out and clog up if allowed to sit for a week or two without being used, so if you really aren't making many prints, you should consider just stopping by your local discount or drug store with your images on a disk/disc/media card and using a standalone kiosk such as the Kodak Picture Maker, shown in Figure 4-1. You pay $5–$7 for a sheet of photos, but think of the money you'll save on equipment and dried-out ink cartridges! Many photofinishers have digital minilabs that use conventional paper and chemicals to produce high-quality photographic prints; they can accept your digital film and deliver a stack of 4 x 6" prints. You can even send your images to labs on the Internet for delivery to you by mail.

✦ **Use a laser printer.** If you have a black-and-white laser printer, you can make quick-and-dirty monochrome prints of your digital images that might be good enough for many applications, such as pasting up in publishing layouts or creating simple posters to promote your rock band's upcoming club date. Color laser printers, at less than $1,000–$3,000 and up, can create fairly decent full-color pictures although these pictures don't have the glossy sheen and true photographic appearance of some of the other options. Color laser printers can be fairly economical, too, because their color toners are inexpensive and can be applied to inexpensive ordinary paper stocks. If you have some other use for a color laser printer (say, printing documents, newsletters, or other work that uses spot color), these devices can fill in for you as an output option for the occasional digital photograph.

Book II
Chapter 4

Adding a Printer
and Scanner

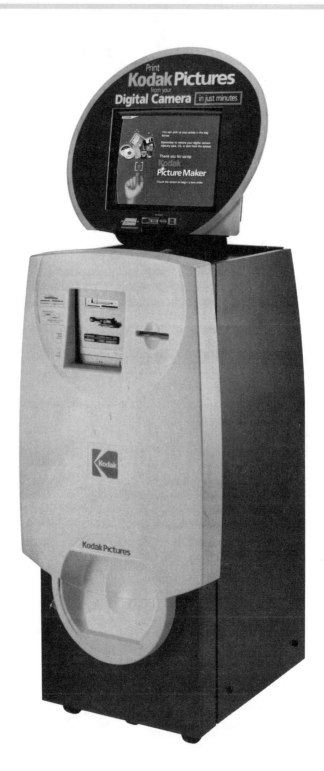

Figure 4-1:
A stand-
alone kiosk
might be
your best
source for
quick, high-
quality
prints.

✦ **Use an ink-jet printer.** These are the most popular, color output option for digital photography right now because they cost very little (decent ink-jets can be purchased for $50–$100) and supplies for them can be purchased everywhere, including your average, all-night grocery store. Their output looks almost exactly like a color photograph when printed on special glossy photo papers. Unfortunately, for each photo you print, you can pay as much as 50 cents to $2 for the materials (ink and paper) alone. After paying $35 for an ink cartridge that was good for only 20–30 8 x 10" prints and then repeating the process once a week for a month, I junked a perfectly good ink-jet printer and replaced it with a model that uses separate ink tanks for each color. Now, when I run out of yellow ink, I drop in a new $8 yellow ink cartridge instead of replacing the whole thing. I tried several of the ink-jet refilling kits, but the ink seemed more easily applied to my hands and clothing than to the cartridge being refilled. So I like using separate, replaceable tanks, like those shown in Figure 4-2.

Figure 4-2: Using replaceable one-color ink tanks is more economical.

✦ **Use a dye-sublimation printer.** Dye-sublimation (dye-sub) technology, although gradually being replaced by ink-jet printers for most applications, is still used at the consumer level in small photo printers that are limited to, say, 4 x 6" prints. In those sizes, a dye-sub printer can be fairly economical even though it uses a fairly complex printing system that involves a roll with a continuous ribbon of color. Each section of the color ribbon is used only once, so you always know exactly how many prints you're going to get before it's time to refill. The quality of these printers is unsurpassed but unlike ink-jet and laser printers, you can't use them for printing documents. Photos are all they can print. These printers cost $149 and up.

✦ **Use a different type of printer.** You can also find various alternate printing technologies, such as thermal wax printers, solid-ink printers, and a few other offbeat types, each with its own advantages. Some of them, called *phase-change* printers, for example, can print photo-quality images on ordinary paper, partially offsetting the cost of their solid wax or resin inks. These are generally expensive printers, often costing $600 to $3,000 or more.

Choosing a Scanner

In many ways, digital cameras and scanners are two sides of the same coin, each with its own advantages and limitations. Both use solid-state sensors to capture a digital image of an object, providing you with fodder for your image editor's magic. Cameras are portable and can grab images of three-dimensional objects of virtually any size, at any distance (up to the moon and beyond!). Scanners pretty much reside on your desktop next to your computer, are limited (for the most part) to two-dimensional originals such as photographs, and can work only with objects that are 8.5 x 11 inches or smaller.

Digital cameras capture an image in an instant; a scanner takes a minimum of 20–30 seconds to produce a scan. High-resolution digital cameras are expensive; if you want 6MP of information, you can pay $1,000 or more. A scanner fully capable of grabbing 135MP of image information (1200 samples per inch over an 8.5 x 11" photo) can cost less than $100.

Whereas digital photographers carefully select what goes into a digital camera image through use of composition and lighting, scanners pretty much capture whatever is already on the original you slap down on the glass. The purposes and capabilities of digital cameras and scanners are so very different that if you're serious about digital imaging, you'll want both a digital camera and a scanner.

One of the best things about scanners is that you can do a lot of other things with them in addition to scanning photographs. Here are some highlights:

✦ **Turn printed text into editable text.** If you create newsletters and want to convert hard-copy text documents (such as newspaper clippings) into editable text, a scanner can use optical character recognition (OCR) to capture the text. Using software usually bundled with the scanner, the scanner translates the image of the text into text files (often with formatting and photos preserved). You can also use OCR with faxes that are clear and perfectly legible to convert those faxes back into an editable document.

✦ **Photocopy documents.** Most scanners have a Copy button on their front panels. Slap an original down on the glass, press the button, and the scanner captures the image and directs it to your printer. It's almost as good as having a dedicated copy machine.

✦ **Send faxes.** If a scanner can serve as a copier, it also works admirably as half a fax machine. Whether or not your work environment has a dedicated fax machine, there's nothing quicker (or more confidential) than using your scanner with your computer's fax modem.

✦ **Manage documents more easily than you can with microfilm.** Some types of records must be retained in some semblance of their original appearance, such as documents with signatures, checks, illustrated reports, and so forth. Offices used microfilm for this sort of document in the past. Today, you can manage documents using a scanner as an input source and a specialized document-management application to file and retrieve the images.

✦ **Capture nonphotographic images.** Perhaps you have line art, charts, logos, cartoons, or other artwork you'd like in digital form. A scanner works as well with nonphotographic images as it does with photos.

Types of scanners

You can find a pretty good overview of the various types of scanners in Book I, Chapter 3. For digital photography, your choices really boil down to one of three kinds of technology as well as several categories based on price and features. I can dispose of the scanner technologies quickly:

✦ **Photo scanners:** These are small scanners designed specifically for scanning snapshots and are often used in tandem with equally compact photo printers. You feed in a snapshot and get a digital image for editing, or you might skip the editing step and direct your scanned output to a photo printer. You can use such a setup as a sort of photocopier for prints, which is great when your scanning needs are limited to snapshots. These scanners can cost a few hundred dollars.

✦ **Flatbed scanners:** These are the most widely used type of scanner. They look and operate something like a small photocopier. You open the lid, place your original face down on the glass, and scan. Flatbeds are usually limited to scanning 8.5 x 11" (or sometimes 8.5 x 14") material, but the movable cover makes it simple to grab images of thick originals, such as books or even some 3-D objects. Larger originals can be scanned in sections and stitched together in your image editing software. Some flatbeds have an alternate light source built in to the lid or available as an add-on that can illuminate transparencies, giving you slide-scanning capabilities. Flatbed scanners can run anywhere from $50–$1,000 or more.

✦ **Slide/transparency scanners:** These are high-resolution scanners used for scanning color slides (in 2 x 2" mounts), strips of film in sizes from 35mm to 6cm in width, or sheet film up to 4 x 5" (or sometimes larger). Photographers who use transparency (positive) or negative film — or who have archives of these kinds of film — prize the specialized capabilities of slide scanners. These scanners cannot scan reflective copy, such as photographic prints. A new crop of film scanners priced at $300 or less has opened up this option to just about any interested consumer who has slides or negatives to scan. However, at the high end, this type of scanner can easily cost $1,500 or more.

All three types of scanners use similar components. All have a place to position the original to be scanned. A light source either reflects off the surface of the original or transilluminates it (in the case of transparencies or negatives). A high-resolution sensor captures the original one line at a time, either by moving past the surface of the original or by capturing light reflected from a moving mirror. Electronics inside the scanner convert the analog information that the sensor captures into digital form. You can find out more about using scanners in Book VI.

Scanner prices and features

Like digital cameras, flatbed scanners fall into several fairly well-defined price and feature categories. You'll find point-and-shoot scanners just like you'll find point-and-shoot digital cameras. There are also general purpose and advanced (*prosumer* — advanced models that can be used both by advanced amateurs and professionals) scanners as well as true professional scanners.

Unlike digital cameras, the primary criterion used to choose a scanner is not the resolution of the scanner. Virtually all scanners on the market claim roughly the same resolution even though in practice, the image quality of these devices can vary widely, even among those with similar specifications. The primary things you should look at when choosing a scanner are the image quality, speed, and convenience. I address these separately later in the chapter, concentrating on general specifications and features for the main flatbed scanner categories first.

Entry-level scanners

Entry-level scanners are the $50–$100 scanners you see on special at your local electronics superstores. They are designed for the casual scanner user — someone who needs to grab an occasional photo or who doesn't have particularly high quality standards.

All you get with one of these are simple scanning capabilities. They're often quite slow and use inexpensive sensors that often can't capture the kind of sharp image that a digital photographer expects. They're easy to use, which makes them ideal for scanning neophytes, but they usually aren't expandable with accessories, such as transparency adapters. Don't expect even a "lite" version of Photoshop to be bundled with a scanner like this; many are furnished only with the most basic image capturing/editing software.

Entry-level scanners are a good introduction to scanning for people who don't know whether they want to get heavily involved with image editing. These scanners are also good for noncritical applications, such as photocopying, faxing, or grabbing images for Web pages.

Intermediate scanners

Spend $100–$200, and you can purchase an intermediate scanner with better quality and speed, more features, and a great deal more versatility. These scanners have enough quality to please all but the pickiest digital photographers and are fast enough that you won't fall asleep between scans when you're capturing a stack of photos on a lazy afternoon.

Intermediate scanners usually have all the convenience features you'd want. These include front-panel buttons that let you scan, make a photocopy, send a fax, or attach a scan to an e-mail. Some can be augmented with simple attachments for scanning slides and usually include a useful selection of software, such as OCR programs, stitching programs that let you stitch together multiple scans into a single image, and image management programs.

Advanced (or business) scanners

Serious digital photographers will probably be happiest with a scanner in this category. Priced at $200–$400 and up, these include everything you need to scan and manipulate photos and other originals, produce better quality, and are faster to boot.

You can find lots of flatbed scanners with slide-scanning capabilities in this group, as well as a few models with automatic document feeders so that you can scan whole stacks of originals one after another. The image quality is better, especially when you need to pull detail out of inky shadows or bright highlights. Improved speed can be very important because owners of these scanners can spend a lot of time during the day using them.

Expect a rich treasure trove of software with a scanner in this class, including a capable image editor (probably along the lines of Adobe Photoshop Elements), OCR, document-management software, fax software, and specialized image manipulation applications, such as applications that let you create panoramas from multiple photos (also called *stitching applications*).

Professional (or prosumer) scanners

I'm not sure there's really a prosumer category in scanners anymore. The advanced, or business, scanners described in the preceding category can handle most of the needs of digital photographers and others who aren't using their scanner professionally. True graphics professionals are really the only ones who need to spend $400–$2,000 or more for a flatbed scanner — and then only if they need some of the special capabilities these scanners provide.

Scanners in this category have all the features found in the advanced category but augment those features with the very best optics, sensors, and electronics available. You truly get the very best scans with these models, particularly if you know how to use the features.

These scanners are also very rugged, having what the automakers used to call (euphemistically) *road-hugging weight.* You can bang one of these scanners around without throwing anything out of alignment, and you can expect them to scan hour after hour, day after day, without protest.

These are the scanners to consider if you are scanning larger originals. An 8.5 x 14" scanning bed is a must, and some models have 11 x 17" or larger scanning beds.

Don't expect to get a copy of Photoshop bundled with one of these models. Anyone who can afford one undoubtedly already has a copy (or two) of Photoshop on hand. You can expect to receive a high-end scanning program, though, with dozens of controls and adjustments so that scans can be both automated as well as fine-tuned to the nth degree.

What scanner features do you need?

There's a lot of overlap in features within and between the various flatbed scanner categories. Some features are more useful than others for the digital photography-inclined. Other features can be deceptive. Later in this chapter, I spend a little time on the two most misunderstood features — resolution and the number of colors captured — and describe the other features briefly in this section.

Scan quality

Scan quality is different from resolution, as I describe in the later section, "Resolution mythconceptions." Resolution of the sensor is only one of the

factors that affect scan quality. The others include the number of colors *(dynamic range)* of the scanner, the quality of the optics, and the electronics used to translate the scanned image for your computer. The most important thing you want to think about is how good the final scan looks. Often, you need to rely on reviews in magazines or Web sites or your own testing to determine this.

Scanner speed

Some scanners operate much faster than others. One scanner might capture an 8 x 10" image at 300 samples per inch (spi) in 20 seconds whereas another might require a minute and a half. You might not care about the speed if you make one scan a day. Conversely, if you're making 100 scans a day, speed matters. Reviews can tell you how fast a scanner is, relatively speaking, but you still might want to test a scanner before you buy it, using your own documents and a computer similar to your own.

Scanning size

Flatbed scanners have a fixed-size scanning bed, usually 8.5 x 11.7" to 8.5 x 14". Even though you might rarely scan a 14"-long original, the larger size is handy to have. I often slap down a bunch of 4 x 6" prints and scan them all at once, cropping and sizing within Photoshop. It's nice to have a larger scanning bed to accommodate more and larger originals when you need to.

Physical size

If your desktop space is limited, you might want a tiny scanner. I favor larger scanners because they tend to stay put without sliding and can better ignore vibrations when heavy-footed colleagues or family members stride past. In any case, even the largest flatbed scanners today are likely to be half to two-thirds the size of the behemoths of five years ago, so you won't have to worry about giving over half your desktop to your image grabber.

Configuration

Along with physical size, other scanner configuration features can be important when desktop space is limited. For example, a few scanners can be set up vertically so they occupy a minimum amount of space. At least one new scanner comes apart, so you can place the scanning element directly on a large original that wouldn't fit in an ordinary scanner's scanning bed. One very cool feature is found in the scanner shown in Figure 4-3, which actually lets you see the original being scanned through a transparent lid. The scanning element is sandwiched between two pieces of glass in the lid, so you can watch it pass over your photograph while it scans.

Book II
Chapter 4

Adding a Printer and Scanner

Figure 4-3:
Some
newer
scanners
let you
see the
subject
you are
scanning
through a
glass sheet.

Bundled software

If you're already well equipped with software, you probably don't need to worry about the bundle furnished with your scanner. I've got several copies of Adobe Photoshop Elements that came with scanners I have but rarely use any of them. Of more interest to me are the advanced scanning programs, such as the versatile Silver Fast application that came with my high-end Epson scanner. You can always upgrade to better software if you're dissatisfied with the applications furnished with your scanner.

You might be more interested in OCR software (to convert documents to editable text), copy utilities (to let you use your scanner as a photocopier), document management programs (to let you file document images and retrieve them by keywords), and other software, such as applications that let you stitch images together to create panoramas.

Type of sensor

The kind of sensor used in a scanner can affect how you use it. In the past, *charge coupled device* (CCD) sensors were the most common sensor used in consumer scanners. These solid state devices capture an image that is conveyed by a sophisticated optical system, often a path measuring a foot or more in length, as mirrors and optics convey the light reflected from the original to the sensor itself.

More recently, a less expensive, solid-state sensor called a *contact image sensor* (CIS) has been used, especially for lower-priced scanners. A CIS sensor moves beneath the glass a few scant millimeters from the original in a much-simplified system that requires no optical path at all. CIS scanners can be very thin and compact (because there is no need to leave room for an optical path) and use inexpensive red, green, and blue (RGB) light-emitting diodes (LEDs) instead of the fluorescent light tube found in CCD scanners. This makes for a cheaper scanner, in more ways than one:

◆ First, CIS scanners often produce poorer quality than the more sophisticated CCD sensor produces. Although quality is improving (some $150–$200 CIS scanners produce great quality), this technology has not been associated with the best overall quality.

◆ Second, CIS scanners typically have very little depth of field, which means they can scan only flat originals held in tight contact with the scanning glass. Even a wrinkle in a paper original can affect the sharpness of some CIS scanners. You can also forget about scanning 3-D objects.

Book II
Chapter 4

Adding a Printer
and Scanner

Until CIS sensors catch up with their CCD counterparts, you probably want to stick with a CCD-based scanner when making your decision. Check the box or specs to find out which you have or visit the vendor's Web site if the information isn't easy to find.

Scanner interface

The kind of interface used to connect your scanner to your computer was once an important consideration. You had to choose between SCSI or parallel port scanners or even slow serial connections. Some scanners required a proprietary interface card.

Today, all scanners come with Universal Serial Bus (USB) or IEEE 1394 (FireWire) connections or both. Either of these interfaces is fast enough for the typical scanner; choose one with the interface that is available with your computer.

Color depth

Color depth indicates the number of different colors a scanner can capture, measured in bits, or *bit-depth*. For example, a 24-bit scanner can capture 16.8 million different colors, and 30–48-bit scanners can capture billions and billions of colors. Most of the vendor-supplied specs about color depth are misleading or false, so I don't advise paying much attention to color depth unless you're scanning transparencies (which require so-called *deep color* capabilities). Most of everything you "know" about scanner resolution and color depth is wrong anyway. I explain both in more detail in the next section.

Resolution mythconceptions

I've written nine books solely on scanners since 1990, and I've tested and reviewed hundreds of scanners for the major computer magazines and Web sites. During this time, one thing that hasn't changed in the last dozen-plus years is all the fuss over scanner resolution. I've received scanners for testing packed in large boxes with 12-inch lettering on the size proclaiming 2400 x 2400 RESOLUTION in garish tones. Scanners are invariably described as *a 1200-dpi, 36-bit color scanner* or some similar terminology, as if those terms summed up the most important qualities of that scanner. Well-meaning people write and ask me what resolution they should look for in a scanner. All the scanner books I've seen, including my own, include recommendations on what scanner resolution to use for particular tasks.

I'm about to share a little secret with you: Resolution is not the most important specification to use when choosing a scanner. It's not even the most important determiner of the scanner's final quality. The optical system and other attributes of the sensor are more important. Even the smoothness of the sensor/mirror transport system can be important. To make matters worse, the resolution figures vendors quote are likely to be false or misleading. And to top it off, unless you are scanning tiny objects that have lots of detail, you will rarely have any use for a scanner's top resolution in the first place. Most resolution figures you see are not only mythical, they're *dangerous*.

Until you've seen a 600 sample per inch (spi) scanner that produces better images than a 2,400 spi scanner, you won't believe this, but it's true. To see why this is true, you need to know how they arrive at those figures.

Resolution is calculated from the number of individual sensors in the sensor array that captures an image. This array is a narrow horizontal strip that extends along the width of the scanner. There is one element for each pixel in that width. For example, an 8.5 x 11.7" flatbed scanner with true optical resolution of 1200 spi has 10,200 elements along the array's width. The sensor itself is less than 8.5 inches wide, of course, because the optical system focuses the image onto the sensor's somewhat narrower width.

The scanner grabs one line at a time by moving the sensor (or a mirror that reflects through the optical system to the sensor) some distance between lines. If the scanner sensor/mirror carriage moves $\frac{1}{1200}$ of an inch between lines in the vertical direction, the scanner is said to have an optical resolution in that direction of 1200 spi. So, your scanner might be described as having a true resolution of 1200 (horizontal) x 1200 (vertical) samples per inch.

Some vendors try to play tricks by moving the sensor a fraction of a full line between scans — say $\frac{1}{2400}$ of an inch — so they can claim, perhaps 1200 x 2400 spi resolution. In practice, blurring caused by the motion of the carriage probably wipes out any resolution gained through this trick, so the spec reported by the vendor is already wrong on at least one count.

True resolution also depends on the sharpness of the optical system used to focus the image on the sensor, so unless the optics are top quality, even the horizontal resolution measurement doesn't really mean a lot.

Things get even more confusing when vendors quote *interpolated* resolution, which is a figure derived from mathematical algorithms used to calculate what pixels would exist if the scanner were capable of capturing them. So, you might have a scanner that boasts 1200 x 1200 spi optical resolution and up to 9600 x 9600 spi interpolated resolution, and neither figure tells you much about the quality of the image.

If resolution really is important to you, the best way to estimate what kind of quality you can expect from a given scanner is to read the laboratory reviews many magazines publish or to test the scanner yourself. I've seen 1200 x 1200 spi CIS scanners that were terrible and 600 x 600 spi CCD scanners that were twice as good at half the resolution.

I offer some advice on choosing resolution for specific tasks in Book VI, Chapter 1.

Color depth confusion

The other misleading specification quoted for scanners is their color depth. Does it really make a difference whether a scanner is a 24-bit, 30-bit, or 48-bit scanner? In practice, color depth — which is better thought of as dynamic range — does make a difference. Greater dynamic range lets you capture better-quality images, with more detail in the shadows and high-lights. Unfortunately, most of the dynamic range figures quoted by vendors are as misleading and inaccurate as their resolution figures.

Why do you need all those colors? There are only 800,000 different pixels in a 4 x 5" photo scanned at 200 spi. Even if every pixel were a different color, you would need only 800,000 unique colors to represent them all. Surely, the 16.8 million colors in a 24-bit image are enough? Alas, that's not true. First, scanners lose a lot of information because of noise in the electronic system. Imagine trying to watch TV while a lively party is going on all around you. Conversation, people walking, and even the tinkling of glasses provide extraneous sounds that degrade the sounds you hear from the TV. You're trying to listen to something while surrounded, quite literally, by noise. Scanners are subject to the same interference, but it's random electrical noise. Even a 30-bit scanner might barely end up with 24 bits of information after the signal-to-noise factor is included.

Moreover, the greater range of colors in some types of originals, particularly color transparencies, means that more colors must be available to represent them accurately. If you want to capture detail in very dark areas (called *D-max* by the techies) as well as in the very lightest areas *(D-min),* you need a heck of a lot of information. That's where extra color depth is valuable.

Unfortunately, scanner vendors quote dynamic range figures based on theoretical constraints rather than the real-world performance of their scanners. I've seen 48-bit scanners that actually produced no better than 24-bit scans. I've gotten superior results from scanners from more conservative vendors who claimed no more than 36-bit dynamic ranges.

Usually, scanners touted for their transparency-scanning capabilities have the best overall color depth performance. But, as with resolution, if dynamic range is important to you, you're better off relying on independent lab results from the magazines or Web sites or testing the equipment yourself.

Chapter 5: Picking Up Some Accessories

*M*ost digital cameras have everything you need to take great pictures, right? And they're not really very expandable because they usually have a nonremovable lens, built-in flash, close-up capabilities, and other features that you might normally purchase as accessories for film cameras. What more could you want?

A lot. One of the most diabolic things about photography is that as you use the capabilities of your camera equipment, you always find even more interesting things you could do if you just had *this* accessory or *that* gadget. A digital camera with a long zoom lens, for example, makes you wish you had a longer zoom. Discovering ways to use your digital camera's built-in flash effectively can make you yearn for a bigger, better external flash.

When the bug really hits you, you'll start searching for previously unknown accessories to help you do things you didn't even know could be done. You'll even think up ways in which having a second digital camera can help you (as a spare, as a smaller camera to keep constantly at hand, and so forth). After you become serious about photography, accessory-itis is sure to strike. I say this from the viewpoint of someone who currently owns more than a dozen single lens reflex (SLR) cameras, a clutch of digital cameras, some 15 lenses, eight or nine flash units, and a closet full of close-up attachments, filters, and other add-ons.

Don't fight it. Enjoy your incurable disease. You can have a lot of fun playing with your accessories, and most of them don't cost all that much, anyway. They help you shoot better pictures, too. This chapter highlights some of the most common and most needed accessories for digital photography.

Getting Support from Tripods

A *tripod* is a three-legged stand, like the one shown in Figure 5-1, designed to hold your camera steady while a picture is composed and taken. Although a tripod might be a little cumbersome to carry along, at times, you'll find one indispensable. Here are some of the things a tripod can do for you:

✦ **Holds the camera steady for longer exposures.** You need a longer shutter speed to capture an image in dim light.

✦ **Holds the camera steady for photos taken at telephoto zoom settings.** Telephoto settings do a great job of magnifying the image, but they also magnify the amount of vibration or camera shake. Even tiny wobbles can lead to photos that look like they're out of focus when they're actually just blurry from too much camera movement. A tripod can help eliminate this sort of blur.

If pictures keep ending up fuzzy when the camera's set for its maximum telephoto zoom setting, it's more likely that the problem is camera shake than a poor autofocus mechanism. At long zoom settings, most digital cameras often switch to a slower shutter speed. The slower shutter speed coupled with the telephoto's magnification of the tiniest bit of camera shake leads to a photo that appears out of focus. It's not that the picture is out of focus at all; it's just that the camera has been vibrating too much. Mounting the camera on a good, sturdy tripod is the best cure for this problem.

✦ **Holds the camera in place so you can get in the picture, too, by using your digital camera's self-timer feature.** This way, you only have to worry about how you look as you make a mad dash into the picture.

✦ **Allows for precise positioning and composition so that you can get exactly the image you want.** This is especially important if you want to take multiple shots from the same spot, and is also useful if you're experimenting with filters or trying different lighting ideas.

✦ **Holds the camera for multipicture panoramic shots that you stitch together into one photo in your image editor, or holds the camera for close-up photography.** I discuss close-ups in Book III, Chapter 2, and panoramas in greater detail in Book III, Chapter 6.

Because most modern digital cameras are fairly lightweight, you won't have to carry a massive tripod like many pros do; just be sure the tripod is strong enough to keep the camera steady. Beware of the models that claim to go from tabletop to full height (roughly eye-level at five feet or more); odds are that they sway like a reed when fully extended. If you have one of the new, low-cost digital SLR cameras like those available from Canon, Nikon, Sony, and Minolta, you might discover that you need a slightly heftier tripod because these models are a bit heavier than the run-of-the-mill digital camera.

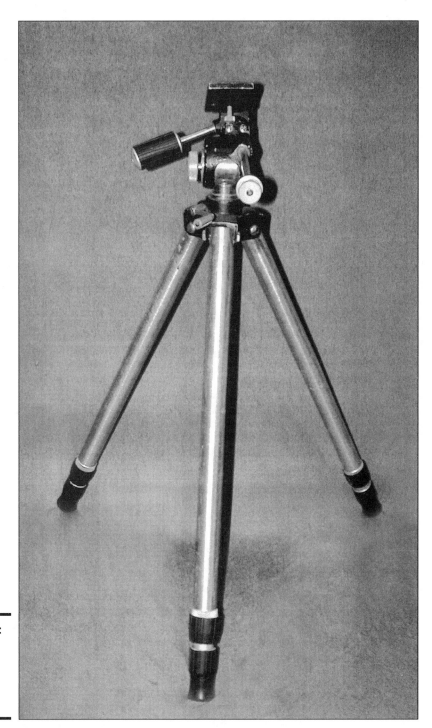

Figure 5-1:
Get the
support
you need
from a
tripod.

Getting multiple shots with a tripod

Here's a trick that shows you just how useful a tripod can be. Multiple shots can be merged to solve difficult lighting situations because using a tripod also allows multiple images from exactly the same camera position. This is important because it can help the photographer correct problems with lighting that's too contrasty.

Many times, a scene is lit in such a way that the difference between the brightest white and the darkest black is greater than the sensor can handle. When this happens, pictures end up with areas that are solid white or solid black and have no detail in them.

When circumstances permit, pros correct this by taking two or more images of exactly the same scene with the camera mounted on the tripod. The first image is exposed so that the highlights are properly exposed; the second image is exposed so that the shadows have detail. *Hint:* When in doubt, take one picture

that's a little overexposed and one picture that's a little underexposed. (One setting above what the camera recommends and one setting below what the camera recommends would be a good rough estimate.) Some cameras have this capability built-in, usually called auto exposure bracketing.

Back at the computer, the two images are merged in an image editing program such as Photoshop so that the combined image carries detail throughout the picture. Using this technique might stretch your comfort zone with both your computer and your camera, but it can also help you improve many photos, such as scenics, that can be taken with the camera mounted on a tripod. You can always take an extra shot at the setting the camera recommends so that you still have the shot you'd have gotten, anyway. That's one of the nice things about digital cameras; you don't have to worry about wasting shots!

Types of tripods

Tripods come in several types of materials, styles, and sizes. Pro units are capable of handling heavy cameras and extending 5–6' high. These tripods are made of wood, aluminum, or carbon fiber and can cost anywhere from a couple of hundred dollars to a thousand dollars or more. You probably don't want one of these. Your ideal tripod is probably a compact model made of aluminum. Here are the common types of tripods:

✦ **Less expensive units:** May range in size from 1–5' tall and cost just a few dollars to a hundred dollars or more.

✦ **Full-size models:** These range from 4–6' tall when fully extended and might have from two to four collapsing sections to reduce size for carrying. The more sections, the smaller the tripod collapses. The downside is that the extra sections reduce stability and provide more points for problems to develop.

✦ **Tabletop or mini-tripods:** These are promoted as lightweight, expandable, and easy to carry, which they are. They can be small enough to carry around comfortably. They're also promoted to be sturdy enough

for a 35mm camera, which they probably aren't unless they're set to their lowest height. Most can easily handle a digital camera, however. If used on a tabletop or braced against a wall with a small digital camera, these units can do a decent job. They can come in handy in places where there's not enough room to use a full-size tripod.

To use a mini-tripod against a wall, brace it against the wall with your left hand while pressing your left elbow into the wall. Use your right hand to help stabilize the camera while tripping the shutter. Keep your right elbow tight against your body for added stability.

✦ **Monopods:** While not exactly a tripod (monopods have only one leg versus three), a monopod does help reduce camera shake. These single-leg, multi-segment poles can just about double the steadiness of the camera.

However, don't try to use a monopod around some protected buildings, such as museums and government facilities because monopods resemble guns from a distance.

✦ **Hiking stick monopods:** Another option is a combination hiking stick/monopod. If you do a lot of hiking, these can be very worthwhile. Although not as sturdy or stable as a high-quality monopod, these hybrids can work quite well with the typical small digital camera. Most of them have a wooden knob on top that unscrews leaving a quarter-inch screw that mates with the camera's tripod socket. (Check to make sure your digital camera has one; not all models do.) Mount the camera on the hiking stick, brace the bottom of it against your left foot, pull it into your body with your left hand, and gently squeeze the shutter release button.

You can find excellent tripods from Bilora, Bogen, Benbo, Gitzo, Lenmar, Slik, Sunpak, and Smith Victor at your photo retailer.

Scrutinizing tripod features

Not all tripods are made alike, so I encourage you to take a close look at how the tripod you're thinking of purchasing is put together. The following subsections are a rundown of what to look for.

Locking legs

All collapsible tripods offer some way of locking the legs in position. Most common are rings that are twisted to loosen or tighten the legs in place. Some manufacturers use levers instead. When buying a tripod, check this part closely. Remember, every time you want to fully extend or collapse the tripod, you're going to have six or more of these locks to manipulate. A good tripod lets you open or close all the locks for one leg simultaneously when the legs are collapsed. (Cover all three rings at the same time with your hand and twist; they're all released, and then with one simple movement, they're all extended. This also works in reverse.)

Range of movement

Some tripod legs can be set to a right angle from the camera mount. This feature can be handy if you're working on uneven ground, such as a hiking trail.

Extra mounting screws

Some tripods offer an extra mounting screw on one of the legs. Hypothetically, this is useful, but its use is rare enough that I wouldn't choose one tripod over another just for this. A more useful extra is a center column post, available on better tripods, that can accept a camera on its low end (for ground level shots) or that has a hook that holds a weight or camera bag. Placing extra weight on a tripod makes it steadier for longer exposures, so this capability is actually very useful.

Heads

A *tripod head* is the device that connects the camera to the tripod legs. On inexpensive models, these are frequently permanently attached. On better quality models (although not necessarily expensive ones), they are removable and can be replaced with a different type. There are quite a few different styles of tripod heads. Many tripod heads that offer a *panning* capability (the ability to spin or rotate the camera on its horizontal axis) also offer a series of 360 markings to help orient the camera for panoramas. Here are some of the types of tripod heads to consider:

✦ **Pan/tilt heads:** These allow you to spin the camera on one axis and tilt it on another. These are generally the cheapest and most labor intensive because you have to make adjustments to multiple levers to reposition the camera.

✦ **Fluid, or video, heads:** These usually have a longer handle that extends from the head. Twist the grip to loosen it, and you can pivot and tilt the camera simultaneously.

✦ **Joystick heads:** Similar to the fluid or video head, this type has a locking lever built into a tall head. By gripping the lever and head and squeezing, you can pan and tilt the camera quickly and easily. These were designed and marketed for 35mm cameras, but they don't work particularly well for these cameras because they're subject to *creep.* Basically, creep occurs when you reposition your camera on a tripod head, lock it, and then notice the camera move a little as it settles into the locked position. Creep can be a very annoying problem with any tripod head, but the joystick models seem to have more trouble with it. *Note:* For a smaller digital camera, these heads might be a better choice simply because these cameras weigh so much less.

✦ **Ball heads:** These are probably the most popular style with pro photographers because they provide a full range of movement for the camera with a minimal amount of controls to bother with. This type of tripod head, shown in Figure 5-2, uses a ball mounted in a cylinder. The ball has

a stem with a camera mount on one end, and when the control knob is released, you can move your camera freely until reaching the top of the cylinder. A cutout on one side of the cylinder allows the stem to drop down low enough for the camera to be positioned vertically. Ball heads range in price from just a few dollars to $400–$500 or more. The best ones don't creep at all, which is why photographers pay so much for them.

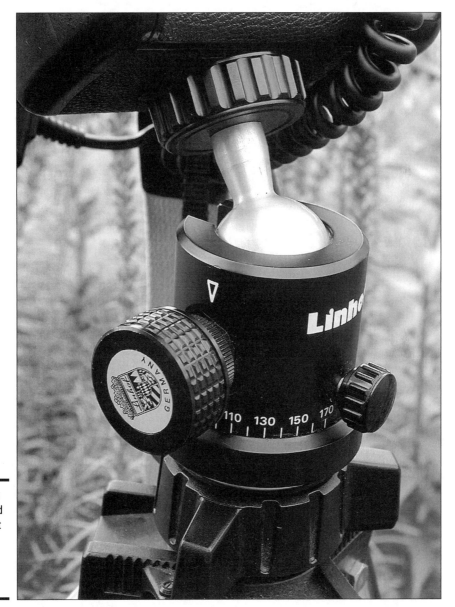

Figure 5-2:
A ball head
is the most
popular
style of
tripod
head.

Checking out tripod alternatives

Several other items on the market are also worth considering for those who need to travel light. A tried and true classic for supporting bigger camera/ lens combinations is the beanbag. Whether you use the basic beanbag that you tossed around as a kid or the one specially designed for photography, by putting the bag on a wall or car roof and then balancing the lens on the bag, you can maneuver your equipment easily while letting the wall or car take the weight of the lens.

You can also find a number of clamp-like devices coupled with the quarter-inch screw necessary to attach them to your camera's tripod socket. You then clamp the camera to a tree limb or fence post or any other solid object, and *voilà!* Instant tripod (don't add water).

These camera-holding clamps range from a modest C-clamp device for just a few bucks up to the Bogen Super Clamp system (www.bogenphoto.com). The basic Super Clamp costs around $30. The basic C-clamp style should do the job for travelers using a shirt-pocket-size digital camera. Those working with one of the larger, SLR-style digital cameras might want to consider a Super Clamp. A local camera store can probably help out.

Making Good Use of an Electronic Flash

Because available light (more commonly known as *available darkness*) is undependable, digital photographers should consider carrying an accessory flash unit. Although most digital cameras have some sort of built-in flash capability, these don't produce a very powerful light. The built-in flash unit is usually good only for a range of up to about eight feet or so, which isn't always enough.

Accessory flash units do more than just provide extra light when it's too dark to shoot without it. Although I cover accessory lighting more thoroughly in Book III, Chapter 3, here are some situations in which an accessory flash is useful:

✦ **Fill flash:** Is your subject standing in the shadows while another part of the scene is brightly lit? If you rely on your camera's light meter, you'll either get a properly exposed subject and overexposed area where the light was too bright or an unrecognizably dark subject and an okay scene. Using an accessory flash lets you balance the light throughout the scene by exposing for the bright area and using the flash to light up the shadows.

✦ **Painting with light:** Suppose you want to take a picture of a building or other large structure, and it's pitch dark out. One technique for handling this situation is known as *painting with light*. Set your camera on a tripod or something equally solid and then pull out your accessory flash unit. Set your digital camera to its bulb (B) or time (T) exposure setting if it has one — or if not, then use the longest exposure possible. While the shutter is open, use your flash to light up sections of the building one section at a time. Here's where the true wonder of the digital camera comes in: You can check your photo as soon as you're done taking it. Although film photographers have been using this technique for years, they've always had to wonder whether they got it right until they got their prints back or saw their negatives in the darkroom.

✦ **Macro, or close-up, photography:** Getting in close calls for lots of light simply because as the camera gets closer to its subject, the area of sharp focus — *depth of field* — diminishes. Using your external flash helps provide enough light to allow an aperture setting for greater depth of field. The external flash also provides more even illumination for your subject. It's best if you use a setup that allows your flash unit to operate while off the camera because lighting your subject from the side brings out more detail than lighting from straight ahead. Some flash units, such as ring lights, are specifically designed for macro photography. (I take a look at ring lights a little later in this chapter.)

✦ **Bounce flash:** Many accessory flash units include a tilt/swivel head that lets you point the unit towards a reflective surface instead of right at your subject. By bouncing the flash off the surface and toward your subject, you create softer light and shadows than you would if the flash was directed straight at your subject.

Bouncing a flash unit this way weakens its effective output because the light has to travel a greater distance to reach the subject. This isn't a problem if the surface is reasonably close, but distance matters. Beware of cathedral ceilings!

✦ **Multi-flash:** It's possible to use multiple flash units to create a lighting setup that comes reasonably close to studio lighting. By positioning these flashes properly, you can either create a nicer portrait lighting setup or distribute the lights well enough to evenly illuminate an entire room.

Built-in flash units can also speed the camera's battery drain tremendously. Because they're positioned right above the lens, the built-in strobes are also a prime cause of *red-eye*. This is a reddish tinge in human pupils (greenish or yellowish in many animals). Red-eye is particularly difficult to prevent when photographing (with flash) young children. An accessory flash can help reduce this effect because you can position it farther from the lens than a built-in unit.

Book II
Chapter 5

Picking Up Some
Accessories

Many higher-end digital cameras offer some method of triggering an accessory flash unit, either by a cable connection or via a *hot shoe* — the device on a camera that holds an external flash and provides an electronic connection to the camera. Many amateur and prosumer level digital cameras, however, offer no such provision. The answer in this case is a "slaved" flash specifically designed for digital cameras (which I discuss in more detail in the next section).

Types of electronic flash units

There are as many different electronic flash units available as there are digital cameras. The following subsections provide a quick rundown on the kinds you'll want to consider.

Before buying flash equipment of any kind, be sure it works with your camera. Flash units can be triggered via the camera's hot shoe, by electronic slaves, by wireless radio triggers, and via several different types of cables. Some cameras can use a generic, old-fashioned connection called a *PC cable* (not named for a *personal computer* but for the Prontor-Compur shutters of the early film cameras that used this connection). These cables are inexpensive and work with any camera that has a PC connection, but all they do is trigger the flash unit. A camera's manufacturer makes another type of cable, known by several different designations (TTL and E-TTL, for example); this proprietary type is specifically for the manufacturer's cameras (sometimes for just one segment of its camera line) and no other, although these cables do work with third-party flashes. The advantage to these types of flash cords (which are much more expensive than PC cords) are that they allow the camera and flash unit to communicate with each other so that the camera can turn the flash's output off when it determines proper exposure is reached.

Small, light minislaves

These units are designed to help augment the camera's built-in flash unit. They're generally useful for adding a little extra dimension to your lighting and as a way of filling in background areas. These units are slaved to fire when another flash unit goes off. Such photographic slaves are photoelectric sensors designed to trigger a flash unit when another flash is fired within the sensor's field of view (in the case of a digital camera, when the camera's built-in flash fires). These slave-triggering circuits are sold as independent units that you can attach to existing flash units, or the circuitry can be built right in to a flash.

Hot shoe mount flashes

These are more powerful than both the minislaves and the camera's built-in flash units. They might or might not offer a tilt or swivel capability. Some

camera systems (usually higher-end digital cameras) offer a cable that hooks up to the camera's hot shoe and allows the flash to communicate with the camera's electronics while being positioned in ways the hot shoe mount won't permit. The advantage to these cables over slaves is that they usually permit the camera/flash combos full range of capabilities. (Some cameras are set to turn off the flash as soon as the correct exposure is reached whereas a slaved flash will continue pumping out light as set.)

Professional models

These units tend to be the manufacturer's most powerful and most advanced flash units. They tend to have lots of features, including built-in slave capabilities and the ability to work with wireless remote systems. In many cases, they're also capable of taking advantage of the digital camera's lack of a true shutter. This means the flash can be used with faster shutter speeds than those used with film cameras. In addition to the manufacturer's flash models, dedicated flashes offered by third-party manufacturers also work with many existing camera systems, like the one shown in Figure 5-3.

Many third-party flash units and lenses are reverse-engineered to work on major brand-name cameras. Sometimes, this equipment might not work with later equipment made by your camera's manufacturer. If a third-party flash causes damage to your camera (and today's highly electronic cameras can be susceptible to damage from improper voltage discharge), the camera manufacturer might not repair the damage under warranty.

Portable studio lighting

Portable studio lighting kits are available that enable a photographer to carry a complete set of lights with lighting stands and reflectors or umbrellas. These kits usually offer two to three lights or more and might also include a backdrop setup. Although these sets are fine for local or cross-country trips, it might be easier to rent such a kit while traveling overseas than it is to pack one along with all your camera equipment while flying. The flash units in these kits often have built-in slaves as well, which are triggered either via a connection to the camera or via a flash unit on or in the camera.

What to look for in a photographic slave flash

A basic slave unit is a small device designed to mate with the flash unit's hot shoe. The slave (good ones have on/off switches) triggers the flash when another flash unit is fired. These slaves have their own hot shoe foot (to mate with stands designed for such things or the L-bracket described in a few paragraphs) and also have quarter-inch tripod sockets in their base so that you can screw them onto an extra tripod.

Figure 5-3:
An external flash can provide a lot more light for your digital camera.

Wireless or radio slaves also exist. These are significantly more expensive but worth it when other photographers and their accompanying flashes are in the vicinity. A regular photoelectric slave doesn't care that it's been triggered by the wrong photographer's flash unit; it's simply done its job.

Wireless triggers work via radio signals, not light. These devices generally offer multiple frequencies to minimize the likelihood of another photographer triggering them.

A standard photographic slave won't work properly with a digital camera because most prosumer and amateur digital cameras emit a *preflash* (to help the camera make some internal settings), which triggers earlier slave designs prematurely. If you're interested in a slaved flash unit, make sure it's designed to work with a digital camera. Nissin, an electronics firm, makes a flash unit known as the Digi-Slave Flash. You can find about a half-dozen different units, ranging all the way up to a pro unit. Check out SR Inc. for pictures and descriptions of the models available (www.srelectronics.com).

Although the slaved flash doesn't help reduce the drain on the camera's battery, the more powerful light still helps improve photos. The photographer also gains the ability to position the light higher up from the lens (usually slightly to the right or left as well) to reduce the likelihood of red-eye and provide a more pleasing effect. Generally speaking, setting the camera's exposure system to automatic can handle the increased flash okay; if you're not satisfied with the result, switch to aperture priority and experiment! The exception is with close-up photos, where overexposure is likely. Dialing in a correction (usually about two f-stops) through the camera's exposure compensation system solves this problem.

An electronic flash unit without power is an expensive paperweight. With the exception of the portable studio lighting kits, which require electrical outlets, electronic flashes usually require AA batteries, although the smallest might take AAAs instead. Rechargeables generally provide an inexpensive option although they tend to recycle (recharge the flash unit) more slowly than alkaline batteries do. PC cables and manufacturer flash cords malfunction (take care not to crimp them), so for important trips, carry extras (especially if you're going overseas, where it might be hard to find a replacement). Some rechargeable batteries also tend to lose their charge faster than alkaline batteries when stored.

Lighting/flash accessories

Depending on your shooting requirements and how much weight you can afford to carry, some accessories out there can help improve your photography. Here's my list of possibilities:

✦ **Brackets:** A nice compliment to the accessory flash route is an L-bracket flash holder. This device mounts to the camera via the tripod socket and has a flash shoe at the top of the L, where you position the flash. In addition to providing a secure hold for the flash unit, the L-bracket tends to provide a steadier grip for the camera. You can even find models designed for the shorter, thinner digital cameras, such as the earlier Nikon Coolpix series (www.nikon.com).

✦ **Background cloths/reflectors:** Garden enthusiasts interested in photographing flowers can bring swatches of colored cloth large enough to serve as a background for your shot of a plant or bloom. Black is a good all-purpose color, whereas red, green, and blue complement common flower colors. Another helpful item is a collapsible reflector; camera stores sell small ones, or you can pick up ones designed as sun blockers for car windows. These reflectors can kick some sunlight back into the shadow areas to help create a more pleasing image. For the most serious flower photographers, a *ring light* or circular flash unit that mounts in front of the camera lens provides an even, balanced light for flower close-ups. A Digi-Slave flash ring light unit can be configured for many amateur and prosumer level digital cameras.

Choosing a Camera Bag

Depending on the size of a digital camera and the accessories accompanying it, a camera bag or pouch could be a necessity. For just the basics — a small camera, extra batteries, extra memory cards, and a lens cleaning cloth — a simple fanny pack does the job and leaves room for hotel keys, money, and identification.

A more serious photographer who's carrying a larger digital camera needs more space. A larger camera bag might be the answer, but for the active traveler, there are some interesting options. Because camera bags are especially useful for traveling photographers, I've included a longer description of the options and features in Book III, Chapter 6, which deals with travel photography.

Acquiring Other Useful Devices

Gizmos. Gadgets. Thing-a-ma-jigs. Many of these items don't fall into any particular type of category, except that they do something useful. Some are quirky but cool, such as little shades that fasten onto the back of your camera and shield your LCD readout screen from the bright sun. Others are serious working tools, like the add-on battery packs described in the next section. Photographers love gadgets, and you'll find lots of them available for digital cameras. Here are a few of the most practical.

A filter holder

A helpful device I especially like is a filter holder engineered by the Cokin company (`www.minoltausa.com/cokin/index.htm`) and sold by most camera outlets. One Cokin holder, designed for cameras that can't accept filters, mounts to the base of the camera via the tripod socket. This adapter allows the use of Cokin's square filters, which slide right into the adapter to

provide a variety of effects and corrections. Note, however, that you could achieve many of the same results in an image editing program. To those more comfortable tweaking things on the computer, filters aren't important. On the other hand, if you're new to computer photo editing, relying on traditional filters might be easier. You can always take one shot with a filter and one without, and then try to tweak the filter-less shot to look like the filtered one. This process can help you figure out how to get the most from your image editing software.

A second camera

Sooner or later, you'll think about buying a second camera, say, when you're ready to leave on that vacation of a lifetime. A small, inexpensive digital camera doesn't cost much, and if the primary camera fails, it might prove worth its weight in gold, photographically speaking. Shop for — or borrow one — that uses the same type of batteries and storage media as your primary camera, if possible. The extra camera can also entice a spouse or child into sharing your love of photography.

Second cameras are easy to come by. Every time I upgrade to a new digital camera, the old one gets passed down to a family member or kept in reserve as a spare camera. My old 3.3MP Nikon Coolpix 995 was great in its day even though I prefer a newer 8MP Konica Minolta model and my trusty Nikon D70. I have no qualms about using it as a backup (it even takes the same CompactFlash memory cards as the Konica Minolta and Nikon D70) or loaning it to my kids when they need to take a few pictures at school.

Cleaning kits

You'll also frequently have need for a good cleaning kit. An inexpensive microfiber cleaning cloth is great for cleaning optics, but first use a blower to blow any dust particles from the lens. You can then hold the lens near your head, fog the lens with your breath and gently (very gently) wipe the lens with the cloth. Canned (pressurized) air also does a good job of blowing dust and dirt off the camera, but make sure the can is held level, or solvents from the aerosol might contaminate the lens.

Damp or dusty conditions call for more serious efforts. Protect your camera inside heavy-duty plastic freezer or sandwich bags while inside the camera bag, thus reducing exposure to dust and moisture. Keep the little packets of silica that come with electronic equipment and place one or two of these in the camera bag to eat up moisture, too. The following section ("Waterproof casings and housings") provides more detailed information about dealing with extreme weather conditions and bags and containers for protecting gear. (Call it the difference between shooting at a dusty ball field on a windy day versus shooting in a windstorm in the desert.)

Waterproof casings and housings

Extreme conditions call for better protection for your camera. Better yet, photography in wet weather, or even underwater, can be fun, too. Waterproof casings that still allow for photography are available from several companies, including ewa-marine (www.ewa-marine.de). These are useful for both underwater photography (careful on the depth though) and above the water shots if you're sailing or boating. Keep in mind that salt spray is very possibly the worst threat to camera electronics there is. Make sure your camera casing provides good protection against wind and salt spray.

Another option for those who want to shoot a lot in wet conditions is a new underwater digital camera. The SeaLife ReefMaster underwater digital camera (www.sealife-cameras.com) comes in a waterproof housing and works both on land and underwater. The camera, which retails for under $400, only produces a 1.3MP file but saves you the trouble of trying to find a housing to fit an existing digital camera. The camera also has an LCD display that works underwater and a fast delete function to make it easier to operate underwater.

For serious underwater enthusiasts, heavy-duty Plexiglas housings now exist for small digital cameras. These housings are available for a wide range of digital cameras and may be found for as little as a couple of hundred dollars.

Filters

Filters, those glass disks that can be screwed onto the front of your camera's lens, are a popular accessory. Here are some of the different kinds of filters you can buy and play with:

✦ **Warming:** Some filters produce what photographers refer to as a warming effect. This filter can help make up for the lack of color in mid-day light and tries to add some reddish-orange color to the scene. Usually these are coded in the 81 series as in 81A, 81B, 81C. Just ask for a warming filter.

✦ **Cooling:** These do just the opposite of the previous type. They add blue to the scene to reduce the reddish-orange color. These fall into the 82 series for daylight conditions.

✦ **Neutral density:** Another type of filter is used to reduce the amount of light available. These neutral density (ND) filters (*neutral* because they have no color, and *density* because they block light) come in handy for things such as achieving the spun-glass effect from moving water. The filter blocks an f-stop's worth of light or more, making a slower shutter speed possible and increasing the blur of the moving water. You can use ND filters to operate at a wider aperture to blur the background in portraits, too.

✦ **Neutral density, take two:** Sometimes a photographer wants to photograph a street scene without cars driving through the photo. By stacking

neutral density filters, it's possible to create such a long exposure, no cars are in the scene long enough to register in the image. Obviously, a camera support of some sort is required (***Hint:*** The ground's pretty stable, too, unless of course you're visiting California). Having a camera capable of extremely slow shutter speeds is also necessary. A neutral density filter is shown in Figure 5-4.

✦ **Split neutral density:** Another version of the neutral density filter is a split neutral density design. This filter provides half neutral density and half clear filtration, preferably with a graduated transition from the light blocking half to the clear half.

The main use for a split ND filter is for occasions when half the scene is brighter than the other. The most common example of this is a bright sky against a significantly darker foreground. This condition is typical of mid-day lighting conditions.

✦ **Polarizers:** Polarizing filters can reduce the glare bouncing off shiny surfaces in your photos. Simply attach the filter and view the image through your LCD display. Rotate the polarizer until the glare disappears. Polarizers can also help deepen the contrast of the sky from certain angles.

Figure 5-4:
A neutral density filter cuts down the amount of light reaching the sensor.

Battery packs

One of my digital cameras uses a lithium-ion (Li-Ion) rechargeable battery that's good for a couple hundred shots. Unless you're involved in a serious photographic project, or leave home on vacation, a single battery (plus one spare) might be all you need. However, that same camera can be fitted with an add-on battery pack that fits under the camera body and holds two more of the same model Li-Ion batteries (increasing the shooting capacity to nearly 600 shots). More importantly, the accessory battery pack accepts standard AA batteries, which the camera itself does not.

You'll find an add-on battery pack like this extremely useful for those shooting sessions that involve treks into back country far from AC power. Or if you're on vacation, you might be unable to recharge your digital camera's batteries until you check into your next hotel, so the additional juice might be handy. If you need an accessory battery pack, you probably also need a charger that works on multiple voltage settings (so it can be used overseas), or with an automobile connector so that you can recharge your batteries on the road.

Book III

Taking Great Pictures

The 5th Wave By Rich Tennant

@RICHTENNANT

"Well, well! Guess who just lost 9 pixels?"

Contents at a Glance

Chapter 1: Tools and Techniques of Composition

In This Chapter

- ✔ Developing a picture concept
- ✔ Centering on your main subject
- ✔ Selecting vertical or horizontal orientations
- ✔ Mastering the Rule of Thirds
- ✔ Using lines to draw interest
- ✔ Balancing and framing your image
- ✔ Avoiding unintentional mergers

Random snapshooting can sometimes yield lucky shots — happy accidents that look good and prompt you to say, "Actually, I *meant* to do that" (even if it weren't the case). Some Pulitzer Prize-winning photos have resulted when the photographer instinctively squeezed off a shot at what turned out to be a decisive moment in some fast-breaking news event. However, lacking a Pulitzer-winner's intuition, most photographers end up with a larger percentage of pleasing photos when they stop to think about and plan their pictures before putting the viewfinder up to their eye.

In this chapter, I tell you about the essentials of photo composition that set you on the road to taking great pictures. I introduce all the basic elements of good composition, such as selecting what to include in a well-designed photograph and what to leave out. You find out some basic rules, such as the Rule of Thirds, and most importantly, when you should ignore the rules for dramatic effect.

Photo Composition: The Big Picture

One difference between good photojournalists and superior photojournalists is the ability to take a newsworthy picture quickly when circumstances don't allow much time for preparation or thought. If you examine the work of these professionals, you find that even their grab shots are well-composed. With scarcely an instant's notice, they can line up and shoot a picture that commands your attention.

The very best photos are usually not accidents; they are carefully planned and composed. That is, such pictures display good *composition,* which is the careful selection and arrangement of the photo's subject matter within a frame. I'm not suggesting you set up your camera on a tripod and wait hours — à la Ansel Adams — in anticipation of the universe settling into exactly the right arrangement. Instead, simply understanding how good composition works and keeping that in mind when you plan your photos can make a world of difference. The following list gives you an overview of how to plan and execute good photo composition:

✦ **Visualizing a concept for your picture:** It's important to know what you want your picture to say and who your audience is.

✦ **Choosing your subject matter:** This isn't as easy as it appears to be. A picture might be filled with interesting things to look at, but you must select which one should be the subject of the picture.

✦ **Deciding on a center of interest:** One point in the picture should naturally draw the eye as a starting place for the viewer's exploration of the rest of the image. With a center of interest, the photo becomes focused and not simply a collection of objects.

✦ **Picking the picture orientation:** Some subjects look best when shown in a tall, vertically oriented frame. Some look best in a wide, horizontal format. A few need a square composition. To make the most of your camera's resolution, choose an orientation when you take the photo rather than cropping it in an image editor.

✦ **Establishing the distance and point of view:** These elements affect your photo's composition and are sometimes difficult to control. For example, when you're attending that World Series game, you can't easily substitute your upper-deck seats for a choice position next to the dugout (although it's worth a try).

✦ **Planning for action:** If your subjects are moving, you need to anticipate where they will be and how they will be arranged when you take the picture.

✦ **Working with the background:** Objects and textures in the background can work for you or against you. The area behind your main subject is an important part of the composition.

✦ **Arranging all within the frame:** How you accomplish arranging within the frame depends on the situation. In some situations, such as at sports events, you can't dictate how the subjects are arranged. For example, no matter how much you want an action shot of Ichiro Suzuki, the Seattle Mariners' star, isn't likely to relocate to center field to accommodate your photo.

✦ **Directing the eye within the frame:** Use lines and curves to provide a guided tour of your image, directing the viewer from one portion to another to finally focus on the main center of interest. Balance the composition to keep the eye from wandering to "lopsided" parts of the image.

Although these guidelines for composition can help you, remember that they are only guidelines. Your instincts and creative sense will tell you when it's a good time to break those rules, grind them up into tiny pieces, and stomp them under your feet in your quest for an unusual, eye-catching picture. If you examine Picasso's earliest art, you'll see that he knew how to paint in the classical style. His legacy is based on knowing when *not* to paint according to the time-honored rules.

Visualizing a Concept for Your Picture

Take some time to visualize your photo before you begin the actual picture-taking process. You don't need to spend hours dwelling over your photo, but you need to have at least a general plan in mind before starting to shoot. The following sections ask — and then answer — the questions that lead you through the process of visualizing a concept for a picture.

What do you want your image to say?

Will your photo be a portrait, a sports action shot, or a scenic masterpiece? The kind of picture you want to take can affect the composition. For example, portraits of teenagers frequently include within the composition props (from skateboards to pigskins) that reflect their lifestyles. For a sports picture, you might want to get a high angle or one from a particular location to include the field of play or other elements that say, "Action!"

A scenic photo can be composed in different ways, depending on what you want the image to say. For example, a photo taken in a national park can picture the grandeur of nature with a dramatic skyline with purple mountain majesties and amber waves of grain. On the other hand, you might be tempted to make a statement about the environmental impact of humans by focusing on trash left behind by careless visitors or perhaps desiccated amber mountain majesties and chemically tainted waves of purple grain. Some of the best photographs use composition to take a stand or say something beyond the photo itself. Figure 1-1 is an example of a photo that makes a subtle statement, juxtaposing the idyllic academic setting of Kent State University in Ohio today with a stark memorial that shows where the body of a slain student fell.

Figure 1-1:
In the background, the peaceful tree-lined campus of Kent State University. In the foreground, a memorial marking where one of four slain students fell.

Where will the image be used?

How the photo will be used can affect composition. If you plan to print the picture in a publication or enlarge it for display in a frame, you want a tight composition to maximize sharpness. If you want to use the shot on a Web page, you might want to step back to take in a little extra and crop later with your image editor because the resolution lost from cropping pixels isn't as critical for Web graphics.

Whom are you creating the image for?

You compose a photo for your family differently from a photo that your colleagues or strangers will view. Your family might like a picture better if the composition revolves around that cute new baby. Create a photo that says, "I've been to Paris," and you'll want to include the Eiffel Tower somewhere in the picture. Colleagues might want to see a product highlighted or the CEO shown in a decisive pose. Subject matter that's extraneous for one application could be important for another.

Selecting a Subject and a Center of Interest

Photographs shouldn't send the person looking at them on a hunting expedition. As interesting as your subject is to you, you don't want viewers puzzling over what's the most important part of the image or perhaps conducting a vote by secret ballot to see who has successfully guessed your intent. Every picture should have a single, strong center of interest. You want to narrow down your subject matter: Rather than include everything of interest in a photo, choose one main subject. Then find secondary objects in the picture that are also interesting (giving the photo depth and richness) but which are still clearly subordinate to the main subject.

Narrowing down your subject matter

Narrowing your subject matter means eliminating everything from your photo that doesn't belong there and concentrating on fewer objects that can form an interesting composition.

Find something in the photograph that the viewer's eye should focus on, thus forming a center of interest. Your center of interest is usually a person, a group, or the object you're seeking to highlight. You don't want eyes roaming around your photo searching for something to look at. Some aspect should jump out and grab your viewers' attention. If other portions of the photo compete for attention, look for ways to eliminate or minimize them.

For example, you can crop more tightly, move to one side or change your angle, ask the extraneous person to leave (your brother-in-law is a good guy; he'll understand), or physically move something to delete it from your composition, as shown in Figures 1-2 and 1-3.

One good technique is to plan several photographs, each using a different part of the subject matter in view. That way, each person or object can take a turn at being the center of interest, and you won't be looking for ways to reduce the competition between them.

Choosing one main subject

You can use several compositional techniques to ensure that the main subject you've selected is, in fact, the center of interest. Here's a quick checklist to follow:

+ **Make sure that your center of interest is the most prominent object in the picture.** You might think of Aunt Mary as a worthy photo subject, but if she's standing next to a '60s-era minibus with a psychedelic paint job, she might not even be noticed. Large, distinctive, highly unusual, or controversial objects are likely to take on a life of their own and seize the focus of attention in your photograph.

✦ **See that the center of interest is either the brightest object in the photo or at least is not overpowered by a brighter object.** Gaudy colors or bright shapes in the background will distract viewers from your main subject. Some elements — such as spotlights at a rock concert or a reflection of the sun on water — become part of the environment and aren't necessarily distracting. Other parts of a photo — such as a bright sail on a boat or a white automobile located behind your subject — can interfere with your carefully planned composition. Eliminate such objects, move them behind something, or otherwise minimize their impact.

✦ **Make sure that only one center of interest is in your composition.** Other things in a photo can be interesting, but they must clearly be subsidiary to the main center of interest. A child seated on the floor playing with a puppy would be interesting. However, other puppies in the photo should be watching or vying for the child's interest, not off somewhere else in the photo engaged in some distracting activity.

✦ **Avoid putting the center of interest in the exact center of the photograph.** Move the important subject to either side and a little toward the top or bottom of the frame. Don't take "center" literally. See Figure 1-4 for an example of a center of interest moved to one side but still somewhat centrally located. I explain how to locate your center in interesting spots later in this chapter.

Figure 1-2:
Too many
subjects
spoil the
shot,
especially
with the
girl in the
background.

Figure 1-3:
This picture is better without the young girl.

Using secondary subjects

Having more than one center of interest is confusing. If you really have several things of importance in a single picture, consider taking several separate photos of each and using them to tell a story. Or, group them together to form a single, new center of interest.

However, you can easily include (and should, in many cases) secondary points of interest that give the photograph depth and richness. A portrait of a child should concentrate on the child's face, but a favorite toy can speak volumes about what this youngster likes to do. A rock singer on stage can command your attention, but a view showing the adoring fans in the front row tells the viewer how popular the performer is. (Conversely, having a scant few bored spectators as a secondary subject can make another statement, turning the picture into a bit of visual irony.)

To successfully use secondary subjects, they should clearly be subordinate to your main center of interest. You can indicate what's secondary in your image through location, brightness, or even degree of sharpness. (**Hint:** A bit of image editing can help you after the fact.)

Figure 1-4:
Move your
center of
interest to
one side.

Choosing an Orientation

The *orientation* of a photo — whether it's a wide or tall picture — affects how you look at the image. When you see a landscape-oriented photo, you tend to think of panoramas and horizontal sprawl. A vertically oriented photo, on the other hand, provides expectations of height. Most subjects fit into one of these orientations; very few photos are actually composed within a perfectly square frame. Square photos are often static and uninteresting and are usually put to work only with subject matter that suits them, such as circular objects or images that have important horizontal and vertical components.

Digital cameras, like most of their conventional, film-camera brethren, are built with a horizontal layout because that configuration is best suited for holding in two hands held side by side. Unfortunately, many photographers unconsciously slip into the trap of viewing every potential photo in a horizontal mode. They only turn the camera 90 degrees when confronted by

subject matter that simply can't be photographed any other way, such as the Eiffel Tower, a rocket headed skyward, or any NBA player taller than a guard.

Here are some tips that will help you decide when it's appropriate to use a vertical composition — and when you should think horizontal instead.

✦ **If you're taking pictures for a slideshow or for a computer presentation, stick with horizontally composed pictures.** Slideshow images are seen sequentially and should all have the same basic frame that is often sized to fill up the horizontal screen as much as possible. Inserting a vertical picture might mean that the top and bottom of your photograph is cut off or appears odd onscreen.

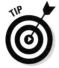

You can still have a vertically composed picture in your slideshow; just mask off the right and left sides in your image editor to produce a vertical image within the fixed-size horizontal frame. The key is to make your vertical image no taller than the short dimension (height) of a horizontal picture in the same show.

✦ **If your subject has dominant horizontal lines, use a horizontally composed image.** Landscapes and seascapes with a prominent horizon, photos of sprawling buildings or bridges (like the one shown in Figure 1-5), many sports photos focusing on more than one team member, and the majority of four-legged animal pictures look their best in horizontal mode.

✦ **If your subject has strong vertical lines, use a vertical composition.** The Eiffel Tower, trees, tall buildings, pictures of individuals (whether full-length or portrait photos), and similar compositions all call for a vertical orientation, as shown in Figure 1-6.

Figure 1-5:
Some
images look
best in a
horizontal
orientation.

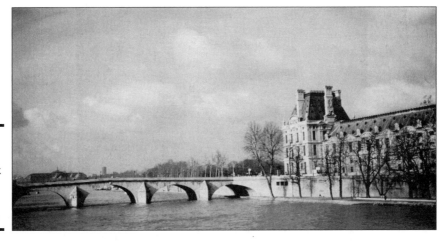

+ **Use a square composition if vertical and horizontal objects in your picture are equally important and you don't want to emphasize one over the other.** A building that is wide but that has a tall tower at one end might look good in a square composition. The important vertical element at one end would keep the image from being too static. Circular images lend themselves to square compositions because the round form fits comfortably inside a square "frame," as shown in Figure 1-7.

Figure 1-6: Vertical pictures are also appropriate for showing height or vertical movement.

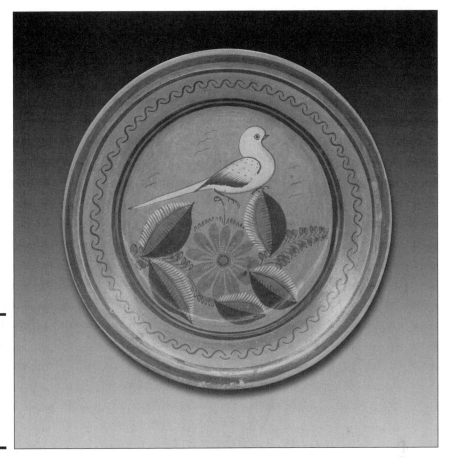

Figure 1-7:
Some compositions look best when presented within a square.

Arranging Your Subjects

A basic skill in composing great images is finding interesting arrangements within the frame for your subject matter. You need to position your subjects, make sure they're facing an appropriate way, and ensure that they are well-placed in relation to the horizon and other elements of your image. Your first consideration when arranging your subject is to choose the subject's distance from the camera.

Choosing subject distance

Choosing the distance to position yourself from your subject to provide the desired point of view is one of the first things to do, but it's not something you do once and then forget about. While you take pictures, constantly examine

your distance from the subject and move closer or farther away if adjusting your position will improve the composition. Here's how to choose a subject distance:

- **To convey a feeling of space and depth, use a wide-angle lens; or, if your back is already up against a wall, move back.** Standing back from your subject does several things. The foreground area becomes more prominent, adding to the feeling of space. You'll also take in more of the sky and other surrounding area, giving additional depth.

- **Make sure that your subjects don't appear too small when you're moving back; they should still be large enough to be interesting.** Moving too far back is the most common mistake amateur photographers make, as shown in Figure 1-8. If you're showing wide-open spaces in your picture, be certain that it's because you *want* to.

- **For photos that emphasize a person, group of people, or a particular object, move in as close as you can.** A close-up viewpoint adds intimacy and shows details and textures of a subject that can't be seen at greater distances, as shown in Figure 1-9. A short telephoto setting is often the best route to getting closer; with a normal or wide-angle lens, you can get some apparent distortion of objects that are very close. With kids or animals, you should not only get close, but also get down to their level and shoot eye-to-eye.

- **Move so you fill the frame completely with interesting things.** Whether you're shooting close up to your subject or at a distance, your composition should not include anything that isn't needed to make the picture. Full frames mean less enlargement and sharper pictures, too!

Optimizing backgrounds

Unless you're taking a picture in the dead of night or on a featureless sand dune or snow field, you'll have some sort of background to contend with. A background can be a plus or a minus, depending on how you use it in your composition. To make the most of your background:

- **Check your background to make sure that it's not gaudy, brightly colored, or busy.** The background should not be more interesting than the subject, nor should it be a distraction.

- **For portraits, a plain background (such as a seamless backdrop) can be effective.** A plain, featureless background can work for portraits as long as it isn't totally bland. Notice how pro photographers who pose subjects against a seamless background still use lights to create an interesting gradient or series of shadows in the background.

✦ **Outdoors, trees, grass, cloud-studded skies, plain walls, and other textured surfaces can make good backgrounds.** Such backgrounds are interesting, without overpowering your subject (see Figure 1-9).

✦ **Watch for strong lines or shapes in the background that don't lead the eye to your subject.** Straight or curved lines are good for compositions but not if they distract the viewer from your subject. Also watch out for things in the background that seem to grow out of your subjects or the borders of the image. (These are *mergers*, which I discuss later in this chapter.)

✦ **Consider using *depth-of-field* (the amount of the image that's in sharp focus) to make your background blurry.** Figure 1-9 uses this technique to make the foliage background less distracting.

Because of how their lenses are designed, consumer digital cameras often show *everything* in sharp focus. Workarounds include using longer lens zoom settings and wider lens openings. You find out exactly what these are and more on depth-of-field in Book III, Chapter 2.

Figure 1-8: But don't move *too* far back.

**Book III
Chapter 1**

Tools and
Techniques of
Composition

Figure 1-9:
Some kinds of back-grounds can be found in nature.

The Rule of Thirds

The position of your subject matter within a picture is one of the most important decisions you make. Whether you can move the subject or objects around, change your position, or wait until everything moves to the right spot, you should constantly be aware of how your subject matter is arranged. Photographers often consciously or unconsciously follow a guideline called the Rule of Thirds. It's simply a way of dividing your picture horizontally and vertically into thirds (see Figure 1-10). The best place to position important subject matter is often at one of the points located one-third of the way from the top, bottom, and sides of the frame.

Placing important objects at imaginary junction points

Follow these steps to compose your pictures effectively using the Rule of Thirds:

1. **Divide the frame into thirds horizontally and vertically.**

Above all, you want to avoid having your subject matter centered. By imagining the frame in thirds, you automatically begin thinking of those ideal, off-center positions.

2. **Try to have important objects, particularly your center of interest, at one of the four intersections of the imaginary lines that divide the picture (see Figure 1-10).**

 Dividing a composition in this way is called the Rule of Thirds, and following this guideline typically arranges objects in a pleasing way.

3. **Avoid having objects at the edge of a picture unless the part that isn't shown isn't important.**

 If you're taking a picture of a group of people, cropping out part of the building they're standing next to or trimming off half a tree that's not an important part of the composition is okay. But don't cut off heads!

When to break the Rule of Thirds

Sometimes, you'll want to break the Rule of Thirds. There are almost as many exceptions to the rule as there are good reasons to apply it, which is why the rule should be considered only a guideline. Think of the Rule of Thirds as a lane marker on a highway. Sometimes you'll want to stay within the markers. Other times, like when you see an obstruction in the road, you'll want to wander outside the lines. If you happen to move from the United States to the United Kingdom, you'll find that it's wise to swap sides and use the lane markers on the opposite side of the road.

Figure 1-10:
To divide
your image
into thirds,
picture the
imaginary
lines shown
on this
image.

You might want to ignore this handy rule when

✦ **Your main subject matter is too large to fit comfortably at one of the imaginary intersection points.** You might find that positioning an object at the "correct" location crops it at the top, bottom, or side. Move it a bit to another point in your composition if you need to see the whole thing.

✦ **Centering the image would help illustrate a concept.** Perhaps you want to show your subject surrounded on all sides by adversity or a threatening environment. Placing the subject at one of the intersection points implies motion or direction, as if the subject were about to flee the picture entirely. However, putting the center of interest in the very center of the picture gives the subject nowhere to hide.

✦ **You want to show symmetry.** Centering a symmetrically oriented subject that's located in a symmetrically oriented background can produce a harmonious, geometric pattern that is pleasing, even if it is a bit static. If the subject itself makes you think of motion, a square image can even boast a bit of "movement," as shown in Figure 1-11.

Figure 1-11: Sometimes a square picture can have an interesting geometrical arrangement.

Some Compositional Guidelines

A photo composition creates an entire world for the viewer to explore. You won't want to destroy the illusion by calling attention to the rest of the universe outside the frame. Here's how to orient people and other objects in a picture:

✦ **If your subjects are people, animals, statues, or anything that you think of as having a front end and back end, make sure they are either facing the camera or facing into the frame rather than out of it.**

If a person seems to be looking out of a picture, rather than somewhere within it, viewers will spend more time wondering what the person is looking at than examining the actual person. The human doesn't actually have to be looking at any object in particular as long as he is looking somewhere within the picture.

✦ **If objects in the frame are moving or pointed in a particular direction, make sure they are heading into the frame rather than out of it.**

A stationary automobile, a windmill, a palm tree bent over by a strong wind, anything with a sense of direction to it should be facing into the frame for the same reason that a person should be looking into it, as shown in Figure 1-12.

Figure 1-12: At left, the main subject is headed out of the frame. At right, she is headed into the frame, even if the ball is on its way out.

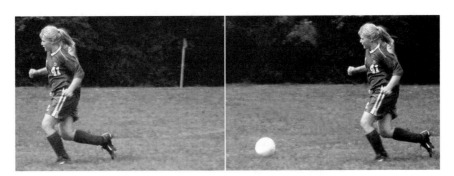

✦ **Add extra space in front of any fast-moving object (such as a race car) so that the object has somewhere to go while remaining in the frame.**

If an object is moving, having a little more space in the frame in front of it is best so that the viewer doesn't get the impression that it's on its way out of view. In Figure 1-12, for example, you wouldn't want to crop the image any more tightly on the left because you'd need to leave room for the speeding ball.

Using Straight Lines and Curves

After you have the basics out of the way, progressing to the next level and creating even better compositions is easy. All you need to know is when to apply or break some simple rules. Just remember that one of the key elements of good composition is a bit of surprise. Viewers like to see subjects arranged in interesting ways rather than lined up in a row.

Lines within your image can help your compositions by directing the eye toward the center of interest. The lines don't have to be explicit; subtle shapes can work just as well. Try these techniques:

✦ **Look for straight lines in your image and try to use them to lead the eye to the main subject area.**

Some lines are obvious, such as fences or a seashore leading off into the distance. These kinds of lines are good when you want a dramatic composition, like the one in Figure 1-13.

✦ **Find diagonal lines to direct the attention to the center of interest.**

Diagonal lines are better than straight lines, which are static and not particularly interesting.

✦ **Use repetitive lines to create an interesting pattern.**

Repetitive lines could be multiple lines within a single object, such as the grout lines in a brick wall. Repetitive lines could also be several different parallel or converging objects, such as a road's edges, the centerline of the road, and the fence that runs along the road. Strong repetitive lines can become a pleasing composition in themselves, like the one in Figure 1-13.

✦ **Curved lines, which are more graceful than straight lines, can lead the viewer gently from one portion of the composition to another.**

Curving roads are a good example of arcs and bends that can contribute to a composition. Other graceful curves include body parts of living things, such as the necks of flamingos, as shown in Figure 1-14.

+ **Look for shapes within your composition to add interest.** Three objects arranged in a triangle make a picture inherently more interesting than if the objects formed a square shape. Your eye naturally follows the lines of the triangle toward each of the three points or apexes, whereas squares or rectangles don't point anywhere. Instead of posing groups of people in rows and columns, stack them in interesting arrangements that make shapes the viewer's eye can explore.

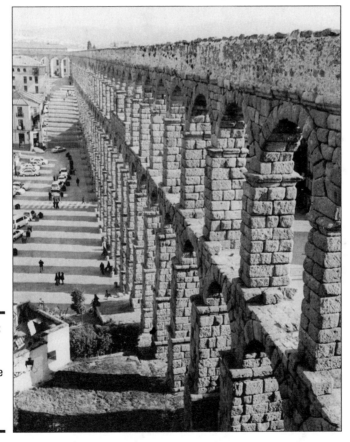

**Book III
Chapter 1**

**Tools and
Techniques of
Composition**

Figure 1-13:
Straight
lines can
lead the eye
to the main
subject
area.

Figure 1-14:
Curved
lines
form
graceful,
more-
harmonious
pointers for
the eyes.

Balancing an Image

If you place every element of interest in a photograph on one side or another, leaving little or nothing to look at on the other side, the picture is imbalanced, like a seesaw with a child at one end and no one on the other. The best pictures have an inherent balance that makes them graceful to look at.

To balance your image, arrange objects so that anything large on one side is balanced by something of importance on the other side. This is not the same as having multiple centers of interest. A group of people arrayed on one side need only be balanced out by having a tree or building on the other. The people are still the center of interest; the other objects simply serve to balance the composition, as shown in Figure 1-15.

You can balance objects in two ways:

✦ **Symmetrical balance:** Have the objects on either side of the frame be of roughly similar size or weight.

✦ **Nonsymmetrical balance:** Have the objects on opposing sides be of different size or weight.

Figure 1-15: Other elements of the photo can balance the composition.

Framing an Image

Photos are frequently put in frames for a good reason: A border around a picture defines the picture's shape and concentrates our attention on the image within the frame. You can use framing to provide an attractive border around your own pictures by using these tips:

◆ **In the foreground, look for obvious framing shapes in which you can place your composition.**

You won't easily miss the most readily apparent frames: doorways, windows, arches, and space between buildings. These have the advantage of being a natural part of the scene and not something you contrived in order to create a frame, as shown in Figure 1-16. In this illustration, the cliffs at the left side of the image partially frame the ocean inlet at right.

Figure 1-16:
Existing objects can be used to create a frame for your photo.

✦ **Make your own frames by changing position until foreground objects create a border around your image.**

Find a curving tree branch and back up until the scenic view you want to capture is wrapped in its leafy embrace. Climb inside something and use an opening as a frame.

✦ **Place your frame in the foreground.**

Shapes in the background that delineate your image don't make an effective frame. You want something that appears to be in front of your subject matter, just like a real frame would be.

✦ **Use a frame to create a feeling of depth.**

A flat-looking image can jump to 3-D life when it's placed in a frame. Usually, you want to have the frame and your main subject in focus, but you can sometimes use an out-of-focus frame to good effect.

✦ **Use a telephoto lens setting to compress your frame and your subject; use a wide-angle lens setting to add distance between the frame and your main subject.**

With a telephoto lens, however, you have to be especially careful to keep the frame in focus.

What's That Tree Doing Growing Out of My Head?

Mergers are the unintentional combining of portions of an image. With our stereoscopic vision, our eyes and brain distinctly separate objects that are farther apart. Other visual clues let us keep objects separate, such as the relative size of the objects compared with our knowledge of their actual size. For example, we know that a tiny human is located in the distance, whereas another one in our field of view that's four times as large is simply closer. However, viewed through the one-dimensional perspective of a camera lens, it's easy for objects that we know are distinct to become merged into one.

We've all seen photographs of hapless photographic subjects posed with what looks like a telephone pole growing out of their heads. Sometimes, the merger is with a border of the image, as in the Figure 1-17, in which the blues singer's microphone appears to be attached to the side of the frame with no visible support. This mistake is easier to make than you might think — and easier to avoid than you realize. Follow these steps:

1. **When composing an image, look behind the subject at the objects in the background. Then, examine the borders of the image to look for things "attached" to the edges.**

By concentrating, you can see how the background and foreground will appear when merged in your final photograph, as shown in Figure 1-17.

2. **If an unwanted merger seems likely, move the subject to either side, or change your position slightly to eliminate the juxtaposition, as shown in Figure 1-18.**

Figure 1-17: An unwanted merger: This microphone growing out of the side of the frame.

Figure 1-18: Changing your position can eliminate an unwanted merger.

Sometimes, it helps to close one eye while viewing the scene.

Like all the other rules discussed in this chapter, you can ignore the antimerger guideline (even if you aren't a captain of industry looking to build a giant conglomerate). Keep in mind that you can creatively use mergers to make photographs that are humorous. You just might want that forest ranger to appear to have a tree growing out of his or her head.

Chapter 2: Close-Up Photography

In This Chapter

✔ Mastering the jargon

✔ Previewing the fun of macro photography

✔ Choosing your location

✔ Assembling the necessary equipment

✔ Taking that photo

✔ Digital single lens reflexes and close-ups

*O*ne area that has really benefited from the digital single lens reflex (dSLR) revolution has been close-up, or *macro,* photography. Although digital cameras of any sort make close-up pictures fairly easy, you always have the pesky problem of trying to figure out whether you framed your picture properly — and whether it's in sharp focus. Tiny LCD displays on the back of a camera should do the job — theoretically — but they're often difficult to view, especially under bright lighting conditions.

With a digital SLR, though, you're *always* looking through the same lens used to take the picture (unless you choose to view the LCD on the back of the camera). Digital SLRs are designed for bright, easy viewing and focusing of your image. Unless the light is very dim indeed, you can usually see almost exactly what you're going to get as well as whether your camera's autofocus mechanism (or your own trusty fingers) have zeroed in on the exact point of focus you want. Digital SLRs can turn a fun activity into an uproaringly good time.

Second-best are the newer cameras with electronic viewfinders (EVFs) that let you view and compose using an internal LCD that shows virtually everything the lens sees. These cameras aren't as easy to focus as digital SLRs, but they are still better than the average optical-viewfinder digital camera for close-ups.

However, you don't need a dSLR or EVF-equipped camera to enjoy close-up photography. Macro photography can be one of the most satisfying forms of digital photography. Any intermediate digital camera has all the features

that you need to take great close-ups that will astound your family, friends, and colleagues. And although a beautiful scenic photo or an attractive portrait will elicit praise and appreciation, a well-crafted close-up photo is guaranteed to generate *oohs* and *ahhs* and, "How did you ever take that picture?" comments. Close-up photography takes us into fascinating new worlds without the time or expense of an exotic trip.

For example, if you collect coins or stamps, miniature teddy bears, porcelain figurines, model trains, or nearly anything smaller than a breadbox (unless you collect breadboxes), you'll love the ability to document your collection. Have a garden full of prize roses? Display them even in the dead of winter through digital photos. Have a thing for insects? Grab a picture of the little beasts in their natural habitat. Some of the best applications of close-up photography involve crafts and hobbies.

You don't have to be a forensic expert specializing in crime scene investigations to find interesting photos in the macro world. Just about any household object, if photographed from an inch or two away, is transformed into an abstract scene worthy of the most arty photographic expression.

If you haven't tried close-up photography, I hope this chapter encourages you to do so. I show you here how to set up a close-up "studio" and take macro photos the painless way.

Defining Macro Photography

The first thing to do as you begin your exploration of close-up photography is to get some jargon out of the way first. There's nothing wrong with calling up-close and personal pictures *close-ups,* but within the photography realm, you'll commonly find some other terms in frequent use (and misuse). Here are some of them.

✦ **Close-up photography:** This term has been co-opted by the movie industry (as in "Mr. DeMille, I'm ready for my close-up" in the film classic, *Sunset Boulevard*). A *close-up* is generally considered to be a tight shot of a single person (say, only the face and shoulders) or another object of similar size. It's okay to refer to close-up photography for what you do with your digital camera, as I've done in the chapter title. That's a term that most people, even photographic neophytes, understand.

✦ **Microphotography:** *Microphotography* results in microphotographs: that is, microfilm images. You wouldn't apply this term to pictures taken through a microscope although it is sometimes (incorrectly) used that way.

✦ **Photomicrography:** This is the correct term for taking pictures through a microscope. Although photomicrography is chiefly within the purview of scientists and researchers, it can also be a fun activity for digital photographers if you have the special equipment needed to hook up a digital camera to a microscope. Everything from microscopic animals to human hairs can make fascinating photographs, but you generally need a higher-end digital camera and some specialized gear to capture the images. Photomicrography is beyond the scope of this book.

✦ **Macro photography:** This is the brand of close-up that is the focus of this chapter. Generally, *macro photography* is considered any picture taken from about 12 inches or less from the subject, down to half an inch or even closer. *Macro* is derived from the Greek word *makro*, meaning *long,* but it's come to mean *large* and the exact opposite of *micro.* However, that's not exactly the case in photography. A macro photograph is not a huge picture (the opposite of a microphotograph) but rather a normal-sized photo of a tiny object that has been made to appear large, as shown in Figure 2-1. You might not even be able to recognize common objects when enlarged in a macro photograph.

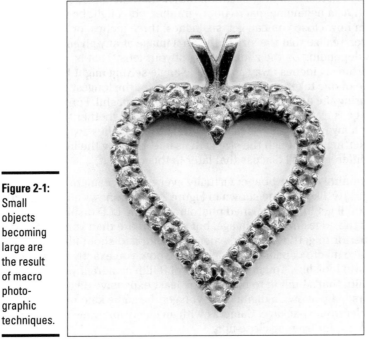

Figure 2-1: Small objects becoming large are the result of macro photographic techniques.

Why Digital Macro Photography Is Cool

Digital cameras and macro photography were made for each other. In many ways, digital cameras can be far superior to an ordinary film camera when it comes to taking close-up pictures. Consider these advantages:

✦ **Close-focusing lenses:** Digital camera lenses are ideal for focusing up close. Without getting too technical, macro photos are made with any camera by moving the lens farther and farther away from the film (or sensor, in the case of a digital camera). Film cameras require moving the lens quite a ways out to get a decent macro effect. For example, a 50mm lens on a 35mm single lens reflex camera (or a digital SLR with a full-size sensor) must be moved four inches out from the film to get a life-size (1:1) image. In contrast, an 8mm lens on a digital camera with a small sensor, roughly the equivalent of the 50mm lens on an SLR, needs to move only a total of about ⅝ of an inch to provide the same magnification. Clearly, close focusing is much easier to incorporate into a digital camera.

In the macro photography arena, you'll see close-focusing capabilities described in terms of magnification rather than the distance from the subject. As a beginning macro photographer, you might be more interested in how close you can get: six inches, three inches, or whatever. However, realize that the size of the final image at any given distance varies depending on the zoom setting of your lens. That is, an image taken from six inches away at the wide-angle setting might be one-fourth the size of one taken from the same distance at the longest zoom setting. Comparing the amount of magnification is more useful. For example, a 1:1 image is exactly the same size in your camera whether taken from one inch away with the wide-angle setting or six inches away with the zoom setting. (Although the size is the same, the way the image looks is quite different, and I discuss that later in this chapter.)

✦ **Easy framing of your image:** Virtually every digital camera features an LCD display, like the one shown in Figure 2-2, that shows almost exactly what you'll get in your finished photograph. (The LCD display might trim a bit of the edges from the image, but getting more than you expected is far superior to getting less.) Inexpensive point-and-shoot film cameras, if they have macro capabilities at all, don't show you exactly what your image will look like. You need to get an SLR film camera if you want the capability that's built in to many of the least expensive digital cameras. Of course, if you own a digital SLR, you get the same kind of framing in an all-electronic package. Cameras with an electronic viewfinder are also easy to use for framing close-ups.

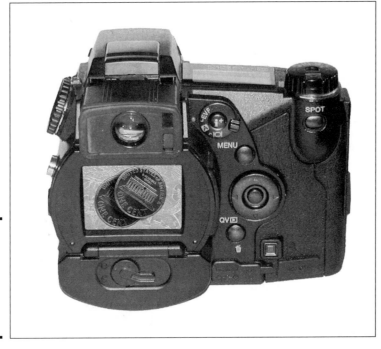

Figure 2-2: LCD viewfinders make it easy to frame your close-ups.

+ **Immediate results:** Close-up photography can be tricky, and the last thing you want is to have to wait for your film to come back from the photofinisher to know whether your pictures came out. With a digital camera, you can review your results on the LCD display immediately, delete bad shots, and keep taking pictures until you get exactly what you want.

Picking a Place to Shoot

Where you shoot your macro photos can be as significant as what you're shooting. You might want to take your photographs in the tightly controlled environment of your kitchen, using a tabletop as your platform for your model trains or other objects. Maybe you want to venture out into the field to stalk the creatures of nature.

Sometimes you have a choice of where you shoot, and sometimes you don't. For example, if you want to photograph sea life at the beach, you pretty much have to take your pictures there. Comparatively, you can photograph a tree

frog on a tree or pop him in a mayonnaise jar along with a leaf and stick to re-create, as comedian Mitch Hedberg says, his natural environment.

Table 2-1 shows some of the advantages and disadvantages of location versus studio shooting.

Table 2-1	Location Shooting versus Studio Shooting	
Factor	*Location*	*Studio*
Setting	Natural environment.	Studio environment.
Transport	Equipment such as tripods, reflectors must be carried. Some items might not be available.	All equipment is right at hand.
Background	No control over background.	Background can be chosen to compliment subject.
Lighting	Realistic natural lighting, but you have less control.	Lighting might look artificial, but you have perfect control.
Environment	Bad weather can be a problem.	Weather is not a factor.
Set Up	Setting up picture can be tedious; settings might be transitory and impermanent.	Setups can be left in place as long as desired.
Consistency	Taking groups of pictures with similar look is difficult.	Control over lighting and backgrounds means a consistent look that's useful for photographs of collections and so on.

Setting Up Your Macro Studio

You don't need a real studio for macro photography, of course. That's one of the cool parts of taking close-ups. Any nook or cranny that you can spare in your home or work environment can be designated as a studio area. All you need to do is keep the area reasonably neat and free of clutter so that you can set up and take macro photos on a few minutes' notice. You can also keep a semipermanent close-up studio, like I do, for stuff that my wife sells on eBay. I have a seamless backdrop up in a little-used corner so that an item that's destined for sale can be set up and photographed anytime. A macro studio, such as the one shown in Figure 2-3, requires so little space that you won't hesitate to dedicate a small portion of your living space in exchange for the convenience of having a special area you can use anytime.

Of course, you're free to create little macro studios on an ad hoc basis, using your kitchen table, hearth, or any convenient location as you need.

Figure 2-3:
Any small
corner can
become a
macro
studio.

Many of the close-up photos in this book, such as Figure 2-1, were taken on impulse right here at the desk where I work. I just grab a piece of white paper from my ink-jet printer, lean it against any convenient support, and drop the object I want to photograph on my miniature, seamless backdrop. I often use the built-in flash of my digital camera with one or two other pieces of printer paper strategically located to reflect the light onto my subject. Less than a minute after I started, I plug my camera into the USB cable that rests by my keyboard and watch my photos appear on the screen.

Of course, you can get better results than I get with my quickie photos if you collect the right equipment and gear for your ministudio. This next section explains exactly what you need.

Background check

In many cases, you want close-up backgrounds that are plain and unobtrusive because they allow your subject matter to stand out without any distracting extraneous material. That generally means a light background for darker objects and a dark background for light objects. You don't need to stick with stark white or inky black backgrounds unless your plan is to drop out the background in Photoshop or another image editor so that you can combine the subject with some other photograph. A light pastel color background often works well for dark objects, and a medium-dark shade looks good with very light objects.

The amount of light that falls on the background helps determine its lightness or darkness. A soft gray background can appear to be almost white or fairly dark depending on the amount of illumination that reaches it. Don't be afraid to experiment.

So-called *seamless* backdrops are very popular. They provide a continuous (seamless) surface on which the subject can rest while blending smoothly into a vertical background. Depending on how you light the seamless backdrop, it can appear to be a single shade or provide varying amounts of separation between the foreground and background, as shown in Figure 2-4.

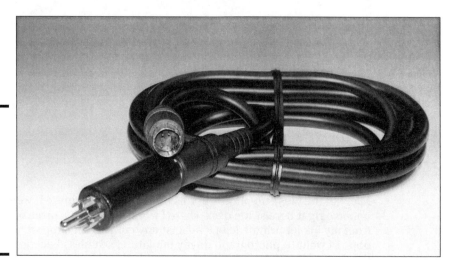

Figure 2-4: Seamless backgrounds make an attractive setting for close-up photos.

Here are the main types of backgrounds that you'll probably use for your macro photography:

✦ **A few yards of cloth:** I really like plain, solid-colored cloth as a backdrop because it's rugged and versatile. If it gets dirty, you can usually just throw it in the wash. I buy pieces about 45–54 inches wide and 8 or 9 feet long in several different colors, including pure black and pure white as well as soft pastels and bright colors. The longer lengths let me use the cloth as a portrait background if I need to.

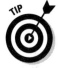

Artificial velour is extremely useful. One side has a soft surface that really soaks up light. A black velour cloth can make a perfectly black background almost guaranteed not to show shadows. The other side of velour has a shinier texture that you can use for some types of photos. Leave the cloth smooth. Avoid fabrics with a pronounced reflective sheen, such as satin/sateen or vinyl. The simplest fabrics won't cost you more than a few dollars a yard.

✦ **A roll of seamless paper:** Rolls of true photographic seamless paper can be expensive (around $40 for a 9-x-36' roll) and hard to find (you need to seek out a camera store that sells to professional photographers). If you can't find such a store locally, online sources sell paper in 53 inches x 12 yards for about $20, although shipping can add a considerable amount to the cost. If seamless paper is what you want, however, you can take a hacksaw and cut the roll in half to make the size a little more manageable for ministudio work. Because seamless paper eventually gets torn and dirty, it's nice to be able to unroll a little more so that you always have a fresh background.

Check out craft and packaging stores for large rolls of sturdy wrapping paper as an alternate source for seamless backgrounds. Avoid the paper with mistletoe and bunnies and stick to plain colors. However, don't be afraid to experiment. A smooth section of Kraft paper (found on rolls of brown shipping paper) might make a handsome backdrop for some subjects.

✦ **Posterboard:** I've used a lot of posterboard as seamless backgrounds for close-up photos of smaller objects. *Hint:* Use duct tape to curve it into place. At a few cents a sheet, you can afford many different colors. However, watch for posterboard that has a slightly shiny surface. If you use it with soft and diffuse lighting, however, that shouldn't be a problem.

Visible means of support

Book III
Chapter 2

You've got to provide support for your background material, your lighting equipment (if you use some), and your camera. Fortunately, the same supports that work for close-ups serve admirably for other types of photography. (See Book III, Chapter 3 for a discussion of gear for people pictures.) If you plan to take a lot of studio-type photos, buying some good-quality equipment of this type can be a shrewd move. I'm still using the same tripod and light stands that I purchased while in college. A few hundred dollars for that stuff seemed like a lot of money at the time, but I haven't had to spend a penny since then even though I've gone from large professional cameras to teensy digital cameras in the interim.

You can buy tripods, light stands, and other equipment relatively inexpensively. However, I can tell you from personal experience that a $100 tripod is a lot more than twice as sturdy and twice as useful as a $50 model. If you're going to spend the money anyway, replacing a flimsy tripod or two, start out with a good one.

Here are some of the supports you can find:

✦ **Background supports:** You'll find that cloth backgrounds are so lightweight that you can support them with almost anything. Duct tape can suspend a piece of cloth from any piece of furniture that happens to be around. I tend to use 7' *light stands,* which are aluminum supports that

telescope down to a compact size and have tripod legs at the bottom to keep them upright. Set up a pair of light stands, suspend a wooden dowel between them as a horizontal support for your cloth, and you're all set.

Light stands can also support some rolls of paper if you substitute a wood closet pole or metal pipe for the wooden dowel. You can also build a simple background stand out of lumber. Or, if you do a lot of shooting (as I do) in a basement area, use metal supports fastened directly to the ceiling joists, as shown in Figure 2-5.

✦ **Lighting supports:** Light stands are good but might be a little too large to position effectively for close-up photography. In many cases, you can skip light stands or special lights altogether and use household desk lamps that rest right on your background setup.

✦ **Camera supports:** A tripod is essential for macro photography. You need to be able to fix your camera in one position and lock it down while you take your photos. That's particularly true if you use your digital camera's LCD display to compose or focus your image. It doesn't matter whether you're relying on your camera's automatic focus or focusing manually: A tripod can give you the fixed position that you need. A tripod also allows you to photograph several subjects from the same distance and angle, thus adding an important measure of consistency.

You can find more information on choosing a good tripod in Book II, Chapter 5.

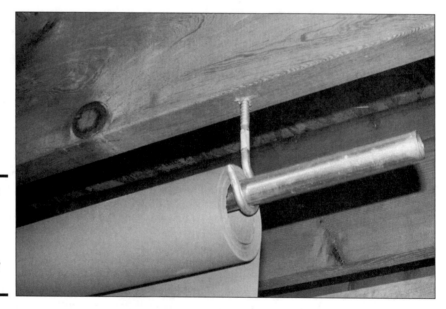

Figure 2-5:
Seamless
paper
can be
supported
in a variety
of ways.

Lighting equipment

Unless your subject is a candle or a glow-in-the-dark Halloween skeleton, you need some sort of lighting to illuminate the scene. Your choices include the existing light in the room, electronic flash, and incandescent illumination, such as desk lamps or photoflood lights. The following sections explain what you need to know about each option.

Existing light

Photographers used to refer to existing light by the term *available light* until someone pointed out that a 400-pound Klieg light is technically *available* if you happen to have one left over from the last motion picture you shot. Today, we call it *existing light* on the presumption that lighting doesn't exist if it isn't already available on-site. Here are some tips for using existing light.

+ **Use with modulation:** You can *modulate* (modify) existing light, of course, if you have reflectors or other gadgets about. If existing light is too harsh, you can soften it by using a piece of white cardboard as a reflector. Foam board also works and is stiffer and easier to position than cardboard.

 Avoid other colors unless you really, really want a color cast in your photo.

+ **Foiled again:** A piece of aluminum foil can make a brighter, more contrasty reflector. Crinkle it up so that the light it reflects is more diffuse. Otherwise, foil behaves a lot like a mirror, which is something you don't want. Mylar space blankets also make a lightweight, portable metallic reflector.

+ **For all in tents:** Pros often use miniature white tents when photographing a shiny object. You can make a simple one out of a translucent milk jug. Place your subject inside the tent, apply plenty of light from the outside of the tent, and then shoot through a hole in the top or side. You'll end up with a beautiful soft lighting and no reflections of the surrounding room on the shiny subject matter.

 Make sure that the camera lens itself doesn't reflect on the object!

+ **Block that light:** Sometimes you want to subtract light rather than add it to your subject. Put black cloth or cardboard outside the subject area to absorb light and darken shadows for a dramatic effect.

When using incandescent lights, make sure that your camera's white balance control has been set for interior illumination. Many digital cameras can be set to automatically recognize and adjust the white balance for various lighting conditions. Fluorescent lighting often requires a different setting, and some cameras will have adjustments for both warm and cool fluorescent bulbs.

Book III
Chapter 2

Close-Up
Photography

Electronic flash

Electronic flash is often useful for quickie shots like those I take right at my desk, but flash is often not the best choice for close-ups. Here are some reasons why not:

✦ **Too much light:** Flash is often too powerful for close-up pictures taken inches away from the camera. Flash is intended for shooting from several feet or more.

✦ **Can't project the outcome:** The effect of the lighting isn't easy to visualize with electronic flash because the subject is illuminated for only a fraction of a second. After you take your photo and review it on the LCD display, you might find that the light is too harsh, is placed incorrectly, or illuminates the wrong part of your image.

✦ **Don't need it for stop-action:** One of the major advantages of electronic flash, stopping the action of moving subjects, doesn't really apply to close-up pictures, which are usually taken of stationary subjects at a fixed distance.

You can use four kinds of electronic flash when taking close-up photos. You can find a more thorough discussion of these flash options in Book III, Chapter 3 (where I discuss photographing people). However, here's a quick summary of your choices.

✦ **Your camera's built-in flash:** This is usually your worst choice for illuminating your subject. For one thing, the flash is likely to be aimed quite a distance past your area of interest — or, in many cases, blocked by parts of the camera or lens. When I use my camera's built-in flash for close-ups, I always include several pieces of white reflective material outside the field of view to bounce the light back onto the subject. Your flash is likely to be too harsh, thus washing out the details of your subject.

Light placed at an angle, rather than straight on, can often produce better close-up illumination.

✦ **External flash:** You can find a connector on many digital cameras for linking to an external flash unit, which you can buy for $50 to $400 or more (for the dedicated units built specifically for the more advanced amateur cameras). Sometimes these are located on top of the camera in the form of a shoe (a *hot shoe*) that can be used to mount the flash and provide an electrical connection at the same time. Or, your camera might have a special connector — a PC connector, as shown in Figure 2-6.

PC doesn't stand for *personal computer* but rather *Prontor-Compur,* which is the German mechanical shutter-building companies that invented the connection.

Optional flash units range from more powerful versions of your camera's built-in flash to expensive studio flash units. Check out Book III, Chapter 3, for tips on how to use external flash units of this type.

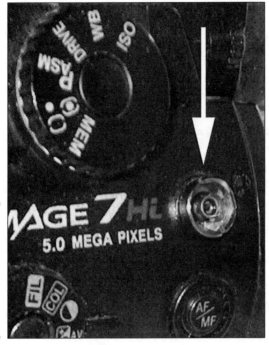

Figure 2-6:
Your camera may have a connection for plugging in an external flash unit.

✦ **Slave flash:** These are a kind of external electronic flash that includes a photocell that triggers the unit automatically when another flash unit is fired. Slaves let you use several flashes at once if you can match the slave's operation to your camera's flash functions. (Some cameras use a pre-flash that can trigger some slaves prematurely.)

✦ **Ring lights:** These are circular flash units that can be fitted around the circumference of your camera's lens. They provide even lighting that is designed especially for close-ups. Usually, only professionals who do a great deal of macro photography can justify the price of a ring light.

Incandescent lights

Incandescent lights — including gooseneck desk lamps (which I use), high-intensity lamps, or photographic floodlights — are great for lighting close-ups. Their advantages include

✦ **Easy preview:** You can see exactly what your lighting effect will be.

✦ **Flexibility:** Your options are wide-open. Use one, two, three, or as many lamps as you need. Arrange them as you like. Create backlit effects or soft lighting. Use a high-intensity lamp when you want a very contrasty quality to your illumination. Turn to a soft-white desk lamp when you need diffused light.

✦ **Inexpensive:** I buy desk lamps for less than $10 and use them in various combinations to get well-lit close-ups. What other photographic equipment can you buy that cheap?

Their disadvantages include

✦ **Heat:** Don't let your high-intensity lamps burn your subject. And forget about using them to photograph ice cream sundaes.

✦ **Power:** You need lots of power and thick cords if you're using multiple incandescent lights.

✦ **Color of their light:** You'll need to make sure that your camera's white balance is set correctly for the reddish hue of incandescent lights.

✦ **Burnout:** Have some extra bulbs available in case one of your lamps burns out during a shooting session.

Other equipment

You might find some other equipment handy when shooting macro photos. For example, slide-copying attachments are available for some digital cameras. These attachments let you make high-resolution digital grabs of 35mm color slides without the need for an expensive slide scanner. (For more information on scanning slides, see Book VI, Chapter 2.) Even if your digital camera focuses closely, special close-up lenses let you get even closer. Here's a run-down on some of the most popular add-ons for close-up photography:

✦ **Slide copiers:** Slide copiers are great for converting your existing collection of color transparencies to digital form. All you need is a close-focusing digital camera and a copier attachment, which mainly consists of a holder for the slide and a diffusing panel that sits behind the slide to soften the light you use to illuminate it. You might be able to get good quality with such a device, and the quality is certainly better than what you get with most flatbed scanners jury-rigged to scan slides.

✦ **Single-lens reflex add-ons:** If you happen to own a digital camera with removable lenses (with basic SLR digital cameras finally dipping below the $1,000 price point, that's not altogether unlikely), you can use similar accessories offered for film-oriented SLRs, such as bellows, extension tubes, and reversing rings.

 • **A bellows,** such as the one shown in Figure 2-7, moves your camera's lens farther from the sensor, enlarging the image over a continuous range. The downside is that the farther the bellows is extended, the less the light that reaches the sensor, producing long exposures. Bellows attachments are also expensive.

- **Extension tubes** do much the same as a bellows but over fixed distances.

- **Reversing rings** let you mount your camera's lens on a bellows so that the front of the lens faces the sensor. With removable lenses that weren't designed for macro photography, reversing the lens can produce sharper results *and* increase the magnification.

✦ **Close-up lenses:** Even if your digital camera focuses very close, you might want to get even closer. That's where close-up lenses come in. Although they're called lenses (because they function as one), close-up lenses look like clear glass filters with a curved surface. These lenses fasten to the front of your digital camera's lens using a screw mount or other arrangement. Labeled with designations such as #1, #2, or #3 (referring to a measurement of magnification called *diopter strength*), you can use only one or use them in combination to produce varying amounts of magnification. The amount of magnification that a particular close-up lens or combination provides depends on the zoom setting of the lens and its normal close-focusing ability.

Figure 2-7: This bellows is expensive but versatile if you have a digital SLR camera.

For example, if you have a lens that focuses as close as one meter, a +1 close-up lens enables you to focus down to half a meter, a +2 diopter to one-third of meter, and a +3 diopter to one-fourth of a meter (a little less than ten inches for the nonmetrically inclined). As you can see, these close-up lenses can bring macro capability to optics that aren't able to focus very close (one meter is the pits, close-up-wise) and can bring super macro capability to lenses that already can focus very close to your subject.

Serious macro photographers purchase a set of several close-up lenses and use them in combination to get the magnification they want.

Shooting Tips for Macro Photography

The first part of this chapter helps outfit you for macro photography. Most of the equipment and gear discussed can be used for location shooting or in your home or office studio although outdoor close-ups can make some of the tools, such as cardboard reflectors, tricky to use.

This next section provides you with tips for shooting good close-up photographs, using common techniques the pros take advantage of all the time, plus a few things I learned myself, the hard way.

Setting up your subject and background

You've chosen your subject to photograph, whether it's a pewter soldier from your collection or a terrified tree frog. You've selected a background to isolate and/or flatter your subject. What's next?

Set up your subject on its background so that it won't move. Although that can be tricky with the tree frog, it's less of a challenge with an inanimate object, such as the pewter soldier. I often use bits of modeling clay that can be hidden underneath an object to hold it at the correct angle. I also use pieces of wood, bent paper clips, or inexpensive clamps. One of the advantages of digital photography is that you can easily remove any supporting device in an image editor.

In the studio, positioning your subject might be all you have to do. On location, you'll likely have to remove unsightly leaves, ugly rocks, maybe some bugs that are wandering through your frame. Clean up any dirt, dying stems, or other objects that you don't want to photograph.

Setting up your camera

In the studio, it's fairly easy to set up your camera on a tripod or other support and not have to worry about it shifting. On location, you might need to

make sure that the ground underneath your tripod is firm and solid. Put a rock under one or more legs, if necessary. If you're shooting on a slope, you might want to lengthen one or more legs of the tripod and shorten others.

Set the tripod a little shorter than the height you actually want to use. You can use the center pole to raise or lower the camera a bit. Don't make the common mistake of setting the tripod too low because if you really crank up the center column, the tripod will become top-heavy and unstable. It sometimes helps to tie a weight onto the center pole to give the tripod a bit of ground-hugging heft. I use the mesh bags, like what oranges or onions are sold in, as a receptacle for rocks. Mesh bags tend to be strong but lightweight, which makes them ideal for this particular task. (Plus, if you happen to encounter an orange grove during your shooting session, you're all set to bring home some dessert.)

You can reverse the center pole of many tripods so that it extends down between the legs of the tripod, thus letting you shoot at an angle down on your subject. Often that's the only way to get the viewpoint you want without having the tripod's legs interfere.

Lights, please

Use your lighting equipment or the existing light to illuminate your subject. In the studio, position two or more lights so that they light up the subject evenly. In the studio or on location, work with reflectors to fill in dark shadows, darken spots that are too bright, and even out your illumination.

The light that falls on the background can be just as important as the light that you use to illuminate your subject. The background light can separate your subject from the surroundings and provide a more attractive photo. See Book III, Chapter 3, for more information on lighting backgrounds.

Remember that the more light you are able to use, the smaller the lens opening needs to be and better the *depth-of-field* (how much of your image is in focus) you'll achieve. If you want a really sharp picture with lots in focus, pump up the light as much as possible — although if you're using electronic flash, not having enough light is rarely a problem. I explain more about depth-of-field later in this chapter.

The quality of the light is as important as the quantity. If you're using electronic flash, you want to avoid the harsh illumination that flash typically provides. I often drape a handkerchief over my camera's flash. This reduces the flash illumination to a more reasonable level while softening the light.

If the electronic flash is still too strong, move back a step or two and zoom in closer. Bear in mind, though, that not all digital camera lenses can focus

closely at all zoom settings. Because of the perverse square law (er, I mean *inverse square* law), a light that is 12 inches from a subject generates only one-quarter as much illumination as it does from 6 inches.

Ready . . . aim . . .

You're all set to frame your photo and press the shutter release. But first, a few words from your sponsor. Keep these final advisories in mind as you take your best shot when shooting up close:

✦ **Watch proportions.** For any particular magnification, the closer you get, the more emphasis is placed on objects very close to the lens. Photograph a figure of a clown's head from two inches away, and his nose will be very large in proportion to the rest of his face, as shown at left in Figure 2-8. Move back a few inches and zoom in to produce the same size image, and the proportions are much more realistic, as shown at right in Figure 2-8.

✦ **Don't forget focus and depth-of-field considerations.** When shooting up close, only a small portion of your image might be in focus. Make sure that's the most important part of your subject! If your camera lets you lock in a focus setting by pressing the shutter release button part way, make sure you've focused on the right area before locking. Depth-of-field is a range, extending one-third in front of the plane of sharpest focus and two-thirds behind it, as you can see in Figure 2-9. There, very little in front of the cat is in focus, but the cat's face itself is fairly sharp. The background, of course, is too far away to be in focus at all, which is how the picture was conceived.

✦ **Crop and center.** Crop (trim) extraneous material and center your subject in the frame (most of the time). Good composition, as I describe in Book III, Chapter 1, usually calls for an off-center subject, but that rule might not apply when shooting close-ups. It might be best to feature your main point of interest right in the center of the frame.

✦ **Use your camera's close-up features effectively.** That includes double-checking to make sure the camera is in macro mode and keeping close tabs on the in-focus indicator (usually an LED) that might appear in your viewfinder.

✦ **Aim and frame.** Make sure that you've framed the subject correctly, without accidentally chopping anything off. You often have to use the camera's LCD display to examine your composition because the built-in optical viewfinder doesn't show the image 100 percent accurately. (Read Book II, Chapter 1, for a basic discussion of viewfinder *parallax* error.) You don't want to chop off the top or sides of your image by mistake. Of course, if you're using a digital SLR, you won't need to worry about this at all.

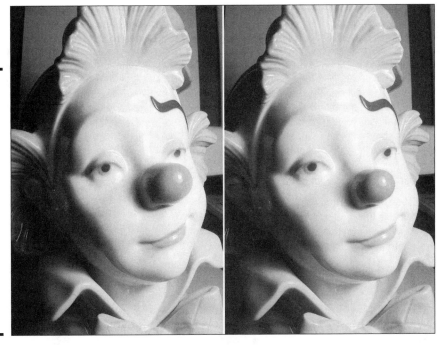

Figure 2-8: Objects photo-graphed very close, such as the clown's nose at left, appear proportion-ately much larger than when photo-graphed at a distance, as at right.

Figure 2-9: Depth of field extends one-third in front of the plane of sharpest focus (the cat's face) and two-thirds behind it.

Depth-of-field and digital cameras

Throughout this book, I mention the copious amounts of depth-of-field that digital cameras offer. This is a good place to mention it again. Because of the relatively short focal length of their lenses, digital cameras help ensure that just about anything you shoot at normal distances will be sharp. Even at close-focus distances, you have to work a little to throw even part of your image out of focus.

If you *want* to reduce depth-of-field a little, say to blur a background for creative purposes, you can do several things. First, try using the telephoto zoom position of your camera. One of my favorite digital cameras works fine in macro mode at its 200mm (equivalent) zoom setting, which has an actual focal length of about 50mm, and can cut down the depth-of-field a bit. Use your camera's aperture priority mode (if it has one) and set the camera for the largest lens opening available. If you want to throw the background out of focus, try focusing a teensy bit *in front* of your main subject, which will probably remain acceptably sharp as the background grows blurrier. Or, focus *behind* the main subject (but only a little) if you need to throw the foreground out of focus.

If your digital camera has a connector for linking the camera to a monitor or TV, you can often use that capability to frame your indoor close-up photos.

Fire!

When you press the shutter release button, a lot of things happen. One quite likely (and none-too-happy) event is that you press the shutter release button too hard, jar the camera during exposure, and produce a blurry picture. Another possibility is that you see something wrong with your composition in the last ohnosecond. (An *ohnosecond* is that interval between the time when you press the shutter release and the instant when you realize that you've made some sort of serious error. An ohnosecond also occurs when you're slamming your locked car door closed and notice your keys in the ignition.) It's not too late!

Avoiding blur

First, avoid human-caused blur by using your camera's self-timer to trip the shutter after a few seconds rather than using your big fat finger. In self-timer mode, you set up your composition, make sure everything is okay, press the shutter button, and then step back and take a few deep breaths until the camera actually takes the photo (blur free).

An alternative is to use an electronic or mechanical, remote shutter-release control to trip your camera's shutter without touching it. A remote release can be a cable that attaches to your camera or an infrared remote control like the one that operates your television, VCR, and virtually everything else in your household. Unlike a self-timer, a remote release lets you take the photo at the exact instant you want — say, when the tree frog has a cute expression on his face.

Some cameras and lenses have anti-shake features that can help you avoid blur, too.

Making sure the camera is done

For heavens sake, don't do anything after you press the shutter button until you're 100 percent positive that the camera has finished taking the picture. If your camera has an optional shutter release sound, turn it on so that you know when the picture is being taken. Learn to differentiate between the sound the camera makes when the shutter opens and the sound made when it closes again.

If your camera has a flashing LED that shows a photo is being saved to your digital film, look for it to begin flashing as an indication that the photo has been taken. The automatic exposure mechanism of your camera just might need to use a long exposure (several seconds or more) to take the picture, and you certainly don't want any sudden movements or grabs at the camera to ruin your shot. Wait a few seconds after you hear the camera's shutter click before doing anything until you're sure that your camera isn't making a lengthy exposure or time exposure. That click might have been the shutter opening (or the digital camera's simulation of a shutter sound), and the camera might still be capturing the picture.

Reviewing your shot

After the photo has been taken, do take the time to review your picture on the LCD display for defects. Look for these common problems:

+ **Poor focus:** Correct and reshoot.

+ **Bad exposure:** Make adjustments using your camera's available exposure compensation modes. (Check your camera manual.)

+ **Bad reflections you didn't notice before:** Move your lights or move your camera until the reflections go away.

+ **Missing tree frog that has departed the scene:** You know, they do make quite realistic-looking plastic tree frogs these days.

**Book III
Chapter 2**

**Close-Up
Photography**

Digital SLRs and Close-Up Photography

As I mention at the beginning of this chapter, digital SLRs are the almost perfect choice for close-up photography because of the increased accuracy you can get with framing and focusing, as well as the greater control that most dSLRs provide over your picture-taking. Here are a few things to consider when using a digital SLR for macro photography. Some of these also apply to cameras with electronic viewfinders.

✦ **Don't forget to use depth-of-field preview.** The digital SLR typically shows you a bright, clear image with the lens wide open, and then closes down the aperture at the moment of exposure. As you know, the depth-of-field at that smaller aperture is likely to be much greater than what you saw with the lens wide open, so if selective focus is important to you, you'll want to use your camera's depth-of-field preview button to glimpse the true focus just before you shoot. An object that appears soft and out of focus through the viewfinder can be objectionably sharp in the final image, as shown in Figure 2-10.

✦ **Investigate add-on focus aids.** An SLR image is usually viewed as projected onto a focusing screen underneath the pentaprism/pentamirror. High-end digital SLRs can offer removable focusing screens that can be easier to focus in dim light or in close-up mode. If you have a dSLR with that capability, investigate the focus aids available to you.

✦ **Not all digital SLRs show the full frame.** When I began my photographic career, the Nikon film camera was highly prized because it was said to display a full 100 percent of the film image through the SLR viewfinder. Other cameras might not. Today, many digital camera viewfinders trim off some of the image, providing only 92–98 percent of the full image. You actually get *more* than what you saw through the viewfinder, but if absolute framing is important to you, be aware that what you see is only *most* of what you get.

✦ **Avail yourself of the mirror lock-up feature, if provided.** Close-up pictures can be especially sensitive to vibration, such as that caused by a pivoting mirror. (The mirror reflects the lens view upward to the viewfinder, and then it flips up out of the way during exposure to let the light pass unimpeded to the sensor. This quick up/down flip inevitably provides a tiny amount of vibration, no matter how carefully the camera was designed.) If you're shooting very close or if your exposure is long, see whether your digital SLR has a *mirror lock-up* feature, which will let you flip the mirror up prior to the exposure. Then, when vibration has been damped, take your picture with the self-timer or remote release.

✦ **Check out bellows, extension tubes, reversing rings, and special macro lenses.** These specialized devices can let you get closer, take sharper pictures, and improve your results, especially if you have a digital SLR with a full-frame sensor.

Figure 2-10: A background that appears to be out-of-focus (top) might be objectionably sharp at the taking aperture (bottom).

Chapter 3: Photographing People

In This Chapter

✔ **Making satisfying portraits**

✔ **Shooting on location or in the studio**

✔ **Building an informal portrait studio**

✔ **Discovering the basics of lighting**

✔ **Arranging multiple lights**

✔ **Creating your first portraits**

Although the first successful photograph, a scene taken from a Paris rooftop by Nicéphore Niépce in 1827, was a scenic photo unpopulated by humans (largely because the exposure took eight full hours!), the most memorable pictures since then have included people. Indeed, the desire to photograph family, friends, and colleagues is why many people own a camera.

When you think of the daguerreotype, Civil War-era portraits probably come to mind. When you imagine a prize-winning photograph, images such as Dorothea Lange's *Migrant Mother* leap into your thoughts more quickly than, say, Ansel Adams' "portraits" of the U.S. National Parks. And when you photographed an architectural treasure such as the Eiffel Tower, didn't you include a family member in the picture?

We're fascinated by photographs of people, so we take lots of them. However, people are the most difficult of all subjects to photograph because of the complexity of human ego, awareness, and opinion. When was the last time the Eiffel Tower complained that your picture made it look too fat? Has anyone ever told you that your photo of the Grand Canyon "didn't really look like the Grand Canyon?" Has anyone worried that the presidents on Mount Rushmore would blink during an exposure?

Satisfying people photography is within the capabilities of every digital camera owner. You don't need an expensive camera to take portraits (although digital SLRs can have some advantages when it comes to using certain accessories, such as multiple light sources). Your basic 2, 4, or 5 megapixel (MP) camera will do just fine. Available light or your camera's built-in flash might work for some kinds of portraits, but I show you the advantages of using off-camera flash in this chapter. The best part about taking digital pictures of people is that you can review the photos instantly, with your subjects, and retake them if the results are less than satisfactory.

This chapter is an introduction to the many facets of people photography. You find out how to take great portraits, capture vivid candid photos, and manage unruly group pictures. If you can handle those, all other forms of digital photography are a snap.

Capturing Satisfying Portraits

The two basic categories of people photography are portraits and candids. *Portraits* are posed photos taken in a controlled environment; *candids* are unplanned pictures taken of people in the act of being themselves. Portraits show people as they'd like to be seen; candids portray them as they really are.

Each category can produce images ranging from the mundane to the sublime. To make the step up from mundane isn't hard. In fact, the average novice can achieve significant improvement through better composition and lighting alone.

You don't need a lot of training to shoot candid photos after you master the features of your digital camera and the rules of composition. You just go out and take pictures. Portraits, on the other hand, demand some special skills if you want the images to look like portraits. The good news is that these capabilities are within the range of the average photographer; you just need someone to fill you in on the tools and techniques that work. That's what this chapter is for.

But first, a few ground rules. Take care of these simple aspects, and you can't go wrong:

✦ **Make it possible for your subjects to look their best.** Suggest that they wear suitable clothes and also invite them to have a change of outfits so they can have pictures with different looks. Encourage them to use a friend or family member to help them prepare. Provide access to a good-sized mirror so that they can check their appearance. A portrait subject who feels confident about his or her appearance will photograph well!

✦ **Get to know your subject's personality.** Be careful about trying to make a somber, serious type individual look cheerful and gay; the picture can look forced and fake. It's easier to get a happy type to look serious, but why? Unless it's an executive portrait (where serious is good), go for the smile. Use what you know about the subject to create a portrait that reflects his or her personality.

✦ **Provide comfortable surroundings to help people stay relaxed.** A clean, organized shooting area puts your subjects at ease, as can some soft mood music. If your subject doesn't feel like he or she is standing in front of a firing squad, your photos turn out much better.

Successful portraiture begins with getting your subjects into the right frame of mind. Relaxed, confident people pose better than nervous, tense ones,

so make every effort to start things off right if you want to get a portrait like the one shown in Figure 3-1.

Figure 3-1:
A relaxed
portrait
is the
best kind.

Shooting in the Studio or on Location

Because portrait sittings are generally carefully arranged, these kinds of shoots offer the photographer the advantage of being able to exercise a great deal of control over creation of the image, both in location and lighting. You can choose to shoot in a studio (which can be any indoor room, including your living room or garage) or on location (which can range from your backyard to a park or other site).

You don't need to have a real studio to shoot studio portraits. You might have a place that serves double-duty as a studio as well as some other function. For example, I took some of my favorite portraits in an attic studio that was little more than a large space hung with multiple rolls of seamless backdrop paper, a few painted backgrounds, and lots of room to arrange lights. When I moved to a newer home without an attic, my studio moved, too, to a 16-x-20' basement area with 10' ceilings directly under my home office. The background paper was easy to hang from the ceiling joists.

For one book I did that called for lots of head-and-shoulders portraits, I pinned a long length of fabric to cover the drapery in front of my patio door, set up a couple of lights, and was able to snap a quick portrait on a moment's notice without the need to run down to the basement where the roomier, full home studio was set up. You can even take portraits in your own living room, which was the case for the mother-daughter picture shown in Figure 3-2. I've left the couch in the photo (at left) but probably would have cropped it or retouched it out when making a print.

And even if you don't have room to set aside for a home studio, you probably have an area that can be temporarily reconfigured to serve as a photographic environment. For example, back the car out of the garage and hang a backdrop — and you have an instant studio.

When I refer to a *studio,* I mean any indoor location that can be used to take posed photographs. I don't mean to imply that you have to build a home studio to use any of the techniques described here.

Deciding whether to shoot in your studio or on location must be based on the kind of photos you want to take. Shooting in a studio offers the utmost in control for a photographer, particularly when you're working in a studio you've set up and become comfortable in. Your studio can become a warm, comfortable cocoon that nurtures your creativity and talent.

Of course, sometimes, we all have to leave our comfortable surroundings and brave the outside world. Location photography may pull us out of our comfort zone, but it also gives us something hard to find in the studio — scenery.

Figure 3-2:
Your own living room can be the scene for your portrait photography.

Think of location shooting as your outdoor studio. Most of the techniques described later in this chapter apply to location photography although you might have to use reflectors instead of external flash units, and you can have less control over your backgrounds. The chief differences in location shooting are these:

✦ **Portability:** If you plan to shoot on location regularly, you need to assemble a versatile kit of equipment that you can set up and break down quickly. Find yourself a duffle bag or two in which you can pack your location equipment quickly so that you can be ready to go at a moment's notice.

✦ **Flexibility:** Because no two location shoots are identical, try for a portable location kit that provides the greatest flexibility for lighting both your subject — and if need be, elements of the location appearing in the shot.

✦ **Creativity:** Put together a portable studio system that lets you create different shots and moods. Consider props that are portable and versatile. Make sure that your kit includes a good set of posing blocks (structures, often of wood or plastic, that can be sat upon or stood on) so that you can adjust the height of various posers. You won't always find a rock or fence post exactly where you need it out in the field!

Location shoots give you the chance to provide your subjects with something different from the typical portrait sitting. Every area has a special site of some sort that can serve as a backdrop for memorable images, such as a gorgeous hotel lobby, public park, forest, or lake. One photographer whom I know lives on some wooded acreage complete with meadows, stands of trees, and a pond. You can bet that he uses these environmental settings as often as possible for his people pictures.

Setting Up an Informal Portrait Studio

Many photographers pursue their art as a hobby or sideline like a simple, informal home studio that can be set up easily and broken down when the shoot's done. Such a studio fills their needs without taking over part of their house.

Others want to have the option of taking their show on the road. A simple portrait studio can also be a transportable portrait studio. Even if you're working on a tight budget, you can come up with a lighting system that improves your photography.

Depending on your needs, a pair of accessory flash units helps give you the balanced lighting that you need if you want to capture that natural-lighting look. If your budget permits a better system, you can build up to a more powerful semiprofessional system. You'll find that an investment in slightly better equipment can be worth it. Portrait lights that I purchased for use with film cameras a few decades ago work just fine with my latest digital cameras, and their initial cost averages out to just a few dollars a year.

Choosing backgrounds

Sometimes you want to pose people in their natural environment, even for formal portraits. A family can be posed in their living room seated on a couch. An attorney can be pictured in front of a wall of law books. (This is almost a tradition. Don't forget to include a flag!) If you apply the same rules of posing and lighting to such a portrait as for more traditional studio portraits, the results will be quite good.

However, most formal portraits call for a real portrait background. For an indoor studio, you'll want something more attractive than just a bare wall for a background; fortunately a wide variety of choices is available for every budget.

✦ **Go disposable with paper.** The simplest choice is a roll of seamless background paper, like that shown in Figure 3-3. These rolls are available in a wide variety of colors and are easy to use. Usually, you just suspend a roll on some kind of hanging support and then unroll as much as you need for a shoot. (**Hint:** Bring enough down to cover a couple of feet of floor and have your subject stand on it.) When a section of the backdrop

paper becomes dirty or wrinkled, you roll down some clean paper, cut off the damaged part, and just throw it away. You can keep a selection of three to five different rolls and switch them as needed.

✦ **Upgrade to fabric.** Other background choices include painted linen backdrops that provide a more interesting texture and color gradient. Because these backgrounds are more expensive and weigh more than the seamless paper, they might not be a great choice for a portable set up or for the home enthusiast (who might need to use the studio for normal family things when not doing photography).

✦ **Use more than one backdrop:** A higher-end system for those making their living doing portraits offers a multiple-background setup that can be used for either a permanent studio or a traveling one. Such a rig has multiple rollers with different backdrops on it. The portrait photographer creates one set of portraits with one background, and then another set with a second or even third background. Often, the backgrounds and poses complement each other — say, an athletic field for a sports-type portrait, with props such as a football in the child's arm. This way, you can create a combination of both formal and informal images.

Nothing is more distracting than using a cluttered wall as a background. Even a simple roll of seamless paper as a backdrop can do a lot to make your portraits look more professional.

Figure 3-3:
Seamless
paper can
be the
simplest
choice.

Selecting supports for lights, camera, and subjects

Good portraits really require lighting beyond the flash built in to your digital camera. In most cases, you need two or more external lights. And because lights, cameras, and subjects all need to be moved from time to time, how you support them is important. Supports need to be light enough to move around easily, collapse small enough to be portable, and yet be sturdy and solid enough to safely hold your gear.

You need different supports for lights, backgrounds, camera, and people. As usual, the choices span all budgets and setups. Try to build a system that will allow for future upgrades or studio expansions.

When planning your support system, aim for versatility and portability. Here are some things to consider:

✦ **Lighting supports:** Your lighting supports should be strong enough to support an external lighting unit, up to and including a relatively heavy flash with soft box or umbrella reflectors (more on these later in the upcoming section, "Lighting gadgets"). You want the supports to be capable of raising the lights high enough to be effective. Look for light stands capable of extending 6–7' high.

✦ **Camera support:** A good, solid tripod that's sturdy enough to support your camera represents the starting point. If your setup is likely to call for a lot of back and forth movement as you shift from individual to group portraits, you might want to consider a camera *dolly* device — a kind of wagon on wheels — that lets you slide your camera/tripod rig back and forth as needed.

✦ **Subject support:** Posing your subjects is easier if you can have them sitting rather than standing (usually why portrait sessions are known as *sittings*). The tool of choice for this sort of thing is the pneumatic posing stool. These stools are much easier to operate than corkscrew-type chairs, which have to be spun to raise or lower them to the right height for portraiture. With a pneumatic stool, you simply press a lever to control an air-driven piston that raises or lowers the chair. At under $100 each, they are reasonably affordable. A posing table is also a useful option, particularly if you need to do a shot of a baby in his or her carrier. You don't need to spring for these devices, however: Stools and tables around the home can serve the same purpose.

If you do want to go with photo gear, you can find lots of different options at most camera stores or advertised in many camera magazines. A good basic setup includes at least one posing chair (preferably two), three light stands (two capable of reaching six to seven feet high and a third, shorter one), a mobile tripod, a posing table, and posing blocks. *Posing blocks* are nesting wooden blocks made in varying heights that are big enough for people to stand on. Using these blocks helps you make people taller as needed to get the proper posing relationships.

Figure 3-4 shows a bird's-eye view of a full-blown portrait setup, including a tripod-mounted digital camera, seamless backdrop paper, a light to provide the main illumination, another light to fill in the shadows, and optional lights to brighten the hair and background. In the center of it all is our victim, seated on a folding chair (although a stool is often a much better choice).

Basic lighting equipment

Lighting your subject properly is one of the most challenging aspects of portrait photography. At your disposal are many different approaches to lighting and also many different types of lighting resources.

A beginning photographer can definitely create a basic, inexpensive lighting system capable of delivering high-quality results. Putting together a lighting kit depends on your budget, what kinds of portraiture you hope to do, and how big a percentage of your photography this kind of shooting is. Obviously, the photographer who needs to shoot only the occasional portrait can get by with a less sophisticated setup than someone who wishes to focus mainly on portraiture. Lighting choices fall into several different categories, as the following sections make clear.

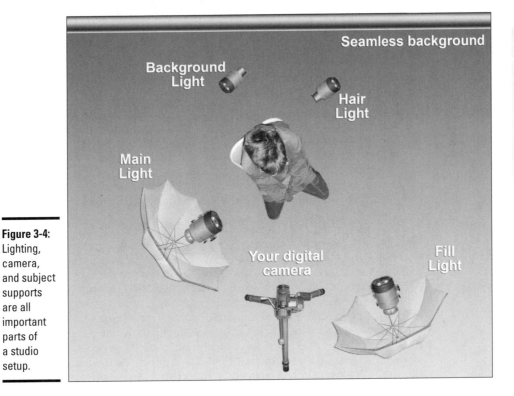

Figure 3-4:
Lighting, camera, and subject supports are all important parts of a studio setup.

Existing light

Existing light is the light that's already there in your environment — that is, before you add flash or other extra light sources. Also called *available light* (or, by wags, *available darkness*) all three terms are a bit of a misnomer. After all, *all* light that you can use exists (unless you're into quantum mechanics, in which case, it only potentially exists until it's observed). *Available light* is equally murky: If you have an electronic flash or a flashlight in working order, both of those are technically available. However, I'll apply those terms to the light that's already on a site, and not the kind of illumination you'd use to photograph Shrödinger's cat.

To make the most of existing light, consider these points:

✦ **Reflectors:** *Reflectors* enable you to bounce light into areas of the scene that need it. Any material that can bounce light into areas of heavy shadow can help make existing light work in your favor. Whether your reflector is an assistant holding a piece of foam board or a reflective disk held in place by clamp and stand, this kind of illumination can be an inexpensive and portable way of making your lighting better. Although some pretty fancy (read *expensive*) reflectors are on the market, spending a lot isn't necessary. A simple piece of white foam board does the job beautifully. Use your main light source (daytime outdoors, that will be the sun) to light a three-quarter section of your subject and then position the reflector to bounce sunlight onto the remaining quarter. This will lighten the shadows and give a greater sense of dimension to your photo. If you want a little less softness in the shadows, use a metallic reflector. You can even press a metal serving tray into use, like the one shown in Figure 3-5, if you can convince a friendly observer to hold it up for you.

✦ **Room lights:** Sometimes your goal is the most natural possible setting and feel to an image. If this means working without accessory lights, managing the room's lights properly can be a big help. If you can position a lamp to throw a little more light to a shadow area, you can clean up a heavy shadow. Or depending on the mood you're aiming for, you can bring your lights all to one side and have your subject emerging from the shadows.

Working with available darkness is one of photography's greatest challenges. However, if you can use it successfully, you can produce exceptionally natural-looking images. Look for ways to control the impact of the building's lights; remember, you don't have to accept what's there. Shift a lamp closer or farther from your subject. Unscrew some light bulbs while leaving others on or mask lighting fixtures with cardboard or *gaffer's tape* (a special kind of tape that won't leave a residue when pulled off the lights when you're done). The difference is worth it. Figure 3-6 shows an outdoor snapshot taken in bright sunlight (at left.) In the version at right, the subject has been moved so that the sun isn't glaring in her face, and a reflector provides soft illumination.

Figure 3-5:
A metal
serving
tray can
function as
a reflector
in a pinch.

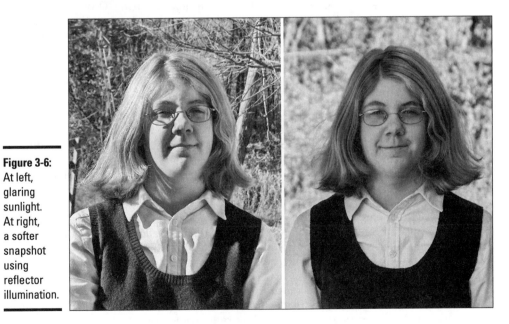

Figure 3-6:
At left,
glaring
sunlight.
At right,
a softer
snapshot
using
reflector
illumination.

Electronic flash

Accessory flash units are your first tool in the battle to correct undesirable lighting conditions. These small, portable light sources provide you with a lot of options and can be used to produce some amazing results. Photographers using a multiple flash setup can produce lighting results similar to those found in the studio. You can put together a small, three-flash lighting kit that can fit in a small suitcase or carrying case. If you're planning to put together such a flash kit, here are some things to consider:

✦ **Supports (again):** You definitely need some sort of system for holding your flash units in position. Lightweight minitripods that can be set on tabletops or other elevated surfaces and positioned as needed work well. The marketplace has also produced a wide variety of clamps with standard ¾" tripod threads that can also hold a flash and be used to position it high enough to work effectively. Some tripods also come with feet or stands they can be mounted on so that they can be set erect on a flat surface.

✦ **Light modifiers:** After you position your flash units, make the quality of your light as pleasing as possible. When used head-on, direct flash is harsh, showing every few flaws and imperfections. Experienced photographers have a number of different ways of solving this problem. One solution is *bounce flash*. Here, the flash units are pointed toward the ceiling, and the light is reflected back down to the subject, thus spreading and softening the light and making it more pleasing. Other tools for improving the quality of light are devices that attach to the flash head and reflect light (such as white cards) or ones that cover the flash head and soften the light as it comes through the device (such as the Sto-Fen Omni Bounce [www.stofen.com, about $20] or a small soft box, which is basically nothing more than a piece of white cloth or other material stretched over a frame).

✦ **Power:** Keeping your flashes firing during a long shoot can be a daunting task if you're relying solely on AA batteries. Devices such as Quantum rechargeable batteries (www.qtm.com; prices vary widely depending on your model) can provide enough juice for your flash units to keep pace even with your most frenetic shooting pace. Many of these units can provide power to a pair of flashes simultaneously.

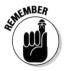

Two or three good flash units with some form of supporting gear and the appropriate light modifiers can give you a very effective portable lighting set up. Such a kit can give significantly better results than just a single flash unit and is versatile enough to be useful in a variety of situations.

Photographic *slaves* — electronic units that trigger multiple flashes not connected physically to the camera — are needed to fire the flashes with either a photoelectric trigger or wireless radio transmitter.

Incandescent lights

Incandescent lighting is the same lighting most of us use to light our homes. Enterprising manufacturers have created inexpensive photo lighting kits that use regular light bulbs instead of more expensive tungsten-halogen lighting setups.

Professional studio lighting

If you're serious about portraiture, you might want to consider professional studio lighting, which isn't really all that expensive for the photo hobbyist who spends a thousand dollars or so on a camera alone. Many digital cameras are capable of firing expensive and high-quality studio lighting kits. These kits, which use very powerful flash heads, provide a predictable, steady light source.

There are several differences between these flash heads and the more common accessory flash units that I discuss earlier. For a start, their power output is measured in watt seconds (ws) versus the guide numbers (gn) that on-camera flashes are usually measured in.

Another difference is that these units draw too much power to get by on either batteries or portable power packs. Instead, an electric outlet feeds them either directly or via a separate power supply (which can usually feed two or more lights at a time).

Using such a high-power system has several advantages:

✦ **More output:** The nearly unlimited power supply means that you can get greater light output. This enables the photographer to shoot at smaller apertures (larger-numbered f-stops). The resulting greater depth-of-field provided by smaller apertures means that you can shoot larger groups of people and have them all in focus. Plus, you get sharper overall images.

✦ **No recycle lags:** You don't have to wait for your lights to recycle. You can blaze away taking shot after shot.

✦ **Flash previewing:** You can take advantage of *modeling lights,* which are incandescent lamps built in to the studio flash that show exactly how the light from the flash will look. Many of the higher-quality studio lights have built-in modeling lights that stay on the whole time you're working. These lights aren't as powerful as the main flash heads, but they do show you where shadows will fall on your subject.

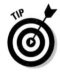

Use modeling lights to check for *hot spots* (bright specular reflections) on eyeglasses.

✦ **More control:** You have more control over lighting. You can set one light for full power and another for a lower percentage of power output — the full-power light acts as a main light while the second less powerful light simply fills in the shadows.

Studio lighting kits can range in price from a few hundred dollars (for a set of lights, stands, and reflectors) to thousands for a high-end lighting system complete with all the necessary accessories. The good news is you don't need the top-of-the-line system to produce top-of-the-line results.

Lighting gadgets

A huge assortment of lighting gadgets is on the market, all promising to be easy to use and producing a higher quality of light. For the most part, these claims are reasonably true. Here's a quick summary of what's available, ranging from useful and just about free all the way up to high-tech and pricey.

Inexpensive (or free!) gadgets

No such thing as a free lunch? Guess again! Check out these great ideas that won't blow your budget:

✦ **The White Card Trick:** This is the all-time classic. Set your flash to bounce mode (point it at the ceiling) and take a 3-x-5" index card or other card and attach it to the flash with a rubber band, as shown in Figure 3-7. Have the card extend three or more inches beyond the flash head. When you fire the flash, some of the light bounces off the ceiling while more light kicks off the white card to throw some light into your subject's face.

✦ **The Spoon Trick:** If your supply of index cards has been depleted, you can always give The Spoon Trick a try. Similar to the preceding method, use a cheap, white plastic spoon much the same way. Some photographers maintain that the curvature of a spoon throws the light out in a curve to provide a more pleasing effect. I've used both methods, and they both work pretty well. It's also pretty easy to carry some rubber bands, plastic spoons, and index cards in your camera bag, or find the stuff at most shooting locations.

✦ **The Alcohol Bottle Trick:** Just so it doesn't look like all I know is different versions of the White Card Trick, here's one that's a little different. Get one of those white frosted plastic bottles of rubbing alcohol (one whose waist is about the same diameter as your flash head). Remove the alcohol (this is important), and then cut the bottom of the bottle about

two inches down the waist. Then snug the waist (the end with the bottom) over the flash head. You can now shoot with the flash head angled almost vertically with a much softer light. (The Alcohol Bottle Trick creates an inexpensive alternative to a product known as the Sto-Fen Omni-Bounce described in the next group.) You can also use a spoon as a reflector.

✦ **The Clear 35mm Film Canister Trick:** If you have only a small, fixed flash — *fixed* as in it won't pivot or tilt, not fixed as in *repaired* (but this won't work if the flash is broken either) — here's another way to soften and spread the light from it. Take a clear, 35mm film canister (see whether one of your less technologically advanced friends has one you can get from them or try a camera store) and tape it over the flash head. Variations of this trick involve placing a sheet of facial tissue inside the film canister to diffuse (soften) the light a bit or using colored tissue papers to change the color of the light the flash produces. This isn't as big a deal these days, when you can produce all sorts of similar effects in an image editing program. Still, if you're not real comfortable trying effects in the computer, this method lets you experiment while taking the shot.

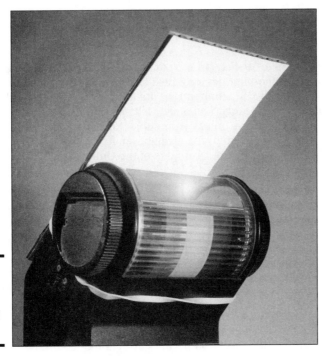

Figure 3-7:
The White Card Trick provides fill lighting.

✦ **Flash brackets:** Many department stores carry cheap, L-shaped flash brackets. Your camera mounts onto the flash bracket, while your flash fits into a flash mount at the top of the L. To use a setup like this, you have to have some way of triggering your flash when it is not attached to the camera. There are several ways to do this. If your camera has a PC connection (and I don't mean the way to connect it to your computer or politically correct; I'm talking about a small circular electrical linkage), you connect your flash via a PC cable. A second method is to use a photo-electric slave to trigger your accessory flash unit. To do this, you use your camera's built-in flash unit, perhaps blocking most of its light output with gaffer's tape or masking tape.

As you can see, you have many inexpensive ways of improving the quality of your artificial light. Even the simple White Card Trick combined with bounced flash gives you much better results than bombing away with direct flash. Keep this method in mind even when your available light is enough for a good exposure because the light kicked forward from the white card is a great way to fill in shadows from ball caps and other similarly billed haberdashery items.

Moderately priced gadgets

For just a few pennies (well, maybe dollars) more, you can add the following items to your lighting toolbox:

✦ **Omni-Bounce:** Sto-Fen (www.stofen.com) makes several inexpensively priced light modifier devices. Best known is the Omni-Bounce, which is a frosted plastic attachment that fits over the flash head and softens the light considerably. The device is used by setting the flash head to a 45-degree angle — unless your subject is more than 15 feet away, and then you set the flash to fire straight-on. Its price is about $20. The company also makes colored versions of the Omni-Bounce, which cost a few dollars more.

✦ **Two-Way:** Also made by Sto-Fen, the Two-Way bounce is a sturdier approach to the White Card Trick and works in a similar manner. Its price is also about $20.

✦ **LumiQuest attachments:** LumiQuest (www.lumiquest.com) makes a whole range of flash attachments offering a whole bunch of different capabilities. These range from simple bounce hoods that kick the flash's output forward and spread it out to ones that perform very specialized functions. Variations of the basic bouncer include attachments to allow some light to bounce off the ceiling while the rest is kicked forward. Another version sends the light through a frosted panel to soften it even more, and a third variation permits insertion of colored panels to change the color of the light that the flash produces while bouncing it.

✦ **Soft boxes:** A *soft box* is an attachment that mounts on the head of the flash and extends out about six to eight inches, with a frosted white panel at the end. This attachment lets the light from the flash spread out a little bit inside the soft box, softening it as it passes through the frosted end. (Pro portrait studios often sport a similar, but much larger version on their studio flashes.) Lumiquest, as well as several other companies, also makes soft box attachments for portable flash units.

✦ **Snoots:** LumiQuest also makes a snoot. (No, the company is not snooty; it makes a snoot.) A *snoot* is a tube-like device that focuses the flash's light to a very small area. A common example of how a snoot is used is to create a highlight on someone's hair.

✦ **Barn doors:** LumiQuest's barn doors attachment fits several of its bounce flash attachments. Barn doors are flat panels, like those shown in Figure 3-8, that can be swung open and closed to more finely tune light output.

✦ **Flash brackets:** Moderately priced flash brackets tend to be sturdier than their inexpensive counterparts. Plus, they usually tend to lift the flash higher up above the camera. Otherwise, things work pretty much the same way.

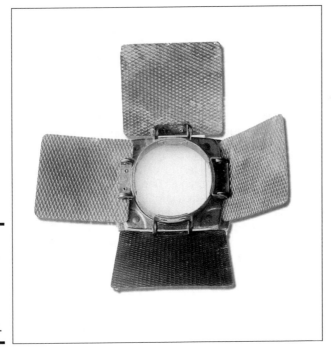

**Book III
Chapter 3**

Photographing People

Figure 3-8:
Open and close barn doors to fine-tune your illumination.

A decent light modifier can be a pleasure to work with, significantly improve your photos, and needn't cost you an arm and a leg. You'll find that many can be had for less than $50. A wide variety of choices are available, depending on your needs. For photographers who work mainly out of a camera bag, a small, collapsible light modifier is a better choice than one of the bigger, more cumbersome units. Those who work from a home studio are better off with one of the bigger soft boxes that give a nice quality light.

Higher-priced gadgets

I'm not talking thousands of dollars here, but costs for the following items can still add up a bit. (***Note:*** Quality rises with the price.)

+ **Soft boxes:** Some companies make a fancier soft box attachment that mounts on the flash head via spring-loaded clips. These devices are bigger and feature a deeper well for the light to spread out before hitting the frosted panel. They also tend to be sturdier than the less expensive versions.

+ **Umbrella units:** Another option is to mount your flash on a combination flash stand with photographic umbrella. This kind of rig lets you set up a multiple flash lighting system that produces very pleasing lighting without the expense of buying portrait studio flash heads. Usually these devices need to be triggered via some form of slave. The price is about $100. You can also get by with *real* umbrellas as long as they're plain white with no pattern, like the ones shown in Figure 3-9. Fold-up umbrellas are inexpensive, and because a fold-up umbrella can be quite small, easy to carry. I pay less than $5 for mine, not including clamps to fix them to light stands or other supports. If one gets dirty, just throw it away and use a new one. The chief disadvantage is that these translucent rain-stoppers let as much light through as they reflect. In fact, you might have better luck using them to illuminate your subject by the light that leaks *through* the umbrella rather than bounces off.

+ **Flash brackets:** Examples in this category tend to be very sturdy and can extend the flash as much as one foot or more higher than the camera. Some offer expanded capabilities — such as the ability to accept a flash umbrella, making for a heavy but versatile rig. Many of the more expensive units, such as several made by Stroboframe, offer the ability to rotate the camera and/or flash for vertical orientation. Go to the following Web site for more information about Stroboframe products:

 `www.saundersphoto.com/html/body_strobo.htm`

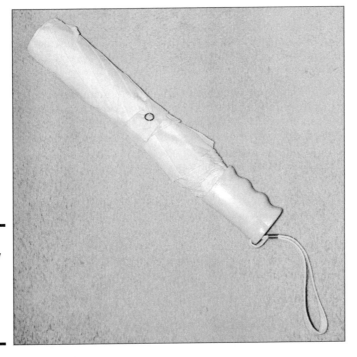

Figure 3-9:
An ordinary white rain umbrella makes a good reflector.

If you're serious about using your digital camera for portrait photography, the equipment mentioned here adds a lot of bang for your buck. The umbrella rigs tend to be better for studio setups whereas the soft boxes and heavy-duty flash brackets stay manageable for photographers who do most of their work on the road.

Choosing power sources

Keeping your portrait flash units supplied with power is a key to effective flash photography. You have several ways of getting juice to your flash heads, and they vary in both price and effectiveness. Don't skimp here if you expect to rely on your flashes. The wrong choice will cost you images and make you miserable. Choose from these power sources:

✦ **AA batteries:** These are the standard power source for your average accessory flash unit. The advantages are that they're inexpensive and can be found almost anywhere. There's a choice among alkaline, lithium, and standard types. Alkaline and lithium are better choices because they

recycle faster than the standard type. Rechargeable versions are available in several different versions, including nickel-cadmium (NiCads), alkalines, and nickel metal-hydride (NiMH). The big disadvantage to all of these is that they drain fairly quickly, leaving you to frantically change batteries while hoping you don't miss a shot.

✦ **Portable battery packs:** Several different manufacturers make high capacity portable battery backs that can provide power for a wide variety of flash units. The best-known manufacturer is Quantum, which makes several different styles along with adapters for most current flash units. Although these rigs are much more expensive than AAs (figure between $150–$200 for a new battery pack and flash module), they can power tons of flash cycles before running out of juice. They also keep your flash firing longer during motor drive bursts (although not indefinitely).

A good, portable power pack can provide enough juice to power a couple of flash units through a wedding, prom, or public affairs event. Having one available can really make your life easier.

Lighting Basics

The idea behind using artificial light is to provide enough illumination to adequately light your subject in a pleasing manner. The simplest, most basic method is to use a single flash — preferably with some form of light modification or by bouncing — with the flash unit raised higher than the camera.

There are several ways to maximize the effectiveness of a one-light photographic system. First and foremost is to get the flash higher than the camera. The closer the flash is to the lens, the greater the likelihood of *red-eye* (that nasty red glare that appears in the eyes when light bounces off the subject's retina), so extending your flash unit's height helps your photography quite a bit. Ways to do this include

✦ **The ol' Statue of Liberty play:** Use an *off-camera shoe cord* (an intelligent cord that communicates between the camera and dedicated flash unit to retain the camera's ability to meter light through the lens) or a PC cord to lift the flash high above the camera. Then either point the light directly at your subject or bounce it off the ceiling.

✦ **L-brackets:** Use an L-bracket — or something based on an L-bracket design, such as a Stroboframe grip — to raise the flash up above the camera.

✦ **Use a flash stand with an umbrella reflector:** This either requires a long PC cord or a wireless transmitter to trigger the flash unit.

One advantage of getting the flash higher than the camera is that it re-creates the single high light source that you're used to seeing naturally — that is, the sun. A second advantage is that by getting the flash higher than the camera and at a higher angle, you reduce the likelihood of red-eye. That's because red-eye is caused by electronic flash illumination reflecting straight back off the retina of the eye into the camera lens. When the light strikes the back of the eye at a higher angle, it's reflected downward and away from the lens.

Using multiple light sources

A more advanced but still basic lighting system calls for multiple lights arranged in one of several different possible ways. Although a multiple-light system doesn't re-create the natural light of the sun, you can create a very pleasing and effective lighting package.

Advantages of a multiple-light system include

✦ **Precise control over how much illumination you provide for a scene:** Even if your lights are more powerful than you want, you can add screens to reduce output or shift your lights farther back.

✦ **More control over the mood of the image:** You can control the location and intensity of shadows and highlights, which can affect the overall mood of the image, whether it's stark and full of contrast or soft and moody.

✦ **An adaptable lighting kit:** You can adapt your lighting kit to a wide variety of shoots and to any number of subjects. Some lighting kits are even versatile enough to be brought on location.

Multiple lighting setups can mean the difference between an adequate portrait photo and a good one. Although a multilight setup doesn't guarantee better quality, getting the hang of such an arrangement will do a lot to improve your portrait photography.

Arranging a multiple-light setup

After you decide you want to use a multiple-light setup, you need to know where to put it. Setting up a multiple-light system isn't very hard; it's just a question of positioning your lights to illuminate your subject in an attractive manner.

With a multiple-light setup, each light has a different role to play. Understanding the basic arrangement helps you get started down the road to good portrait photography.

Main light

Surprise, surprise. This is your primary light source. The main light provides most of the illumination for your subject. An effective two-light studio system can even be set up with a big main light firing straight on your subject through a big soft box (not the kind that mounts on an accessory flash, but a big studio model about 18 inches tall and 36 inches wide) with a second back light to separate your subject from the background (more on back lights in minute).

This principle also works with a smaller shoe mount flash and soft box, but the quality of the light won't compare with that of the studio system. Generally, the difference is noticeable when you're trying to shoot larger groups or doing a lot of sittings. For an occasional small group and a limited number of exposures, the small portable system does the job pretty well.

The following list fills you in on some ways to maximize the effectiveness of your main light.

- **Get it up high.** Your main light should be higher up than your subject. You don't have to be ridiculous here; keeping the light about a foot or so higher than your tallest subject will do the trick.

- **Make an effort to improve the quality of your light.** You can do this either via a soft box or by using an umbrella system.

- **Provide enough power to shoot at a small aperture, thus giving you greater depth-of-field.** Because shooting through a soft box or off an umbrella costs you some light, you need a lot of power to shoot a big group at f/11 or f/16.

- **Recycle quickly.** How quickly your main light recycles (recharges so that it can be ready to fire again) is very important. You want your lights to keep pace with your workflow, not the other way around. During a sitting, it's important to develop a rhythm with your clients while posing and photographing them. A break in that rhythm, particularly one caused by your lights not being ready, can make your life difficult.

You want your main light to provide a soft, even illumination with enough power to keep your subject in focus from front to back. Most often, the main light is set up a couple of feet to the right or left of your subject's center line and angled toward that center. Figure 3-10 shows a portrait subject illuminated only by a main light.

Figure 3-10:
The main
light
provides the
dominant
illumination
in a photo.

Fill light

The fill light is the light that's used to fill in the shadow areas created by the main light. For the most versatile system, plan on using the same model flash for your fill light as you do for your main light. This gives you the option of setting the same power ratios — the settings on your flash that reduce or increase the amount of light emitted — for each light. Such a lighting system with two comparable lights about six feet apart angled toward the center point of your sitting enables you to build up your group size without having to reconfigure your lighting — which a huge advantage if you're doing a large number of portraits during the course of a day.

Just because you can bomb both flash heads away at their highest power settings and create an even light doesn't mean that you have to. You can always dial-down the power setting on your second flash head and create a more interesting lighting effect for your subject. Experiment with 2:1 and 3:1 power ratios to see which you prefer.

If you have a fill light that doesn't let you reduce or increase the power, try moving the flash back a bit or perhaps placing a diffuser (such as a handkerchief) over the flash. Thanks to your digital camera's review feature, you can quickly see whether you've reduced the amount of light enough.

Here are some tips for setting up your fill light:

✦ Your fill light should be roughly the same height as your main light although slightly lower is okay.

✦ The fill light should also receive some kind of modification, via an umbrella, soft box, or *diffusion screen* (a thin screen-like material that diffuses or softens the light).

The fill light helps balance your portrait lighting and creates a sense of depth to your image. Used properly, it can also create a moody or romantic image through the carefully controlled play of shadows. Figure 3-11 shows the photo with a fill light added.

Hair light

A *hair light* is a small, carefully controlled light used to put a highlight on the subject's hair. This type of lighting can also be referred to as *rim lighting.*

Most often, hair light is controlled via either a snoot or through a barn doors attachment on a flash head. The light itself doesn't need to be particularly powerful because it's responsible for lighting only a small area. Most often, a hair light is positioned closely to the subject (just out of the camera's view) via a *boom* (raised arm attached to a lighting stand) that allows it to reach into the portrait area from up high.

Figure 3-11:
A fill light
brightens
the
shadows.

To use a hair light, position it so that the light is directed almost straight back into the camera, raking across the top of the subject's head. See the effect like the one shown in Figure 3-12.

Background light

A background light, as its name suggests, is used to light up the background as well as create some separation between the subject and background by making the background lighter than the main subject.

This light is generally mounted on a small lighting stand and is pointed upward at the background; a small screen is usually mounted on the light to help spread the light over the backdrop. Be careful to position it so that the lighting stand stays hidden behind your subject.

When using the background light, keep the following tips in mind:

+ Set the background light about two feet from the backdrop and about two to three feet off the ground.

+ Try to keep your background light on a separate power circuit than your main and fill lights. Because the main, fill, and background lights are usually the most powerful lights in your setup, having them on the same power supply or circuit will probably stress your power source more than it can handle.

+ Angle the background light upward about 45 degrees so that the light spreads upward and outward from below your subjects.

+ Mount a diffusion screen (which can be as simple as a handkerchief or any other diffusing material) on the light head to soften it as it spreads up the backdrop. Using the screen helps prevent the light from creating a *hot spot* (those annoying bright areas that can crop up in a background if the light isn't spread evenly).

Adding a background light to your portrait setup makes for a cleaner, more pleasing portrait — like the one shown in Figure 3-13 — because it helps separate your subjects from the background. Although hardly the most important light in your setup, your subjects can get lost in a dark background without a background light.

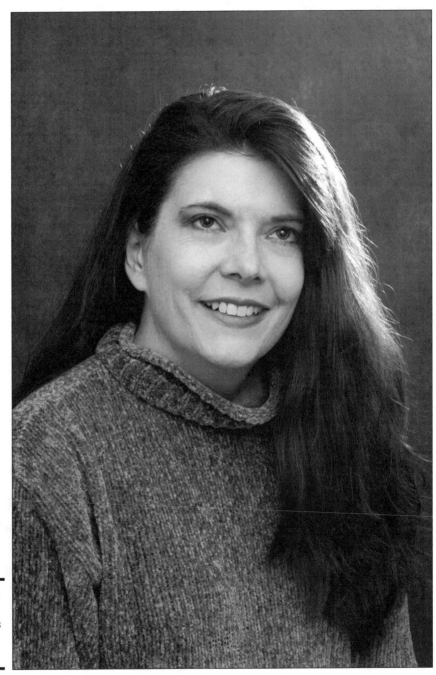

Figure 3-12:
A hair light
emphasizes
the edge of
the head.

Figure 3-13:
A background light separates the subjects from the background (natch!).

Additional light sources

Using the four lights discussed in the preceding sections will take care of the majority of lighting situations, but they're certainly not the only tools to create interesting lighting. For some neat alternatives, try one (or more) of the following:

✦ **Reflectors:** Rather than using a fill light, a photographer sometimes bounces light from an angled main light into a reflector positioned near the model but still outside the picture area. This can be a good solution if you don't own a second electronic flash.

✦ **Window lighting:** Another charming source of light can be the nearest window. Window-lit portraits require a bright, sunny day with sunlight pouring through the window. Position your subject on a chair near the window. Make sure that your digital camera takes its exposure reading from the portion of his or her cheek that's illuminated by the sunlight. If done properly, your subject appears to emerge from the shadows bathed in a golden glow. A variation of this lighting technique is to use a reflector to kick some light back into the shadow area so that some detail is returned to the side that doesn't receive sunlight.

✦ **Sun and fill:** A typical example of this form of lighting is the swimsuit model at the beach. The model is positioned so the early morning sunlight acts as the main light, and a reflector is positioned to direct some light into the shadow areas. This is a very nice style of lighting; unfortunately, it requires you to get up early!

The preceding two methods can produce some beautiful lighting but are hard to use for groups or a large number of sittings. It can be hard to schedule a sitting for this kind of lighting technique, too.

Basic Lighting Techniques

If you understand the basic lighting equipment and how it's used (which I describe in the previous sections), you're ready to discover common techniques that you can apply with main, fill, background, and hair lights. In this section and the next, I describe several different lighting techniques, each with its own advantages and disadvantages. Although you can set up a basic lighting style that produces an even, acceptable light that works for a variety of situations, doing so doesn't necessarily bring out the best in your subject. Still, you might find yourself in a situation that calls for you to photograph a large number of setups as efficiently as possible. Such jobs — weddings, church directories, and proms, to name a few — come up quite often and call for photographers to shoot lots of different setups (which photographers call *sittings*) quickly.

**Book III
Chapter 3**

**Photographing
People**

Keep the following basic lighting setups in mind for those times when you have to shoot a lot of sittings as efficiently as possible:

✦ Set up your main light straight down the center and use a big soft box to spread and soften the quality of the light. Set up a second light as a background light, and you're good to go. Depending on the size of your soft box, the power of your main flash head, the size of your backdrop, and your posing resources, you can easily light a 15- or 16-person group. There's not a lot of flexibility to this setup, though.

✦ Use a three-light arrangement with a pair of identical flash heads firing into umbrella reflectors as your main and fill lights. Set both flash heads for the same power output so that you don't have to worry about rearranging your subjects according to shadows. Set your lights up about six feet apart, with each pointed toward the center posing spot, and about four or five feet up from your subject.

These basic lighting setups will get you started. You can take a nice, professional looking portrait with either of these lighting arrangements, but your portraits won't look much different from those of the photo studio at your local department store.

Advanced Lighting Techniques

Which technique you choose depends on your subjects' features. One style of lighting can flatter a person's face while showing another's poorly. Each technique can be created with a basic three-light lighting kit.

As you increase your photographic capabilities, effectively using more advanced lighting techniques can help you stand apart from the MegaMart down the block.

Short lighting

Two forms of advanced lighting techniques rely on turning your subject's head so that his or her face isn't staring directly into the camera. One of these is *short lighting,* where the main light source comes from the side of the face directed away from the camera, as shown in Figure 3-14. (The other is *broad lighting,* which I discuss in the following section.) Sometimes referred to as *narrow lighting,* short lighting is a valuable lighting style because it tends to narrow overly broad faces.

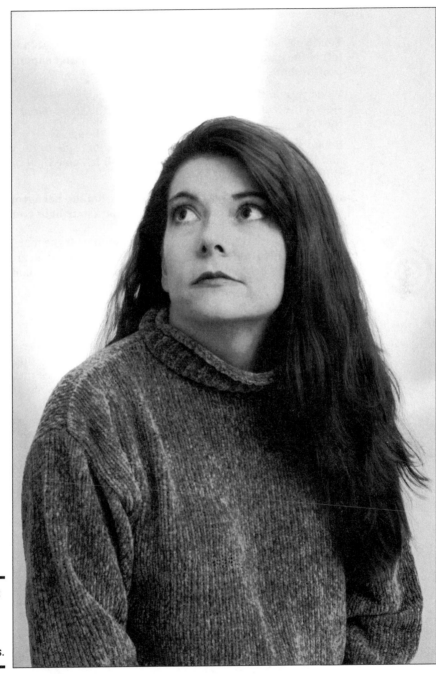

Figure 3-14:
Short
lighting
narrows
broad faces.

To set up a short lighting arrangement, do the following:

1. **Turn your subject's face so that it's angled somewhat to the right or left of the camera (not too much, though; this isn't supposed to be a profile shot).**

 When you do this, the side of the face you can see more of is the broad side of the face; the side you see less of is the short or narrow side of the face.

2. **Set up your main light to illuminate the short side of the subject's face and then add a fill light or reflector to fill in some light on the broad side of the face.**

3. **Add a fill light to separate your subject from the background for a good three-light setup and a hair light for a four-light configuration.**

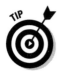

Short lighting is a particularly nice form of lighting for the female face because it accentuates the eyes, cheeks, nose, and mouth in an attractive way. This style of lighting can also be used to make a broad male face look thinner.

Broad lighting

Broad lighting, as shown in Figure 3-15, is pretty much the reverse of short lighting. It widens narrow or thin faces by emphasizing the side of the face turned toward the camera. Here the subject's face receives the main light on its broad side, with a fill or reflector used to lighten or eliminate the shadows on the short side.

This is a useful lighting technique for thin faces, but use it carefully with women, who may not appreciate having their faces widened even if you think the look would be more flattering.

To set up a broad lighting arrangement, do the following:

1. **Turn your model's face so that the main light illuminates the broader side of the face.**

2. **Use your reflector to bounce some light into the shadow areas of your subject's face.**

 Be careful with this lighting technique because it can make a normal face seem very full.

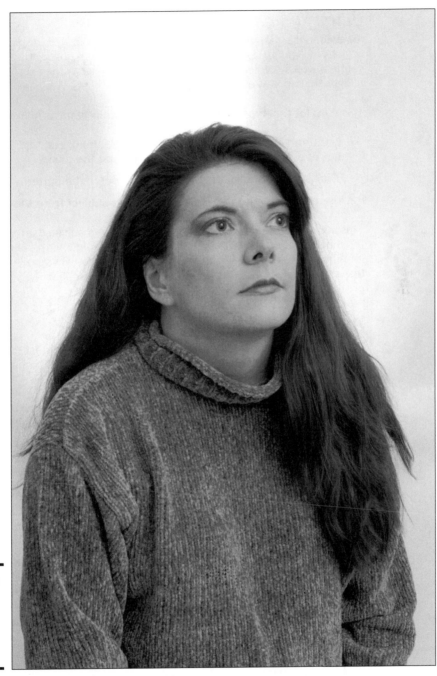

Figure 3-15:
Broad
lighting
widens
narrow or
thin faces.

Butterfly lighting

An even more glamorous style of lighting that works well for posing women is *butterfly lighting*, as shown in Figure 3-16. This type of lighting creates a subtle butterfly of light with the bridge of the nose as the axis for the "wings" of light that spread over the eyes and cheeks.

To set up for this type of lighting, configure your lights as follows:

1. **Position your main light straight on to your subject, high above his or her eyes with the light pointed directly on the nose.**

 This is what enables the light to spread out in the butterfly pattern.

2. **Use a background light to separate your subject from the backdrop.**

This style of lighting doesn't work as well for men because it tends to throw too much light on the ears. Butterfly lighting should always be considered for a female subject although that doesn't mean you always need to choose this style. If you use it with a girl or woman who has short hair, the same problem with the ears can occur.

Backlighting

Backlighting, also known as *rim lighting,* can create an almost magical glow or halo-like effect for your subject. An example of backlighting is shown in Figure 3-17.

This lighting style calls for your main light to be placed behind the subject while a fill light prevents the face from falling into shadow. The result is a rim of light highlighting your subject's form.

Here are some ways of using this lighting style:

✦ **Full backlighting:** In this technique, the main light is positioned directly behind the subject, about even with the subject's head. Check your composition carefully to make sure that the light is hidden from the camera's view.

✦ **Side rim lighting:** Here you're trying for just a hint of backlighting to add some glow to one side of the head. This is similar to hair lighting. In this case, though, use a small light rather than your main light. Set up a small light with a snoot (a conical light modifier discussed earlier in this chapter) on a boom pointed at the side of the head, away from the camera. If you don't have a boom arm, try using a light stand as close to your model as possible while keeping it out of the shot.

Practice this technique and get the hang of it. Rim lighting and backlighting are valuable lighting techniques for certain types of portraiture, such as a bride's portrait. Just be careful not to overdo it.

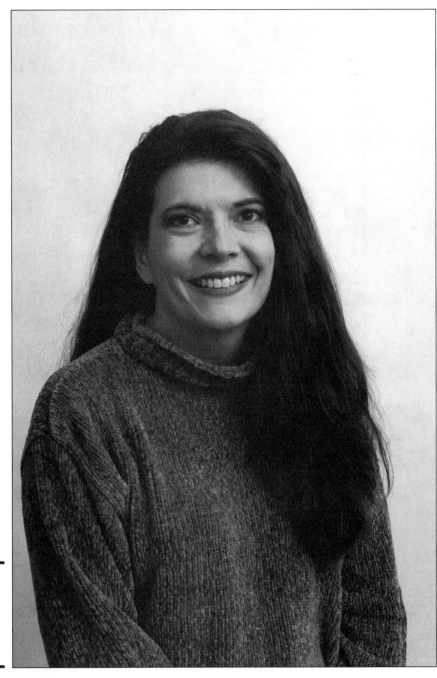

Figure 3-16:
Butterfly
lighting is
good for
portraits of
women.

Figure 3-17:
Backlighting
is dramatic.

Taking Your First Portraits

Studio portraiture is about making your subjects look as they would like to appear — not necessarily as they really are. When you're setting up your poses, reflect upon how to make people look their best.

A good portrait photographer inspires confidence not only in himself but also in a client. The better you can make a person who's posing for you feel about how they look, the better her pose — and the better her feeling about the whole portrait experience. This works in your favor because your subject will likely be interested in buying your photographs.

People pose for portraits for different reasons and in different situations. If you're working on a tight schedule with a lot of sittings in a relatively brief period of time (say a wedding or church directory shoot), you don't have a lot of time to get to know your subjects or establish a rapport, especially for a family. Instead, consider a routine that works something like this:

1. **Pose the family.**

Have Mom seated and Dad as one of the side elements in the diamond pose. See the sidebar, "The diamond pose," elsewhere in this chapter. Then build the rest of the pose with other family member(s).

2. **Shoot the family portrait.**

3. **Pull the kids from the family pose.**

4. **Keep Mom and Dad in place and photograph their portrait.**

5. **Pull Mom and Dad from the sitting and set the kids up into a new diamond pose (depending on how many kids you need to photograph).**

Usually, it's best to pose a group of male children in a line from tallest to shortest. If there's a sister or two, seat the oldest boy and pose the oldest girl as the next diamond element with her hands on his shoulder.

6. **Ask the parents for any special poses they would like.**

Don't be afraid to take special requests; they're usually very likely to be appreciated.

With most families, Mom is usually the decision maker when it comes to things such as family portraits. Make sure you keep her happy. Have brushes and combs on hand as well as lint brushes so that everyone can make sure they look their best. It also doesn't hurt to have some conservative ties and scarves on hand just in case someone has an accident on their way over.

**Book III
Chapter 3**

**Photographing
People**

When you're doing large numbers of portraits (when word gets out how good you are, you're bound to be the hit of the next family reunion!), strive for the most efficient posing setup and flow possible. People who are sitting around in their finery waiting to be photographed can get pretty grumpy, particularly if there's more than one group waiting. A typical pose, using the diamond configuration, is shown in Figure 3-18.

Try to be flexible enough for a special request because sometimes these can be very profitable. I was once part of a team shooting portraits for a church directory when a husband mentioned that he and his new wife never had a wedding portrait done. We suggested that they come back after our shooting schedule was done in their best suit and wedding gown, and we'd do a series of portraits for them. The couple loved the idea, and we spent an hour creating different poses and portraits and ended up with a huge order! Most importantly, we accomplished this without inconveniencing other members of the church and gained a reputation for enthusiasm and service amongst that particular church's members.

If you're working under a more generous time schedule and aiming for a higher-end product, take the time to make your subjects comfortable and see what they're looking for in a portrait sitting.

Figure 3-18: You end up with an attractive pose like this one when using the diamond arrangement.

Although you might still be looking at the basic family portrait package (family, couple, children), it's also very possible that each family member might need individual portraits as well. This could be the time to bring out more specialized types of lighting, such as the broad lighting and short lighting discussed earlier in this chapter.

Be sure to offer your clients some extra poses for each family member, particularly for those kids who go for a variety of sports images in a big way. Have props such as soccer balls, baseball gear, footballs and helmets, and other such items on hand.

✦ **Husbands and wives:** Offer husbands and wives the basic couples pose but also suggest a second pose that illustrates their love and commitment to each other (standing close, gazing into each other's eyes). Depending on their age and demeanor, a more whimsical pose might also be in order. If so, having the husband get down on one knee to re-create his marriage proposal while the wife "thinks" about it can be cute.

✦ **Kids:** A brother and sister can be posed in a diagonal with the boy seated and the girl angled behind him with her hands folded on his shoulder. This is a basic couples pose, but the relationship issue isn't important. If you have two posing stools, you can seat both diagonally one behind the other. A pose that works with two boys is to have them sit back to back with their heads turned toward the camera.

✦ **Mothers and daughters:** Seat Mom and have her daughters arranged in the appropriate number of elements for a diamond pose. Another option — if you have the posing boxes to do so — is to seat Mom on a posing stool and have a daughter or two seated at her knee. A third daughter (the oldest) would be diagonally behind Mom with her hands on her shoulder. If I had them, I'd load the scene with flowers.

✦ **Fathers and sons:** A simple pose would be to seat Dad and build a diamond around him. A more adventurous pose would be to have Dad standing slightly sideways with his off camera hand in his pocket looking at his son(s) posed about a foot away (one diagonally behind the other) while one tosses a ball in the air (the sons watch the ball; Dad watches the sons). A simpler variation would be to have the sons remove their suit jackets (if this is a dressy portrait) and sling them over their shoulders (off camera side) while Dad regards them with arms folded across his chest (still properly attired).

✦ **Infants:** For a fancy pose, look for an old-fashioned baby buggy or other such prop. A lot of choices are available, including simulated giant seashells for the baby to sit in or bearskin rugs to lie on. Generally, how you pose an infant depends on his or her age and physical abilities, such as whether or not the infant can sit up unsupported. Babies younger than six weeks old usually can't focus their eyes on any specific point, so they present a special challenge. Usually, it's best to leave them in their carrier and go for a reasonably tight shot.

The diamond pose

Diamonds are a photographer's best friend. Professional portrait photographers use a diamond formation as their basic foundation for a group photo. Establish your anchor person (usually the mother in a family portrait) and seat him or her. Place the father (or second individual) behind the anchor and halfway to the side. Elevate the seated person so the top of his/her head is level with the nose of the standing person. Have the standing person place his or her hands one on top of the other, slightly angled on the seated person's shoulder. (This is the basic pose for a couple, by the way.) Then do the same with the third person to balance the trio. (This gives you a basic pose for three people.) Place the fourth person directly behind the first person and positioned so that the heads of Subjects 2 and 3 come up to the nose of the fourth person. (Have sturdy wooden boxes or blocks of varying sizes for people to stand on.) Have Subjects 2–4 lean slightly forward from the waist so that their faces are as close to being on the same plane as the first person as possible. That makes everyone on the same plane of focus. Avoid gaps between bodies and make sure that people are close to each other. You have a basic posing system that's expandable to fit 20 people or more.

As a general rule, pose multiple people closer together than they would normally stand if left to personal space comfort levels. Your goal is to maximize the use of space by filling the frame as effectively as possible with people, not backdrop or props. This doesn't mean that you're doing nothing but headshots, though. If you're doing a wedding or prom shoot, people will be in their finest clothes and showing that clothing is appropriate. Certainly the bride in her wedding gown deserves at least one photo that shows her entire dress, including the train.

Shooting the Portrait

Your first family enters your studio ready to have a portrait taken. After you exchange pleasantries, be sure to point them in the direction of the mirrors and check their appearance for any last second adjustments.

When everyone's ready, begin arranging the sitting. Start by seating the mother and build your diamond around her. Make sure each person is sitting or standing up straight. (Place your hand on the front of a shoulder and two fingers at the base of the spine and apply gentle pressure to straighten them up.)

Have your subjects focus their eyes slightly to one side of the lens. Have them bring their chins up slightly so they're looking slightly up and away from the camera.

While seating your subjects, remember the following:

✦ **Make sure that your subjects are sitting up straight.** Slouching just doesn't look flattering to anyone.

✦ **Check to make sure clothing is as wrinkle-free as possible.** Tug suit jackets to straighten out wrinkles if need be.

✦ **Use your modeling lights (if you have them) to make sure you minimize the glare from eyeglasses as much as possible.** No one wants to look like Little Orphan Annie with no eyes.

✦ **Provide a mirror, as shown in Figure 3-19, so your subjects can check themselves over just before you take the picture.** Knowing they look good helps people relax.

Use this time to get your subjects in position and into the right mood for the portraiture. Remember to stay positive and encouraging. Be sure to tell them they look good. Crack a few jokes while positioning people to keep them relaxed, too.

Posing your subjects

In order to properly pose your subjects, keep in mind that you are dealing with two separate tasks: positioning them in such a way to make them look their best and simultaneously creating a pose that's not too unbearable to maintain for several minutes.

Start out by posing the lowest seated person, as follows:

1. **Pose the bottom person in the diamond so that he or she is comfortably seated on a posing stool; elevate the person's legs so they are at a right angle to his or her body.**

2. **Place a small posing box for the subject to place his feet on for best comfort while he is holding the pose.**

3. **Angle the subject so that he is at about a 45-degree angle to the camera lens.**

Make sure this subject is comfortable in the basic pose because he has to hold the pose longer than anyone else. I usually put the mother in this position for these reasons. First, she looks natural as the base of the diamond. Second, she's usually trying to set a good example for the rest of her family. Third, if she's already in the pose, she can't meddle with your work with the rest of her family. (Don't underestimate this reason, whatever you do.)

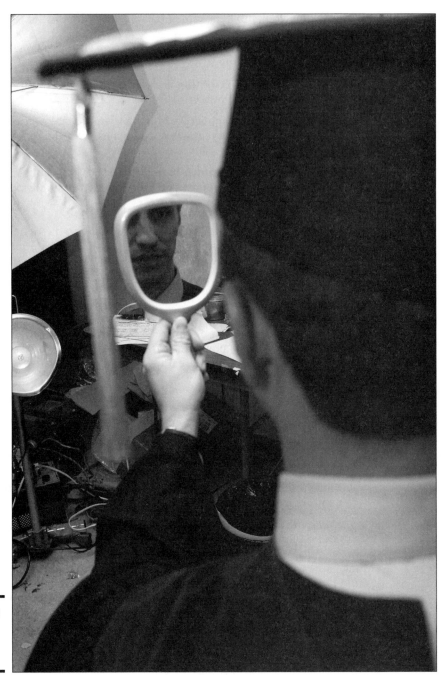

Figure 3-19:
Putting
every hair
in place.

With your first person in place, it's time to move on to Subject 2:

1. **Set the second person upon a posing stool angled behind the first person.**

 Normally, this would be the father, but there are no hard and fast rules here. Position the individual so that his head is properly positioned in relation to the mother within the diamond pose.

2. **Have your subject place his on-camera hand (the hand facing the camera) on his hip.**

 Be forewarned: Couples are always trying to put their arms around each other's waists. Don't let them; it's touching, but it doesn't photograph well. If dealing with spouses or a couple in a relationship, let them put their off-camera hand on their partner's hip out of sight of the camera.

3. **Have the second subject lean slightly into the first person so that you don't have any gaps between their bodies.**

 Make sure both are still sitting up straight. If a gap exists, you can turn the stools slightly to bring the shoulders a little more square to the camera and close the gap. You can also slide the chairs a little closer together.

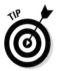

Keep in mind that the pose you're setting up with the husband and wife (or whatever significant pair you're posing) also makes an excellent pose for when you do the couple's portrait. Don't let them get up when the family/group shot is done, or you'll just have to re-create this pose all over again.

After you've got Mom and Dad posed, add the kids. Start with Kid 1:

1. **First take the smallest child and place her on the bottom person's other side, using a posing box to raise her up to the right height.**

2. **Turn the third subject toward the bottom person (roughly at the same angle as the second subject).**

3. **Move the third subject so that she is about halfway behind the bottom sitter.**

 The second and third subjects should be close together, but it's not mandatory that their shoulders touch. Just avoid a gap between those two posers and the bottom subject.

You've set the base for a diamond pose and created a good three-person sitting that will work for posing a trio. Remember to keep the relationship between the three heads consistent so that a line drawn across Subject 2 and Subject 3's faces travels over their eyes. Their mouths should be even with the first poser's eyes.

**Book III
Chapter 3**

**Photographing
People**

Now add Subject 4:

1. **Place your fourth person behind Subjects 2 and 3 and raise him up (if necessary) by using a posing box.**

 Subject 4 fills any gap between Subjects 2 and 3, which is why it wasn't that important to squeeze them in tight.

2. **Square Subject 4's shoulders toward the camera.**

3. **Adjust the height of Subject 4 so that his mouth is on a line with the eyes of Subjects 2 and 3. Have Subject 4 lean slightly into the others.**

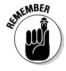

 That last little part about leaning is important. Ideally, you want all the faces in the same plane for the best possible focus. Even when shooting at f/11 or f/16, it's still better to have all faces on a line for best appearance. After you get everyone lined up properly, check your modeling lights to make sure that no one is casting shadows somewhere they shouldn't be.

If you have more than four individuals you need to pose, take the following guidelines to heart:

✦ **Use the topmost person in your original diamond as the base person for another diamond group.**

 This lets you add three more people the same way you added Subjects 2 through 4.

✦ **If you have more than seven sitters, start building diamonds outward by using the left- or right-most person in the lower diamond as the side anchor of a new diamond.**

✦ **As you build your additional diamonds, take care to make sure that everyone's faces line up properly in the same focal plane.**

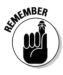

✦ **Make sure that everyone is on steady ground.**

 As you have more and more people standing on posing blocks, your group's inherent stability suffers. You don't want to see them collapse into your backdrop and lights.

Working with a large group is a difficult challenge because the number of variables increases to almost unmanageable numbers. Take a moment before setting up the pose to do a little planning.

Visualize the group pose before you start assembling it to avoid wasted time and effort after you get started. Take a moment to explain to the whole group that you're going to take a lot of shots of the group pose to maximize your chances of getting an exposure with as many good expressions as possible.

Arranging your lighting

Create a triangle with your base posing stool as its apex. Set up your main light and fill light about six feet apart and six feet from the posing stool.

Position your background light about two feet behind the posing stool and then position the background approximately one to two feet from the background light.

If you're using a hair light, position the light angled about 45 degrees behind the subject's head pointed toward the camera. Take a moment to check your viewfinder to make sure that no part of the hair light protrudes into the photograph. Read about positioning a hair light in the earlier section, "Hair light."

Taking the picture

After setting up the lights and arranging your subjects, start thinking about taking the picture.

I recommend triggering the camera via a remote so that you can maintain eye contact with your subjects. Many digital cameras (both professional and point-and-shoot types) offer some method of triggering the shutter without tripping the shutter button. If yours doesn't, you can still fire the camera via the shutter button while looking over the camera at your subjects.

Before tripping the shutter, go through this very quick checklist:

1. Is everyone standing up straight?

2. Are their heads properly arranged so that their faces are directed toward the camera?

3. Is everyone looking either directly toward the camera lens or in the direction you've designated? (Some poses may look better if you have your subjects looking slightly past the lens.)

4. Is everyone smiling?

Be ready to work fast. Holding a pose is a tiring chore. People lose their patience if you take too long to trip the shutter, so be ready to run through the checklist quickly.

Don't be afraid to stop and correct someone who's relaxed his or her pose. It doesn't do you any good to trip the shutter if someone doesn't look good.

I usually hold the remote behind my back when tripping the shutter during a portrait session in order to keep people from realizing I'm about to take the picture. This is important for two reasons:

✦ I don't want to give people a reason to shift their eyes in the direction of my hand when I'm taking the shot.

✦ Many people anticipate the flash firing and blink their eyes when the lights fire.

Remember to keep watching your subjects as you trip the shutter. You can usually catch the blinkers if there are any and know you need to take another shot.

Advantages of Digital Cameras

Digital cameras offer you many advantages in portrait photography. Most important of all is the chance for the photographer to review the pose before the subjects leave. Because you can spot problems before your victims skedaddle, you have a chance to correct them while everyone's still there.

Another huge advantage of the digital camera is that it gives you a chance to make sales while your customers are still excited from their sitting and still in high spirits after all that positive feedback you've been giving them. (You have been giving them positive feedback, haven't you?)

Film photographers have to factor the cost of film, processing, and making proofs into their costs of doing business, thus driving up their margins. As a digital photographer, you can afford to take all the shots you want without damaging your bottom line (provided you have enough media to get you through a long shooting session, of course).

Learn to use your digital camera's review feature to its best effect. Here's a list of some of the things you should be analyzing as you play back your shot:

✦ **Make sure that the photo is properly focused.** Although you can't be dead sure while reading your camera's LCD screen, you can at least eliminate really poor shots. If you have a digital camera that can be hooked up to a television to play back images, by all means do so! This will help you get a better look at your images. You can also show the images to your clients while at the same time taking their order. (If they're not satisfied, you can also offer to reshoot the sitting while they're still dressed for it.)

✦ **Check for any obvious errors.** Such errors could be gaps appearing between people, bad expressions, or wrinkled clothes. Straighten out the clothing, as shown in Figure 3-20. Also make sure the subject's hair looks good and that the image is properly exposed.

✦ **Check for any lighting errors.** These include lights that shine where you don't want them to, bad shadows, and so forth.

✦ **If your subjects are wearing glasses, check for any hot spots that might be too difficult to clean up in an image editing program.** Repositioning someone's glasses is easier than it is to do heavy computer retouching, so make your job easier when you can.

✦ **Check for any blinkers.** This can be pretty tough with small LCD screens; a TV monitor makes this easier.

Figure 3-20: Make sure the subject's clothing isn't in disarray.

**Book III
Chapter 3**

**Photographing
People**

I once worked for a portrait firm (before the digital revolution hit its stride) that spent quite a bit of money to develop a portrait system that simultaneously exposed a piece of film plus captured a low-resolution digital image. The photographer would hand the salesperson a floppy disk with the images, who would then show the images to clients while giving the sales pitch. Such a system made portrait sales much more effective because people were seeing the results of their sitting while they were still excited and upbeat about the process — and thus more likely to buy prints.

Most of today's digital cameras offer a similar capability via an RCA or video-out capability that allows you to hook up a TV monitor, as shown in Figure 3-21. You (and your subjects) can view images on a larger screen.

Figure 3-21:
You can probably connect your digital camera to a TV and preview your portraits as you take them.

Chapter 4: Shooting for Publication

In This Chapter

✔ **Finding outlets for print publication**

✔ **Shooting for local newspapers**

✔ **Publishing in magazines and similar markets**

✔ **Photographing for company newsletters**

✔ **Effective public relations photography**

✔ **Taking photos of products**

*F*or some readers of this book, becoming a published photographer might be a lifelong goal. Many avid photographers hone their skills, trying to reach professional levels in a quest for a published credit line.

However, the average digital camera buff more commonly ends up shooting for publication for more practical reasons. Perhaps your parent-teacher association drafted you to publicize school events. Or maybe your small company doesn't have a full-time photographer, so you — with your digital camera wizardry — seem perfect to snap a portrait of the founder for the organization's newsletter. Perhaps you're a recognized expert in your hobby, customizing vintage Atari game consoles, and would like to have a few photographs published in one of the technical magazines devoted to '80s-era games.

Digital photography lends itself to all these situations because you can take a picture on a moment's notice, review your results on your camera's LCD display, take *another* picture if you need to, and then produce a digital file or print that's ready for publication in a few minutes. Most professional photographers shooting for newspapers, magazines, catalogs, and other publications now use digital cameras — and you can, too.

In all these cases, your digital pictures are going to end up in print, and you need to know some things in order to shine when shooting for publication. This chapter explains the differences in taking pictures for print as opposed to photography destined for Web sites, desktop presentations, or a personal photo album. You can also find some tips on how to get published and advice on preparing your work for publication.

Finding Outlets for Print Publication

Whether you simply want to get published to satisfy yourself or you need to have your photos published to satisfy the expectations of your friends, boss, or colleagues, you can find lots of outlets for your digital work. Here are a few of the most common. I look at them in more detail later in the chapter.

+ **Local newspapers:** Although larger newspapers rarely publish photos from readers, smaller local papers usually welcome submission of photos on behalf of your school, club, or even business. Or, you can make a habit of showing up at public meetings or fast-breaking news events. Supply enough good shots in a variety of situations, and the paper might take you on as a part-time *stringer* (a freelancer with an ongoing affiliation with a publication). Because digital pictures can be snapped and transmitted to a newspaper over phone lines just minutes after an event takes place, electronic photos are especially apt.

+ **Trade magazines:** These are the unseen publications that nobody knows about, except for the millions of people within a particular industry. You might never have heard of *Repro Report* magazine unless you're a member of the International Reprographics Association. I had never heard of it, either, when I started taking pictures for the magazine (way back when it was still called *Plan and Print.*) However, that publication (and many like it) is constantly looking for photos taken at member businesses, conventions, and other venues. These trade publications are good outlets for digital photography, and I've managed to have my own photographs published in hundreds of them. You can do it, too.

+ **Company publications:** Companies of any size can never have enough photographers. If your organization is small, management might be delighted to find a photographer who's outfitted with fast and flexible digital gear and who's also ready, willing, and able to snap photos for company newsletters, annual reports, and other official publications. Even larger organizations with a full-time photography staff might be receptive to photos that you take at events that their pros are unable to cover.

+ **Special interest publications:** Every hobby or special interest, from collecting Seat Occupied signs from defunct airlines to protecting your right to arm bears, probably has a publication of some sort. If you share that interest, you can easily get your digital photos published.

+ **External PR and advertising:** Most organizations can use photos for public relations or advertising purposes. If you're good, your work can accompany news releases or be incorporated into less formal advertising layouts. Digital cameras are good for these applications because you can create a photo in a few minutes, ready for review and approval by the high mucky-mucks in an organization.

✦ **Self-publication:** The fastest route to getting your digital photos printed is to publish them yourself. Whether your interests stem from a favorite hobby or from the most arcane conspiracy theories, if you have a computer, you can create a newsletter, fanzine, or other publication and spice it up with your own photos. The best part about self-publication is you have absolute control over which images are used, how they are sized and cropped, and who gets to see them. And who knows? If your work is good, you might get paying subscribers to cover part of your costs. In my case, I knew that no publisher would possibly want to print my illustrated guidebook to repairing vintage videogames. So I took the photos, laid out the manual, and published it myself, as you can see in Figure 4-1. I've sold thousands of copies on eBay of something that I put together just for fun.

✦ **Product photographs:** Your company probably needs photos of its products for use in advertising, PR, and so forth. You can take them with your digital camera.

Shooting for publication isn't as hard as many people think provided you remember that you don't start out shooting for slick, nationally distributed magazines any more than aspiring ball players begin by playing shortstop for the New York Yankees. If *National Grocer* is your target rather than *National Geographic,* you have a shot.

Figure 4-1: Publish your own fan magazine or other publication and put your photos to work.

Local newspapers

Your local paper is probably willing to consider your digital photos of a local event, particularly if it's a small paper. Larger newspapers prefer to use their own photographers — not because they don't think your photos are good enough but because of journalistic ethics reasons. Big papers frequently face charges of journalistic bias and must be able to vouch that a given photograph hasn't been manipulated in ways that would make it misleading. Photographs supplied by businesses can't be used unless they are clearly labeled as a photograph originating with that organization. However, bear in mind that even big cities have small, special-interest papers that can be a market for your pictures.

Also remember that you don't have to limit yourself to just one community newspaper. More often than not, neighboring newspapers have circulation areas that overlap. If you know your neighboring communities well, you can also market your talents to their newspapers.

Newspaper photography is fun and challenging. This type of shooting isn't especially rewarding financially, but it does provide valuable experience because you learn to adapt your photographic ability to the environment. No other type of photography offers the shooter as little control over the shooting conditions as photojournalism. For some of us, that's the best thing about it.

Understanding what newspapers need

The key to getting published in your local paper is understanding what it does and doesn't need from you. Newspapers have small photo staffs and can't be everywhere at once. They'll send a photographer (*shooter* in the lingo of photo editors) to a major event or fire or accident, but if several events happen at the same time, shooters probably will have to cover one or two events and let the others slide. For example, I regularly cover events at my kids' school and submit them to the newspaper. Our paper even prints the articles that accompany the photos, as you can see in Figure 4-2.

Here are some of the kinds of photos that smaller newspapers would love to receive:

✦ **Events:** Your club or fraternity is having its annual barbecue or banquet or get-together of whatever form. It's not a big enough deal for the local paper to send someone to cover. If you can produce some useable images along with enough information to caption them properly, you can probably get at least one of them published. Newspapers are willing to run photos like these because people like to see their pictures in the paper — and that helps sell newspapers.

*Life*Times

RAVENNA

Teacher makes science 'egg'citing

Students motivated by newly implemented hands-on activities

Just how much does a larger parachute slow the fall of a plummeting egg? What is it like to go on an archaeological dig? Is it really possible to predict the weather? Lively experiments and creative projects are providing the answers to questions like these at Immaculate Conception School in Ravenna.

New science teacher Monica Thornton is helping elementary and middle school students discover the exciting practical applications for the dry theories and statistics found in most science books.

"Hands-on projects are a way to get all the kids interested in science," Thornton said. "Many of the students who aren't as good at traditional book-learning excel when they're asked to put what they're learned to work. I'll explain what happens to the calcium in an eggshell when the egg is left in vinegar, and the next day two or three kids will come back with the 'rubberized' egg."

Although she's been teaching at ICS for only two months, Thornton has already taken her

Figure 4-2:
Local newspapers are welcome territory for freelancers.

✦ **Sports:** The paper's shooter(s) cover the big events, such as football, basketball, baseball, and so on. Your opportunity comes with the sports that don't quite get their due. For example, shoot track and field events (not necessarily the big weekend meets with 50 schools and a thousand athletes but the local dual meet). Sports such as tennis, field hockey, or lacrosse seldom get as much coverage as the big three (football, basketball, and baseball). Study your local paper to see what sports it seems to favor and then try submitting shots for the sports it doesn't seem to cover. Good action photos are particularly important. If you can regularly capture peak action well, your photos will be used. See Book III, Chapter 5, on sports photography for more information on how to take good sports photos with a digital camera.

✦ **Spot news:** Spot news includes things such as traffic accidents, fires, and robberies. It can be tough to succeed at selling this kind of photo unless it's your main focus. If so, a police/fire scanner is a must. Remember, though, that it doesn't do you any good if you're covering the same news as the paper's staffer. Small-town papers tend to need this kind of material most and are sure to send out their own staffers at the first hint of a big story, but you might have a shot at publication if you're in the right place at the right time to take a photo of something that no one else

managed to grab. (Some spot news opportunities don't last very long, which is why they're called *spot news.*) And because your digital camera film doesn't need processing, your photos are timely.

Although dramatic photos of spot news events can produce eye-catching portfolio shots, don't forget that it's human emotion that creates the most memorable images. This is perhaps the most difficult part of photojournalism — intruding upon the tragedy of others and recording it for the world to see. Pros don't really have a choice in this matter — it's part of the job. Freelancers, however, can choose either side of the deal.

You might run across organizations claiming that as part of their membership fee, you'll receive a press pass that will get you across police lines or into events. *Be very skeptical of such claims.* Usually, an organization, such as the state police (in some states at least) or event organizers, issues a press pass. There is no universal press pass that gets you into any event. In fact, even working news photographers with state-issued press passes won't get into many events (pro sports and rock concerts for instance) unless they're specifically cleared for that event as well by the event organizer.

✦ **Hard news:** These are major news events, such as a speech by the mayor, a visit by the governor, certain press conferences, demonstrations, and political rallies. They're frequently open to the general public although official photographers might be given a special area to shoot from.

✦ **News feature photography:** Feature photos and *news* feature photos are different. A news feature image accompanies a legitimate story with a feature edge — say an article on family TV-watching habits or a story on civil war re-enactors.

✦ **Feature photography:** This part of the paper deals with the lighter side of the paper. You might shoot a feature package on Elvis impersonators or pictures of a local restaurant for a review. This is the one section of the paper where you'll frequently see *created images,* or what are sometimes called *photo illustrations.* You can often tie some local happening in to a historical event to give your feature photo an interesting angle. On May 4 of every year, I always find a ready market for photos of the Kent State University campus.

Working as a Professional Newspaper Photographer

Whether you submit photographs to newspapers as a representative of your organization, as a freelancer for pay, or as an official stringer for the newspaper, you want to conduct your business in a professional manner. There are lots of points to consider. For example, do you want to be a freelancer or a stringer?

Avoiding the Grip 'n' Grin cliché

Grip 'n' Grin — it's the standard shot of any event. You know, one person is giving an award, and one person is receiving it. They stand there gripping the award, with each other looking right at the camera and grinning. Photo editors hate these pictures. They all look alike, and the only people who are interested in looking at them are the ones receiving the award and maybe the ones giving it. Take the shot, give the awardee a print, and then get a shot that has a chance of being used.

Rather than take a Grip 'n' Grin shot, provide a sense of what the event is about. If it's a barbecue, get behind the grills and take a shot of somebody getting a hot dog through a haze of smoke with a big smile on his or her face (hopefully wearing a cap or T-shirt with the name of the organization on it). You can mention the award presented at the event in the *cutline* (caption), but there's really no need to show it. More information on preparing images for publication appear later in this chapter.

Being a stringer versus freelancing

Nonstaffers come in two types of affiliations: being a stringer or being a freelancer. The difference is in just how attached you and the newspaper are to each other.

Here's what being a stringer involves:

+ **Regular assignments:** Stringers receive assignments from the paper they're affiliated with, frequently with a guarantee of pay, even if a shot isn't used.

+ **Pseudostaffer:** Still considered an independent contractor, stringers are generally issued a newspaper press pass, like the one shown in Figure 4-3, or the paper gets a state credential for them (if in a state that issues them).

+ **Free supplies:** Stringers frequently receive supplies, such as film (in the old days), notebooks, pens and pencils. You might be able to get your newspaper to chip in for some extra digital film, which could be handy if you're rushed to get a shot published and need to simply hand over your memory card.

+ **Loyalty:** Both the stringer and the newspaper are expected to show some level of loyalty to each other, although it might not be a lot. Generally, a paper has a specific number of stringers and a rotation policy to have some fair manner of distributing assignments. By the same token, a stringer doesn't shoot for the paper's competition. (Usually, the expectation is that you won't shoot for a newspaper that is sold in your paper's distribution area.)

Figure 4-3:
If your work
is good, a
small-town
newspaper
might issue
you a press
pass.

Additionally, stringers are generally considered independent contractors for tax purposes. This is occasionally a point of contention between newspapers and state employment officials who scrutinize such arrangements carefully to see whether such relationships should be considered employer/employee instead of contractor/client. You should be aware of tax responsibilities in this situation, too.

Working as a freelancer also has some advantages and disadvantages:

✦ **Freedom:** Freelancers have no affiliation to any particular newspapers, so they receive no support from any paper. However, they are free to work for any newspaper and to sell pictures to the highest bidder if they stumble on a potential Pulitzer Prize winner.

✦ **More freedom:** Because freelancers are unaffiliated, they either don't get assignments or are at the very bottom of the list of those who do. That simply means that freelancers have to develop their own opportunities, which can help sharpen their news sense.

Freelancers don't have to worry about employee/employer relationships because they're total free agents as independent contractors, but the same tax responsibilities apply. As a stringer or a freelancer, you can likely deduct the cost of your equipment and expenses involved in doing business. You

might also have to make quarterly tax payments if this is your primary source of income. (I'm not an accountant, however, so I can't give you tax advice; I urge you to consult a professional for the details.)

Special considerations for news photography

Here are some things to think about when photographing news events:

- **Be aware of emotions.** Tempers can run high at both spot and hard-news events. Sometimes, law enforcement personnel can overreact when things go wrong. Cameras can be broken, film can get confiscated, and photographers can be threatened. More and more often these days, police (although to be fair, still not that often) try to stop press photographers from working, First Amendment considerations be damned. In such situations, newspaper photographers tend to have their newspaper's resources behind them, whereas a freelancer probably doesn't. It's best to accept that you're not on a level playing field in such circumstances. There are stories of photographers who've played sleight of hand with their film and turned over an unexposed roll of film when someone demanded their images. I've been ready to do so myself once or twice, but it's a judgment call for each photographer to decide what risk he or she is willing to take. In small towns, you can avoid problems by getting the police and firefighters on your side. Give them prints and work hard at getting favorable photos of them in the newspaper.

- **Be different.** Your best bet as a freelancer is to deliver something different than what everyone else is doing. One of the best news shots I've ever seen came from a presidential campaign several decades ago. The photo is of a president answering questions with a mountain of photographers pressed together shooting away. One enterprising shooter had enough of a sense of the moment to take a few steps back and record the insanity of the situation. In the process, he got a timeless photo that far exceeded the images his counterparts created.

- **Look for unusual angles.** Shoot from up high and down low. Try and get the shot with several different focal lengths, too.

- **Be careful not to get locked in on the main event.** Sometimes, the best shot comes because you look beyond the setting and uncover human nature at work. Young children can offer interesting opportunities because they don't hide their reactions or feelings as much as adults do. A sleeping child at a political event or wedding can show humor and make a comment about how sometimes adults take themselves too seriously.

- **Look at the participants who aren't center stage.** Is there a clandestine conversation going on? Do they look bored? Are they looking in the opposite direction of everyone else?

News photography strives for impact. Eye contact and emotions are key ingredients. Don't be afraid to compose your shot tightly. The image should have a single focal point, not multiple ones. Whether you're shooting for a newspaper or the World Wide Web, space is valuable, and images should be tightly cropped and easily understood.

Book III
Chapter 4

Shooting for
Publication

Newspaper Web sites have created a new concern for freelance photographers. Many papers now require freelancers to sign over more rights or all rights to any images used in the paper as a result of some recent court decisions. These rulings have said that freelancers still retain the other rights to their images even if a photo appeared in the paper. Because many newspapers were making their entire issue available online, the decisions meant that the papers were violating the freelancer's copyrights. Most of the time, the loss of the additional copyright doesn't receive any additional compensation. Only you can decide whether giving up all rights to a particular image is worth the chance to get your work published.

Getting your foot in the door

How do you become a stringer or freelancer? I recommend making initial contact by mail. A simple introductory letter identifying yourself as a photographer interested in working as a stringer or freelancer, plus some samples of your work, should be enough. Don't overdo it on the number of samples you send. Two or three shots that demonstrate your ability are enough.

Then, follow up. In your letter, say you're going to call in a day or two to discuss how you might be able to help the paper. All you're aiming for at this point is a chance to meet the editor, show him or her your portfolio, and sell the idea of your contributing. The smaller the newspaper, the better your chances (although the smaller the pay, too).

Be thorough in your examination of the potential marketplace. Many areas have more than one newspaper and thus more than one opportunity for freelancing.

Magazines and Magazine-Like Markets

Breaking into magazine, book, or stock photography presents a different set of challenges and opportunities. Magazines offer the most opportunities. You can find many different types of magazines that aim toward a variety of audiences. These magazines include

+ **Trade journals:** Although perhaps not glamorous, these specialized publications are good potential sources of sales for enterprising digital photographers. A *trade journal* is a magazine that covers a specific industry or profession. These magazines are seldom found on newsstands but are instead distributed mainly via subscriptions. Although they might not pay very well (if at all), they tend to be the easiest magazine market for novices to break into. If there's a trade journal for your particular profession or trade, you probably have a good place to start because you already have knowledge and experience in the industry. Your chances of acceptance improve even more if you can package a story with your photos. This is also a good market for event photos within your industry,

particularly if you can produce interesting images. You can also cover local stores and companies in your area with the idea of doing a feature about their operations for the trade publication.

✦ **Special interest magazines:** These are mass-market publications geared toward a specific interest. Think magazines such as *Tennis, Popular Photography, Cat Fancy*, and so on. This market is harder to break into than the trade journal market because these magazines tend to pay better than trade journals and also because more writers and photographers want to be published in them. Read the guidelines, study the magazine thoroughly, and query the editor before submitting anything. In many cases, these magazines are more receptive to photo-only queries. Regional travel magazines can be a good bet. If you get a good photo of an unusual or out-of-the-way travel destination, like the one shown in Figure 4-4, you could have a sure sale.

✦ **Mass market major magazines:** *Time, People, Cosmopolitan . . .* these are the heavy hitters of the magazine world. They're also incredibly diffi-cult publications for beginners to sell to. Many times, these magazines won't even consider unsolicited submissions and probably won't take your query letter seriously, either, unless you have some kind of estab-lished track record as a professional photographer. An amateur photog-rapher generally needs a remarkably newsworthy image to have a chance to sell to one of these magazines.

Other markets include

✦ **Books, textbooks, and photo books:** The good news is that this market can be a reasonably easy one to break into. The bad news is that book editors are notoriously cheap, grumpy, and hard to deal with. (Just kid-ding! They're actually kind, supportive, and generous; plus they edit books such as this one.) Unfortunately, the book publishing industry is extremely competitive, and the sad truth is that many books don't turn a profit. (Please buy an extra copy of this one! It will make a great gift.) So although there is a need for good photography, there's seldom a lot of money in it. Find a publisher whose line of books appeals to you and query about its photographic needs and policies or check the appropri-ate market guidebook. A coffee table or photo book is a tough sell even for established pros and requires the highest quality photographic images to support the higher resolution these books demand.

✦ **Stock photography:** The concept sounds great: Sell the same image over and over and make lots of money. No, it's not a telemarketing scam or multilevel marketing scheme; it's the world of stock photography. You deal with stock photo agencies, which keep carefully categorized images in a database that they can access to provide virtually any sort of picture (including yours) at the request of a client. To break into this business, you'll need lots and lots of photos (thousands) to make taking you on worth the agency's time. Figure 4-5 shows an example of a generic photo that *might* be useful as a stock picture.

Figure 4-4:
Photos of hard-to-get-to locations are easy to sell.

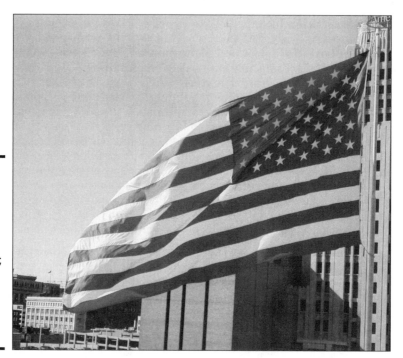

Figure 4-5:
For stock photography, you don't want just one flag picture; you need dozens for clients to choose from.

+ **Web stock agencies:** A number of small stock outlets have sprung up on the Internet thanks to its worldwide reach, easy accessibility, and relatively low cost compared with the prime ZIP code real estate used to house the big agencies. The problem facing the small Web outlets is that they seldom have enough images to make photo buyers happy. The advantage to them is that they can provide a starting point for photographers whose portfolios are too small to interest the big agencies. Of course, if your stock of images is that small, the odds are against your having much success. Still, most operate on a 50/50 split arrangement with no charge for displaying your images, so it's an opportunity for you to get a lot of images online without having to have a Web site or server of your own.

Shooting stock pictures is one area in which having a spouse and kids might actually pay off. Photos of family interaction, pensive teens, and children at play are all marketable stock images. How about a boy and his dog? A girl and her cat? Study advertisements and brochures. Although teams of professional artists, designers, and photographers sometimes create images specifically for an ad or brochure, more often than not, they've been put together from stock images. Advertisers sell products by showing normal everyday people whose lives are enriched by their products. Theoretically, your family qualifies as normal. (Heaven knows, I wish mine did!)

Never forget this omnipresent law of the photograph seller-to-be: *In focus and properly exposed.* It's amazing how often these basics don't get met when people submit photos to their local newspaper. From personal experience, I know. At one newspaper I worked for, I was the one who had to weed through all those pictures trying to find something we could actually use.

So start by sending your best work. Publishable photographs are different than fine art. Their purpose is to communicate as simply and effectively as possible. Because you can do that, here's how to take the next step toward seeing your work in print.

+ **Plan on being organized.** Have a filing system that enables you to identify and locate a particular image.

+ **Be ready to do some research.** Your local library is sure to carry references — such as *Photographer's Market* — and the publication itself. Consider investing in your own copy because *Photographer's Market* provides information on a wide range of possible markets.

+ **Consider ordering your own business cards and stationery in order to present a professional appearance.** If your budget allows, consider a promotional piece, such as a four-color postcard or print showing some samples of your best work.

Book III Chapter 4

Shooting for Publication

Making the leap to published photographer is within the reach of many talented amateurs. It's just a question of understanding what markets are out there, how to make contact, and what the markets need.

Making contact

The magazine industry does not respond well to unsolicited photographs and manuscripts. Although you have a better chance of getting published with a trade journal than most others, you improve your chances by sending the publication's editor a carefully worded missive indicating what he or she can expect.

Sometimes, a publication accepts unsolicited photos or manuscripts. You can usually find this information noted in the magazine's *masthead* located inside the first few pages of the magazine, which lists publisher, staff, and contact information. If that publication does accept unsolicited submissions, be selective. Don't bombard an editor with a submission per week or more. (Editors can get restraining orders, too.) Instead, send your best. Either include a SASE (self-addressed, stamped envelope) with enough postage for the editor to return the photos to you or attach a note saying they don't have to come back. (Back in the days of typewritten manuscripts or hand-printed photos, this whole issue used to be a much bigger deal than it is now.)

Write a query letter, in which you introduce yourself. (Talk about your experience in the industry, plus your experience as a writer and photographer if it might help.) Let the editors know what your photo or story idea is and how you plan on approaching it. Also indicate that you're familiar with the publication's guidelines for writers.

Writer's and photographer's guidelines are frequently available on the Web or by mail and are sometimes even noted in the publication itself. Books such as the *Writer's Market* and *Photographer's Market* appear yearly, providing useful information on many publications. Generally, this information tells you how publications want materials submitted. (Do they accept digital photos? Should you submit prints with them? How should prints be packaged? Do the publications even accept work from freelancers?) Publications such as trade journals are more forgiving if you violate their writer's guides than other magazines are, but it's still best not to do so. (Remember, you're trying to convince them that you're a professional.)

Whatever individual guidelines a publication has, you'd be wise to keep the following in mind:

+ **Be enthusiastic!** You can't expect editors to get fired up about your idea if it sounds like you find it dull. Tell them why you think their readers will want to read your story.

✦ **Submit on spec.** If the editor is interested in your work, mention that you'd be willing to submit it on speculation *(spec),* which means that you prepare the work at your own risk, with no guarantee that the publication will use it. This kind of thing lets the editor know that he can encourage your submission without having to worry about what will happen if you're rejected. (Editors have nightmares about beginning contributors threatening lawsuits because they expected to be published even though all the editor did was agree to look at a submission.)

✦ **Send in your tear sheets.** If you have samples of published work (usually referred to as *tear sheets*), go ahead and submit the best one or two (three at the most) pieces you've done, like those shown in Figure 4-6. Quality is tremendously more important than quantity here. If you don't have something good to submit, don't submit anything at all unless the editors or guidelines ask for it. Frequently, editors take on mediocre writing with good photography simply because they can improve poor writing but might have trouble finding good photography.

Trade journals are the best place to start if you're interested in expanding beyond newspaper work. They tend to be receptive to freelancers and provide the opportunity to contribute both photos and text. If writing isn't your thing, see whether you can team up with a newspaper staffer or stringer who's also looking to expand his or her reach.

Figure 4-6:
Send in
some
clippings
or tear
sheets
of your
published
work.

Editors hate submissions and query letters that make it obvious the people contacting them haven't even looked at their magazine. Most publications offer copies at a reasonable rate for would-be contributors, or your local library may have back issues available. Get to know the magazine before you propose a story idea. Studying back issues tells you whether you've been beaten to the punch by another contributor, or you might find out that a publication is the wrong market for your submission.

Submitting photos

Quite a few publications remain cautious about digital submissions for final publication (perhaps accepting CD submissions for portfolio samples) and might not even be willing to consider them. If the fact that your images are digital is the only thing preventing them from acceptance, consider converting them to analog artwork. A few publications accept prints, but these are in the minority. Generally, the hands-on favorite for submission even now is transparencies, or *slides.* The good news is that you have a couple of ways to get 35mm slides made from digital files:

✦ Online photo labs frequently offer this service. One such lab is www. slides.com, which charges about $4 per slide.

✦ Get a 5 x 7" or 8 x 10" print made from your digital file and load your film camera up with a good quality slide film. Then, either set up a *copy stand* (camera is placed perfectly parallel to print with two lights placed at 45 degree angles to the print) or your tripod, and photograph the print.

As time goes by, more and more publications are accepting digital images. Odds are high that your local newspaper will. It's a nice feeling to discuss an image with an editor, e-mail him or her the image, and find out that it's been accepted all in a single afternoon (particularly when you're selling a shot for the second or third or fourth time).

Getting model releases

A *model release* is written permission to use a person's likeness. These documents, available from any photo store, are popular with publishers because they help protect the publisher from nuisance lawsuits. The need for model releases depends upon how the images are to be used. Newspaper photographers, for instance, seldom bother. Editorial use is generally recognized by the courts to support the public good and provides some protections to such publications expected to meet that need. Usually newspapers, news magazines, and books are considered to meet the editorial-use standard although most book publishers desire model releases anyway. Advertising photography, on the other hand, receives no such help. If your photo is going to help sell a product, have a model release for every *recognizable* individual in the shot.

Even as a newspaper photographer, I still tried to be careful when it came to photographing children. Usually I'd look for the adult caretakers first, introduce myself to them, explain my purpose in taking pictures of the kids, and give them one of my business cards before asking their permission to shoot. Perhaps this was more than I needed to do, but parents rarely objected after they knew who I was and why I was taking pictures of their kids. Skip this approach, and you might end up explaining yourself to a state trooper instead. Also, a parent or guardian must sign model releases for minors if you want those releases to count.

A model release doesn't give you *carte blanche* to play with a person's image, which is something that's very easy to do with a digital photograph. Taking someone's image under innocuous circumstances and then placing it into what could be considered an embarrassing photo composite could leave you open to a lawsuit. When in doubt, be careful and consult with a lawyer or discuss the potential use with your subject (making sure your model release reflects the potential use and the subject's awareness of it). Model releases are particularly important for stock photography, where the image could end up being used for just about anything.

In some cases, public figures receive less privacy protection than private citizens when it comes to editorial photography. (Think of how the paparazzi chase celebrities. If you followed your private citizen neighbor around that way, no doubt your future cellmate would probably be amused to learn how you ended up in jail.) No such leeway exists to advertising-related uses, particularly because celebrities can argue that their likeness does have a monetary value and that your image is lowering its value.

Shooting for Publication

This section details the special needs of each of the most common types of photography for publication, such as groups and PR photos. In each section, you can find suggestions for taking great photos in a variety of situations. You'll find that these photos fit in with many different types of publications, from newspapers to trade magazines or company in-house newsletters or magazines. The tips in this section can be applied to many different types of print destinations.

Understanding group photography basics

Photographing groups can be an interesting challenge, one that calls for more skill as the number of people in the shot grows. As you add more and more people to the frame, it becomes more difficult to catch a moment where everyone has a pleasant expression. As the numbers increase, faces get smaller, making it increasingly difficult just to make sure everyone is visible in the shot.

Group shots are popular — and for the photographer who can do a good job, rewarding. As souvenirs of large events, they're a well-accepted and comparatively easy way to commemorate a gathering. People have also become so trained to expect a group shot that trying to get through an event without taking one is almost a sacrilege. Thankfully, good group photos aren't impossible; they just need some planning and the right tools. They're perfect for trade publications looking to publicize member groups, or for your local newspaper.

Pose your group to conform to your camera's image area. For virtually all digital cameras, this means a horizontal rectangle that conforms to a roughly 2:3 aspect ratio.

Posing a group depends upon how many people you're working with. Book III, Chapter 3 covers this topic in more detail, but the following sections dish out some helpful information.

Photographing groups of two to two dozen

Although 20 people might not seem like a small group, the techniques that you use to photograph collections of two dozen people or fewer are similar. Diamonds are a photographer's best friend. Professional portrait photographers use a diamond formation as their basic foundation for a group photo. You can find more about the diamond formation for groups in Book III, Chapter 3.

The way it works is to establish your anchor person (usually the mother in a family portrait) and seat that person. Place the father (or second individual) behind the anchor person and halfway to the side. Elevate the anchor person so that the top of his or her head is level with the nose of the standing person. (Have the standing person place his or her hands, one on top of the other and slightly angled, on the anchor person's shoulder. This is the basic pose for a couple, too.) Now, on the opposite side of the anchor person, pose the third person the same way you posed the second person to balance the trio. (This gives you a basic pose for three people.)

Now place the fourth person directly behind the anchor person and positioned so that the heads of subjects two and three come up to the nose of the fourth person. (Have sturdy wooden boxes or blocks of varying sizes for people to stand on.) Have subjects two through four lean slightly forward from the waist so that their faces are as close to being on the same plane as the first person as possible. You do this so that everyone is on the same plane of focus. Make sure that people are close to each other so there aren't any gaps between bodies. Now you have a basic posing system that's expandable to fit 20 or more people.

If you can't use a diamond-shaped pose, switch to a row arrangement, with a mix of sitting, kneeling, and standing subjects. Generally, four people or fewer make your first row. If you have five people, you can shift to a two-person front row and three-person back row.

Composing effective group shots

The general rule is that people don't buy portraits because their knees look good. Compose the shot from roughly above the waist to a little bit above the tallest person's head. Of course, this rule has a couple of exceptions. Wedding portraits should include all the finery, and so should formal events where people are in gowns and tuxedos. When in doubt, take two shots — one long and one tighter — and let your subjects pick the ones they prefer. Most professional portrait photographers offer at least two different poses to pick from. Here are some tips for arranging groups:

✦ **5 to 7 people:** Start with your basic 4-person diamond pose (see the preceding section), and then start building a second diamond on top of the fourth person of the first diamond. Use that person as the anchor person for the second diamond.

✦ **8 to 20 or more people:** As you add more and more people, keep joining new diamonds with existing diamonds until this system starts becoming unwieldy. Generally, this happens somewhere between 10 and 20 people although experienced portrait pros can manage bigger groups. As the numbers grow, pay careful attention to whether your lights and backdrop are up to the challenge. (As your diamond stack grows taller, the height of the backdrop might not reach as high as the top of the uppermost diamond.)

✦ **More than 20:** At whatever point you feel uncomfortable with fitting a larger number of people into diamonds, switch to rows. Once again, remember the dimensions of your viewfinder. Keep the number of rows and columns proportioned so that you fill the frame effectively. With the rows and columns approach, divide each row in half and angle the halves into each other so that you can bring people closer together. Have your tallest rank kneel, position your shortest rank behind them, and then work your way back (tweaking if the tallest and shortest are so extreme that this alignment doesn't work). As you position each row, make sure that you can see each person's face from your camera position. When you use this technique for a large group, your first and most important goal is to make sure nobody's face is blocked.

Managing the group

People tend to get impatient in such situations, especially if they're among the first to get posed. Staying enthusiastic and cheerful buys you time and patience from your subjects. Here are some ideas that have proven to work in the past:

**Book III
Chapter 4**

Shooting for
Publication

✦ **Don't worry, Mon.** Explain to your subjects not to worry about posing until everyone is in place. Keep them relaxed as long as you can because posing is tiring and stressful for most people.

✦ **Please, stay put.** I usually stress to people that I'm going to take more than one photo and ask them not to flee like startled deer the first time my flash goes off. (Every time they laugh at one of your jokes, you've gained a couple of more minutes of patience from them.)

✦ **Avoiding flashers.** If your digital camera uses a preflash or red-eye reduction of any sort, either turn it off (if possible) or alert your subjects to ignore the preflash. Otherwise, they'll release their poses just as the main flash fires. When you're ready to shoot, tell everyone to look directly into the camera lens. Look carefully through your viewfinder and quickly check each person to make sure you can see everyone's face. If you can't, stop and correct poses. If you can, start shooting.

Lighting groups

See Book II, Chapter 5, and Book III, Chapter 3, for more information on lighting. Here are some general tips that you can use when lighting photos that you hope will be publishable, however:

✔ **The pro way:** To light this setup, use a pair of studio lights firing into umbrellas or soft boxes about 6 feet apart and angled toward the center of the group. A third light is positioned behind the group and pointed at the backdrop to provide some separation from the backdrop. Set your light's power output to maximize your depth-of-field. *Safety tip:* If you're doing multiple sittings, use masking tape or gaffer's tape to tape down your cables so that people don't trip over them.

✔ **The serious amateur way:** A less professional setup that can still deliver good results is to use multiple slaved portable flashes (see Book II, Chapter 5 for an explanation of photographic slaves) without the backdrop. This approach has three problems: The flashes don't recycle as quickly as the studio lighting setup, the flashes

don't put out as much light (meaning you have to go with shallower depth-of-field), and the lack of a backdrop means the photo's background will probably detract from the overall image quality. Few publications will use a photo that has a distracting background.

✔ **The not-so-serious amateur way:** One flash, straight ahead. It's not elegant, the light's kind of harsh, and there's the risk of red-eye, especially with kids. Getting your flash up higher helps prevent red-eye and gives you a nicer light, but even one flash can do you some good because it helps clean up shadows on your subjects' faces.

✔ **The "Oh My God, What Were You Thinking?" way:** The camera's built-in flash. You've got to be kidding. Most built-in flash units have a range of about 8 feet. It might do some good with a small group, but it's useless with a big one. Publications will reject large group photos poorly lit with a puny flash unit.

Keep your sense of humor no matter how challenging the group shot gets. If you can keep everyone smiling and relaxed, you'll get a good shot sooner or later.

Try to have people say something that will make them smile. *Vacation!* is usually successful, as is *Hawaii. Stock options* used to work well with business types, but with the current market conditions, you might get tears these days. (Remember, you're going for smiles, not hysterical laughter here.) Having people say, "Cheese" is a no-no. Every portrait photographer has a bag of phrases to get his or her subjects to smile.

Back in my days shooting portraits, I had different phrases for families, parents, boys, and girls. *Vacation* and *Hawaii* work for just about anyone. *Yes, dear* and *honeymoon* work nicely with couples, as does *10 more kids!* (Some moms get a look of terror when they hear this one, though.) Young children generally smile for *Cowabunga, Dude* (even if it is getting kind of dated), but any cartoon hero catchphrase will probably work. For teenage boys, a sequence beginning with *girls* for shot one, *lotsa girls* for shot two, and *lotsa girls in skimpy bikinis* for shot three is just about guaranteed to work. These days, a similar male-oriented sequence for teenage girls also works.

PR Photography

Public relations photography frequently looks like photojournalism, but note an important difference: Newspaper photography tries very hard to be balanced, objective, and unbiased, but PR photography doesn't.

The goal in this kind of shooting is to present your client in the best possible light. This kind of photography calls for a good sense of diplomacy and the ability to work as a member of the team with the company's public relations personnel. Generally, the PR department has some specific ideas of what message it would like the image to convey.

PR photography can take many forms, ranging from creating executive portraits for senior company personnel to special event photography to taking photos for the company newsletter or a sales brochure. PR doesn't apply only to businesses, either. Your social organization or church might need some useful PR. Perhaps a new church has been opened, and the parish could use an attractive photo like the one shown in Figure 4-7, for publicity or the bulletin. Anything newsworthy is ripe for PR photography. The next sections cover the particular varieties of PR photography in greater detail.

Executive portraits

If you have a staff position with a company or if operate your own photography business, you may be called upon to shoot pictures of the top brass of a company or organization. Executive portraits can vary and include basic

head-and-shoulders portraits, commanding-executive-in-charge-at-the-helm/ desk photos, and leader-with-his-or-her-troops pictures. You can find more on shooting portraits in Book III, Chapter 3, but for now, check out the basic kinds of executive portraits you might be asked to shoot.

✦ **Head-and-shoulders shot:** This is a basic portrait. Use a portable studio lighting setup and take a variety of shots and poses, including smiling, visionary, and serious. Don't be surprised if an executive has some very clear ideas about how he or she wants to look. You and the PR staffer should look the execs over carefully to make sure they look their best. If they don't, offer them a mirror and a comb (if their hair is out of place) or a lint brush if their clothes need it. Use an appropriate backdrop. The PR types in your organization might be able to suggest the best backdrop for a particular executive.

✦ **The desk shot:** This portrait shows the captain of industry hard at work at his or her desk. Skip the backdrop, but check the background thoroughly through your viewfinder. Some honors and photographs are fine, but if it's too cluttered, consider changing camera angles a little to clean things up. Because you're shooting the exec at his or her desk, indications that it's a working space are important. A neatly arranged pen set and a single document on the gleaming mahogany desk is plenty. Whatever you do, don't show a messy, cluttered desk.

✦ **The confab:** This shot's a bit trickier. The idea is to show the exec as an in-charge leader. Usually, it's done with the standing exec giving instructions to a pair of underlings. The exec is turned toward the camera (slightly angled) with the underlings posed mostly away from the camera. Underlings should be carefully selected (this is the PR department's job) because it's an opportunity for the company to show it's an equal opportunity employer, or minority employer, or whatever.

✦ **Setting:** The setting is usually in the nicer section of the company headquarters, but it could also be in a location shoot that showcases something about the firm. The location could be anywhere business-appropriate, such as a shipyard, an oil field, a factory assembly line, or a restaurant.

✦ **One of the gang:** This shot is for the charismatic executive whose rapport with the troops is legendary. Forget the suits, mahogany desk, and rich carpeting. Instead, he or she is dressed casually. In fact, it should be hard to tell the executive from the employees, except for the fact that everyone in the photo is hanging on his or her words.

✦ *Really* **one of the gang:** From time to time, you'll need to take a head and shoulders shot of someone who really is one of the gang: a non-executive, non-manager, ordinary star-of-the-warehouse type. Maybe he or she had a great bowling score on behalf of the company team. Or he's had perfect attendance for 10 years. In such cases, a formal portrait would be inappropriate. You need to be prepared to grab a simple, flattering head-and-shoulders shot, like the one shown in Figure 4-8.

Figure 4-7:
You might be the only one qualified to take an attractive shot to publicize the opening of a new building in your area.

Figure 4-8:
Sometimes you'll photograph non-executives for the company newsletter, too.

Being able to produce a wide range of executive photos is a good skill for a PR photographer because there's always a place for these images, whether it be the company newsletter or the latest annual report.

Company events

Shooting company events usually revolves around documenting activity for outside company publications and also for distribution among employees. Usually, this means that the photographer is expected to take a lot of pictures — and the biggest challenge is in being thorough enough.

Here are the main types of company events you'll be called on to capture:

+ **Company dinners:** A company holds a dinner for a lot of reasons. Plan on getting photos of the speakers, award recipients (if any), company executives, and as many attendees as possible. Special-event dinners (fund drive events, seasonal parties, recognition of company accomplishments) should also include photos that show why the event is being held. For tips on how not to shoot presentations, see the "Avoiding the Grip 'n' Grin cliché" sidebar earlier in this chapter.

+ **Company outings:** Sometimes, an organization holds a retreat or conference. These gatherings feature a variety of events — some meant for fun and other for training. Plan on lots of shots of individuals participating in these events. Start by making sure you get the bigwigs. While you're looking for good photographs, make sure that your shots are positive and also present the employees in a good light.

+ **Company-sponsored sporting events:** Book III, Chapter 5 — the one on sports photography — applies here, with the added reminder that you're still shooting a corporate event first and an athletics meet second. Document elements that show the company relationship to the sports event (banner, logo, or whatever), and get good souvenir photos for the amateur athletes (particularly if they are company employees). Posed shots and camaraderie photos are good, too.

+ **Family events:** Sometimes a company holds an open house for employee families to come see what their family members do and where they work. Get plenty of shots of employees demonstrating their jobs for their families.

+ **Community relations events:** Many companies work hard to be good corporate neighbors. Employees are encouraged to volunteer as mentors or to give time to public service efforts, such as Habitat for Humanity. If you're asked to shoot a community relations event, plan on getting newspaper-type photos for use in the company newspaper or newsletter (and remember, positive images here). You should also take pictures for the company to hand out to its workers as well. (Companies motivate and reward employees for doing things like this: T-shirts, coffee mugs, and souvenir photos are the top three.)

Arranging a PR event worth photographing

If you're shooting for your own company and your company is a small one, you might find yourself dubbed the in-house PR "expert" and asked to help put together events covered by photographers other than yourself. You really need to understand the needs of other photographers, too! Putting together a photo-worthy event calls for an understanding of the needs of the photographers you're inviting and for optimizing your own chances to get good photos alongside them. Press photographers are paid to create strong, exciting visuals.

Here are some things you can do to make an event more likely to be a success:

✦ **Pick a location that provides a strong backdrop for the speaker or ceremony.**

✦ **Include elements that reinforce the purpose of the event.** For example, at a groundbreaking or building dedication, try to get some construction equipment in place to frame the podium or platform. Hang banners from the buckets of front-end loaders that identify your company and project.

✦ **Give the other photographers handouts that will make it easier to identify each person participating in the event.** This should include a photo of each person, with his or her name and title securely attached to the picture. (It can be a printed sheet with bio. It doesn't have to be an actual print.)

✦ **If holding an outdoor event, be prepared for bad weather by having an awning available onsite.** Try to set up things so that photographers can still get a good backdrop for their photos.

On the day of the event, check on all the small details that can come back to haunt you, such as confirming the presence of equipment, banners, handouts, and so on. Next, check the weather forecast. Have some people available to help answer questions from the photographers or provide extra handouts.

Refreshments for the press and guests are a good idea, but you don't need to go to extremes. Actually, you should probably worry more about having the appropriate refreshments for the company bigwigs than the media.

Other photoworthy events

Sometimes, your company welcomes members of the community inside its doors. This can be a welcome opportunity for creating images that you can place in your local papers.

✦ **School tours:** Does your company do something that might make a good tour for the local school? If so, bringing a group of school kids in will provide tons of photo ops (opportunities). Some typical images include an employee demonstrating a piece of equipment to the kids or one of

Book III
Chapter 4

Shooting for Publication

the kids learning to use a piece of gear (keeping safety in mind at all times). Be sure to have your company's name or logo on equipment so that it shows up in the photo.

✦ **Mentors:** Does your company have a mentors program? If so, the interaction between your employees and their protégés can also make a good image. In this case, you're shooting at the school instead of your facility, so you won't have as many ops to get your company's name in the shot, but at least make sure it's in the caption.

Producing placeable PR photos

Successfully placing images taken specifically for PR purposes with your local media is both art and science. Remember that you're trying to meet your needs (placing your company's photos) as well as the newspaper's (strong images).

Newspapers know what you're trying to do — namely, get your company some free publicity and credibility. They also know that they have an advertising department that exists to help pay the bills. They're not giving away free space, but if you supply a good image, it's got a chance at being used.

Also, understand your markets. Many local newspapers are willing to consider photo submissions, but each paper has its own criteria for acceptance. Newspapers use PR photos for a variety of reasons, including the ones listed here:

✦ The images are of high quality and show members of the community doing something newsworthy (building homes for Habitat for Humanity, running a dunk tank to raise money for charity, and so on).

✦ The images fill a need that the newspaper couldn't fill on its own because it was understaffed or it was a weekend and too many events were going on to cover them all.

✦ The newspaper is willing to "sacrifice" a couple of pages to run photos from groups and organizations that want publicity. It's easy to tell whether your newspaper does this; look for the section near the back that has a couple of solid pages of Grip 'n' Grins (those trite photos of two people shaking hands and grinning at the camera).

Many newspapers also run a Neighborhood or Region section. (There are lots of names for this part of the paper.) Such a section is geared toward the local community. In fact, when a newspaper hits a certain size, it will probably print a different section for local communities as a special insert, which gives you even more opportunities to place photos. Even if your company isn't located in a community that the paper has a section for, some employees who work for your company probably live there.

Printing your PR photos

After you create your publishable PR images, give yourself the best chance that you can to get them used. Read Book VII, Chapter 1 for printing digital images in detail, but here are some general observations.

As a bureau chief for one publication I worked for, I was frequently amazed at the number of low-resolution inkjet prints that I used to receive from PR and marketing people. To make matters worse, they were frequently printed on cheap typing paper. Needless to say, they weren't used. (I'm not referring to proof images accompanying a digital file here either; those are okay.)

Instead, you should use one of the newer, high-resolution ink-jet printers (1400 dpi or higher) capable of producing photos that are as good as those you get from conventional film and photofinishers. If you don't have such a printer, your local drugstore or department store might have a stand-alone kiosk or an in-house digital mini-lab that can produce high-quality photos from your digital files.

Writing cutlines

Cutlines, or captions if you prefer, are vital to getting your photos used. Newspapers know nothing infuriates a reader more than seeing his or her name misspelled or being misidentified in a newspaper photo. As a result, most papers set very strict policies for their own staff on this kind of thing (usually, three strikes and you're out of a job).

**Book III
Chapter 4**

Good cutlines provide the basic information and get it right. Here's the kind of information to include:

**Shooting for
Publication**

+ **Check spelling.** Make sure that you have the correct spelling for the names of everyone appearing in the picture and triple check to make sure that no typos sneak through.

+ **Identify subjects.** Make sure that each name is identified with the proper person. Usually, it's done from left to right (or *l to r*).

+ **Summarize the event.** Describe what they're doing and why it's important. Make sure to also identify your company or client.

+ **Identify yourself.** Provide your photo credit (*Photo by*). Include contact information, in case the publication needs more information about the people in the picture or the event.

REMEMBER

Cutlines need to be accurate, concise, and informative. Plus, the cutline is your chance to mention your organization's name in the publication. Although short cutlines will do the job in most cases, longer versions can serve as a

mini-news release. Here's a (slightly modified) example of a longer cutline, from a photo actually published in my local paper:

> When faced with a barnyard full of animals who didn't want to help, "Do It Yourself" was the solution for the Little Red Hen in a production of the children's play, performed by the kindergarten class at Immaculate Conception School in Newtown. The young thespians who demonstrated the importance of cooperation included, from left, Johnny Smith, Janie Doe, William Roe, and Samantha Brown. For more information on the kindergarten or pre-school classes, call the school office at (331) 555-1212.

Preparing the cutline for submission

After you write your cutline, affix it to the print — and do it in such a way that the print and cutline won't be separated by accident.

How the pros do it

When Philadelphia Mayor John Street wanted to announce his plans for an anti-blight initiative, his staff put together a carefully crafted day for the press. The day began with a morning briefing with coffee and pastries. More importantly, the media was given a full briefing manual describing the mayor's plan. During the briefing, Mayor Street and his team introduced his plan and the people whom he hoped would make it succeed. Although those of us who were working press photographers grabbed some photos at this point, we all knew these images weren't going to get much play.

After the briefing was over, we headed out to waiting city trolleys for a tour of the areas that the mayor hoped to turn around. At this point, we were informed that we'd be getting a three-hour tour of the city, which caused the press corps to begin singing the theme song from the old TV show, *Gilligan's Island.* (You know, "A *three-hour tooour!"*) We were also given box lunches.

During the next few hours, we were presented with a number of carefully planned photo ops. Face it — a city like Philadelphia has a large number of abandoned buildings (several thousand according to the briefing we were given), and yet every time we stopped, it would be in front of a single derelict structure instead of a row of vacant houses.

When it came time for the mayor to climb into a front-end loader to knock down a derelict structure, there was just one small section of a building left for him. Every other building in that development had already been demolished.

The reason for these photo ops was obvious. The mayor's staff wanted to make sure the images in the media created the impression that the problem was manageable. The mayor facing a city block of vacant, ruined buildings would have looked too much like an underdog taking on an insurmountable challenge.

The standard method is as follows:

1. **Set your margins so they're narrower than the print's horizontal dimension and give your cutline a top margin of about one and a half inches.**

2. **Print out the caption and trim the sides and bottom to about a quarter inch from the text while leaving the top margin alone.**

3. **Turn the print face down and position the face-down cutline on top of it. Line the cutline up so that the top line of text is slightly below the bottom of the print and use a small piece of tape to affix the cutline to the back of the print.**

4. **Turn the print and cutline face-up and fold the cutline sheet up and over so that it covers the photograph.**

 Now your picture and cutline, as shown in Figure 4-9, will fit neatly into an envelope and with the cutline sheet, offering some protection for the face of your print.

5. **Before sticking your print in the envelope, though, sandwich it between two pieces of corrugated cardboard and rubber band the sandwich together to keep it from being damaged in transit.**

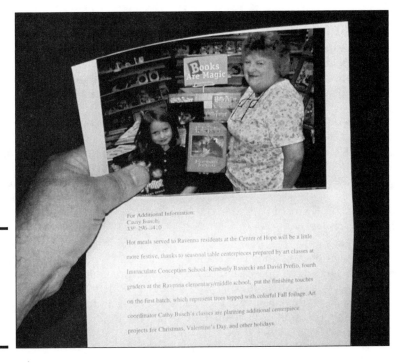

Figure 4-9:
Photo and cutline should be carefully fastened together.

Professional packaging and presentation will help you put your best foot forward and improve your chances of getting your photos accepted.

Submitting the photo

After you assemble a nice professional package, prepare a cover letter telling the editor why you're sending these photos.

+ **Be brief.** You need only a few paragraphs to explain what the event was about, when it was held, and where.

+ **Include contact info.** Make sure that the appropriate contact information is also provided in your letter.

+ **Send to the photo editor.** Check the newspaper's masthead and address the envelope to the photo editor (if the paper is big enough to have one), the Neighborhood section editor if the paper has a Neighborhood section, or just the editor if it's a really small paper.

+ **Keep a log.** Identify the image (something like 20050821.03 for 2005, August 21.third photo release of the month), the newspaper(s) you've sent the photo to, and the date you mailed it. Make sure your cutline includes this release number. Also identify whether the photo is for immediate release or for use on a particular date.

Following up

A few days after mailing your photo submission, call the newspaper and ask to speak with the appropriate editor. Say you're calling to follow up on a photo submission. When you're connected, identify yourself and say you're checking to see whether the editor needed any additional information.

Also be sure to check the appropriate papers to see whether they've run your image. If so, buy a couple of copies for tear sheets for your files. Note the log number on your file copy so that you can match it with the appropriate photo. Get in the habit of comparing your successful and unsuccessful images so that you can see what kinds of images your local paper favors.

Product Photography

Product photography is certainly a specialized type of photography, but one that offers good opportunities for the enterprising photographer. *Product photography* is all about making your clients' products look as good as possible. You can do this in several ways, and you can find more information on photographing objects in close-up in Book III, Chapter 2.

Although you could think this type of photography as the exclusive preserve of the big-name advertising photographers, agencies, and art departments,

the reality is far different. Opportunities for this type of work are very open to talented, freelance photographers.

Product shot opportunities

Lots of manufacturers make product lines that are sold through catalogs. There is a constant need for fresh images because these catalogs come out as frequently as once a month. Success in this type of photography calls for several skills:

✦ **Speed:** Be prepared to work quickly and efficiently. Set up a standard lighting package that provides clean, even lighting. Generally, this means setting up a tabletop station with a pair of lights that rake across the product at 45 degree angles and that are positioned at a right angle to the camera.

✦ **Simplicity:** Your tabletop setup should be as simple as possible. Plan on using seamless paper that you can advance on a roller. Then, when one section gets dirty, you can just advance it to another stretch of clean paper. Your close-up photography skills should be well-honed, too, because many product shots are closeups of components like those shown in Figure 4-10. See Book III, Chapter 2, to read more about snapping close-up photos.

**Book III
Chapter 4**

**Shooting for
Publication**

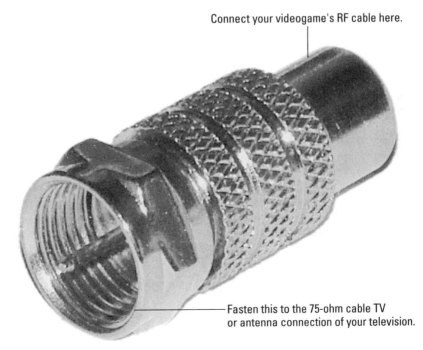

Connect your videogame's RF cable here.

Figure 4-10:
Close-ups
are the
meat-and-
potatoes
of product
photo-
graphy.

Fasten this to the 75-ohm cable TV
or antenna connection of your television.

✦ **Flexibility:** Your digital camera and tripod rig should be versatile enough for you to be able to change its position quickly and easily. Some tripod manufacturers offer *dollies* (a small platform with rollers) that the tripod can be mounted on so that you can reposition it easily.

✦ **Record keeping:** Be sure to have a workable record-keeping and indexing system set up so that you can keep track of what you've shot and when because clients frequently need this info.

Product demo shots

Product demo photos are designed to either show what the product can do or how it is correctly used. The idea is to create an image that shows a typical user successfully using the product for its designed purpose. Some examples include

✦ **An attractive person reclining on a pool float, looking relaxed and happy.** (Selling the pool float.) Shoot this scene from a variety of angles, including getting up on a ladder to shoot down on her. Use an image editing program to tweak the pool water's color to be a nice rich blue. Be careful in your choice of lenses here, though: Longer focal lengths are more flattering. You probably need flash here to clean up any shadows, too.

✦ **Cyclists standing with their bikes happily discussing their planned ride.** (Selling the bicycle.) Use a long telephoto for this image. The couple and the bikes should be in focus, but the background shouldn't. Use late-afternoon light to give a rich glow to the scene.

✦ **A woman stroking her pet cat while it laps up a saucer of milk — and not just any milk, but a specially formulated milk just for cats.** (Product box can also be in the photo or composited in later.) Use your portable studio lighting setup here and a short telephoto or modest wide-angle lens, depending on how much space you have to set up your photo.

✦ **A business person working on a portable computer.** (Selling the computer.) If the shot's outside, use fill flash and a medium telephoto. If it's inside, use your portable studio lighting kit and a medium telephoto lens. Set your aperture depending on your background. For the outside shot, generally a wide-open lens that throws the background out of focus works fine. Inside, if you have a particularly good background (say, a nice study), take advantage of it and stop down to increase your depth-of-field.

✦ **The product posed as it is set up for use.** Figure 4-11 shows a shot arranged to show how a product is used. All the extraneous information has been excised, making the final photo abundantly clear.

The idea is to sell viewers on the idea that buying this particular product will enrich their lives in one way or another.

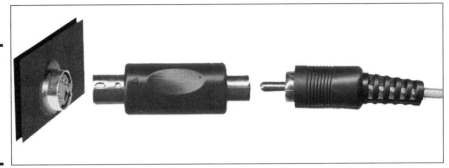

Figure 4-11:
This photo
shows
exactly
how the
product is
hooked up.

Of course, sometimes you don't want to show the product being used. When that happens, the photographer must invoke a mood the product manufacturer finds desirable. For instance, I'd never show a sample of kitty litter being used the way the manufacturer designed. Instead, I'd create an image of a cat bathing itself in the foreground with a dinner party in the background. The text for the ad could then read, *Brand X Kitty Litter — you'll never know it's being used.*

Chapter 5: Sports and Action Photography

In This Chapter

✓ Choosing your equipment

✓ Taking outstanding sports pictures

✓ Choosing your spot for your sport

✓ Capturing your first action photo

✓ Shooting sequences

Digital cameras offer at least one advantage and one disadvantage when used for sports and action photography. The big advantage lies in the ability to shoot an almost unlimited number of pictures in your quest to capture the peak moment of action but without burning up dozens of rolls of film. In times past, professional photographers had an edge in this department because they could justify using tons of film at a single event. Today, mistakes and bad shots can be erased from reusable digital film, so your errant photos aren't necessarily captured for eternity.

The chief disadvantage to digital cameras is that many models don't respond as quickly as you like when the shutter release button is pressed. Even a pause of half a second is too long when the decisive moment in a contest is framed within your viewfinder or LCD display for an instant.

Fortunately, the advent of affordable digital cameras allows photographers who don't have a newspaper or magazine paying for film to shoot enough to create high-quality sports images. And, there are lots of ways to work around the digital camera's main drawback. This chapter focuses how to use the strengths of digital photography to get great sports and action photos, offering tips for minimizing the technology's weaknesses. Read on to see what pros and amateurs alike can do to get the picture.

Choosing Your Weapons

Sports photography calls for a range of tools that can help put you in the best possible position to get the shots you need. This doesn't mean that you need to break the bank to get good images, though. Many of the current crop of

digital cameras — from digital single lens reflex cameras (SLRs) to point-and-shoot versions — offer powerful capabilities of their own.

I cover the basics of choosing a camera, lenses, and accessory choices in more depth in Book I, Chapter 2. However, sports photography does have several particular needs. Here are some of the things that you should consider when assembling your sports photography arsenal. I explain these key needs in more detail later in this chapter, but this summary will get you in the proper equipment frame of mind:

✦ **Go long with telephotos.** To get the best sports photos, you want to get as close to the action as possible. That's enough of a challenge for pros equipped with press passes and access to areas set aside for their use. Imagine how tough it is for someone who has to get shots from the stands. If you can't get close, your digital camera's telephoto zoom setting or add-on telephoto attachment is your best friend. For sports photos, a camera with a 3:1 or 4:1 zoom lens is almost essential. You can find prosumer digital cameras that take you even closer with 10:1 zoom ratios.

✦ **Go wide.** Wide-angle capability also comes in handy for sports photography. Certain sports, such as skateboarding and roller blading for instance, photograph quite well from a low position using an extreme wide-angle view. A wide-angle capability is also great for getting an overall view of a sports venue or crowd, as you can see in Figure 5-1.

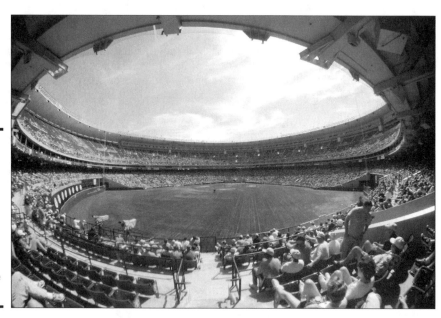

Figure 5-1: A wide-angle lens attachment for your digital camera can provide ultra-wide views of the crowd.

✦ **Light up your sports life.** If you want to shoot sports at night, an accessory flash unit can greatly improve the quality of your photography because that brief flash of light can freeze action. External flash units can even be a big advantage during the day if you're photographing outdoors sports such as baseball because the flash lights up those inky shadows on the upper face caused by the caps many athletes wear to shield their eyes. Of course, you have to be close enough for the flash to be useful.

✦ **Take along lots of digital film.** Sports photography can fill your digital storage media faster than most other photographic enterprises. At an exciting game or match, you might find yourself shooting more photos in two hours than you took during your entire vacation. Yet, other than timeouts or halftime, you have very little time to review your photos and erase the duds to free up storage space. The solution is to take a lot of digital film with you and use it freely.

Digital camera features and action photography

You can find information on specific digital camera types and their features in Book I, Chapter 2. This section reviews how some of those features can be best applied to action photography.

Viewfinder

Most digital cameras have an optical viewfinder and a color LCD panel. Others have an electronic viewfinder (EVF) and a color LCD panel on the back of the camera. You'll need to determine when to use each of them when taking sports photos. Some general rules to keep in mind are

✦ **Use the optical viewfinder to follow action prior to squeezing off a shot.** You can view the subjects continually through the viewfinder under just about any lighting conditions. Although optical viewfinders can be difficult to use under very low light levels (when you need to use a flash instead of existing light to take the picture, anyway), optical viewfinders are still a better choice than the LCD panel for following fast-moving events.

✦ **Try keeping your other eye open while looking through the optical viewfinder.** This trick gives you some peripheral vision that will alert you when the action is about to enter the frame.

✦ **If your camera has an EVF, you might find it convenient for viewing fast action prior to snapping the shutter.** Note, though, that some EVFs produce a smeared image when you move the camera to follow action, and may blank out a split second before the photo is taken, so you'll be shooting blind.

Using your camera's LCD review feature

Here are some things to look for when reviewing your action shots:

✔ **Composition:** One of the most valuable things that your LCD screen can do for you is confirm that your composition is what you want it to be. With sports photography, you're dealing with athletes moving quickly and sometimes (seemingly) at random. Being sure they're where you want them to be in the frame is a good thing.

✔ **Sharpness:** LCD screens aren't necessarily an accurate way to judge image sharpness. However, some cameras offer the ability to magnify a portion of your image, which can help you see whether your camera's autofocus or your manual focusing is close. If not, you can switch autofocus modes (some cameras let you choose which area of the frame to focus on, or

whether the camera locks the focus when you press lightly on the shutter release) or switch to manual focus.

✔ **Exposure:** Your camera's LCD screen can help you determine whether your exposure is on target. Some cameras let you call up a *histogram*, which is a kind of scale that shows the distribution of brightness values throughout the image. The histogram can help you judge your exposure. If your exposure isn't spot on, you can make changes immediately so that subsequent action shots are better.

Shooting outside in bright sun makes it hard to use your LCD screen effectively. The Hoodman company (www.hoodmanusa.com) makes a variety of hoods that offer some shade for the LCD screen and make it easier to read in the sun.

✦ **Digital SLRs are even better for sports photography.** They provide a bright, clear view (like an optical viewfinder), but you can see through the taking lens except for a tiny fraction of a second when the picture is actually being taken. You'll be "blind" for a much shorter period than with an EVF; you might barely notice the interval.

✦ **The LCD screen is invaluable for reviewing your images immediately after creating them.** Most cameras can be set to display an image on the LCD for a few seconds while it's being saved to your digital film. Take the opportunity to review the image. Even if it's great, you might learn something that will enable you to do better on the next shot!

Electronic flash

An electronic flash unit can be a big help to your action photography whether it's day or night. You can use flash for good photos in a number of ways. Here are a few:

✦ **Let there be light.** An accessory flash unit can provide enough light for you to shoot by when it gets too dark for even your highest ISO (film speed) setting to be useable. (For more on ISO ratings, see the upcoming section, "Setting your ISO speed.")

✦ **Freeze your frame.** Accessory flash units produce an incredibly brief burst of light (somewhere on the order of up to $\frac{1}{10000}$ of a second in duration). Also, because the flash unit provides the main source of light (if it has enough power), it has the ability to stop action. You should be careful, however: When using flash at a slow shutter speed setting, the *ambient* light (the available light other than the flash itself) can register a ghost image trailing the image captured by the flash. This can sometimes be a cool effect — but only if it's intentional.

✦ **Cleaning up the shadows.** Even when there's more than enough light for good sports photography, many times even the brightest conditions can't change the fact that athletes wear ball caps or tree limbs cast shadows. An accessory flash unit can help get rid of those shadows.

Tripods

Sports photography usually calls for such high shutter speeds to stop action that no photographer would use a tripod to prevent blurry photos from camera shake unless you're using a high-end digital camera with a huge telephoto lens (which isn't something the average digital photographer needs to worry about). Instead, sports photographers use a tripod to simply help support the camera. Here are some considerations specific to sports photography you should consider. (Read Book II, Chapter 5 for more detail on tripods.)

✦ **Great support:** A good sturdy tripod can be invaluable for holding and steadying your camera, particularly at telephoto lens settings. Some sports, such as football, call for too much movement on the photographer's part for tripods to be useful. (You'll constantly be running up and down the sidelines.) When photographing track and field, baseball, and softball, however, you benefit greatly from having a tripod to support your camera.

✦ **A second camera rig:** When shooting baseball and softball games, I frequently set up a second camera that is prefocused on a key spot, such as first base, second base, or home plate. A tripod enables you to switch back and forth between two cameras easily and quickly.

✦ **Panning:** This technique involves following the action as it moves across your image frame. Panning is discussed in greater detail later in the section, "Panning," but a tripod with a panning head can greatly improve your efforts at this technique because it allows free horizontal movement while keeping the camera steady vertically. Figure 5-2 shows some action stopped by panning in the direction the soccer player was moving.

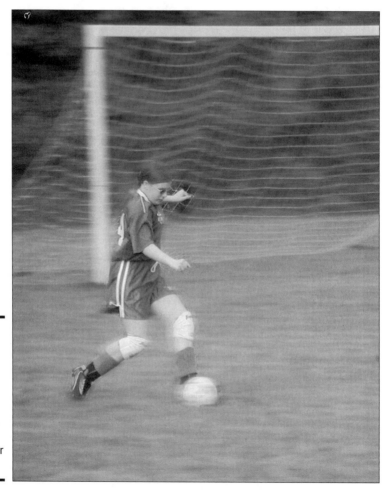

Figure 5-2:
Pan the camera in the direction of movement to stop action at slow shutter speeds.

✦ **Monopods:** For sports that call for photographers to be active, a monopod frequently works better than a tripod because it's easier to pick up and carry around. A good monopod is fairly thick and heavy, both to be strong enough to support the weight of a big telephoto and also so that you can brace against it. A lot of inexpensive units are on the market that promise all sorts of capabilities; make sure you hold out for a good solid monopod and not one of the flimsy ones.

✦ **Shoulder stocks:** These devices are modeled on rifle stocks and work on the principle that by bracing the lens into your shoulder, you can hold it steady.

Lenses and attachments

Because sports photography calls for the ability to cover large swatches of field and fast moving athletes, long lenses or attachments to extend the reach of your point-and-shoot camera's built-in zooms will really help improve your results. Your choice of lens or zoom settings is in part dependent on what sports you plan on shooting:

✦ **Wide-angle settings:** Unless you're very close to the action, wide-angle settings won't be a big part of your sports photography. For example, wide-angle lenses are currently in vogue for skateboarding photography. These lenses can give your sports shots a very different look, if you can get close enough to your subject to fill the frame.

✦ **Short telephoto settings:** Telephoto settings equivalent to a 35mm camera's 85mm–135mm lengths (which is how digital camera manufacturers measure their optics' magnifications) have a lot of uses in sports photography. These are great for indoor sports, such as basketball and volleyball, and can also be handy for nighttime sports under the lights. If your digital camera has a maximum aperture of f/2.8 or larger, you can take photos in lower light levels. Make sure that your camera doesn't use a smaller lens opening, which would defeat your ability to take indoor shots.

✦ **Medium telephoto settings:** These are usually in the 180mm–200mm range. This is a very versatile setting that can come in handy when shooting almost any type of sport.

✦ **Long telephoto settings:** Some digital cameras have long telephoto settings that are the equivalent of 300mm–400mm on a 35mm film camera. These are the lenses of choice for both football and baseball photography because they allow great reach and the ability to keep shooting even when outdoors under lights. Be careful that your long lens doesn't reduce your shutter speed beyond the ability to capture the action.

✦ **Super telephotos:** You probably won't have access to super telephotos unless your digital camera has interchangeable lenses. I'm talking about the really big guns here — the 500mm and 600mm telephotos. These lenses are almost too big for sports photography and are almost the exclusive reserve of nature and bird photographers. They can be useful for times when you just can't get very close to the action and have a pretty small subject. (Gymnastics events come to mind.)

✦ **Add-on lenses for point-and-shoot digital cameras:** Many point-and-shoot digital cameras can accept lens converters that attach to the front of the camera's built-in zoom lens. These converters can screw into the lens filter mount, clip onto the lens barrel, or attach via an ingenious adapter barrel and are frequently available in both wide-angle and telephoto

flavors. I recommend going with the manufacturer's version, which is specifically designed for your camera, but if your camera's manufacturer doesn't offer the accessory lens you need, look at third-party options.

Be very careful if someone tries to sell you an add-on lens for a video camera. Video cameras get by with much lower resolution than digital still cameras. A lens designed for a video camera probably won't produce very good results on a digital still camera.

Digital cameras and latency

Before you move into tips for taking great digital sports photos, you probably should spend a few minutes considering the deep, dark secret that digital camera manufacturers don't want you to think about: When you press that shutter release button, many cameras have a noticeable time lag before the picture is actually taken. Although this lag is but a minor inconvenience if you're taking a photo of the Eiffel Tower, that delay can be fatal when photographing sports. Fortunately, there are some things you can do about the phenomena known as *latency* and *shutter lag.*

Once upon a time, you pushed the shutter release button, and the camera took the picture. As cameras have gotten more and more sophisticated, more and more things have to happen before an image is created.

Dealing with latency

Latency is the time required to write the image you've just taken to your storage media. When you take a picture with a film camera, the shutter releases, and the image is immediately registered on the film at the speed of light, so to speak. When you take a picture with a digital camera, the image has to be captured and then recorded onto your memory card. The image capture and storage process can take a second or two — or even longer. How long the process takes and whether your camera will continue taking additional photos while writing to the card are important questions.

Some digital cameras use *buffers* (built-in memory) to temporarily let you keep shooting while the buffer contents write to removable memory. If you keep shooting, eventually the buffer fills, and you have to stop until it's made enough room for you to resume shooting. Other cameras might not be able to use their buffers for their highest resolution files but will let you keep shooting if you chose a lower-resolution setting. It's a tough choice, but sometimes the ability to keep shooting overrides the desire for the highest possible resolution. Things that affect latency (that you can control) are

✦ **Media:** Some forms of media accept data faster than others. CompactFlash cards tend to write information faster than *microdrives* (tiny hard disk drives). Some CompactFlash cards write data faster than others. Look

for ones rated for faster write times (frequently marked 4X, 8X, or 12X). Several photo-oriented Web sites have conducted their own tests of compact flash cards.

✦ **Resolution:** The more data the camera has to write to the card, the greater the latency period. Non-compressed formats like RAW and TIFF can take the longest to write. If you know that you can get by with a lower-resolution setting, you can speed up things considerably by going with the lower resolution. This can be a tough decision because after you give up quality, you can't get it back. On the other hand, missing a shot because you're waiting for your last few images to write to your memory card is one of the more frustrating experiences that a photographer can enjoy. Film photographers miss shots while changing rolls of film, but digital photographers miss them because of latency. It's not a perfect world, but it is a great reason to get a second camera.

Understanding your equipment and its capabilities and limitations is important for the digital photographer interested in making winning sports photographs. If sports photography is your overriding concern, several cameras on the market are geared toward the sports shooter. Both Canon and Nikon have top-of-the-line digital SLRs that are highly capable photographic tools well designed for this kind of work (but not cheap!). For those of us on a tighter budget, Olympus makes a lower-resolution digital camera capable of 15 fps (frames per second) bursts (for a max of 10 frames). It may be worth considering.

**Book III
Chapter 5**

**Sports and Action
Photography**

Dealing with shutter lag

Latency isn't the only thing that can slow down your picture taking. Many things happen when you press the shutter, including activating light-sensing features and bringing autofocus up to speed. If you have a microdrive hard disk storage device, the time needed for its drive platters to start spinning is a factor as well. The result is *shutter lag,* which is the delay between the moment when you squeeze the shutter and when the camera actually fires. Thus, you have to anticipate the decisive moment and trigger the shutter early enough to cause the image to be created at the best possible moment.

Just like top baseball pitchers study the habits and preferences of the hitters that they face, sports photographers need to become familiar with the specifics of the sport they're shooting. Being ready to shoot and looking in the right direction can give you enough of a head start to compensate for the delay in firing time.

Timing your shot properly

Here are some ways to time your shot so that you can take a great picture even when shutter lag delays capture of that decisive moment.

✦ **Anticipate the action.** Many sports have a particular rhythm. If you can become sensitive to that rhythm, you can anticipate that peak moment of action and determine how far in advance to trigger the shutter. If you're shooting a baseball or softball game, you can position yourself down the third base line and wait for a play at first. It takes a certain amount of time for a throw to make it across the field to the first baseman, so you can trip the shutter in time for the ball to reach the mitt. Anticipation can work for you in non-sports action photography, too. You can wait until just before the real action starts, as shown in Figure 5-3, which was taken just as the flume ride started down the incline.

Figure 5-3: By pressing the shutter button just before the flume ride started down the slope, I was able to freeze the action.

✦ **Go with the flow.** Follow the action with your camera and gently squeeze the shutter as you keep your eye on the ball (or athlete). In sports such as basketball or soccer, you can track the person bringing the ball down the field.

✦ **Pick your spot.** Many sports direct action to a particular location. For instance, long jumpers are headed toward the landing pit, so you can know within a couple of feet where the athlete will land. Be prepared to trigger the shutter as the athletes launch themselves and stay with them until landing. Some sports have goals, some bases, and some baskets; sooner or later, every sport has a spot that you just know will see action.

✦ **Use manual focus.** Some digital cameras allow more control over their capabilities than others. If your camera lets you deactivate autofocus, for instance, you can prefocus on the expected action spot and reduce your camera's shutter lag time. A similar technique works for cameras that let you lock focus. Lock focus on the spot you're keying on just before the play starts, and you give yourself a head start on the action.

✦ **Lock in your focus.** If your digital camera requires you to press the shutter halfway to activate autofocus and autoexposure (and, with cameras using mini-hard disks, to start your microdrive spinning), you can do this in advance and have everything operating at just the right time. The problem with this technique is it can drain your camera's batteries in a hurry, so plan on having lots of extra juice if you want to do this.

✦ **Use autofocus selectively.** Does your digital camera let you pick a different button to activate autofocus instead of the shutter button? If it does, you can combine this feature with the previous technique to decrease battery drain. (Autofocus uses lots of power.) Keep the shutter pressed halfway while awaiting the next event. Then, as soon as you need to, press the second button to activate autofocus. (This takes a little practice, but it does work.) It also works well for the prefocusing suggestion made a couple of paragraphs earlier. Some cameras have a continuous or single autofocus setting. Switching to the single setting can save power because your camera doesn't constantly refocus each time you move the camera a little.

**Book III
Chapter 5**

**Sports and Action
Photography**

Taking Great Sports Photos

This section deals with tips for taking great digital action photos in a variety of different sports situations. That's the great part about sports photography: There are so many different sports. Just when you think you've explored everything that can be done for soccer, soccer season is over, and it's time to grab some basketball shots!

Elementary, middle school, and high school sports are great training grounds for people who want to become good sports photographers for these reasons:

+ **Speed:** Because the players aren't as fast and as skilled as those at the college level (and up), the excitement generally unfolds at slower speeds, making life easier for the novice sports photographer who's trying to follow the action.

+ **Access:** School athletic events are much more accessible than college or the pros. Return the favor by offering the coach or the boosters a copy of your shots for their awards dinner.

Don't be afraid to experiment, either. There are always elements of an event that provide dramatic imagery, even if it's not the typical sports action shot. Think about close-ups of equipment, low-angle shots of the playing field, and portraits or studies of spent, exhausted athletes at the end of the game. Look for shots that show the emotion and intensity that the athletes bring to the sport.

Choosing your sport and your spot

Knowing where to position yourself can be a real challenge for novice sports photographers. It's also vital to give yourself the best possible opportunities to get great shots.

Your goal is to be in position to capture peak action in the right direction (getting that great catch with the athlete's back to you doesn't do you much good). Generally, this means you want to be far enough in front of the action to be effective, yet close enough to fill the frame.

Determining the right spot is largely dependent on the sport you're shooting. Your choice of available zoom settings can also play a role.

Football

If you're photographing high school or peewee football, you can often get right down on the sidelines to take photos like the one shown in Figure 5-4. At the lowest levels of the sport, you can pretty much get whatever access you want. Even at the high school level, you can probably get on the sidelines if you explain you're trying to build a sports portfolio. For most college and professional games, you need some form of accreditation from the team itself. Still, sometimes even a small, local newspaper can secure such access for its photographers, so working for such a publication could get you in. Here are some tips for photographing football:

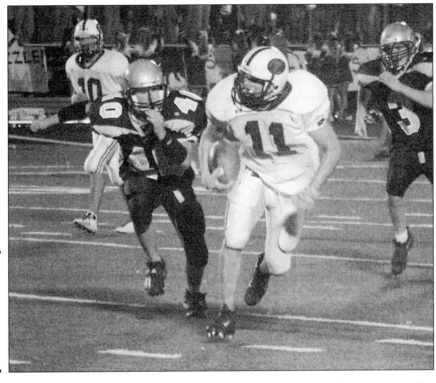

Figure 5-4: Most football action can be captured from the sidelines.

✦ **Keep your distance.** Photographers generally stand about 8–15 yards up field from the line of scrimmage. Don't get much closer than this, or the line officials block your view. This puts you in place for a shot of a running play or quarterback sack in the backfield while still giving you a chance to turn and lock on to a receiver in case of a pass play to your side of the field.

✦ **Use a second camera.** A second digital camera set to its wide-angle setting can also be a good idea. This camera can be quickly grabbed and brought up to shooting position if a play comes right at you. (Be careful to avoid being run over.)

✦ **Keep other spots in mind.** As teams approach the goal line, you can move to the area behind the end zone and shoot straight at the quarterback or running back attempting to leap over the defensive line. Because the team's players sit near the midfield, you can't shoot around this area. Also, plan on getting some shots of the coach yelling from the sidelines and players on the bench. Cheerleaders are good for a couple of shots. If it's a particularly cold day, some shots of the fans bundled up in the stands are worth taking.

✦ **Be patient.** Football demands patience and determination on the part of the sports photographer simply because so much of the sport takes place too far away from where you're standing for you to be able to shoot it effectively. Just stay with the game and be prepared for the action when it finally does head toward you.

Football is one sport where the more you know about the game and the particular teams that are playing, the more effective you can be. Understanding that one team favors short, quick passes while another favors a more conservative ground game helps you predict where the next bit of action will take place.

Baseball and softball

For these sports, there are several likely places for a photographer to work from. One of my favorites is directly behind the backstop, shooting through the links to get a shot of the pitcher just as he or she releases the ball (ideally framed between the batter and umpire). I also like shooting from just behind the dugout, which is where I took the picture shown in Figure 5-5.

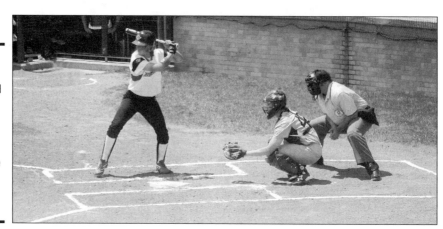

Figure 5-5: Shooting from behind or next to the dugout can give you a great perspective at baseball or softball games.

Here are some other tips for shooting ballgames:

✦ **Get behind the plate.** Many times, I start behind the plate to make sure I get a useable image as quickly as possible before moving on down either the first or third baselines. Usually, I head down until I'm about 5 or 10 feet below the base. From this spot, I can get good shots of the batter, a side view of the pitcher, and a good angle for plays at second base.

✦ **Move down the baseline.** After that, I continue on down the line until I'm as much as 15 or 30 feet past the base. This position gives me a shot at the runner racing to first or third.

✦ **Watch that runner on first.** If there's a runner on first, sometimes I prefocus my tripod-mounted camera on second base in case there's a close play there. Here's where knowledge of the sport and the teams involved can give you a big advantage. The stolen base is one of the more exciting plays in baseball or softball. If you're ready before the play begins, you have a much better chance of getting a good shot of the action.

Much like football, baseball's lowest levels of skill are wide-open to any photographer who cares to shoot them. College and the pros are much harder to gain access to — although once again, a newspaper job might give you a chance. Softball tends to be easier to gain access to. Sometimes, a one-sided game is easier to shoot than a close one. There tends to be lots of scoring, including plenty of people stealing home.

Basketball

Hanging out behind the backboard is a great place for getting good shots. I probably spend 80 percent of the game here. Rebounds, scoring, fights over the ball — it all happens under the boards. Here are some other good locations for shooting hoops:

✦ **Take to the bleachers.** I take some shots from up in the bleachers with a telephoto prefocused on the rim. This is a good location for getting the rebounder pulling the ball off the rim and a good look at the player's face. Try to find a spot a little higher than the rim. This generally calls for a longer zoom lens setting, about 100mm–135mm for a digital camera.

✦ **Head for the sidelines.** I also shoot along the sideline with a longer zoom setting to get a shot of a ball handler bringing the ball up court. From this position, I can also look for a shot of the coach yelling instructions to the players and pivot to grab some crowd intensity shots. Sometimes you can catch a tense moment as the ball is thrown back into play, as shown in Figure 5-6.

✦ **Don't forget half time.** Now's the time to look for shots of the coach and players talking strategy. A wide-angle gets you in close when possible (easy for high school ball and younger, but you probably won't be able to get that close for college and the pros).

Basketball is a great sport for a novice photographer who's looking to build a sports portfolio. It's possible to get good photos without having to break the bank on a camera with an ultralong telephoto lens zoom setting.

Book III
Chapter 5

Sports and Action Photography

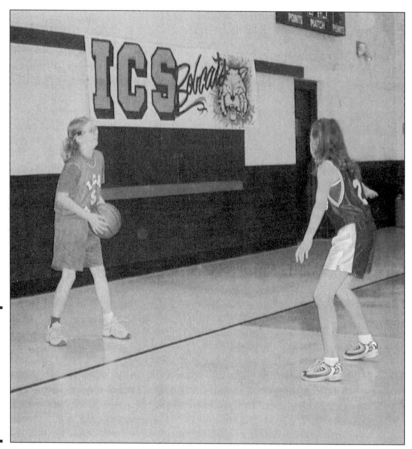

Figure 5-6:
Sometimes the tension of putting the ball into play can make a good photo.

Soccer

Soccer is a little like football in terms of the field and sidelines action, but this sport has lots of unique aspects, as well. Here are some tips:

✦ **Get behind the net.** Behind the net and to one side of it are good locations to catch scoring attacks, but you spend long periods of time counting blades of grass when the action moves to the other side of the field.

✦ **Take to the sidelines.** Positioning yourself on the sidelines puts you in place for good ball-handling shots. If you move down the sidelines closer to the net, you'll be in position to get the goalie in action.

✦ **Reach out and grab someone.** If you have a digital camera with a long zoom lens, you can try to reach from one end of the field to the other to get the goalie straight-on. Or, you can even grab a shot from way up in the stands, as in Figure 5-7.

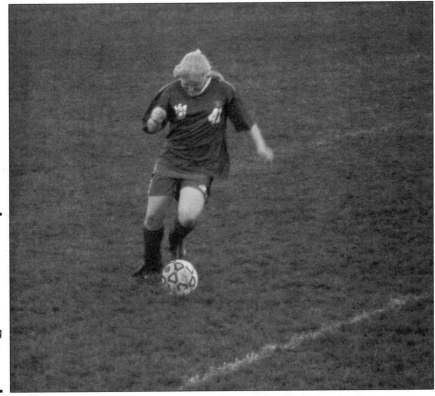

Figure 5-7: This action photo was taken from up in the stands with the longest zoom setting available on the digital camera.

✦ **Going for the wide look.** For variety's sake, try a shorter focal length while lying on the ground. This will give you a second shot, but not a main photo.

Soccer can be a difficult sport for the point-and-shoot digital camera simply because of the size of the field. The best place to work from is the spot behind the net and to one side. An occasional shot through the net works, too, but becomes a cliché if this is the only image you ever capture.

Other sports

Other sports all have their own special challenges and opportunities. Here's a brief rundown on some other popular action opportunities:

✦ **Hockey:** Stand behind the goalie or on the sidelines just above the goal. Players tend to make a lot of contact behind the net trying to control the puck, so there's some good action there. Another place where big hits

happen is the area between the blue lines — the neutral zone. If your lens is long enough, get some shots of the face-offs. Don't forget about reaction shots either. Hockey is tough simply because your movement can be so restricted.

✦ **Tennis:** You can stand behind the court shooting the player on the far side of the net straight-on. Don't worry about the fence; if you're using a telephoto setting, you can shoot through the links. On the sidelines, I favor shooting when the player is running from side to side after a ball but only when the player is moving toward me. Either a monopod or tripod will work for tennis.

✦ **Golf:** Shoot from the side when the player is teeing up (but not during their swing) or straight-on if the course conditions permit. You can also shoot straight-on from a safe distance when a player is putting.

✦ **Track:** So many events, so little time. Whenever possible, I try to shoot track events from as close to straight-on as possible, generally as runners are coming around the turn or at the start of a race when the line of runners is beginning its break. For shuttle hurdles (teams of hurdlers shuttling in each direction), I try to position myself at the midpoint of the track so that I can zoom from longest to shortest focal length as I move from runner to runner.

✦ **Field events:** So many events, so many different ways to shoot them. Unlike track, which tends to use the same quarter-mile track surface for its events, the field competition presents more challenges. Fortunately, shot put, javelin, and discus can all use the same basic philosophy: Namely, get in front of the athlete with a little offset to the side (and far enough away to be out of range) so that you can shoot straight-on as the athlete releases whatever it is he or she is throwing. Setting yourself up behind the landing area is a good strategy for both the long jump and pole vault, while positioning yourself to the side and slightly behind the bar works well for high jumping. (The hard part is racing from side to side because jumpers will come from both the left and right.)

✦ **Gymnastics:** Any position that lets you shoot the athletes coming directly toward you is a good location. If circumstances allow you to get close to the action, wide-angle lenses can give your images a different look.

✦ **Adventure water sports:** I'm talking white-water rafting, kayaking, and canoeing here. Generally, you have a choice of two good locations. The first is downstream, just below a rapid, so that you can get the boaters in action. The second is from a bridge, looking down on the river, which gives you a nice alternate shot. Don't be afraid to get in tight and compose from the top of the boater's head down to his or her paddle in the water. It's not necessary to show the entire boat.

✦ **Rock, alpine, and speed climbing:** If possible, either get on top of the rock and shoot down on the climbers, or get on a ledge that's level with a point the climbers will reach during their ascent. If you're on the ground when they begin the climb, a wide-angle shot from the side and below gives a useable image, and you can play with silhouettes if you want to try something different. Also from ground level, you can try a telephoto shot of the climber against the wall. For a speed climbing competition, a longer telephoto setting gets you in tight and compresses the competitors more closely together. I prefer to shoot speed climbing from the side because it emphasizes the extreme body contortions the climbers go through.

✦ **Extreme sports:** Both straight-on and profile shots provide good images for many of these sports. For skateboarding, inline skating, and BMX bike events, shorter focal lengths work well, depending on how close to the event you can get. Wakeboarding calls for very long lenses, a monopod, and a position on the riverbank that gives a good view of as many jump points as possible.

Increasing dynamic range

High-contrast situations, such as ski slopes, present a special challenge for digital cameras. Because sports photography frequently revolves around frame-filling action with just one or two athletes, the easiest way to deal with high-contrast lighting is to use flash to balance the light between your subject and the background.

✔ **Metering:** Take a meter reading off a *mid-tone* (something equivalent to medium gray) and find the correct exposure for the overall scene. Then set your flash to output enough light so that your subjects' illumination matches the background. (This tip probably applies only to those with higher-end cameras and very powerful flash units.)

✔ **Filtration:** Special low-contrast filters have appeared on the market in the past few years. Although sticking another piece of glass in front of your high-quality lens risks degrading image quality, a well-made filter can be worth the investment. Photographs made with low-contrast filters generally require a little extra tweaking in an image editing program (nothing extreme), but the results can be well worth it.

✔ **Linear TIFFs:** If your camera offers a RAW mode capable of producing 16-bit linear TIFF files and if your image editing program can work in layers, you have another method of dealing with high-contrast lighting. Just capture the image twice — once as a linear TIFF (which will appear underexposed) and once as a regular TIFF. Copy the regular TIFF directly over the linear TIFF (Shift+drag with the Move tool if you're using Photoshop), and then create a layer mask. Activate the layer mask and then drag the gradient tool from top to bottom.

**Book III
Chapter 5**

Sports and Action Photography

◆ **Motor sports:** These sports are among the fastest growing events from a fan standpoint. Auto racing is one of the toughest photographic challenges, even for modern professional camera equipment. Those cars are fast! Try to catch them on the curve when they're moving a little bit slower. This can also give you a three-quarter view of the car. Or, pick a spot where you can get the cars coming at you. This type of action is easier to capture. Fast moving racing cars can also present a good opportunity for creative blur shots (more on this topic later). Use a modest shutter speed (say 125th of a second) to keep the starter sharp as he waves the flag to begin the race. If you do it right, the starter stays sharp while the cars and flags are blurred. Other good opportunities include shots at the starting line or in the pits. For motor-cross events, where the motorcyclists are catching big air, you want to be located some distance away from their take-off point. Side shots of the athlete and bike as they come even with your position are also good.

◆ **Horse racing/dressage:** For horse racing, station yourself where the track curves so that you can shoot the animals coming straight toward you; then get three-quarter and profile shots as they round the curve. For the specialized horse maneuvers called dressage, study a book on the desired movements and looks each animal should present. Be ready to shoot them head on and in profile and three-quarter pose.

◆ **Swimming:** Shots from head on and from the side are pretty much your only choices here. Start by shooting head on and time your shot to catch the swimmer rising up from the water. You might need an accessory flash unit and a butane-powered hair dryer for battling lens fogging. Don't underestimate just how difficult it is to keep your equipment in working condition because of all the moisture and humidity in the air. Keep extra packets of *desiccant* (a powdered moisture-grabbing agent) in your camera bag and a microfiber cloth within easy reach. Try to get to the swim meet site at least a half hour early so that your equipment has a chance to come up to room temperature and humidity. Package your camera and lenses in sealable plastic bags during this warm-up period so that condensation forms on the bag, not the lenses.

Winter sports: A special case

Winter sports such as skiing and snowboarding present a special challenge for the digital photographer because of the amount of contrast inherent in snowy conditions. Such lighting conditions often fool your camera's exposure system. If your digital camera lets you shoot in RAW mode and capture images as linear TIFF files (check your camera's instruction manual to see how), use that option. It gives you the maximum amount of information when you're editing the image later. You'll be glad you did.

Accessibility

Most events are accessible at all but the highest levels of play. Even high school and junior college sports cut serious amateurs some slack if they want to get closer to the action (on the sidelines or behind the baseline).

When you get to the point where the athletes are making their living playing the sport — or for the highest levels of NCAA play — that starts to change. Even minor league ball has restrictions on what you can do and what kind of equipment you can use. Pro-level events are even more restrictive. Plus most professional organizations only grant access based on your agreement to use your images only for editorial purposes. High-profile sports organizations like Major League Baseball, the National Football League, and National Basketball Association guard the marketing potential of their sports and athletes very closely.

At least one type of competition, extreme (or *action*) sports, provides unparalleled access

for the average enthusiast. Many times, while shooting events at the X-Games, I've been on one side of a fence chatting with spectators a foot or two away on the other side, who were in position to get the exact same shot I want.

These sports tend to be very photogenic, too. Plus the athletes tend to be fan-oriented, which can lead to good fan-athlete interaction shots. Because the financial rewards for many of these sports come more from endorsements than from prize money, the athletes actually try to cultivate their fans — a lesson that some professional sports seem to have forgotten. Extreme sports fans tend to be almost as flamboyant and colorful as the athletes, too. Look for mohawks, spiked hair, body piercings, and tattoos. Most fans don't mind if you want to get a shot of their particular fashion statement; they're usually pretty proud of it. Just first ask whether it's okay.

Generally, a good image occurs when the skier or snowboarder turns about 15 or 20 feet from your position. (Try to avoid the snow spray.) Another good shot is when the athlete becomes airborne. Be careful that you aren't so busy looking through the viewfinder that you lose track of the skier or boarder coming right at you. (Don't laugh; it happens.)

I usually rely on the medium to longer zoom lenses plus an accessory flash. Because these sports are done on snow-covered mountains, I try to travel light and with my equipment balanced in waist pouches or equipment belts rather than a camera bag. A camera backpack works well, too, but makes it harder to get at your equipment in a hurry. Having a flash available is very important because otherwise, you have to choose between overexposed snow and an underexposed subject.

Taking Your First Action Photo

As a would-be sports photographer, one of the most important things you can do is become knowledgeable about the sports you want to shoot. The most successful sports photographers are the ones who can anticipate the next play or event and put themselves in position to trip the shutter in time to record the moment.

Many times, you have decisions to make long before the action starts. Is this a situation where you're going to use the zoom on the camera and try to react to what happens? Or are you picking a spot, prefocusing, and waiting for action to reach that location? Both are valid methods, and most photographers alternate between them as the game goes on.

Whenever possible, sports shooters try to analyze the situation to see whether they can understand what will happen next. Third and long yardage or first and 10 in football are good examples. In the former, a pass is likely; in the latter, a running play. You can follow the receiver on your side of the field if you think a pass play is likely or key in on the quarterback to get a shot of the pass or the pass rush. For the running play, you can key in on the backfield and be ready to catch the hand-off and ensuing running play.

Setting your ISO speed

Being able to change the film speed or ISO (International Standards Organization) rating of your camera on the fly is one of the great benefits of owning a digital camera. Be sure to check your camera's instructions to see how to change the ISO setting.

When conditions permit, I always try to work at 100 or 200 ISO to get the highest quality images. Most digital cameras are optimized to provide their best quality at those settings. If I'm shooting outdoors under most daylight conditions, an ISO setting at 100 to 200 usually allows me an action-stopping shutter speed of $\frac{1}{2000}$ of a second or higher, which is good for the majority of sports. (For more on choosing shutter speeds, see Book I, Chapter 2.) If I have to move indoors or if the sun is getting lower in the sky, I ratchet the speed up to 400 ISO and use a flash unit if circumstances permit. It's during uneven lighting situations when being able to change ISOs whenever you want is a great help.

Although my digital camera allows using ISO settings as high as 800 and 1600, I try to avoid these settings unless it's the only way to keep shooting. Images made at this ISO tend to need a little more tweaking in an image editor than lower ISO shots and also offer less margin for error when it comes to exposure. Cameras vary, and so do photographic tastes. Test out your camera before taking your first action shots so that you can determine whether your camera's ISO choices produce results that meet your standards.

High ISO settings let you use faster shutter speeds, which means sharper images, but higher ISO settings also produce noisier images: *Noise* is the digital film version of conventional film's grain. Still, a sharp, noisy image is preferable to a noise-free, fuzzy one.

Understanding how to stop action

Today's athletes are well trained, well conditioned, and well prepared. As a result, they're faster than ever. To freeze their movements, you need to use either a fast shutter speed or an accessory flash unit. Another consideration is the relationship between the direction in which your subject is moving and your camera's orientation. Here are some tips to keep in mind:

✦ If your subject is moving toward you or away from you, you can get by with a slower shutter speed than if your subject is moving across your field of view. It's hard to say generally what a good minimum shutter speed is because the shutter speed needed to stop action varies from sport to sport, but faster is always better. Figure 5-8 shows a speedboat and water skier headed away from the camera. The action was stopped at a relatively slow $\frac{1}{25}$ of a second.

✦ As light levels drop, an accessory flash's quick burst of light can freeze action that a slow shutter speed might not. Whether you can use flash tends to depend on the particular sport you're shooting. I've never had any problems shooting football or basketball with a flash unit. Athletes such as tennis players tend to be more sensitive to flash photography, so I plan accordingly. When in doubt, check with the event organizer to see whether they have a specific policy or watch what other photographers are doing. Many times, if you're setting your flash for fill lighting rather than as your main light source, the burst of light is brief enough and low enough in intensity that the light won't be a problem. Keep in mind that you have to be within the effective range of your flash's output capability for it to do any good.

**Book III
Chapter 5**

Sports and Action Photography

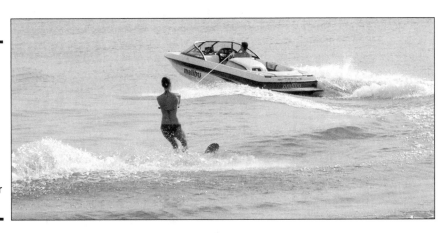

Figure 5-8: Action headed toward or away from the camera can be stopped at a relatively slow shutter speed.

Controlling shutter speed

How do you get your camera to use a short shutter speed to stop action? You might have to check your camera's instruction manual to find the exact controls, but here are the options you should look for:

✔ **Shutter priority mode:** In shutter priority mode, you can choose the exact shutter speed you want to use (such as $\frac{1}{500}$ or $\frac{1}{1000}$ of a second), and the camera's automatic exposure control will choose the f-stop lens setting appropriate for that shutter speed. Keep in mind that depending on the lighting conditions, you might not be able to use the very shortest shutter speeds at all. In dim light, for example, your camera might not be able to take a photo at any shutter speed shorter than $\frac{1}{250}$ or $\frac{1}{125}$ of a second because there simply isn't enough light.

✔ **Manual shutter speed/exposure settings:** On some cameras, you can set both shutter speed and f-stop manually. If you can do that, it's up to you to interpret your camera's light meter to provide the correct combination of shutter speed and f-stop for a proper exposure.

Short-duration shutter speeds can often be the key to stopping action. The brief time that the shutter is open registers only an instant of motion. Longer shutter speeds give your subject time to move farther or make more movements while the image is being recorded, which results in blurred photographs.

Generally, your choice is to use the fastest shutter speed possible. For many prosumer digital cameras, this frequently means $\frac{1}{1000}$ of a second. This speed is fast enough to stop any human motion and will freeze many other elements of most sports.

Stopping action with slow shutter speeds

You can often stop action using a slower shutter speed, too. Indeed, the effects might be more realistic than the frozen-statue look that you get when sports participants are stopped dead in their tracks. Here are some tips for stopping action at slower shutter speeds:

✦ **Look for momentary pauses.** Many times, a sport has a moment of peak action where the action hesitates before movement returns. Think of a jumper on the ascent. At the top of the leap is a moment of stasis — hanging in space before dropping back down, as shown in Figure 5-9. If you're forced to shoot at too low of a shutter speed, try to time your shot for that moment. Another example is a tennis player, just after tossing the ball to serve. If the server uses a high toss, he or she has to wait

for the ball to drop before hitting it. The tennis player up at the net is another example. Although the racket and ball might be moving very quickly, the athlete's body usually isn't traveling very far or fast.

✦ **Try to shoot the action moving directly toward the camera.** Athletes and machines moving toward the camera require a slower shutter speed and faster autofocus to freeze motion than those moving laterally across the camera's field of view.

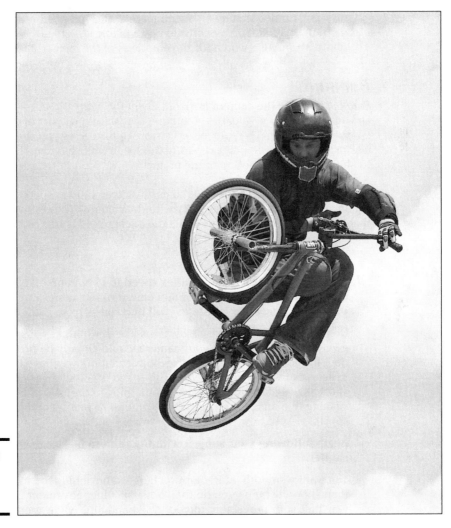

Figure 5-9: Catch the action at its peak.

✦ **Concentrate.** The most dramatic image can be the concentration of the athlete the moment before he or she begins play. Think of the pitcher looking to the catcher for a sign, or a tennis player just before serving the ball. Another example is the linebacker poised for the snap of the ball before rushing the quarterback. There's also the free-throw shooter pausing a moment before shooting.

✦ **Find action in nonaction moments.** Another shot to look for is one that shows the price the athlete pays for his or her sport. This can be football players on the bench with steam rising off their heads, or a spent distance runner leaning on a teammate at the end of a race. A shot of a distraught athlete being consoled by a fellow athlete is a classic sports photograph. Also watch for the emotions of the fans or cheerleaders.

Panning

Panning (moving the camera horizontally in the same direction of motion as your subject) is a valuable technique that should be part of every serious sports photographer's repertoire. This procedure gives you the best of both worlds: freezing the important part of the scene while blurring the background to show the furious motion of the moment.

The idea behind the technique is to use a slower shutter speed while following an athlete or an object laterally with the camera. The result is a subject that's in relatively sharp focus while the background is blurred.

Here's how to put panning to use:

1. **Select a moderately slow shutter speed to give yourself a long enough stretch of time for the lateral movement of the camera to register — but not so long as to create overall blurriness from camera shake.**

 Don't you just love precise directions like this? But seriously, if I could give you exact numbers, your camera would already be programmed to do it for you. There's no exact recommendation; you have to experiment to see what works best for you. The speed is going to vary from sport to sport as well. Start out by trying something in the $\frac{1}{45}$–$\frac{1}{60}$ of a second for running humans. Work your way to around $\frac{1}{350}$ of a second for motor sports and see how this works for you.

2. **Begin following your subject with the camera before tripping the shutter.**

 You want a smooth lateral motion here, so beginning the move first and then shooting helps you do that. Your panning movement is steadier if you limit your movement to your waist and hips while keeping your feet planted and your knees together. This will also help reduce camera shake. Also make sure to keep your elbows braced against your body to help turn yourself into a human monopod. Most people find that using an actual monopod generally doesn't work very well, but for a few, it works.

If circumstances permit, a tripod with a tripod *panning head* (one that allows the tilt and yaw controls to be locked while the panning direction swings free) can make for a smoother pan. Certainly a photographer who's just starting to experiment with the panning technique might find that a tripod makes things easier.

3. Trip the shutter as gently as possible.

You're trying to avoid a downward snap in your movement. The old cliché is to squeeze the shutter — not press it.

4. Continue your lateral panning movement for a second or so after the shutter has closed.

This is a case where proper follow-through is just as important for the photographer as it is for the athlete.

5. Repeat this process at least a half dozen times or more.

It seldom works perfectly the first time. (It's okay; you're not paying for film here.) Good panning is something you have to work at. Don't give up on the technique if your first few attempts (or more) don't pan out. (Sorry, just couldn't resist the pun!)

This technique gives you dramatic images that accurately convey the sense of motion the sport involves. Sometimes, the photograph of the athlete flying through the air or running down the track with the background blurred does a better job of conveying the speed of the event than a moment of frozen action.

Action approaching the camera

Action approaching the camera is also more dramatic because the camera can maintain eye contact with the athlete or create a sense of power from the approaching machine coming right at the viewer.

Because these images produce such drama, work on capturing them well. Mastering this aspect of sports shooting will do much to improve your sports photography. Help your camera's autofocus system work its best by prefocusing on a spot a few feet ahead of where you hope to take the picture. Lock on to the approaching athlete and give your camera a chance to acquire the athlete and bring its autofocus up to speed. If you're working with a digital SLR with a zoom lens, you can give yourself more time and distance for the shot by acquiring your subject at the extreme telephoto end of its range and continuing to shoot while racking the zoom through its full range to its widest setting.

Circumstances don't always permit you to get this shot. Still, photography is about putting yourself in a position to give yourself the best possible chance to catch the action. If you couple that with shooting a large number of images, you can increase the likelihood of success.

**Book III
Chapter 5**

**Sports and Action
Photography**

Using blur creatively

In some circumstances, you just don't have enough light or a fast-enough lens to set the shutter speed as high as you would like. Stopping action can be a good photographic technique when you're covering sports, but it's certainly not the only one. When circumstances don't allow you to freeze motion or when you want to create something that looks different from what everyone else is doing, deliberately trying to blur your image can create something special. Figure 5-10 shows a picture in which the blurring creates a photo that says "action!" more clearly than any frozen-in-time photo.

To create a successful photograph, the key elements of the image need to be in focus — not necessarily every single part of it. Your subject's eyes and face need to be in focus. If their body or hands or feet are blurred, that shows just how fast they're actually moving. Some sports, such as tennis, are easy. There's a pretty forgiving difference between the shutter speed you need to freeze the athlete's body and the speed necessary to freeze the moving tennis racket or ball. The same goes for hockey because the player's stick and the puck blur quite easily at shutter speeds that comfortably freeze the player.

When successful, this kind of image can actually be more dramatic than freezing action. Here's how to try this technique:

1. **Figure out what shutter speed is slow enough to blur the faster moving parts of the body while being fast enough to freeze the face.**

 This varies from sport to sport, so be prepared to experiment.

2. **Timing your shot to coincide with a moment of peak action, such as the athlete at the top of his or her leap.**

 Many sports call for the athlete's head to stay still while the rest of the body explodes in action. (Think of a golf swing where the player's head stays down through the entire stroke.) Other sports require the head to travel through a range of movement as they stroke through the ball. (You know, *keep your eye on the ball*.) For these sports, the head eventually stops as the athlete follows through to complete the stroke. The end of this follow-through determines where the athlete's body movement is frozen, although the ball or puck and stick or racket might still be moving.

After you get the hang of using blur creatively, you've added a powerful tool to your photographic arsenal. The essence of many sports is the athlete's ability to move as fast as possible. Blurred hands, feet, limbs, and wheels convey the speed of modern athletes and machines in a way that frozen figures can't. Try to experiment with creative uses of blur each time you're

on a shoot. Just manage it the way most photographers do: We start out working for an image that we know gets the job done. After we get our "money" shot, we can start working for something a little more creative. This is the time to try for the panning or creative blur photos.

Figure 5-10: Blurring adds to the excitement of this photo.

Taking the Picture

After you choose your shutter speed, take a strategic position, and know what kinds of opportunities might be coming your way (literally!), take the picture. Watch the action closely, frame the image in your viewfinder, and snap away.

Capturing great sports moments

As you shoot, keep some simple concepts in mind. For example, here are some things to look for in a great sports image:

+ **Full extension:** The athlete at the top of a leap or in full stride represents one example of the decisive moment in sports photography.

+ **The coiled spring:** The moment before release when muscles are tense and the body is coiled represents another key moment in sports. This image shows the athlete just before he or she explodes into action. Think of the shot put thrower just before release, the shot still pressed into the chin, or the baseball pitcher, arm reared back ready to reverse direction and fire the ball at the batter.

+ **Emotion:** A great sports image doesn't even need to be a good action shot. Catch the athlete or fan in a moment of extreme emotion, and you've gotten a memorable image. Watch the fans, watch the coaches, and watch the athletes watching the other athletes. There's more to sports than just sports.

Most sporting events are carnivals of colors, patterns, and personalities. They provide a wealth of photographic opportunities not limited to just the playing field. Enthusiastic photographers, curious about the world around them and with an eye to more than just the game, can produce great sports photos no matter what camera they're using.

Setting up for predictable action

Having an understanding of the sport you're photographing can put you in a position to take advantage of your ability to predict impending action. Here are a couple of ways to use that ability:

+ **Prefocusing:** Sometimes an athlete needs to reach a specific location as part of a play. If I'm photographing a baseball or softball game and a runner makes it to third, I swing my tripod-mounted camera to cover home and prefocus on home plate. I still follow the action with my hand-held camera, but I also position myself so that I can quickly fire the second camera for a shot of a runner sliding home. Prefocusing on the forward end of the basketball rim is another example. You're now ready to get a shot of the center leaping for a rebound.

A separate electronic flash unit, such as the 'round–the–lens ringlight used to capture this close-up, can give you the flexibility you need in challenging photo situations. You can read more about choosing electronic flash, cameras, and other accessories in Book II, Chapters 1 and 5.

A scanner can do a better job than a digital camera for some kinds of image capture simply because scanners have higher resolution. At left, the coin was scanned at 300 samples per inch. At right, you can see how much more detail is available at 2400 samples per inch. You'll find lots of information on choosing a scanner in Book II, Chapter 4. Tips for using a scanner are collected in Book VI, Chapter 1.

Seamless backgrounds are one of the most useful accessories for photography of all kinds of objects. Read about accessories such as backgrounds in Book II, Chapter 5.

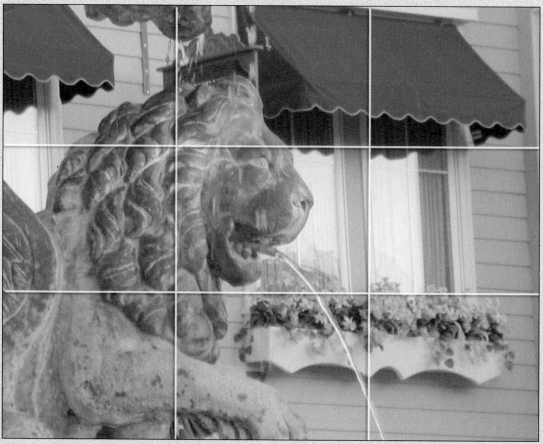

Place your center of interest at one of four imaginary points located one-third of the way from the top, bottom, and sides of your image. The basic rules of composition can be found in Book III, Chapter 1.

Lines in your photos can lead the eye from one point to another, as you'll see from the examples in Book III, Chapter 1.

Although most compositions won't be square, some subjects do lend themselves to a square format. That doesn't mean the image has to be static, as you can see in this shot.

Use parts of the surrounding structures to frame an image and improve your composition.

Repeating lines also add interest to a composition, as in this photo of an old prison. Find out more about image composition and snapping great pictures in Book III.

Close-up photos can be taken in your home or garden, so you can always find something interesting to shoot without the need to leave home. You'll find great ideas and tips for shooting close-ups in Book III, Chapter 2.

Selective focus can be used to concentrate attention on part of a photo. A blurry background also disguises clutter.

A simple white card placed off to one side can fill in dark shadows in an outdoor portrait. Interesting lighting effects (made easy) are discussed in Book III, Chapter 3.

When shooting for publication, look for dramatic shots that are worth a page of their own. You'll see how to take PR photos and other pictures suitable for publication in Book III, Chapter 4.

Waterproof cases available for many digital cameras enable you to take exciting sports photos like this one.

Catch the action at its peak if you want to grab a compelling sports photo. Discover some secrets of the pros in Book III, Chapter 5.

A high shutter speed can freeze the action, but you still
need to press the shutter release at the decisive moment.

Travel photography is more than monuments and scenery.
Capture local color to get a good sense of place in your
travel photo series. Tips for getting the best shots in a wide
range of travel situations are found in Book III, Chapter 6.

Sunsets are one of the easiest and most beautiful scenic photos you can take. Some photographers specialize in them.

Use the foreground to frame an image of a distant shore, adding three-dimensional perspective.

Be careful when photographing buildings. If you tilt the camera up to take in the upper portion of the building, the structure can appear to be falling back, as in this photo. It's better to step back a bit and shoot with the camera parallel to the front of the building, as in the second picture.

Leave your shutter open for a few seconds to capture the breathtaking beauty of fireworks, as in this shot.

A sturdy tripod that holds your camera steady during long exposures will help you take eye-catching night-time shots.

One of the most important features of image editing programs, such as Photoshop or Paint Shop Pro, is their ability to let you correct the contrast and color balance of your digital photos. You'll see the basics of fixing color casts in Book IV, Chapter 1, and Book V, Chapter 5.

Wish you hadn't caught another photographer in your photo of a grazing donkey? Snip her out using the cloning tools found in most image editors.

It's hard to tell where the young girl was in this retouched photo. You'll find information on retouching in Books IV and V.

An image editor's saturation controls let you perk up the richness of the color in photos like this one. Book V is full of photo fix-up tips.

Image editors let you take one element from a photo and add it to another, as with this castle that was plopped down on a hillside.

You can improve the colors, lighten shadows, and make other changes to photos using an image editor so that you can get great shots like this one. Image editing is discussed in Books IV and V.

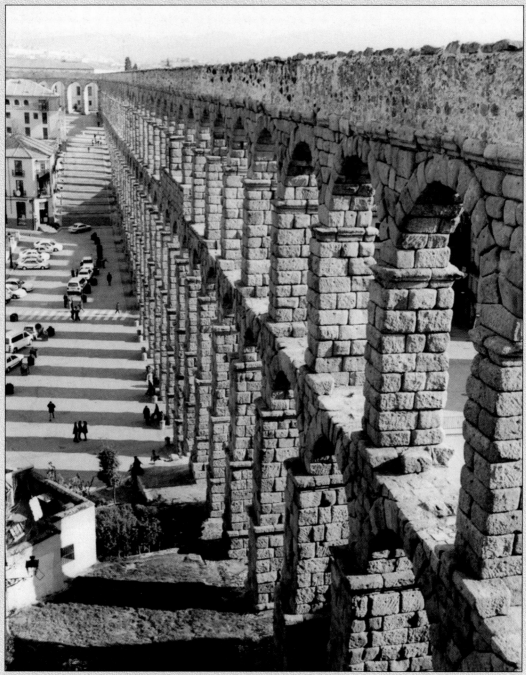

Converging lines and repeating shapes make this an interesting photo. Turn to Book III, Chapter 1 for more about great image composition.

✦ **Zone focusing:** This technique takes advantage of the depth-of-field that comes with using a smaller lens opening. (Depth-of-field is covered in greater depth in Book III, Chapter 2. In simple terms, the smaller the lens opening, the greater the range of sharp focus from one point to another on a line from the lens.) The idea here is to choose a lens opening that's small enough to create a zone of sharp focus. The zone should be deep enough to give you about a 5-foot range where everything is in focus. Then, instead of worrying about focusing, you can just concentrate on what happens in that zone and shoot as appropriate. Zone focusing works well on a sport such as basketball, where you know you can expect action to take place in a location about 5 to 10 feet from the basket. Using an external flash unit (which many point-and-shoot digital cameras can do) should enable you to shoot at f/5.6 or f/8, which gives you that 5-foot range or greater. In Figure 5-11, the focus was set ahead of time for the ramp, so when the athlete spun around, the camera was already set for the picture.

Sometimes, you need to do more than just capture one good shot of sports action. You need to get the entire sequence of movements that make up an entire run or the execution of a particular move or trick.

Pros get these sequences by using high-speed motor drive cameras that can capture as many as 8 or 10 pictures per second (usually expressed in frames per second). Although one or two prosumer-level digital cameras are capable of high-speed, motor-driven photography, most are only good for about 3 fps at best. Even the Canon D30 that I use most of the time is good only for this same slow speed, and that's only if I use a fast enough shutter speed. (A slow shutter speed means the camera has to wait longer before taking the next shot. So a shutter speed of say, $\frac{1}{1000}$ of a second, lets the motor drive function more efficiently than a shutter speed of $\frac{1}{60}$ of a second.)

Even with a limited motor drive capability, a photographer can still create effective photo sequences. Once again, a little planning and foresight can help you get the best possible results. If you can predict the path the athlete is going to take, you can better follow that path with your camera. Another thing that you can do is back out your composition a little to give you some margin for error. You don't want to have a great sequence of shots with your subject ruining it by drifting in and out of the frame.

Here are some tips for getting good action sequences:

✦ Visualize the path that you expect your subject to travel.

✦ Prefocus on the point where you expect to start shooting.

✦ Set the fastest shutter speed you can to give your motor drive the best possible chance of advancing at its best speed.

✦ Compose your shot to give your subject some room to move within the frame.

✦ Shoot several sequences to make sure you get at least one useable sequence. Remember that you're trying to get four or five good shots in a row, not just one, so it becomes that much harder to be sure that they're all in focus and well composed. Take lots of shots.

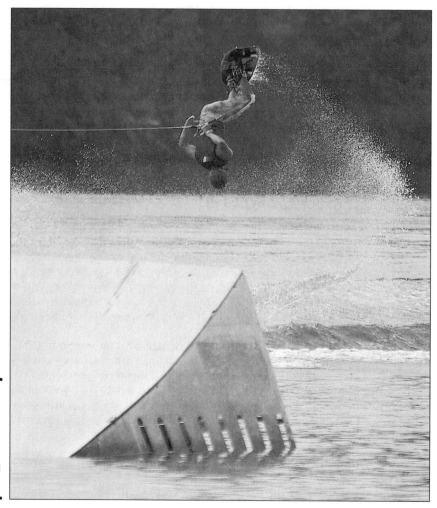

Figure 5-11:
If you know where the action is going to be, focus ahead of time.

Don't expect to get a good sequence on your first attempt. This is another one of those techniques that you need to practice beforehand. You're trying to understand how your camera works in this kind of situation and determine whether you can tweak your gear to perform better. Some cameras require you to drop down to a lower resolution in order to shoot fast enough to get a good sequence of images. Because you're trying to get multiple images, the loss of resolution might not be as bad as you think. After all, you'll have the group of images to take the place of one shot.

Some digital cameras don't offer a continuous shooting capability. Others offer it only at a lower resolution setting than you're really comfortable using. Just because you can't blaze away like the pros doesn't mean you can't tell a multiple-picture story of a sports event.

A good sequence of photographs tells a story. If you're shooting an event where an athlete makes more than one run or attempt (long jumpers get six tries, for instance), work on getting the sequence you want by shooting a different aspect of each attempt. Be careful how you identify the finished result, though. There's nothing wrong with showing how each element of the jump works through a sequence of images, but representing it as the individual elements of one jump is the kind of thing that gets photographers in trouble.

Capturing the fans

When I feel I have a good set of strong action images, I like to concentrate on getting reaction shots from the fans. Athletes achieve at least some release through their physical exertion, but fans have no such outlet. Find someone who seems to be particularly expressive and shoot that person through the course of a particularly tense phase of the competition. Use a longer focal length to isolate the fan and to avoid attracting attention to your photography.

Chapter 6: Travel Photography

In This Chapter

✔ **Choosing the right equipment**

✔ **Getting ready to go on the road**

✔ **Mastering the best travel photography techniques**

*T*aking pictures while traveling can be the most rewarding long-term benefit of a trip. Although memories of a particular location fade as the years go by, the images that you create will still be there to remind you of a special time in your life. Plus, face it: Photography is fun! Knowing that you've taken a good picture of that special location gives you a particularly satisfying feeling. Lasting friendships can be made during a trip, and being able to send your new friends pictures of the time you shared together can help cement your friendship.

If you've traveled using a film camera in the past, you'll find that vacationing with a digital camera offers some terrific advantages over traditional picture-taking tools. Digital cameras can be smaller and lighter than their film counterparts, so they take up a lot less space in your luggage. They have no film that airport security X-ray cameras can damage. And as you take photos, you can check them using your digital camera's built-in LCD screen.

This chapter offers advice to aspiring photographers who are intimidated by the idea of trying to take good pictures in unfamiliar surroundings.

Choosing Equipment

A photographer on the road needs a selection of gear that's versatile enough to handle the unexpected but doesn't need to be burdened like a Sherpa on a Mt. Everest expedition. Carefully considering which key pieces of equipment to take — and which to leave behind — can make the trip less stressful and more productive.

Selecting a camera for your needs

Choosing a camera to use while traveling is an important decision, one that you might have already made long before your trip. After all, most of us are unable to buy a camera specifically for a vacation. You'll want to

keep a camera's travel photography capabilities in mind whenever you pur-
chase a digital model. A huge variety of digital choices are out there today,
offering a tremendous range of capabilities. Pros might use digital camera
backs for medium format cameras or digital SLRs using interchangeable
lenses, whereas serious amateurs have tons of less expensive options.
Key decisions revolve around lens versatility (for more options while taking
pictures), file size (more megapixels equal bigger pictures), and how much
control the camera gives you over shooting decisions.

Although the average consumer might never see or use one, high-end digital
gear is interesting, nonetheless. Medium format cameras (the ones that take
the 2-inch rolls of paper-backed film) often have interchangeable backs that
hold the film. You can sometimes replace the back with a component that
has a digital-imaging sensor instead of film, bringing digital photography
capabilities to roll-film cameras that weren't originally designed for digital
photography. Digital SLRs (single lens reflex cameras) usually allow you to
view through an optical viewfinder using the same lens that takes the picture.

When purchasing a camera, most of your decisions revolve around what kind
of photographer you are and what kind of travel pictures you expect to take,
as the following sections make clear. No matter which category you fall into,
your digital camera should have the basic features that you need to make a
broad range of travel photography easy and carefree.

Professional photographers

Pros like to be ready for anything, even when they're not on the clock. You
never know when a quick shot taken while on vacation can turn into a sal-
able image. If you're a professional photographer, look for

✦ Compatibility of a digital system with your current film camera's inter-
changeable lens system, if at all possible. Right now this means Canon,
Nikon, Fuji in Nikon mount, Sigma, Sony, Minolta, Pentax, and a few
other vendors.

✦ A choice of camera bodies offering 3–14MP sensors, rapid sequence
shooting ability, and other features, depending on your shooting needs.
Travel photography can sometimes be as fast-paced as sports shooting
and can require high-resolution images for reproduction.

✦ A choice of flash units and accessories, such as those shown in Figure 6-1,
to meet your shooting needs. A professional system needs to be flexible
enough to accommodate all the gadgets needed for top-of-the-line travel
photography.

Figure 6-1:
Professional photographers need the most flexible gadgetry for their digital toolkits.

Serious amateurs

The best serious amateur photographers are often professionals in every aspect except monetary reward. They frequently spend a lot on their hobby and might even be looking at the same systems desired by pros. Their needs will certainly include

+ A high-resolution (4–8MP) camera with large capacity memory (with the ability to accept interchangeable memory cards). These features enable you to grab travel photos suitable for printing at large sizes, which you can then display on the wall.

+ Extreme zoom lens capabilities, preferably with a 10X range. This range is ideal for reaching out and grabbing a small detail from a panoramic scene.

+ Add-on accessory lenses to extend a zoom's capability even farther.

+ Rapid-shooting capability to allow taking pictures quickly at festivals or other fast-moving travel experiences. (The running of the bulls at Pamplona comes to mind!)

Enthusiastic amateurs

Amateur photo enthusiasts love photography but have other interests — such as travel! With more limitations on their budgets, they need top-quality *prosumer* cameras. These cameras are aimed at consumers but have features that will please advanced photographers. These include

✦ Medium- to high-resolution (2–6MP) camera with decent capacity memory (with the ability to accept interchangeable memory cards). These cameras enable you to print vacation snapshots in sizes as large as 5 x 7" to 8 x 10".

✦ Versatile zoom lens (between 3X and 10X) for taking close-up shots of distant scenic features or for capturing locals being themselves.

✦ Add-on accessory lenses to extend range even farther, or to widen the view to take in monuments, castles, or cathedrals penned in by their surroundings.

Vacationers who simply want to take good photos

You know who you are: You want pictures that are sharp and clear, colorful, and good enough to make a batch of 4 x 6" snaps of your best shots. You like digital photography and want to capture some travel memories, but can't spend a huge amount for your equipment. These photographers need

✦ Low- to medium-resolution (2–4MP) cameras with the ability to accept interchangeable memory cards

✦ A versatile zoom lens, at least a 3X zoom

Choosing key camera features

Here are some key features to look for, no matter what kind of travel photographer you are. You'll find more information on these features in Book I, Chapter 2.

✦ **Optical zoom range:** A powerful zoom enables you to compose your image carefully and cover a lot of photographic territory on your travel treks. With a good zoom, you can also take advantage of lens effects, such as selective focus (explained later in this chapter).

✦ **Interchangeable memory cards:** Some cameras try to get by with just built-in memory. When the memory is full, you either stop shooting or delete images, neither of which is a happy option during a once-in-a-lifetime vacation. The ability to change cards enables you to just keep shooting. Fortunately, virtually all digital cameras that do have non-removable, built-in memory also include a slot for a flash memory card.

✦ **Sufficient megapixels:** The more megapixels, the better. This is true for several reasons. First, higher resolution (more megapixels) allows for larger prints of your prized vacation shots. Second, higher resolution lets you crop down to a smaller view of that monument you just couldn't get close enough to and still get a good quality print.

✦ **Interchangeable lenses:** These days, an increasing number of affordable digital cameras use interchangeable lenses. These give a photographer a wide range of choices for high-quality travel photography. Being able to select from a range of different focal lengths — plus being able to control *depth-of-field* (the range of image sharpness as it appears throughout the photograph) — gives the photographer tremendous power over the photographic image. Sometimes manufacturers offer add-on lenses for noninterchangeable lens cameras, too.

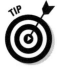

Think about taking a second camera along, too, particularly if this is more than just a run-of-the-mill vacation. A small, inexpensive digital camera might not cost much. If your primary camera fails, your backup camera could be worth its weight in gold photographically. Shop for or borrow one that uses the same type of batteries and storage media as your primary camera, if possible. The extra camera can also entice a spouse or child into sharing your love of photography. Encourage them to shoot their own photos on the trip.

Choosing lenses for travel

Look at your camera's built-in capabilities, including the range of magnifications available from your zoom, as well as the ability to add supplementary telephoto, wide-angle, or close-up lenses. You find more on lenses in Book I, Chapter 2. Travel photographers need three basic capabilities:

✦ **Wide-angle:** Being able to fit more into a picture comes in handy when you're shooting scenics and architecture, like the image shown in Figure 6-2.

✦ **Telephoto:** Capturing native wildlife or sports shots without getting dangerously close is an invaluable capability.

✦ **Macro:** These lenses are essential for getting close-ups of native insects, signs, or documents.

With at least some capabilities in each of these ranges, you can shoot a broad selection of travel photos without necessarily having to physically move closer or farther away from your subject.

Considering a tripod

A *tripod* is a three-legged stand designed to hold your camera steady. You can find more detailed coverage of tripods in Book I, Chapter 2.

**Book III
Chapter 6**

Travel Photography

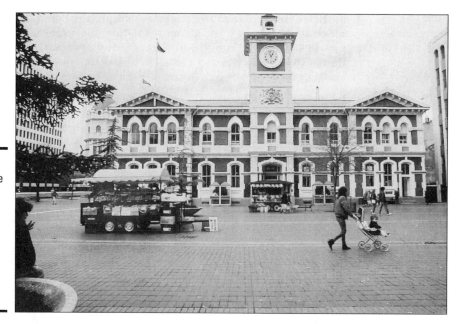

Figure 6-2:
Wide-angle lenses, like the one used to take this shot, can be useful in tight quarters.

Although a tripod can be a little cumbersome to carry along on a trip, this camera support can do several things for you. A tripod is great for holding the camera steady if you are using longer shutter speeds in dim light or using a telephoto lens. If your camera has a timer feature, you can use a tripod to get yourself in the picture.

A tripod definitely leads to better pictures, but only if you use it. If you find the idea of lugging one around too much of a bother during your vacation, plan on a different tool, such as a unipod, beanbag, or one of the other options discussed later in this chapter. It's okay — you're on vacation!

Choosing an electronic flash

Although most digital cameras have some sort of built-in flash capability, these are usually only good for a range of about eight feet or so, which isn't always enough. Because available light (more commonly known as *available darkness*) is undependable, the traveling photographer should consider carrying an accessory flash unit.

Accessory flash units do more than just provide extra light when it's too dark to shoot without it. The reasons why an extra flash can be particularly helpful for travel photography include the following:

✦ **Using fill flash:** If you're planning to shoot a companion in partial shade or wearing a ball cap, an accessory flash can help you clean up the shadows. Because the supplemental light isn't trying to light the whole scene, filling can be accomplished by smaller, less powerful flash units (such as the camera's built-in flash) or even by a reflective surface. A 3 x 3' piece of folding Mylar or a silver coated auto sunshield held by a helper to reflect the sunlight into the area where the sunlight can't reach provides a nicely lit photo, as shown in Figure 6-3.

✦ **Painting with light:** If part of your trip takes you into a dark place, such as a thirteenth-century church that doesn't have any spotlights shining on it, an accessory flash might help. You can use the *painting with light* photo technique with a tripod or firm support, covered later in this chapter.

✦ **Macro/close-up photography:** If you want to take close-up shots of typical local jewelry, markers, or insects, you need to provide a lot of light in order to get enough image sharpness to create a good-looking image.

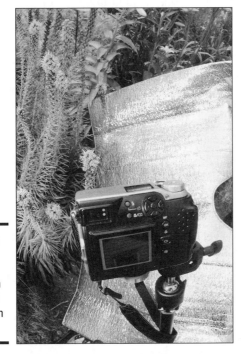

Figure 6-3:
Keep a compact reflector in your travel bag to fill in shadows.

Many higher-end digital cameras offer some method of triggering an accessory flash unit, either by a cable connection or via *hot shoe* (the connection found on the top of many digital cameras that holds the flash and provides electrical contact with the camera). Figure 6-4 shows the hot shoe found on one model Olympus digital camera. Many consumer-priced digital cameras, however, offer no such provision. If you have a camera without the means for adding an additional flash, a slaved flash specifically designed for digital cameras might be your answer. (A *slaved* flash has a built-in light sensor that triggers the slaved flash when your camera's flash fires.)

Accessory lighting is covered more thoroughly in Book II, Chapter 5.

Selecting a camera bag

Depending on the size of a digital camera and the accessories accompanying it, a camera bag or pouch could be a necessity. For just the basics — a small camera, extra batteries and memory cards, and a lens cleaning cloth — a simple fanny pack will do the job and leave room for hotel keys, money, and identification. If you're a more serious photographer who's carrying a larger digital camera or an interchangeable lens digital SLR, you need more space. Although a larger camera bag could be the answer, the active traveler should consider these factors:

✦ **Size:** Your camera bag should be roomy enough to hold your basic camera setup and also leave some room for an extra piece of gear or two such as filters or extra batteries that you'll be glad you have when you're hundreds or thousands of miles from home.

✦ **Flexibility:** An ideal bag includes multiple compartments that can be reconfigured (with hook-and-loop tape) so that you can adapt the bag to the different configurations of camera outfits that you might need. You'll often find that your equipment needs vary from place to place on vacation. At one destination, you might need easy access to your extra flash unit. At another, you'll want to grab your add-on wide-angle lens quickly.

✦ **Sturdy strap:** Much travel is done on the run. A travel-friendly bag has a main strap that runs around the sides and bottom of the bag and that's securely stitched, not grommetted into the fabric. (Don't underestimate the importance of this one, folks!)

✦ **Toughness:** To stand up to the rigors of travel, a bag should be made of rip-stop nylon or canvas. If you're really into leather, though, you don't have to rule this material out, either — if the bag is well constructed.

✦ **Security and convenience:** The bag should offer multiple methods of closing. Usually a good bag offers a fast method of closing (frequently with hook-and-loop tape or clasps) and a more secure method of closure (zippers or clips) that takes more effort to open and close but makes accidental opening less likely.

✦ **Protection from the elements:** The bag needs a top flap that closes over the main compartment in such a way that if hit by rain, the water is channeled down the bag sides. Water shouldn't be able to seep through a zipper channel or closure point, as might be the case with the bag shown in Figure 6-5. Although the zippered closure on this leather bag looks secure, it does little to protect the sensitive digital camera equipment inside from rain.

Figure 6-4: A hot shoe lets you attach an external flash.

Figure 6-5: This closure will let water leak onto your camera.

At some point, you can cross over the line that divides vacation photographer from pack mule. Do a dry run with all your gear before leaving. Now ask yourself whether you're comfortable with the idea of lugging that stuff around with you on your vacation. The only right answer to the question is the one that satisfies you.

Keeping your camera powered

Modern cameras use batteries like there's no tomorrow, particularly digital cameras with their power-draining LCD screens and built-in flashes. That's not much of a burden when you're shooting close to home. But if you're traveling — far from AC power or a ready source for batteries — power is a prime consideration. If you plan to shoot pictures for more than a couple of hours, take along spare batteries to use until you get back to civilization.

Predicting battery life is a bigger challenge than taking good pictures, simply because the figure varies depending upon your particular camera, how much you review your shots on the LCD finder, how many pictures you take, what kind of media you're using, how much you use your internal flash, what type of batteries you're using, and what the temperature is. (Batteries drain faster in the cold.) If you're careful with the LCD screen and flash and keep the camera warm, four AA batteries could last from 30–80 shots depending on the camera.

Here's how to maximize your battery life when on vacation:

+ **Short reviews:** Most digital cameras let you set how long the LCD stays on for review after a shot is taken. Choose the briefest setting. You can always review an individual shot for a longer period if need be.

+ **Flash with care:** Built-in flash units reduce battery life by half. Use an accessory flash if possible.

+ **Battery choices:** AA lithium batteries tend to last longer than other battery types, so if you use these, you can extend the active life of your shooting session before replacements are necessary. They also handle cold weather better. You should always carry at least one set of extra AA batteries (more if you shoot a lot).

If you're traveling in your home country, chances are you already know how easy or difficult it is to feed your camera, but even here in the United States, not every type of battery can be found in the "boonies." If your camera requires one of the less common types, your digital camera can become a paperweight before your trip is half over.

If your camera uses AA or AAA batteries, rechargeable batteries are the best answer (with an extra set of backups or two or three) for each device you bring that needs them. Choose nickel metal-hydride (NiMH) rechargeable batteries if you can because they have more power, are safer for the environment, and have several technical advantages over other types. If your camera doesn't use a common battery type, bring lots more than you think you'll need. Remember, if you have to buy batteries at a popular tourist destination, you'll probably pay a lot more than you normally would at home. If you're lucky, you'll have a camera that can accept a rechargeable battery pack and use regular AA batteries as well. Some packs, like the one shown in Figure 6-6, are the same form factor as a pair of AA cells.

Of course rechargeable batteries need to be recharged. If you're going overseas, make sure that you have the proper adaptors for whichever country you're visiting. Don't automatically assume there will be plenty of outlets, either. I recently went on a Bahamas cruise and found that our stateroom had only one outlet. Because I'd come prepared with a power strip, we could still plug in my laptop, battery chargers, fan, and my wife's hair dryer and curling iron. Without such foresight . . . well, my wife and I would surely have ended up fighting over a single outlet.

Figure 6-6:
Some rechargeable packs can be replaced with conventional AA cells.

Camera bag alternatives

If a traditional camera bag doesn't do everything you need, consider some alternatives. Here are some of the most popular:

- ✔ **Backpacks:** An alternative to the camera bag is the camera backpack. These range in size from small — just enough for just the camera, a couple of lenses, and some accessories — to massive carry-alls. One drawback is that you have to take the pack off and put it down every time you need to retrieve something.

- ✔ **Modular belt systems:** I use one of these myself, and it's great if you don't plan on sitting down very often. It puts the weight on your hips and leaves multiple lenses and accessories within easy reach even when wearing a backpack. The modularity of the system means that it can be configured for almost any sort of shoot.

Several manufacturers make modular belt systems, including Tamrac (www.tamrac.com), Lowepro (www.lowepro.com), and Kinesis (www.kinesisgear.com/index.html). These belts are festooned with loops, and separate pouches are mated to the belt with hook-and-loop tape. The advantage to this system is that the belt can be configured for different needs and matched to each day's shoot. Pouches are also available to hold cellphones, water bottles, and other nonphotographic items.

- ✔ **Chest bags:** A chest bag enables you to carry your camera harnessed to your chest where you can get to it quickly and easily. Most of these style bags can also be switched to a belt and positioned to ride on the hip as well.

Another option, especially for those headed for a week or two in the backcountry, is a solar powered battery charger from ICP Global Technologies (www.icpsolar.com/). This unit can charge four AA batteries in four hours or so, depending on how bright a day it is. (Good luck if you're hiking in the Pacific Northwest.) The hard part might be finding a way to keep the device pointed toward the sun while you're backpacking through the forest. You may also want to consider whether carrying the unit's weight (1.3 pounds) in extra batteries would be more efficient.

By the way, many of today's camera makers have resorted to marking the battery compartment orientation markings through indentations (+ or –) in the molds used to make the compartments, rather than painting on the markings with white paint. If your camera is one of those, consider finding a way to mark it yourself with something more visible.

Other useful devices

Gizmos. Gadgets. Thing-a-ma-jigs. Many of these items don't fall into any particular type of category except that they do something useful. Here are some of the most popular photo widgets:

✦ **Cleaning kit:** A cleaning kit includes these items:

- **Microfiber cleaning cloth:** These are useful for keeping lenses and bodies clean.

- **Blower brush:** Use this first and blow off any dust or small particles.

- **Silica packets:** These absorb any moisture that gets in your camera bag. Keep in a plastic freezer bag that can double as a camera raincoat in bad weather.

✦ **Rain poncho:** I always keep a cheap plastic rain poncho in my camera bag, along with a better rain poncho in my car. Add to that a supply of plastic bags of various sizes and some artist's tape that's easy to apply and remove from the camera.

Make a raincoat for your camera from a plastic freezer bag. Draw the end of the bag over the camera's lens barrel and cut a hole large enough for it to shoot through. Wrap the artist's tape around the end of the barrel and bag to hold the bag in place, and you've got a low-cost rain poncho for the camera. Thread the camera strap through the end of the bag that opens and press as much of the seal together as possible. If it's hard to see through the viewfinder, turn the LCD display on and use that to compose the photo. Figure 6-7 shows you what this camera raincoat looks like. Put a clear or ultraviolet filter over the front of your lens to provide even more protection from the moisture.

✦ **Towel:** Carry some paper towels so that you can towel off any moisture that gets inside the freezer bag. Toss a silica packet or two in with the camera before closing the bag to help keep the inside dry. It's also a good idea to have something to dry your hands with so you're not touching the camera with wet hands. A good choice for this kind of thing is a Pack Towel, which is a lightweight towel that dries quickly and is sold in many department stores' camping sections.

✦ **A pencil eraser:** Sometimes a thin film of corrosion builds up on the battery and terminal contacts. The cure for this one is to take a pencil and gently rub both the battery and terminal contacts with the eraser and reinsert the batteries, making sure that they're right side up.

✦ **Polypro gloves:** Several outdoor clothing companies make lightweight gloves out of polypropylene or some brand-name version, such as Capilene or Thermax. Outdoors enthusiasts prize these synthetic materials because they *wick* (transfer) moisture away from the skin to the outside of the material, making them seem warmer because the skin stays dry. Wearing a pair of these in damp conditions will help keep your hands dry. When you need to touch the camera, pull a glove off, and you've got a dry hand to work with.

Book III
Chapter 6

Travel Photography

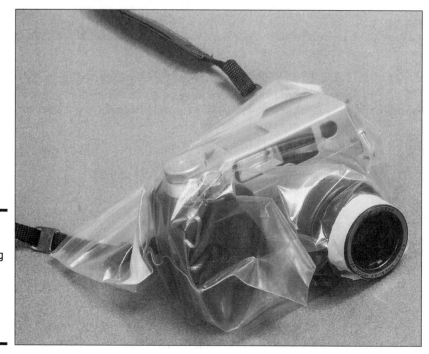

Figure 6-7:
A zip-closure bag and tape can make a raincoat for your camera.

✦ **Artist's or masking tape:** If the conditions are both dusty and windy, protecting the camera can be vital and difficult. Fine grit sand or dust can blow inside the camera's seals and mess up internal mechanisms. The same plastic bag technique described in a preceding bullet is good, but consider taping as much of the bag end shut as possible to get the best possible seal.

If you're traveling abroad and want to be sure you won't be hassled on your return, visit a U.S. Customs & Border Protection office and ask for a Certificate of Registration (form CF4457). You have to bring your gear to the customs office where they will confirm your gear and stamp the form. This will guarantee you won't be asked to pay a duty on your gear. Find the location of the nearest customs office at www.customs.ustreas.gov. Most travelers skip this step and do just fine, but if you have new gear and are going somewhere known for electronics, filling out the form is a good idea.

Getting Ready to Go on the Road

You won't like surprises after you leave home and begin taking pictures. One key to successful travel photography is making as many preparations as you can ahead of time, so you'll be organized and confident when you begin capturing memories. Here is a checklist of things to do before you leave:

✦ **Create a packing list:** As you prepare for the trip, put together a packing list for the photographic gear. Plan a dry run to make sure everything fits in whatever camera bag or case you're using.

✦ **Carry it on:** All but the cheapest camera equipment should be included with carry-on luggage. If you're taking more than just a basic digital camera and memory cards, make sure that the camera bag is small enough to meet carry-on space limits. Record serial numbers for pieces of equipment that have them and have a packing list in a separate bag in case the camera bag gets lost or stolen. Check with your insurance company to see whether camera equipment is covered under your policy. If it isn't, see whether you can add a *rider* (a special add-on to your policy) for the trip.

✦ **Have some in-flight reading:** How familiar are you with your camera and accessories? Maybe it would be a good idea to dig out the instruction manuals and pack them in your carry-on so that you can reacquaint yourself with some of the camera's more esoteric features.

Meeting Your Storage Requirements

Just like going on vacation with a film camera, the digital camera needs a steady supply of (digital) film, like that shown in Figure 6-8. Because of the newness of the technology (particularly overseas and in Third World countries), photographers need to ensure that they have enough memory capacity for the trip.

**Book III
Chapter 6**

Travel Photography

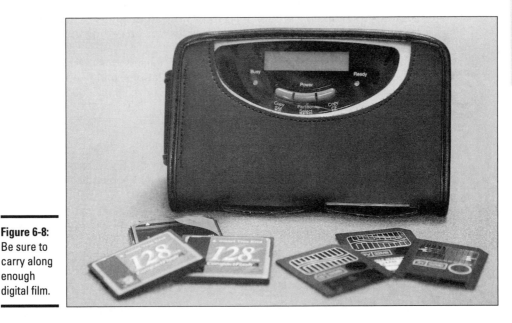

Figure 6-8:
Be sure to carry along enough digital film.

Here are some considerations when bulking up your storage for a trip:

✦ **Have enough memory.** Will you be able to get an entire vacation's worth of pictures with your current supply of memory? Remember that you tend to shoot a lot more while traveling. If you don't think you're going to have enough capacity, consider buying more. Alternatively, you can carry a laptop computer (if you have one) so that you can transfer images and free up memory each night. (Test this process before you go to make sure you have what you need to transfer images.)

✦ **Try a portable hard drive.** In between a pocketful of memory cards and a notebook computer are portable hard drives. These drives can accept CompactFlash cards and other types of removable storage with the proper adaptor (floppy users are out of luck). For about $200, far less than a laptop, you can get a portable drive with several gigs of storage space for fewer dollars per byte than a CompactFlash card. If you go this route, try to acquire the device a couple of weeks before the trip so that you have time to make sure you can work it properly. Manufacturers of portable hard drives include Sima Corp (`www.simacorp.com/photo.html`) and Nixvue Systems (`www.nixvue.com`).

Even with all the extra memory cards or a portable hard drive, you're still carrying less than the equivalent in number of shots worth of film.

Tried-and-True Travel Photography Techniques

If you've prepared well, you'll be ready to take great pictures when you reach your destination. This section tells you a little about some of the most popular types of travel photography and provides tips on getting the best shots.

In all cases, keep local, regional, and national sensitivities in mind when choosing your subjects. Some buildings, installations, and people shouldn't be photographed because of security, personal, or religious concerns. When in doubt, ask for permission.

Shooting scenics

Scenic photos are high on the list of pictures people try to bring back from their travels. After all, you've got to prove you went someplace nice, don't you? Here are some tips for shooting great scenics:

✦ **Don't hurry.** The effort to record a site's beauty all too often results in quick snapshots hurriedly snatched while with a tour group or during a sightseeing drive. Some places are spectacular enough that this approach actually works; most of the time, it's hit or miss.

✦ **Not all light is created equal.** The best light of the day occurs when the sun is low in the sky. Early morning and late evening sunlight produce dramatic shadows and rich warm colors, when the sun's light is more red/orange than any other time during the day. If a site on your trip is particularly important, plan on being there during the *golden hours,* as photographers call them. Try to do a reconnaissance of the location a day or two beforehand so that you can see whether the sun rises or sets behind what you're shooting.

When the sun is rising or setting behind the scene, it creates the opportunity for a dramatic backlight silhouette. This is a difficult exposure situation because the camera is pointing directly into the sun. Don't underestimate the additional risk for the photographer, who must be careful not to stare directly into the sun.

✦ **Create silhouettes.** For a good, solid black silhouette of a building, structure, landscape feature, or person, the camera should be set about two full f-stops smaller than what the light meter indicates for the main scene. Your goal here is a bright, orange-red sun (the most dramatic kind). Depending on your camera, you can either change aperture settings directly, or use the exposure compensation dial to get the exposure you need. Take several shots at one f-stop increment to make sure there's a good exposure, like the one shown in Figure 6-9.

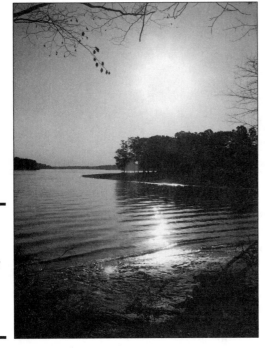

Figure 6-9:
A sunset offers the opportunity to create dramatic silhouette photos.

✦ **Keep it steady.** Have your camera mounted on a tripod while doing scenics. The added stability reduces the effects of camera shake and allows for a slower shutter speed. Reducing the shutter speed enables you to use a smaller aperture (larger f-stop number), which creates greater overall depth of field for the sharpest possible picture. If a tripod isn't available, try to find something sturdy to brace the camera on or against. Walls, car roofs, wooden chairs, and countertops can all make excellent emergency tripods. Bracing the camera vertically against a post or column will also help keep it steady enough to help compensate for too slow a shutter speed for hand holding.

✦ **That cloud looks like a. . . .** Take advantage of cloudy skies, which provide more visual interest than a plain, washed-out-blue sky, as you can see in Figure 6-10. When the clouds are in hiding, compose the image so that it has minimal empty sky at the top of the frame.

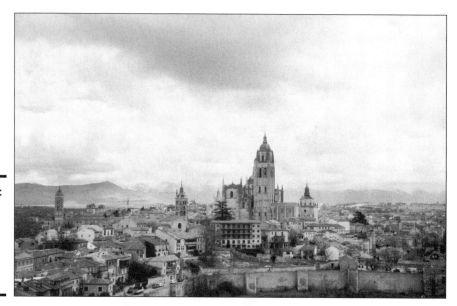

Figure 6-10: Clouds can add a dramatic element to travel photos.

Capturing monuments and architecture

The Arc de Triomphe, the Empire State Building, the Golden Gate Bridge. Monuments, architecture, and engineering marvels can provide stunning images and a record of your journey. You can take your photography to a whole new level by following some simple techniques.

Many of the techniques described earlier for scenics are also applicable to photographing these man-made wonders. Some special techniques, however, apply only to man-made objects.

Taking a shot in the dark

Don't put your camera away when the sun sets. Buildings, monuments, and bridges take on an entirely different look at night when they're all lit up. Here are some of the things to keep in mind when taking pictures of monuments after dusk:

✦ **Support your camera.** Once again, use your tripod or some other camera support. Many cameras suggest using flash at this point; don't. Some cameras automatically set the flash under such conditions; override it if you can. You don't want to overpower the existing illumination with flat, bright, electronic flash. Most of the time, flash used in nighttime scenes spoils any mood or ambiance that exists.

✦ **Go long.** The idea here is to get a long enough exposure to turn the headlights from cars and trucks into long ribbons of color wrapping around the base of the structure, while its own lights help give a sense of its form.

✦ **Shoot by the sea, by the sea, by the beautiful sea.** Finally, if you're photographing in a river or ocean town, a boat can make a fine shooting platform. Just keep in mind that motor vessels' powerful engines cause the decks to vibrate, and a tripod isn't much help in such circumstances.

When the sun goes down, check out the nearest amusement park. Set your camera on a tripod or something solid and do a long exposure of the Ferris wheel or roller coaster or any of the other rides with bright lights and fast motion.

Book III
Chapter 6

Travel Photography

Painting with light

Sometimes, a building is too big and too dark for normal photographic measures to do the trick. For these situations, the pros paint with light. This technique calls for using a long exposure and firing off multiple flash bursts to illuminate the object in sections. Here's how to do it:

1. **Set your camera on a steady surface.**

 A tripod is good, but so is a short wall or the ground. Keep your camera steady because if the camera moves, the illuminated areas move, too, putting them out of alignment.

2. **Adjust camera for a time exposure.**

 Check your camera manual to learn how to set your camera for a time exposure.

3. **Decide what areas of your subjects need painting.**

4. **Trigger a time exposure (or have helper do it) using your digital camera's particular time exposure controls.**

 Experiment with different times, from ten seconds to a minute or longer.

5. **Paint by triggering your external flash multiple times.**

Move the flash around to illuminate the subject in sections. As you move, keep your body between your light source and camera if you don't want the light source to appear in the photo.

Photographers use another technique called *writing with light,* which can be lots of fun. It's an especially apt technique for travel photography because it can be used to photograph buildings, monuments, and other scenes that would otherwise be difficult to capture at night. This is another trick that takes advantage of a long exposure and a solid shooting platform, such as a tripod, a wall, or the ground. The idea is to take a pencil torch (penlight) and point it towards the camera lens while the shutter is open. You can either swirl it around, or try to write a specific message. Here's how to do it:

1. **Plan what you want to do. It's good to rehearse a couple of times with someone watching through the viewfinder.**

This way, you know if the camera's positioned properly to get everything. Besides, you have to write backward (so that the words aren't reversed in the picture) — don't you think that takes some practice?

2. **Set the camera to shutter priority and give it a long time (long enough for you to do what you want, probably several seconds or more).**

3. **Write with light by pointing the light at the camera lens from your subject position.**

4. **Review the image with the camera's LCD screen.**

5. **If necessary, make some adjustments to your shutter speed based on what you see in the LCD, using a longer or shorter speed as required.**

6. **If you want to get really fancy, have a friend or spouse fire off a small flash after you're done writing but before the shutter closes.**

This helps illuminate you while still allowing your writing to show.

Don't forget that fireworks, like those shown in Figure 6-11, are a kind of "writing with light." You can use the same techniques that I just described except that you let the aerial display create your image for you. Use a tripod, and set your camera for exposures of a second or two. Set the camera for about ISO 100, and start your exposure just before the fireworks reach the top of their arc. Try leaving your shutter open for several sets of displays, covering the lens with your hand between displays to capture several in one exposure. Take along a penlight so that you can adjust your camera's settings in the dark! Time exposures of moving lights and traffic (think the Strip in Las Vegas) are also great ways to paint with light.

Keystoning

Keystoning, also known as *perspective distortion,* happens when the photographer tries to fit an entire building in a photo by tilting the camera up. The problem with this approach is that when the camera is no longer perfectly parallel with the building, any straight lines on the long axis of the image converge until they meet at the top. The photographer ends up with a photo of a building with a wide base and a pinpoint top that appears to be falling away.

How to avoid it? Because the problem comes from the lens and the building not being perfectly parallel, the easiest way to correct that problem is to bring them into line. You might be able to do this by finding a way to gain some elevation. Sometimes, a nearby hill can provide a distant vantage point. Sometimes, another building with an accessible roof is available. Unfortunately, all too often, neither solution is available, and the only option is to point the camera up and take the picture.

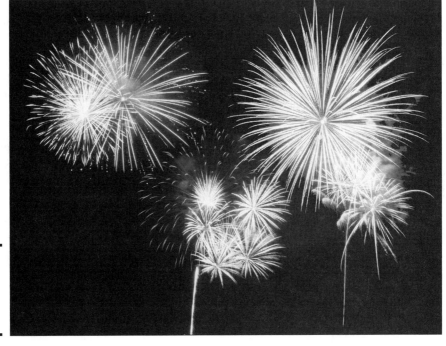

Figure 6-11: Fireworks are a kind of writing with light.

**Book III
Chapter 6**

Travel Photography

Shooting panoramas

One of the most frustrating moments of travel photography comes when you find yourself literally surrounded by the beauty of nature and have no way to capture all that surrounds you in a single photo. A digital camera, tripod, and the right image editing software, however, make capturing a 360-degree panorama possible. Basically, you take a series of shots for your panorama and then *stitch* the shots together (line up the images into one image) on your computer. Although you can stitch images together in any image editor, specialized stitching applications are easy to use. Follow these steps to shoot a panoramic shot:

1. **Mount your camera on a tripod and set the camera's appropriate zoom setting.**

 You don't have to set the zoom lens to its widest setting. Zooming in a little closer means that you'll capture more detail per photo. If your main subject is distant, zooming in lets you capture more of the important part of the scene without wasting space on unnecessary foreground details.

 The more shots you take, the more you'll have to stitch together, and the greater the chance the software might have trouble creating a seamless panorama. Generally speaking, three to six images are most manageable.

2. **Level the camera.**

 The closer you can come to a perfectly level camera, the better job your software can do with the final image. Buying an inexpensive level (as small a unit as possible) at the local hardware store is highly recommended. Set the level on top of the camera and adjust the tripod until the camera is level.

3. **When you take the first picture, waste a shot by photographing your fingers in front of the lens. (Don't worry about focusing or exposure.)**

 This makes it easy to see where you began the sequence. Do the same when you've completed each sequence.

4. **Make your first shot of the scene at either the left or right end of the panoramic swing that you intend to make.**

 If your camera is capable of manual exposure, take several readings throughout the scene and try to come up with an average setting for the entire range.

5. **Take subsequent pictures.**

 Make sure each shot overlaps the previous one by 20–30 percent.

6. **If possible, do a second sequence of images, particularly if lighting was erratic.**

7. **Stitch them all together back home, using an image editor or stitching software.**

Packages such as PhotoStitch (furnished free with Canon cameras for Windows and the Macintosh (as shown in Figure 6-12) or Photoshop's built-in panorama capabilities are easy to use and a lot of fun. Your digital camera may come with similar applications.

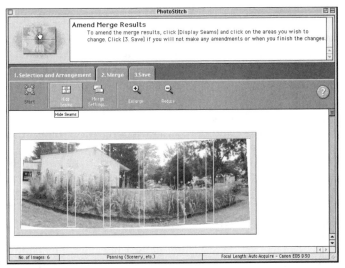

Figure 6-12: Stitch images together in PhotoStitch.

Book III
Chapter 6

Travel Photography

Photographers who are really serious about getting good 360-degree panoramas can try a special tripod head made by Kaidan (www.kaidan.com). The Kaidan head enables you to mount the optical center (or *nodal point*) of the camera lens directly over the tripod's pivot point for the most accurate positioning possible. These heads range from a little over $140 to several hundred dollars or more. Unless you're a perfectionist, though, you can get satisfactory results without one.

Shooting adventure sports

Adventure sports, such as white-water rafting, rock climbing, scuba diving, and similar activities, entail different risks and require different precautions to protect your precious equipment.

✦ **Dry boxes:** Climbers and hikers need to keep their gear dry using waterproof camera bags or other equipment. Sports such as white-water rafting and kayaking call for even greater protection. Usually, these boaters protect their gear in a dry box setup. The best known manufacturer of these is Pelican (www.casesbypelican.com), which makes cases with foam insides that can be cut to fit specific camera gear. If using one of these, take very good care of the O-rings that provide the watertight seal for the box. Veteran river runners sometimes rely on Army surplus

ammo or rocket boxes, which also provide a watertight container for gear, but without the form-fitting foam. If using one of these, make sure that the camera is properly cushioned from the bumps and jolts that white water entails. If you protect your camera from water, you can easily take photos like the one shown in Figure 6-13.

✦ **Carabineers:** These are the oval clips that climbers use to secure themselves to safety ropes; you can use them to clip the dry box to your off-road vehicle. If you're immersed in a water activity, the clips can also secure your dry box to the raft or inside the kayak. The boaters will run the rapid, catch an eddy at the end of it, unpack the camera, and start shooting. Once again, placing a silica packet or two in one of these cases will help keep dampness from damaging equipment.

✦ **Underwater digital cameras:** Another option for those who want to shoot a lot in wet conditions is a new underwater digital camera. I've used underwater cameras even when I wasn't *planning* to go in the water. (You never can tell where a hike will end up.) The SeaLife ReefMaster underwater digital camera comes in a waterproof housing and works both on land and underwater. The camera, which retails for under $400, only produces a 1.3MP image but saves you the trouble of trying to find a housing to fit an existing digital camera. The camera also has an LCD display that works underwater and a fast delete function, both of which make it easier to operate underwater. Check out the manufacturer's Web site at www.sealife-cameras.com for more information.

✦ **Waterproof casings:** More extreme conditions call for better protection. Waterproof casings that still allow photography are available from several companies, including ewa-marine (www.ewa-marine.de). These are useful for both underwater photography (careful on the depth, though) and above the water if sailing or boating.

Keep in mind that salt spray is very possibly the worst threat to camera electronics there is. A camera housing provides good protection against wind and salt spray.

✦ **Deep-diving housings:** For serious underwater enthusiasts, heavy-duty Plexiglas camera housings now exist for small digital cameras. These housings are available for a wide range of digital cameras and can be found for as little as $200.

Photographing people

There are lots of reasons to photograph people while traveling and also some reasons not to. Photographing law enforcement or military personnel without getting their permission first can be a bad idea.

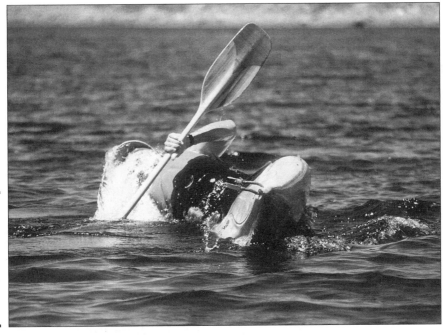

Figure 6-13: To take a photo like this, you need to protect your gear from water.

With the heightened concern about terrorism these days, many security forces, including our own, have become much more sensitive about people photographing and videotaping government facilities and employees. While traveling in Israel and South America, seeing armed military personnel walking the streets wasn't unusual. Even a decade ago, it wasn't a good idea to grab a snapshot of them, and I wouldn't even consider it these days unless I'd gotten their permission first.

When photographing people in other areas of the country or in foreign lands, remember that effective travel photography needs to create a sense of place. Any time the photographer can use lifestyle, surroundings, work, or clothing to show the region or culture involved, he or she has achieved at least one measure of success. Certain elements can help your photos convey your location:

✦ **Clothing:** Different cultures have different tastes in clothing and jewelry.

✦ **Design:** Advertisements, homes, and buildings will look different whether you're overseas or in the United States.

✦ **Products:** Soda cans, candy bars, and other packaging is different in other countries, and sometimes even in the U.S.

✦ **The natural world:** Plants and wildlife might be noticeably different in other locations.

In addition to creating a sense of place, these tips can help you effectively photograph people while traveling:

✦ **Be aware of cultural sensitivities.** Some cultures frown upon photographic images of other human beings (that includes cultures in the United States, as well). In many Middle Eastern and Third World countries, women wear clothing designed to hide their appearance. In some of these countries, photographing them can be a serious taboo (as can a man speaking to one of them to even ask permission to take their photo).

✦ **Check out the local customs.** Although taboos that have their origins in religious beliefs can stay constant for millennia, official taboos can shift frequently. Check with the U.S. consular office for the country that you're visiting to learn what's okay and what isn't. This Web site — `http://travel.state.gov/travel/warnings.html` — also has information on individual countries and policies.

✦ **Ask first.** As a newspaper reporter and photographer, my philosophy was to shoot first and ask questions later. (You can always talk to people after an event's over, but you can't re-create photos.) Photojournalists working in a newsgathering capacity though are afforded some liberties that are considered out of line for tourists. (And that's in this country; the rules vary from country to country.) In the case of a traveler photographing others without their permission, it's a behavior that many would at least consider rude.

✦ **Pretend I'm not here.** One of the reasons why pros prefer to shoot first and then ask is because people appear more natural when they don't know that they're being photographed. A common way of dealing with this problem is to ask permission and then explain you'd like the picture to look "natural" and could they please go back to what they were doing and forget you're there.

✦ **Be forgettable.** Although your subjects likely start out self-conscious, after a few minutes, they tend to become involved in their activity and forget you're there.

✦ **Give them feedback.** Be aware of human psychology. People who are posing tend to wait for some feedback at first — namely the click of the camera that tells them you're satisfied. If they don't hear it because you're waiting for them to forget you're there, they tend to become concerned that you're not happy with what they're doing. Take advantage of the digital advantage (being able to delete bad shots) and take a photo or two at the start. Your subject will relax a little and begin to forget you're there.

Another technique works well if you have a camera with a fairly wide-angle lens. Set the zoom to the widest possible focal length and hold the camera waist level and as perpendicular to the ground as you can. I usually try to do this one-handed with the camera strap helping me keep the camera under control. Most people relax even more at this point because they don't expect

you to shoot now. At this point, when I see the shot I want, I trip the shutter. This technique works better if you're familiar enough with your camera to have a good idea of what its wide angle covers from a certain distance.

This "shooting from the hip" can be a tricky proposition ethically. At least one journalism professor who I know feels that it's a violation of trust between a photographer and the subject.

As a photographer, I believe it's important to be sensitive to your subject's feelings on the matter. Because I'm shooting digitally, I take the shot and then explain that I've taken a shot and show it to the person I've photographed. I then let him or her decide whether or not the photo should be deleted. Most people don't mind at all, but I've slept better at night by immediately deleting the shot if the person is unhappy with it. This all gets a lot harder if you and your subject don't speak the same language. Sometimes, the combination of pantomime and the preview capability of the digital camera can be enough for you to get by.

Capturing people and their places

After the issue of getting permission from your subjects is out of the way, consider how to photograph them. Being able to capture people in their own environment is where you can really feel the advantages of your digital camera. It's lightweight and versatile and can take plenty of photos. Here are some ways to make the most of its advantages:

+ **Shoot as much as it takes.** If what you want can be achieved in just one shot, so much the better. Still, there's nothing wrong with multiple shots to achieve the same thing, provided the images build upon one another.

+ **Capture the environment.** At least one shot should show the individual within his or her cultural environment. After that image is out of the way, focus on smaller details. Look for things that would be unusual back in your own home.

+ **Use lighting.** Don't forget to consider lighting. Unless your subject's in direct sunlight, some sort of fill flash is necessary. (The term *fill* flash comes from its use not as a main light source, but as an additional light to fill in areas that are hidden from the main light.)

+ **Hands can speak volumes.** Sometimes a person's hands can reveal his or her work history. Work roughened, they can speak of years of manual labor and toil. Or a close-up of hands holding small tools or repairing a watch, for instance, can show great dexterity.

+ **Capture the essentials.** Who is this person? What shows your subject's identity? A new mom cradling her baby, a farmer on his tractor, and a cyclist on her bike are just a few possibilities.

+ **Move in close.** Medium shots and close-ups provide greater intimacy than full-body or head-and-shoulder shots. A well-focused, tight composition of a person's face (cropped in to just eyes, nose, mouth, and not much more), packs a lot of intimacy. If your subject wears glasses, try a profile shot (also tightly composed), as shown in Figure 6-14.

+ **Go for variety.** Make sure to take a mix of horizontal and vertical photos. For people shots, take lots of verticals because the human body breaks down to a series of elements that are taller than they are wide.

+ **Show people working, playing, and relaxing.** Even on a mountain climb, like the one shown in Figure 6-15, quiet moments reveal another side of your subjects. Social gatherings and religious meetings are also prime opportunities for good photographs. Look for community festivals, too, where you can get lots of people, costumes, and events going on. In such freewheeling settings, people are less concerned about being photographed, and you can probably get away with taking wider shots without having to check with every individual for their permission. Performers, in particular, are quite used to being photographed.

Figure 6-14:
Get close to
make your
subject
the star.

Figure 6-15: Even on a mountain slope, you can capture a quiet moment.

Documenting Your Trip

Pull together everything from the earlier sections in this chapter to create memorable photos of your trip. Documenting a vacation is more than grabbing some pretty pictures of your travels; it's creating a visual narrative that re-creates the magic of your trip all over again. This section wraps up travel photography with some final tips for getting great vacation pictures.

Varying your shots

Try for a mix of shots and camera angles. Shoot some close-ups, and shoot from far away. You can do a lot of things to avoid having all your photos look alike.

✦ **Put the camera on the ground for a worm's eye view.** Makes that church look even more imposing.

✦ **Get a bird's-eye view.** Renting helicopters gets expensive, but there are other ways of getting up high and shooting down. You were going to climb that monument anyway, right? Take advantage of the elevation. Even simpler, climb a staircase and shoot straight down. Take advantage of cable cars. Take advantage of a hot air balloon ride for some once-in-a-lifetime scenic photos, like the one shown in Figure 6-16.

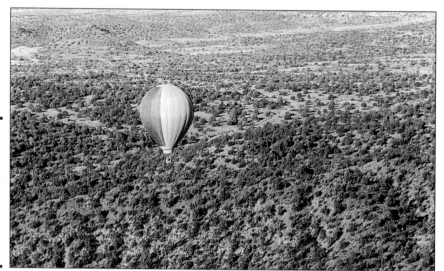

Figure 6-16:
A bird's-eye view can provide an unusual vantage point for travel photos.

✦ **Turn the camera vertically when appropriate.** Many scenes lend themselves to vertical images, yet most people still grip the camera horizontally. Monuments, people, and buildings are all taller than they are wide. Turn the camera on its side.

✦ **Shoot from more than one vantage point.** Do like the pros do. Shoot it high, shoot it low, shoot it horizontally, vertically, get closer, move back, walk around it. While doing this, remember to consider what's in the background.

Composing your shots

How you arrange the elements within your photo has a lot to do with how much impact they convey. I talk about composition in more detail in Book III, Chapter 1, but here are some things that can help improve your photographic composition:

✦ **Leading lines:** Strong linear elements can be used to pull the eye into an image. Straight lines, diagonal lines, and S-curves all show movement and can depict strength, direction, or grace. For example, the curves of a U.S. flag rippling in the wind combines an S-curve with the strong lines of the stripes.

✦ **Framing:** Use natural elements, such as window frames or tree branches, to form a natural border along a corner or around the image. Figure 6-17 is an example of this concept.

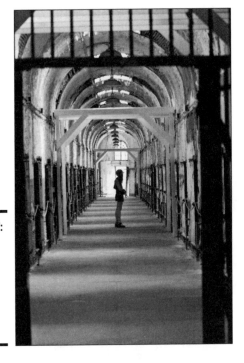

Figure 6-17:
Lines and framing are used effectively in this interior photo.

+ **Rule of Thirds:** Divide the frame in thirds horizontally and vertically. Where the thirds intersect is a good place to place your subject. You can also use this to show a course of movement. For example, putting an airplane coming into the frame into the top-right third conveys a sense of moving downward through the frame.

+ **Balance:** Ever see a picture of someone sitting on a park bench with one end missing? Without the missing support, it seems like the person is going to drop like a rock. You can find examples of photos using balance and these other prime rules of composition in Book III, Chapter 1.

Getting organized

Close focusing (or macro capability) is another one of the digital camera's best features. By introducing details of the location you're visiting, you can trigger memories of your experience years after the trip has ended.

On that cruise I mention earlier in this chapter, my wife and I were fortunate to stay in an owner's suite, one of the nicest cabins on the ship. Each afternoon, we received a treat of some sort from one of the ship's staff along with a card announcing whom it was from. Before enjoying our delicacies, we made sure

to photograph the dish and card together, as shown in Figure 6-18, and made sure we kept the card for a scrapbook as well. The photo album from this trip includes many such details and provides a much fuller and richer representation of our trip.

Figure 6-18: Photograph keepsakes and other unusual bits of your environment as you travel.

Now take it a step further. Think of your photographic coverage as a series of still images that tell a story rather than a group of individual pictures that stand on their own (even though they should).

✦ **Signs, signs, everywhere there's signs:** Use street and highway signs, or even the one and only South Pole (shown in Figure 6-19) to show where you are or where you're going. Photograph maps and brochures, too. Don't just settle for snapshots of these images; try to use lighting and depth of field to turn them into interesting images in their own right.

✦ **Cultural and language differences:** Signs differ from country to country. In the U.S., signs read *End of construction.* Years ago, on a trip through New Zealand, I photographed a sign, shown in Figure 6-20, that proclaimed *Works End,* with a cemetery in the background.

Figure 6-19:
The South Pole is one sign that you've traveled far and wide.

Figure 6-20:
A sure sign that your travel work is never really at an end.

+ **More signs:** Street and road crew signs are only one type of photographic target though. Distinctive shop, restaurant, and tavern signs also provide reminders of where you've been.

+ **Newspapers/newsstands:** Check the local newsstands. In at least some countries, newsstands say something about where you're visiting. For that matter, a close-up of the day's headline during your visit can make a good introductory graphic if you're giving a presentation.

+ **Trailheads:** If this is a wilderness trip, most trailheads are well marked. Photograph the signs. Shoot the trail maps, too. Your packs, supplies, and other gear should also be documented. Follow the same approach if you're on a white-water, skydiving, or ski trip.

+ **White water:** For white water, shoot as many rapids as possible. (Only my fellow paddlers will get that pun.) Photograph the rapids from the side because that field of view gives a better sense of scale than a head-on shot. If you can, get a raft or kayak in the photo because that will help show the rapid's size.

+ **River scenes:** Wilderness rafting trips include many other photo opportunities as well. Photos of *swimmers* (the white-water euphemism for someone who's inadvertently become one with the river) and their rescue will provide dramatic images. The lunch buffet (if on a commercial trip) provides an opportunity for humor if you get shots of some of the sandwiches the guides make. (Guides traditionally eat after the paying guests have gone through the buffet. As a result, some of the sandwich ingredients get pretty creative. Mine usually included cold cuts, veggies, chunky peanut butter, and thick slices of onion.)

+ **River scenes (part 2):** Don't forget that white-water rivers generally offer spectacular scenery, too. Plus, you can take shots of all the preliminaries — inflating the rafts, getting gear together, putting on wet suits and life jackets.

+ **Rock climbing:** Scenery, gear, climbers. Oh yeah, don't forget the rocks. Seriously, mix close-ups, wide-angle shots, and action images of the climbers. Take advantage of the bright colors and patterns of the clothing that rock climbers wear, and the chocks, friends, and *nuts* (protective equipment that climbers use to anchor into the rock for all you non-climbers out there) are great subjects for close-up shots. So are chalk-covered fingers. Also, get lots of angles: Shoot from below, above, and alongside the climbers.

+ **Moods:** Everything doesn't have to be bright and sunny in your travel photos. Don't be afraid to shoot moody, misty, rainy days, like the one shown in Figure 6-21, to show yet another side of your journey.

+ **Papers, please:** Don't forget close-ups of your travel documents. They're also part of the story you're telling.

You'll soon discover that good photography is all in the details. Visiting foreign cultures provides a wealth of these details that help show how different or similar we are. Close-ups of jewelry, magazines, and candy and food packaging help emphasize that you've gone somewhere different.

Figure 6-21:
Even moody scenes can tell part of your travel story.

Book IV

Basics of Image Editing

Contents at a Glance

Chapter 1: What You Can and Can't Do with Image Editing Tools

In This Chapter

✔ Fixing faded and distorted color photos

✔ Adjusting lights and darks

✔ Fine-tuning sharpness and contrast

✔ Eliminating dust, blemishes, and other artifacts

✔ Rearranging, removing, and adding content

✔ Merging images

*W*ith all the seemingly miraculous things that you *can* accomplish with image editing tools, it would be easy to assume that there's nothing you *can't* do. You'd think that you could take any image, in any condition, and make it beautiful — but is that really the case? Well, yes and no. Although you certainly can do a great deal to repair serious tears, rips, stains, scratches, as well as the effects of aging and improper photographic technique, you can't solve every and any problem all the time — at least not simply or easily.

You just can't fix some problems so that the photo looks as though the problem never existed. You can't, for example, take a photo in which everything was out of focus from the beginning and make it as crisp and clear as the photographer probably intended. If, however, one part of the photo is in focus and the other parts are a blurry distraction, you can blur them out even further so that they're just a pleasant backdrop to the properly focused portion. Or, you can remove them altogether, eliminating the unpleasant aspects of the image. You'll find that in some extreme cases, your images might require some compromise when editing them, giving up one thing to gain another. Or success might require a willingness to work with only the parts of the photo that are salvageable, discarding the rest.

Correcting Colors

As you probably know, digital camera images are made up of the red, green, and blue primary colors of light. (You'll find more on this in Book II, Chapter 1.) These colors can be combined to produce nearly all the colors you can see on a video monitor. When your digital pictures are printed, they are expressed as their complementary colors, the primaries of pigments.

The complement of red is cyan; the complement of blue is yellow; and the complement of green is magenta. Everyone has seen a color wheel that shows these relationships; if you haven't, you can find one at `www.dbusch.com/colorwheel.jpg`.

Knowing these relationships can be useful when it comes time to correct colors. For example, as I show you later in this chapter, you fix a photo that appears to be too red by removing some red or by "adding" its complement, cyan. (In the next subsection, you'll see why "adding" is in quotes.) Similarly, you can remove green or "add" magenta; remove blue or "add" yellow.

We've all seen photos with a strange green, yellow, or red tinge, where skin looks weird, hair colors aren't anything close to what appears in nature, leaves are blue, grass is yellow, and basically everything looks alien. The color problem can happen either when the photo was taken or during development. Sometimes photos that looked okay in the beginning change color over time. Regardless of the cause, you can fix most color problems — with some exceptions, of course.

Most image editing applications provide tools for adjusting a photo's color levels. Depending on the features of your favorite application, you might or might not be able to add color or change color effectively, and this is perhaps one of the most important tests for evaluating multiple image editing applications. If you can't get rid of a ruddy, sunburned look in a photo or eliminate the nausea-green tinge in a picture, consider looking to another application for serious photo editing.

You can't add color that isn't there

Typically, adjusting image color involves changing existing color levels. If the photo is a color image, you can adjust the levels of whatever color is in unwanted abundance so that the tones are more natural. However, color correction can't add color that isn't there in the first place. For example, in an overpoweringly red image, removing the red cast might not leave enough green and blue colors to produce a realistic image. One of the things that you can't do with an image editor is fix the color of images that are too far off the deep end in terms of color balance.

Similarly, if the image is in black and white or has faded so much that it's hard to tell whether it was ever in color, adding that touch of color to a photo might not be so easy. You can't simply increase or decrease one or more colors if the colors aren't there in the first place.

You can, however, add layers to your image and color them in by using your editing software's fill color and painting tools. In doing so, you create a color wash on top of a faded or black-and-white photo. Think of it as the clear plastic overlays in the old anatomy books, in which each successive layer

added some content (the respiratory system, the digestive system, and so on) until the body was complete. You can add layers of color on top of the faded image, achieving the look of rich color that's currently missing.

Do keep in mind, however, that when you add color layers to a very faded or black-and-white photo, the results often look fake, sort of like how colorized black-and-white movies look a little funky. To put it bluntly, people's teeth look blue instead of white, and natural things (grass, trees, flowers, and so on) never look quite natural. If you want to brighten a faded color, you can probably use an editing tool or two to bring back a bright blue dress or some lush green lawn, provided that there's enough color to work with in the original.

Fixing color casts

A *color cast* is a tinge — a shade of red or maybe yellow — that discolors your image in whole or in part. Casts occur for a variety of reasons, including the age of the photo, the quality of your scanner (if you scanned a printed original), the print from which you scanned the image, or the film used to take the picture. If a cast appears in an image captured with a digital image, you might need to adjust the white balance of your cameras to compensate for the different colors offered by various types of illumination. (See your camera's instructions to learn how.)

Most digital editing applications offer tools for getting rid of a cast, usually with a name like Color Balance or Color Cast. Here's a general description of the necessary steps:

1. **Open the image with the unwanted color cast.**

2. **Choose your image editor's Color Balance, Color Cast, or similar command.**

 The dialog box opens with an array of tools, as shown in Figure 1-1.

3. **Choose whether you want to apply the change to the Shadows, Midtones, or Highlights.**

Figure 1-1:
Use your
image
editor's
Color
Balance
to help
rebalance
colors.

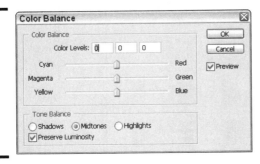

4. Move the Cyan/Red, Magenta/Green, or Yellow/Blue slider away from the color of the unwanted hue.

For example, if your picture is too blue, move the Yellow/Blue slider toward Yellow.

5. Click OK to apply the change when you're satisfied.

Applications such as Paint Shop Pro, Photoshop, and others have a Preview option. Make sure that you leave the Preview option selected in the dialog box. Leaving it checked means that you don't have to apply the changes just to see them in your image. If you do apply them and then decide you don't like the change, choose Edit⇨Undo (or your image editor's equivalent) to go back.

If your application doesn't refer directly to a color cast, you can use any tool that adjusts tone, including dialog boxes and toolbar settings that allow you to adjust the levels of color in the image, one color at a time. This enables you to increase the level of blue, red, green, or yellow (or perhaps cyan or magenta), and you can tweak one or more of them until the photo looks more natural and normal.

Another tool in Photoshop and Photoshop Elements is the Variation tool, which gives you several different versions of an image to choose from, enabling you to add more red, green, or blue. You can adjust color intensity for any one of these colors in your image and view Before and After versions of the image. In Photoshop, choose Image⇨Adjustments⇨Variations. If you're using the lower-priced and nearly as powerful Photoshop Elements, choose Enhance⇨Adjust Color⇨Color Variations. Figure 1-2 shows the Elements Color Variations dialog box as well as a subject in a variety of tones.

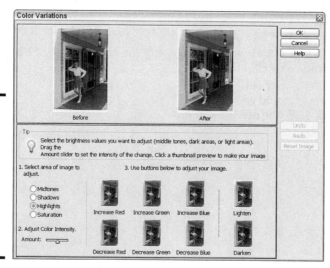

Figure 1-2: Color Variations lets you choose the best color balance from a selection of images.

What do you do if none of the color correction tools in your image editing software do the trick? You can try a different application, or you can appreciate the photo for what it is. If it's an old photo, the color problems can add charm. If it's a new image and there's no excuse other than film or technique, just chalk it up to experience. You can also try rescanning a print on a different scanner or after recalibrating your scanner (follow the manufacturer's instructions). You can find out more about scanners in Book VI, Chapter 1.

Causes of color catastrophe

Where does bad color come from? Generally it comes from a digital camera that's been adjusted to the wrong *white balance* setting (say, set to indoor light when you're shooting outdoors), environmental color casts (such as sunsets or bright snowy conditions), or, in the case of film images, age of the film, bad film, bad development technique, poor print quality, or a bad or poorly adjusted scanner. These factors in a poorly colored photo apply to most color problems — unnatural tones, images that are too bright, too dark, faded, and so on.

Of course, if you've had nondigital photography experience, none of this is news, and you probably know what to do to make sure that the images you take, develop, and print are not color-challenged. However, if you're a fledgling photographer or simply enjoy taking photos of family, friends, and vacation spots (and have no idea what you're doing beyond focusing and shooting), you might not know how to prevent problems in the future. Some things to consider include the following:

✦ **Use appropriate film and/or white balance settings.** When shooting with a traditional (not a digital) camera, use film intended for the types of shots you'll be taking. Some films are balanced for indoor use; some are better for outdoor use. Digital cameras, too, need to be balanced for the light source, so you'll want to make sure that your camera is set for Automatic White Balance (AWB) or adjusted manually for the type of lighting you'll be shooting under.

✦ **Check printer settings.** If you're printing a digitally captured image, the color could go wrong entirely because of the printer's color settings, eliminating the need to edit the image. Use your image editor's calibration tools to correct for the vagaries of your particular printer. Try printing the image on someone else's printer to determine the common denominator.

✦ **Calibrate your monitor:** Use your software or monitor's instructions to calibrate your monitor to help ensure that what you see is what you can expect to get.

Book IV Chapter 1

What You Can and Can't Do with Image Editing Tools

✦ **Fix problems with scanner software.** If you're scanning from a print, you get whatever sins were committed when that photo was taken, developed, and printed. Take note of any problems and be ready to accommodate them by using your scanner software — if color correction tools are included in its toolbox — or by using your image editing software. Better to have noticed the problem before you scan, print, and/or share the image online!

✦ **Store images properly.** Because aging causes many color problems when the dyes in the three color layers of prints fade at different rates, store your images in a cool, dark place, and make sure that they contact only acid-free paper. Acids in some papers damage photos; you can avoid this problem by using photo albums and storage boxes that were made in the last 10–20 years. Don't reuse the old photo albums that came over with your family on the Mayflower; the paper could contribute to the aging process.

If you have a precious image that you display in a frame, don't expose it to direct sunlight. Hang or stand any framed images in a place that gets only reduced ambient sunlight or only low-level incandescent or fluorescent light from bulbs. Direct, bright sunlight fades images the worst. And because the colors in photos don't fade at the same rate, your previously natural-toned image can turn yellowish, reddish, greenish, or some combination thereof.

Adjusting Brightness and Contrast

Other components that you'll want to fix with your image editing software include brightness and contrast. Detail can be lost when an image is overexposed, faded, or just too bright. Detail can also be lost when an image is too dark because of a failed flash or simply a very dark subject. A day that looks perfect for picture taking to you can result in washed out faces, shiny foreheads, light-eating shadows, and an overall lack of definition. You can eliminate many of these problems by adding and removing light in your image with the help of the brightness and contrast controls found in just about any worthy image editing package. Figure 1-3 shows a photo that's been improved simply by adjusting the brightness and contrast.

With most image editors, you'll have several choices for fixing these problems:

✦ **Quick Fix:** Many image editors have a *quick fix* command, with a variety of tools for tweaking just about any aspect of an image. You can adjust brightness, color, focus, contrast, flash, and backlighting. You can also rotate the image. Like with the Variations feature (which I discuss in the earlier "Fixing color casts" section), you can also preview a Before and an After version of your image, as shown in Figure 1-4. Previewing versions enables you to see whether the adjustments are having the desired effect before committing them to the image.

Figure 1-3:
Sometimes photos need adjustments to brightness and contrast.

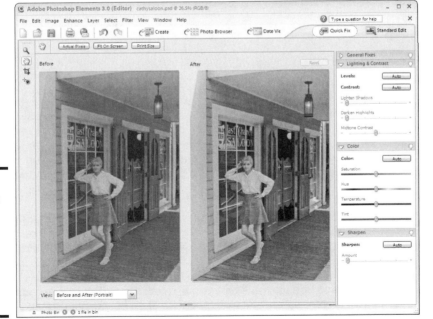

Figure 1-4:
Photoshop Elements' Quick Fix feature helps tweak your images.

✦ **Auto Contrast:** This is an easy one. Many image editors, including Paint Shop Pro and the Adobe products, have an Auto Contrast or Automatic Contrast Enhancement command. Choose this command, and voilà! Your image is adjusted, using existing color and brightness levels to determine a happy medium.

✦ **Auto Levels:** This automatically adjusts the relationship of the tones for you.

✦ **Adjust Lighting:** You can also find special commands to adjust for *backlighting* (images that are illuminated primarily from behind) or *fill flash* (to provide additional front illumination).

✦ **Adjust Brightness and Contrast:** Use your image editor's manual Brightness/Contrast dialog box, like the one shown in Figure 1-5. You can enter values or move sliders or other controls to change these two integral levels in the image. Some image editors, such as Photoshop and Elements, show you the original image at all times so that you can preview the effect. Other image editors might have a Preview option that you must use to see your changes before committing to them by clicking OK.

Figure 1-5:
Enter values to modify the brightness and contrast of your image.

Murky shadows and washed-out highlights

Most of the tools that I describe earlier in this chapter adjust the entire image, making the whole photo brighter, better, more natural-looking, and so on. If you want to tinker with specific areas of the image — an unwanted shadow in the corner, for example, or a single beacon-like forehead — you can use your image editing software's selection tools before issuing the commands, or you can use various brush-based tools to apply more or less light in specific areas.

Huh? Brush-based? That means painting — painting more light here, more dark there; using a big brush here to add a lot of light to a big area; and using a small brush there to add just a little dark or light where it's needed. Most (if not all) image editing packages offer corrective tools for adding and removing light and dark. Figure 1-6 shows a toolbox with typical Dodge, Burn, and Sponge tools that you use to lighten, darken, and remove (respectively) color saturation from portions of an image. Some image editors use

the regular brush to perform these tasks. For example, Paint Shop Pro has Dodge and Burn modes for its brush, turning the Brush temporarily into Dodge and Burn tools. Corel PhotoPaint tucks its Dodge and Burn tools into the Effect tool. All work in a similar manner.

Figure 1-6:
Typical Dodge, Burn, and Sponge tools.

Go into the light with the Dodge tool

Use a *Dodge tool* to add light to an image by applying it with a brush that you customize in terms of the size, shape, and even texture. Most applications offer a similar tool, if not the ability to completely customize the brush. You can find more information about the Dodge tool in Book IV, Chapter 2 (along with extra info on the Burn and Sponge tools, too). To use the Dodge tool, follow these steps:

1. **Click the Dodge tool in the toolbox.**

Choose the appropriate options on the Options bar that appears above the workspace, as shown in Figure 1-7.

Figure 1-7:
Set the options for the Dodge tool here.

2. **Set the size of your brush so that you don't apply a large light area to the image if you don't want one.**

3. **Adjust the *intensity* or *opacity* of the brush (how much light each click or stroke of the brush applies).**

4. **If you really want to control the effect, use the Range option to choose what is lightened — Shadows, Midtones, or Highlights.**

 - *Shadows:* Use this if your image has very dark corners where details are lost.

 - *Highlights:* Use this if you have a bright spot that needs to be brighter.

 - *Midtones:* Use this default if you want to brighten an area that's not in sun or shadow.

5. **Begin lightening by either clicking a single spot or dragging the mouse over an area.**

 The more passes you make over one spot, the lighter it becomes.

Need to brighten a single object, such as a face or a flower? Size your brush to the face or flower in question (so that the brush is the same diameter as the object), and click the object with the Dodge tool. You can click multiple times, if needed, to achieve the desired level of lightness.

Keep away from the light with the Burn tool

Opposite to the Dodge tool, which adds lightness, the *Burn tool* adds darkness. You can revive lost facial features or other details where the sun, too much flash, or age-induced fading have washed them out, and you can add depth by simply darkening areas in the image for aesthetic reasons. Using the Burn tool is much like using the Dodge tool except that wherever you click or drag, darkness is added, and lightness is taken away.

Living up to its name, the Burn tool can give you a singed, brown tone if you overuse it. If you click or drag repeatedly in an area with the Burn tool, instead of a simple darkening effect, the spot will look as though a flame came dangerously close to it, and the area began to char. Easy does it! Figure 1-8 shows an image that has been both dodged and burned.

Saturating and desaturating lights, darks, and colors with the Sponge tool

Using the *Sponge tool* is like using a sponge to remove a stain or to saturate fabric with dye. You can use the Sponge tool to take away light, dark, and color, or to add more of the same. Found in Photoshop Elements (and in Photoshop and other applications as well), the Sponge tool has two modes: Saturate and Desaturate. The names give the effects away, and the tool is simple to use:

Figure 1-8:
The original photo (left) is first dodged to lighten some shadow tones (center), then burned to darken some light tones, such as the sand (right).

1. **Set your brush size so that you're applying the Sponge tool to an area no larger or smaller than desired.**

2. **Choose a Mode (Desaturate or Saturate) for the tool, if your image editor uses the same tool for both modes.**

 - *Desaturate:* Use Desaturate to tone down the color richness.

 - *Saturate:* Use Saturate to increase the vividness of the color.

3. **Adjust the Flow (amount of desaturation or saturation achieved) by dragging the slider to increase or decrease the default 50% level.**

4. **Click or drag with the tool to add or take away color, light, and dark from the image.**

 You essentially wash out the image if you desaturate and add more life if you saturate.

When you saturate with the Sponge tool, remember that you can add more of what's already there only. You can't add color to a black-and-white photo, and you can't add vivid blue to an image where there is no blue to begin with because of fading or degraded colors.

Maintaining consistency

Consistency is a lot like conformity: Too much is not good, and too little can cause problems. The world would be pretty dull if everyone were the same, but some degree of conformity and consistency usually makes things run more smoothly. The same can be said for photos. No photo should have the

same levels of light and dark throughout it, as only a picture of a white wall or a black, starless sky can have no need for defined depth, implied dimension, or just plain old variety.

When you're adjusting the lights and darks in your image, keep this delicate balance in mind. You don't want to make the lights and darks uniform over the whole image, yet you don't want to have very dark darks in one spot and very light lights in another. Artistic images that are meant to convey a message, and in which you want people to see that you've tinkered with reality, are another story — there are no limits or boundaries there. But for photos of people, places, and things that are meant to be realistic and clear images, you want to keep the signs of your tinkering to a minimum, and you want to achieve the right levels of consistency.

How is that done? By using the right tools the right way. If you're dodging or burning an image, use brush sizes that allow gentle effects. Using very small brushes over a large area is bound to show the strokes or clicks. Using the tools too much causes some areas to be much lighter or darker than others, probably giving you unnatural results that look like you went overboard.

Of course, using the tools that apply to the entire image also gives you consistency. Any Auto command makes universal adjustments based on what's in the image to start with, and your results will be pretty tame and consistent. Using tools that allow you to drag sliders or enter new levels and have the settings affect a selected area only or the entire image if nothing is selected also creates consistency because your mouse skills and brush-based tool settings are not part of the equation. This gives you less control over the degree of lightening or darkening but can provide gentler, more subtle results.

Reviving lost detail

Perhaps your photo has too much contrast, and the details of the items caught in the brightest spots are unrecognizable. Or maybe your photo has faded with time, and fine details are lost. Are the details lost forever? Probably not, assuming that you have time, patience, and the right tools to bring them back to life.

Choosing the revival method

The method used to bring back lost details varies by the situation and the situation's cause. For example, if the details were lost to too much light, using the Burn tool reduces the light and brings out the missing features, textures, or whatever's been blighted by the light. If the details are hidden in shadow, the Dodge tool can shed some light on these details and reveal them once again. Adjusting contrast and brightness levels can revive details lost to too much or too little of those levels, and you can even use color to bring things out. How do you choose? The best strategy is to figure out what went wrong and reverse it, using a tool that applies the opposite attribute.

Re-creating lost detail

If you're skilled, patient, and have good eyesight, you might be able to zoom in extremely close to your image and use painting and drawing tools to re-create details that are irretrievably lost. You have to be very careful, though, and avoid it in faces and natural things (such as flowers and plants) because pulling it off is nearly impossible. Things usually look drawn and end up drawing attention to the problem. You can, however, re-create textures (such as a brick wall or a stubbly patch of cement) and industrial or man-made items (such as the edge of a car bumper or the handle on an umbrella). The results can be surprisingly good, even for someone who might be a bit shaky on the mouse.

You can use your image editor's Paint Brush and Pencil or similar tools to draw missing items, such as the edges of petals that are being sketched in Figure 1-9. The keys to your success are

◆ Setting the brush or pencil to a very small size (3 or fewer pixels).

◆ Zooming in as close as you can. (Be prepared to zoom back out periodically to check your progress and see your work in context.)

◆ Working slowly and deliberately.

Figure 1-9:
Use a small brush or pencil to restore lost details.

Does what's missing appear elsewhere? If so, steal a copy and replace the missing detail. I've successfully replaced lost content with faces, furniture, grass, trees, walls, cars, and sleeping dogs. You can, too, by using the tools that I discuss in the section, "Removing Unwanted Image Content," later in this chapter.

Not to be negative (pardon the photographic pun), but sometimes lost detail is simply lost. If an overzealous flash completely washed out someone's face, short of drawing in his or her features by hand, you might not be able to bring back eyelids, a nose, cheekbones, the contour of his lips, and so on. Not every photo can end up framed and admired or viewed by adoring millions online. If you've used every brightness, lighting, and contrast tool that your software has to offer, you can try a different or more powerful package, or you can do your best and hope nobody notices that Aunt Mary doesn't have a nose.

Using Blurring and Sharpening Tools

Another way to revive lost details is to apply a filter that sharpens the image by heightening the difference between adjacent pixels. This increased intensity of color and brightness makes everything stand out, as shown in Figure 1-10, where some of the image has been sharpened, and the rest was left as it was. You can use the Sharpen filters that come with all image editing applications or use the Sharpen tool found in the toolbox of just about any image editing program. Using the filter requires selecting the area to be sharpened and then applying the filter, whereas the tool requires the standard brush-related adjustments (such as the size of the brush and the degree of sharpening it applies). You can find more information on the Blur and Sharpen tools in Book IV, Chapter 2.

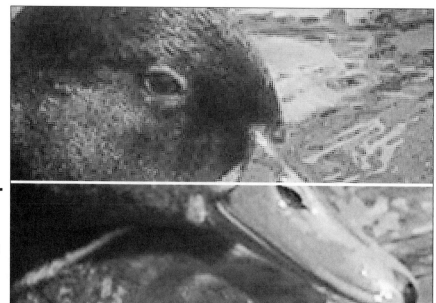

Figure 1-10:
Sharpening
enhances
the contrast
between
adjacent
pixels.

Sharpening here and there

If you want to sharpen the entire image, use a filter to do the sharpening. If your software doesn't have filters, check for a Sharpen command or reasonable facsimile thereof — any command that performs an automatic, all-over sharpening will do. The other benefit of this process is that it's a simple one in most image editors. Corel PhotoPaint, Paint Shop Pro, and Adobe's image editors, for example, all have a simple Sharpen command that you can apply directly, along with more sophisticated versions if you need more control.

If you want to sharpen an area, you can also use the filter or automatic sharpening command, but you have to make a selection first, directing the software to the spot you want to sharpen. You can repeat the process to sharpen two or more noncontiguous areas. Or if your software supports selections that are not touching, select all the areas that are to be sharpened and then apply the filter or related command.

When I need to sharpen a little here, a little there, a bit more here, and a whole lot there, I use the Sharpen tool that some image editors provide for "painting" sharpness. It works like a painting tool in that you click and/or drag your mouse over the image to apply the sharpening effect, and you can repeat your mouse movements in the same spot if you want more of a sharpening effect in one place than in another. You can dictate the size of the sharpened area by adjusting your brush size, and you can control the intensity of the sharpening by adjusting the strength setting.

To use a Sharpen tool, follow these steps:

1. **Turn on the Sharpen tool by selecting it from your image editor's toolbox or menu.**

2. **Set your brush size so that you can control how big an area is sharpened with each click or drag of the mouse.**

3. **Set the strength for your sharpening effect.**

 A good default value is 50%, but you can raise or lower that level as needed by dragging the slider or other control.

4. **Begin sharpening by clicking or dragging over the area to be sharpened.**

 Clicking sharpens an area the size of your brush tip, and dragging allows you to sharpen in a freeform area, following an edge or working within a desired region of the image.

Be careful not to sharpen too much. Too much sharpening results in bizarre-looking bright pixels that end up hiding details because the individual pixels stand out too much. Figure 1-11 shows an image where the sharpening went a little overboard. Sharpening can also increase your file size.

Figure 1-11:
Too much
sharpening
is not a
good thing!

To keep the sharpening results as subtle as possible, avoid using a very small brush size (10 pixels or fewer) if you're sharpening an area that's more than 20 pixels wide and/or tall. Why? Because you'll be able to see your brush strokes as you apply the sharpening. An exception would be the sharpening of a very small spot, which would obviously call for a very small brush, and you can select the area first, which helps control your effects by restricting them to the selected area.

Blurring for effect

Sometimes the best way to draw attention to something is to draw attention away from something else. The bride doesn't *have* to wear the biggest, most ostentatious dress to stand out against her bridesmaids; she can instead dress them in colors that blend in with the flowers — and by contrast, she stands out. The same is true for photos, especially those with a lot of content that you need to keep but want to keep people from noticing too much.

Figure 1-12 shows a photo of a dandelion against a leafy background. The outdoorsy setting is important to give the image context, but the dandelion is the real focus. To make it stand out, the background has been blurred, and

its details are diminished. Other than being able to tell that the background consists of foliage, there isn't much about it that you would notice or be drawn to visually.

Blurring is the exact opposite of sharpening in that instead of heightening the contrast difference between adjoining pixels, the color and brightness differences are reduced so that pixels are much closer to each other in terms of their color levels, brightness, and contrast. You can go too far with blurring and end up with something that isn't even recognizable; conversely, you can blur not enough, leaving the content as distracting as ever. The key is to find a happy medium where objects are still recognizable, but nobody will spend much time looking at them.

Like sharpening, you have choices as to how to apply blurring. You can use your image editor's Blur tool (which works just like the Sharpen tool, except for its results), or you can use the Blur filters. Many image editors offer specialized Blur filters that do cool things, such as making an image look like it's whipping past the camera (the Motion Blur) or like it's spinning in place (Radial Blur). The plain old Blur filter simply blurs the entire image or a selection therein — it's as simple as that. In Figure 1-13, Motion Blur has been applied to the entire image.

Figure 1-12:
Blurring
everything
else makes
your main
subject
stand out.

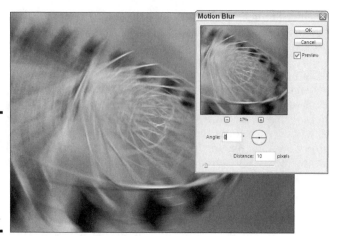

Figure 1-13:
Motion Blur adds the appear-ance of movement to an image.

To apply a blur to everything but the focus of the image, follow these steps:

1. **Select the object or area that should not be blurred.**

This can be done on an image that's all on one layer. Or, if your software supports layers, you can select the object or area and then cut it to its own layer to keep it separate from the rest of the image during the blur-ring process.

2. **If you're working all on one layer, invert the selection so that every-thing but the selection can be blurred.**

Most image editors, including Corel PhotoPaint, Paint Shop Pro, and the Adobe Photoshop products, let you invert a selection by pressing Ctrl+Shift+I (or ⌘+Shift+I if you're using a Mac).

With the not-to-be-blurred section protected, you can begin blurring the rest of the picture.

3. **Click your image editor's Blur tool to activate it and then set the way the tool should work by choosing the brush size and strength, just as described for the Sharpen tool.**

4. **Begin dragging the mouse in the area to be blurred. You can go over some areas more than once, increasing the blurring effect in those spots.**

Unlike many other types of retouching, blurring is very subtle and is hard to overdo.

5. **When you've finished blurring the area, turn off the selection and view your results.**

If you opted to use the Blur filter, after making the selection and inverting it so that everything but the selected area can be blurred, you can choose your editor's Blur filter. The blurring effect is uniform throughout the selection, and you can intensify it only by repeating the command.

Unlike the regular Blur command, the special blurs found in most image editors have dialog boxes that allow you to set how much blurring will occur and exactly what special effect will be achieved.

When using blurring in your photos, keep the following points in mind:

+ Try combining Blur effects. For example, blur by hand and then apply one of the special Blur filters, or combine more than one special blur filter for a completely unique effect. If your software doesn't offer special blurs, you might consider one that does, such as Photoshop Elements, which I used for all the demonstrations in this chapter.

+ If your editing software supports layers, you can do a very cool thing with the Motion blur (or with a manually created motion effect, created by horizontal or vertical strokes with the Blur tool). Duplicate the object that should be in motion and put it on its own layer. Then blur that duplicate, and place it behind the static version on the original layer. Voilà! Your object is sitting still after rocketing into position via the Motion blur.

+ If you're a Photoshop or Photoshop Elements user, don't confuse the Smudge and Blur tools. The *Smudge tool* literally smears adjoining pixels, as though you've run a greasy paw across a chalk drawing. You can use the Smudge tool to blend two contiguous areas of color or texture, but the effect is much more dramatic than blurring.

Repairing Damage, Small and Large

Damage comes in all shapes and sizes — little specks of dust; scratches thin and wide, short and long; water marks or discoloration from tape; missing corners. The following sections walk you through all kinds of repairs.

Removing artifacts (or tiny blemishes)

No, I'm not talking about ancient clay pots, unearthed by archaeologists. *Artifacts* are the little stray marks, blips, and other tiny blemishes that appear on images when they're captured and manipulated electronically — the kinds of blemishes shown in Figure 1-14. The term *artifact* is also sometimes applied to the dust and scratches that accumulate on printed photos and that end up in the digital version of the photo after it's scanned. Unlike an ancient clay pot that you'd probably want to keep, artifacts in your images

are usually not desirable, and you'll want to get rid of them. Although few photos are as damaged as the example shown in Figure 1-14, most scanned images will have at least a few dings.

Finding an artifact's source

When dealing with artifacts, it's useful to note how they got there. If the artifacts appeared after you resized an image or a portion thereof (stretching it with your mouse to increase its width, height, or both), the solution might be to undo the resizing and then save the file in a format that's more supportive of the resizing process. If the artifacts were there from the time the image was scanned, you can try brushing off the original to make sure none of the spots are from dust that can be removed (as opposed to the nastiest kind of dust, which becomes embedded in the photograph itself). In lieu of that, remove the marks with your software's various painting and cleaning tools.

So what's a file format that supports the resizing process? JPEG is a good choice because it supports more colors than GIF (assuming that your image is bound for the Web or that you're trying to keep the file size small to facilitate sharing online). TIFF is another good choice if your image file size doesn't matter and you plan to print the image rather than display it on the Web.

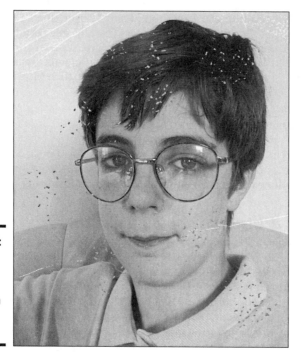

Figure 1-14:
Dust and scratches inevitably show up on scanned photos.

Sweeping away dust

Dusting off your originals before scanning them is an obvious preventative measure, but it rarely removes the ground-in dust or the scratches and scuffs that appear over time, even on relatively new photos. If you store your pictures in a box or desk drawer and they rub up against each other, damage is bound to occur. For very old photos, the porous papers used back then absorb moisture and dirt, so stains and dust attack them much more easily than newer, coated photographic papers. Obviously, storing your images in a safe, protective environment (remember to use only acid-free paper!) is best, but if you haven't done that, all might not be lost.

You have several choices for removing dust and scratches, and in most cases, personal preference, skill, and the degree of damage will dictate which tool you choose. For example, you can use any of the following tools found in editors such as Photoshop, Photoshop Elements, and others to get rid of small spots, scratches, and other tiny blemishes:

✦ **The Brush tool:** The Brush tool can be used to paint out the spots.

✦ **The Pencil tool:** For tiny, tiny spots, you may like the precision of the Pencil tool, which works much the same as the Brush tool except that the dots or lines drawn are sharp-edged.

✦ **The Smudge tool:** The Smudge tool is a favorite of mine if I just need to smear a little of the surrounding color onto the spot, much as I'd do if I had a painting with an unwanted dot of color on a field of another color. You can find more information on the Smudge tool in Book IV, Chapter 2.

When you paint, pencil, or smudge out a dot or small scratch, you can't duplicate any pattern that's in place. For example, if the spot is on a piece of fabric, such as a coat or dress, the fabric's texture will be lost on that tiny spot even if the color is restored and the spot is no longer visible. For the kind of tiny spots and marks I'm talking about here, this is rarely a problem. For larger areas, however, the lack of texture stands out as clearly as the original mark did, so use the Clone tool (found in both Photoshop and Photoshop Elements, as well as other editing programs) to copy sections of the pristine textured area onto the damaged area. The use of this type of tool is discussed later in this chapter (see the section, "Removing Unwanted Image Content").

Painting over the dirt

Because your image contains only little marks on a plain background that you can easily remove with the Brush or Pencil, you decide that painting or drawing out the spot is the answer. You're ready to make the artifacts go away. With the photo in question opened and onscreen in your favorite editing program, follow these steps:

1. **Click the tool that you want to use.**

- *Brush:* Use this tool if you're painting out a small dot or a tiny scratch.

- *Pencil:* Choose this tool if you need a thin, precise line to get rid of the artifact in question.

2. **Set the size of the brush or pencil, choosing one that's roughly the same size as the dot or scratch that you want to eliminate.**

If you're dealing with a scratch, draw or paint a line that's only a tiny bit wider than the scratch itself.

3. **Use the color-sampling tool — the Eyedropper — to sip up the color from the surrounding unmarred pixels.**

With Photoshop or Photoshop Elements, hold down the Alt/Option key to convert the Pencil or Brush tools temporarily into an Eyedropper. This sets the painting/drawing color so that it matches when you brush or pencil the marks out. Figure 1-15 shows sampling in progress.

4. **With the proper color selected, go back to the desired tool (the Brush or Pencil) and begin painting or drawing out the unwanted artifacts.**

You can click to get rid of a small dot or drag to get rid of a scratch.

Figure 1-15: The Eye-dropper samples a selected color so you can paint with that color.

Smudging or blurring out the paint lines

If you painted out a mark but feel that your retouching is too visible, you can use Undo (usually Ctrl+Z, or ⌘+Z if you're using a Mac) and start over, or you can use the Blur or Smudge tools (set to an extremely tiny brush size) to make the edges of the painted dot or line just a bit fuzzy. This action removes any visible edge to the color that you apply to the image. Figure 1-16 shows a painted-out scratch being repaired by blurring the edges of the repair with the Blur tool.

To address any concerns about dust and scratches that can't be repaired, let me say this: Every image editing application that I know of offers the ability to select a color from within the image and then use that color for painting or drawing so that you can brush or pencil out tiny blemishes. The tools involved are simple to use, and this sort of repair is easily within the grasp of beginning users.

Spackling over more serious damage

More extreme than scratches and scuffs, missing content is the kind of serious damage that might make you think a photo is unsalvageable. Not all image editing packages are capable of fixing dramatic problems, but many are. If your software has cloning, patching, or similar tools, you could be in luck. However, if all you have are paint brushes and the ability to copy and paste selections, you might not be so lucky. Figure 1-17 shows a seriously damaged photo, with a corner missing. Painting, drawing, and pasting are clearly not going to work in a situation like this! But given the right tools, you can restore the missing corner by filling it with the remaining image content and thus creating a nearly seamless repair.

Fixing more serious damage requires *digital spackle,* which works a lot like the gloppy white spackle that you apply to your walls to fill in holes from where pictures were hung or someone gouged the plaster while moving furniture. Photos can also suffer from the same sort of dents and dings, and you need to fill in the holes and gashes with something, right? You can use content from within the image (or from another image), or you can create new content from scratch.

Preparing your spackle

Unfortunately, image editors don't come with a spackle tool, but you can create your own spackle by using the various tools at your disposal. The most common tool for this application is the Clone tool or Clone brush, depending on your image editor. The spackle that you create depends on what kind of damage you're repairing. You can fill in small areas with solid colors, applied with a Brush tool, or you can clone existing content from nearby and place it over the damage. Your choices are virtually unlimited, and the success that you see is based only on your mousing skills (for those tight corners and tiny repairs), patience, and how much time you have to devote to the task.

**Book IV
Chapter 1**

What You Can and Can't Do with Image Editing Tools

Figure 1-16:
Blur a
painted-out
scratch.

Figure 1-17:
When you
have an
entire
corner
missing
from your
photo,
serious
repairs are
needed.

Replacing content that's ripped or torn away

Although you might not be able to put the corner back exactly as it was, you can make it look as if there were never a missing corner. If that sounds like a contradiction, consider that what was in the corner might be unknown. What if the corner were missing before you even got the photo? If you don't know what used to be in that corner, you can't put it back. What you can do, however, is create a new corner from existing content and make it look like it's always been there. To get started, follow these steps:

1. **Think about what you could use to replace what's missing.**

 If you know what's missing, this isn't difficult. If the missing or damaged portion doesn't tell you anything about its original state, however, you might have to decide what remaining content can be used to rebuild the corner.

2. **Click the Clone tool.**

3. **Choose a brush size and set the Opacity to 100%.**

4. **Zoom in to the area you want to work with.**

5. **Choose the source area for cloning, as shown in Figure 1-18.**

 Some image editors require right-clicking to select a source area. In others, you have to hold down the Alt key (if you're a Windows user) or the Option key (if you're on a Mac) as you click the area that you want to clone.

6. **Click and/or drag over the damage, watching as the sampled content covers it.**

 Figure 1-19 shows cloned content filling in the missing corner.

If you want to be able to apply the same exact cloned spot to the entire damaged area, be sure to select the Aligned option on the Options bar (or the Cumulative option with some image editors) before you start painting the cloned content onto the damage. This setting allows the original sample to be used repeatedly. If you leave this option unchecked, the Clone tool continuously resamples the photo while you paint with the tool, meaning that the sampled content might be slightly different each time you clone.

Your filling needn't come from the same image! You can use the Clone tool to sample content from another image and then apply it to the damaged photo. Just open up the new image, sample the content (press the Alt or Option key as you click the content to be cloned), and then switch back to the damaged photo. With the Clone tool still selected, begin to click and/or drag to place the cloned content in the image.

Figure 1-18:
Sample the
area you
want to
clone.

Figure 1-19:
Paint
over the
damaged
area with
the cloned
texture.

Removing Unwanted Image Content

Signs of wear and other types of physical damage aren't the only things you might want to get rid of when editing your images. A person, car, garbage can, building, plant, tree, or just about anything can become objectionable if you didn't want it to be in the picture in the first place. Rather than tearing all your wedding photos in half, consider replacing the unwanted spouse with more of the background or a large potted plant. Someone forget to move the car before taking a picture of your house for the real estate brochures? Get rid of the car, replacing it with curb and grass, as though the car had been in the garage all along.

It might seem like some sort of complicated sleight-of-hand, but replacing one piece of content with another is really rather simple. If you've already tried repairing scratches, stains, and tears, you're more than ready to tackle the process of removing unwanted people, places, and things. You need software that has Clone and/or Patch tools (or reasonable facsimiles), and you need to understand how the Clipboard works (so you can copy and paste content in big chunks). Sound like too big a job? Never fear — it becomes clear in the next few paragraphs!

Delete your ex-brother-in-law

Family members are often hard to deal with. No matter how much we love them, we sometimes wish they'd make themselves scarce, if only for a little while. But what if your ex-family member — someone you thought you'd never have to see again — is still haunting your family photos? Starting with a group photo, follow these steps:

1. **Identify the unwanted person and use a selection tool — preferably a freeform or magnetic selection tool — to select him or her.**

 You don't have to worry about getting a little of the surrounding image as long as it doesn't remove someone else's arm or the side of a face.

2. **Press the Delete key to get rid of the selected person.**

 The background layer or any other underlying layer's content now shows through the hole.

3. **Fill the hole with other content — more of the photo's background content if you were all standing in front of one of those lovely painted backdrops, or use the sky or extend a nearby wall or stand of trees.**

 Whatever's behind the rest of the group can be extended to fill in where the now-missing person once stood. Your choices for filling in are as follows:

 • Copy content from elsewhere and paste it onto the hole.

 • Use the Clone tool to fill in the hole with sampled content from elsewhere in the image.

Whatever method you choose depends on three things:

1. How big the hole is that the deleted person left behind

2. Whether you have a lot of alternate content to use as fill

3. Whether there are lighting issues

Perhaps everything but the deleted person is in shadow, and you can't seamlessly apply that dark content in his or her place. If lighting is the problem — and you have Photoshop — you'll want to use the *Patch tool* (a kind of super-Clone tool that adjusts for texture and lighting) so that the lighting of the destination is preserved when you patch the hole. If the hole is huge or there's no background to use, you might need to copy content and paste it into the hole, perhaps even going to another image to get the filler. Figure 1-20 shows a Before and an After of the same image. In the after version, the unwanted element (in this case, my grandmother's dog, who always tried to bite me) has been replaced by more of the surrounding grass and shrubbery.

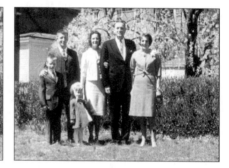

Figure 1-20: Hide the dog behind the shrubbery.

What if the unwanted person isn't against a background or is sitting in front of someone else and deleting him or her will leave you with half of a person? Consider bringing someone in from another picture and putting him or her in place of the person you're deleting. You can always resize a new person from a smaller or larger image, and you can use your image editor's Burn or Dodge tools to adjust lighting if the substitute person comes from a darker or lighter image. Use the Blur or Smudge tools to make the stand-in blend in so that none of the edges are obvious.

Cranial tree-ectomies

You've probably accidentally taken (or posed for) a picture in which a tree or a lamp or some other object appears to be growing out of someone's head. It's just a matter of standing in front of the lamp at just the right spot, and

you end up looking like you're wearing a lampshade. If you're standing in front of a row of trees, with the right positioning, you can look like the pot for a very large plant. What to do? Perform a cranial tree-ectomy or a lampo-suction and remove that unwanted growth!

Your options for performing these types of surgery are very similar to those you'd use to replace an unwanted person or thing in a picture. However, in this case, you're simply moving the tree or lamp (or whatever) so that it's still in the picture but not in an unfortunate spot. You can get rid of the offending object entirely, but if the tree or lamp is a nice feature in the picture or if you have no realistic alternative to replace it, moving it is much easier than losing it.

Moving a tree or other object just enough so that it's not coming out of someone's head in the photo requires two tools: a selection tool (I use the Lasso here) and a Move tool. Any editing software worth its salt has both of these tools, and they work very much the same as this Photoshop Elements-based procedure:

1. **Open the photo with the offending tree and make sure that it's active in the workspace.**

 Figure 1-21 shows a picture with a man who seems to have sprouted shrubbery from his skull.

2. **Activate the selection tool of your choice.**

 It should be a freeform selection tool rather than one that selects only rectangular or elliptical areas.

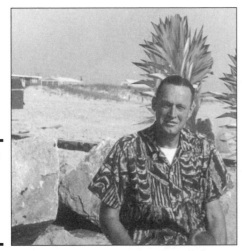

Figure 1-21: Shrubbery growing from his skull? You can fix it.

3. **Select the tree (or lamp, or whatever is in an inopportune spot), as shown in Figure 1-22.**

4. **Activate your image editor's Move tool and then click the selected object.**

5. **Drag the object to another spot.**

 A few inches away from the person's head usually does the trick. Figure 1-23 shows the shrub moved farther out of the photo so that it's just entering from the right.

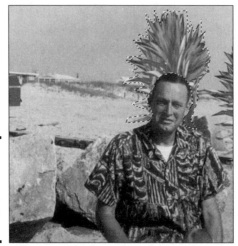

Figure 1-22: Select the unwanted object so that you can move it.

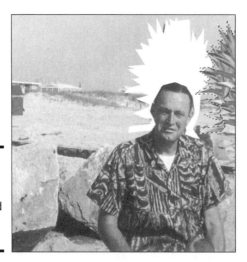

Figure 1-23: Here, the shrub has been moved to another location.

6. Deselect the moved object.

7. With one of the tools introduced earlier in this chapter for filling in content, fill in the hole that's left behind after moving the object, as shown in Figure 1-24.

The tree is moved, and the spot where it was has some kind of content in it, hopefully masking the original problem entirely. Perhaps the filling doesn't quite blend in with the surroundings because of a sharp or otherwise obvious edge to the filling, so a little recovery is needed.

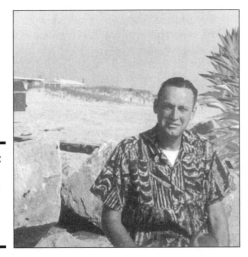

Figure 1-24: The Clone tool is used to fill in the empty space.

8. Use any of the following tools/techniques to put the finishing touches on your image:

- Use the Blur tool, set to a low strength, to soften any obvious edges on the filled-in content.

- Use the Smudge tool, also set to a low strength, to smear any hard edges between similar content.

- Use the Clone tool to apply additional content on top of the unwanted hard edge, and then blur or smudge again as needed.

9. When the image looks perfect, save it.

Consider saving it with a new name (using the Save As command so that you can rename it) to preserve the pre-tree-ectomy version for amusement or blackmail.

Combining Pictures

Throughout this chapter, most of what I discuss is repairing and improving individual photos, fixing spots, scratches, tears, replacing missing content, and moving stuff around to make things better. This isn't the end of even a low-end, image editing application's capabilities, however. You can do a lot with multiple images, combining them into a single image and using special effects for a really creative result.

When combining images, there really aren't any rules. You can combine black-and-white photos with color images, professional portraits or photographic artwork with amateur or family photos, pictures of people with pictures of places — anything that makes sense to you. You can create a collage, assembling parts of various photos into what's a composite image like the one shown in Figure 1-25, or you can mix content from two or more photos and retouch the combined result to make it look like the combined content had been together from the start.

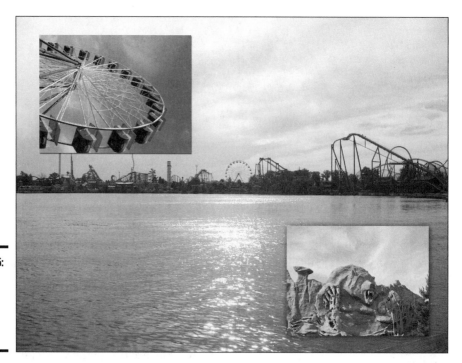

Figure 1-25:
You can
combine
several
photos
into one.

Is there anything along these lines that image editing software *can't* do? With the midrange to top-level packages, the limitations are fairly . . . limited. You might run into limitations in terms of special effects and retouching capabilities, which can hamper the success of the creative side of your combinations, but those would be software-specific limitations, such as not being able to adjust the opacity (see-through quality) of content within a photo, or not being able to place different parts of a composite image on separate layers.

Pasting content from other images

Whether you're using a Windows-based PC or a Mac, you have the ability to cut, copy, and paste content from one file to another, or to share and duplicate content within the same file. This capability makes it easy to take content from one photo and add it to another, either by removing it from its original location or making a copy that appears in both photos.

To copy content from one photo and paste it into another, follow these steps, which work in virtually any image editing package:

1. **Open both the *source image* (the one where the content you want currently resides) and the *target image* (the one that will receive the copied content).**

2. **In the source image, use a selection tool to select the content that you want to copy.**

 You can use either a freeform or geometric-shaped selection tool. Your choice depends on the shape of the object that you want to copy.

3. **Choose Edit➪Copy.**

 This places a duplicate of the selection in your computer's memory, where it will wait for you to paste it.

4. **Go to the target image and choose Edit➪Paste.**

 In Figure 1-26, a moon that was cut from an image is now pasted into a different photo.

5. **When the pasted content appears in the target image, activate the Move tool and then drag the content into the desired position within the photo.**

 Note that if you're using software that allows you to put different parts of an image on separate layers, the pasted content is probably on its own layer — a layer created automatically through the pasting process. You can leave the content on this separate layer or use your software's layer-handling commands to merge the paste layer with the rest of the photo. Of course, you'd do this only after your pasted content was placed in the desired spot, and you're sure you don't want to move it again.

REMEMBER

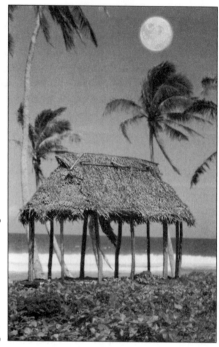

Figure 1-26:
This moon
has been
copied from
one photo
and pasted
into another.

You can activate the Copy and Paste commands with your keyboard as well as through the Edit menu. To copy, press Ctrl+C, and to paste, press Ctrl+V. If you're on a Mac, the shortcuts are ⌘+C and ⌘+V, respectively.

Using layers to create overlapping images

Assuming that your software does support layers, your pasted content will be on separate layers — one new layer per paste. This is good in that it makes it easy to move things around, repositioning pasted stuff so that it's in just the right spot. Separate layers also enable you to hide pasted content if you're not sure you really want to use it. Rather than deleting the pasted content (which you might regret if you change your mind), you can simply hide the layer that it's on, and then you won't see it until and unless you choose to display that layer again.

Keeping things on separate layers has another benefit. By having different elements of your image on individual layers, you can overlap the layers and rearrange the layers to restack the overlapping content. As shown in Figure 1-27, the same image was copied, overlapped, and stacked in several layers. Images can be restacked in as many configurations as you can imagine but only because each individual part has its own layer.

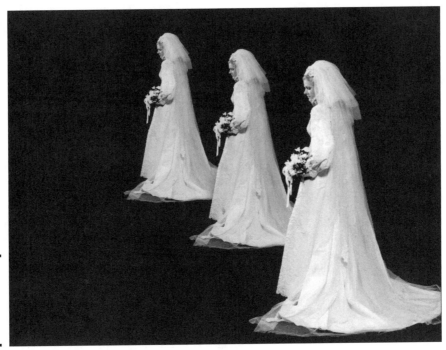

Figure 1-27:
You can stack layers to overlap content.

Hiding layers

After something is pasted into your image, the pasted content is on its own layer. If you no longer want to see that layer's content, just hide the layer by clicking the icon next to the layer number. The icon varies from image editor to image editor. In Paint Shop Pro, the icon is a pair of spectacles; in Photoshop Elements, the icon is an eyeball.

In any case, after it's hidden, the layer's content doesn't display onscreen nor will it print. If you want to bring it back, simply click the box where the eye icon was, and the icon reappears, as will the layer's content.

Rearranging layers to change object stacking order

If you want to change the stacking order of two or more overlapping elements in a photo, simply drag the layers up or down in the Layers palette. The topmost layers represent the content that's on the top of any overlapping stack, and the lower layers are underneath. Dragging a layer up moves it up in the stack, and dragging a layer down puts it beneath the other layers.

**Book IV
Chapter 1**

What You Can and Can't Do with Image Editing Tools

Deleting layers

If you just plain don't want a layer anymore and hiding isn't the answer, delete the layer. To do this, just drag the unwanted layer to the trash can icon, located at the bottom of the palette in some image editors (Photoshop CS) or at the top in others (Photoshop Elements and Paint Shop Pro, for example).

Adjusting opacity for interesting effects

When layers overlap, you can achieve very cool results by making one or more of the layers less opaque (more see-through) so that underlying layers can be seen. Reducing the opacity of the elements on top of a background makes it possible to see that background image and recognize its content. Or, you can use transparency to de-emphasize some parts of an image and emphasize others. The elements on top of the background remain visible, but their slightly see-through nature integrates them more fully with the image as a whole. Figure 1-28 shows a picture used in an eBay auction: Only the widget in the center is for sale. The semi-transparent objects at the left and right are shown to illustrate how the widget works.

Converts S-Video to RCA/Composite!

Connect to RCA cable.

Figure 1-28:
You can make some layers semi-transparent.

Plug into S-Video jack.

For applications that support layers, the opacity controls are found in the Layers palette, and you adjust the opacity of an entire layer, not just portions thereof. Some editing applications allow you to select content on a single layer and reduce or increase its opacity independently. Using the popular Photoshop Elements program as an example, follow these steps to adjust a layer's opacity, making the objects on underlying layers more visible:

1. **Open the image containing the layer that you want to adjust.**

2. **Access your image editor's Layers palette or dialog box.**

3. **Within the Layers palette, click the layer you want to make more or less opaque.**

4. **Choose your image editor's layer opacity control and use the slider to adjust the opacity level.**

 Opacity is set at 100% (not see-through at all) by default.

 As you adjust the opacity, the results appear immediately within your image. You can undo your result if you don't like it, or simply go back to the Layers palette and readjust.

An opacity of 0% renders the active layer completely invisible, and you can use this to your advantage, making a layer disappear, and then slowly increasing its opacity until you achieve the very level of visibility you want. You can also back down from 100%, but starting at 0% can make it much easier to find the right setting for a layer that you want to be very, very faint.

**Book IV
Chapter 1**

**What You Can and
Can't Do with Image
Editing Tools**

Chapter 2: Common Editing Options

In This Chapter

✔ Touring typical image editing tools

✔ Creating original content with painting tools

✔ Focusing your efforts with selection tools

✔ Smoothing the rough spots with blending tools

✔ Fixing photographic errors with correction tools

The main set of editing tools found in virtually all image-editing applications fall into four categories: painting, selecting, blending, and correction. There are no hard and fast rules, however, as to when to use these tools, and you'll find yourself using painting tools to make corrections, blending tools to create original painted effects, and any other variety of mixing and matching of tools and tasks that your editing jobs require.

This chapter provides an overview of the editing tools common to most image editing programs. I use Adobe Photoshop Elements and Jasc Paint Shop Pro as the primary examples, but most of these tools are available in other image editors, such as Microsoft Photo Editor, Adobe Photoshop, Corel PhotoPaint, and others. Whatever application you're using now or will use in the future, the basic concepts are the same for these four tool categories and the tasks you perform with them. So don't worry about not being able to apply instructions or examples from one application to another!

This chapter is intended to be an introduction to the tools that you'll find in virtually all image editors. I show you how to use some of these functions in more detail using Photoshop and Photoshop Elements in Book V.

Checking Out Your Editing Toolkit

As shown in Figures 2-1 and 2-2, your tools in both Photoshop Elements and Paint Shop Pro are very similar. You might even notice that some of the tools' buttons are nearly identical. These similarities exist for a very simple and logical reason: The things people need to do to photographs — reversing the signs of aging, wear and tear, and photographic errors; or applying aesthetic preferences — are universal. Nobody has thought of something that the

other guy hasn't added to his software. Other than some of the very low-end packages with extremely limited toolsets (such as Microsoft Photo Editor), a full set of tools for performing these tasks is found in pretty much the same arrangement, and the tools are used in pretty much the same way. So, the information you pick up in this chapter can be applied across the board. You can find a summary and comparison of the features in a broad selection of image editors in Book IV, Chapter 3.

Figure 2-1:
The tools in
Photoshop
Elements
3.0.

Figure 2-2:
The tools in
Paint Shop
Pro.

If you don't see your application's tool kit, you can usually redisplay it by choosing it by name from the Window menu. The preferences for how tools are used are normally found through the Edit menu, as shown in Figure 2-3, which shows the Photoshop Elements Edit menu and Preferences submenu. From this list, you can control just about every aspect of a tool's appearance and use as well as some general settings for the application as a whole.

As you take the time to visually check out your tools, you can identify them quickly by placing your cursor over a tool to display a *ToolTip,* which shows the names and sometimes the purpose of the individual tools. As you mouse over a tool, its name appears in a small box; the name that pops up in Figure 2-4 is Eraser Tool, which is a handy feature for removing portions of an image.

Figure 2-3:
You can set preferences for each tool.

Figure 2-4:
A ToolTip explains the tool's function.

TIP

Just a key or click away if you're a Windows user, Help can be found by pressing the F1 key at any time. Most applications support *context-sensitive help*, which means that if you're using a particular tool or have a particular dialog box open and press the F1 key, Help pertaining to that tool or dialog box appears when the Help window opens. The Mac OS also offers a Help menu, and the same Help articles appear when you search by topic.

Painting Tools

Spotting the painting and drawing tools in any image editing package isn't difficult. They look like paint brushes and pencils, and there are often airbrush and spray-can alternatives as well. When you use a painting tool, you can customize several options in just about any application. Although some applications definitely do offer more options than others, any program worth its salt lets you set the following paintbrush options:

✦ Brush size and type

✦ The shape of the brush bristles

✦ The strength of the flow of paint coming out of the brush

✦ The opacity of the paint applied by the brush

Figure 2-5 shows brush options in Photoshop, and Figure 2-6 shows the brush options that Paint Shop Pro offers.

Pencil tools offer many of the same options that you can find for a Paint Brush tool — size, shape, intensity, and color. The color setting is usually established in a color selector tool unrelated to the Paint Brush or Pencil, but the foreground color chosen is the color that the painting or drawing tool applies. I talk about setting your painting color later in this chapter.

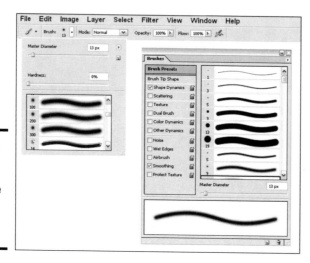

Figure 2-5:
You can choose a Brush style or type before painting.

Figure 2-6: Features such as setting the opacity of the paint offer extra flexibility.

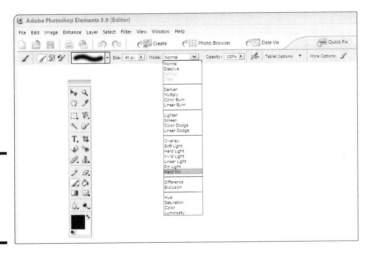

Customizing your Brush and Pencil tools

To customize your Brush or Pencil tool, you can use the options presented when the tool is activated. As shown in Figures 2-7 and 2-8, the options for painting and drawing are quite similar in Photoshop Elements and Paint Shop Pro, respectively.

Figure 2-7: Photoshop Elements' painting options.

To apply customizations to a tool, click the tool to activate it and then use the available drop lists, radio buttons, check boxes, sliders, and menus. Sometimes the options appear on a toolbar; other times, they appear in a palette. It all depends on the software you're using.

You can often save your settings for a particular tool. Figure 2-9, for example, shows a typical image editor's tool presets palette. You can set up groups of options for each tool and have more than one setting for a tool, which enables you to have different paintbrushes for different tasks.

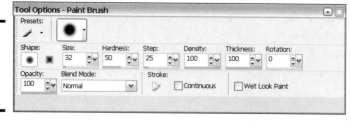

Figure 2-8:
Paint Shop
Pro's
painting
options.

Figure 2-9:
Many image
editors offer
reusable
tool
settings.

Choosing a paint color

Most applications offer a single color-selection tool that applies to any of
the tools that apply color to the image. For example, in Paint Shop Pro, the
color-selection tools are in a panel down the right side of the workspace.
Whatever color you choose for the foreground color applies to the Paint
Brush, Pencil, and the *Flood Fill tool* (which is just a tool for applying a solid
color to an area or closed shape).

Selecting foreground and background colors

Using Photoshop Elements and Paint Shop Pro as typical products, Figures
2-10 and 2-11 show the color-selection tools in both applications. Photoshop
Elements' Set Foreground Color button (or the Set Background Color button,
if that's what you want to do) spawns the Color Picker, which offers RGB
(red, green, and blue) and HSB (hue, saturation, and brightness) levels for
each color chosen. Just click the color you want. If you're working with a
Web-safe palette (a technique used in the olden days to work with only the

240 colors that could be displayed in all browsers before full color became the rule), the hexadecimal number for the selected color is displayed as well, or you can use that text box to choose a color by its number.

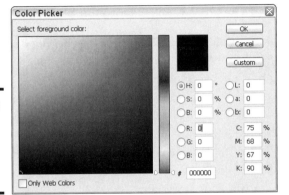

Figure 2-10:
Choose colors here in Photoshop Elements.

Figure 2-11:
Paint Shop Pro has a similar color chooser dialog box.

If you're using Paint Shop Pro, clicking the Foreground Color or Background Color button opens a Color dialog box (as shown in Figure 2-11), which offers pretty much the same set of color-selection tools.

Both color-selection dialog boxes offer similar tools for making your color selection. To choose a new foreground color, follow these steps:

1. **Open the Color or Color Picker dialog box by clicking the current foreground color button.**

2. **In the dialog box, click a color in the palette.**

 Alternatively, you can enter color levels if you know them. If you know the hexadecimal number for a Web-safe color, you can enter that as a way to choose the color, too.

3. **Make any adjustments to the color, choosing a lighter, brighter, or darker shade as needed.**

4. **Click OK to confirm your selection.**

After your color is set, you can use any painting, drawing, or filling tool available to you, and then that color is applied to the image.

Sampling colors from the image

If a color is already in your image (or anywhere on the workspace or your Windows or Mac desktop), you can *sample* it, which means sipping up the color with a sampling tool, such as the Eyedropper tool or variation found in all image editors. When you sip up a sample of the color, the color information is stored, and the color that you sampled becomes the new foreground color. Figure 2-12 shows sampling in progress.

Figure 2-12: You can sample existing colors to duplicate any particular hue.

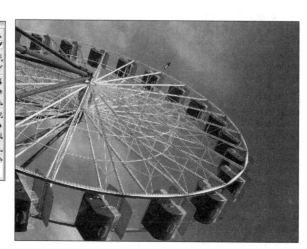

Sampling colors makes it easy to find compatible colors and to keep your colors consistent throughout a single image or in related images that need the look of a running theme. If, for example, you retouch a photo by adding brighter colors to clothes, cars, flowers, and other objects, you can sample those colors afterward, which will allow you to use those same shades in other places.

To sample a color, click the sampling tool, and your cursor changes to an eyedropper. Then click the image at the spot where the desired color is currently in use. Remember that you can also click title bars, buttons, backgrounds, or images on your desktop — anything that's visible while the sampling tool is active can be sampled and turned into a paintable color in your editing software.

Applying the paint

After you customize your painting tool by choosing the size, style, opacity, strength, and color for the brush, pencil, or other painting device, you're ready to get painting! The technique for painting doesn't vary much from application to application. With your mouse or other pointing device in hand, you're ready to go. Just click and drag, and watch the paint flow onto the image.

Painting and drawing freeform lines

When you're painting by hand and applying freeform lines, there are no real rules. You can set the line to just about any width, shape, style, and color you desire, which you see as you paint. If you set the line to a particular level of opacity, you see that, too. The only control that's not easily established is your mouse ability. If your hand is shaky, you're working too quickly, or you're not paying attention, you might not like your results.

Take your time, go slowly, and don't do the entire job in one stroke. Why? If you make a mistake at the very end, using Undo from the Edit menu will undo the entire job. Instead, paint in shorter strokes. You can see from the Undo History palette shown in Figure 2-13 (available in Adobe's image editors) that the Brush tool has been used several times in succession to form the apparently continuous line in the image. Every time you release the mouse button, you create an individual stroke even if the pause doesn't show on the line itself.

Filling a shape with the Brush tool

Remember coloring books? You scrubbed away with your crayons, filling in shapes, trying to stay within the lines. Or, if you were like me, you went outside the lines and created new shapes all together! In any case, you can use your editing software's painting tools to fill in shapes and areas simply by

applying paint the same way you'd apply crayon to a shape on a coloring book page. Figure 2-14 shows a shape being filled in with the Brush tool, set to a large size and a soft style so that no obvious scribbles are visible.

Figure 2-13:
Use the Undo History palette to track the steps you apply.

Figure 2-14:
You can fill a shape with color as easily as with a coloring book.

If you want a nice, uniform fill for a shape or an area, consider using the Fill tool that comes with your software. The *Fill tool* applies a solid color with no visible brush strokes. On the other hand, if you want a brushed look or want to vary the intensity by painting over certain spots more than others, you can use the Brush tool. Don't use the Pencil tool, though, or the result will look too "sketchy."

Painting and drawing straight lines

With all image editing packages, holding down a key (the Shift key in Photoshop Elements and Paint Shop Pro) while you use the Brush and the

Pencil tools constrains the drawing to a single direction. This trick is helpful when you need to draw straight lines.

To make use of this feature, follow these steps:

1. **Click the painting or drawing tool you'd like to use (Brush or Pencil) to activate it.**

2. **Click the image at the spot where the straight line should start.**

3. **Press and hold the Shift key.**

4. **Click where the line should end.**

A straight line connecting the beginning and ending points will be painted/drawn automatically, with the visual characteristics of the Brush or Pencil settings you established. Figure 2-15 shows a box that was painted with a textured Brush tool.

Figure 2-15: This box was painted with a textured brush.

Because the Pencil tool provides a sharp-edged, crisp line, it's a good tool to use if you need to create a very clean line or lines. It's also great if you need to draw very fine lines that measure as small as one pixel.

Using specialty painting tools

Specialty painting tools refer to any painting or drawing tools that aren't your basic Brush or Pencil. These tools often work like the basic ones, at least in terms of how you apply them. Just drag and/or click your mouse, and the paint is applied. The look achieved is where these tools deviate from the basic painting and drawing tools.

With some image editors, the specialty tools are actually variations on the basic tools. For example, in the Adobe products, you can turn on the Airbrush option when you're setting up the Brush tool to give the lines and strokes an airbrushed look. You can also turn on Wet Edges, which gives a watercolor look to whatever you draw. Figure 2-16 shows the dialog box from which you can choose brushes that have a Wet Edges look.

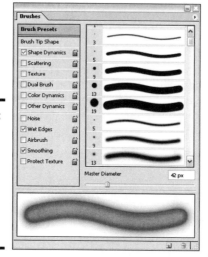

Figure 2-16: Your image editor's Color Balance dialog box helps rebalance colors.

Other products, such as Paint Shop Pro, have an actual Airbrush tool, separate from the Brush and the Pencil tools. The tool has its own settings for size and intensity of the lines drawn, as shown in Figure 2-17. When you paint with this tool, your results really look like paint that was sprayed on.

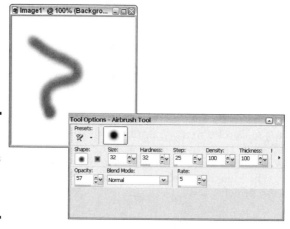

Figure 2-17: Paint Shop Pro includes a separate Airbrush tool.

Paint Shop Pro also has a Picture Tube tool that, by default, applies paint as though you're squeezing thick paint out of a tube. Its results are shown in Figure 2-18, where you can see the 3-D look of the lines drawn. Not all applications have a tool like this, but many do. In Photoshop or Photoshop Elements, you could apply drop shadow and beveling options to the lines after drawing them, ending up with a 3-D-looking result.

Figure 2-18: The Picture Tube lines look like you've squeezed thick paint out of a tube.

Another cool thing that the Picture Tube tool does is allow you to add pre-designed shapes, such as garden vegetables, blades of grass, musical notes, flowers, and stars. Figure 2-19 shows an assortment of lines drawn with the Picture Tube tool, and perhaps you can think of some ways to use them in your photos. For example, you could use the Garden Veggies option to paint a bowl of produce on a tabletop that was bare or had something unappealing on it to begin with.

Figure 2-19: You can get these lines with the Picture Tube tool.

To choose one of these picture options with Paint Shop Pro, follow these steps:

1. **Click the Picture Tube tool to activate it.**

2. **From the Tool Options palette, click the arrow next to the large picture box.**

An array of alternative pictures is displayed, as shown in Figure 2-20.

Figure 2-20: Choose the image you want to apply in a brush-like way from the list.

3. **Click the picture that you want to apply.**

4. **Go back to your image, and click and drag your mouse or other pointing device (or trackball or similar device) on the image to dispense the picture.**

You can use this technique an unlimited number of times.

By setting the size of the brush, you can control the size of the pictures you apply with the Picture Tube tool. For example, if you want tiny veggies or very short grass, you can use a small brush size to apply them.

If you're a Photoshop or Elements user and feeling dejected because this cool tool is not available in your application, take heart. You can apply leaves and grass with the Natural Brushes brush set, and you can download third-party brush sets off the Internet. Check out sites such as the National Association of Photoshop Professionals (www.photoshopuser.com) and follow links for all sorts of third-party add-ons that expand what Photoshop and Elements can do. You can also search the Internet using www.google.com for tons of brush sets that you can download for a reasonable price. Just enter **"Photoshop brushes"** in the search box (including the quote marks).

Using the Eraser as a painting tool

Taking away color can be as effective a drawing or painting technique as applying the color in the first place. As shown in Figure 2-21, erasing the content of one layer reveals what's underneath, creating very interesting visual effects. (To use this technique, you have to be working in an application that supports layers.) You could apply a layer of solid color on top of your photo layer, and then erase through the color layer to reveal certain parts of the photo.

You can also use the Eraser to reshape an area of solid color, whether that area was filled with color with a Brush or a Fill tool. Just as you would erase a drawing done on paper if you make a mistake, the Eraser tool can remove unwanted content in your image.

To use the Eraser tool to remove color, simply click the layer you want to erase, and begin dragging the eraser in a path that removes the content you want. You can "draw" with the eraser or simply scrub out areas of color. You can also reduce the opacity of the Eraser tool so that it removes only some of the color, leaving a see-through film behind.

Figure 2-21:
Erasing the content of one layer reveals the image underneath.

Selection Tools

For many edits, you need to focus the software's attention on a particular part of the image, thus controlling where and how the edits take effect. For example, if you want to increase or decrease the contrast in a certain area of the image and nowhere else, you want to select that area before invoking the contrast-adjustment tool so that you don't end up changing the contrast in an area that's fine as-is.

All image editing programs provide selection tools. Some provide more than others, and some provide more options for using them than others do. A variety of selection tools and options is one of the marks of a flexible and powerful application. All good image editors offer the following tools for selecting content. The names of the following tools might change from application to application, but the jobs these tools perform remain the same:

✦ **Marquee:** This type of selection tool allows you to select geometric shapes — rectangles, ovals, and in some cases, vertical rows or horizontal columns that are a single pixel wide.

✦ **Lasso:** This freeform selection tool often comes in three varieties:

 • A basic lasso

 • A magnetic lasso that adheres to certain colored pixels

 • A polygonal lasso that allows you to select areas with multiple straight-lined sides

✦ **Magic Wand:** This type of selection tool selects by color, based on a starting pixel or group of pixels. Need to make everything that's blue turn green? The Magic Wand is the selector tool for you.

✦ **Paintbrush or Mask Select:** Some applications offer a paintbrush-like tool that allows you to make a selection by painting. Others allow you to enter a Mask mode, where your standard Brush tool acts as a selector to create a mask of what you want to include in the selection, and when you switch back to the normal mode, your mask has turned to a selection. Alternatively, you can specify that what you don't paint turns into a selection instead.

Making geometric selections

Geometric selections — rectangular and oval-shaped regions — are good if you're preparing to make an adjustment or apply a fill to a large area and don't mind if the area doesn't follow the shapes within your image. As shown in Figure 2-22, you can select a square area and apply paint to it to create a frame around the central images in a figure.

Cathy006.psd @ 100% (Layer 1, RGB/8#)

Figure 2-22:
Paint around the edges of a selection to create a natural-looking frame.

Before shape tools were added to most image editing applications, using the Marquee selection tools was the only way to map out an area and fill it with color — creating solid-filled squares, rectangles, circles, and ovals. Most applications come with shape-drawing tools now, enabling you to draw just about any geometric shape or symbol (hearts, arrows, and so on) and then fill them with color. This strips the Marquee tool of one of its original jobs, but it remains an important weapon in your image editing arsenal.

Using the Marquee selection tools

To use the Marquee or geometric selection tools, simply click the tool and drag from the upper or lower corner of the desired selected area and diagonally away from that starting point. The farther away you drag, the bigger the selection becomes, as shown in Figure 2-23. Here, a rectangular area is being selected, and the distance and angle from the starting point dictates the selection's size and proportions.

Cathy006.psd @ 90.9% (Layer 1, RGB/8#)

Selecting perfect squares and circles

If you want to select a square or circle instead of a rectangle or oval (often called an *ellipse*), you can add keystrokes to the process. In most image editors, holding down the Shift key while you drag the Marquee or other geometric selection tool creates a perfect square — if you're using the Rectangular Marquee tool. If you're using the Elliptical Marquee, holding down the Shift key selects a perfect circle. Paint Shop Pro offers a set of selection options, as shown in Figure 2-24, in which the Freehand Selection tool is chosen. If you prefer a rectangular selection instead, you can use the drop-down list within the Tool palette to select a square or circle rather than a rectangle or an ellipse. You can also select rounded-corner rectangles in Photoshop, Elements, and Paint Shop Pro.

Changing and resizing selections

If you've already selected a geometric-shaped area on your image and realize you wanted a different area or a larger or smaller area, you can always deselect and start over. If the area you've selected is fine but you want to add to or take away from it, however, you needn't restart from scratch. You can

simply augment or reduce your selection by using keyboard shortcuts or tool options that are provided while the selection tool is active.

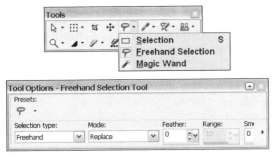

Figure 2-24:
Paint Shop
Pro includes
a variety of
selection
tools.

If you're using Paint Shop Pro or any of the other higher-end applications, you can use the Shift key to add to a selection or the Ctrl key (⌘ on a Mac) to reduce a selection. Make your selection first. Then hold down the Shift key or Ctrl key (⌘ on the Mac) and create an additional selection. The new selection will be added or subtracted from the first selection you made. You see a plus or minus sign appear with your selection cursor, respectively.

In most image editors, you can use four alternative selection modes from the Options bar. In Figures 2-25 through 2-28, I use the *Magic Wand tool,* which selects contiguous pixels based on their color to add or subtract from the main selection. I could have used one of the other selection tools instead, however. (Read more about the Magic Wand later in this chapter.)

+ **Selection:** Figure 2-25 shows a rectangular selection made out of the overlapping rectangle and circle. The dotted lines represent the limits of the selection.

Figure 2-25:
A standard
selection,
created
with the
rectangular
Marquee
tool.

**Book IV
Chapter 2**

Common Editing
Options

✦ **Subtract from Selection:** In Figure 2-26, I held down the Alt key (Option key on the Mac) and used the Magic Wand to click in the circle area, subtracting the circle from the selection and leaving a corner cut out of the rectangular selection.

✦ **Add to Selection:** In Figure 2-27, I went back to the original rectangular selection, and held down the Shift key while clicking in the circle with the Magic Wand. This added the circle's area to the selection.

✦ **Intersect with Selection:** In Figure 2-28, I used the Intersect option, which produces a selection that results in two selections overlapping — in this case, creating a quarter-circle.

Figure 2-26:
The area of the circle has been subtracted from the selection.

Figure 2-27:
The area of the circle has been added to the selection.

Figure 2-28:
This selection results from the area in which separate circle and rectangle selections overlap, using the Intersect option.

Want to make a selection that looks like a frame? Use your application's tool for reducing a selection to select a rectangle or square within a larger rectangle or square selection. The smaller selection cuts the center out of the first selection, leaving a frame-like selection that you can fill with a solid color or pattern. This can also be done with concentric circular or elliptical selections.

You can move your selection without moving the selected content within the image if you point to the very edge of the selection (the dashed line) and drag *after* drawing the selection. This allows you to reposition the selection before you fill it with paint, delete its contents, or apply a filter or special effect to the selected area.

Drawing freeform selections

The ability to draw the borders of a freeform selection is what really enables you to do fine editing in a photo. Without the freeform selection tools in your application, you can't select a person's face, a scratched area, a shadowy area that needs to be lightened, or any other nongeometric region within an image. Most applications offer alternatives for the Lasso or Freeform selector tools — the ability to have the selection follow along like-colored pixels or to draw a polygon (an irregular, straight-sided shape) with the selection tool. With these alternatives, there isn't anything too large, small, or oddly shaped to be selected.

Using the Lasso or Freehand selection tool

Using the Lasso (in Photoshop and Elements) or the Freehand selection tool (in Paint Shop Pro) is really easy if you follow these steps:

1. Click to activate the tool.

2. Move your mouse onto the image and find the spot where you'd like to begin your selection.

3. Click to begin the selection and then drag, drawing the shape selection you want.

4. Come back to the beginning of the selection. When you've met or passed the starting point, release the mouse button to complete the selection.

 If you release the mouse button anywhere else, the program will draw a straight line from that point to the original starting point, closing the selection.

Selecting polygonal areas

When you click the Lasso or Freehand selection tools, options become available. In Photoshop or Elements, the Options bar displays different Lasso modes, as shown in Figure 2-29. Similar options are available for the Freehand tool in Paint Shop Pro, through the Tool Options palette.

Figure 2-29:
The Lasso tool's Options bar in Photoshop Elements.

With the Polygonal Lasso (Photoshop Elements) or the Point-to-Point Freehand tool (Paint Shop Pro), you can make your selection by following these steps:

1. Click to activate the selection tool.

2. Use the tool's options to set it to Polygonal or Point-to-Point mode.

3. Click your starting point on the image.

4. Rather than dragging, move the mouse to the next point in your polygon — where you want to make a corner and start another side.

5. Continue clicking and moving, each time drawing a new side for your selection, until you come back to your starting point.

6. **When you're back to the beginning of the selection, click the starting point to close the shape.**

 If you can't find the exact pixel where your selection began, just double-click when you get close. The software closes the shape for you, forcing the endpoint to meet the starting point that you couldn't see or find manually.

Your freeform selections needn't be a single closed shape. You can draw figure 8's or any kind of freeform looped shape, using either the freehand or polygonal modes. Go crazy!

Using magnetic selection tools

Magnetic selection tools create a selection that "clings" to the outline of an object, according to pixel colors that define the object's edge, as you drag. These tools are very handy because they enable you to follow the edge of an object or objects, restricting your selection to very finite areas of the image. Nearly every editing package has a tool like this. In Photoshop and Elements, it's the Magnetic Lasso; in Paint Shop Pro, you select the Smart Edge option for the Freehand tool.

To use the magnetic selection tools, follow these steps:

1. **Click the Lasso or Freehand (or other similarly named tool in your application) to activate it.**

2. **From the tool's options, choose Magnetic (Photoshop or Elements) or Smart Edge (Paint Shop Pro).**

3. **Find the spot where you want to begin your selection; click there.**

4. **Continue making the selection by dragging along the edge of the object or area you want to select.**

 The tool adheres to the edges of that object or area, following the like-colored pixels, as shown in Figure 2-30.

5. **If you see an area coming up where the tool might fail because the pixels aren't diverse, click again to redirect the selection process, and then continue dragging.**

 You can click as often as you like along the way, controlling the direction that the selection takes.

 The same process in Paint Shop Pro uses the Smart Edge tool, from which a rectangle follows you as you drag. While you click to continue in a new direction, the previously dragged selection adheres to the shape.

6. **Come back to your starting point, and click (or double-click if you're not sure you're at the exact starting point) to end and close the selection.**

Figure 2-30: The Magnetic Lasso in Photoshop and Elements sticks to the edges of objects.

Selecting with the Quick Mask mode

Photoshop offers a Quick Mask mode, in which you can use the Brush and the Pencil tools (as well as the Fill tool) to paint a protective mask over parts of the image. This makes it as easy as painting to make a selection because when you return to standard working mode, the mask turns to a selection. Alternatively, everything *not* painted becomes a selection.

To work in and make a selection through Quick Mask mode, follow these steps:

1. **Click the Quick Mask Mode button in the bottom section of the Photoshop toolbox.**

2. **Click the Brush or the Pencil tool, adjusting its settings just as you would if you were painting or drawing color onto an image.**

 You want to increase or decrease the size to accommodate the level of detail that you want to achieve in your selection.

3. **Begin outlining the area you want to select, and note that a see-through red mask appears wherever you've painted, as shown in Figure 2-31.**

4. **After you outline the shape or area, use the Fill tool to fill in the shape that you want to turn into a selection.**

 This makes a solid mask that will translate into a selection of the entire area.

Figure 2-31: The selection you're painting appears as a semi-transparent red mask.

5. **When you finish masking the area you want, switch back to Standard mode.**

 When you're out of Quick Mask mode, your mask turned into a selection. You can now work with the selection as you would one that you created directly with any of the other selection tools or methods.

If you want to select everything but a particular object or area, first mask that area. Then when you get back into Standard mode, choose Select⇨ Inverse from the main menu.

Selecting with the Paintbrush Selection tool

Photoshop Elements has a Paintbrush Selection tool that you can use to paint a selection. The tool gives you the flexibility and familiarity of a Paint Brush tool and also allows you to select snaking paths or to select a freeform shape by filling in an area with the Brush tool.

Selecting pixels by color with the Magic Wand

The selections that you can make with the Magic Wand (or like-named tool) often resemble those you'd make with the Lasso or Freehand selection tools.

They're freeform shapes and — like selections made with the Add to Selection option turned on — they can encompass multiple noncontiguous areas. The difference between those selection tools and the Magic Wand, however, is that the Magic Wand makes selections based on an initial pixel sample. For example, this enables you to select all the blue areas, all the white areas, or all the areas that are the same as or quite close to any color or shade within your image. Figure 2-32 shows a selection made with the Magic Wand. In this case, this woman's entire blue dress is selected and can now be retouched as desired.

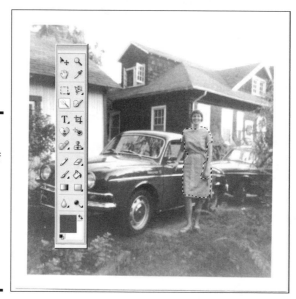

Figure 2-32: Select all the pixels of a particular color with the Magic Wand in Photoshop and Photoshop Elements.

Abracadabra! Using the Magic Wand

The Magic Wand selects pixels within your image based on a pixel you sample by clicking it. It's a simple process but one that you can master and use to your advantage if you know exactly how it works.

To use the Magic Wand tool, follow these simple steps:

1. **Click the Magic Wand tool to activate it.**

2. **Click a pixel that's the color of the pixels that you want to select in your image.**

Figure 2-33 shows the sampling in progress.

3. **If you don't get all the pixels you wanted, press and hold the Shift key while you continue to click pixels around in the image, adding to the Magic Wand selection.**

 Figure 2-34 shows a selection in progress as well as a noncontiguous area of similarly colored pixels being added to the existing selection.

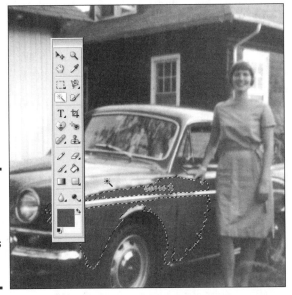

Figure 2-33: Click a pixel that's the same color as the pixels you want to select.

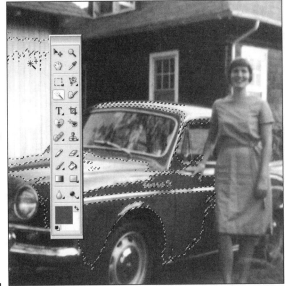

Figure 2-34: Add pixels to your selection by holding the Shift key and clicking in another area.

Book IV Chapter 2

Common Editing Options

If you get more pixels in the selection than you want, reduce your selection by switching to Subtract from Selection mode (Photoshop or Elements) or by using the Ctrl key (⌘ for Mac) to take away from the existing selection. When you click an unwanted area within the selection, those pixels are no longer selected.

If you didn't get as much of the image as you want, check the tool's options settings, such as Tolerance, to include more pixels. You can tweak the number of selected pixels by expanding the tolerance; or, press the Shift key and click in the additional area you hoped to select, in order to add to the selection.

Controlling the wand's magic

Any wand settings that you could possibly tweak are located on the tool's Options bar (in Photoshop and Elements) or in the palette or Tool options bar of other image editors. The settings work differently, depending on the application you're using.

In any case, you will see a Tolerance setting, which is a threshold for the sensitivity of the wand. The higher the number you set for the Tolerance setting, the more pixels that the software sees as selectable — a risky approach if you're working with a black-and-white photo or a color photo without a lot of color diversity throughout. You can make other application-specific adjustments that when used in conjunction with the Tolerance setting, can assure you of the exact selection you wanted. These adjustments include the following:

✦ **Match Mode** (Paint Shop Pro) allows you to choose what pixel attribute is compared to the surrounding pixels. You can choose from RGB Value, Hue, Brightness, All Opaque, or Opacity. If you choose RGB Value (the default), the surrounding pixels are compared in terms of their levels of red, green, and blue. And, if they're close enough to the sampled pixel (based on the Tolerance you set), they are selected.

✦ **Contiguous** (Photoshop/Elements) is a check box that allows you to choose whether the selection includes pixels that aren't touching the sampled pixel or any of the pixels that were selected on the first click with the wand. If you turn on the option (it's off by default), you get a smaller selection, which might be just what you want. If you turn it off, any pixels meeting your Tolerance setting are selected, no matter where in the image they're found.

✦ The **Use All Layers** option (Photoshop or Elements) allows you to select pixels on (who'd have guessed it) all the layers of the image. If you turn this on (it's off by default), you can select all the pixels that meet your tolerance requirements, no matter which layer they're on. If you want to restrict your edits to a particular layer, however, you'd want to make sure this option is off.

You might find it easier to set your Tolerance setting low so that you don't get more of a selection than you wanted and then use the Add to Selection option or use the Shift key to augment the selection by clicking again on a new spot, which resamples the image and compares surrounding pixels against a different sample pixel. Like most things in life, it's easier to start small and add what you need than to grab too much and then have to give some of it back or start all over again.

Blending Tools

Blending is another word for mixing — combining separate things to make a new thing. When it comes to photos that you're retouching or editing for content, blending is used to make new content seem as though it has always been in what's really a new environment. Blending is for retouching — applying strokes of paint that cover a stain or pasted areas that fill in a hole, disappear into the neighboring content.

Any good image editing application offers at least one or two blending tools, and again using Photoshop, Photoshop Elements, and Paint Shop Pro as examples, you'll find no lack of blending tools available, including

+ The Smudge tool (Photoshop/Elements)

+ The Blur tool (Photoshop/Elements and Paint Shop Pro)

+ The Scratch Remover tool (Paint Shop Pro)

You can use other tools to blend one thing into another, but they're not necessarily tools that are classified as blending tools, per se. For example, you can use the Clone Stamp tool to eliminate the signs of an obvious patch job, to add consistency to an area with spotty colors or textures, or to heal a damaged area that stands out like a sore thumb. Sometimes, the Clone Stamp's results need a little blending of their own, though, and that's when the actual blending tools come into play.

Smudging and smearing your colors

The *Smudge tool* smears color from one area of the image onto another area, much like how you blend dry pastels with your fingertip or how children apply paint to paper with their hands. You can use this tool to blend hard edges, to soften blemishes (when actually patching them would rob the image of too much texture), and to smear away small spots or scratches. You can use the tool in black-and-white or color images.

Using and controlling the Smudge tool

To use the Smudge tool, just click it to activate it and start smudging. The default settings are appropriate for most uses, but you can adjust them. The

most effective setting to adjust is Strength, which controls the degree of smearing that the Smudge tool achieves. A low strength creates very subtle results, and a high strength achieves dramatic results. A setting in the middle (50%) gives you an effective smudge without making a mess.

Other adjustments are available on the Mode drop-down menu, which allows you to control which aspect of the smudged pixels is affected by the smudging process. You can choose to Darken or Lighten the pixels or to affect their hue, saturation, color, or luminosity (brightness). Not sure which one to choose? Tinker a bit and undo your handiwork by pressing Ctrl+Z (⌘+Z) if you don't like the results.

Smearing with the Finger Painting option

The Finger Painting option (available with Photoshop and Photoshop Elements's Smudge tool) allows you to smear the current foreground color into the area you're smudging. You can use this option to incorporate new colors — or brighter, more vibrant versions of existing colors — by virtual finger-painting.

Don't forget the role that the brush size can play in the Smudge tool's effectiveness. Too big of a brush can smear more of the image than you wanted, whereas too small of a brush can result in obvious, sketchy-looking smudges. It's a real Goldilocks situation: You want the one that's just right, and sometimes only experimentation helps you find the right size.

Blurring the edges

The Blur tool found in most image editors works by eliminating a little — or a lot — of the contrast differences between adjacent pixels, thereby helping parts of your image to become blurred or out of focus. You control how much of an effect the tool has by adjusting its settings — Strength and Brush Size being the most dynamic. You also control where it works by where you place your mouse as you scrub over unwanted edges and distinctions. You can use it to draw attention to part of the photo by blurring nonessential content. Or, in the blending context, you can use it to make hard lines, pasted content, and other unwanted edges disappear. Figure 2-35 shows an image that's ripe for blurring; you can see the hard edges where the white flowers were pasted into the image. Figure 2-36 shows the blurred result. The hard edge is gone, and you can hardly tell that the new content was pasted into place.

How do you know when to blur and when to smudge, when to clone and when to paint? There are no hard and fast rules although I wish there were. We all spend time trying one technique and then undoing it in favor of another. A good guideline to keep in mind, though, is the old adage that *Less is more.* If you have a small problem (such as tiny scratches or minor stains or spots), a small solution is warranted, and that usually calls for a subtle tool. If you have

a large-scale problem — such as major amounts of unwanted content, big tears, or missing portions of the photo — a larger-scale solution is probably required.

Using the Scratch Remover

Paint Shop Pro offers a very cool tool — the Scratch Remover. Unlike Photoshop's multistep Healing Brush and Patch tools, this tool works quickly and easily:

1. **Click the Scratch Remover (shown in Figure 2-37) to activate it.**

 The Tool Options palette appears.

2. **Check the options palette for any adjustments you'd like to make to the size and shape of the Scratch Remover itself.**

3. **Go to the image and click and drag over the unwanted scratch.**

4. **When the remover's shape encompasses the scratch, release the mouse.**

 The scratch is gone, in favor of a seamless duplication of surrounding content in its place.

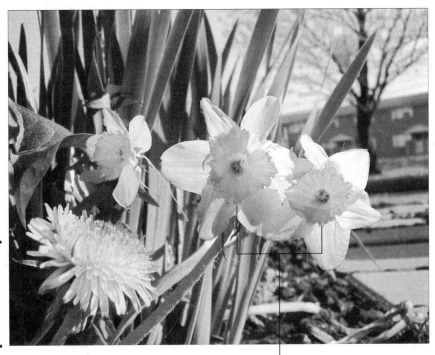

Figure 2-35: The edges around the pasted-in flowers are too harsh.

These flowers were pasted into the photo.

Figure 2-36:
The hard
edge is
gone after
blurring.

Figure 2-37:
Paint Shop
Pro's
Scratch
Remover
tool
removes
dust and
scratches.

You can also use the tool to get rid of unwanted small content, such as an unruly cowlick that's sticking up on someone's head, a blemish on a face, a stain on a tablecloth, or whatever tiny imperfections you'd like to be rid of.

TIP

Finding it hard to decide which application is best? Don't make a decision — use two or more applications, and work with them on a situational basis. I love Photoshop and Photoshop Elements and would consider either one a required program for anyone working with photos or just about any other types of images. However, I love Paint Shop Pro's Scratch Remover tool, using it instead of Photoshop's Healing Brush and Patch tools whenever I can. You

might find yourself in the same boat — torn between two applications — but you needn't choose, especially if you're shopping in the under-$100 range!

Correction Tools

The word *correction* implies the presence of a mistake — something to be fixed. Photos, both those taken professionally and those captured by total amateurs, can be rife with color, lighting, and exposure problems. Whether your image was printed and then scanned or taken with a digital camera, it can suffer damage from poor storage, low-end equipment, or even inadequate previous attempts to clean up things.

Whatever the source or cause of your photos' problems, you can find a comprehensive set of corrective tools in just about any image editing application. If you don't find them, move on and find an application that offers tools such as

✦ Color-correction tools that saturate and desaturate colors

✦ Brightness and contrast adjustment tools that add and remove light

✦ Red-eye removers

✦ General retouching tools that make quick, overall color, light, and exposure corrections in a single step

I admit that the number of corrective options can be confusing. However, like choosing the right blending or selection tool, choosing the right correction tool is done on a case-by-case basis. Don't underestimate the value of some reasoned trial-and-error editing!

Using the Sponge tool to add and remove color

Discussed briefly in Book IV, Chapter 1, the Sponge tool, found in both Photoshop and Photoshop Elements, adds color (in Saturate mode) or removes color (in Desaturate mode), depending on how you set up the tool. There's a Sponge version of Paint Shop Pro's Retouch tool, too.

To use the Sponge tool in Photoshop or Photoshop Elements, follow these steps:

1. **Click the tool to activate it.**

2. **Choose Saturate or Desaturate mode, using the tool's Options bar.**

3. **Adjust the Flow, which controls how much saturation or desaturation occurs.**

4. **Choose the right brush size for the area to be sponged.**

A small brush might give you undesirable results when used in a large area, and a big brush can go too far. Choose a brush that allows you to fix the problem area with the least amount of clicks or brush strokes.

5. **Apply the Sponge tool to the image, clicking and/or dragging to add or remove color where desired.**

Passing over the same spot more than once intensifies the sponge effect. You wash out or add more color on each successive pass where too much color has been sponged away.

Why would you want to take color away? Perhaps you added too much color in a previous editing session, and the edit can't be undone. Or maybe you simply want a more subtle, faded look to some of or your entire image. New photos are often faded for a more vintage look or in preparation for the use of an artistic filter that makes the photo look like a drawing or painting.

Adjusting lights and darks

Although there are dialog boxes galore that you can use to adjust the light levels in your photos, the tools on the toolbox/toolbar that allow you to paint light and shadows where they're needed are always a real timesaver. It's also much easier to control the amount of light or shadow you're applying and to control where you're applying it if you use a brush-based tool to apply it. You can set the brush to as large or small a size as you want, and you can zoom in and adjust single pixels or very small groups thereof, as needed. You can also apply light and shadow to very large areas; by going over the same spot more than once, you can easily intensify the effect.

Dodging to add light

Photoshop and Photoshop Elements offer a Dodge tool, described briefly in Book IV, Chapter 1, that allows you to add more light to any image simply by clicking and dragging the tool over the area needing more light, as shown in Figure 2-38. Many other image editing applications have the same tool. In the case of Paint Shop Pro, for example, applications offer a retouching tool that has dodging capability.

To use the Dodge tool, follow these steps:

1. **Click the tool to activate it.**

2. **Check the tool's Options bar and make any desired adjustments.**

Your options are

- **Size:** The size of the brush that you use to dodge the image. Use a size that won't show the individual strokes, but that's not so large that it dodges an area larger than you intended.

- **Range:** Choose which tones the dodge will affect in the image — the Highlights, Midtones, or Shadows.

- **Exposure:** This percentage is set to 50% by default and allows you to control the intensity of the dodge effect. Lower numbers result in a more subtle effect than higher numbers.

3. **Click and drag over the area to be dodged.**

 If you feel that you need to confine the Dodge effect to a very specific area, you can select that area first, using a freeform selection tool, such as the Brush selector or the Lasso. That way, you don't end up with obvious blocks or circles of lightened image content.

4. **You can go over areas more than once.**

 Each pass heightens the Dodge effect, so don't go overboard!

Figure 2-38: The Dodge tool is used to lighten areas, such as the shadows of the upside-down amusement park ride (left) that have been lightened (right.)

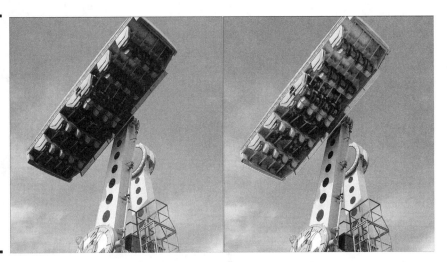

The term *dodge* is not specific to any software product; it is a photographic term for holding back the light that forms part of an image as a print is exposed onto photographic paper by an enlarger.

Burning to add depth and shadow

Burning is a photographic term, and its definition is the opposite of dodging. It involves adding extra exposure to part of an image while a print is exposed by an enlarger.

That sounds contradictory, doesn't it? Adding more exposure time darkens the image? Note that image forming light is held back — that's the key. The Burn tool reduces the amount of light, which deepens shadows and reduces

the detail-killing light that can wash out parts of your image. Figure 2-39 shows an image in dire need of the Burn tool — if only to even out the very stark effects of the sun on specific parts of the road image.

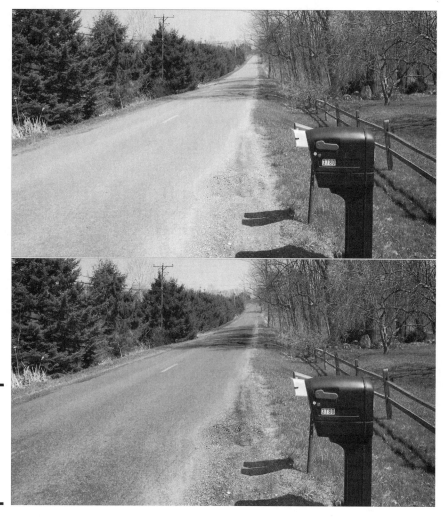

Figure 2-39: The Burn tool darkened the road in this country scene.

Using the Burn tool in most image editors is very much like using the Dodge tool. Even though their effects are opposite, their functioning is nearly identical:

1. **Click the tool to activate it.**

2. **Adjust any desired settings on the tool's Options bar, including Size, Range, and Exposure.**

These options have the same meanings as they do for the Dodge tool except that increasing exposure here increases the darkening effect. Your software might have different terms for these settings, but they do the same things. (I'm using Photoshop Elements here.)

3. **Click or drag over the area of the image to be darkened, being careful not to lose more detail by creating shadows that are too dark or too obvious.**

Living up to its name, overuse of the Burn tool can make your image look singed. If yours is a color photo or a black-and-white photo in RGB mode (where there is color information beyond simple shades of gray), the Burn tool can add a brownish tone, making the photo look as though it were exposed to high heat or flame. Unless you *want* your photo to look toasted, take it easy with the Burn tool.

Chapter 3: Choosing the Right Image Editor for You

In This Chapter

✔ Choosing an image editor that matches your needs and skills

✔ Comparing the capabilities of the popular image editors

✔ Using different image editors for different tasks

Deciding which image editor is right for you is not an easy task — at least not on the order of something simple, such as choosing what photo lab to send a traditional camera's film to. When you take a picture with a traditional film camera, you send the exposed film to a photographic lab for processing and printing. You can change your mind about which lab to use on a whim. In addition to performing the physical and chemical processes required to generate prints from the exposed film, the lab technicians routinely adjust exposure, color balance, and other details to improve the quality of your photographic prints.

With digital pictures, however, you can use an image editor to perform all the functions of a traditional photo lab, but you can't change editors with each roll of film. When you choose an image editor, you're making a long-term commitment unless you have the resources to buy and use multiple image editors. Book IV, Chapter 1 fills you in on the kinds of things that you can and can't do with image editing tools. Book IV, Chapter 2 describes some of the basic features common to all image editors. This chapter compares the features of some of the leading image editors and helps you decide which is best for you.

Looking at Popular Image Editors: The Basics

No one image editor is right for every digital photographer. Different image editing programs offer different feature sets and take different approaches to manipulating digital images. The trick is to find the program (or programs) with the features and approach that most closely match your needs and working style. Image editing programs range in capabilities from extremely limited to impressively powerful. And you probably won't be surprised at the similar range in price, from free or low-cost for programs with limited capabilities to several hundred dollars for high-end programs.

A simple image editor was probably included on the disc that came with your digital camera. Dozens of others are available on the shelves of local computer stores or as free downloads from the Internet. Like the one-hour photo lab, these programs are quick and easy to use for viewing your images and producing simple prints, but the capabilities are usually quite limited. Your search for an image editing program will undoubtedly extend beyond the simple, view-and-print utilities, as well as those already included in the Windows and Mac operating systems. However, wanting more capabilities than the low-end programs offer doesn't necessarily mean that you should go all the way to the other end of the spectrum. An assortment of midrange programs just might fit your needs very nicely.

The available image editing programs can be roughly grouped into four tiers:

✦ Adobe Photoshop stands alone at the top as the *de facto* standard for professional image editing. If you're working with images professionally, you need to own and use Photoshop. Although you might also find one of the other editors helpful for specialized tasks, Photoshop is your meal ticket.

✦ The second tier is composed of highly capable image editors. Although they might not match Photoshop's every feature, they have the power and versatility to meet the needs of many digital photographers. The image editors in this tier often feature wizards and dialog boxes to automate common tasks, but the main focus is on direct access to the image with a variety of manual selection, retouching, and painting tools.

✦ The third tier of image editors sacrifice some of the raw power and versatility of the first and second tier programs in favor of dramatically improved ease of use. Most common image editing tasks are automated or made more accessible through the use of wizards and dialog boxes that walk you through the steps required to complete the task. The programs in this group might also have the ability to access your image for direct manipulation with retouching and painting tools, but the manual editing features are somewhat limited. The main emphasis is on the program's automated editing tasks.

✦ The fourth tier is composed primarily of the simple, view-and-print utilities although some of the programs also have some limited image-editing capabilities. These programs often feature simple and attractive user interfaces with big graphical buttons for each task. They are very easy to use but offer only a very limited assortment of simple image editing options, such as cropping and overall color balance. Generally, these programs don't enable you to select and edit a portion of an image with manual retouching tools.

Because the purpose of this chapter is to give you a brief overview of some of the popular image editors and to assist you in identifying the program that might be right for you, I skip the bottom tier. These programs come and go

and don't usually have the level of support needed for serious image editing. The focus in this chapter is on the other (top) three levels.

Adobe Photoshop — Alone at the Top

Adobe Photoshop, as shown in Figure 3-1, is the big kahuna of image editing programs. Available for both Windows and Mac OS, it is the *de facto* industry standard by which all the other image editing programs are measured.

Figure 3-1: An image being edited in Photoshop CS.

Over the years, Photoshop has earned a place in nearly every digital imaging professional's toolbox. The latest version, Photoshop CS, only cemented that position. In fact, for many graphics professionals, Photoshop is their primary tool for everything from resampling image files and changing the file format, through photographic retouching and image enhancement, to creating original illustrations and artwork.

Photoshop is a professional-level tool, but you don't have to work at a major advertising agency, photography studio, or printing plant to use it. Even though buying a copy of Photoshop requires a significant investment of money and the time spent learning to use it, it's not beyond the reach of small businesses, serious digital photography hobbyists, artists, and others who need access

to its powerful tools and advanced features. You'll need a computer powerful enough to run it, of course. (Read through Book II, Chapter 2 for the scoop on computer requirements.) You can find attractive upgrade offers from time to time that let you purchase a full copy of Photoshop for a fraction of its regular list price. When you own Photoshop, additional upgrades (as Adobe releases new versions) are relatively economical.

What's good about Photoshop

Photoshop didn't attain its stature as the leading high-end, image editing program by accident. It has a well-deserved reputation for delivering a very complete feature set. In short, this is one powerful program. No matter what you want to do with an image, odds are that Photoshop contains the tools that enable you to do it.

Photoshop can read, write, and manipulate all the industry-standard file formats (such as TIFF and JPEG, which are the two that most digital photographers will use almost exclusively) as well as many not-so-standard formats. You can resample images to change the image size, resolution, and color depth. Photoshop excels at providing images that are optimized for specialized uses, such as commercial printing and Web graphics. Photoshop also enjoys close ties with several leading page-layout programs and Web-development programs (especially the other Adobe products, PageMaker, InDesign, and Go Live).

Photoshop provides a rich set of tools for everything from simple image manipulation (cropping and color balance adjustments, to name two) to selecting complex shapes from an image and applying sophisticated filters and effects to the selected area. Photoshop also includes a full set of painting tools that you can use to retouch your images or to create original artwork.

As if Photoshop's built-in features weren't complete enough, Adobe designed Photoshop to accept filters and other program extensions provided by third-party suppliers. As a result, a robust aftermarket has evolved to supply a wide assortment of plug-ins that make it quick and easy to apply all manner of textures, edge treatments, special effects, and other image manipulations to the images that you edit in Photoshop.

What's not so good about Photoshop

Photoshop is undeniably a powerful program, but you do pay a price for all that power: Photoshop is an expensive program. The price of admission for accessing Photoshop's power is a significant investment in money and learning time.

At a little over $600, Photoshop is expensive to purchase initially. (Upgrades won't cost you as much.) But the cost of the program doesn't stop there. If you're a serious Photoshop user, you probably want to add one or more

plug-in packages, which each cost as much as a typical midlevel image editor. And then there are the inevitable upgrade costs when Adobe releases the next version of Photoshop with all its cool new features. The upgrade price for a new version of Photoshop is more than the full purchase price of most other image editors, but the cost is still reasonable when you consider what you're getting.

In addition to its monetary cost, Photoshop is also expensive in terms of the time that you need to invest in order to use it. The demands of learning to use this program are probably the most significant barrier for the casual user. Photoshop's power and versatility make it a complex program, and that complexity creates a steep learning curve. Getting started working with the program right out of the box can be challenging. Even after you learn the ropes, performing some simple tasks can sometimes be cumbersome in Photoshop. The program's breadth and depth make it difficult to master. Often, even the graphics pros who use Photoshop on a daily basis haven't explored all its many capabilities.

Photoshop is an ongoing commitment, too. It's not the sort of program that you can use once a month and pick up where you left off. It works best when used on an everyday basis so that the commands and shortcuts become second nature. Attempt to use a special feature after not working with Photoshop for a month, and you'll probably find yourself diving into the (excellent) built-in Help system.

What you can do with Photoshop

What can you do with Photoshop? The short answer is, "Almost anything! (within reason!)"

In fact, it's difficult to come up with anything that you'd want to do to a digital image that can't be done in Photoshop unless it's outright impossible in the first place (such as transforming a total train wreck of a photo into a work of art). Oh sure, a few tasks are faster or easier to perform in some other programs. However, it's hard to find a visual effect that can't be duplicated in Photoshop if you're willing to invest the time and effort to get acquainted with the program's tools and to use those tools in innovative ways. Best of all, Photoshop has many features that are useful to those using digital cameras, including the ability to work with *RAW camera files* (the basic, unprocessed camera file with all the original information captured by the camera) for many popular models, facilities for matching colors between images taken under different lighting conditions, and a new feature for stitching panorama photos seamlessly. You'll find a description of Photoshop CS improvements in Book V, Chapter 1.

Here's just one very simple example of an image enhancement that you can create with Photoshop. Suppose you don't like the flat, uninteresting sky in the picture shown in Figure 3-2. No problem — you can quickly add some better clouds by following these steps:

1. **Click the Magic Wand tool and then adjust its settings.**

The Magic Wand tool is the second button down in the right column of the toolbox on the left side of the Photoshop window. You adjust the settings for the Magic Wand tool in the Options bar across the top of the Photoshop window. In this case, I used a tolerance setting of 50 and selected the Anti-Aliased and the Contiguous options. Those settings tell the Magic Wand to select only the pixels in the sky. (For more information on how the Magic Wand tool operates, see Book V, Chapter 2.)

2. **Click the sky with the Magic Wand tool.**

Photoshop selects the sky for editing and marks the selection by sur-rounding it with a "marching ants" marquee.

3. **Open a file with better clouds and select the clouds using the Marquee tool.**

4. **Copy the clouds by pressing Ctrl+C (or ⌘+C on a Mac) and then switch to the original castle image and press Shift+Ctrl/⌘+V) to paste the image into the selection.**

Figure 3-3 shows the finished image with clouds added to the sky.

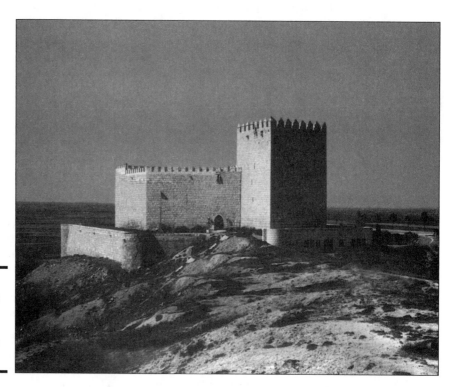

Figure 3-2:
This image needs a more interesting sky.

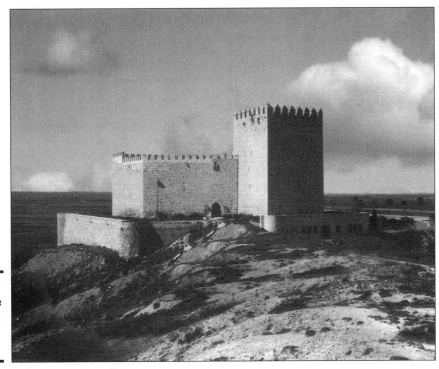

Figure 3-3:
Clouds have
been added
to the
image.

Where to get Photoshop

Photoshop CS costs about $600 and is available from most computer stores, catalogs, and online software outlets. For more details, or to purchase directly from the manufacturer, go to www.adobe.com.

Second-Tier Image Editors

The second-tier image editors are a diverse lot. They all have the ability to edit and manipulate digital images, and they emphasize direct access to the image over wizards and other automation for editing tasks. They are all less expensive than Photoshop. However, that's where the uniformity ends.

Some of the programs in this tier are niche products that excel at dealing with particular kinds of images, whereas others are general-purpose image editors with nearly as much versatility as Photoshop CS. Each of the programs in this tier has its own set of strengths and weaknesses. Depending on your specific needs, the program that is a perfect fit for you might be unsuitable for another digital image maker.

**Book IV
Chapter 3**

**Choosing the Right
Image Editor for You**

Adobe Photoshop Elements

Photoshop Elements 3.0, the little brother to the full Photoshop program, is available in similar (but not identical) versions for both Windows and Mac OS. Adobe created Photoshop Elements (often shortened to just *Elements*) as a more accessible version of Photoshop for the numerous people who want to use Photoshop but don't need some of its more advanced features.

Photoshop Elements, as shown in Figure 3-4, shares much of the same user interface with its big brother, Photoshop, although in a revamped form because Elements 3.0 was introduced after Photoshop CS. Compared with the full version of Photoshop, Elements has an abbreviated feature set, but it includes most of the basic image editing tools that the typical digital photographer needs on a regular basis. That includes image selection, retouching, and painting tools; a generous assortment of filters; and the ability to expand those filters by accepting the same Photoshop plug-ins as its sibling program.

What's good about Elements

Photoshop Elements is competitively priced at about $100. Elements is considerably less powerful than its big brother, Photoshop, but by sacrificing some of the immense power of Photoshop, Adobe created a program that is significantly less complex and is therefore simpler and easier to use than Photoshop.

Figure 3-4:
Photoshop
Elements 3.0
at work.

In general, Adobe did a pretty good job of selecting which Photoshop features to include in Elements. The program's feature set is a reasonably good match for the needs of the typical digital photographer. Most of Photoshop's standard selection, retouching, and painting tools are available in Elements. If your image editing needs revolve around retouching and manipulating individual pictures one at a time, you'll probably never notice the more advanced Photoshop features that are missing from Elements.

Rest assured, though, that Elements isn't just a cut-down version of Photoshop. The program includes a few interesting features that Photoshop lacks. For example, Elements features an un-Photoshop-like Palette bin (shown at the right in Figure 3-4) with quick access to features like How To, Styles and Effects, and Layers. You can also store palettes in more traditional Photoshop nested tab palettes, as shown in the lower right of the figure.

The automated commands on the Enhance menu make quick work of common image editing tasks, such as adjusting backlighting or color cast. As a result, an occasional user working with Elements can complete those tasks faster and more accurately than a seasoned graphics pro working with Photoshop. You can read about color casts in Book IV, Chapter 1.

Elements also makes a good set of training wheels for Photoshop. After you master this program, you can use Photoshop much more easily than if you started from scratch.

What's not so good about Elements

The similarity of the Elements *user interface* (the arrangement of menus and floating palettes superimposed on the workspace containing multiple document windows) is a boon to Photoshop users and wannabes who might need to switch back and forth between the two programs. However, the Photoshop interface isn't known for its ease of use. Many newcomers to the program don't find the menu arrangements and other details to be very intuitive.

What you can do with Elements

One very nice feature of Elements is the broad array of automatic fixer commands, which can adjust color, contrast, lighting, or even all of these at once via the Smart Fix feature. (Elements also has an Auto Smart Fix command that does all these things automatically.) Follow these steps to apply the Auto Contrast command to an image you're editing in Photoshop Elements:

1. **Open the file containing the image you want to edit.**

 The image opens in the Elements workspace and is shown in the Photo Bin at the bottom of the window, as shown in Figure 3-5.

Figure 3-5:
Photoshop
Elements 3.0
at work.

2. Choose Enhance➪Auto Contrast from the menu.

Elements examines your photo and applies the necessary contrast changes.

3. Save the enhanced file.

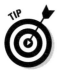

If your image looks muddy and unnatural after applying the Auto Contrast command, try applying the Enhance➪Auto Levels command to restore a more natural tonal range.

Where to get Elements

Photoshop Elements 3.0 costs about $100 and is available from most computer stores, catalogs, and online software outlets. For more details or to purchase directly from the manufacturer, go to www.adobe.com.

Corel PhotoPaint

Corel PhotoPaint is the image editing program that is included in the popular CorelDRAW Graphics suite. Various versions of this program are available for both PCs and the Mac.

PhotoPaint, as shown in Figure 3-6, is a reasonably full-featured photo retouching and image editing program. Although its feature set cannot match the full version of Photoshop, PhotoPaint stands solidly among a second tier of products that deliver a large portion of Photoshop's functionality for a relatively small portion of that program's price. PhotoPaint is far more powerful and versatile than programs that stress ease of use, such as Roxio PhotoSuite.

PhotoPaint offers a full set of selection, retouching, and painting tools for manual image manipulations and also includes convenient automated commands for a few common tasks, such as red-eye removal. PhotoPaint also accepts Photoshop plug-ins to expand its assortment of filters and special effects.

What's good about PhotoPaint

Corel PhotoPaint is a respectable product as a standalone image editor. However, its greatest strength is its integration with CorelDRAW and the rest of the Corel graphics suite. If you use CorelDRAW to create and edit graphics, you've probably got PhotoPaint installed on your computer, and you'll feel right at home using the product. All the menus, dialog boxes, and palettes behave just as you've learned to expect from your experience with DRAW.

Figure 3-6:
Corel
PhotoPaint
comes
with the
CorelDRAW
graphics
suite.

**Book IV
Chapter 3**

Choosing the Right
Image Editor for You

What's not so good about PhotoPaint

Perhaps the worst thing about PhotoPaint is that it's only available as part of the CorelDRAW graphics suite. At a $400 street price, the CorelDRAW graphics suite is a good value, provided that you need the main CorelDRAW program and any of the other components of the suite. However, $400 is a lot to pay for PhotoPaint alone, especially because other image editors in this tier are available for around $100.

What you can do with PhotoPaint

You can do many of the things possible with Photoshop except for complex color separation tasks. It's an all-around good editor for the average user.

Where to get PhotoPaint

To get PhotoPaint, you need to purchase the CorelDRAW graphics suite for about $400. The suite includes the CorelDRAW graphics program, PhotoPaint, R.A.V.E. (a Web animation program), TRACE (a bitmap-to-vector conversion utility), CAPTURE (a screen capture utility), and a large assortment of fonts and clip art. The CorelDRAW graphics suite is available from the usual list of computer software suppliers. For more details, or to purchase directly from the manufacturer, go to www.corel.com.

Jasc Paint Shop Pro

Jasc Paint Shop Pro, as shown in Figure 3-7, is one of the leading second-tier image editors. It's a general-purpose image editor for Windows only that has gained a reputation as the "poor man's Photoshop" for providing a substantial portion of Photoshop's capabilities at a fraction of the cost. The program lists for about $100, but you can often find it for sale at a substantial discount.

Paint Shop Pro features a fairly complete tool kit that includes selection, painting, and retouching tools for direct manipulation of your images. There's also a sizable collection of wizard-like commands that automate common tasks, such as removing red-eye and scratches. Paint Shop Pro includes a nice assortment of filters and effects, and you can expand that assortment by adding most any of the Photoshop plug-ins.

What's good about Paint Shop Pro

Paint Shop Pro has been around for a while, so the program has had time to evolve and mature. Over that time, it has developed a reasonably robust feature set and a refined user interface. Many people rate Paint Shop Pro as the easiest to use of the general-purpose image editors, and it's among the lowest priced programs in its class.

Paint Shop Pro supports layers, which enable you to achieve some fairly sophisticated editing effects. This is a surprising capability in such a low-cost image editor.

What's not so good about Paint Shop Pro

The breadth and depth of the Paint Shop Pro feature set is a little uneven. The program shows surprising depth in some areas (such as the availability of layers) and shallowness in others (such as the limited choice of selection and paint tools). Also, some tools (such as the Histogram Adjustment command) require more knowledge and experience to use effectively than do the corresponding tools in some of the other editors.

You need to evaluate the program carefully to determine whether its particular strengths and weaknesses are a good match for the mix of work you need to do. Fortunately, you can download a free trial version of Paint Shop Pro so that you can try the program before you buy it. Check out www.jasc.com for the try-out copy.

Figure 3-7:
Paint Shop Pro has many of the features found in Photoshop.

Book IV
Chapter 3

Choosing the Right
Image Editor for You

What you can do with Paint Shop Pro

Paint Shop Pro includes a large number of special effects filters. It also includes a useful little command that helps you select the filter you want to use. Here's how it works:

1. **Choose Effects➪Effect Browser from the main menu.**

The Effect Browser dialog box appears, as shown in Figure 3-8. The dialog box contains a list of effect filters on the left and a thumbnail (small) preview on the right.

Figure 3-8:
Paint Shop
Pro's Effect
Browser
gives you
fast access
to an
amazing
number of
effects.

2. **Click an item in the Effects list to preview the effect.**

When you click an item in the list, a Sample Preview thumbnail shows an approximation of how the effect will look on your image. Continue trying different effects until you find one you like.

3. **Click Apply.**

The Effect Browser dialog box disappears. This is the equivalent of choosing the corresponding effect from the Effects menu. If no settings are available for the selected effect, the effect is applied immediately. Otherwise, the effect's dialog box appears.

4. **Adjust the settings in the effect-specific dialog box as needed.**

Depending on the specific effect you selected, you might need to set options to control the intensity of the effect and other attributes.

5. Click Apply.

The dialog box disappears, and Paint Shop Pro applies the effect to your image.

Where to get Paint Shop Pro

Paint Shop Pro started life as a shareware program but has since expanded its market presence and gone mainstream. As a result, it now sports the slick packaging and complete documentation that most people expect from a commercial software product. You can buy the boxed version of Paint Shop Pro at all the usual computer software outlets. You can also order the product from the Jasc Web site at `www.jasc.com`. A time-limited free trial version is available for download at the site.

Macromedia Fireworks

Fireworks is the image editing program from Macromedia, the same folks who produce the market-leading Web development software (Dreamweaver) and Web animation software (Flash). Fireworks MX is available as either a separate, standalone program, or bundled with Dreamweaver, Flash, and Freehand (a drawing program) in the Studio MX package, and runs on both Windows and Mac machines.

Fireworks, as shown in Figure 3-9, has all the features it needs to handle most any routine image editing chore. The basic selection, retouching, painting, text, and drawing tools are all present and accounted for, and the program supports layers and Photoshop plug-ins to expand its basic filters. However, Fireworks doesn't try to be the most versatile general-purpose image editor on the market. Instead, the program excels in the more specialized job of preparing images for use on the Web.

What's good about Fireworks

Fireworks really shines at two kinds of Web-related activities:

✦ **Creating Web graphics, such as banners, image maps, and rollover buttons:** Fireworks provides an excellent set of tools for working with text and with shapes, and the program can automatically generate the HTML and JavaScript code needed for rollover effects and image maps.

✦ **Optimizing images for use on the Web:** The Preview tab of each document window in Fireworks allows you to instantly preview different image optimization settings while you edit your image. The Image Optimization dialog box pulls all the various file format, color depth, size, and resolution settings together into one place where you can experiment with various settings and observe their effect on file size and image quality.

Figure 3-9:
An image
being
edited in
Fireworks.

Fireworks is bound in a symbiotic relationship with Macromedia Dreamweaver. Although each product works independently, using them together can dramatically streamline the usual process of optimizing images for a Web page under development. For example, if you're building a Web page in Dreamweaver and need to optimize an image on that page, all it takes is a couple of mouse clicks to open the image in Fireworks' Image Optimizer dialog box. With a few more mouse clicks, you can optimize and save the image and then return to Dreamweaver, where the newly optimized image appears automatically on the Web page being edited. You have to see this feature in operation to appreciate just how slick it is and how much time it saves.

What's not so good about Fireworks

Fireworks' concentration on creating and optimizing images for the Web leaves it a bit weak in some other areas. For example, although the basic image editing tools are present in Fireworks, the selections of retouching and painting tools aren't as comprehensive as you might find in some of the other image editing programs.

The list of file formats available for import and export is also somewhat restricted. All the major file formats (such as TIFF, JPG, and GIF) are represented, as well as Fireworks' native PNG format and a number of others, but the list of supported file formats is less than half as long as its counterparts in some other image editors.

What you can do with Fireworks

One of the key features of Fireworks is its ability to optimize images for the Web. Here's an example of that feature at work:

***1.* Choose File➪Export Preview from the main menu.**

The Export Preview dialog box appears, as shown in Figure 3-10. On the right side of the dialog box is the preview pane that shows how your image will look when saved with the current settings. If necessary, adjust the zoom setting (the drop-down box showing a percentage at the bottom of the screen) to adjust the size of the preview image. Drag on the preview image to bring different portions of the image into view.

***2.* Adjust the settings in the Options tab.**

Select the file format, quality, smoothing, and other settings as needed. Depending on the file format that you choose, the other setting boxes change to reflect the options that are available for that file format.

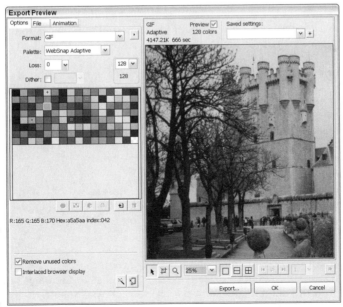

Figure 3-10:
Optimizing an image for the Web.

3. Experiment with different settings as needed.

Adjust the settings and note the effect on the preview image and on the file size and download speed display above the preview box. If necessary, adjust the image size settings on the File tab as well. Keep trying different settings on the Options tab until you achieve the smallest file size that still retains acceptable image quality.

4. Click the Export button.

The Export Preview dialog box disappears, and Fireworks exports your image to a file using the settings that you selected.

Where to get Fireworks

Fireworks MX is available from all the normal suppliers for less than $300. However, if you do enough Web development or graphics work to justify buying Dreamweaver, Flash, or Freehand in addition to Fireworks, it's hard to beat the Studio MX package, which includes all four products for a list price of $799. If you shop around, you can probably find Studio MX for less than $600. For details about Fireworks and the other Macromedia programs, go to www.macromedia.com. A time-limited trial version of Fireworks is available for download at the site so that you can try the program before you buy it.

Corel Painter

Painter, available for Windows and Mac computers, is a unique image-editing program from Corel. In fact, the term *image editor* is a bit of a misnomer for Painter. It's more of a program for creating original images than it is an editor for images from your digital camera.

Painter 8, as shown in Figure 3-11, specializes in re-creating in digital form a wide range of traditional artist media, such as charcoal, pastels, and various kinds of paint. Painter includes a basic assortment of tools that you can use to edit existing images, but the program is really designed for artists to use in creating original illustrations.

What's good about Painter

Painter's natural media effects are really impressive. Although other programs allow you to select different paintbrush tools and adjust their color, size, edge softness, and a few other attributes, Painter takes the concept of brush effects to a whole new level.

In Painter, you can define not only the characteristics of the brush but also the texture of the paper or canvas; the thickness of the paint on the brush; and how the paint, brush, and paper interact. As a result, the program can realistically simulate the very different effects of a watercolor wash on hot-press paper, oil on canvas, pastels on a sanded board, or any of a huge

assortment of other media/material combinations. Painter comes with a large inventory of predefined brushes and art materials that you can use or modify to suit your artistic impulse. With the right settings, you can even watch the digital paint drip and run.

Note: A pressure-sensitive graphics tablet and pen is an essential tool for using a program such as Painter. The pen gives you much better control of the cursor than a mouse, and the pressure-sensitive tip adds a new dimension to your digital brush strokes. A graphics tablet makes any image editor easier to use, and you can't use Painter effectively without one. Expect to pay $50–$150 and up for one of these.

What's not so good about Painter

Painter can be confusing and difficult to work with at first. It has a bewildering array of palettes filled with options that allow you to exercise precise control over each brush stroke. Just learning where everything is can be a challenge, and working your way through the various options each time you want to do something can be tedious. After you gain experience with the program, it becomes easier to use, but learning to use Painter effectively takes no small amount of time and commitment. This isn't a program that lends itself to occasional, casual use.

Figure 3-11:
An image
being edited
in Painter.

Painter's image editing capabilities are more attuned to the needs of an artist who wants to incorporate a portion of an existing image in a new composite composition — not so much for routine image enhancements and corrections. If you're looking for a digital darkroom where you can crop, color correct, and repair your digital photographs before printing, you need to look elsewhere.

Painter is second only to the full version of Photoshop as the most expensive product in this roundup of image editors. Its price tag (about $300) is not unreasonable if you really need its specialized natural media brush effects, but its high price puts Painter beyond the reach of most hobbyists equipping a typical digital darkroom.

What you can do with Painter

Painter is designed for digital artists to use when creating illustrations from scratch. However, you don't always have to start every image with a blank canvas. Painter can also apply its rich assortment of paper textures to an existing image. Here's how:

1. **Select the paper texture that you want to use by expanding the Papers menu in the Art Materials palette and then clicking a paper sample to select it.**

2. **Adjust the Scale, Contrast, and Brightness sliders as needed.**

3. **Choose Effects⇨Surface Control⇨Apply Surface Texture from the main menu.**

 The Apply Surface Texture dialog box appears, as shown in Figure 3-12.

4. **Adjust the settings in the dialog box as needed.**

 Drag the various sliders to change the settings. You can exercise precise control over the depth and character of the texture, how the light strikes and defines the texture, and how the texture is applied to the image. As you adjust the settings, the Preview box shows a sample of how the settings affect your image.

5. **Click OK.**

 The Apply Surface Texture dialog box disappears, and Painter displays a progress box as it applies the texture to your image. After a moment, your newly textured image appears.

Where to get Painter

Like most of the other programs in this roundup, Painter 8 is a commercial software product that is available through the normal purchasing channels.

It's a bit of a specialized product, so you might need to go to a larger software dealer or one that specializes in graphics products. The suggested retail price is close to $300. A time-limited free trial version of the program is available for download. For more information on Painter, including how to get the free trial download, visit `www.corel.com`.

Ulead PhotoImpact

Ulead PhotoImpact, as shown in Figure 3-13, is a general-purpose, Windows-only photo editing program with a particularly robust feature set. In fact, PhotoImpact is second only to Photoshop in the overall scope of its features.

In addition to the usual selection, cropping, and fill tools, PhotoImpact features a rich assortment of brushes for painting, retouching, and cloning. You'll also find tools for text and vector shapes as well as tools for creating slices and image maps for use on the Web. PhotoImpact supports layers and includes a generous collection of effects filters, which you can expand with Photoshop plug-ins. Auto-process commands are available to automate many of the most common image correction and enhancement tasks.

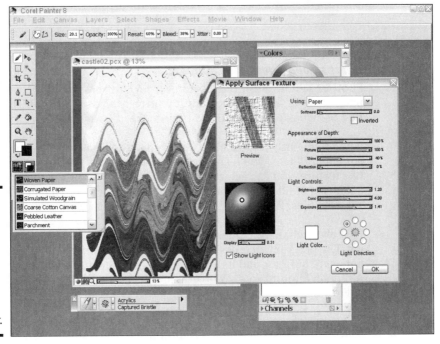

Figure 3-12: You can apply surface textures to your electronic canvases with Painter.

Book IV Chapter 3

Choosing the Right Image Editor for You

Figure 3-13:
Photo-
Impact is
almost as
versatile as
Photoshop,
for a lot less
money.

What's good about PhotoImpact

PhotoImpact is one of the most powerful and versatile of the second-tier
image editors, and yet it's modestly priced at less than $100. This combina-
tion of high capability and low price makes PhotoImpact an excellent value.

If you frequently find yourself performing the same image manipulations on
a number of files, you'll appreciate PhotoImpact's batch operations. With
this feature, you can select multiple image files and then apply any one of
a long list of filters, enhancements, or auto-process commands to all the
selected files. What a timesaver!

PhotoImpact also includes some specialized features for creating Web graph-
ics. The program includes wizards to help you create Web backgrounds, ban-
ners, and buttons, and its image optimization features are especially strong.
Although PhotoImpact's Web graphics features aren't quite as slick as those
in Fireworks, they're quite good.

What's not so good about PhotoImpact

PhotoImpact's user interface can be a bit quirky and inconsistent in places.
Some of PhotoImpact's features, although effective and very useful, feel like
they are the result of grafting separate modules onto the program instead of

seamlessly integrating the features into the program. Overall, the PhotoImpact user interface is not as polished as Photoshop, Fireworks, or PhotoPaint. To be fair, however, after you get past the program's quirks and idiosyncrasies, you'll find that PhotoImpact is a very capable, Windows-only image editor.

What you can do with PhotoImpact

PhotoImpact is a versatile image editor, capable of most any image manipulation you might want to do. It's hard to pick just one example to show here.

PhotoImpact comes with a generous assortment of effect filters. It's lots of fun to play around with the filters. Here's an example of a filter that gives an image the look of an oil painting:

1. **Choose Effect⟿Artistic⟿Oil Paint from the main menu.**

 The Oil Paint dialog box appears, as shown in Figure 3-14. The Dual View tab shows two thumbnails: your original image on the left and a preview of the effect on the right.

2. **Drag the sliders to adjust the Stroke Detail and Level.**

 Adjust the sliders as needed to achieve the desired effect. You can also use the spin boxes to the right of each slider if you want to make more precise adjustments.

3. **Click OK.**

 The Oil Paint dialog box disappears as PhotoImpact applies the effect to your image.

Figure 3-14:
The Oil Paint
dialog box.

Where to get PhotoImpact

PhotoImpact is available from many of the same software dealers that carry most of the other programs in this chapter. The suggested retail price is about $90. You can also order PhotoImpact direct from the Ulead Web site at www.ulead.com. The site also offers a time-limited free trial version that you can download.

Third-Tier Image Editors

The third-tier image editing programs specialize in making the most common image editing tasks fast and easy to do. Typically, it takes just a few mouse clicks to open an image, make a simple adjustment or two, and then print or save the picture. These are the programs to choose when fast and easy is more important to you than powerful and versatile.

If your image editing needs are very basic, you might use one of these programs as your main image editor. However, you're more likely to use these programs to complement a more powerful editor. They can make quick work of routine stuff that doesn't require the power of your other editor.

Microsoft image editing software

Microsoft's image editing software doesn't get the attention that the big-name Microsoft programs get. Despite the Microsoft name, these Windows-only programs aren't the dominant programs in its class. However, all are respected players in the field.

Picture It! is a simple program that makes it easy to access your images (whether they are in your camera or scanner, or stored on your hard drive) and then edit and print those images with a minimum of fuss. The image editing capabilities are limited when compared with first-tier and second-tier editors, but they cover the basics. You can do things such as cropping, rotating, adjusting brightness or color balance, and fixing red eye and scratches. Picture It! also includes a modest collection of effect filters and edge treatments that you can apply to your images. The program even includes some basic painting tools as well as tools for adding text and shapes to your images.

Microsoft's imaging software comes in several variations, ranging from the simplest and least expensive Picture It! Photo Premium ($49.95) to Digital Image Pro ($99.95) and Digital Image Suite ($129). The key differences between them is the number of artistic design templates and photos (1,500 templates and 2,400 photos, respectively, versus 3,000 templates and 5,000 photos in the two upper-end products.) The newest versions add more filters (200 instead of 10 for the low-end version) and retouching tools, including flash and backlight corrections; dodge and burn tools; and the ability to

adjust shadow, midtone, and highlight levels independently. Digital Image Pro/Suite also accepts Photoshop plug-ins for even more filter effects and has a total of 3,000 templates.

What's good about Microsoft image editors

Like most Microsoft products, Picture It! and Digital Image Pro/Suite have a slick-looking user interface that is well thought out and easy to use. Microsoft can afford to invest time and money in focus groups and usability testing — and it shows.

These editors also have the ability to select several image files and apply the same adjustment to all the selected files at once. This ability isn't unique to the Microsoft editors, but it's unusual in image editors at this level.

What's not so good about Microsoft image editors

The added features of the Digital Image Pro/Suite versions are an obvious attempt to give the program capabilities comparable with some of the second-tier image editors. In my opinion, the attempt falls short. However, you might find that Digital Image Pro/Suite gives you just enough capability to handle your occasional image editing tasks without needing a more advanced editor.

What you can do with Microsoft image editors

Programs in this tier excel at quick fixes. Here's an example of making a couple of quick adjustments to an image that is slightly off color in Picture It!:

1. **Click the Levels AutoFix button in the left toolbar.**

 Picture It! automatically adjusts brightness and contrast to achieve a full tonal range of blacks, whites, and all the tones in-between.

2. **Click the Adjust Tint button in the left toolbar.**

 Picture It! displays the Adjust Tint panel on the left side of the program window. Make sure the Whole Picture tab is selected.

3. **Click the Eyedropper icon and then click an area of the picture that should be white.**

 Picture It! automatically adjusts the color settings as needed to render the selected area as white. If the image still doesn't look right, you can try clicking another white spot or adjusting the Color and Amount sliders manually.

4. **Click the Done button at the bottom of the Adjust Tint panel.**

 The Adjust Tint panel disappears, and Picture It! returns to the normal display with the changes applied to your image.

Book IV
Chapter 3

Choosing the Right
Image Editor for You

Where to get Microsoft image editors

Microsoft Picture It! and Digital Image Pro/Suite are available in many retail software stores and online outlets. You can also order the program direct from Microsoft. For more information, go to www.microsoft.com/products/ imaging.

Roxio PhotoSuite

Roxio PhotoSuite, another Windows-only program, is perhaps the best known of the third-tier image editors. (**Note:** Roxio PhotoSuite was formerly known as MGI PhotoSuite.) It's inexpensive (less than $50) and easy to use. The program's opening screen is uncluttered and features big, graphical icons with lots of interactive feedback. This approach is a stark contrast to the multiple toolbars and floating panels that fight for the user's attention in most of the first-tier and second-tier image editors.

Despite PhotoSuite's apparent simplicity, it offers a reasonably good assortment of image editing tools for this level of image editor. You'll find basic versions of the standard selection, paint, clone, erase, and fill tools, plus an effect brush and tools for drawing simple shapes (but not text). And of course, you can crop and rotate the image, remove scratches and red-eye, and touch up the brightness and color balance, among other things.

PhotoSuite also includes tools to help you organize and distribute your pictures. You can gather a set of pictures together into an album and then share an individual picture or an entire album on the Web, show them as a slide show, or send them via e-mail. You can even install your pictures as wallpaper on your Windows desktop or display an album of pictures as a screen saver.

What's good about PhotoSuite

PhotoSuite's strength is its ease of use. The uncluttered user interface keeps the screen simple and clean. A permanent panel on the left side of the screen contains either buttons that enable you to select a procedure or detailed instructions that walk you through the procedure step-by-step.

The built-in projects make it easy to create greeting cards, calendars, report covers, and many other items that incorporate your pictures into the design. This is a nice bonus that enables you to use your pictures in fun and interesting ways without needing another program to do so.

What's not so good about PhotoSuite

The almost stark simplicity of the user interface means that most of the available tools and options are hidden from view at any given time. You often have to drill down through several layers of options to reach a specific tool

or apply an effect. The program's constant hand-holding is helpful for newcomers, but after you learn the ropes, you might find yourself getting impatient and wishing that you could jump straight to the desired effect with fewer intermediate prompts and clicks.

What you can do with PhotoSuite

Starting with one of PhotoSuite's project templates, you can create a pretend magazine cover containing a digital image from your collection. Just follow these steps:

1. **Open the image that you want to use for the cover and perform any needed enhancements and touchups.**

2. **Click the Compose button in the top toolbar.**

A dialog box appears so you can select a new project.

3. **Click the Fun Stuff button in the Create New Project panel and then click the Magazine Covers button.**

4. **Select a category from the drop-down list, click the cover template of your choice, and then click Next.**

PhotoSuite displays the magazine cover template, ready to receive your image.

5. **Drag the thumbnail for your image from the Library panel and drop it onto the template; then click Next.**

PhotoSuite inserts the image into the template and automatically sizes it to fit. If your image wasn't already available in the Library panel on the right side of the PhotoSuite window, you could have used the buttons in the Magazine Covers panel on the left to open an image from your computer, camera, or scanner.

6. **Adjust the size and position of the image in the template (if needed) and then click Finish.**

Your project is done and ready to print.

Where to get PhotoSuite

Roxio PhotoSuite is available from most software retailers. You can also order it from the Roxio Web site at www.roxio.com.

Apple iPhoto

Although it has very limited editing capabilities, Macintosh owners will want a copy of iPhoto, which is free, works smoothly and intuitively (if you're running Mac OS X), and does a lot more than just edit pictures. In fact, iPhoto's

strengths are in importing pictures from your digital cameras, organizing your photos into Photo Libraries, creating prints, and even sending pictures by e-mail.

You can touch up photos by rotating, cropping, removing red-eye, converting to black-and-white or sepia, and performing a few other fine-tuning steps. Apple finally added brightness and contrast controls to iPhoto, which had been lacking in earlier versions. Figure 3-15 shows an iPhoto album open and ready for use.

Figure 3-15: Import, sort, and make minor edits on your photos with iPhoto for Mac OS X.

Deciding Whether You Need More Than One Image Editor

Sometimes one is just not enough — image editor, that is.

Obviously, every image editing program doesn't have a feature set that is identical to every other image editor. Some editing tasks, such as cropping a picture, are common to all the editors, but many other features are available in some editors and not others. Not even Photoshop includes every available image editing feature.

If you evaluate your image editing needs thoroughly and inspect the features of the available editors carefully, you might be able to find one editor that has just the right mix of features to match your needs. If you're fortunate, you'll find an editor that has all the features you need, and whatever features are missing from that editor are in areas that you don't care about. It could happen (especially if your image editing needs are modest), but don't count on it.

A much more likely scenario is that you find one editor that fulfills most of your image editing needs. Then you need to find a second (or third) editor to handle the editing tasks that your main editor just can't manage.

You might also find that an image editor doesn't perform all editing tasks equally well. A specific editing task might be easier to perform in one editor but more cumbersome in another. If your main editor is a little awkward to use for some tasks that you do frequently, it might be worthwhile to keep another editor around that can handle those tasks with aplomb.

The following list summarizes some common situations in which multiple image editors are called for:

✦ **Artists:** Artists who use Painter for its ability to create images with natural media effects often use another image editor (usually Photoshop) to further manipulate those images and prepare them for publication and other uses.

✦ **Web developers:** Fireworks is a favorite of Web developers who build pages in Macromedia Dreamweaver MX because of the close interaction between those programs. Although Fireworks MX is great for optimizing Web images and creating Web graphics, those users frequently turn to another image editor to retouch photographic images.

✦ **Photoshop users:** Serious Photoshop users often keep one or more other image editors around to take advantage of a particular feature that is available only in the other editor. Basically, the other editor serves as an auxiliary utility program.

✦ **Digital photographers:** Many digital photographers have Photoshop or one of the higher-end, second-tier image editors for serious work but find it easier to use one of the simpler programs to access images from their camera and make quick adjustments and prints.

Instead of investing the big bucks in Photoshop, some digital photographers find that they can get all the features and capabilities they need with a combination of two or three other image editors.

Book V

Editing with Adobe Photoshop and Photoshop Elements

The 5th Wave By Rich Tennant

"Hey- let's put scanned photos of ourselves through a ripple filter and see if we can make ourselves look weird."

Contents at a Glance

Chapter 1: Latest Features of Photoshop Elements 3.0 and Photoshop CS

In This Chapter

✔ Photoshop and Photoshop Elements together

✔ New shared features

✔ New features in Elements 3.0

✔ New features in Photoshop CS

*W*hen I wrote the first edition of this book, the state of the art in high-end image editors was Adobe Photoshop 7. For powerful but easy-to-use, entry-level image editors, Photoshop Elements 2.0 was the way to go. Within 18 months, however, both were replaced with newer, better, and more powerful editions with lots of extra features and improvements. For this book's second edition, the amazing advancements in digital cameras in the past few months were only half the battle. I also had to take into account the changes made for Photoshop CS and Photoshop Elements 3.0.

Some of the changes and improvements were small, but some were fairly Earth-shaking. If you were familiar with either of these image editors before (or are still using the older versions), you'll want to review this chapter to see what's new and different. You just might glean enough to prompt an upgrade to the latest release — or, if you're already working with Photoshop CS and Elements 3.0, you might discover some changes you didn't even know about.

The Relationship between Photoshop and Photoshop Elements

As most Photoshopoholics know, Photoshop and Elements share many of the same underpinnings and programming code. Indeed, in some respects, Elements can be considered a version of Photoshop, with some capabilities missing or disabled. Their interfaces, dialog boxes, and many features are virtually the same. They use the same filters and also have tool palettes that are quite similar.

However, the differences are not quite simple enough to allow Elements to qualify as a "watered down" version of Photoshop. Development on each of these applications is ongoing and staggered, with releases scheduled at roughly 18-month intervals. Photoshop CS was introduced about 18 months after Photoshop 7, and Elements 2.0 came out just before Photoshop 7 and Elements 3.0 a little after Photoshop CS.

This staggered overlapping sometimes means that one program has a feature destined to appear in the next release of the other. For example, Elements 2.0 had a palette well that later appeared in Photoshop 7. When Photoshop CS was introduced, it had a nifty new Filter Gallery that Elements 2.0 lacked but which finally appeared in Elements 3.0. As a result, you can probably look at the latest features found in Elements 3.0, such as the docking tool palette, Photo Bin, or Photoshop Album integration (available only in the Windows version), and hazard a guess that these might be found in whatever replaces Photoshop CS.

The relationship between the two programs becomes even more complex when you consider that Photoshop includes some features that will *never* show up in Elements and vice versa. Users of Elements probably don't need the ability to work with 16-bit channels or CMYK (cyan/magenta/yellow/black) files, and Photoshop workers wouldn't deign to use some of the quickie fixes found in Elements — although the new Red Eye Removal tool would be appreciated *anywhere*.

You can expect Photoshop and Elements to continue to converge and diverge, as appropriate, with features crossing from one application to the other during their overlapping development cycles.

What's New in Photoshop CS and Elements

Photoshop CS and Photoshop Elements share some new features that weren't available in their predecessors. Here's a quick listing of the most important ones:

✦ **Filter Gallery:** Adobe has created a new multi-purpose dialog box — the Filter Gallery (as shown in Figure 1-1) — that presents thumbnail examples of some (but not all) of the available filters. You can preview each of these to see how they will affect your image; most importantly, you can stack them to combine several filters at once. You can even determine the order in which the filters will be applied.

I have two complaints about the Filter Gallery. First, it can be gosh-awful slow to load. If all you want to do is apply the Glowing Edges filter, it's frustrating to wait while your image editor (apparently) loads information about all the available filters. Second, the example effect thumbnails

use a generic image that tells you nothing about how the filter will look on your own image. You have to click the thumbnail to apply the effect to the big preview window. Of course, more realistic thumbnails would take even longer for the Filter Gallery to load, so we're probably better off with things the way that they are.

✦ **Camera RAW import:** A filter for importing digital camera RAW files was an extra cost option with Photoshop 7 but is now included for free with Photoshop cs and Elements 3.0. This import plug-in lets you open the unprocessed digital camera files that can be produced by many digicams these days. You can apply adjustments to white balance, sharpness, saturation, and many other parameters just as if you'd made the modification in your camera. The RAW import plug-in returns some important control to the digital photographer.

✦ **Photo Filter effect:** Both Photoshop and Elements gained the new Photo Filter effect, which makes it easy to simulate various warming and cooling filters, plus underwater filters, red, green, and blue filters, and other add-ons used with glass lenses on conventional and digital cameras.

✦ **Lens Blur filter:** The new Lens Blur filter produces more realistic blurring effects that can emulate the look you get with actual camera lenses.

✦ **Crop and Straighten feature:** Photoshop cs and Photoshop Elements 3.0 can automatically crop and straighten images, as shown in Figure 1-2.

Figure 1-1: Both Photoshop cs and Elements 3.0 include a new Filter Gallery.

Figure 1-2: Dragging a few handles in the Crop tool can automatically align and straighten images.

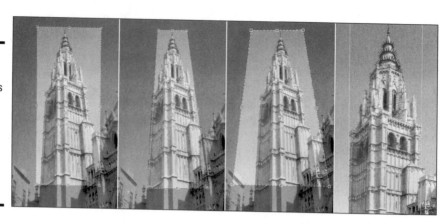

+ **Live Histogram palette:** Both editors now have a live Histogram palette (used to display and make tonal changes) that you can keep active on your workspace at all times so that you can constantly monitor any tonal changes you make in real time, as you make them. This might be an advanced feature for some Elements users, but you'll learn to live with it and love it.

What's New in Elements 3.0

Lots of things are new in Photoshop Elements 3.0 in addition to the Filter Gallery and RAW file support mentioned in the preceding section. Many of the changes involve little more than changing menu or tool locations. For example, the Adjustments submenu has been relocated from the Image menu to the Filter menu. And some menu entries have been renamed to make them easier to understand or to denote more explicitly exactly what they do. For example, Quick Fix has been renamed as Fix Image.

Elements' Tool palette has been made more Photoshop-like. The Clone Stamp, Crop tool, and Move tool have been relocated. The Blur, Sharpen, and Smudge tools, which formerly each had separate buttons on the Tool palette, have been combined on a single button. The same integration has been applied to the Burn, Dodge, and Sponge tools, too. Of the additional new capabilities, the most important include these:

+ **Cookie Cutter tool:** This new tool has capabilities similar to the Shape tool in Photoshop, allowing you to create shape outlines that can be enlarged or reduced in size. These outlines serve as clipping masks to include or exclude portions of your image, as shown in Figure 1-3.

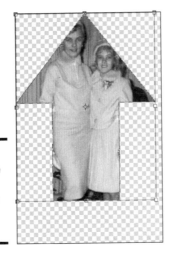

Figure 1-3:
The Cookie
Cutter tool
can create
clipping
shapes.

♦ **Healing Brush/Spot Healing Brush:** The Healing Brush first appeared in Photoshop 7 and has now migrated to Elements 3.0, along with a simpler version called the Spot Healing Brush. Both let you clone pixels over damaged areas of your image without completely overwriting the image area underneath. The healing takes into account the hue and brightness of the pixels being copied over when creating a smoother blend of replacement pixels.

♦ **Red Eye Removal tool:** Elements 2.0 had a Red Eye Brush, but this all-new tool is more automated and powerful. You can simply click in the red-eye that needs to be fixed or drag a selection around it. The tool then conducts a search-and-destroy mission looking for red pixels, changing them to a darker hue that you can control. Unfortunately, this new tool doesn't work with the yellow or green animal equivalent of human red-eye.

♦ **Docking Tool palette:** You can drag the Tool palette all over the screen in its two-column mode or drag it to the left side of the window and dock it as a one-column palette that stays out of your way.

♦ **Palette Bin:** The Palette Well of Elements 2.0 has been replaced by a Palette Bin at the right side of the screen. You can expand and collapse the palettes to view as many or as few as you want.

♦ **Photo Bin:** Thumbnail images of currently open files appear in the optional Photo Bin at the bottom of the screen. Instead of hunting around for minimized images with no clue as to which is which, you can see a thumbnail of the one you want and activate it with a click.

✦ **Quick Fix/Standard Edit modes:** Tabs at the top of the Elements window let you switch quickly between Quick Fix and Standard Edit modes, depending on whether you need only a few of Elements' tools for some rapid repairs or want access to all of them.

✦ **Photoshop Album integration (Windows only):** Elements 3.0 has an organizer function that uses Photoshop Album as its base. You'll find working with the organizer's catalogs a quick way to find and retrieve the photo you want from your growing collection.

✦ **Divide and conquer:** Elements can separate multiple pictures scanned in one step into individual files, automatically.

What's New in Photoshop CS

Photoshop CS boasts tons of new features, many of them of interest to digital photographers. The Camera RAW import mentioned earlier in this chapter is of primary interest to those of us who like to have maximum control over our digital pictures. Here's even more to be happy about:

✦ **File Browser:** The photo browser feature makes it easier to search for pictures by keywords that you assign, and integrate more closely with other Adobe Creative Suite applications, such as Illustrator CS and InDesign CS.

✦ **Web Photo Galleries:** Photoshop CS includes templates for creating your own Web photo galleries without the need to learn HTML.

✦ **Match Colors:** This feature is great for when you have several photos taken in one session and you'd like to make sure the colors match between them. This capability lets you match colors even if the pictures were taken under different lighting.

✦ **16-Bit Channels:** Although your 24-bit images have red, green, and blue channels of 8 bits each, many scanners and digital cameras can create files with 12-bit or 16-bit color channels. Photoshop CS lets you work with the longer dynamic range of those files for many functions.

✦ **Automated panoramas:** Photoshop CS has a new Photomerge facility that combines multiple images into seamless panoramas, complete with blending.

Chapter 2: Making Selections

In This Chapter

✓ Making rectangular and elliptical selections

✓ Selecting single-pixel columns and rows

✓ Creating freeform selections

✓ Making polygonal selections

✓ Selecting image content based on colors in the image

A wag once noted that, "Time is what keeps everything from happening at once." In a similar vein, *selections* are what let you modify only part of an image, without danger of your changes slopping over into parts of a picture that you *don't* want to manipulate. Selections let you fine-tune your photos a little at a time, making it easier to get the effects that you want.

Creating selections of the parts of the image that you intend to modify is the key to successful image manipulation. Indeed, the first step in many editing procedures is to focus the software's attention on the stuff you want to edit — an area that needs to be lighter, darker, a different color, or removed altogether. For this purpose, Photoshop and Photoshop Elements both offer a series of specialized tools that allow you to select geometric shapes, rows and columns of pixels, freeform shapes, and polygons. You can also find tools for making selections based on colors and pixel comparisons. The selection tool that you choose is based on the kind of area you want to select and the nature of the image itself because each method has its own advantages and disadvantages. There are no hard and fast rules for when to use a particular tool over another; experience and experimentation show you which ones work best and in which situations to employ them.

Making Simple Selections with the Marquee Tools

Photoshop has four tools that all go by the moniker Marquee: the Rectangular Marquee tool (for rectangles and squares), the Elliptical Marquee tool (for ovals and circles), the Single Row Marquee tool (to choose only one line of pixels), and the Single Column Marquee tool (used to select a column that's one pixel wide).

The Marquee tools in Photoshop and Photoshop Elements are very simple to use. For example, you can drag the Rectangular or Elliptical Marquee tool to select a rectangle or oval. Hold down the Shift key to select perfect squares

and circles. Photoshop's Marquee tools are shown in Figure 2-1. You can select the Marquee tools by clicking them in the Tool palette, or by pressing Shift+M (Windows or Mac) and repeating until the Marquee tool that you want is highlighted in the Tool palette.

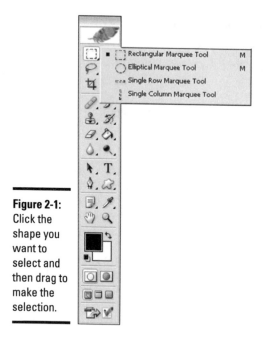

Figure 2-1: Click the shape you want to select and then drag to make the selection.

Photoshop Elements offers the same two basic shape selection tools — the Rectangular and Elliptical Marquees — but does not offer the Single Row or Single Column options. Figure 2-2 shows a rectangular selection in progress, using Photoshop Elements.

Selecting geometric shapes

When you're ready to make your geometric selection, the procedure is quite simple. It requires only that you identify the layer that contains the area you want to edit and that you select that layer first. Then, you're ready to make the selection, following these steps:

1. **Click the Marquee selection tool in the Tool palette and choose the shape (Rectangular or Oval) that you want to use.**

2. **Move your mouse onto the image and click where you want the selection to begin.**

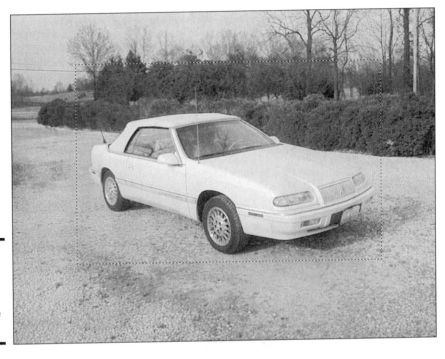

Figure 2-2:
Click and
drag
diagonally
to make the
selection.

3. **Drag away from the starting point, and set the size and proportions of your selection by controlling the distance from and angle at which you drag the mouse.**

4. **If you want a perfect square or circle, press and hold the Shift key (Windows and Mac) while you drag; release the mouse and then the key when the selection is complete.**

When using the Shift key to make a perfectly square or circular selection (equal in width and height), be sure to release the mouse before releasing the Shift key when your selection is complete. If you release the key first, the selection will snap to the size and shape it would have been had you not used the Shift key at all.

Both the Rectangular and Elliptical Marquee tools allow you to choose from different Style settings. Your choices are Normal, Fixed Aspect Ratio (Constrained Aspect Ratio on the Mac), and Fixed Size. If you choose either of the latter two, additional options appear on the tool's options bar, through which you can enter the ratio or dimensions, respectively. If you're using Normal, these options are dimmed.

Selecting single-pixel rows and columns

Photoshop's Single Row Marquee and Single Column Marquee tools allow you to select a row or column that's one pixel wide simply by clicking the image to make the selection.

After you make the selection, you can delete it, paint it, fill it, cut, or copy the selection. You can use these Marquee tools to draw grids on the image, as shown in Figure 2-3, by filling selections with a solid color. These tools are also useful for creating a perfectly straight line anywhere on the image, going either up and down or left to right. If you want a soft edge to the selection, you can use the Options bar to set a Feather (fading) amount in excess of the default 0 pixels.

Figure 2-3:
Many applications operate almost identically in Mac and PC versions.

Adding to, reducing, and combining selections

The Marquee tools' Options bar (Photoshop Elements' version is shown in Figure 2-4) offers four icons that you can click to customize your selections. You can find these same tools, with the same power, in the Options bars for the Lasso and the Magic Wand tools, as well. The buttons are descriptively named, and it's quite clear what they do:

+ **New Selection:** Creates an entirely new selection

+ **Add to Selection:** Adds more area to an existing selection

+ **Subtract from Selection:** Removes part of a selection

+ **Intersect with Selection:** Creates a selection from only the overlapping area of two selections

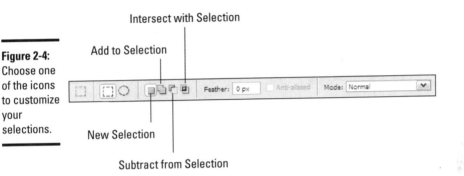

Figure 2-4:
Choose one
of the icons
to customize
your
selections.

Intersect with Selection

Add to Selection

New Selection

Subtract from Selection

Each button represents a selection mode and controls whether you can add to, take away from, or create a new selection based on the overlapping areas within two concurrent selections. If you're in New Selection mode, each time you click and drag the mouse, a new Marquee selection is created, replacing any other selections currently in place. If you switch to Add to Selection mode, you can select noncontiguous areas on the image, or you can make your current selection larger. Figure 2-5 shows both a set of noncontiguous selections (lower right), and a selection that was created by selecting two overlapping rectangles (upper left).

The Subtract from Selection mode enables you to cut away from an existing selection or to deselect noncontiguous parts of an initial selection. For Figure 2-6, I originally created a rectangular selection that went all around the tower; I tightened the selection by subtracting rectangular sections from the lower half of the original selection.

Using the Intersect with Selection mode allows you to create new selection shapes, such as the semicircular selection shown in Figure 2-7. This semicircle selection was formed from the overlapping areas of a circle and a rectangle. You can also move from one mode to another when you build or tear down selections.

Selection created from overlapping selections

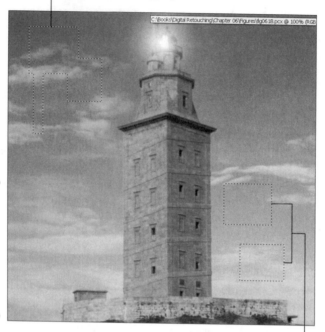

Figure 2-5:
Use Add to
Selection
to create
multiple
selections,
or to extend
a selection.

Two noncontiguous selections

Figure 2-6:
The original
selection
around the
tower was
trimmed by
subtracting
rectangular
sections
from it.

Figure 2-7:
The left and middle selections produce the selection shown on the right when intersected.

Snagging Irregular Shapes with the Lasso Tools

The Lasso tool, available in both Photoshop and Photoshop Elements, is a freehand selection tool. You can use the regular Lasso tool to draw freeform shapes that become selections, or use the Polygonal Lasso tool to select polygons by dragging around an object with straight lines. You can also select by drawing using the Magnetic Lasso tool. In this case, you guide the cursor around an object, and the software selects pixels by comparing them with adjoining pixels and then chooses the ones that are different on the basis of color and light. In all its incarnations, the Lasso is a pretty powerful selection tool — probably the one I use most when retouching photos. A Lasso tool selection is shown in Figure 2-8.

Figure 2-8:
The Lasso can select irregularly shaped objects.

Selecting freeform shapes

The main Lasso tool is extremely easy to use. Just click and drag, drawing a shape around the section of your image you want to select. It's just a matter of drawing a loop around the area to be selected.

The other important thing to remember is to *close* your selection by coming back to the starting point. This prevents the software from guessing how you'd like the shape to finish, which usually results in some of the intended selection (the tiger's head) being omitted, as shown in Figure 2-9. If you don't close the shape, Photoshop and Elements do it for you by connecting the start and end points with a straight line.

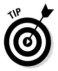

The Lasso Options bar offers a Feather setting, which allows you to add a number of fuzzy pixels to the selection's edges. This gives any fills applied to the selection a softer edge. Obviously, the higher the Feather setting you establish, the softer the edge. A higher Feather setting also extends your fill or other edits, such as filter effects, farther beyond the actual selection.

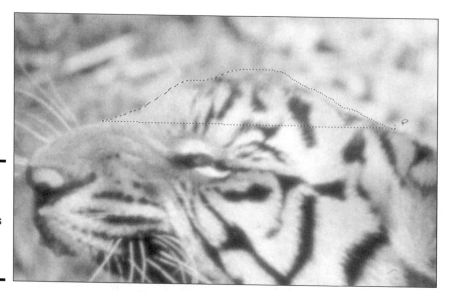

Figure 2-9:
Don't let
Photoshop
or Elements
close the
selection
for you.

A *polygon* is a multisided shape, such as a hexagon, an octagon, and any other three-or-more-sided shape. Triangles are polygons as are squares and rectangles. You have rectangles and squares covered by the Marquee tool, but what if you want to select a triangular shape, a shape that looks like a big sunburst, or perhaps an irregular non-geometric shape? You use the

Polygonal Lasso tool, as shown in Figure 2-10. From simple shapes to complex, many-sided stars, the Polygonal Lasso tool gives you freeform selections with the precision of straight sides and sharp corners.

The tool works easily enough, and you can make it select just about any size or shape on your image by following these steps:

1. **Make sure that the layer you want to edit is the active layer; use the Layers palette to make your choice.**

2. **Click the Polygonal Lasso tool in the Tool palette to activate it.**

3. **Click the point in your image where you want to begin making the selection.**

4. **Click the point where you want to create the first corner.**

 This creates the first side, and you can now draw the next side.

 Don't drag the mouse; just click where you want the corners to appear.

5. **Continue clicking until you've drawn all the sides that your selection needs.**

6. **Come back to the starting point, and click (double-click if you're using a Mac) to close the shape and create the selection.**

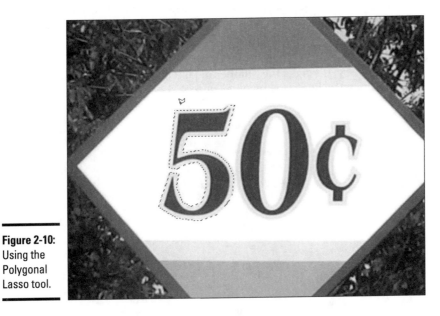

Figure 2-10:
Using the
Polygonal
Lasso tool.

You can make your sides as small as you want (just a few pixels in length) or as long as you want. You can select the edges of complex shapes by drawing many short sides. You might find this handy when there isn't enough color difference between pixels to use the Magnetic Lasso tool effectively.

Selecting magnetically

If you want to select a particular object and that object is a different color or shade than the objects touching it, use the Magnetic Lasso tool to select it. The Magnetic Lasso tool works by following the edges of content in your image, comparing pixels while you drag your mouse, and automatically snapping to the edges where pixel values vary enough, based on your settings for the tool's options. Use the Magnetic Lasso's Options bar to control the Magnetic Lasso tool's sensitivity, detail, and the number of pixels it's comparing while you move along your desired path. Pen Pressure (or Stylus Pressure in some versions of Photoshop) might be dimmed unless you are using an accessory drawing device.

Before using the Magnetic Lasso tool, you can adjust the following settings in the Options bar:

✦ **Width:** Sets how far from the mouse path (as you drag) the pixel comparisons will be made.

✦ **Edge Contrast:** Set the sensitivity anywhere from 1% to 100%. The higher the percentage you set, the higher the contrast must be between compared pixels before the Magnetic Lasso tool snaps to pixels to build the selection.

✦ **Frequency:** Changes the number of fastening points (or nodes) that you see along the line, as shown in Figure 2-11.

Figure 2-11:
The more fastening points you specify, the closer the selection will adhere to the object you're selecting.

To use the Magnetic Lasso tool, you follow a procedure that's similar to the one you use for the Lasso and the Polygonal Lasso tools, with minor variations:

1. **Make sure that the right layer is selected so that your changes made after making the selection apply to the right content.**

2. **Click the Magnetic Lasso tool in the Tool palette to select it.**

3. **Make any necessary changes to the tool's settings so that it will work to the best of its ability within the photo at hand.**

 You can adjust the width of the Magnetic Lasso tool's attraction, how many points it lays down, and the amount of contrast that must be present for the attraction to take hold. The default values work best in most situations.

4. **Click the image to begin your selection.**

5. **Move the cursor and click along the edge of the desired object.**

 A click redirects the line whenever it begins to veer off the path you'd like it to follow.

6. **When your moving and clicking takes you back to the starting point, click the starting point to finish the selection.**

Clicking to redirect the Magnetic Lasso's path is especially helpful if you get to a section of the photo where there isn't very much difference between the color and brightness of the pixels and the object you're trying to select. Sometimes, the Edge Contrast setting won't help you, and you have to redirect the selection yourself or use the other Lasso tools to augment or reduce the selection after using the Magnetic Lasso tool to make the main selection.

Has your Magnetic Lasso gone crazy, and you can't bring it back into line by clicking and moving? Press the Esc (Escape) key to abandon the current selection and start over.

The Magic Wand Tool's Digital Prestidigitation

The Magic Wand tool selects based on color. If you want to select all the flesh tones on a face or all the green leaves on a tree, you need only turn on this tool and click somewhere on the face or on a particular leaf, and the rest of the face or tree that matches the brightness level and color of that original pixel is selected. You can make adjustments to the way the tool works, increasing or decreasing the Tolerance level required for a match, which will

increase or decrease the number of pixels that are selected when you click the mouse on the image. The higher the Tolerance level you set, the wider the range of pixels included in the selection.

Making and adjusting selections based on color

You can augment your selection (without changing selection modes) by pressing and holding the Shift key while you click the image. For example, as shown in Figure 2-12, more of the picture is selected by clicking a slightly different shade of the color originally selected with the first click of the Magic Wand tool.

To reduce the amount of the image that's selected, press the Alt key (Option if you're on a Mac) and click an area that's selected. The pixels in that area are removed from the selection, and you can continue adding to the selection elsewhere or simply perform whatever edit you'd planned for the color-based selection.

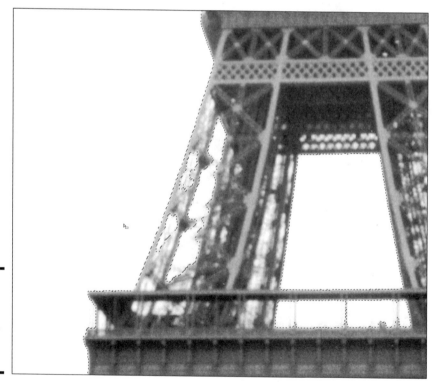

Figure 2-12:
Keep clicking to select more of the image.

Controlling the magic

To increase or decrease the threshold for the tool's selections, adjust the Tolerance setting on the Options bar (as shown in Figure 2-13). The higher the Tolerance you set, the more pixels that Photoshop or Photoshop Elements sees as a close match for the original pixel that you clicked. If you set the Tolerance to a very low number (15 or less), you'll find that very few pixels meet the selection criteria.

Figure 2-13:
Setting the
Tolerance
level.

Another setting that's useful for controlling the selection made by the Magic Wand tool is the Contiguous option. This option, when selected, limits the selection to those pixels touching the original pixel you clicked, and to the pixels touching those pixels, and so on. If you want to select pixels that aren't touching the original and the first batch that is selected, clear this option or use the Shift key and click elsewhere in the image.

Specialized Selection Tools

Both Photoshop and Photoshop Elements offer tools that go beyond the normal selection tools that you'd find in just about any image editing application. By giving you the ability to paint your selections with a familiar tool — the Brush tool — you can make very fine or very large selections quickly and easily.

In addition, both applications offer a Select menu, which you can use to control the existing selection, no matter which selection tool you used to make it.

Using the Selection Brush tool

Photoshop Elements offers a selector tool that's not found in Photoshop — and it's one that might make you choose Elements at times, even if you have Photoshop, too. The Selection Brush tool (see Figure 2-14, which shows the active tool and its Options bar) allows you to select a snaking, freeform line by dragging your mouse in any design you desire.

The Selection Brush tool

Figure 2-14:
Photoshop
Elements
has a
Selection
Brush tool.

You can set the size and style of the brush, and you can also set the brush to Selection or Mask mode:

✦ **Selection mode** simply creates a freeform, snaking selection that follows the path of your mouse while you drag. You can paint over and over in an area to select a shape rather than a snaking line, or you can use a very big brush to select a large area with a single stroke.

✦ **Mask mode** places a light red wash over the whole image except for the places where you dragged the Selection Brush tool. If you made no selection prior to entering Mask mode, your strokes with the Selection Brush tool create the masked areas. Masked areas are excluded from your selection. If you revert to Selection mode, your masked areas are not affected by any subsequent editing in the form of painting, filling, deletion, or use of the Edit, Copy or Edit, Cut commands.

Selecting in Quick Mask mode

Much like Element's Selection Brush in Mask mode, Photoshop allows you to place your image in Quick Mask mode and then use the Brush, Pencil, and Fill tools to make a selection, or to paint the area that you *don't* want selected (whichever is easier for you). To enter Quick Mask mode, click the Quick Mask button in the toolbox and then begin painting or drawing the outline of the area to be masked, as shown in Figure 2-15. If you want to fill a shape and make that a mask, use the Fill tool to mask the area inside the outline. If you want to paint the area that is not selected instead, double-click the Quick Mask icon on the Tool palette before entering Quick Mask mode and choose Color Indicates Mask Area (instead of Color Indicates Selected Area) in the dialog box that pops up.

When you return to Standard Editing mode, your mask becomes a selection that excludes the areas you painted, drew, and/or filled. If you want them to become the selected areas, choose Select➪Inverse from the main menu to invert the selected and masked areas.

Figure 2-15:
Quick Mask mode lets you paint selections.

Not sure when you'd use Quick Mask mode? Imagine a selection that's so small or fine that you can't make it with anything but the Brush or Pencil tool, set to 1 pixel. Or if you simply feel more comfortable with the painting and drawing tools, you might do better making your selection with familiar features.

Using the Select Menu

The Select menu is used to control and manipulate your existing selections, to create selections, and to deselect areas that are currently selected. As shown in Figure 2-16, which shows Photoshop Element's Select menu, many of the menu commands also have keyboard shortcuts.

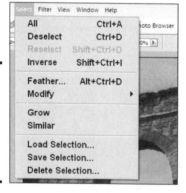

Figure 2-16:
The Select menu lets you modify, load, and save selections.

One of the most convenient commands on the Select menu is the Inverse command, which you can use to turn a mask into a selection, or a selection into a mask. If you selected an area with one of the selection tools, you can invert that selection so that everything but that area is selected and editable. Conversely, if you use Quick Mask mode (Photoshop) or the Selection Brush in Mask mode (Photoshop Elements) to make a mask, you can invert that mask so that the previously masked and uneditable area is now the selected, editable area.

Another very useful command on Photoshop's version of the Select menu is the Transform Selection command. With it, you can reshape an existing selection, as shown in Figure 2-17. Here, I start with an oval selection, created with the Elliptical Marquee tool, and I reshape the oval by dragging the box handles that appear on the perimeter of the selection when I issue the Transform Selection command.

While transforming your shape, you can rotate it (point to the corner handles; when your mouse turns to a bent arrow, drag clockwise or counter-clockwise), and then make the shape wider, narrower, taller, or shorter. You can also resize it from the corner handles to make it bigger or smaller while retaining the current width-height ratio. The Transform Selection command also invokes a new set of options on the Options bar. You can enter a degree of rotation, new width and height dimensions, and new position (X and Y) coordinates.

When you finish making your selection transformations, press Enter to formally apply them. If you want to skip the transformations in progress and return to the selection as it was, press the Esc (Escape) key.

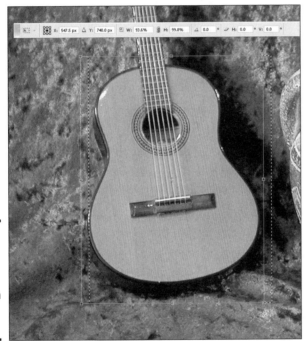

Figure 2-17:
Photoshop lets you transform selections in size, shape, or rotation.

Chapter 3: Brushing Away Problems with Digital Photos

In This Chapter

✔ Identifying Photoshop and Photoshop Elements' Painting and Drawing tools

✔ Mastering the use of brushes and pencils

✔ Customizing Brush and Pencil tools for specific jobs

✔ Finding third-party brush sets online

*O*bviously, Photoshop and Photoshop Elements' painting tools have many uses when it comes to creating original artwork. You can paint pictures from scratch, starting with a white or transparent background, and paint or draw anything from the realistic to the abstract. These original works of art can end up in print, on the Web, or both. Because this is a book about working with digital images, however, I focus on their use for retouching and editing photographs.

Photoshop and Photoshop Elements' Painting and Drawing Tools

The two applications' painting and drawing tools are basically the same, but you can find a few in Photoshop that you won't find in Elements and vice versa. Table 3-1 lists all the painting and drawing tools, identifying which of the two applications contains them.

Table 3-1	Painting Tools by Application
Tool	*Available In*
Brush tool	Both
Impressionist Brush tool	Photoshop Elements
History Brush tool	Photoshop
Art History Brush tool	Photoshop
Pencil tool	Both
Airbrush tool	A brush option in both applications

You can find more tools for customizing your brushes in Photoshop than in Elements, and more third-party brushes available online were created for Photoshop. You won't feel terribly limited or bored by Elements' brush customization tools, however, and the core settings for size, shape, color, and so on are in both applications.

This chapter concentrates on use of the Brush and the Pencil tools. The History Brush tool (which restores parts of an image from a saved version) and the Art History Brush tool (which does the same thing but adds a brush stroke effect) are beyond the scope of this book. You can find an entire chapter on using these two tools and related implements in the *Photoshop CS For Dummies All-in-One Desk Reference For Dummies,* by Barbara Obermeier (Wiley). You can find more on the Impressionist Brush tool (which paints using artsy brush strokes) in *Photoshop Elements For Dummies,* by Deke McClelland and Galen Folt (Wiley).

However, all the controls for setting the size, fuzziness, and other parameters of the Brush tool *do* apply to other brush-like tools, such as the Art History Brush tool, Blur/Sharpen tools, the Toning tools (Dodge/Burn/Sponge), and Clone Stamp. Thus, what you read in this chapter can be applied to those tools as well.

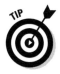

Some people consider the Smudge tool as a painting tool because it can be set to apply the foreground color if you put it in Finger Painting mode and also because it does manipulate colors how a brush or your fingertip would if you were working with real paints or pastels. On the other hand, it's more of a retouching and special effects tool. You can find more about it in Book V, Chapter 4.

Working with Brushes and Pencils

Photoshop's and Photoshop Elements' brushes and pencils are easy to use and customize and can apply a wide variety of colors, textures, and special effects. Painting and drawing with Photoshop or Elements mostly requires a steady hand and the proper view so that you're zoomed in close enough to see what you're doing if you're retouching a very small spot or rebuilding some details lost to damage or fading. Figure 3-1 shows an extremely magnified view of a portion of an image, with the Brush tool at work filling in some rough spots in an old photo.

You can also paint larger areas, filling in space lost to a tear or to add a colored frame around an image. You can even create new content: Just paint lines or shapes or simply apply a wash of color to a black-and-white or faded color photo for an interesting effect. Whatever your painting or drawing goal, these two applications offer the right tools for the job.

Figure 3-1:
You can
paint out
scratches,
stains, or
dust spots
if you zoom
in tight
enough.

Painting with the Brush tool

The Brush tool, found in both Photoshop and Photoshop Elements, can paint tiny dots, short strokes, or longer lines as small as a single pixel in width or as large as several hundred pixels. Using the tool is easy. Just click it on the Tool palette (or press *B* on the keyboard) to activate it, and drag or click (or both) on the image. You want to make sure that you're painting on the appropriate layer first, of course.

If you want to control how the brush applies paint, you can change the following settings before you even start painting:

✦ **Color:** The color or tone painted by the brush.

✦ **Size:** The size of the brush. Note that in Elements 3.0, you can set the size directly from a slider in the Options bar.

✦ **Mode:** How the pixels painted by the brush blend with existing pixels.

✦ **Opacity:** The transparency of the pixels.

✦ **Flow:** How quickly the pixels are applied while you stroke.

✦ **Airbrush:** Changes any brush tool to a fuzzy airbrush effect.

With the exception of color, you can adjust all these settings from each tool's Options bar, as shown in Figure 3-2. If you're using Photoshop, you can tinker with several more settings (and a few more for Elements users, too), but I get

to those in the upcoming section, "Customizing Your Brushes and Pencils." The settings listed here are those that you'd want to adjust whenever you're painting. More elaborate changes would be needed in fewer and more specific cases.

Figure 3-2:
The Brush Options bars for Elements 3.0 (top) and Photoshop cs (bottom).

One setting — Color — can't be set from the Options bar but can be set through the Color Picker. You can open the Color Picker by clicking the toolbar's Set Foreground Color button, shown at left in Figure 3-3. From within the Color Picker (shown at right in Figure 3-3), you can choose a color by eye, by setting color levels (move the sliders in the H, S, and B [Hue, Saturation, and Brightness] or the R, G, and B [Red, Green, Blue] boxes), or by entering a hexadecimal number in the # field to create colors in the language of your Web browser. Select the Only Web Colors check box if you want the Color Picker to show only the 240 colors considered completely Web-safe.

If you want to paint with a color currently in use elsewhere in the image or in another open image, click the toolbar's Eye Dropper tool, and sample (click) the color that you want to use. This makes that color the new foreground color.

Figure 3-3:
Click the Foreground Color button (bottom left) to access the Color Picker (right).

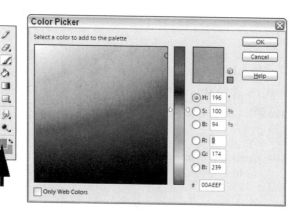

Working with the Pencil tool

The Pencil tool is also found in both applications and works much like the Brush tool. The only real difference is the nature of the line drawn. Just like you'd expect a paintbrush to apply a relatively soft line, you'd expect a pencil to draw a sharper line, depending on the hardness of the lead. The Pencil tool works just as you'd expect and also offers its own set of adjustments through the Options bar in Elements, as shown in Figure 3-4. (The Photoshop CS version is similar.) From the Options bar, you can control the Pencil's size and density so that you can make whatever large or small edits are required.

Figure 3-4:
The Pencil Options bar in Elements 3.0.

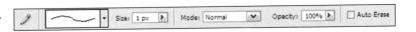

Use the Pencil tool's settings to control the size, mode, and opacity of the line you draw. You can also choose from a smaller set of styles, most of which are solid, fine lines. The Options bar also has an Auto Erase option, which allows you to draw the background color over any pixels currently colored in the foreground color as well as apply the foreground color only where no color is currently applied. Auto Erase is sort of a confusing name because no real erasing occurs — but you get the idea.

Customizing Your Brushes and Pencils

Beyond the basic adjustments that you can make with the Brush and the Pencil tools' Options bars, you can work with an additional set of options in Photoshop Elements (see Figure 3-5) or with a set of Brush Presets (shown in the Photoshop interface in Figure 3-6).

The Photoshop CS Brushes palette consists of 11 different options, each of which has its own dialog box. To view each of the 11 sets of options, make sure that Expanded View is selected in the Brush Palette's fly-out menu (that right-pointing triangle at the upper right of the palette). Selecting any of the 11 sets of options will then make that option's dialog box appear. Make the changes you want in each option's dialog box. You can activate or deactivate any particular option by marking the check box located to the left of the option name. Figure 3-7 shows the settings for the Texture option.

Figure 3-5:
Photoshop
Elements
offers some
extensive
brush
controls.

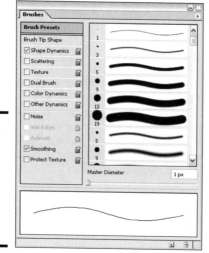

Figure 3-6:
Photoshop
has an
entire
palette
devoted
solely to
brushes.

Refer to the preview area at the foot of the Brushes palette to see how your new settings affect the brush size and shape that you select. The sample stroke provided shows you what effect the brush will have when you apply it to your photo.

If your Brushes palette is missing, simply choose Window➪Brushes from the main menu to bring it back. You can also place it on the docking well (next to the File Browser) or drag it to the workspace to move freely like the rest of the palettes. Your choice.

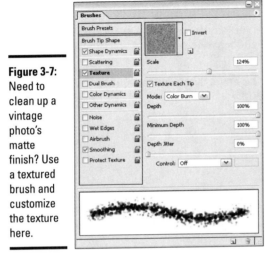

Figure 3-7:
Need to
clean up a
vintage
photo's
matte
finish? Use
a textured
brush and
customize
the texture
here.

Choosing the right size and shape

Whether you're working in Photoshop or Photoshop Elements, the success
of your brush and the direct effect of setting the right size and shape for it
are the same. Photoshop Elements offers a list of Brush Presets in the form
of a drop-down list, as shown in Figure 3-8, accompanied by a separate Size
setting and the More Options button.

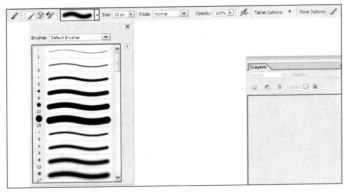

Figure 3-8:
Photoshop
Elements'
Brush
presets
provide an
extensive
set of styles
and shapes.

To change the shape of your brush in Photoshop Elements, follow these steps:

1. **Click the Brush tool on the Tool palette to activate it.**

2. **From the Options bar, set the style and size of the brush, using the
drop-down list and slider, respectively.**

3. **Click the brush next to More Options on the Options bar.**

4. **In the resulting dialog box, adjust the angle by entering a number or by dragging the arrow in a clockwise or counter-clockwise direction, as shown in Figure 3-9.**

You might find that a specific angle is more desirable for painting the kind of strokes you want, and you can use this setting to set that angle.

Figure 3-9:
Drag the brush schematic's arrow to change the angle of the brush tip.

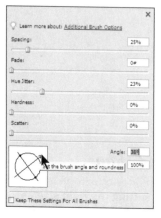

5. **Adjust the Roundness setting the same way — by entering a number or by dragging the big black dots closer to or farther away from the center of the sample brush shape, as shown in Figure 3-10.**

Dragging inward makes for a horizontally flatter brush; dragging outward makes the brush vertically flatter.

Figure 3-10:
Make your brush a soft, round fat brush, or a lean, mean flat brush.

6. **Tinker, as desired, with other sliders (Spacing, Jitter, Hardness), whose names are very self-explanatory.**

7. **Click your image to begin painting or click somewhere on the workspace to close the More Options box.**

If you're using Photoshop, you can change your brush shape by using the Brush Tip Shape option of the Brushes palette, as shown in Figure 3-11. The resulting settings look very much like Elements' settings. You can drag a brush tip schematic to change the angle and roundness of the tip, and you can also adjust the size (diameter) of the tip itself.

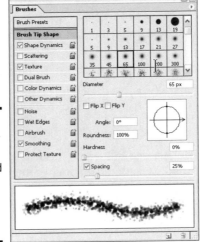

Figure 3-11:
Control your
Photoshop
cs brush and
its shape,
size, and
roundness
setting.

Here's a quick summary of all the customization changes you can make to Photoshop's brushes:

✦ **Brush Tip Shape:** Here you can select the size and shape of the brush tip, including its diameter, angle, roundness, hardness, and spacing.

✦ **Shape Dynamics:** Make your brush strokes appear to be more natural and less machine-like (especially if you're using a digital tablet) with these adjustments. They modify the degree of randomness or variation produced when a stroke is drawn, including the amount of fade, size, jitter angle, roundness, and other options. The higher the value, the greater the amount of variance produced for each option. Note that some of these options apply only when you are using a pressure-sensitive digital tablet.

✦ **Scattering:** Use this control to vary the amount and position of individual brush marks in a stroke. The higher the value, the larger the number of brush marks and the farther apart they are. When Both Axes is

selected, the brush marks are distributed radially as if on a curve. The Count controls the number of brush marks at each spacing point. The higher the value, the greater the number of marks.

✦ **Texture:** The Texture control lets you add a preset or custom pattern to a brush stroke.

- *Invert:* Mark the Invert check box to reverse the light and dark pixels in the pattern.

- *Scale:* The Scale control adjusts the size of the pattern in each stroke.

- *Texture Each Tip:* Texture Each Tip renders each tip as it is stroked, giving a more saturated effect.

- *Depth:* The Depth control sets how prominent the pattern appears against the brush stroke.

- *Minimum Depth:* Minimum Depth specifies the minimum depth that the paint of each stroke shows through the pattern.

- *Mode:* Mode lets you choose one of Photoshop's blending modes.

✦ **Dual Brush:** Yes! You can have a brush with two tips. The second tip can have attributes of its own, which you can set here. You can also specify a blending mode between the two tips so that the brush strokes merge together in a predetermined way.

✦ **Color Dynamics:** You can also create a multicolored brush with this control. It uses your foreground and background colors to generate variations that give the stroke a more natural, organic look. You can introduce jitter to the hue, saturation, brightness, and purity of the colors as well as some randomness between the foreground and background colors as a stroke is drawn.

✦ **Other Dynamics:** These controls add some natural-looking randomness to the opacity and flow factors of a brush, again making the brush stroke look more natural and less machine-like.

Here's are some tip characteristics that you can modify:

✦ **Noise:** This adds random pixels to your brush tips, giving them texture, which works especially well with feathered brushes that fade out at the edges.

✦ **Wet Edges:** This option creates a stroke that looks like a watercolor, with color that builds up along the edges.

✦ **Airbrush:** This option gives the brush tip a fuzzy, airbrushed look.

✦ **Smoothing:** Use this control to help smooth out curves when drawing arcs with the brush, which is especially helpful with a pressure-sensitive tablet.

✦ **Protect Texture:** If you want all your textured brush tips to use a uniform texture, apply this option.

Obtaining third-party brush sets

The brush sets that come with Photoshop and Photoshop Elements are fairly extensive (see Photoshop's in the Brush drop-down list options menu, as shown in Figure 3-12), but you might pine for more of them.

A quick online search will net you several sites where third-party brush sets are available, usually for a small charge. Some sites probably offer brushes for free, but these are not in abundance. One site to check out is www. graphicxtras.com/products/psbrush.htm. This particular site is chock-full of interesting new brushes, which you can order for about $30 (U.S.). The site charges in U.K. pounds, so the day's exchange rate dictates what you pay.

Figure 3-12:
Lots of
brushes
come with
Photoshop
cs, but you
might want
more, more,
more!

Chapter 4: Restoring Images

In This Chapter

- ✔ Shedding light and casting shadows
- ✔ Blending and bringing focus to your images
- ✔ Healing wounded photos

*A*dobe's image editing applications do a great job of fixing problem images. Some of the most common problems that you'll encounter with your photos (both old and new) relate to lighting, clarity, detail, and damage done by poor storage methods. Even a vintage photo, if properly stored, won't show unacceptable signs of age. Any photo, however, that was stored in a drawer or put in a frame and exposed to direct sunlight for years will start to look a little old, a bit shabby, and probably have lost much of its detail and depth. It might also have scratches and scuffs, as shown in Figure 4-1, which displays a photo with several problems that require Photoshop or Elements' restorative tools.

This chapter focuses on some of the tools available to you for repairing your digital images.

Figure 4-1: You can paint out scratches, stains, or dust spots if you zoom in tight enough.

Adding Light and Shadows

Whether because of fading with time or poor original photographic technique, many of your photos might need more light or more shadows — or more of both — in different areas of the same photo. What to do? Photoshop and Photoshop Elements' Dodge and Burn tools to the rescue!

Using the Dodge tool to lighten tones

The Dodge tool lightens portions of your image. The process is simple:

1. **Click the Dodge tool in the Tool palette to activate it.**

You might need to switch to the Dodge tool if the Burn or Sponge tool is currently displayed on that button in the Tool palette. Hold down the Shift key and press O until the tool that you want is active.

Multiple tools that are nested under a single icon are indicated by a tri-angle in the lower-right corner of the icon on the Tool palette.

2. **Observe the Options bar, as shown in Figure 4-2, and decide whether you need to make changes to the range of tones that will be affected or the exposure (degree of intensity) that the tool will apply.**

Figure 4-2:
The Dodge tool's Options bar in Elements; Photoshop's Options bar is similar.

The Range drop-down menu determines which tones the Dodge tool affects: Shadows (the dark areas), Highlights (the light areas), or Midtones (everything in between). Most of the time, you want to stick to Midtones, but if you want to open up some inky shadows or darken areas that are a little washed out, you can do that, too.

The Exposure menu determines how rapidly the lightening process occurs. Avoid lightening too much, too quickly, when you use a high value. A value between 15 and 35 percent enables you to lighten slowly. You can always return to an area and lighten it some more if you haven't applied enough dodging.

3. **Using the Options bar, set the size of the brush that you'll use to apply the light.**

You can choose the kind of brush you use just as you would the ordinary Brush tool. Both use the exact same Brush palette. You can find more on setting brush sizes in Book V, Chapter 3.

4. Drag over the area to be lightened, or click a single spot, such as a face or some other distinct area that's suffering from too much shadow.

Figure 4-3 shows the woman's face before and after dodging.

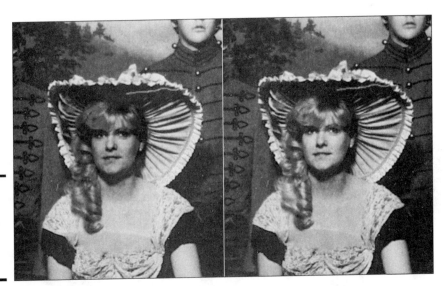

Figure 4-3:
Use the
Dodge tool
to lighten
shadows
in faces.

If your image isn't very crisp and detailed and you have no desire to make it that way, use one of the textured brush settings for the Dodge tool. This can apply light in a dappled or mottled way, matching the image's overall look — perhaps a desirable one, in the case of vintage photos.

Burning your image to darken areas

The opposite of the Dodge tool, the Burn tool darkens areas. This can bring out facial features lost to a sunny day, faded details in clothing or a garden, or add depth lost to a photo that's faded with time or exposure to sunlight.

To use the Burn tool in either Photoshop or Elements, follow these simple steps:

1. Click the Burn tool in the Tool palette to activate it.

The Burn tool might be hidden under the Sponge or Dodge tool, which both share the same position on the toolbox. Hold down the Shift key and press *O* on the keyboard until the Burn tool is active.

2. Check the Options bar (as shown in Figure 4-4) for any adjustments you'd like to make.

You can adjust the range and exposure, which respectively control which elements of the image (Shadows, Midtones, or Highlights) are affected by the Burning process and how quickly the darkening process takes place.

Figure 4-4:
The Burn
tool's
Options bar.

3. Choose a Brush size, using the Brush palette used for all Photoshop brush-like tools.

4. Begin darkening your image by dragging over the areas to be made more shadowy, or by clicking a single spot.

Figure 4-5 shows a face being darkened by a single click with a brush that's set to the same diameter as the face.

Figure 4-5:
Paint with
the Burn
tool to
darken
an area.

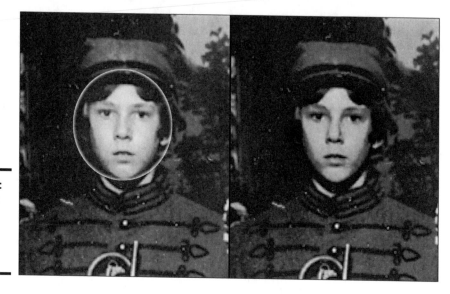

Don't go too far with the Burn tool. If your image is color, excessive use of the tool creates a brownish, singed look that literally looks as though the image were burned. If your image is in black and white or grayscale, this won't happen, but the worst that can occur is that your burned areas look so dark that their details are obliterated.

Using Smudging, Sharpening, and Blurring Tools

When it comes to retouching photos with Photoshop and Photoshop Elements, you'll probably use the Sharpen and Blur tools quite frequently. These tools are good for heightening or diffusing details in some of an image, an entire image, or along the edges of content that's been pasted into the picture from elsewhere. The Smudge tool is also a powerful ally, but you might find that good mouse skills are required before you can make really successful use of it. Figure 4-6 shows these three tools in Photoshop Elements. Like in Photoshop, the tools share one button, and you must switch between them by holding down the Shift key and pressing *R* (on the keyboard) until the icon for the tool that you want appears. This isn't an operational hardship, but it makes identifying them in one image here rather difficult!

Figure 4-6:
The Blur, Sharpen, and Smudge tools in Photoshop Elements.

Although the Sharpen tool's name clearly indicates what it does, the Blur and Smudge tool names might lead you to believe that the tools essentially do the same thing. In reality, however, the Blur tool is a more finely grained tool than the Smudge tool is in terms of its results. Whether applied to a small area or painted over a large field, the Blur tool's effects are uniform: It makes the affected area fuzzy and less distinct. (Technically speaking, the Blur tool reduces the contrast between the pixels, and our eyes see this reduced contrast as blur.) The Smudge tool smears the pixels into each other, and its effects are entirely dependent on the length and direction of your mouse or pen strokes.

What the three tools do have in common is how highly dependent they are upon their Options bar settings — or rather, how much *you* are dependent on the settings. Without controlling how drastic or subtle an effect these tools have, you might end up with very little blurring or too much sharpening — or perhaps some smudging that makes you look like you were drunk when you tried to retouch the photo. Figure 4-7 shows an image where the Sharpen tool was taken a bit too far; instead of adding contrast between pixels (to make them all stand out just a bit), the result is a very unpleasant effect — definitely not what you'd want.

Finger painting to blend colors and textures

The Smudge tool is used to drag color from one spot to another spot right next to it. Think of it as working the way your fingertips work if you're blending pastels or chalk on paper. The smudging process can smooth an edge or blend two adjoining colors, or smoosh out a background, as shown in Figure 4-8. You can also turn on a Finger Painting option and bring the current foreground color into the mix, smearing it into the image at whatever point you're dragging the mouse.

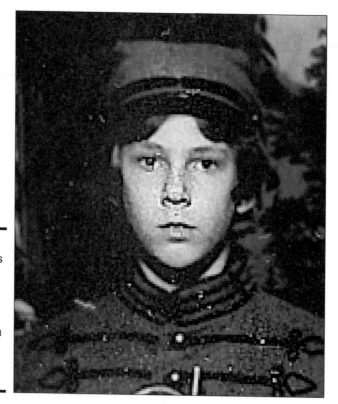

Figure 4-7: A little goes a long way with the Sharpen tool. Take care as you set up how the tool works.

Figure 4-8:
Blend a
background
or soften
sharp edges
with the
Smudge
tool.

To use the Smudge tool, follow these steps:

1. **Click the Smudge tool in the Tool palette to activate it.**

This displays the Options bar, as shown in Figure 4-9.

Figure 4-9:
Control the
effects of
the Smudge
tool.

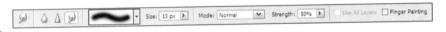

2. **Using the Options bar, change the setting in the Strength drop-down menu to make the smudging more dramatic (a high percentage) or subtle (a low percentage).**

3. **If you'd also like the Smudge tool to adjust the lights, darks, tones, and colors of the area that's smudged, choose an appropriate setting in the Mode drop-down menu.**

The Mode setting controls how the original pixels and smudged pixels are blended together. Your options are

- *Normal:* No change to the quality of the colors or tones where you smudge. They just get smudged.

- *Darken:* In addition to smudging, a Burn tool effect is applied.

- *Lighten:* In addition to smudging, a Dodge tool effect is applied.

- *Hue:* Smudges only the hue of one area onto another, dragging the shade from your starting point onto another adjoining area of the image.

- *Saturation:* By smudging with this setting in place, you're smudging the color intensity instead of the image content.

- *Color:* Smudge color from one area to another without distorting the physical content.

- *Luminosity:* This mode smudges the brightness of your starting point onto the adjoining areas through which you drag the Smudge tool.

4. **Set the Brush size by using the Brush palette, just like you set all other Photoshop brush-like tools.**

5. **Click and drag to smudge the image.**

You pull color from the starting point onto the ending point.

The last four mode options allow you to adjust the color and quality of the color as you smudge. I recommend that you tinker with the area using other color- and hue-adjustment tools first, and then smudge in Normal mode.

Don't use the Smudge tool to smudge large areas of your image unless you're going for a really smudgy background, as in the case of Figure 4-8. In most other instances, although you can use a large brush size and make a big smudge, you'll regret it because you'll end up distorting the image instead of blending areas within it. For the best results with most images, use a small brush and use it in small areas.

Using the Sharpen tool to add detail

The Sharpen tool heightens the contrast between adjacent pixels so that each of the pixels stands out more. This can help you take a blurry or faded photo and improve the apparent detail in the image. Small features, textures, and the like can be brought out by making the pixels in and around them more diverse.

In versions 1.0 and 2.0 of Elements, the Sharpen tool lived all by itself on its own button on the Tool palette, but from Version 3.0 onward, it shares a button with the Blur and Smudge tools just like in Photoshop. In either case, the tool has the same options (see Figure 4-10) and works the same way.

To sharpen some of or the entire image, follow these steps:

1. **To control the area in which the sharpening will take place, use a selection tool — Marquee, Lasso, or Magic Wand — from the Tool palette to select an area within the photo.**

2. **Click the Sharpen tool to activate it.**

3. **Use the Brush palette to adjust the brush size and whether you want a hard-edged or soft-edged brush.**

 A smaller brush enables you to sharpen a very specific area, whereas a larger brush heightens pixel diversity in a wider area, with more generalized results.

4. **Reduce or increase the intensity of the sharpening effect by adjusting the Strength setting from its default of 50%.**

 Be careful not to sharpen too much, or you'll end up with pixels that are so bright and diverse that detail can actually be lost.

5. **From the Mode drop-down menu, choose the mode setting that you want for the Sharpen tool.**

 The mode setting controls how the pixels are blended. The modes are the same as those for the Smudge tool — described in the preceding section's steps list — and include Color, Hue, Saturation, or Luminosity. Normal mode is good for most jobs.

6. **Click and/or drag over the area to be sharpened.**

 You can go over the same spot more than once, but again, don't go too far. Figure 4-11 shows both effective (left side of face) and ineffective sharpening (right side of face). Subtle effects are usually preferable to the overly dramatic.

Figure 4-10:
Using the Sharpen tool in Photoshop.

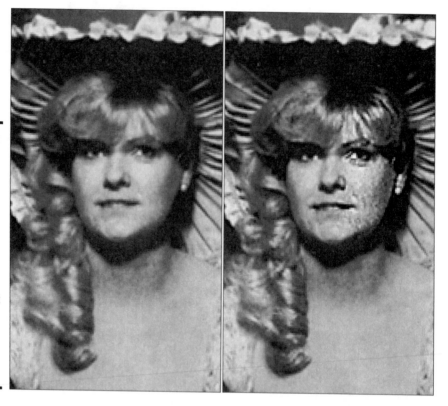

Figure 4-11:
At left, the unsharpened version. At right, the left side of the face has been sharpened effectively, but the right side of the face has been sharpened too much.

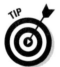

Sharpen and Blur filters are available through the Filter menu in both Photoshop and Photoshop Elements, and you can achieve more uniform results with them than with the brush-applied Sharpen and Blur tools because the mouse is removed from the equation. The filter is applied evenly over the selected area or the entire active layer of the image. You can read more about filters in Book V, Chapter 5.

Blurring some or all of your image

The Blur tool is the Sharpen tool's opposite. Instead of increasing the diversity between adjoining pixels, the pixels are made more similar (reducing the contrast), with their color and light levels adjusted so that no individual pixels stand out too much. Obviously, you can blur a lot or blur a little: The degree to which the tool is applied determines how much contrast is removed from the pixels that you brush over with the Blur tool. Blurring can be used as a quick-and-dirty substitute for cloning over unwanted pixels. Figure 4-12 shows at left a scan of an old photograph that was folded and wrinkled along the bottom edges. I could have used the Clone Stamp to copy pixels over the wrinkles, but because this area of the subject would look better if de-emphasized anyway, blurring the lower-left and lower-right corners was faster.

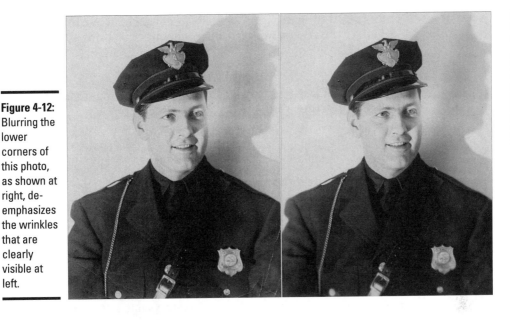

Figure 4-12:
Blurring the lower corners of this photo, as shown at right, de-emphasizes the wrinkles that are clearly visible at left.

To use the Blur tool, follow these steps:

1. **Check to see that the layer you want to work with is selected in the Layers palette.**

 If the Layers palette isn't visible, you can choose it from the Window menu.

2. **If you want to restrict the blurring to a particular area of the image, use the appropriate selection tool (Marquee, Lasso, Magic Wand) on the Tool palette to select that area.**

3. **Click the Blur tool to activate it.**

 The tool has its own button in Photoshop Elements, sharing a spot with the Sharpen and Smudge tools in Photoshop.

4. **Observe the tool's options when they appear on the Options bar, as shown in Figure 4-13.**

Figure 4-13:
The Blur tool's Options bar.

Size: 13 px | Mode: Normal | Strength: 70% | ☐ Use All Layers

5. **Adjust the setting in the Strength drop-down menu (set to 50% by default) to increase or decrease the amount of blurring that each click or stroke applies to the image.**

 Obviously, a low setting results in very subtle effects.

6. **Set the brush size and type (such as hard- or soft-edged) for the area you'll be blurring using the Brush palette.**

 Use the smallest brush you can if you need to blur a very small or detailed area. If you want to blur a large area, use a large brush so that you can avoid the obvious signs of retracing your steps with the tool.

7. **Click or drag over the area to be blurred.**

 Some scrubbing with the mouse might be required if you want to get rid of a very sharp edge between two parts of the image. Figure 4-14 shows the edge of content that was pasted into a photo, and the Blur tool is making the edge disappear so that the pasted content looks like it was always there.

Sometimes you can use the Blur tool to make another part of the image seem sharper in comparison. For example, if the Sharpen tool is having undesirable effects on your image, use the Blur tool to soften or remove the details surrounding the parts of the image to which you want to draw attention.

Figure 4-14: For maximum control and subtle (yet effective results), scrub along the unwanted hard edge with a low-strength Blur tool.

Finding Relief with the Healing Tools

Both Photoshop and Photoshop Elements have tools that are considered purely restorative tools. They're intended for removing the signs of age, wear and tear, and outright damage in the form of tears, rips, scratches, and missing content.

In Photoshop 7 and CS, you can find two tools designed specifically with healing in mind:

✦ The **Healing Brush,** which copies pixels from one place to another while modifying the copied pixels so that they take into account the texture and brightness of the underlying image.

✦ The **Patch Tool,** which overlays a portion you want to repair with a patch taken from another area, but modified so that the patch takes into account the texture and brightness of the image underneath.

In Photoshop Elements 3.0, you'll find similar aids:

✦ The **Healing Brush,** which works in much the same way as the Healing Brush in Photoshop.

✦ The **Spot Healing Brush,** which performs its healing magic only on specific areas you click, such as dust spots.

✦ The **Red Eye Removal tool,** which is not found in Photoshop. The tool gets rid of that demonic pupil caused by the flash bouncing off the subject's retina.

You can also find a Clone Stamp tool in both applications, which copies undamaged content and allows you to paint it over damaged areas. You can do this to replace missing content, cover up damaged content, or simply edit the content of the image by painting over things you don't want. Unlike the Healing Brush and the Patch tools, the Clone Stamp obscures any detail being copied over.

The Clone Stamp isn't purely a restorative tool. It has many uses in the creation of original artwork and in images that aren't photographic in nature. Its restorative uses are extensive, however, so I've grouped it here with the healing tools.

Using the Healing Brush

The Healing Brush is so named because it repairs or heals the current image being painted over — using it doesn't replace it completely. The Clone Stamp

(to be discussed shortly) replaces content in one place with selected content from another spot in the image. The color and lighting in the source spot are cloned and placed in the target location as well, which might not be what you want if you'd like to preserve a realistic look.

The Healing Brush is a bit more intelligent and a bit less heavy-handed. As shown in Figure 4-15, this view of a single image shows the Healing Brush effects. The tear at the right side of the photograph is partially healed, and the healed portion matches the surrounding content even though the healing content was derived from a spot on the other side of the image (marked by the cross-hair to the left of the woman's face).

To use the Healing Brush, follow these steps:

1. **Identify the area to be healed, and pick content from elsewhere in the image that you can use to heal the wound.**

2. **Click the Healing Brush in the Tool palette to activate it.**

 A set of options appears in the Options bar, as shown in Figure 4-16.

Figure 4-15: Select the healing content (see the crosshair at left in the photo) to apply to the "wound" (at right) and then paint the corrections onto the image.

Figure 4-16:
The Healing
Brush's
Options bar.

3. **Using the Options bar, establish the following settings. You can leave them at their default settings if you want, but you might want to make adjustments:**

 - *Brush:* The Brush setting allows you to choose the size of the brush you'll use and whether it is hard- or soft-edged. This is the same setting that you use to control the way any content is applied with a brush-based tool.

 - *Mode:* Choose how the pixels will blend. Normal is the default setting and is probably your best choice because it lets the tool work as it's intended. With the Normal setting, the Healing Brush takes the healing content and applies it to the damage, and then lets the "band-aid" content blend in with the surrounding area. You can also use the modes described in Book V, Chapter 3.

 - *Source:* If the *Sampled option* is selected, the Healing Brush copies pixels from a place that you select in the image. This is the default because it assumes you're going to choose a spot on the image — somewhere where there is no damage — and use that as the band-aid for the damaged area.

 If the *Pattern option* is selected, you can paint a pattern over the area to be healed instead of pixels from another part of the image. If you select this option, the pattern that you apply takes on the color and lighting of the surrounding pixels. This can be a useful option if you're replacing missing content and have to invent the fill entirely. Figure 4-17 shows a pattern applied to an area and the interesting effect that it creates to cover a stain on the carpet. The content within the circular cursor has not yet changed to match the surrounding pixels, but you can see the previous clicks that place a pattern in context.

 - *Aligned:* When you select your source area (where the healing content is taken from), you can select this option so that the distance or offset between the source and target remains the same as you paint over larger damaged areas. This option is unchecked by default, which means that the same original source spot is used to fill all the damaged area that you paint over with the Healing Brush. If you enable this option, new source areas are selected each time that you apply the Healing Brush.

Figure 4-17:
Applying a
pattern.

4. **After you adjust all the settings you want or need to, begin using the Healing Brush. First, sample the spot that's used to heal the damage by pressing the Alt key (Option on a Mac), and clicking the healing content that you want to use.**

5. **With your healing content chosen, go ahead and click or drag over the damaged area.**

 The content you sampled (with the Alt or Option key and your mouse) covers the damage.

You might have to wait a few moments for the healing effect to finish. A lot of calculating goes on as Photoshop matches the copied pixels to the new location's darkness and texture. At first, it might look like the exact color and lighting from the source area is being duplicated on the damaged (target) area. If you wait a second, however, you'll see the Healing effect occur — the content you applied with the Healing Brush automatically blends into its surroundings, like a chameleon blending into the leaf or twig on which it sits.

Working with the Patch tool

Unlike the Healing Brush, which allows you to paint content from one place to another, the Patch tool works by applying a selected shape from one spot on the image to a damaged spot somewhere else in the image. You can use this tool to cover damage (such as scratches, spots, and stains), or you can use it to replace unwanted content with something more visually appealing.

Photoshop Elements does not offer this tool; only Photoshop 7 does. You might find it quite like using Copy and Paste to copy content from one place to another, which is a procedure supported by both applications. The difference between using the Patch tool and doing a simple Copy and Paste to

cover up unwanted content or damage is simple. The Patch tool is a little more intuitive and a little more chameleon-like in that when you place the patch over the unwanted content, the lighting and shading in the target area is applied to the patch. To make use of this really helpful tool, follow these steps:

1. **Check the Layers palette to make sure the right layer is active.**

If it isn't visible, you can activate it from the Window menu. This prevents your patching the wrong layer's content onto another part of your image.

2. **Visually choose which part of the image you want to use to cover the unwanted or damaged area.**

3. **Click the Patch Tool to activate it.**

You might have to switch to it from the Healing Brush because these two tools share one spot on the toolbox.

4. **Using the Options bar (as shown in Figure 4-18), choose either Source or Destination for the patch.**

If you didn't select the patch area before turning on the tool (and I haven't had you do that in these steps), select Destination.

Figure 4-18:
Source or
Destination?
Choose
which
direction
your patch
will follow.

5. **Take the mouse and draw a line around the area that you want to use as the patch.**

It's a lot like using the Lasso tool, as shown in Figure 4-19.

6. **Drag the selected patch area onto the damaged/unwanted spot.**

Wait a second and see the lighting and shading change to make the patch match the surrounding pixels so that the patched content blends in.

7. **If you have a large area to patch, you can do it in small pieces, repeating Steps 5 and 6 for each piece.**

Figure 4-20 shows an extra kitten's face added to a former pile of three kittens. The shading and lighting of the new face match its location among the existing kittens.

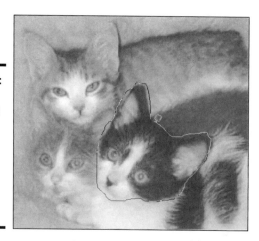

Figure 4-19:
Select the
Destination
patch to
place on
top of the
damaged
areas or
unwanted
content.

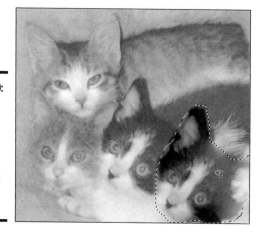

Figure 4-20:
Patch a
portion of
the image
over other
content to
make more
of a good
thing.

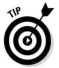

When your entire damaged or unwanted area is patched, you can go through and use the Blur or Smudge tool as needed on any visible edges. If you placed one large patch over a large trouble spot, you might have to blend it with any drastically different adjacent pixels. Sometimes, if the damaged area is a very light color and a dark area is right next to it, the patch-matching won't be as smooth as you'd have hoped.

Cloning content to cover damage and unwanted content

The addition of the Patch tool and Healing Brush to Photoshop 7 might have eliminated more than half the uses for the Clone Stamp for many users, but if

you use Photoshop Elements or an earlier version of Photoshop and have no Healing Brush or Patch tool to rely on, you'll find the Clone Stamp to be a helpful tool.

The Clone Stamp duplicates content from one place and allows you to click and place it one or more times in the image, covering existing content (thus the term *stamp* in the tool's name). Figure 4-21 shows a good candidate for Clone Stamp fixing. Unlike the Patch tool, there is no matching of the stamped content to the surrounding pixels in the target area. If you stamp green grass on a blue couch, you get green grass on a blue couch — you don't get a blue, grassy texture on a blue couch.

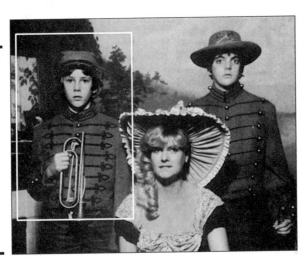

Figure 4-21: Can we create a portrait of the bugle boy alone? Unfortunately, his mom's hat and shoulder intrude into the picture.

To use the Clone Stamp, follow these steps, which are quite similar to the steps for the Healing Brush and Patch tool combined. I use Photoshop Elements here:

1. **Verify the layer you're in, making sure that the layer containing the content you want to clone is highlighted in the Layer palette.**

 You can switch to another layer later when you stamp the content onto the image.

2. **Click the Clone Stamp tool in the Tool palette to activate it.**

 The Options bar (as shown in Figure 4-22) appears, offering several settings that you can tweak to control how the tool is applied, including

Figure 4-22:
The Clone
Stamp's
Options bar.

- *Brush:* This pop-up palette at the left side of the Options bar contains the brush styles you set for painting, erasing, or using any brush-applied tool. Pick a brush from the palette based on your target area, going for a size that's just a bit smaller than the area you want to stamp over. You don't want to leave an obvious edge to a single stamping of content. With two or more stamps in the area, you can avoid a clumsily pasted look.

- *Mode:* When the cloned content is pasted, you can choose a mode to control how the pixels are merged. The Mode controls were discussed earlier in the section, "Finger painting to blend colors and textures." Normal works for most jobs, but you might want to experiment.

- *Opacity:* If you want to see through your stamped content, reduce the opacity from the default 100%.

- *Aligned:* This keeps the same distance/offset between the sampled spot (where you clicked the Alt key, or Option key on the Mac) and the stamped area. If you leave this off (the default), the cloned location keeps changing as you move your mouse and continue stamping.

- *Use All Layers:* If you want your cloning and stamping to use and affect your image as it appears when all the layers are visible, select this option. It's unchecked (off) by default, just so you don't make more of an impact on your entire image than you might have intended.

3. **After you customize the tool as needed, you're ready to clone and stamp. To clone the spot that will be used to cover unwanted content, hold down Alt (Option key on a Mac) while you click the spot that you want to clone.**

 The mouse pointer changes when you're in clone mode, and a crosshair appears in the center of your brush point.

4. **Release the Alt key (Option key on a Mac), and apply the cloned content by clicking to cover the unwanted content, as shown in Figure 4-23. Here, multiple copies of the cloned content are being applied over a large area to cover the seated woman's shoulder and hat.**

Note that I've also used the Clone Stamp to remove some dust spots and other artifacts from the background and uniform.

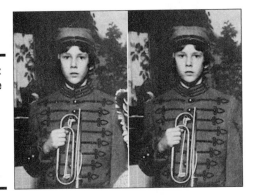

Figure 4-23: Remove the edge of the hat and shoulder with the Clone Stamp tool.

Removing red-eye

Another tool that Photoshop Elements users can call their own is the Red Eye Removal tool. This tool literally allows you to click or paint away those glowing pupils that affect pets, children, or anyone else wide-eyed and close enough to the camera and its overzealous flash. Figure 4-24 shows an image in dire need of red-eye treatment.

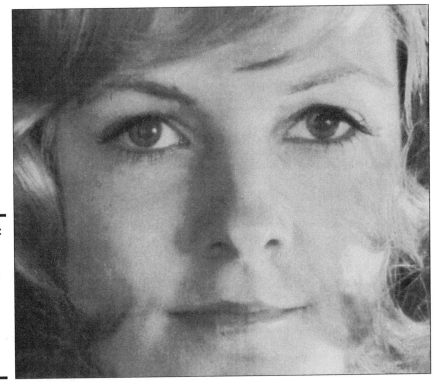

Figure 4-24: Have some demonic eyes to fix? Use the Red Eye Removal tool in Elements 3.0.

Using the Red Eye Removal tool requires use of the Options bar (as shown in Figure 4-25). To use the Red Eye Removal tool, follow these steps to customize the tool's effects and apply them to the glowing eyes in question:

Figure 4-25:
The Red Eye
Removal
Tool's
Options bar.

1. **Check to see that the layer with the demonic eyes is in fact the active layer in the Layers palette.**

2. **Click the Red Eye Removal tool in the Tool palette to activate it, and consider the following options:**

 • *Pupil Size:* This is the size of the brush you'll use to paint over the red-eye.

 • *Darken Amount:* This is the degree you want the red eyes darkened.

3. **Click in the area that includes the red-eye effect.**

 The tool automatically seeks out the red tone and darkens it, creating more natural-looking eyes.

4. **If both eyes are glowing (they usually are), you can repeat this process for the second eye.**

 Figure 4-26 shows both eyes exorcised, with no glow remaining.

The current version of Elements 3.0's brand-new Red Eye Removal tool does not work with the similar yellow or green eye effect produced in animals. Try using the Color Replacement tool instead. For best results, be careful not to apply the same exact pupil color to both eyes. Usually, the lighting on the individual eyes is slightly different, which affects both the glow you're trying to get rid of and the desired pupil color. If you apply too dark or too large a pupil, the results look fake.

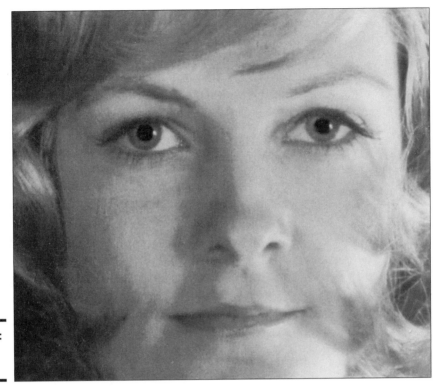

Figure 4-26:
No more
glow here.

Chapter 5: Correcting Faded, Funny, and Funky Colors

In This Chapter

✔ Mastering the color balancing act

✔ Controlling the intensity of color

✔ Improving color quality overall

*P*hotos displayed on a sunny wall or desk can fade from the exposure to sunshine, even if you live in a rainy climate. You'd be surprised how just a small amount of sunlight can fade a photo if it's exposed long enough. Time can fade photos — especially those that were shot long ago — printed from old negatives, on old photo paper. You might also have photos that looked a bit odd from the start — perhaps there was too much red or green, or the colors looked washed out from the minute you had the photo developed or captured it with your digital camera.

Regardless of the cause, color photos present a whole host of color balance, level, and quality issues, and Photoshop and Photoshop Elements are well prepared to deal with them. This is where Photoshop's status as the standard for photo retouching software kicks in. You can find several ways to manually and automatically adjust color levels and quality. Photoshop Elements has many of the same tools that Photoshop does, as well as a few of its own.

Using Automated Tools in Photoshop and Elements

Your first stop when attempting to correct your colors and tones are the automated tools built right into both Photoshop and Elements. These tools are a kind of training wheels that work well for some basic image problems but don't allow the kind of fine-tuning that you want to apply to really optimize your photos. Try these first, and then turn to some of the more advanced options described in the rest of this chapter.

Auto correction in Photoshop

Your automated toolkit in Photoshop is located in the Adjustments submenu of the Image menu and includes

✦ **Auto Levels:** This command automatically examines the tonal values in your image, including the lightest tones (highlights), the middle tones, and the darkest tones (the shadows). Then it attempts to provide a balance among all those tones so that the lightest tones are not washed out, the darkest shadows still have some detail, and the middle tones are right in the middle.

✦ **Auto Contrast:** This command looks at how many different tones are in your image. If only a few are present, your image could have excessive contrast. If the image information is spread evenly among hundreds of different tones, your image might be low in contrast. Photoshop attempts to redistribute the tones to provide a more pleasing picture.

✦ **Auto Color:** This command attempts to determine whether the color in your image is heavily biased toward one color or another and then removes excessive color to provide some correction. (Remember, no image editor can *add* color that isn't there; colors can only be removed, leaving whatever other colors are present.)

None of these commands has any options. You just invoke them and evaluate your results, so I don't have to tell you how to use them.

Auto correction in Photoshop Elements

Elements has the same three tools found in Photoshop, under the Enhance menu: Auto Levels, Auto Contrast, and Auto Color Correction. Elements also includes an Auto Smart Fix command that attempts to apply all three of these commands, as appropriate, at one time.

You can throttle back the amount of correction applied by Smart Fix by moving a slider in the Adjust Smart Fix dialog box. Move the Smart Fix slider from 0 percent (almost no correction) up to 200 percent (a whole lot of correction) until you get the effect you like. The current effect can be viewed in the original image's window as you adjust the slider.

Photoshop Elements also has a Quick Fix mode (select it by clicking the Quick Fix tab at the right side of the main window), as shown in Figure 5-1, with an assortment of correction tools for general fixes, lighting and contrast, color, and sharpening. Each of these has an Auto button that you can click to apply the automatic version of that correction, as well as sliders for applying the fixes manually. Read more about manual fixes in the next sections.

Figure 5-1:
The Quick
Fix mode in
Elements
gives
you fast
access to
automated
and manual
correction
tools.

Adjusting Color Balance

Say a photo has too much red or yellow, or the whole picture is too dark or
too light. These problems — problems you might think would require multi-
ple tools and several steps to solve — could just be a couple of clicks away
from their solutions. With automatic color and lighting adjustment tools,
commands that address specific color levels, and Photoshop's Channels
palette, you have the power to make sweeping changes to your photos or
sections thereof, significantly shortening the amount of time that you spend
editing and improving your photos.

Adjusting color levels

Both Photoshop and Photoshop Elements offer a Levels command. In
Elements, it's squirreled away under the Enhance⇨Adjust Lighting submenu;
in Photoshop, you can find it on the Image⇨Adjustments menu. Or, just press
Ctrl/⌘+L to bring up the dialog box directly.

The Levels command in either application allows you to set the highlights
and shadows in an image by dragging three Input Levels sliders (in this case,
a set of three black, gray, and white triangles along the slider axis) to adjust

the Levels histogram. A *histogram* is a visual representation of quantities — in this case, levels of tones. The sliders, as shown in Figure 5-2, allow you to adjust levels of shadows, midtones, and highlights.

Figure 5-2:
Adjust
shadow,
midtones,
and
highlight
levels.

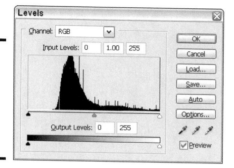

As you drag the Input Levels sliders, you see the levels of light and dark changing in the photo. You can control the effects by using the Set Black Point, Set Gray Point, and Set White Point eyedroppers to click pixels in your image. (The eyedroppers are located under the Options button in Figure 5-2.) As you do this, you see the image change accordingly. You'll find more on working with the Levels command in *Photoshop CS All-in-One Desk Reference For Dummies,* by Barbara Obermeier (Wiley).

While in Levels, double-click each of the Eyedroppers in turn to open the Color Picker so that you can choose new colors for these three levels (Shadows, Midtones, and Highlights). Alternatively, you can choose new color levels by clicking existing shades within the image. As you make your selections (using the Color Picker or the image itself) and okay them, you see the results in your image.

Using the Variations dialog box

The Variations command (Color Variations in Elements 3.0) is a useful feature found on the Image⇨Adjustments submenu in Photoshop and on the Enhance⇨Adjust Color submenu in Photoshop Elements.

The Variations/Color Variations command enables you to view a series of thumbnails, each showing a different color or contrast effect. As shown in Figure 5-3, clicking the Darker thumbnail shows you how adding more black to the image will affect it. If color adjustment is your goal, you can see what will happen if you bump up the Blue component just by clicking More Blue (in Photoshop) or Increase Blue (in Photoshop Elements).

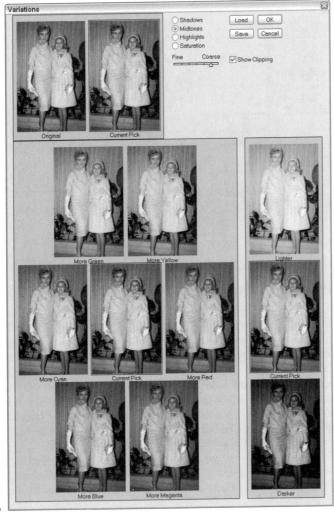

Figure 5-3:
Photoshop's
Variations
dialog box
lets you see
your results
in the
Current Pick
version of
the image.

While you're experimenting by clicking the Variations thumbnails, you can always click the Original thumbnail to return all the thumbnails to their default states. You can view the effects of multiple changes, such as making the image lighter, adding more of one or more colors, or switching between the Midtones, Shadows, Highlights, and Saturation radio buttons. No matter what variations you're considering, Photoshop lets you see your results in a Current Pick thumbnail, and Photoshop Elements shows an after version of the image, as shown in Figure 5-4.

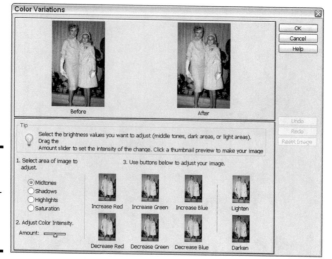

Figure 5-4:
Before and
after thumb-
nails in
Photoshop
Elements.

Equalizing colors

The Equalize command has been christened with a name that clearly tells you what it does. Found on Photoshop's Image⇨Adjustments submenu and on the Filter⇨Adjustments submenu in Elements, the command evenly distributes color over the range of brightness levels throughout your image (or in a selected area) from 0 to 255. When the Equalize command is issued, Photoshop or Elements locates the brightest and darkest pixels, and the rest of the colors are adjusted, making white the brightest value and black the darkest. Then all the colored pixels that fall between these two extremes are *equalized,* or made to fall between the two extreme shades.

If you don't select part of your image before issuing the Equalize command, no dialog box appears; the changes just take place automatically over the entire image. If you do make a selection first, a dialog box appears, as shown in Figure 5-5.

Use this dialog box to indicate whether you want to equalize a selected area only or equalize the entire image based on the selected area. In Figure 5-6, only part of the image is equalized, and it's easy to spot it. Therefore, be careful that you don't make the rest of your image look shabby by improving just a small amount so drastically.

The Equalize command affects each image differently. The effect depends on how damaged, faded, and light or dark the image was to begin with. Don't assume that if equalization was a big problem solver in one photo, it will be as successful with another.

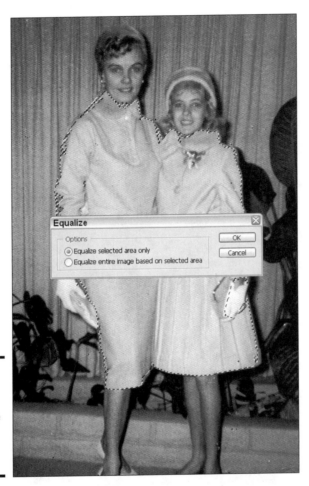

Figure 5-5:
Indicate
how you
want to use
a selection
to equalize
colors.

Fixing a color cast

A *color cast* is a tinge — a shade of red or maybe yellow — that discolors your image, in whole or in part. Casts occur for a variety of reasons, including the age of the photo, the quality of your scanner (if you scanned a printed original), the print from which you scanned the image, or the film used to take the picture. If a cast appears in an image captured with a digital image, you need to reset something on the digital camera (what you change and how you change it varies by the camera). A digital camera is rarely the culprit, however. Your cast probably came from one of a print, film, or age problem instead.

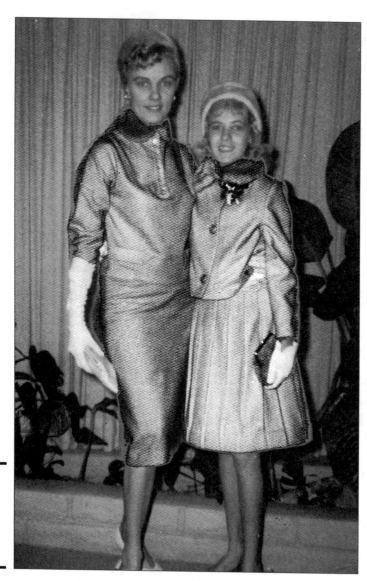

Figure 5-6:
Equalizing
just part of
your image
might be
too drastic.

To get rid of a cast, use Photoshop Elements' Color Cast command (Photoshop doesn't have it) to rid an image of any unpleasant preponderance of a single color. Just follow these steps:

1. **Open the image with the unwanted color cast.**

2. **From the main menu, choose Enhance⇨Adjust Color⇨Remove Color Cast.**

The Remove Color Cast dialog box opens, as shown in Figure 5-7, offering instructions.

3. **Use the dialog box's Eyedropper tool (already activated within the dialog box) to click the gray, and then white, and then black points in the image.**

 As you click in the image (about three times — one for gray, one for white, and one for black), the color cast in the photo changes.

 You can keep clicking different spots until you like the results or bail out entirely by clicking Cancel.

Figure 5-7:
Correct a color cast and get rid of any dominant shade.

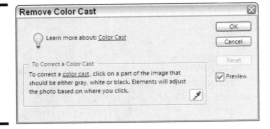

Make sure that you leave the Preview option on in the Remove Color Cast dialog box. Most applications offer a Preview capability in dialog boxes that adjust visual elements. Leaving it on means that you don't have to apply the changes just to see them in your image. If you do apply them by clicking OK and then decide you don't like the change, choose Edit⇨Undo from the main menu.

Displaying and using channels

Channels are the different individual color layers that make up your image. Most photos are either in RGB (red/green/blue) or CMYK (cyan/magenta/yellow/black) modes, and photos in those modes have either three (in the case of RGB) or four (in the case of CMYK) channels.

Photoshop's Channels palette (not found in Elements) allows you to view the individual channels for your photo, as shown in Figure 5-8. If the Channels palette is not visible, you can display it by choosing Window⇨Channels.

The channel that includes all the colors (the RGB or CMYK channel) is displayed when all the individual channels are showing in the photo, and it turns off (the eye disappears from that channel in the palette) if any one of the channels is hidden.

Figure 5-8:
Photoshop's
Channels
palette lets
you view an
image's
basic color
components.

Use the Channels palette to focus the editing of your image on a single color channel's content or on a combination of two or more channels. For example, if you want to make changes only to the red portions of an image, you can edit the Red channel alone without disturbing the Green or Blue channels. You can edit any channel that's visible. When you hide all but one channel, your edits affect only the channel that's active. To edit a single channel, keep these rules in mind:

✦ White applies the selected channel color at 100 percent intensity.

✦ Black wipes out the channel's color wherever you paint or draw it.

✦ Use a shade of gray to apply the channel's color at a lower intensity.

To display a channel, make sure that the eye appears next to the channel in the Channels palette. If you want to hide a channel, click the eye to the left of the channel. You can't turn off the RGB or CMYK channel directly; it's only visible if all the other channels are visible, too. Using Channels is a complex topic, and I recommend checking out *Photoshop CS All-in-One Desk Reference For Dummies* for more information.

Working with Color Intensity and Quality

Automatic tools that ask nothing — or just ask a few questions and then make global corrections to color and light — can fail you. In these situations, Photoshop and Photoshop Elements can help. These applications provide targeted tools that you can apply manually to adjust color, lighting, brightness, and contrast. Whatever your photo's color difficulty is, however, chances are that these tools offer a quick and easy solution:

+ The Sponge tool for saturating and desaturating color

+ The Brightness/Contrast dialog box

+ The Curve dialog box, for adjusting individual colors

Increasing and decreasing color intensity

Found in both Photoshop and Photoshop Elements, the Sponge tool adds color (in Saturate mode) or removes color (in Desaturate mode), depending on how you set up the tool.

The Sponge tool can come in handy if you added too much color in a previous editing session, and the edit can't be undone. Or perhaps you simply want a more subtle, faded look in some or all of an image. New photos are often faded to look vintage or in preparation for the use of an artistic filter that will make the photo look like a drawing or painting.

Regardless of your motivation, the Sponge tool is very simple to use. To saturate or desaturate color in either Photoshop or Photoshop Elements, follow these steps:

1. **Click the tool in the Tool palette to activate it.**

In Photoshop and Elements 3.0, the Sponge shares a space on the Tool palette with the Dodge and the Burn tools. Hold down the Shift key and press O to cycle through the three tools until the Sponge is active. Elements versions prior to 3.0 gives the Sponge tool its own spot.

2. **Choose Saturate or Desaturate mode, using the tool's Options bar, as shown in Figure 5-9.**

Figure 5-9:
The Sponge tool's Options bar.

3. **Adjust the *flow* — how much saturation or desaturation occurs — by using the Flow drop-down menu. In some Mac versions of Photoshop, Pressure does the same thing.**

4. **Use the Brush drop-down menu and choose the right brush size for the area to be sponged.**

A small brush can give you undesirable results when used in a large area, and a big brush can go too far. Choose one that enables you to fix the problem area with the least amount of clicks or brush strokes.

5. **Apply the Sponge to the image by clicking and/or dragging to add or remove color where desired.**

Passing over the same spot more than once intensifies the sponge effect. You add or wash out more color on each successive pass, as shown in Figure 5-10, where too much color has been sponged away.

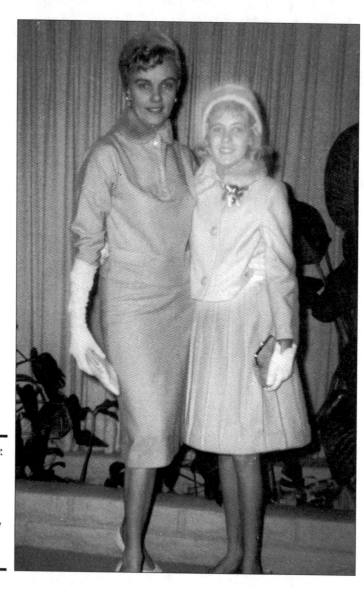

Figure 5-10:
Too much Sponge in Desaturate mode can wash away all your colors.

Tinkering with brightness and contrast

Although automatic tools can correct brightness and contrast, you might want to control these levels manually. To do so, you can use the Brightness and Contrast command found in the Image⇨Adjustments submenu (in Photoshop), or the Enhance⇨Adjust Lighting ⇨Brightness/Contrast sub-menu (in Photoshop Elements). In either application, the command opens a dialog box, as shown in Figure 5-11, that offers two sliders. One adjusts the brightness, and the other adjusts the contrast.

Figure 5-11:
Adjust brightness and/or contrast with this handy dialog box.

 Although the Brightness/Contrast controls are tempting for the beginner, most of the time, they are the *worst* choice for making corrections to your photos. That's because they provide uniform changes in brightness or contrast of *all* the pixels in your image or selection. That might work out in some cases, but most of the time, the results will be terrible. If you bump up brightness to lighten shadows, you'll find that your highlights are now completely washed out. Darken highlights, and your shadows will turn black. And rarely will any photograph need adjustment in contrast over its entire image. I recommend using the Levels command (discussed earlier in this chapter) and Curves (discussed next) as your Photoshop or Elements proficiency increases. Each of these commands deserves most of a chapter of its own, and that's what you'll find in the companion books to this one, *Photoshop CS All-in-One Desk Reference For Dummies,* by Barbara Obermeier, or *Photoshop Elements 3.0 For Dummies,* by Deke McClelland and Galen Fott (both by Wiley).

Riding the curves

Another way to adjust the tones in your image is to work with the Curves dialog box, available in Photoshop (but not in Elements) through the Image⇨ Adjustments⇨Curves submenu. You can use this box (see Figure 5-12) to adjust the entire range of colors in your image. To adjust the tones and color balance, drag the curved line with your mouse up, down, left, or right, and watch the Preview to see how the adjustments affect your image. You'll also want to use the set of three eyedroppers to set the shadow, midtones, and highlight samples from within the image, and then readjust the curve.

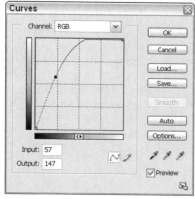

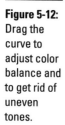

Figure 5-12:
Drag the
curve to
adjust color
balance and
to get rid of
uneven
tones.

If you want to change only certain color levels in the image, choose
which color channel you want to adjust by selecting that channel within
the Channels palette. If you want to adjust multiple (but not all) channels,
press and hold the Shift key as you click to select more than one channel.

Chapter 6: Restoring and Enhancing Photos with Filters and Special Effects

In This Chapter

- ✓ Understanding how filters work and what they do
- ✓ Using Photoshop Elements' special effects for images and text
- ✓ Finding third-party filters and other plug-ins

*F*ilters allow you to apply groups of effects and formats to your images, whether to a specific selected area or to the entire image on one or more of its layers. Filters add or change the color and texture of your images, or you can use filters to add patterns. Each of the filters in Photoshop and Photoshop Elements enables you to control how the filter affects your image, and most filters give you a preview so that you don't have to formally apply the filter to your image until you see how it will look.

Telling you everything you need to know about using filters is beyond the scope of this book. After all, Photoshop and Elements each include more than 100 different filters that span a broad range of special effects. But this chapter certainly gets you started using these fascinating tools. For more detailed information on using filters, check out *Photoshop CS All-in-One Desk Reference For Dummies*, by Barbara Obermeier (Wiley).

The main thing to remember when using filters is to experiment and have fun with them. Several of the illustrations in this chapter are not simply digital photos with a filter applied to them. Some of them are digital creations in their own right, using a combination of digital photos cut and pasted together, special editing techniques, and a bit of filter special effects magic.

Working with Photoshop and Photoshop Elements' Filters

Both applications provide the same filter categories, shown in the Photoshop Elements menu displayed in Figure 6-1. Photoshop's Filter menu is similar, with Extract, Liquify, and Pattern Maker commands added for good measure. (Liquify is located in the Styles and Effects palette in Photoshop Elements.)

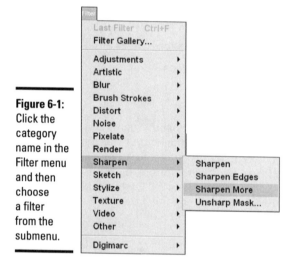

Figure 6-1: Click the category name in the Filter menu and then choose a filter from the submenu.

Filters can be used for many different purposes, including creating original works of art from scratch. However, for the purposes of this discussion on editing digital photos, the filters that I discuss fall into three categories: corrective, artistic, and special effects. As it just so happens, these are the kinds of filters that you're likely to use to retouch photos for personal or professional use. As for those filters that fall outside these categories, you can take your newly found knowledge of the filters that I actually cover and apply it when you go experiment with other filters. And just think of the fun you'll have with the trial and error process!

Understanding how filters work

When you open the Filter menu, you see all the filter categories, each followed by a right-pointing triangle that spawns a submenu. Most of the categories have at least four filters in their submenus, and most of them have several more filters to choose from.

Just about all the Filter commands work through either a dialog box or the Filter Gallery found in both Photoshop and Elements. Either mode enables

you to both preview and customize the filter's effect. Figure 6-2 shows a stand-alone filter dialog box, for the Smart Blur effect.

Other filters are accessed through the Filter Gallery, which presents you with a large number of filters to choose from, all of which can be quickly tried out from within the Gallery. You can even add several filters together, change their order, and preview the results of the combination before you apply the effects. Figure 6-3 shows the Filter Gallery in Photoshop Elements 3.0. Elements also has other effects in the Styles and Effects palette.

Figure 6-2:
The standalone Smart Blur filter dialog box and preview pane.

Figure 6-3:
The Photoshop Elements 3.0 Filter Gallery is similar to the one found in Photoshop CS.

Before I discuss individual filters, consider these important filtering tips:

✦ Filters can be applied only to the active layer, and only if that layer is visible. If your photo has only one layer, this is a moot point.

✦ You can limit the filter's effects to a selection by using the various selection tools before applying a filter.

✦ If you don't make a selection before you apply a filter, the filter is applied to the entire active layer.

✦ Certain filters work only with certain file types. If your file type doesn't support a certain filter, the filter command is dimmed in the submenu.

Not all filters have a dialog box or appear in the Filter Gallery. Some of them, called *single step filters,* have no options to bother with and are applied the instant you click the command in the Filter menu, within a particular category's submenu. The downside? You have no control over the effects although you can select a section of your image beforehand. If you don't like the results, though, you can easily use the Undo command or the History palette to get rid of the effect.

Fixing flaws with corrective filters

Corrective filters are those that improve the quality of the image without distorting it, changing the content significantly, or applying any stylized effect. The three that are most appropriate for a discussion of digital photos fall into three Filter menu categories: Blur, Sharpen, and Noise.

These three categories contain several filters, each performing a relatively subtle effect, depending on the settings that you employ in the available dialog boxes.

Blur filters

Use the Blur filters (Blur, Blur More, Gaussian Blur, Motion Blur, Radial Blur, and Smart Blur) to soften the content of your image. The Motion and Radial blurs do a bit more than soften. They actually give the appearance of circular movement (Radial) or movement through space (Motion). The Blur and Blur More filters don't have dialog boxes; the commands automatically apply a modicum of blurring to your image in its entirety or to a selection you make before issuing the command.

Use the Blur and Blur More filters instead of the Blur tool when you want uniform results. When you use the Blur tool, your mouse has the greatest effect on the results. You might be able to see the strokes that you used to apply the blur, or you might miss some spots or apply the effect unevenly. If

you use the filter, the same amount of blurring is applied everywhere, with no strokes or places that are blurred more or less than somewhere else.

In Photoshop and Elements, the last filter used is repeated at the top of the Filter menu so that you can access the filter quickly if you want to use it again in the current session. In both applications, the keyboard shortcut to reapply the most recently used filter is Ctrl+F (⌘+F on a Mac).

The specialized Blur filters — Gaussian, Motion, Radial, and Smart — have their own dialog boxes where you can choose the degree of blurring achieved. The Gaussian Blur filter is the one you'll be using most often because it allows a high degree of control over the amount and type of blur applied. Figure 6-4 shows the Gaussian Blur dialog box and a Gaussian Blur applied to part of an image.

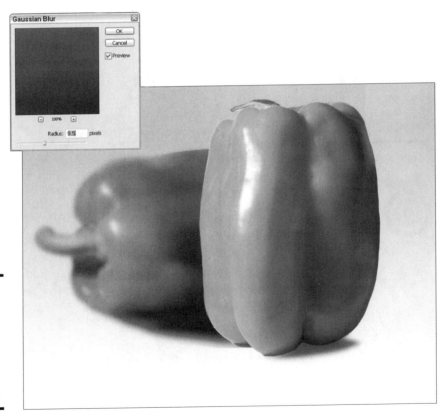

Figure 6-4:
Gaussian Blur lets you apply customized blurs to all or part of your image.

For the Motion blur, you can also choose the direction in which the object is supposed to be moving. Figure 6-5 shows a preview of the Motion Blur effect on an image created in Photoshop using actual photos blended together in a creative way.

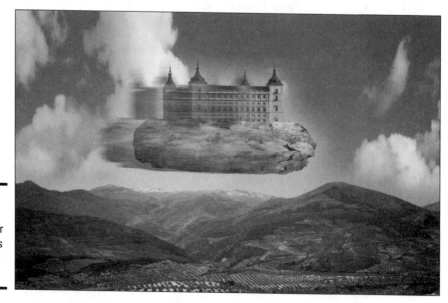

Figure 6-5: Zoom! The Motion Blur filter makes your image take off.

The Radial blur completely distorts everything to which it's applied. If you want to create a background that appears to be spinning around or behind parts of the image, select the content that will remain static and copy it to a new layer. Then apply the Radial Blur to the original layer, which should be placed behind the static content layer. Voilà! Your objects are in the center of a hurricane, but they've not moved a bit. Figure 6-6 shows a fanciful image created in Photoshop from an actual vacation photo I took in London, with the addition of some type and special filter effects.

Sharpen filters

Just as the Blur and Sharpen tools are opposites, so are the Blur and Sharpen filters. They're the same in one respect, though — the filters apply the effect in a uniform way, whereas the tools are entirely dependent on your brush size, mouse movements, and selection to control them. These are the four Sharpen filters:

+ **Sharpen:** This filter has no dialog box. Just choose the command, and a uniform, subtle sharpening effect is automatically applied. You might want to repeat it two or more times if you need more sharpening than it manages to apply in one pass.

Book V
Chapter 6

Restoring and
Enhancing Photos
with Filters
and Special Effects

Figure 6-6:
The Radial
Blur filter
was only
one of the
special
effects
applied to
this image.

✦ **Sharpen More:** This is Sharpen on steroids. The filter applies more sharpening in one fell swoop than the Sharpen filter.

✦ **Sharpen Edges:** This makes the edges, determined by a group of pixels varying in color and light levels from an adjoining group, stand out by sharpening the connecting pixels. If you have content in your image that just fades into its surroundings, this might be the filter for you.

✦ **Unsharp Mask:** Despite its confusing name, this filter does sharpen images. Very similar to Sharpen Edges, this filter adjusts the contrast of edges. This filter is the only Sharpen filter with a dialog box, as shown in Figure 6-7, which you use to control the effects.

Noise filters

Among the Noise filters, the Despeckle and Dust & Scratches filters are the ones you use to retouch photos. You use them to deal with artifacts, such as dust spots or scratches that are distracting or obscure parts of an image.

The Despeckle filter finds the edges in an image and blurs everything but those edges. Although this sounds overly destructive, it can have an interesting effect that blends together parts of an image despite differences in color and texture that existed in the original. This tool is also good at minimizing the halftone screen effects of photos scanned from newspapers or magazines.

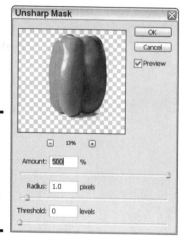

Figure 6-7:
The
Unsharp
Mask filter
can refine
the detail of
any photo.

The Dust & Scratches filter eliminates much of the noise (dust, scratches, small spots) by changing pixels that are very different from their surroundings, making them more similar. You can use the Dust & Scratches dialog box (as shown in Figure 6-8) to adjust the Radius and the Threshold settings, which determine the scope and degree of the effects, respectively. Figure 6-9 shows the results of adjusting these settings.

The steps in using this filter are pretty simple:

1. **Choose Filter➪Noise➪Dust & Scratches from the main menu to open the filter's dialog box.**

2. **Zoom in on the area with the greatest degree of dust and scratch damage by using the Hand tool and the + sign button to get closer.**

The Hand tool appears when you mouse over the preview. This helps you determine whether your settings are doing the trick.

3. **Adjust the Threshold setting by dragging the slider.**

Watch the preview for the desired result to appear.

4. **Adjust the Radius, again by dragging the slider.**

Don't go too far with your Radius adjustment. The image can become so blurry that any details in the photo are indistinguishable.

5. **Click OK to apply the filter.**

**Book V
Chapter 6**

Restoring and
Enhancing Photos
with Filters
and Special Effects

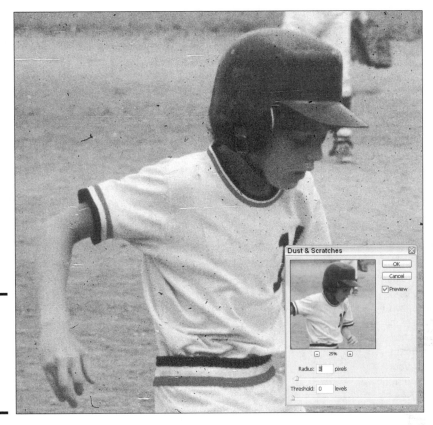

Figure 6-8:
This photo
needs the
Dust &
Scratches
filter in a
big way!

Turning photos into paintings with artistic filters

The filters found in three of the Filter menu's categories — Artistic, Sketch, and Brush Strokes — are not truly restorative or retouching filters, at least not traditionally. However, as more people are either capturing images digitally or scanning prints, their needs and desires with regard to those pictures have become more sophisticated and complex. It's not good enough to just scan a wedding photo and enlarge it for a framed copy on the piano. You might want to make the photo look like a drawing done with pastels or a painting created with oils. For gifts, cards, Web graphics, and interesting marketing materials, you can turn any photo into an apparent work of hand-done art, as shown in Figure 6-10. Here, a photo has been filtered to look like a painting, with soft shapes and a slight texture that mirrors the weave of watercolor paper. I used the Ink Outlines and the Accented Edges filters, followed by a heavy-duty application of the Unsharp Mask filter.

Figure 6-9: Although some details have been softened, most of the dust and scratches have been efficiently removed.

Using artistic filters also performs another important role. If your image is simply beyond repair or beyond your skills or interest level to repair it, you can hide a multitude of sins with the right filter. If your image is scuffed and scratched and you don't feel like dealing with each individual injury, just clean up the most offensive or extreme of the marks and then apply a filter such as Colored Pencil or Dry Brush. This way, you create something entirely new while still preserving the content and history of the original image by hiding the damage that would have normally relegated the image to a drawer rather than a frame.

When you use these filters, you always get a dialog box, such as the one shown in Figure 6-11. Through the dialog boxes, you can customize how the artistic effect is applied — the thickness of the brush or pencil strokes, the frequency of them, how detailed the effect is, the intensity of the effect, and

Book V
Chapter 6

Restoring and
Enhancing Photos
with Filters
and Special Effects

so on. You can select an area before using the filter to restrict the amount of the photo that's affected, or you can apply the filter to the whole image.

Figure 6-10:
Photos become paintings and drawings with the use of artistic filters.

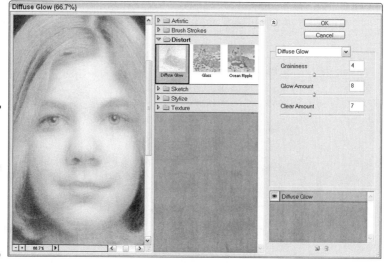

Going a little crazy with special effects filters

The Distort and the Stylize filters (found in both Photoshop and Photoshop Elements) and the Liquify command (found only in Photoshop) are the least conservative effects. These unusual effects change the appearance of some or all of your image by stretching, pulling, or pinching or by mimicking textures and overlays, such as rippled water, glass, or the appearance of the image being ripped apart by a strong wind.

You might be wondering how on Earth you'd use these filters to restore or retouch a photo. Well, you wouldn't. However, you might use them to create an interesting piece of digital art, using one or more of your photos — or to achieve a symbolic look that's suggested, but not artistically realized, in a photograph you've restored traditionally. For example, if you have a photo of someone's boat, it might be interesting to apply the Ocean Ripple filter to the water in the image, and the Wind filter to the boat's sails. That's a bit literal, but you get the idea.

As you work with these filters, their dialog boxes help you control how the filters work their special effects magic. You can change the size of the tiles or cracks in an image, choose which texture to apply, and adjust the degree of pinching or twirling to use. Figure 6-12 shows the Emboss filter dialog box (one of the Stylize filters), featuring the settings you can adjust to create a very interesting relief map of your drawing. Check the preview window as you drag sliders and enter values. When you like the results, click OK, and they are applied to your image or a selection within it.

**Book V
Chapter 6**

**Restoring and
Enhancing Photos
with Filters
and Special Effects**

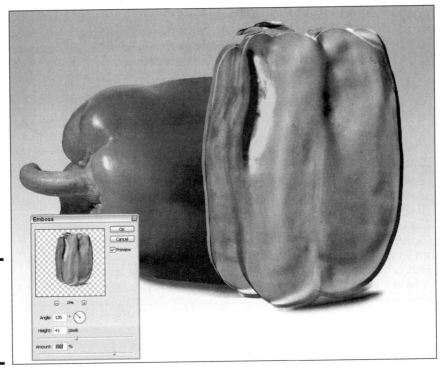

Figure 6-12:
Emboss is
one of the
filters that
provide a
3D effect.

For a brief description of the more creative filters, check out the following:

✦ **Texture filters:** These filters apply artificial textures to your image. Figure 6-13 shows Stained Glass (top), Craquelure (middle), and Grain (bottom) applied to different sections of a single image, purely for demonstrative purposes.

Use the Texturizer filter (found in the Texture category) to apply textures, such as Canvas, Sandstone, and Burlap to your photo. These textures make a photo look like it's printed on very textured paper or some sort of fabric.

✦ **Distorting filters:** These filters manipulate the apparent shape of your image content, as shown in Figures 6-14, 6-15, and 6-16 where the Ocean Ripple, Pinch, and Glass filters have been applied to the same photo. By creating an apparent shape to the surface of the image, the content looks as though it's being viewed through some sort of distorting lens, or as though the photo exists within a substance, and not simply on paper or a computer screen.

Figure 6-13:
Stained
Glass (top),
Craquelure
(middle),
and Grain
filters
(bottom).

Figure 6-14:
Ocean
Ripple filter
applied to
an image.

Book V
Chapter 6

**Restoring and
Enhancing Photos
with Filters
and Special Effects**

Figure 6-15:
Pinch filter
applied to
the same
image.

Figure 6-16:
Yet another
variation
using the
Canvas
option of the
Glass filter.

✦ **Stylize filters:** This category is sort of a hodgepodge of filters that don't really fit anywhere else. With names like Emboss, Glowing Edges, Solarize, and Wind, you'd be hard pressed to find a more descriptive yet nondescript name for them. As shown in Figure 6-17, I applied the Wind filter to the pepper at the left, and Glowing Edges to the pepper at the right. The results are extreme and might go beyond your intentions for dealing with digital photos. On the other hand, these examples might inspire you to create something unique.

✦ **Liquify:** This is a command on Photoshop's Filter menu, but it isn't really simply a filter. Instead, it's a miniprogram of its own that gives you a full set of distorting and manipulative tools for pinching, twisting, scrunching, pulling, bloating, shrinking, or doing just about anything that sounds like some form of torture to your image. Figure 6-18 shows the Liquify window and some distortion in progress.

Don't hesitate to mix and match with filters. Apply one, then another, then another after that. Stacking their effects can give you unexpected and often quite beautiful results. Don't be afraid to experiment with different combinations!

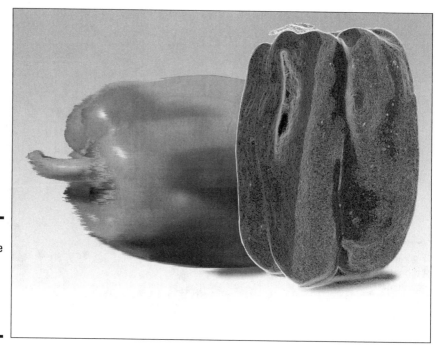

Figure 6-17:
Here are the Wind filter (left) and Glowing Edges filter (right).

Book V
Chapter 6

Restoring and
Enhancing Photos
with Filters
and Special Effects

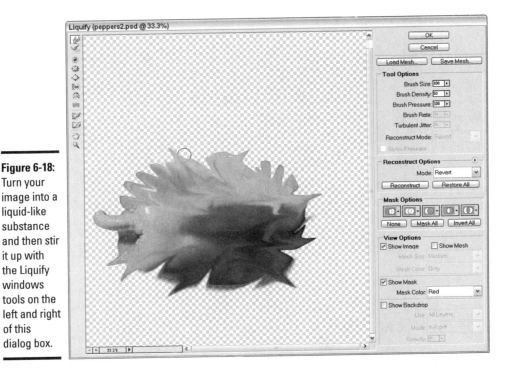

Figure 6-18:
Turn your image into a liquid-like substance and then stir it up with the Liquify windows tools on the left and right of this dialog box.

The Photoshop Elements' Effects Tab Palette

Very similar to filters, Photoshop Elements has a list of effects that you can apply to some of or your entire image. The Effects are actually canned applications of Elements' filters in predetermined ways. Watch the status bar at the bottom of the screen as an Effect is applied to see the names of the filters used as they are added in turn. You can view the effects in the form of a list, or as a series of thumbnails, as shown in Figure 6-19. The effects can either be applied to a selection within your image or to the entire active layer.

To switch between List and Thumbnails views of the Effects palette, click the More button at the upper-right corner of the list and make a choice from the menu that appears.

If you choose to view the effects as a list, you see additional effects that apply only to text (the word *Type* appears next to them). These allow you to create type that looks like wood, chrome, glass, pipe, or just about anything you can imagine. Figure 6-20 shows the List view of the Effects palette, and a Type effect selected.

Figure 6-19:
View the
vast array of
Photoshop
Elements'
Effects that
you can
apply to
your image.

Figure 6-20:
View the
Effects as
a list, and
access
Effects
intended
for use on
text only.

Book V
Chapter 6

Restoring and
Enhancing Photos
with Filters
and Special Effects

Displaying and moving the tab

The Effects palette is normally docked at the right side of the Photoshop Elements window when the Palette Bin is visible; if you click the tab, you can display the palette with its top still docked. If you want to move the palette around, you can simply drag it away from the Palette Bin by grabbing the tab with your mouse. You can move it anywhere on the workspace, and even minimize it in place by clicking the Minimize (–) button to shrink it to just a title bar. When you want to use it again, click the Maximize (X) button. You can also close the Palette by clicking the triangle on the left of the tab.

Applying an effect

After you understand how to see either the thumbnails or list of effects, and you know how to manipulate the Effects palette (see the preceding sections), you can apply these cool effects to your photo and text. Just follow these steps:

1. **Select the portion of your image to which you want the effect to apply.**

 If it's text, make sure that the Type layer in question is active and double-click the Type icon on the layer to select all the text on that layer.

2. **Display the Effects palette.**

 If you want to apply an effect to your image (not to text), drag the desired thumbnail onto your image. After a delay — how long a delay depends on your available system resources — the effect is applied to the image. If you have part of your image selected, drag the thumbnail into that selected area. You'll get an effect like the one shown in Figure 6-21, in which I applied Psychedelic Strings to the background.

If you want to apply a Type Effect, remember that you have to be in list view to see those effects. When you have the effect in view, either drag it from the list onto your Type layer or click the Apply button while your type is selected.

Click the drop-down list in the upper-left corner of the Effects palette to choose from different effect groups — Textures, Frames, Text Effects, Image Effects — to be displayed alone. The default setting for this drop-down list is All, which shows all the available effects. Choosing one of the groups in the drop-down list distills the displayed set down to just that group.

Figure 6-21:
Photoshop
Elements'
Effects are
an easy way
to apply
canned filter
transforma-
tions.

Getting Your Hands on Third-Party Filters

To find third-party filters for Photoshop (many of which work with Photoshop Elements as well), simply do a search online for *"filters for Photoshop."* Be sure to use the quotation marks to restrict your search to sites that contain that exact phrase. Otherwise, you'll find sites pertaining to filters (for coffee, oil, air), and sites pertaining to Photoshop but not to filters. Of course the first few will pertain to both, but you'll have to wade through some losers, which is good to avoid.

The Web is a great place to find other Photoshop products, such as *actions* (automated series of procedures that create special effects at the click of a button), brush sets, and pattern sets. Do a search for *"Photoshop add-ins"* or *"third-party Photoshop tools,"* and you'll get an ever-growing list of sites where you can download all sorts of cool stuff — usually for a fee, but some-times for no charge. Figure 6-22 shows the kind of looks you can get from non-Adobe filters.

Book V
Chapter 6

Restoring and
Enhancing Photos
with Filters
and Special Effects

Figure 6-22:
Many amazing filter effects for Photoshop and Elements are available from non-Adobe sources.

In addition to searching the Web, you can find interesting filters and other stuff by poking around these sites:

✦ **Alien Skin Software,** found at www.alienskin.com, makes Eye Candy 4000, Xenofex, and Splat! plug-ins. Its three-pack (of all three programs) retails for $299. Eye Candy 4000 alone costs $169.

✦ **Auto FX's DreamSuite,** found at www.autofx.com, has two Series products. Series One provides special effects for graphics, text, and photos, and these effects are all easy to use. Series Two has features that allow you to turn your photos into puzzles (great gift idea for family photos, or as a promotional item for clients), plus 11 other special effects. Series 1 retails for $199, and Series 2 for $149.

✦ **Andromeda,** at www.andromeda.com, offers several different filter sets, including light-scattering filters, lens filters, screen and mezzotint filters, outlining and woodcut filters, and special focus filters, ranging in price from $30 to $95. Andromeda also makes Velociraptor, which is a filter that puts trails on image contents, giving the objects the appearance of movement that's sort of a Photoshop fireworks display.

The variety of filters is quite wide, from conservative yet cool effects to real psychedelic experiences.

A *plug-in* is a piece of software that adds to an application, expanding its capabilities. Check out www.photoshopuser.com, the official Web site of the National Association of Photoshop Professionals (NAPP). Their site lists lots of plug-ins, providing links to their manufacturers, and ratings of the various products so that you can avoid downloading any lemons. The association also offers other goodies. I'm a member, and their magazine is great. Your membership fee entitles you to subscribe to the magazine for just $10 a year and to attend seminars and training. You also get advance notice of Photoshop-related events.

Book VI

Restoring Old Photos

The 5th Wave · By Rich Tennant

"Jeez—that's impressive! Let's see that airbrush effect again."

Contents at a Glance

Chapter 1: Scanning Print Images

In This Chapter

✔ **Preparing your originals**

✔ **Selecting resolution**

✔ **Choosing other scanner controls**

*I*f you're a beginner to scanning, you basically have three ways of scanning a color or black-and-white print: You can do it quickly, you can do it easily, or you can produce a high-quality digital image. If you're new to scanning, you can probably choose the fast route, do things the easy way, or tediously create the best quality scan you can. If you want your scanning experience to be all three (fast, easy, and aesthetically satisfying), you need to read this chapter.

Modern scanning software helps you make the right decisions as you capture images from prints, but you still need to know what you're doing and what questions to ask yourself before you start. For example, what resolution do I use to scan a particular image? What other settings do I need to make? How can I scan problem prints with stains, scratches, bad color, or other defects?

Getting good scans is worth a book in itself — indeed, I've written nine scanner books since 1990, including one just on scanning transparencies and negatives. But this chapter provides you with the basic information you need in order to grab good-looking images from prints, without hassles, 99 percent of the time. Whether you're restoring photos or planning to incorporate scanned prints into digital photo images, you can find what you need here. You'll find more information on fixing scanned old, blemished, or faded photos in Book V, Chapters 4 and 5.

Prepping an Image for a Scan

The first thing to do before making a scan is to prep your original. Although you might not have a lot of control over the artwork you need to scan, you can still do some things ahead of time to improve your chances of success. Here are a few tips:

✦ **Start with the best available original.** Don't use a copy print, if you can avoid it. Use a print that's been made recently from the original negative. Older prints are sure to have some scratches, or their colors might have aged over the years. You might even want to scan from the original negative or slide instead of a print. (See Book VI, Chapter 2, for information on scanning transparent originals.) However, as long as you're scanning from a print, use the newest and best print you can find. If the print is housed in an album, frame, or cardboard display, carefully remove it before scanning. If removal will damage the picture, um, don't.

✦ **Start with the largest print that fits on your scanner.** If you can choose between a 4 x 6" print and a 5 x 7" print, use the larger print. Because of the grain of the color emulsion in the print, a larger version is likely to be sharper and, more importantly, have a longer *tonal range* — the range of colors from very lightest to very darkest. An 8 x 10" print might be even better, but there is a point of diminishing returns. An 8 x 10 might not be any sharper or better; it might simply show the grain of the film in a larger form, particularly if the print was made from a 35mm negative taken with an inexpensive camera. In addition, some scanners are known for having uneven illumination at the edges of the scanning area. A 5 x 7" print centered in the scanning glass won't suffer from this defect; an 8 x 10" print can't avoid it.

✦ **Clean the print and your scanner glass before you scan.** If you scan a dusty print, like the one shown in Figure 1-1, or if dust is on the glass plate or scanning bed of your scanner, you end up with an image that has dust spots that you must remove in your image editor. Dust the print carefully with a cloth, and use Windex and compressed air on your scanner's bed.

✦ **Make sure the image is aligned properly on the scanner glass.** If you scan a print that's rotated slightly, you can always straighten it out in your image editor. Of course, you lose some quality, particularly when straightening horizontal and vertical lines that could have been scanned with proper alignment in the first place. Some scanner software actually can straighten skewed pictures for you, but you want to avoid that feature when possible. The straightening uses the edges of the photo for reference, and that might not coincide with the correct orientation of the image (if the picture itself was printed skewed, for example).

Lining up images when they're face down on the scanner glass is tricky. Sometimes I hold the print up to the light and draw a straight line with a pencil on the back of the print. Then I can make sure the line is parallel to the top edge of the scanner glass so that the image in the photo is perpendicular to the direction of the scan. Hewlett-Packard has helped this problem by introducing a scanner with a transparent lid: You can see exactly how the print is aligned when you close the top.

Figure 1-1:
Dust off
your prints
before
scanning!

Working with Scanner Settings

When you're ready to scan an image, you find an array of settings, and this section is here to guide you through them. Setting the resolution probably gets the most attention, but your scanner likely has other settings — such as interpolation, sharpening, blurring/descreening, and halftone — that might also help you get the best possible scan. Read on to find out what these settings do, when they're useful, and how to set them.

Choosing a resolution

What's the best resolution to use for a particular scan? Note that this is very different from the question, "What's the top resolution I want for my scanner?" The thing is, the top resolution available in any scanner is unlikely to be of much use to you, and the figures the vendors provide don't really tell you much about the image quality you get at a given resolution, anyway. (For more on the sordid tale of how scanner manufacturers play with resolution numbers, see Book II, Chapter 4.)

Even so, particular tasks have recommended resolutions. Unless you're working with a special image, you probably want to keep within the guidelines that I lay out in this section.

Why not simply use the highest resolution of your scanner at all times and be done with it? The following lists reasons why this is a dumb idea:

✦ **Too much resolution wastes valuable hard disk space.** A 4 x 5" image scanned at 200 samples per inch (*spi* — the number of points in the image captured per linear inch) has 800,000 pixels and can be up to 6.4MB in size (with the image compression provided by file formats such as TIFF and JPEG; the actual size on your hard disk is likely to be smaller). Scan the same image at 2400 spi, and you can end up with a 76.8MB file! It wouldn't take long to fill up a hard drive with those babies; even if you archived them to a CD-ROM, you'd be able to fit only ten images on the CD. At 200 spi, you can pack 125 images on the same CD.

Printers measure resolution in dots per inch (dpi), and scanners measure it in samples per inch (spi).

✦ **High-resolution (res) images take a long time to scan.** Depending on your scanner model, you might be able to scan that 200 spi image in ten seconds or so, but you're sure to wait for two or three minutes when scanning the same photo at 2400 spi.

✦ **High-resolution scans of prints don't contain any useful information.** This is the most important consideration, when you get right down to it. When you scan at a resolution higher than you need, all you're capturing is the grain of the paper (see Figure 1-2) or perhaps the film used to make the print. You're also getting beautiful close-up details of any scratches and dust on the original film plus any dust you forgot to remove before you scanned.

Also keep in mind that you actually need to consider three different resolutions:

✦ **The resolution of the scanner that captures the image:** I cover scanner resolution in this chapter.

✦ **The resolution of the display device that shows the image in your image editor:** Display resolution isn't something that you can do much about. You're probably working with a 17–19" color monitor and have the display resolution set to anywhere from 1024 x 768 pixels to (as in my case) 1920 x 1440 or thereabouts.

✦ **The resolution of the output device, such as a printer that you'll use to reproduce the image:** The resolution of the output device, such as a 600 dpi laser printer, a 1440 dpi inkjet, or a high-resolution image setter, can affect the resolution you scan at. The higher the resolution of the output device, the more of your scanner's resolution that you can actually put to work.

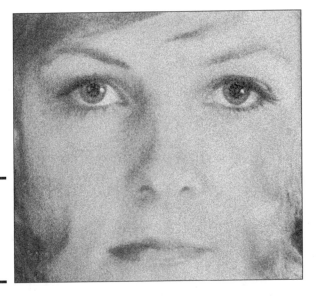

Figure 1-2:
High resolution can just highlight the grain.

Here are some guidelines for choosing a resolution for the two most common kinds of scanning tasks.

Line art

Line art includes black-and-white or color drawings comprising only solid lines, dots, or other strokes, with no shading. Artwork that has already been printed, such as photos clipped from publications, also qualifies as line art because although such images might look like photographs, they're actually composed of black and white halftone dots.

Line art can usually be scanned effectively at the same resolution that you'll use to print the image, or a fraction of it. If a 600 dpi laser printer outputs an image, use 600 spi. If you'll be using a 1440 dpi inkjet, consider using 720 spi (or something close). Doing this allows a 1:1 (or 4:1, if you halve the output device's resolution to make your scan) correlation between scanned pixels and printed dots. This reduces the chance of the stair-step effect known as *jaggies*. A 3200 spi scan is shown in Figure 1-3.

Why not use 1440 spi when outputting to an inkjet printer? You'll find that the extra detail isn't needed, your image file is four times as large (compared with a lower resolution), and your file takes longer to print. However, if you're scanning something that really does have fine details and is so small that you can avoid mega-file sizes (postage stamps and other small engravings are the classic example), you can use the higher resolution.

Figure 1-3:
High-res
scans
of line
art can
provide
sharp
images.

Black-and-white and color photos

Black-and-white and color photos are known as *continuous tone* images because they contain a full range of tones from very light to very dark as well as all the shades in between. Photographs are a whole different ball-game compared with line art.

As you scan photos, choose a resolution based on two factors: What do you plan to do with the photo, and will you be manipulating it in an image editor? Do you plan to enlarge it? For example, a print destined for a Web page might look just fine scanned at 75 spi because 75 spi is all you need for screen reso-lution. The same original scanned for reproduction using a printer should be scanned at around 150–200 spi. If you intend to manipulate the photo in your image editor or reproduce it at a size that's larger than the picture's original dimensions, use a higher resolution: perhaps 300 spi. Notice that none of these recommendations approaches the 1200–2400 spi top resolution of most scanners. High resolutions simply aren't required for photographs.

Most image editing books and even some scanning books provide you with arcane formulas that you can use to calculate scanning resolutions for photos. These are usually based on the *halftone frequency* (the number of lines of halftone dots per inch in the "screen" used to create the halftoned version of your photograph). These formulas are needlessly complex. Who, other than professional photographers and other pro graphics workers, actually

knows whether a photograph will be printed using an 85-line screen or a 133-line screen or some other frequency?

Today, digital photographers don't have to worry about these details. The halftoning is automatically handled by the printer driver that resides in your computer, and you don't need to know much about what's happening. If you scan a photo at 150–200 spi (or up to 300 spi if enlarging it), you'll get good results most of the time. The real pitfall is scanning at too high a resolution, which wastes your time and hard disk space. Your concern will probably be more on how to remove moiré effects, which I discuss shortly.

Many newer scanners can actually calculate an optimal resolution for you. You tell the scanner software what type of destination your image is intended for (Web page, laser printer, imagesetter, and so forth) and select a size for the image (50%, 100%, and so forth). Based on this information, the scanner then chooses the right resolution for you.

**Book VI
Chapter 1**

Scanning
Print Images

Interpolate, schmerpolate

I might as well tackle the topic of interpolation because you're going to e-mail me and ask about it anyway. Questions about scanner interpolation are the second-most common (after resolution) queries that I have received in the last decade.

Interpolation isn't limited to scanners, of course. You think so only because scanner vendors like to trumpet their products' interpolation prowess in their specifications lists. *Interpolation* is a process used to create new pixels anytime an image is made larger or smaller or changed to a color depth other than the one at which it was captured.

Photoshop uses interpolation all the time. If you enlarge or reduce an image, Photoshop has to create more pixels (when you enlarge) or fewer pixels (when you reduce) to represent the same image. Photoshop also needs to come up with a new set of pixels when you change an image from, say, 24-bit, full color to 8 bits and 256 colors. Within Photoshop, interpolation is almost always a bad thing (even if it's a necessary thing) because you always lose some quality when your image editor obliterates real, actual pixels and replaces them with best-guess estimates. You should, therefore, try to retain your image at its original resolution (such as the resolution it was taken at with your digital camera) until you absolutely have to resize it. And always keep an unedited version of the file to fall back on, should you need to!

Sometimes, the term *interpolation* is reserved for making larger images from a given resolution. You'll see the term *downsampling* used for the type of interpolation used to produce a smaller image. I'm not particularly fussy about terminology that's not often used correctly anyway, so I use interpolation to mean both enlarging and reducing images or scans.

When scanning, interpolation isn't quite as evil because the scanner is working with the original image and can avoid some of the quality loss that plagues your image editor.

Some sort of scanner interpolation takes place whenever you scan at anything other than the native resolution of the scanner. That means if you're using a 1200 spi scanner and scan at 2400 spi, the scanner actually captures 1200 samples per inch but creates 1200 new pixels to make the resolution seem higher. The same scanner at 300 spi must figure out which 300 pixels per inch best represent the full 1200 spi scan.

Actually, when scanning in even fractions or increments of the scanner's optical resolution, the results are usually quite good. The problems start when you try to scan something at 5000 spi or 332 spi.

As the scanner interpolates an image, it doesn't simply duplicate pixels (say, doubling all the pixels in a 1200 spi scan to produce a 2400 spi image) or throw away pixels (to create a 600 spi scan). Instead, the interpolation algorithm examines the pixels surrounding the new pixel and produces one with characteristics that closely match the transition between the pixels. That is, if one pixel is dark gray and the next pixel is light gray, a medium gray pixel is created to insert between them, as shown in Figure 1-4.

Figure 1-4:
Interpolation examines the pixels in the top line and creates the new pixels in the bottom line.

Interpolation is not all smoke and mirrors. A good interpolation algorithm can accurately calculate the pixels that would have been captured by the scanner if it had been able to scan at the interpolated resolution used. That is, you do get additional information through interpolation. However, there are diminishing returns. A 9600 x 9600 spi interpolated image is not eight times as sharp as one scanned at a true 1200 spi resolution.

Following are the most common interpolation algorithms, which have official names:

✦ **Nearest Neighbor:** With the Nearest Neighbor algorithm, the new pixels are created by examining the nearest pixel in the position where the new pixel will go. This works fine with line art, where the pixels change in easily predicted ways. However, the method doesn't allow for the fine and random gradations of tones found in photographs.

✦ **Bilinear:** This algorithm examines the pixels on either side of the target pixel and produces better quality images than the Nearest Neighbor method although it is a little slower.

✦ **Bicubic:** The slowest commonly used method is also the best. Bicubic resampling uses sophisticated formulas to calculate the new pixel based on the pixels found above, below, and to either side of the new pixel.

Photoshop CS added two new interpolation options: Bicubic Smoother and Bicubic Sharper. These can be used to fine-tune the most popular interpolation algorithm, making it (you guessed it) either smoother or sharper than the unadorned Bicubic version.

Sharpening

You might think of sharpening as a way to increase the resolution of an image without boosting its file size. That's not exactly true. All scanners include optional sharpening routines to enhance images as they are scanned. (In most cases, leaving this feature turned on is a good idea.) Sharpening actually only increases the apparent resolution of an image by increasing the contrast between pixels, but it works very well.

In use, a scanner's sharpening routines examine squares of pixels that are, say, 5 pixels on a side. Depending on the values of the other 24 pixels in the square, the scanner might (or might not) darken or lighten the center pixel to increase the contrast between that pixel and its neighbors. If the scanner determines that there is a significant difference in contrast between the center pixel and its neighbors, it can increase the contrast even further, making the pixel look sharper, at least in relation to its neighbors. The sharpening algorithms look at every pixel in an image as it relates to its neighboring pixels and increase the contrast as appropriate to enhance the sharpness. Pixels that are included in "edges" in your image are lightened or darkened to make them more distinct, as shown in Figure 1-5.

Because sharpening brings out details that are present in an image but that the scanner can't see otherwise, sharpening really can enhance the apparent resolution of the final image. That's why sharpening in the scanner is probably useful when making most scans. Don't overuse it with photographs, however, because the extra contrast can be objectionable.

Figure 1-5:
Higher
contrast
(right) can
equal extra
sharpness.

Blurring/descreening

The opposite side of the sharpening coin is a common scanner feature called *descreening*. Descreening is used when you scan an image that has already been printed and that contains halftone dots, such as those found in newspapers, magazines, yearbooks, and other publications. The process blurs the image slightly, by reducing the contrast between the edges (in this case, the dots) and tends to make the halftone dots merge together. In practice, I've found that descreening settings in most scanners tend to overdo the blurring, and you can get much better scans of halftones by doing the blur yourself in Photoshop cs or another image editor, as shown in Figure 1-6. Descreening can also help you avoid the *moiré effect* (an objectionable pattern caused by interference between the arrangement of the original halftone screen and the pixels in the scanned image).

Knowing when to halftone

Scanners sometimes have a halftone setting that lets you apply the halftone dots at the time the scan is made. If you know what size your printed image will be and what device will print the image, you can specify a halftone pattern that the scanner can apply.

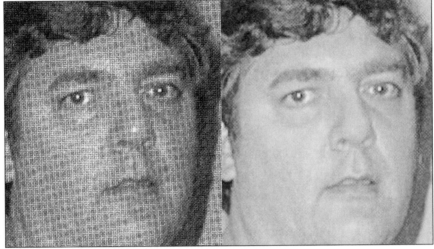

Figure 1-6:
You can usually produce better descreened halftones, like the one at right, in your image editor.

This is generally not a good idea, and most scanners don't support this feature anymore. Because all the continuous tone information is lost, you can't edit the image or scale it to a different size.

You can also apply the halftone dots in your image editor. Photoshop lets you apply various dot and dithering schemes, and this might be the choice of sophisticated users who know exactly what they want and need. This was even a good idea back when printers could reproduce only 300 dpi.

In most cases, however, simply letting your printer apply the halftone dots is best. Laser printers today usually have resolutions of 600 dpi and up, and they have a lot more dots to work with when creating halftone dots (360,000 per square inch with a 600 dpi printer versus a mere 90,000 dots per square inch with a 300 dpi printer).

Other scanner controls

When you're scanning prints, other controls at your disposal might include automatic and manual exposure controls, fancy charts called *histograms* that let you compensate for tonal variations in your photos, color-correcting tools, or even a *densitometer* that lets you measure precisely the lightness, darkness, and color values of your image before you scan. Which of these should you be concerned with? Some controls actually duplicate similar features found in your image editor. How can you decide? Here are some guidelines:

✦ If you're in a big hurry and only need to scan a couple photos, use your scanner's automatic features and don't worry about fine-tuning your scan. You can do that later in your image editor.

✦ If your original image is of good quality, your scanner's auto settings will work well. You might not even need to make corrections in your image editor.

✦ If quality is very important and your original is a difficult one, use your scanner's controls to get the best original image possible because a good scan enables you to get better results. For example, color correction in an image editor can never add colors that are missing from the scan. However, you might be able to make adjustments with the scanner to grab those colors when the image is captured.

✦ If you're scanning a group of images with the same problems, it often makes sense to use your scanner's controls to correct the problem once and then scan each successive image using the same settings. Applying the same tonal or color corrections to a large group of images in an image editor can be tedious.

✦ Your scanner might have controls not found in your image editor. For example, my scanning software has Image Type controls that I can use to precisely set the exact type of image being scanned. My choices include Evening, Landscape, Skin Tones, Night, Snow, and Shadow. The scanner has built-in settings for those types of photos, and I can choose an appropriate image type to apply the settings before I ever make a scan.

✦ You want to use automated features that make your scans go faster. For example, my scanning software has choices for output resolution that include Newspaper, Magazine, Art Print, Photo Print, and others. I can choose a destination and let the software choose the resolution for the scan.

A great deal of your flexibility depends on the scanning software you use. Some scanning applications are fully automated, which means they collect information during a prescan and then determine the kind of image (that is, a color photo, grayscale photo, or line art), the proper exposure, and even what resolution to use. Other software lets you make these settings yourself.

I like to use automation when it is likely to give me a good scan as long as I can use manual settings when I need to. For example, my favorite scanning software lets me choose a color filter to scan through. That's a great tool for removing stains from a spoiled black-and-white photograph.

For example, if there's a greenish stain on the photo (who knows where *that* came from?), I can choose to scan through a light green filter. The green stain is invisible to the scanner through the green filter, so the stain fades away. (The filter is simulated by manipulating the red, green, and blue information of a full-color scan.) Meanwhile, the details in red and blue are made darker and more visible. This works because the light green filter blocks only some of the red and blue. (If it really let only green light through, the red and blue tones would appear as black.)

Or, I might have a page with blue ledger lines and faded reddish text, as shown in Figure 1-7. I can use a light blue filter to make the lines vanish, simultaneously making the reddish text darker because the blue filter passes all the blue light but blocks some of the red (and green). This technique is great for scanning legal and family records, deeds, and similar documents.

Scanner controls can save your bacon if you know how to use them effectively.

Figure 1-7:
The blue
lines are
diminished
while the
reddish text
is darkened
in the
bottom
version.

Chapter 2: Restoring Images Captured from Slides, Negatives, and Other Formats

In This Chapter

✔ **Preparing your originals**

✔ **Selecting resolution**

✔ **Choosing other scanner controls**

*W*ith the introduction of film scanners for $200–$300 in the past year or so, slide and negative scanning has finally come of age. If you have a collection of 35mm slides or come across a treasure trove of family negatives, you can now bring them into the digital realm easily and inexpensively. Although film's days as a primary snapshot medium are numbered, there's no reason why you can't enjoy working with your film-originated photos in your image editor.

Scanning old photos, slides, and negatives is a great way to preserve and share your family history, especially when you restore the images using the techniques described in the next chapter and elsewhere in this book. Your great-great-great grandchildren will love you for it!

Of course, scanning prints and other opaque documents (or *reflective originals*) is far more common than scanning transparent originals, such as slides and negatives. In fact, most scanners can't handle anything but reflective originals. Sometimes, however, your only copy of an image will be a transparency or negative. Other times, you might have both a hard copy reflective original and a transparency or negative film version, but the film is a better choice for scanning because film is usually in better condition and contains all the information originally captured. (You find out the difference between reflective and film originals in the "Types of Originals" section later in this chapter.)

Scanning film is not quite as intuitive a process as grabbing an image from a print. You can't slap the slide or negative down on the glass and press a button to begin scanning. Some of the same prep work I describe in Chapter 1 of this mini-book is necessary, and you have additional considerations to think about as well. This chapter helps you put slide and negative scanning in perspective and offers some tips for getting the best results.

Film and Photography

Although film has long been a key part of the photography process, the casual snapshooter has never given film much thought ever since the late 1960s. For the last 30 years, a sparkling color print for sharing or display has been the main goal of amateur photography, and film has been just a means to an end. As proof, consider your own pre-digital photographic work. You've probably got prints filed away in albums and other prints in frames on your piano or over the fireplace. There are prints in your wallet and perhaps a few stuck to your kitchen appliances with magnets. The prints you aren't using right now are probably stacked in shoe boxes. But do you have any notion at all where the *negatives* used to make those prints are?

Of course you don't, despite the valiant efforts of film manufacturers and photofinishers to provide you with film storage envelopes or, in the case of the Advanced Photo System, permanent archiving in the same cassette used in your camera. Unless you're the fastidious type, when you want a reprint of a favorite picture, you probably take a print down to your finisher and have a copy made. Film is pretty useless, right?

Actually, film made photography as we know it possible. Until George Eastman introduced the first commercial transparent roll film in 1889, amateur photography was a daunting hobby indeed, pretty much limited to dry plates and other clumsy media that ordinarily only a professional photographer would be willing to mess with. For the hobbyist, photography was a daunting and potentially expensive hobby.

Black-and-white negative film made it possible to produce compact and more affordable cameras that anyone could use. By 1936, color photos (in the form of Kodachrome slides) became feasible, and in 1942, Kodacolor film for prints made the modern color snapshot possible. Is it a coincidence that the modern refrigerator, now universally used to display these prints, was invented at roughly the same time? I don't think so.

Amateur photographers used a mixture of color slides, black-and-white film/prints, and color film/prints to capture their memories for several decades until automated low-cost color printing in the '70s (and the ubiquitous mini-lab in the '80s) finally relegated both color slides and black-and-white prints to the professional photographers and serious amateurs.

Why scan film?

If you still shoot film regularly, you'll find lots of good reasons to shoot either slide film or print film and then scan the respective positives/ negatives. Slide film — for the creative control it offers you — is the choice of professionals for a reason. What you shoot is what you get. When you shoot color negative film, the prints you get might vary significantly from what you saw through your viewfinder. For example, if you deliberately underexpose a shot to produce a silhouette effect, the automated printing system at your photofinisher will try to thwart your creative efforts by pumping extra light on your print. Instead of a silhouette, you get a washed-out image with highlights that are too bright. The figure here shows a typical image that's suffered these vagaries. You can see the tower better in the lower version, but it's not the dramatic silhouette that the photographer pictured.

Or maybe you took a picture at sunset and are surprised when the reddish colors you remember are printed a little bluer than you'd like by the automated machinery. And try as hard as you like, Kentucky bluegrass is going to come out green.

However, when you shoot slide film, what you see is what you've got. If the film is processed well and if you were using the proper film for the lighting conditions, your image appears exactly as you composed and focused it. You can then make your scan and get the exact picture you've visualized.

All this fuss probably makes you realize exactly how great digital photography is: You can take pictures the way you want them and never have to worry about your photofinisher messing with your vision. In one sense, slide film is the closest thing to digital imaging we've got. Transparencies can make a valuable complement to digital cameras for photographers who want the most versatility in their image-capturing options.

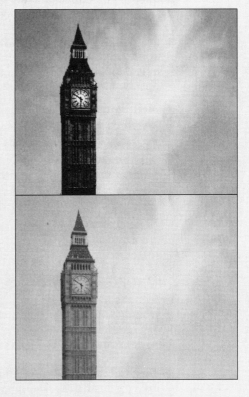

**Book VI
Chapter 2**

Restoring Images
Captured from
Slides, Negatives,
and Other Formats

Today, if you take pictures, you either use a color print film (and end up with prints) or work with a digital camera (and end up with electronic images and prints). If you have slides or negatives to scan, you probably are a serious amateur or professional photographer or need to convert an older stash of film originals to digital form.

Scanning Options

If you want to scan transparencies or negatives, you have four primary options (ignoring the truly professional alternatives, such as drum scanners, which aren't available to the amateur digital photographer). I list them in order of descending quality.

Let the pros do it

Your photofinisher is equipped with high-resolution scanners that can convert your slides or negatives to a digital format. They can deliver the finished product to you on a high-resolution Kodak Photo CD or a lower-resolution Kodak Picture CD. Going this route is a good idea for several reasons:

✦ **No equipment to buy:** If you have an archive of film originals to convert and don't plan to scan slides or negatives on a regular basis, you'll find it economical to use your photofinisher's equipment and personnel instead.

✦ **Better quality:** The pros have better equipment than you're likely to purchase and can give you better overall quality.

✦ **Less time:** I scan slides and negatives all the time. It's time-consuming. After you've spent most of an afternoon scanning 30 or 40 slides, you'll wonder why you ever wanted to do the job yourself.

✦ **Lower cost:** Unless you have a ton of film originals to scan on a continuing basis, it will take you a very, very long time to amortize the cost of a good slide scanner compared with the small fee your finisher will charge for each scan.

Buy a slide scanner

Dedicated slide scanners are high-resolution devices designed specifically for scanning slides, transparencies, and negatives. With the new breed of inexpensive film scanners, just about anyone can justify one of these beasts. There are some advantages to choosing this method, too:

✦ **Customized quality:** Although your photofinisher will give you standardized results that look good, you might want to scan a particular original in a particular way to produce the exact image you want. Perhaps the information in the highlights is most important, and you don't care whether the shadows go black. Perhaps you want to scan only a particular portion of the original. If you have your own slide scanner, you can customize your scan to meet your own creative needs.

Do-it-yourself limitations

You'll probably run into some limitations when scanning film yourself using an inexpensive slide and negative scanner or when using your flatbed scanner. Here are a few things to keep in mind:

✔ **35mm only:** The least expensive dedicated film scanners handle only 35mm and smaller film formats. If you have 620/120 roll film or sheet film, like those used in old box and view cameras, twin-lens reflexes, or even "press" cameras, you won't be able to scan it yourself. Film scanners that work with larger sizes typically cost $1,000 or more.

✔ **Size limitations:** Even flatbed scanners that can capture film can probably scan only limited sizes. Perhaps your unit can accommodate up to 2¼" wide film (6cm) but no larger. If you're lucky, you may have a flatbed that works with 4 x 5" or 5 x 7" sheet film.

✔ **Dust busting limitations:** More expensive scanners use a sophisticated feature called Digital ICE to remove dust from film. This hardware/software combination is actually able to discern dust spots on film and remove them without degrading the rest of the image. Lower-cost scanners might have some sort of software "dust brush" that actually blurs the image a bit.

✦ **Quicker turnaround time:** I tell colleagues that I scan my own transparencies because of the turnaround time. My scanner sits on a table behind me, so all I have to do is turn around. I can have a scan on my screen in five minutes; if I used a photofinisher, I'd probably have to wait a week to get my results. If you're in a hurry, making your own scans is definitely faster.

✦ **Lower cost for higher volumes:** If you do your own scans, your biggest costs are the scanner and your own time. If you make many scans of slides and negatives over time, your in-house capability will eventually pay for itself if you factor in the time you expend running to the photofinisher. It takes a lot of scans to pay for a dedicated scanner, but serious amateurs and professionals can justify their expenditure more quickly than they realize. (Don't forget the fun factor, too.)

Use a transparency-capable flatbed

Many flatbed scanners come with a slide-scanning attachment (chiefly a light source to transilluminate the originals) and have sufficient resolution and dynamic range to do a decent job scanning slides. This option has a few advantages:

✦ **Lower cost:** There's no expensive dedicated slide scanner to buy. You can find flatbed scanners that can grab decent film images for $300 or so.

✦ **Acceptable quality:** If "good enough" is good enough, you'll find that flatbeds do give you enough quality to work with. You can still do some of the same customization steps with your scanner that make the dedicated slide scanner attractive. Hey, it beats paying a gazillion dollars for a slide scanner, doesn't it?

✦ **Quicker turnaround:** Again, just turn around and scan your slide or negative. No running to the photofinisher.

Figure 2-1 shows a typical scanner with a built-in transparency light source.

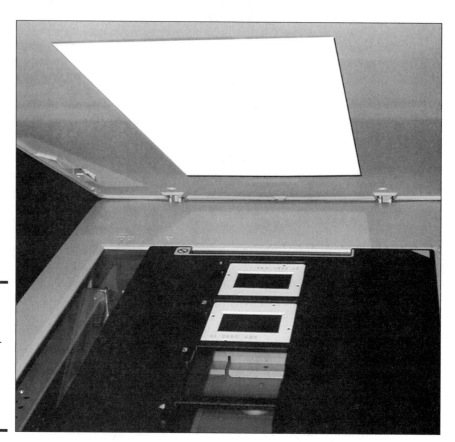

Figure 2-1:
Some scanners have transparency light sources built into the lid.

Try the Rube Goldberg approach

Before I ever had a slide scanner or flatbed with a transparency attachment, I was happily scanning my own slides using my own cobbled-together apparatus. All you really need to scan film originals is a flatbed scanner with high-enough resolution to do a decent job with small pieces of film (probably a minimum of 1200 samples per inch); a carrier of some sort to hold the film or slide flat against the scanner glass while blocking off other stray rays of light; and a broad, even, diffuse white light source.

I don't recommend such arrangements if you plan to do much film scanning, but if you're in a pinch, you might see what you can put together. Rube Goldberg would be proud.

I don't list bullet-point advantages of this approach because other than cost and the sheer joy of the do-it-yourself experience, there aren't any. However, you can try to copy film using your digital camera and a homemade rig if you're very daring. A few camera vendors offer slide-copying attachments for their digital cameras. They can cost $100 or less and give decent results if your expectations aren't high.

**Book VI
Chapter 2**

Restoring Images
Captured from
Slides, Negatives,
and Other Formats

Types of Originals

One reason why you might scan film is that it's the only form of an image you have. You might not have a print at all, or the print you do have might be too small or might have suffered some damage. Scanning even a well-made 4 x 5" print won't yield the same detail you can get from a high-quality scan of an original negative or slide. The original always has more information than a second-generation copy, such as a print.

To successfully scan film originals, you need to understand the differences between prints, negatives, slides, and transparencies. I summarize them in this section.

Prints

You already know about scanning prints if you used the tips in Chapter 1 of this mini-book. However, it's useful to go a little deeper into prints (so to speak) so that you can better understand the challenges that film originals present.

Prints consist of color dyes (or a black-and-white emulsion in the case of monochrome prints) coated on a substrate of paper or plastic. You view prints by the light that passes through the dyes or emulsion and reflects back to your eyes. Scanners capture images of prints in much the same manner, using sensors instead of eyeballs.

Every print has light areas, dark areas, and tones in between. The lightest areas with detail (minimum density, called *Dmin* by the techies) can be no lighter than the whiteness of the paper itself. For that reason, photographic manufacturers are constantly looking for ways to produce whiter and brighter papers. The very darkest areas with detail (maximum density, called *Dmax*) are determined by how much light the dyes or emulsion can absorb. The better the Dmax, the darker the dark areas of a print appear to be.

The difference between the very lightest areas and very darkest areas is the *dynamic range,* or tonal range, of the photo. Even the best photographic papers don't have whites that reflect all the light back to our eyes (only a mirror can do that) or blacks that absorb all the light (only a black hole does that). The dynamic range of a print is fairly limited. No print comes close to taxing the dynamic capabilities of a scanner.

Slides

The term *slide* is usually applied to a 35mm transparency that has been cut from the film strip and placed in a mount so that it can be inserted in a slide projector. Larger film sizes can also be mounted and projected this way, but they usually aren't (except in the case of large overhead transparencies used in schools and business).

Slides, like the other transparent media that I describe next, have an interesting characteristic when compared with prints: Slides are not usually viewed by reflected light (at least, in the strictest sense). Slides, transparencies, and negatives are lit from behind *(transilluminated)* and viewed by the light that passes through them. Of course, a slide can be projected onto a screen and viewed by the light that reflects off the screen, but that's another matter. You can view any slide quite well by shining a diffuse light through it and viewing it directly, as shown in Figure 2-2.

The limitations of the substrate don't apply to slides. That is, where a very white piece of paper might reflect 75–80 percent of the light striking it, a slide can easily pass almost 100 percent of the illumination (in the clear or almost-clear areas). The dynamic range of a slide is likely to be much, much greater than that of a print. You can easily find detail in the lightest areas of the slide as well as detail in the darkest areas. That presents a challenge to the scanner: It must have an extended dynamic range that's capable of registering both those bright details and dark details. For a longer discussion of dynamic range and scanners, see Book II, Chapter 4.

Transparencies

In one sense, color transparencies are nothing more than color slides without the slide mount. You can even ask your photofinisher to process your 35mm slide film but not mount it, if you want, giving you long strips of 24mm x 36mm transparencies.

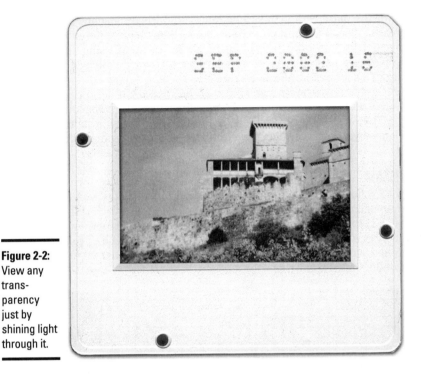

Figure 2-2:
View any transparency just by shining light through it.

Book VI
Chapter 2

Restoring Images
Captured from
Slides, Negatives,
and Other Formats

Transparencies come in other sizes, too. The most common roll film sizes are 2¼ x 2¼ inches (now more commonly referred to as 6 x 6cm), 2¼ x 2¾ inches (6 x 7cm), 2¼ x 3½ inches (6 x 9cm), and so forth. Transparencies also are available as sheets of film in 4 x 5", 5 x 7", 8 x 10", and 11 x 14" sizes (among others).

You also see very large transparencies used for advertising display in large light boxes, on up to the mammoth 60' wide Kodak Colorama ("The World's Largest Photograph"), which graced the east balcony inside Grand Central Station in New York City from 1950–1990.

Black-and-white or color negatives

Negatives are the film that can be used to make prints (and also film positives, including slides, if you want to go that way). They have a reversed image, with the dark areas of the subject appearing light in the negative, and vice versa. In a color negative, the colors are also reversed, so blues appear to be yellow, reds appear to be cyan, and greens appear to be magenta.

There's an additional complication in the orange mask that overlays all color negative films, which exists to provide better separation of the colors when printed on photographic paper. Because a scanner doesn't respond to the light passing through a color negative the way color paper does, there's no

need for the mask, which has to be removed during the scan. Things get interesting because different vendors' color films have different types of orange masks. Photofinishers compensate for these by using filter packs designed for a particular type of film. Any negative-capable scanner has settings to accomplish the same thing.

Like color slides and transparencies, negatives have the same long dynamic range. That makes them much better for making prints but increases the challenges your scanner faces in capturing all that extended information.

Exotica

As your reputation for old photo restoration magic grows, you'll be called upon to scan and fix up some really old, faded pictures of a rather exotic (for our 21st-century eyes) nature. These can include daguerreotypes, silver prints, 19th-century glass plates, or even tintypes like the one shown in a wretched, unrestored version at top in Figure 2-3, and a wretched, partially restored version at bottom.

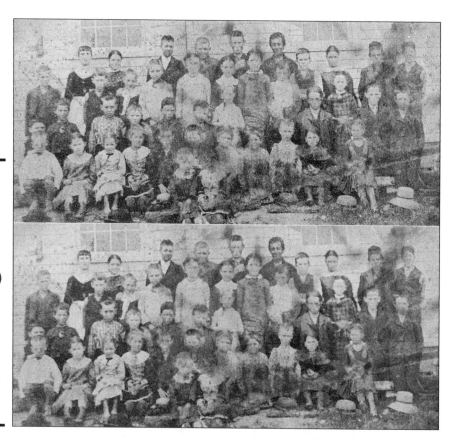

Figure 2-3: Family members who discovered this old damaged tintype (top) were pleased when even a small amount of the picture information could be restored.

Although these old photos were captured using different technologies, they all will share some common attributes. First, they might be contained in folders, glued to cardboard, or tucked away in frames. Be very careful when removing them for scanning to avoid damaging the photo.

Second, the old pictures will likely be faded, dark, or low in contrast. You want to increase the contrast and sharpness in your scanner's controls, if possible, because the improvements you make can sometimes be even better than what you could achieve later in your image editor. That's because the scanner is working with the original material.

Finally, your old photos probably have dust spots, pits, mottling, and other defects that can't be removed by scanning alone. Your best bet is to try and correct these problems in your image editor. I recommend scanning the photo several times, using different tonality settings. You'll end up with several versions, each with different details brought out. You can combine the best portions of each to create one finished photo.

Book VI
Chapter 2

Restoring Images
Captured from
Slides, Negatives,
and Other Formats

Scanning Film

If I haven't scared you off scanning slides, transparencies, and negatives by now, it's time to get to work. You need to refer to the instruction manual for your scanner and the slide scanning software for the exact steps to follow, but here are some general tips.

Prepping the film

You absolutely must make sure the film is clean, particularly if you are scanning a 35mm slide or negative. Sometimes dust settles on the film when it's still wet and becomes embedded in the emulsion side; sometimes film just gets plain dusty. Because small film images are enlarged many times as you work with them, you magnify the size of the dust or other artifacts at the same time. For example, a 24mm x 36mm transparency enlarged to 5 x 7" is blown up roughly 5X — and each tiny dust mote is visible when magnified that much.

Dust on either transparencies or negatives appears as dark black dots when scanned, of course, because the dots block the light from passing through to the sensor. However, when scanning a negative, you reverse the negative image to create a positive, turning the dust spot into a white speck. Tiny white specks can blend in with lighter areas of your image a little and are fairly easy to retouch out of the dark areas. (That's not to imply that you can go ahead and scan dusty negatives.) Dust on transparencies shows up as dark spots that are very visible and unsightly, so you should take extra care to make sure your transparencies are extremely clean when you scan them.

Clean dust from either a transparency or negative with a soft brush, an ear syringe, or a blast of canned air. Be careful not to allow the residual dust to scratch your soft film as you remove it. Soft brushes and air are your best tools. Figure 2-4 shows a typical slide scanner's film carriage. Dust off the film after you mount it in the carrier.

Film always has two sides: an emulsion side (where the image information is stored) and a base side. The emulsion side is usually dull looking when compared with the shiny base side. If you're somewhere that is fully lit, you can tell which is which by holding the film sideways and looking across the film. If you view a strip of negatives, you'll find that the film curls toward the emulsion side. If you plan to scan a Kodachrome slide, the emulsion side appears to be etched. There is another way to tell, which works even in total darkness, but you're not going to like it. Back in my darkroom days, when I wanted to know which was the emulsion side of a piece of film or photographic paper, I'd put an edge between my lips. The emulsion side sticks to your lip. If you want to test this out, don't slobber all over the image area of an important image.

Figure 2-4:
Dust off your film after inserting it in the scanner's carrier.

You can sometimes remove stubborn artifacts by soaking the film in distilled water. However, this works only if the dust hasn't replaced some of the image-forming part of the emulsion. In addition, the water removes the protective chemical applied to color film as a last step (black-and-white film is simply washed and allowed to dry after processing), so you need some of that solution if you want your film to last after cleaning. As you might guess, washing film should be done only as a last resort and only by those who know what they are doing. In the olden days, photographers used to do wild and crazy things with film to make it printable, including soaking it in oil to mask scratches and printing it "wet."

Performing the scan

When your film is clean and you're ready to start scanning, here are the steps to follow:

**Book VI
Chapter 2**

Restoring Images
Captured from
Slides, Negatives,
and Other Formats

1. **Place the film on or in the scanner (depending on whether you're using a flatbed scanner or a dedicated film scanner) in a holder designed for it.**

 The holder masks off the areas outside the image portion of the film. This is an important step that reduces the possibility of stray light striking the sensor, thus reducing the amount of contrast in your image.

2. **Insert the film in the holder so that the emulsion side of the film is facing the sensor.**

 You want the light to pass through the film's base side and leave through the emulsion side. If you do the reverse, the light passes through the emulsion and is then diffused by the base side, giving you an image that is less sharp than it might be.

3. **Make sure you've done whatever is necessary to turn on your flatbed scanner's transparency light source.**

 Usually, this step is performed in the scanning software. If you're scanning a color negative, your scanning software has a dialog box, like the one shown in Figure 2-5, that lets you specify what brand and type of color film is being scanned. That ensures that the orange mask and other characteristics of that particular color negative film are dialed into the scanning software. You can find the brand name of the film printed along the edge of the film itself.

4. **First do a *prescan*, which is the step that all scanner software provides to let you capture a preview image before doing the main scan.**

 While you're viewing the prescanned image, your scanning software might offer various controls that let you choose black points and white points (the darkest and lightest areas of the image that contain image information).

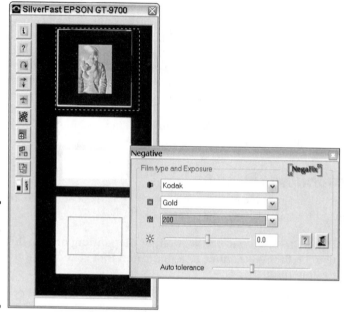

Figure 2-5:
Choose your
film brand
and type to
optimize the
scan.

5. **Make any corrections that are appropriate using the dust removal, sharpening, brightness, contrast, and tonal controls of your scanner software.**

 The options vary widely from program to program.

6. **Set the black points and white points and then choose your resolution.**

 If you're making an important scan, you'll want to choose the highest optical resolution your flatbed scanner provides, typically 1200 to 2400 spi. A dedicated film scanner has resolution choices in the 2700 to 4000 spi range (and up). You can choose the setting recommended for the size of film you're scanning.

 Be prepared for a long wait while the scanner painstakingly captures all that detail. A good scan of a transparency is a beautiful thing to behold, so I can assure you it's worth the wait!

Chapter 3: Some Common Fixes for Vintage Photos

In This Chapter

✔ Returning a faded picture to brighter days

✔ Working with sepia tone tools

✔ Replacing what's been lost to rips, tears, and deep scratches

*E*arlier image editing chapters in this book introduce you to the tools and techniques that you need to edit and restore many different types of photographs. In this chapter, you can take the information in those earlier chapters and apply that knowledge to vintage photos. (If you jumped to this chapter, I suggest that you read through the chapters in Book IV and also Book V, Chapter 4.)

After all, vintage photos present a unique situation. They're often the most cherished yet the least cared-for photos we have. I don't know about you, but boxes of them are in my house, and I'd cry for weeks if they were lost. But am I storing them properly? Making sure they don't get damp, too dry, too hot, and so on? Nope. So they're precious to me, but I don't have the time to put them all into acid-free paper photo albums or frame them, and the boxes keep getting moved around, stored wherever there's room with no regard for the temperature or humidity. Inside the boxes, the photos are scuffing each other every time the box is moved.

So what can I do? Of course, the first step is to properly store and archive them, but in addition to or in lieu of that, I can scan them, store the scanned files in my computer, use image editing software to clean them up, and then print them. The printed digital versions can be kept in frames, hung on the wall or stood up on the piano, with no fear of sun damage. I can give them as gifts and store the really precious ones in a safe place so that I always have a backup of the last known picture of my great-great-great grandmother, should anything happen to the original. Better yet, I can make copies on multiple CDs or DVDs and store them in several different locations (such as a safety deposit box) to guard against even the worst-case scenarios.

If this sounds like a good plan to you — and I assume it does, or you would not be reading about restoring old photos — then read on. In this chapter, I explain some common solutions to all-too-common problems — photos that

are showing the signs of age, wear, and tear. If you need to get your old photos into digital form, you might want to check out the material on scanning in Book VI, Chapters 1 and 2.

Repairing Vintage Photos: The Basics

Vintage photographs present some very common problems, some of which are explored in earlier chapters. Over time, the image fades because of age; developing procedures; the paper it was printed on; or exposure to the sun, extreme heat, or dampness. Dampness can cause even more harm because mold can grow, which eats away the coating on the photos and can damage the paper as well. In many cases, multiple culprits have been and are at work, and you'll have multiple problems — faded image content along with scuffs, scratches, stains, mold, dust, and outright damage in the form of rips, tears, and missing corners. Figure 3-1 shows a vintage photo that was originally glued to a piece of cardboard. Over time, the cardboard dried out, and one of the corners has cracked and fallen off. The image itself is quite faded; the original crisp blacks and whites are now very muted shades of gray. Some old images may be in the form of slides or negatives, which have their own deterioration problems.

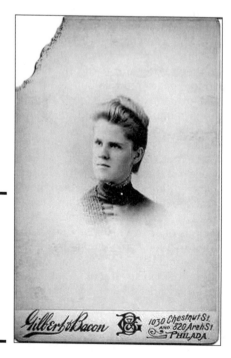

Figure 3-1: Faded, worn, and torn old photos often present multiple problems.

When faced with an image like this, you need to perform a little triage. What do you do first? Improve the color? Replace the corner? Clean up the scratches and scuff marks? It really depends on the location and severity of the problems and which problems bother you the most.

Consider these ideas for how to approach an image with multiple problems:

✦ **If multiple problems are in a single area, solving one might solve the other(s).** Consider a torn corner, with a big stain on it. If you paste content from the opposite corner over it (rotating the pasted content, of course), you might get rid of the stain, too (assuming that the other corner isn't similarly stained). I discuss replacing torn or missing content later in this chapter.

✦ **If a portion of the edge or frame is missing, try to crop out the damaged part.** When you can crop around the image, you eliminate the need to replace the missing corner or side. Of course, you have to consider whether the missing portion includes part of the image that is important to the composition of the image. Figure 3-2 shows an image that can be cropped to just the important parts, eliminating hours of restoration work that would have been spent rebuilding the damaged mat the image was glued to.

Figure 3-2:
Crop away the damaged edges, leaving a cleaner, neater image.

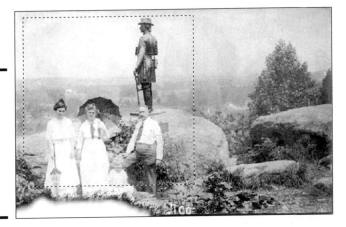

✦ **Assess the damage if you can't crop it out:** If you can't crop, how bad is the damage? Does it lend an air of history to the picture? Part of the charm of vintage photos is that they look old. The places, people, clothes, scenery, and architecture all add to that charm. So if the photo itself looks like it was taken in 1897, what's the harm in that? If the damage is on someone's face or across the front of the family home, yes, try to fix it. If the damage is on the periphery or doesn't detract from the overall appeal of the image, consider leaving it alone.

✦ **Tackle structural problems first.** First replace that missing corner or fill in that the hole or deep crack in the photo. Then go about improving color quality, eliminating tiny scratches and spots, or bringing out detail lost to fading or bad lighting. You'll find more information on replacing missing or damaged content later in this chapter.

✦ **Work slowly and deliberately.** Don't try to work fast or do too many things at once. Your results show your approach, and a slap-dash job leaves you with a slap-dash photo. If the picture is that precious or historically important, it's worth laboring over, zooming in to get things right, editing pixel by pixel.

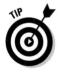

When restoring photos, you probably want to go against my advice in Book VI, Chapters 1 and 2, in which I say that high resolutions aren't needed for scanning photographs. Scanning a photo for restoration is a special case. You may want to scan at a fairly high resolution, from 300 to 600 samples per inch (spi). You can always reduce file size later when optimizing a photo for use on the Web, or if you need to send the file via e-mail or store it on some low-density disk. By scanning it at a high resolution, you get all the color, light, and texture information possible, and all that information gives you more to work with. If you scan at lower resolution and a face's features have been lost to time, you won't have as many colors and details to work with as you rebuild that face. When the image looks right, you can reduce the resolution for a more reasonably sized file. You end up with a photo that's about the same resolution as an ordinary photo you've scanned, but you'll be glad you had some extra information to work with during the restoration.

Replacing Depth and Detail

One of the things that gets lost when a photo ages is the detail — the textures, the features, the small elements that gave the photo clarity and interest when it was new. The details can be scuffed off by constant abrasion of the photo's surface, or they can be bleached away by exposure to the sun. If your photo's details are lost to either or both of these causes, you can find tools in virtually any image editing application to solve the problem:

✦ **Burn and Dodge tools** deepen shadows and brighten highlights, respectively. You probably need to use these tools during restorations more than when working on ordinary photos because you encounter faded images and dark areas more often in old photos.

✦ **Sharpening filters and tools** bring image content into focus. Again, restorations need this kind of manipulation because, frankly, many old photos weren't that sharp to begin with.

Shedding light on the subject

I talk about the Dodge (lightening) tool found in Photoshop and Elements in Book V, Chapter 4. However, most image editing applications have a Dodge or similarly named tool. *Dodge* is an old photography term, so it's not specific to any particular software manufacturer's lingo. You can use the Dodge tool to add light to images that you're restoring by clicking and/or painting over the image, after customizing the tool as needed to make sure it creates the desired effect.

To use your image editor's Dodge tool, follow these simple steps:

1. **Click the Dodge tool to activate it.**

 You usually find the Dodge tool on your image editor's Tool palette. It might also be a special mode for the Brush tool.

2. **Check out the tool's options, whether they appear on a bar or in a dialog box or palette, and adjust the intensity or strength of the tool (how much light it will shed) and the size of the brush with which you're applying the light.**

3. **After the settings you want are in place, click or drag over the area to be lightened.**

4. **If the results are too harsh or dramatic, undo them (press Ctrl+Z on a PC/⌘+Z on a Mac), tweak the tool's settings, and try again.**

You might find that the Dodge tool actually removes detail if you use it too much. It's best used when shadows are so deep that detail is impossible to discern or when age has darkened (rather than lightened or washed out) image content.

Don't be afraid of dark shadows

In most image editing applications, you can find a Burn (darkening) tool, too. The Burn tool intensifies dark shadows to make a faded shadow in an old photograph dark again or add darkness where there was none. In the process, using this tool can heighten the perceived level of detail in a photo. Adding detail to a faded photograph is difficult, but using the Burn tool can help. As shown in Figure 3-3, when a faded face in this old-time photo is slightly darkened with the Burn tool, the features become more distinct.

The Burn tool works much like the Dodge tool, and here are the simple steps:

1. **Click the Burn tool to activate it.**

 You can find the Burn tool on the Tool palette of most image editors, or as a special mode of the Brush tool.

This typically activates an Options bar or palette that gives you settings to control how the Burn tool works.

2. **Set the Burn tool's options to the levels needed.**

These usually are settings to specify whether the burning is applied to highlights, midtones, or shadows, and how big a brush is used to apply the darkening effect.

3. **When your settings are in place, drag over the image to darken it.**

You can also click one or more times on a spot that needs more darkness, as shown in Figure 3-4.

Figure 3-3:
The left half of the face is the original; the right half was burned to bring out details.

Figure 3-4:
Click or drag to apply more shadows.

Just like a big fire is much worse than a little one, a little burning is good, but too much is destructive. Don't go over and over a spot with the Burn tool because you'll end up scorching the image with so much darkness that you lose some or all of your image detail.

Creating focus by sharpening images

Many old photographs were taken with relatively long exposures by today's standards, resulting in blurs from the movement of fidgety subjects. In addition, many old-time cameras had what photographers would call *soft lenses* that produced a somewhat blurry rendition. You can sharpen such images with manual tools, such as brush-based tools that allow you to paint on a sharpening effect with your mouse, or you can use sharpening filters to do the job in a more uniform way. Either method has the same effect in terms of how the focus is achieved. When you *sharpen* an image, you're increasing the contrast between adjacent pixels. By making dark pixels darker and light pixels lighter, you make each pixel stand out — therefore, its neighbor stands out, too. The sharpen tools and filters can be taken too far, of course, but if used sensibly, they can bring out the details that you thought you'd lost forever.

Running with Sharp (en) tools

Using a Sharpen tool (you can find one in just about any image editing application) is pretty straightforward. Before using a Sharpen tool, however, do make sure that you're on the right layer if your image has layers. Also, if you want to confine your sharpening to a specific area, make sure that area is selected. Now, go!

1. **Click the Sharpen tool to activate it.**

 You can usually find this tool in the Tool palette of your image editor. When you click the tool, an Options bar or palette appears.

2. **Use the tool's Options bar or palette to control the way the tool works.**

 You can usually adjust its intensity, and you can always choose a larger or smaller brush size to control how much of your image or selection is sharpened with each click or drag.

3. **Click and/or drag over the area to be sharpened.**

 You can go over the same spot more than once, but don't go too far. Figure 3-5 shows the results of sharpening that's been overdone, producing an exaggerated, pixilated effect.

Figure 3-5:
Only knives
can't be
too sharp.
Photos
can be
sharpened
beyond
recognition.

Focusing with filters

Sharpening with a filter requires, of course, that your software program has filters — or at least special-effects tools that perform this particular kind of task. If you're using Paint Shop Pro, PhotoImpact, Corel PhotoPaint, or many other image editors, you have at your disposal various sharpening filters that you can use to apply generalized sharpening or edge-specific effects to your old photographs. Located on the Filter menu (or its equivalent) in most

editors, you can apply an all-over sharpening or an *unsharp mask effect* — a mask that applies sharpening to the edges within a photo and blurs the rest. The results might be just what the doctor ordered!

To use the typical Sharpen filters, follow these steps:

1. **Locate the Filter menu, go to the Sharpen submenu, and choose the filter that you want to apply.**

2. **If you choose any of the Sharpen filters other than Unsharp Mask, the sharpening occurs without any intervention from you; there is no dialog box or anything to adjust.**

3. **Choose Unsharp Mask, if it's available in your image editor.**

 Use the settings in this dialog box to control the intensity of the results. A preview window within the dialog box makes it easy to see how your adjustments to the filter's settings affect the outcome.

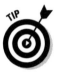

If you want all-over sharpening in your image or portion thereof, you might prefer using the Sharpen filters because there's no chance of your mouse strokes being visible or of going too far in one spot and not far enough in another. You can focus the filter's effects by making a selection prior to invoking the filter command, which limits the filter's effect on the entire image but still gives you a uniform result within the selected area.

Correcting Faded Colors

Of course, not all old photos are black and white. Many treasured pictures date from the 1950s or later, when family photographers began the great changeover to color film. Unfortunately, films of that day weren't as stable as they are today, and the colors of many of these old pictures have faded drastically. When colors wash out over time, they take with them the information that was originally available in the image. Was it a sunny day with a blue sky? Was it summer? Winter? What color dress is your grandmother wearing? Was that a brown dog or a black dog? To get the answers to these questions, you go to your image editing software and ask whether the original colors can be restored. If you have the right software, the answer should be yes. You might have to make up some stuff, depending on how washed out and faded the photo has become, but some quick and easy tools can resurrect whatever color is still available.

Adjusting color levels

Most image editing applications have several automatic color-adjustment tools. Some of these tools work without requiring any information from you,

and others present a dialog box that you can use to decide how much color and which colors to increase or balance. Using Photoshop and Paint Shop Pro as examples, you can use the following commands:

✦ Photoshop's Levels, Auto Levels, and Auto Color commands

✦ Paint Shop Pro's Color Balance, Hue/Saturation/Lightness, and Colorize commands

These commands are found on menus. In Photoshop, they're located on the Image➪Adjustments submenu. In Paint Shop Pro, you can find them on the Color➪Adjust submenu or on the Color menu itself.

If you see an ellipsis (...) after a menu command, a dialog box appears when you choose the command. If there is no ellipsis, the command is one that just happens. You choose it, and it does its job, whatever that may be. The job it does is based on default settings that are part of the program, and you might or might not be able to edit these settings.

Increasing saturation

When it comes to controlling color, you don't have to rely purely on menu commands and dialog boxes to revive your image colors. If you'd prefer, you can use your mouse to manually adjust colors, clicking and dragging to add or take away color with the Sponge tool, found in both Photoshop and Photoshop Elements.

The Sponge tool adds color (in Saturate mode) or removes color (in Desaturate mode), and you can control how much color is added or taken away through the tool's Options bar.

To adjust your color intensity with the Sponge tool, follow these steps:

1. **Click the Sponge or Desaturate tool to activate it.**

You can find this tool on the Tool palette of most image editors.

2. **Choose Saturate or Desaturate from the Mode drop-down list in the Options bar (or your image editor's equivalent).**

3. **Adjust the setting in the toolbar's Flow drop-down menu.**

Some image editors use Pressure or Opacity to indicate this parameter, instead.

A greater number here could mean more saturation or more desaturation, depending upon what mode you choose in Step 2.

4. **Use the image editor's Brush menu to set the brush size for the area to be edited.**

 You want to choose a brush that's big enough to do the job without a lot of repeated strokes. Each pass over the same spot increases the effects of the tool in that spot.

5. **Drag your mouse over the area to be sponged, being careful not to go over the same spot too many times.**

 Going over the same spot too many times or a Flow setting that's too high makes your strokes seem too obvious.

Adding color adjustment layers

What if the color is really gone and you can't retrieve it or rejuvenate it? You're faced with the same decision that Ted Turner faced when his organization began colorizing old movies. What color was that dress, really? How about that hat? The sky is blue and the grass is green, but some of the other colors are pure guesswork.

Fortunately, however, guessing the color is the hardest part when making a photo restoration of a faded color picture. You can add any color you like via a new layer. Of course, this approach requires that your software supports the use of layers, and that you're familiar with the Layers palette in your application — how to select a layer, delete a layer, and so on. I use Paint Shop Pro for this demonstration.

So what does a new layer do for your color? Well, nothing if it's just a regular old blank layer. But if it's an *adjustment layer,* it can do a lot. Figure 3-6 shows the Layer⇨New Adjustment Layer⇨Color Balance dialog box in Paint Shop Pro.

Adjustment layers

Adjustment layers are special layers that control a particular type of modification, such as brightness/contrast, color balance, hue/saturation, or even curves. Any changes that you make to a particular adjustment layer apply only to the layers stacked beneath the adjustment layer in your image editor's Layers palette. The advantage of adjustment layers is that you can change the adjustment at any time or even turn it off entirely to cancel the changes or to review what your image looks like without the adjustment. In contrast, if you apply a particular modification directly to a layer — say, to change color balance — there's no easy way to reverse that adjustment without reverting to an earlier state in your image editing process.

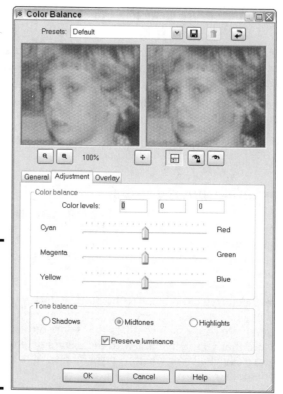

Figure 3-6:
When you
create a
new Color
Balance
Adjustment
Layer, this
dialog box
appears.

This same process is available in Photoshop — just use the Layer⇨New Adjustment Layer command, and its submenu offers a similar set of choices for the role the new layer will play.

To create an adjustment layer, follow these steps:

1. With your faded image open onscreen, choose Layer⇨New Adjustment Layer⇨Color Balance from the main menu bar.

The dialog box that appears enables you to raise and lower the color components, one level at a time. If your image is in RGB (red/green/blue) mode, you have those three levels to adjust. If your image is in CMYK (cyan/magenta/yellow/black), those are the levels that you can tweak.

Each of the New Adjustment Layer submenu commands produces a different dialog box, and each dialog box offers sliders and text boxes into which you can enter levels for the image component being adjusted — brightness or contrast, hue, lightness, and so on. If it's not clear which of these components your image needs help with, be brave and do some experimenting. You can always undo an edit by pressing Ctrl+Z (⌘+Z on a Mac).

2. **Make your adjustments by dragging the sliders to the left or right, or by entering new color levels.**

 You can also choose which elements of your image you're going to adjust: Shadows, Midtones, or Highlights.

3. **To see the results of your adjustments before you commit to them by clicking OK, click the Proof button (the big eye) to get a preview in the image window.**

 With some image editors, the results of your change appear in the main image window as you apply them.

4. **When you like the results, click OK to apply the changes to your image.**

 A new layer appears in the Layers menu, as shown in Figure 3-7.

Figure 3-7: Each adjustment layer you add appears on the Layers menu.

 Of course, if you change your mind after adding an adjustment layer, you can use the Undo command or History palette (if you're using Photoshop or Elements) to go back in time before the adjustment layer was created. You can also delete the layer, and your image returns to its original state.

 The Applied Science Fiction division of the Eastman Kodak Company offers a selection of Photoshop-compatible plug-ins that can streamline correcting colors and tweaking your images in other ways. Visit its Web site for more information (www.asf.com).

Getting Nostalgic with Sepia Tones

Don't you love those old brownish photos? So much warmer than black and white but not as garish as color. A sepia tone photo just says *vintage photo*. Over time, sepia tone photos can become less sepia. They can fade to a

yellowish pale color or be mistaken for a dirty black-and-white photo if the fading is allowed to go too far.

If your sepia tone photos aren't very sepia anymore or if areas of them have been bleached by sun damage or abuse, you can restore the sepia-ness to the whole image or just part of it. You can also take a black-and-white photo and make it look like a sepia tone image.

Evening out existing sepia tones

Your sepia tone photo is blotchy. Some of the photo still has those warm sepia tones, but other areas are faded and dull. What to do? Select the faded area; in Paint Shop Pro, choose Effects⇨Artistic Effects⇨Sepia. I use Paint Shop Pro here just as an example, by the way; most image editing applications have a similar feature. Even if your particular program doesn't offer it, you might be able to find a third-party effect that you can download off the Internet — a filter for Photoshop, for example.

To use Paint Shop Pro's Sepia Toning dialog box, follow these steps:

1. **Select the area to be adjusted.**

I recommend using a freeform Lasso selection tool. Avoid the geometric shape selectors because they make the adjusted area stand out too much.

2. **Choose Effects⇨Artistic Effects⇨Sepia from the main menu.**

The Sepia Toning dialog box opens, as shown in Figure 3-8.

3. **Use the Amount to Age slider to increase or decrease the amount of sepia added to the image.**

The Before version of the image appears on the left, and the After version on the right.

4. **When you like how the After version looks, click the Proof button (the big eye) to see the change previewed in your image window.**

5. **If you're happy with the preview, click OK to apply the changes to your image.**

If you're tinkering with a very small area, use the Sepia Toning dialog box zoom tools (located between the Before and After images in the dialog box) to get close enough to judge the effectiveness of your adjustments.

Converting a black-and-white photo to sepia tone

The process of converting a black-and-white photo to sepia tone is virtually identical to the process of evening out the sepia tones in a photo that's already a sepia tone image. The only difference is that you might have to change the color mode of your image beforehand. If your application (Paint

Shop Pro, in this case) sees your image as a true black-and-white or grayscale image, the Sepia command is dimmed in the Effects submenu.

What to do if you're dimmed? Choose Image⇨Increase Color Depth. One or more of the submenu's commands (as shown in Figure 3-9) become available, depending on the photo's current color status. Choose the highest depth level possible because the more color information you add to your image, the more color manipulation you can perform.

After you make this change, the Sepia command becomes available, and you can open the Sepia Toning dialog box and go to work making your black-and-white photo into a fake sepia tone

Figure 3-8:
Sepia tones
looking
sapped?
Restore
their original
glory with
the Sepia
Toning
dialog box.

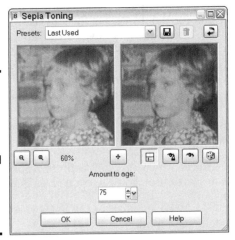

Figure 3-9:
Increase the
color depth
of a black-
and-white
photo to
access
the Sepia
command.

Rip! Replacing Torn or Missing Content

Although you encounter physical defects in all kinds of photos, these defects seem more prevalent in old pictures that have been stored carelessly, maybe ripped out of an album a time or two, or even pinned up on a bulletin board. Cracks and crevices are the sort of damage that you might think is beyond repair. How wrong you'd be if you thought that! Although not all image editing packages are capable of fixing these instances of very serious damage, most of them are. Certainly Photoshop, Photoshop Elements, and Paint Shop Pro — three of the most popular tools available — are capable of restoring even the most seemingly hopeless photo.

Sometimes the answer to your problem is much easier or straightforward than you thought it would be. In the case of photo editing, nothing is simpler than a paintbrush. You pick the color to paint with; set the size and style of the brush; adjust the shape of the brush; and paint over the scratch, scuff mark, or other type of small mark on your image. What could be easier? Most packages have more sophisticated tools; some even allow you to borrow content from one spot in the image and use the content elsewhere. But if the scratch or spot is really tiny, do you need to go to any more trouble than you'd go to if you had to touch up a tiny chip in your car's paint? No. You'd whip out the touch-up paint, and goodbye chip. You probably wouldn't call the auto body shop and have the car sanded, primed, and painted.

When you're ready to take the easy way out, follow these steps with your application's Paint Brush or Brush tool. You can even use a Pencil tool if your scratch is very thin:

1. **Click either the Brush or Pencil tool.**

 Use the Brush for larger areas or damage with edges that are soft, such as scuff marks, abrasions, or tears. Use the Pencil tool if your scratches are very fine and sharp-edged.

2. **Set the options so that they fit with the task at hand.**

 When the tool becomes active, so do its options. As shown here in Photoshop Elements (see Figure 3-10), you can adjust the size, shape, and style of the Brush tool, which controls how and how much color it applies.

3. **Select the color you want to apply in order to cover up the flaw in your image.**

 In Photoshop, you have the Color Picker, opened by clicking the Foreground Color button on the toolbox. Other applications might have a color-sampling tool in the brush palette or along the side or bottom of the application window.

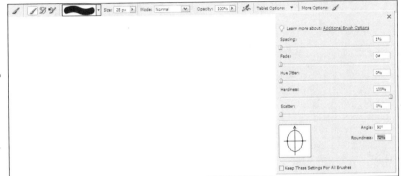

Figure 3-10: Change the specs for your brush to meet your needs.

4. **With the proper color selected, go back to the desired tool (the Brush or Pencil) and then begin painting or drawing out the unwanted scratches, scuffs, and spots, as shown in Figure 3-11.**

 You can click to get rid of a small dot, or drag to get rid of a scratch.

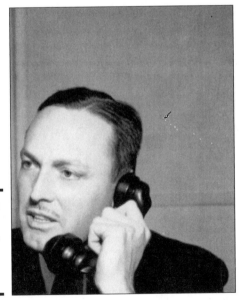

Figure 3-11: Paint away the scratch, spot, scuff, or other small mark.

Got a long stretch of scratch to cover? Don't try to do it in one stroke. Instead, nibble at the problem with short strokes, one after the other. That way, if you mess up, you can undo the small changes with the Undo command or the History palette without undoing your entire painted line. Only the last short stroke where you went astray disappears.

Book VII

Printing and Sharing Your Digital Images

Contents at a Glance

Chapter 1: Printing Your Final Result

In This Chapter

✔ Figuring out whether and when you need to print your photos

✔ Choosing the right printer for the job

✔ Understanding the printing process

✔ Hiring a professional printing company or service bureau

Digitally captured and retouched photos live on your computer. That's where they came to life, whether you captured them with a digital camera or scanned a printed original. It's also where they might have been doctored for any number of purposes — to make them smaller so that you can e-mail them to friends and family, to make them safe for use on a Web page, or to make them picture-perfect for printing.

However, unless you deal only in Web images or onscreen presentations, you probably need lots and lots of prints of your photos. In this chapter, you discover when and how to print your photos, which printers do what kind of job, and how to create the best-quality print of your digital images. Book II, Chapter 4 contains more information about choosing printers.

Why Do You Need Prints?

The reasons why you might need to print your photos are as numerous as the photos themselves. Look for your own reasons among those in this list:

✦ You need to create a suitable-for-framing version of a photo that was too small or too damaged to be framed before you edited it. You can transform that wallet-sized photo into a framed picture suitable for the top of your grand piano. Or perhaps a picture has wrinkles or tears that you can fix with your image editor before making a pristine, new print. See Book VI for tips on restoring damaged photos.

✦ You want to create a backup print of a very precious photo in case something happens to the original. Better yet, display the duplicate and keep the precious original in a safer place, such as a safety deposit box. Put a backup copy of the digital version of the original in the box, too, so you won't have to duplicate your editing efforts.

◆ You're building a portfolio of your digital artwork, and you need a printed copy to show to prospective employers or clients. Make as many prints as you want economically to distribute them far and wide.

◆ You need a *proof,* or printed evaluation image, that you submit to some-one who can't view the image online for his or her approval. You can fiddle with the proof print to make sure it's an accurate representation so that the person passing judgment on it will have the best copy possible to approve.

◆ You require an evaluation proof for comparing the digital image with the hard copy original and just viewing the file electronically won't provide the necessary information about print quality. The proof of the pudding, in this case, is in the viewing.

◆ Your photo is for printed marketing materials, such as ads, brochures, or flyers, and you need to create camera-ready art that a professional printer can use to create the finished materials. Although many professional printers today can work with digital files, some cannot, so you might need a print for the print shop's use.

◆ You want prints to share your best photos with family, friends, and unwary victims.

◆ When I prepare publicity pictures for my local newspaper, I always provide the original photo on CD-ROM. However, I also include a print so that the editor can decide whether the photo is worth using without having to pop the CD in a drive and going to the trouble of viewing it.

Although this chapter's title is "Printing Your Final Result," you might also want to print versions of your image as you go along in the editing process. Because computer monitors aren't capable of displaying colors exactly as they'll print, you might want to print at least one in-progress version of your image so that you can check for color, clarity, and other qualities before you commit the final version to that sheet of expensive photo paper. You can purchase lower-priced photo paper for your test prints (printing on plain old inkjet paper might be misleading), and then use the good stuff for your final printout.

Why does the same photo look different if you print it on plain inkjet paper than it does on photographic paper? The porous nature of regular inkjet paper absorbs more of the ink, and this affects the reflective quality of the colors. Images look darker, contrast is lost, and overall quality is diminished if you print on porous paper. If you print on glossy or matte photographic paper, where a coating on the paper prevents absorption, your photo's color and content stand on their own, unaffected by the paper. No details, color, or contrast is lost.

Evaluating Your Printing Options

After you know that you need to print your photo, it's time to decide how to print it. If you have only one printer and no money for or access to another printer, the decision is really made — you'll use your one and only printer. If you have the cash for the perfect printer for your particular photo, that's great. If you don't have the cash but have access to a variety of printers, that's great, too. With the assumption that you have some choices available to you, consider the list of printing possibilities, listed in Table 1-1. You'll find more information on choosing printers in Book II, Chapter 4.

Table 1-1		Printer Options
Type of Printer	*Price Range*	*Comments*
Inkjet	$50–$350	Great for color prints. Good text quality, too.
Laser	$600–$3,000	Fast, economical for text. Not the best choice for images.
Dye-sublimation	$600–$1,000	Best color print quality. Can't handle text.

Inkjet printers

The name *inkjet* gives you an idea of how the inkjet printer works — assuming that the word *jet* makes you think of the water jets on a whirlpool bath or spa. The way these printers work is rather simple. One system is exclusive to the Epson product line, which uses piezoelectric crystals that make the ink cartridges vibrate. (The crystals are sandwiched between two electrodes, which make the crystals dance.) Different levels of voltage cause the crystals to vibrate differently, which adjusts the colors and the amount of color sprayed through a nozzle onto the paper. Other inkjet printing systems use heat and other properties to control the flow of ink.

Color inkjet printers can create photo-quality images, assuming you use good quality photo paper for the output. Price isn't necessarily an indication of print quality, and you should print a test page before making a purchase or go on the recommendation of someone who owns the same model.

Laser printers

Laser printers work very much like photocopiers. A laser beam is aimed at a photoelectric belt or drum, building up an electrical charge. This happens four times, once for each of the four colors used to make all the colors in your image. The four colors are cyan, magenta, yellow, and black. The electric charge makes the colored toner stick to the belt, and then the belt transfers the toner to the drum. The paper rolls along the drum as it moves through the printer, which transfers the toner from the drum to the paper. Then either pressure or heat (or both) is used to make the toner stick to the paper.

Color laser printers are more expensive than inkjet and black-and-white laser printers although some of the newest models cost only a few hundred dollars more than a business laser printer. If you're creating camera-ready art for very important, detailed publications, you probably want a color laser (assuming the images are in color) rather than an inkjet, but the image quality is not as good as what you'd get with a dye-sublimation printer.

Dye-sublimation printers

Here, the name of the printer doesn't tell you much about the way the printer works. Despite their cryptic name, dye-sublimation printers work in a relatively straightforward way. A strip of plastic film, a *transfer ribbon,* is coated with cyan, magenta, and yellow dye. When a print job is sent to the printer, a thermal print head heats up the page-sized (4 x 6" to 8½ x 11") panel of plastic transfer ribbon. Variations in temperature control what colors and the amount of color that are applied to the paper. Because the paper has a special coating on it, the dye sticks.

Although not as popular as they once were, because of the increasing quality available from inkjet printers, dye-sublimation models provide an excellent image, especially for color photos. The subtle results are great for professional designers, artists, and photographers. The expense can be prohibitive for small businesses and home users, but the lower-priced models might be within reach.

Touring the Print Process

Regardless of the photo editing and retouching software that you're using to process your photographs, some aspects of the image printing process are the same. With most image editors, the print process consists of the following options:

✦ You get to choose which printer to print to. If you have a black-and-white laser and a color inkjet, for example, you can choose to output to the color inkjet.

✦ You can choose how many copies to print and the sizes for your prints.

✦ You can choose to print only part of the image by choosing the Selection option. (This assumes that you made a selection before issuing the print command.)

✦ You can adjust your printer's properties to print at different levels of quality, assuming the printout is the final version.

✦ You can choose to print crop marks, which can help you or a professional printer cut along the edges of the printout. If you want to frame a 5 x 7" photo, for example, and you're printing it on 8½ x 11" paper (letter size), the crop marks can help you cut the paper down to fit inside the frame and within any mat you're using.

Preventing surprises with Print Preview

Before you commit your image to paper, you might want to see a smaller view of an image in the context of a sheet of the currently set paper size, just to make sure everything is okay. This prevents nasty surprises, such as printing your favorite portrait in horizontal format. In virtually all software programs, you choose File⇨Print Preview to see how the printout will look. Figure 1-1 shows the Print Preview window for the Mac (on top) and Windows in Photoshop CS. The Windows and Mac versions are more or less identical, with the locations of some of the features slightly different. If you're happy with what you see, go ahead and issue the Print command (File⇨Print or Ctrl+P) to open the Print dialog box.

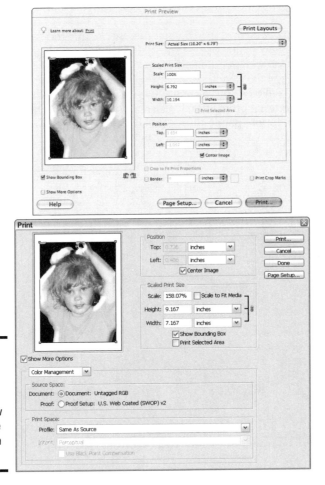

Book VII Chapter 1

Printing Your Final Result

Figure 1-1: A Print Preview window shows how your image will look on paper.

Higher-end photo editing packages (such as Photoshop) let you choose to print color separations, which means printing each of the image's colors on a separate sheet. This can be helpful to a professional printing firm that might use your printout to create the films that will generate your prints.

Understanding your output options

In the Print Preview dialog box, you can print the image by clicking the Print button, and you can also change the scale (size) and location of the image on the paper. With some image editors, a Show More Options check box opens an extension of the original dialog box. Options here might include applying a caption to your image or turning on crop marks. You might even be able to apply a background color and a border, which can be helpful if you're printing an image for framing and don't have a mat for the frame.

The Page Setup dialog box, which you open by clicking the Page Setup button in the Print Preview dialog box, is shown in Figure 1-2. The appearance of this dialog box can vary, depending on the printer. Figure 1-3 shows a slightly different version, for the Canon i860 printer, attached to a Macintosh. The Page Setup dialog box allows you to change the printer you're sending the job to and to view your printer's properties. It's also another place to choose portrait or landscape orientation, paper source (such as manual feed or automatic tray), or paper size.

Figure 1-2:
You can specify paper orientation and size.

Figure 1-3:
The options
may differ
slightly,
depending
on the
printer
you're
using.

Page Setup

Settings: Page Attributes

Format for: i860

Canon i860

Paper Size: US Letter

8.50 in x 11.00 in

Orientation:

Scale: 100 %

Cancel OK

Printing your photos

When you're ready to print your work, choose File⇨Print and use the Print
dialog box to take advantage of your printing options — which printer to
use, how many copies to print, and so forth.

If the software you're using offers a drastically different set of options
through its Print dialog box, you can usually press the F1 key to open the
software's help files. If that doesn't work (although it should because most
applications support this feature), use the Help menu and look for help arti-
cles that pertain to printing. The software might have also come with a Read
Me file (a file that came with the software if you downloaded it from the Web)
or a printed manual that you can refer to.

Of course, before you click the Print or OK button to begin the print job,
you'll want to make sure the right paper is in the printer and be sure how
your particular printer wants the paper fed — good side down, the proper
end in first, and so on. The printer should come with instructions, if not in
a printed manual then right on the printer trays themselves, through little
pictures of paper with arrows to show you how and where to insert the
paper. Most photographic paper has a good side (which has the image-
enhancing coating on it), and most paper has a repeated brand name on
the back (making it easier to tell which side you want to print on). You
can also lightly fold a sheet of paper and compare the sides: The whitest
side is usually the print side.

If you're not sure about which side to use or any other parameters related to
an image you're about to commit to hard copy, do a test print first. I always
do that when I'm getting ready to print a bunch of copies of a single image.
In the worst case, you'll print one on the wrong side and have to do it again,
wasting only a single sheet of paper. If you're planning to print several copies
of the image, wasting a single sheet is better than printing all ten copies on
the wrong side of the paper or with some other defect that could have been
corrected!

Using Professional Printing Services

Also known as a *service bureau,* a professional printing firm offers services to graphic artists, photographers, fine artists, businesses (for business cards, brochures, and so on), and the general public. Chains (such as Kinko's, AlphaGraphics, and Kwik Kopy stores) offer such services, and some office supply stores print your graphic files for a fee.

You can also find small, privately owned printing services (which might charge more than the chains do), where you get very personalized service and might find the staff more willing to help you if you're not entirely sure what you need to provide in order for them to do a job for you.

Finally, an increasing number of retailers are equipped with digital minilabs, which can accept your digital photographs and make prints on the same conventional photographic paper used for film images. Your options for professional printing are increasing.

I used service bureaus for many years, back in the days when laser printers could output text at no more than 300 dots per inch (dpi). Service bureaus were an economical way to produce black-and-white *camera-ready* pages (those which can be photographed by the printer to make printing plates) without the need to purchase a high-resolution printer or *imagesetter* (a high-resolution printer especially suited for images). Those can be costly. Today, most laser printers have 600 dpi or better resolution, so the need for service bureaus for text output is reduced. They are still a good idea for making full color prints from your digital photos if you don't own a color printer that provides sufficient quality.

Choosing a service bureau

Choosing professional services from your local MegaMart is easy: You can run down to the store, talk to the people who will be making your prints, and view a few samples to see how well they do. Selecting a service bureau/ printing service is a little more complicated. You can always check the Yellow Pages online or in print, or you can ask friends and business associates for referrals. The best people to ask are graphic artists or people who work for an ad agency; they're likely to use service bureaus pretty extensively, and their recommendations would be valuable.

Before you hire a service bureau to print your photos, you want to ask the folks there a few questions:

✦ What do they charge, and how do they determine their prices? Do they have minimum fees?

✦ When can they finish the job? Note that most service bureaus will want to fit your job into their normal queue of projects. They might have an extra charge for rush jobs. Find out what constitutes a rush job: Is that overnight service, or is anything less than a week a rush job?

✦ What file formats do they support (so you know the format in which you should save your photo after editing it)? At one time, service bureaus could handle only Macintosh files and common Macintosh formats, such as TIFF or PICT. Today, most service bureaus support all platforms and all image file formats. It doesn't hurt to check, though.

✦ Can you view a sample of the printout before paying for the final copies? It can be helpful to view a proof or evaluation copy.

✦ Is the kind of output you're looking for something they've done before and done frequently?

With answers to these questions in hand, you can choose the right service bureau for your needs. If the person you're working with isn't open and cooperative with you, run, don't walk, to another company. I've worked with both kinds of service bureaus — the kind where the staff assumes you should know everything and don't want to be bothered explaining things, and the kind where folks are more than willing to help and answer any question, no matter how simple it is. Obviously, the former type of company doesn't deserve your business, and the latter type of company is best.

Tell them what you want, what you really, really want

After choosing a service bureau to work with, you need to discuss your exact printing needs. When you tell the person helping you how you plan to use the printout, he or she should

✦ Suggest the type of paper for the printout.

✦ Tell you what file format you need to use (a PSD file created in Photoshop, a TIFF file, and so on) and whether you need to provide printed, camera-ready art.

If you do need to provide camera-ready art, ask whether you need to provide *color separations* (each color within your image, printed on a separate sheet of paper) and what kind of paper the bureau prefers you print to. If you have only an inkjet printer, the serviceperson might balk at your using it to create the camera-ready art. In general, though, any good service bureau prefers to get the image as an electronic file, either directly or over the Internet, so that the staff can work with the image as needed to give you the printout you require.

Knowing when you need a service bureau

In the end, the choice whether to work with a service bureau comes down to money because time is money, and money buys quality if you shop carefully for printing services and/or your own printer. If you need a perfect, absolutely beautiful printout of the photo and can't afford a high-end printer of your own (or don't know anyone who has one you can use), you need to spend the money to have a service bureau create the printout for you. If you need a high-quality printout and have a quality dye-sublimation or color laser printer at your disposal, you might be able to do the printing on your own.

If I sound as though I'm disregarding the role of inkjets in the printing process, I'm not. I've printed many photos with an inkjet printer and given them as gifts, used them as camera-ready art for brochures and business cards, and so forth. Some of my original artwork has also been printed on an inkjet, and the items look just fine in a portfolio. The printer you use all depends on the quality printout you need and on whether the printer you have is capable of providing it. You might love the output that your inkjet generates — if so, that's great. You've just saved some money, and you have a quick and easy way of creating your prints!

Some photo quality inkjets do a wonderful job on images but fall down on the job when trying to print text. If a project contains both images and text and you only have a photo quality printer, you should consider a service bureau.

Chapter 2: Sharing Pictures on the Web

In This Chapter

✔ Sharing your digital photo masterpieces with friends and family

✔ Showing off your business online

✔ Using commercial sites to share your pictures

✔ Creating your own Web page for displaying pictures

*O*f course you can e-mail your photos to personal and business contacts, but most people are pretty tired of getting images attached to e-mail messages. They have to download the images in order to open and view them, and if they're on a dial-up connection to the Internet, that can be a time-consuming pain. Perhaps their e-mail box has severe limitations on the size of e-mails, or even though they have permission to receive personal e-mail at work, they don't want to clog up the company mail services. And, with so many viruses being sent as e-mail attachments, folks tend to be leery of files sent to them, even from close acquaintances. Just getting your e-mailed photos delivered can be a challenge.

And after the download is (finally) complete, then what do your recipients do with the pictures? If they don't need the image themselves, or if the subject of the photo isn't near and dear to them, they either throw it out (into the Trash or Recycle Bin), or they squirrel the images away in a folder they'll never open again. I have one on my Windows desktop called Other People's Images, where I drag all the pictures that I would feel bad tossing but have no real use for.

So if e-mail isn't the best way to share pictures with people who need or want to see them, what is? You have several options, including posting them on your own Web site or using one of many image-sharing services. In this chapter, you discover what Web sharing tools are available, how to pick the one that's right for you, and how to get busy sharing photos on the Web.

Appreciating the Advantages of Web Sharing

Images shared on the Web are distributed on your nickel, so to speak. By using the Web to share images, you eliminate the other person's need to

save or throw out the images you've sent. He or she can view them, say "Aw, isn't that cute!" or "Wow! Cool car!" and that's it. No need to download, save, throw out, or do anything with the image other than just look at it. If people want to save or print the image after they view it, that's up to them, but it's not required or even firmly suggested. Figure 2-1 shows a page of images, posted to a Web site. All people have to do to see the pictures is type the Web address (`www.laurieulrich.com/webpix`, in this case) into their browsers, and *voilà!* There are the photos.

By using the Web to share pictures, you're saving your image recipients' time, hard drive space, and aggravation by creating a single repository for all the images you want to share. You're also making it much easier for yourself to keep an up-to-date selection of images available to all who want to see them, so the Web option is a win-win proposition.

Before you share a batch of photos with the world (remember, the Internet is international!), check the photos for anything you'd regret sharing with the rest of the population. You probably want to avoid sharing identifying features, such as addresses and people's last names, which enable strangers to make undesired contact with you. Another thing to check for is embarrassing content. Going over the images with a very discriminating eye before you share them will pay off in the long run.

Figure 2-1:
Here's a
page of
images
posted to
a Web site.

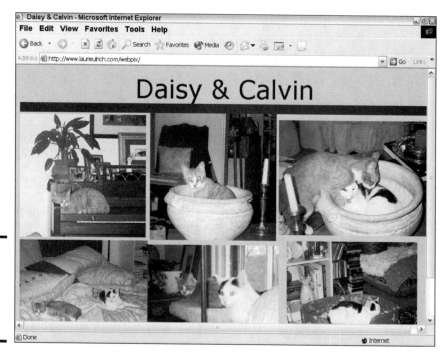

Sharing your personal photos

The benefits of using the Web to share personal photos are obvious. You can share vacation photos, school pictures, shots of your new house, pool, car, bathroom tile — whatever. Through your pictures online, you can share all the stuff that you'd tell people about in a holiday newsletter. Think of the savings in postage alone! Instead of enclosing that extra sheet (or sheets) of paper, just write inside your holiday card the Web address where your photos can be found, and your work is done. If most of your friends and family have e-mail, you can alert them that way and save your wrist the strain of writing a Web address 50 times. Figure 2-2 shows an e-mail message with a Web address in it, set up as a link. Recipients need only click the link in the e-mail, and they're taken directly to your photos, wherever they're stored.

Many e-mail programs will create such a hot link for you. For example, if you type anything that begins with http:// into recent versions of Outlook, Outlook Express, the Mail application for Macintosh, or America Online's mail system, the e-mail software automatically converts the address into a hot link, colors it blue, and supplies an underline that lets the recipient know the link is live. With some e-mail software, you might have to make sure the Rich Text (HTML) option is turned on. If your software is set to create messages only in Plain Text, the hot links might not be created automatically.

Figure 2-2:
Clicking the link in this e-mail will take you to the Web site referenced.

The recipient must also have the HTML option active for your link to be hot when the message is received. If not, the recipient can still jump to your Web page by highlighting the link, copying it (usually by pressing Ctrl+C, or ⌘+C on a Mac), and then pasting the link into a browser's address bar (using Ctrl+V or ⌘+V on a Mac). Although many folks who send and receive mail already know how to copy and paste links, you might want to include instructions on how to do this in your e-mail message.

Of course, some sharing is very targeted. You want your friends from college to see one batch and your family to see another, and you don't necessarily want the two camps to see each other's photos. How can you control it? By telling only certain people about certain images. Other than someone deliberately searching for your photos online, people will only go and look at the photos you're directing them to; by controlling whom you tell, you control who sees your images. Of course, if you want everyone and anyone to see all of your photos, you can store them all in the same place and use your name to identify them, making it possible for anyone to find them by searching the Web.

So where are these Web sites where your pictures can be found? They're everywhere — from the You've Got Pictures feature at AOL offered in conjunction with a big name in cameras, Eastman Kodak Company. These sites are easy to use, easy to access, and make sharing your photos with whomever you want very simple. I talk about different sites and the pros and cons of each a little later in this chapter; you can check out more coverage of online galleries in Book I, Chapter 5.

Sharing images with business associates

So you've opened a new warehouse or have a new product to offer. Don't spend the extra cash printing up thousands of brochures or product information sheets, and certainly don't skimp and print up black-and-white flyers because printing in color is so expensive. Color is cheap online, and the cost (if any) of sharing your images online is just a tiny fraction of the cost of printing.

You can put color images on your own company Web site, or if you don't have one yet, you can usually get some free Web space from the people you're already paying to provide your e-mail and Internet connection — your ISP (Internet service provider). Whether your ISP is an online community, such as AOL or MSN, or another firm such as Mac.com's HomePage, EarthLink or AT&T, you can take advantage of the free Web space allocated to each customer. Although you probably don't have a lot of space, it might be just enough to share a bunch of photos because photos saved for the Web (in GIF or JPEG format) are much smaller in file size than photos shared in other formats. Even if your ISP gives you only 10MB of space, you can get a lot of photos in that space.

To find out whether your ISP offers free Web space, you can call its support phone number or go to its Web site. AOL makes it easy. By choosing Hometown from AOL's Community menu, you can create a personal or business Web site.

Just as AOL offers a lot of help in setting up your home page, most ISPs offer either online or phone support to coach you through the process. The folks at most ISPs assume that if you're using their free space rather than registering a domain of your own, you're probably not a full-fledged Web designer. Using EarthLink as an example, going to `www.earthlink.net/home/benefits/webspace` takes you to a page where you can start your own Web page, using free tools like Trellix. In fact, one of the things you can do with EarthLink's Free Webspace is to create a photo album. Ah, great minds think alike!

Choosing a Sharing System

There are really too many free Web page hosting sites to list, and determining which ones will remain active during the life of this book is just too difficult. You'll find an up-to-date guide to free or nearly free hosting services at `www.clickherefree.com`. (Of course, I'm hoping *that* service doesn't become defunct soon, too! If it does, just do a quick Google search to find others.) Your best bet is your ISP or big operations like AOL, MSN, Kodak, and others, which are likely to be with us over the long haul. Of course, longevity might not be important to you. After all, when one service pulls up stakes and packs up its tent, you can always switch to another, newer free service. As a bonus, you don't have to worry about erasing all your outdated photos on the old service. They'll do it for you when they close up the shop.

You have a lot of choices. You can use an online sharing system to display your images. Most of these systems offer the space for free. You can build your own Web site using the free space that your ISP offers, or you can register your own domain and set up your own space on a host's Web server. In this case, a host offers space on its computer for you to store your pages, usually for a monthly or annual fee. You can also set up your own *Web server* (a computer that serves up Web pages to people on the internet), but I wouldn't recommend it solely to store your images.

My current favorite hosting site is at AffordableHOST (`www.affordablehost.com`). I currently have four domains hosted there for me and my family, paying a grand total of $5.95 per month for the privilege — because one account can host several other domains and share the space and Internet traffic (known as *bandwidth*). Each domain I registered costs $12.95 per year. My kids each have their own domain, and I have a couple that I use to promote some sideline activities, as shown in Figure 2-3.

Figure 2-3:
If you don't
want to use
all your Web
space to
display
pictures,
promote a
hobby or
sideline
business
activity.

With all these options, choosing a sharing system is easy. The best option for you just depends on what you want, how much you're willing to pay, and how much time you want to devote to setting up your images online. From simple and setup in no time to slightly complex and completely customized, the choices run the entire spectrum.

Using commercial sharing sites and services

Commercial normally means *for a fee,* right? Well, not necessarily. Many of your sharing options are free or use something that you're already paying for. In the case of an online community (such as AOL), if you're a member, you're already paying for that membership, which enables you to send and receive e-mail, chat, surf the Web, and so forth. For AOL's monthly fee, you get access to the Internet and to its community features. One of those features is You've Got Pictures, which enables you to view your images online and allows others to view them, too. You also get free Web space with your membership, which you can use for storing and displaying your photos. Doing business with an organization that sees you as a member is easy. The organization wants to provide services you'll come to depend on, and that's all part of keeping you as a customer. Therefore, you'll find both the

You've Got Pictures and Hometown features easy to use and simple to maintain, and you can get technical support when you need it. AOL doesn't want you to go away mad.

You can find useful services for the Macintosh at www.mac.com. For $99.95 a year, you get .Mac mail, HomePage, iDisk (100 MB of disk storage accessible from anywhere through the Internet), .Mac address book and bookmarks, and more than 400 different .iCard greeting card templates. If the mandatory $100 one-year sign-up is too steep for you, a 60-day free trial is available. Signing up is easy. Figure 2-4 shows the signup sheet.

Other commercial sharing services — Web sites known as *online galleries* — allow you to post your images for free in exchange for making you look at ads around the periphery of the Web page that displays your images. The thinking is that by exposing you (and those you send to the site to see your photos) to the ads, the gallery's advertising partners gain exposure to a considerable customer base. Others provide free space simply because they want to be nice or to perpetuate an interest in photography. Some sell software, which they offer you throughout their site, enticing you to buy their image editing and/or photo album application. You don't have to buy, but the companies figure that many people will.

Quite a few different services are available. Your best bet for finding them is to type **Online Galleries** or similar key words into the Google search engine (www.google.com) to find services like Club Photo's Photodrop. Most offer similar features, so, as an example, I describe the biggest and bestest — AOL's You've Got Pictures/Kodak Picture Center — in the following section.

Using You've Got Pictures and Kodak Picture Center with America Online

If you're a member of AOL or find its monthly fee to be low enough to join just so you can take advantage of their picture display features, you'll find that the AOL system is very easy to use. To share pictures online using the You've Got Pictures feature, follow these steps. Before sharing pictures online using the You've Got Pictures feature, make sure your digital camera is attached to your computer or that you have scanned photos that you're ready to upload from your hard drive.

Kodak offers similar services directly from the Kodak Picture Center Online. Go to www.kodak.com and search for Picture Center to locate the most current URL for this evolving service.

Figure 2-4:
Macintosh
users can
sign up
for .Mac
services
that include
e-mail and
Web space.

AOL made some interesting changes in its You've Got Pictures capabilities with the latest updates to its software. The photo sharing site is now called the Picture Center on the opening screen, and a large Sponsored by Kodak logo appears on the You've Got Pictures welcome page. However, the capabilities remain much the same as with earlier AOL versions. From the site where your pictures are stored (which you can share with others, letting them know that they can see the pictures online), you can save the images to your computer for editing and printing. You can also order things such as mugs and T-shirts with your images on them, or order enlargements and high-quality reprints.

To share pictures online with the You've Got Pictures feature, follow these steps:

1. **Click the Create Album button.**

A dialog box pops up showing you exactly how to upload your photos to an album you can display over the Web. There's an Add Pictures Now button that lets you browse your hard disk for photos and then move them to an album layout page. You can select specific pictures for display and rotate them.

2. **Click the Add Pictures Now button, and a wizard leads you through the steps needed to upload the photos to the Picture Center.**

You can add or edit a title or create captions and also choose an album style that suits your personality. AOL currently offers various layouts and backgrounds ranging from patterns and textures to special occasions, colors, and animals.

3. **Notify any or all the people in your AOL Address Book that you have pictures up for viewing.**

AOL includes an e-mail facility that you can use to notify people of your new album if you want to. The boilerplate e-mail includes instructions on accessing the album.

4. **[Optional] Print your album photos.**

The print store has facilities for making prints from photos in your gallery at reasonable prices, creating super-sized prints, producing photo greeting cards, and ordering customized photo picture gifts, including ceramic picture mugs, mouse pads, jigsaw puzzles, sweatshirts, and T-shirts.

Why would you need to order prints if you can just print the online images? Web-safe image formats (normally JPEGs for photos) are often posted at a less-than-best quality to save loading time when someone visits the page where the images are displayed. Therefore, if you print the online version of the image, you're likely to get a grainy or less detailed version of the image. If you have a high-resolution version of the image on your own computer, you can print from that, or you can order the prints (for a fee) from Kodak, through the same AOL site where you posted your Picture Center images for sharing.

AOL Visions Galleries

This section of the Picture Center offers a variety of photos to view. You can see galleries submitted by other AOL users as well as view special exhibitions. In recent months, the AOL Visions Galleries have included displays by Associated Press Pulitzer Prize winners, a Fall Folio of autumn leaves, nature photographs, and home renovation pictures taken from the *This Old House* PBS television series.

Digital Camera Center

This section offers lots of tutorials that help you learn more about your digital camera, including a Digital Question of the Week, a Digital Cameras 101 basic course, a review of the latest digital cameras, and a beginner's My First Digital Camera section. Of course, these sections might change by the time you visit the Digital Camera Center, but discovering the new goodies is half the fun!

My Pictures

This section is reserved for viewing and maintaining any albums you have created in the Picture Center. The page includes three departments:

+ **Pictures on My Computer:** Photos on your hard disk that you haven't uploaded to AOL yet.

+ **My Albums Saved on AOL:** Multiple albums you've created from pictures you've uploaded.

+ **Albums I've Received:** Your friends can send you their albums, which you can keep on AOL and view whenever you want. You can also edit any of the albums using the AOL tools.

You can purchase a dock for your digital camera (a Kodak digital camera, of course), which links your camera directly to your computer and Kodak's EasyShare software to facilitate posting your images online and sharing them with others. To get to the site and find out about what they offer, go to www. kodak.com. From the resulting Web page, you can click the EasyShare listing in the Site Index and find out more about the system.

Using your own Web space

Whether your ISP provides the space for free or you enlisted a paid host to provide you space for your own domain, you can use your Web space to store and display photos that you want to share with friends, family, customers, and business associates. Putting the images online requires a series of simple steps:

1. **Prepare your photos for use on the Web by opening them in a photo editing package, such as Photoshop Elements, and saving them in a Web-safe format.**

The two formats that all Web browsers (notably Internet Explorer and Netscape Navigator) can deal with are GIF and JPEG. JPEG is best for photos because it supports the multitude of colors and shading within the images. Figure 2-5 shows the Save for Web dialog box in Adobe Photoshop cs and a photo being prepared for Web use. (Photoshop Elements has a similar facility.)

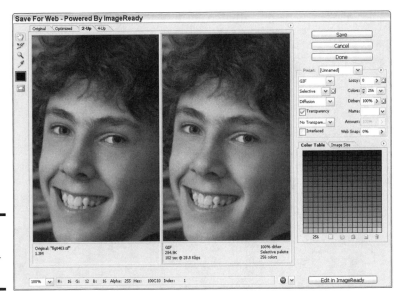

Figure 2-5:
Optimizing
pictures for
the Web.

2. **Set up the Web page where the images will be displayed.**

 You can use a variety of graphical tools to design the page (Microsoft
 FrontPage, Macromedia Dreamweaver, Adobe GoLive) or you can create
 a page by writing HTML (HyperText Markup Language) code. If you're
 using an ISP's free Web space, the ISP gives you step-by-step procedures
 for creating a Web page, and the software does most of the work for you.

3. **Upload the Web page and the images.**

 This is typically done with FTP (File Transfer Protocol) software. If you're
 using AOL or your ISP, it might provide an Upload page that loads both
 the Web page you set up and the images you want to display.

 You can find free FTP software online from sites such as www.tucows.
 com and www.hotfiles.com. You can also do a search for *"Free FTP
 Software"* at Google (www.google.com). When doing a search with a
 phrase like that, remember to use the quotation marks, which help
 refine the search to the exact phrase you've typed. Venerable oldies like
 WSFTP LE, shown in Figure 2-6, are very popular. *Newbies* (new online
 users) might prefer a program like FTP Explorer, which has a Windows
 Explorer-like interface. You can upload files simply by dragging them
 from a Windows Explorer pane to the FTP Explorer window. Similar
 programs exist for the Macintosh, such as Transit.

4. Visit the page online to see how it looks.

You always want to check your page online to see whether it's okay before you send people there to see your images. With any luck, it won't look like my page, shown in Figure 2-7.

If you want to make changes, open the Web page file on your own computer, make the changes, and upload it again.

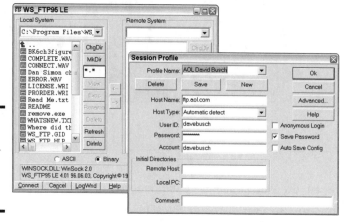

Figure 2-6:
WSFTP LE is a popular FTP client for Windows.

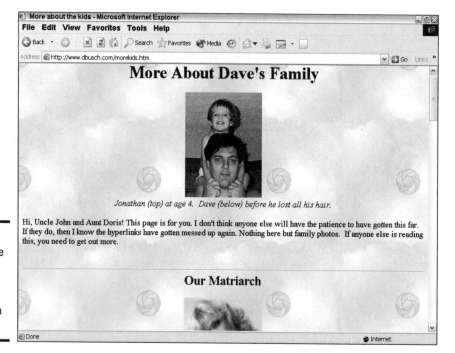

Figure 2-7:
With a little work, your Web page will look better than this!

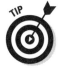

If you check your page online and you see red Xs (in Internet Explorer) or gray icons with a question mark (in Netscape Navigator) where images should be, this means that the browser can't locate the image that's supposed to be there. Check your Web page settings to make sure that you have the right pictures in the right places, and check to see that you've uploaded all the images to your host's Web server. If this happens to you just once, you'll understand the importance of testing your Web pages after uploading them. Nothing's more embarrassing than sending someone to your site and having them report that the images are missing!

As time goes by, you can always expand and improve on your Web pages. Here are a few things to try:

+ **Refreshing content:** Edit your Web pages and add new pictures. Or take down the old ones entirely and replace them with your latest shots. As you become more proficient in setting up images and designing Web pages, your site can grow with you.

+ **Organizing pictures:** Set up multiple Web pages and use them to categorize your images. Set up a Vacations page, a Baby Pictures page, or a Graduation Ceremony page. Any category or special topic can have its own page.

+ **Adding links:** Create links on your Web pages that take visitors to other people's sites or to online galleries where you have other pictures stored. If you're a real photography bug, maybe you have some of your more artistic shots stored on a gallery site. Through a link on your own page, you can direct people to your works of art.

+ **Letting others join in:** Set up a family Web site and have each branch of your extended family post their own images to individual pages. This can help distant members of the family stay in touch (add e-mail links to the pages so people can view the images and then immediately write an e-mail to talk about them), and let everyone in the family know about new arrivals and special events like family reunions.

+ **Advertising your business:** If you're in business, use the space to show pictures of your products, services, staff, locations — anything that will enhance your customer's interest in you and your business. Like a family site with individual pages for different branches of the family or types of pictures, businesses can also categorize their images and set up individual pages to house each group.

If you thought your only goal for that box of old photos was to go through and put them in an album, you can see that you can do so many more things with your images. The Internet makes it possible to share pictures with anyone, anywhere, and it won't cost you much money or take up much of your time. Have fun!

**Book VII
Chapter 2**

**Sharing Pictures
on the Web**

Glossary

additive primary colors: The red, green, and blue hues used alone or in combinations to create all other colors you capture with a digital camera or scanner, view on a computer monitor, or work with in an image editing program like Photoshop, Photoshop Elements, or Paint Shop Pro. *See also* subtractive primary colors *and* CMY(K) color model.

airbrush: The airbrush is an image editing feature that simulates an artist's tool that sprays a fine mist of paint. It is used for both illustration and retouching.

ambient lighting: Soft, nondirectional lighting that bounces off walls, ceilings, and other objects in the scene, rather than appearing to come from a single light source.

angle of view: The area of a scene that a lens can capture, determined by the focal length of the lens. Lenses with a shorter focal length have a wider angle of view than lenses with a longer focal length.

anti-alias: A process that smoothes the rough edges or *jaggies* in images by creating partially transparent pixels along the boundaries that are merged into a smoother line by our eyes. *See also* jaggies.

aperture-preferred: A camera setting that allows you to specify which lens opening or f-stop you want, with the camera selecting the required shutter speed automatically, based on its autoexposure system. *See also* shutter-preferred.

artifact: A type of noise in an image, or an unintentional image component produced in error by a digital camera or scanner during processing. For example, a "hot" or "dead" pixel in a digital camera sensor can show up as a white or black dot in your photos.

aspect ratio: The proportions of an image as printed, displayed on a monitor, or captured by a digital camera.

autofocus: A camera setting that allows the camera to choose the correct focus distance for you, usually based on the contrast of an image (the image will be at maximum contrast when in sharp focus) or a mechanism such as an infrared sensor that measures the actual distance to the subject. Cameras can be set for *single autofocus* (the lens is not focused until the shutter release is partially depressed) or *continuous autofocus* (the lens refocuses constantly as you frame and reframe the image).

averaging metering: A light-measuring system that calculates exposure based on the overall brightness of the entire image area. Averaging tends to produce the best exposure when a scene is evenly lit or contains equal amounts of bright and dark areas that contain detail. Today, most digital cameras use much more sophisticated exposure measuring systems based in center-weighting, spot-reading, or calculating exposure from a matrix of many different picture areas.

backlighting: A lighting effect produced when the main light source is located behind the subject. Backlighting can be used to create a silhouette effect. Backlighting is also a technology for illuminating an LCD display from the rear, making it easier to view under high ambient lighting conditions. *See also* front-lighting, fill lighting, *and* ambient lighting.

balance: An image that has equal elements on all sides.

bit: A binary digit — either a 1 or a 0 — used to measure the color depth (number of different colors) in an image. For example, a grayscale 8-bit scan may contain up to 256 different tones (2^8), and a 24-bit scan can contain 16.8 million different colors (2^{24}).

black: The color formed by the absence of reflected or transmitted light.

black point: The tonal level of an image where blacks begin to provide important image information, usually measured by using a *histogram*. When correcting an image with a digital camera that has an onscreen histogram, or within an image editor, you'll usually want to set the histogram's black point at the place where these tones exist.

blur: In photography, to soften an image or part of an image by throwing it out of focus or by allowing it to become soft because of subject or camera motion. In image editing, to soften an area by reducing the contrast between pixels that form the edges.

bounce lighting: Light reflected from a surface, often ceiling or walls, to provide a soft, natural-looking light.

bracketing: Taking a series of photographs of the same subject at different settings to help ensure that one setting will be the correct one. Many digital cameras will automatically snap off a series of bracketed exposures for you. Other settings, such as color and white balance, can also be bracketed with some models.

brightness: The amount of light and dark shades in an image, usually represented as a percentage from 0 percent (black) to 100 percent (white).

buffer: A digital camera's internal memory, which stores an image immediately after it was taken until the image can be written to the camera's non-volatile (semi-permanent) memory or a memory card. A buffer lets a camera capture a burst of images.

burn: A darkroom technique, simulated by most image editors, which involves exposing part of a print for a longer period, thus making it darker than it would be with a straight exposure. The term is also slang for creating a CD or DVD, using writing software.

calibration: A process used to correct for the differences in the output of a printer or monitor when compared with the original image. After you calibrate your scanner, monitor, and/or your image editor, the images you see onscreen more closely represent what you'll get from your printer even though calibration is never perfect.

Camera RAW: A plug-in included with Photoshop CS and Photoshop Elements 3.0 that can manipulate the unprocessed images captured by digital cameras. *See also* RAW.

camera shake: Movement of the camera, aggravated by slower shutter speeds, which produces a blurred image. Some of the latest digital cameras have *image stabilization* features that correct for camera shake, and a few high-end interchangeable lenses have a similar vibration correction or reduction feature.

cast: An undesirable tinge of color in an image.

CCD: Charge-Coupled Device. A type of solid-state sensor that captures the image, used in scanners and digital cameras. *See also* CMOS.

center-weighted metering: A light-measuring device that emphasizes the area in the middle of the frame when calculating the correct exposure for an image. *See also* averaging metering, spot metering, and matrix metering.

chroma: Color or hue.

chromatic aberration: An image defect, often seen as green or purple fringing around the edges of an object, caused by a lens failing to focus all colors of a light source at the same point.

chrome: An informal photographic term used as a generic for any kind of color transparency, including Kodachrome, Ektachrome, or Fujichrome.

CIE (Commission Internationale de l'Eclairage): An international organization of scientists who work with matters relating to color and lighting. The organization is also called the International Commission on Illumination. This color model is based on human perception and is considered the most accurate.

close-up lens: A lens add-on resembling a filter that allows you to take pictures at a distance that is less than the closest-focusing distance of the prime lens alone.

CMOS: Complementary Metal-Oxide Semiconductor. A type of solid-state sensor that captures the image; used in scanners and digital cameras. *See also* CCD.

CMY(K) color model: A way of defining all possible colors in percentages of cyan (C), magenta (M), yellow (Y), and frequently, black (K). Black is added to improve rendition of shadow detail. CMYK is commonly used for printing (both on press and with your inkjet or laser color printer). A few image editors, including Photoshop, can work with images using the CMYK model.

color correction: Changing the relative amounts of color in an image to produce a desired effect, typically a more accurate representation of those colors. Color correction can fix faulty color balance in the original image or compensate for the deficiencies of the inks used to reproduce the image.

color filter array: A colored panel placed over the sensor that keeps the sensor's photosites (which are sensitive to all colors) from responding to light other than the color assigned to that pixel/photosite.

composite: In photography, an image composed of two or more parts of an image, taken either from a single photo or multiple photos. Usually composites are created so that the elements blend smoothly together.

composition: The artistic arrangement of the main subject, other objects in a scene, and/or the foreground and background.

CompactFlash: A common storage media used in digital cameras, music players, and other devices.

compression: Reducing the size of a file by encoding using fewer bits of information to represent the original. Some compression schemes, such as JPEG, operate by discarding some image information; others, such as TIFF, preserve all the detail in the original, discarding only redundant data. *See also* GIF, JPEG, and TIFF.

continuous autofocus: An automatic focusing setting in which the camera constantly refocuses the image as you frame the picture. This setting is often the best choice for moving subjects. *See also* single autofocus.

continuous tone: Images that contain tones from the darkest to the lightest, with a theoretically infinite range of variations in between.

contrast: The range of difference in the light to dark areas of a photo.

contrasty: Having higher than optimal contrast.

crop: To trim an image or page by adjusting its boundaries.

dedicated flash: An electronic flash unit designed to work with the automatic exposure features of a specific camera. Most such devices actually measure the light reaching the sensor as a way of determining proper exposure settings.

densitometer: An electronic device or software tool used to measure the amount of light reflected by or transmitted through a piece of artwork, used to determine accurate exposure when making copies or color separations.

density: The ability of an object to stop or absorb light. The less light reflected or transmitted by an object, the higher its density.

depth-of-field: A distance range in a photograph in which all included portions of an image are at least acceptably sharp.

depth-of-focus: The range that the image capturing surface (such as a sensor or film) could be moved while maintaining acceptable focus. *See also* depth-of-field.

desaturate: To reduce the purity or vividness of a color, making a color appear to be washed out or diluted.

diaphragm: An adjustable component found in cameras, similar to the iris in the human eye, which can expand and contract to provide specific sized lens openings, or f-stops.

diffuse lighting: Soft, low-contrast lighting.

diffusing: Softening detail in an image.

diffusion: The random distribution of gray tones in an area of an image, producing a fuzzy effect.

digital single lens reflex (dSLR): A high-end digital camera that accepts interchangeable lenses, used usually by professionals or advanced amateur photographers.

digital zoom: A way of simulating actual or optical zoom by magnifying the pixels captured by the sensor. This technique generally produces inferior results to optical zoom.

dither: A method of distributing pixels to extend the number of colors or tones that can be represented. For example, two pixels of different colors can be arranged in such a way that the eye visually merges them into a third color.

dock: A device furnished with some digital cameras that links to your computer or printer, allowing interfacing the camera with the other devices simply by dropping it in the dock's cradle.

docking: The ability to lock toolbars, palettes, and other features of the interface at a fixed location, usually one edge of an application window.

dodging: A darkroom term for blocking part of an image as it is exposed, thus lightening its tones. Image editors can simulate this effect by lightening portions of an image with a brush-like tool.

dot: A unit used to represent a portion of an image, often groups of pixels collected to produce larger printer dots of varying sizes to represent gray or a specific color.

dot gain: The tendency of a printing dot to grow from the original size to its final printed size on paper. This effect is most pronounced on offset presses using poor quality papers, allowing ink to absorb and spread, which reduces the quality of the printed output, particularly in the case of photos that use halftone dots.

dots per inch (dpi): The resolution of a printed image, expressed in the number of printer dots in an inch. You'll often see dpi used to refer to monitor screen resolution or the resolution of scanners. However, neither of these uses dots; the correct term for a monitor is pixels per inch (ppi) whereas a scanner captures a particular number of samples per inch (spi).

dummy: A rough approximation of a publication, used to evaluate the layout.

dye-sublimation (dye-sub): A printing technique in which inks are heated and transferred to a polyester substrate to form an image. Because the amount of color applied can be varied by the degree of heat (and up to 256 different hues for each color), dye sublimation devices can print as many as 16.8 million different colors.

electronic viewfinder (EVF): An LCD located inside a digital camera, used to provide a view of the subject based on the image generated by the camera's sensor.

emulsion: The light-sensitive coating on a piece of film, paper, or printing plate. When making prints or copies, it's important to know which side is the emulsion side so that the image can be exposed in the correct orientation (not reversed). Advanced image editors, such as Photoshop, include Emulsion Side Up and Emulsion Side Down options in its Print Preview feature.

equivalent focal length: A digital camera's focal length translated into the corresponding values for a 35mm film camera. For example, a 5.8–17.4mm lens on a digital camera might provide the same view as a 38–114mm zoom with a film camera. Equivalents are needed because sensor size and lens focal lengths are not standardized for digital cameras, and translating the values provides a basis for comparison.

EXIF: Exchangeable Image File Format. Developed to standardize the exchange of image data between hardware devices and software. A variation on JPEG, EXIF is used by most digital cameras, including information such as the date and time a photo was taken, the camera settings, resolution, amount of compression, and other data.

existing light: In photography, the illumination that is already present in a scene. Existing light can include daylight or the artificial lighting currently being used but is not considered to be electronic flash or additional lamps set up by the photographer.

export: To transfer text or images from a document to another format.

exposure: The amount of light allowed to reach the film or sensor, determined by the intensity of the light, the amount admitted by the iris of the lens, and the length of time determined by the shutter speed.

exposure program: An automatic setting in a digital camera that provides the optimum combination of shutter speed and f-stop at a given level of illumination. For example a sports exposure program would use a faster, action-stopping shutter speed and larger lens opening instead of the smaller, depth-of-field-enhancing lens opening and slower shutter speed that might be favored by a close-up program at exactly the same light level.

exposure values (EV): EV settings are a way of adding or decreasing exposure without the need to reference f-stops or shutter speeds. For example, if you tell your camera to add +1EV, it will provide twice as much exposure by using a larger f-stop, slower shutter speed, or both.

f-stop: The relative size of the lens aperture, which helps determine both exposure and depth-of-field. The larger the f-stop number, the smaller the f-stop itself. It helps to think of f-stops as denominators of fractions, so that f/2 is larger than f/4, which is larger than f/8, just as ½, ¼, and ⅛ represent ever-smaller fractions. In photography, a given f-stop number is multiplied by 1.4 to arrive at the next number that admits exactly half as much light.

So, f/1.4 is twice as large as f/2.0 (1.4 x 1.4), which is twice as large as f/2.8 (2 x 1.4), which is twice as large as f/4 (2.8 x 1.4). The f-stops that follow are f/5.6, f/8, f/11, f/16, f/22, f/32, and so on. Most digital cameras have f-stops limited to a range of about f/2.8–f/8.

feather: To fade the borders of an image element so that it will blend more smoothly with another layer.

fill flash: A camera setting that causes the electronic flash to always fire, which produces the effect of filling in shadows in brightly illuminated images.

fill lighting: In photography, lighting used to illuminate shadows.

filter: In photography, a device that fits over the lens, changing the light in some way. In image editing, a feature that changes the pixels in an image to produce blurring, sharpening, or other special effects.

FireWire (IEEE 1394): A fast serial interface used by scanners, digital cameras, printers, and other devices. Introduced for the Macintosh and now found on all new Macs, FireWire is often an extra-cost option on PCs.

flat: An image with low contrast.

flatbed scanner: A type of scanner that reads one line of an image at a time, recording it as a series of samples, or pixels.

fluorescent illumination: Light produced by a tube coated on the inside with a material that glows. Mercury vapor in the tube emits ultraviolet radiation that's converted to visible radiation by the fluorescent coating. The most important aspect for photographers to consider is that fluorescent illumination doesn't have a true color temperature like daylight and tungsten illumination does, so special filtration or white balance settings must be used to compensate for color shifts. *See also* tungsten illumination.

focal length: The distance between the film and the optical center of the lens when the lens is focused on infinity, usually measured in millimeters.

focus: To adjust the lens to produce a sharp image.

focus range: The minimum and maximum distances within which a camera is able to produce a sharp image, such as two inches to infinity.

focus tracking: The ability of the automatic focus feature of a camera to change focus as the distance between the subject and the camera changes. Some cameras use *predictive focus* to guess where the proper focus point will be, based on the movement direction of the main subject.

four-color printing: Another term for *process color,* in which cyan, magenta, yellow, and black inks are used to reproduce all the colors in the original image.

Four Thirds: The Four Thirds system is a new open standard for digital SLR cameras with interchangeable lenses using a ⅘ inch image sensor. Adopted by a few manufacturers, the Four Thirds system establishes a common standard for lens design and mounts, improving compatibility between lenses and camera bodies even if they are produced by different manufacturers.

framing: In photography, composing your image in the viewfinder. In composition, using elements of an image to form a sort of picture frame around an important subject.

frequency: The number of lines per inch in a halftone screen.

front-curtain sync: The default kind of electronic flash synchronization technique, originally associated with focal plane shutters, which consist of a traveling set of curtains, including a *front curtain* (opens to reveal the film or sensor) and a *rear curtain* (follows at a distance determined by shutter speed to conceal the film or sensor at the conclusion of the exposure).

Front-curtain sync causes the flash to fire at the beginning of the exposure — in the instant that the first curtain of the focal plane shutter finishes its movement across the film or sensor plane. With slow shutter speeds, this feature can create a blur effect from the ambient light, showing as patterns that follow a moving subject with subject shown sharply frozen at the beginning of the blur trail (think of an image of The Flash running backwards). *See also* rear-curtain sync.

front-lighting: Illumination that comes from the direction of the camera. *See also* backlighting *and* sidelighting.

full-color image: An image that uses 24-bit color, 16.8 million possible hues. Images are sometimes captured in a scanner or digital camera with more colors, but the colors are reduced to the best 16.8 million shades for manipulation in image editing.

gamma: A numerical way of representing the contrast of an image. Devices such as monitors typically don't reproduce the tones in an image in straight-line fashion (all colors represented in exactly the same way as they appear in the original). Instead, some tones might be favored over others, and gamma provides a method of tonal correction that takes the human eye's perception of neighboring values into account. Gamma values range from 1.0 to about 2.5. The Macintosh has traditionally used a gamma of 1.8, which is relatively flat compared with television. Windows PCs use a 2.2 gamma value, which has more contrast and is more saturated.

gamma correction: A method for changing the brightness, contrast, or color balance of an image by assigning new values to the gray or color tones of an image to more closely represent the original shades. Gamma correction can be either linear or nonlinear. Linear correction applies the same amount of change to all the tones. Nonlinear correction varies the changes tone by tone, or in highlight, midtone, and shadow areas separately to produce a more accurate or improved appearance.

gamut: The range of viewable and printable colors for a particular color model, such as RGB (used for monitors) or CMYK (used for printing).

Gaussian blur: A method of diffusing an image using a bell-shaped curve to calculate the pixels which will be blurred, rather than blurring all pixels, thus producing a more random, less "processed" look.

GIF: An image file format limited to 256 different colors that compresses the information by combining similar colors and discarding the rest. Condensing a 16.8-million-color photographic image to only 256 different hues often produces a poor quality image, but GIF is useful for images that don't have a great many colors, such as charts or graphs. The GIF format also includes transparency options and can include multiple images to produce animations that may be viewed on a Web page or other application. *See also* JPEG *and* TIFF.

grain: The metallic silver in film that forms the photographic image. The term is often applied to the seemingly random noise in an image (both conventional and digital) that provides an overall texture.

gray card: A piece of cardboard or other material with a standardized 18 percent reflectance. Gray cards can be used as a reference for determining correct exposure or white balance.

grayscale image: An image represented using 256 shades of gray. Scanners often capture grayscale images with 1,024 or more tones but reduce them to 256 grays for manipulation by Photoshop.

halftone: A method used to reproduce continuous-tone images, representing the image as a series of dots.

high contrast: A wide range of density in a print, negative, or other image.

highlights: The brightest parts of an image containing detail.

histogram: A kind of chart showing the relationship of tones in an image using a series of 256 vertical bars, one for each brightness level. A histogram chart typically looks like a curve with one or more slopes and peaks, depending on

how many highlight, midtone, and shadow tones are present in the image. Histograms can appear in camera displays or in image editing software to help judge an image. They identify the shadows, midtones, and highlights of an image.

hue: The color of light that is reflected from an opaque object or transmitted through a transparent one.

hyperfocal distance: When a lens is focused on the hyperfocal distance, the depth-of-field extends from half that distance to infinity. The point can be calculated or looked up in tables.

image rotation: A feature found in some digital cameras, which senses whether a picture was taken in horizontal or vertical orientation. That information is embedded in the picture file so that the camera and compatible software applications can automatically display the image in the correct orientation.

image stabilization: A technology that compensates for camera shake, usually by adjusting the position of the camera sensor or lens elements in response to movements of the camera.

incident light: Light falling on a surface, as opposed to light reflected from a surface.

indexed color image: An image with 256 different colors, as opposed to a grayscale image, which has 256 different shades of the tones between black and white.

infinity: A distance so great that any object at that distance will be reproduced sharply if the lens is focused at the infinity position.

interchangeable lens: Lens designed to be readily attached to and detached from a camera; a feature found in more sophisticated digital cameras.

International Standards Organization (ISO): A governing body that provides standards used to represent film speed, or the equivalent sensitivity of a digital camera's sensor. Digital camera sensitivity is expressed in ISO settings.

interpolation: A technique that digital cameras, scanners, and image editors use to create new pixels whenever an image is resized or changed in resolution, based on the values of surrounding pixels. Devices such as scanners and digital cameras also use interpolation to create pixels in addition to those actually captured, thereby increasing the apparent resolution or color information in an image. For example, in a typical digital camera, pixels capture only red, green, or blue information, so the other colors present at that image position are calculated by using interpolation.

invert: In image editing, to change an image into its negative; black becomes white, white becomes black, dark gray becomes light gray, and so forth. Colors are also changed to their complementary color; green becomes magenta, blue turns to yellow, and red is changed to cyan.

iris: A set of thin overlapping leaves in a camera lens that pivots outwards to form a circular opening of variable size to control the amount of light that can pass through a lens. *See also* diaphragm.

jaggies: Staircasing effect of lines that are not perfectly horizontal or vertical, caused by pixels that are too large to represent the line accurately. *See also* anti-alias.

JPEG (Joint Photographic Experts Group): A file format that supports 24-bit color and reduces file sizes by selectively discarding image data. Digital cameras generally use JPEG compression to pack more images onto memory cards. You can select how much compression is used (and therefore how much information is thrown away) by selecting from among the Standard, Fine, Super Fine, or other quality settings offered by your camera. *See also* GIF, TIFF, *and* EXIF.

landscape: The orientation of an image in which the longest dimension is horizontal; also called wide orientation.

latitude: The range of camera exposures that produce acceptable images with a particular digital sensor or film.

layer: A way of managing elements of an image in stackable overlays that can be manipulated separately, moved to a different stacking order, or made partially or fully transparent.

lens: One or more elements of optical glass or similar material designed to collect and focus rays of light to form a sharp image on the film, paper, sensor, or a screen.

lens aperture: The lens opening, or iris, that admits light to the film or sensor. The size of the lens aperture is usually measured in f-stops. *See also* f-stop, diaphragm, *and* iris.

lens flare: A feature of conventional photography that is both bane and a creative outlet. It is an effect produced by the reflection of light internally among elements of an optical lens. Bright light sources within or just outside the field of view cause lens flare. Flare can be reduced by the use of coatings on the lens elements or with the use of lens hoods. Photographers sometimes use the effect as a creative technique, and some image editors include a filter that lets you add lens flare at your whim.

lens hood: A device that shades the lens, protecting it from extraneous light outside the actual picture area that can reduce the contrast of the image or allow lens flare.

lens speed: The largest lens opening (smallest f-number) at which a lens can be set. A fast lens transmits more light and has a larger opening than a slow lens. Determined by the maximum aperture of the lens in relation to its focal length; the speed of a lens is relative: a 400mm lens with a maximum aperture of f/3.5 is considered extremely fast, and a 28mm f/3.5 lens is thought to be relatively slow.

lighten: An image editing function that is the equivalent to the photographic darkroom technique of dodging. Tones in a given area of an image are gradually changed to lighter values. *See also* dodging.

lighting ratio: The proportional relationship between the amount of light falling on the subject from the main light and other lights, expressed in a ratio, such as 3:1.

line art: Usually, images that consist only of white pixels and one color, represented in Photoshop as a bitmap.

line screen: The resolution or frequency of a halftone screen, expressed in lines per inch. The term is used within the printing industry.

lithography: Another name for offset printing.

lossless compression: An image-compression scheme, such as TIFF, that preserves all image detail. When the image is decompressed, it is identical to the original version.

lossy compression: An image-compression scheme, such as JPEG, that creates smaller files by discarding image information, which can affect image quality.

luminance: The brightness or intensity of an image, determined by the amount of gray in a hue.

LZW compression: A method of compacting TIFF files in image editors and other applications by using the Lempel-Ziv Welch compression algorithm, which is an optional compression scheme also offered by some digital cameras.

macro lens: A lens that provides continuous focusing from infinity to extreme close-ups, often to a reproduction ratio of 1:2 (half life-size) or 1:1 (life-size).

macro photography: The process of taking photographs of small objects at magnifications of 1X or more.

magnification ratio: A relationship that represents the amount of enlargement provided by the macro setting of the zoom lens, macro lens, or with other close-up devices.

matrix metering: A system of exposure calculation used in digital cameras that looks at many different segments of an image to determine the brightest and darkest portions.

maximum aperture: The largest lens opening or f-stop available with a particular lens, or with a zoom lens at a particular magnification.

mechanical: Camera-ready copy with text and art already in position for photographing to make printing plates.

midtones: Parts of an image with tones of an intermediate value, usually in the 25–75 percent range. Many image editing features allow you to manipulate midtones independently from the highlights and shadows.

moiré: An objectionable pattern caused by the interference of halftone screens, frequently generated by rescanning an image that has already been halftoned. An image editor can frequently minimize these effects by blurring the patterns.

monochrome: Having a single color, plus white. Grayscale images are monochrome (shades of gray and white only).

negative: A representation of an image in which the tones are reversed: blacks as white, and vice versa.

neutral color: In image editing's RGB mode, a color in which red, green, and blue are present in equal amounts, producing a gray.

noise: In an image, pixels with randomly distributed color values. Noise in digital photographs tends to be the product of low-light conditions and long exposures, particularly when you have set your camera to a higher ISO rating than normal.

noise reduction: A technology used to cut down on the amount of random information in a digital picture, usually caused by long exposures at increased sensitivity ratings. Noise reduction involves the camera automatically taking a second blank/dark exposure at the same settings that contains only noise, and then using the blank photo's information to cancel out the noise in the original picture. With most cameras, the process is very quick but doubles the amount of time required to take the photo.

normal lens: A lens that makes the image in a photograph appear in a perspective that is like that of the original scene, typically with a field-of-view of roughly 45 degrees. A quick way to calculate the focal length of a normal lens is to measure the diagonal of the sensor or film frame used to capture the image, usually ranging from around 7–45mm.

optical zoom: Magnification produced by the elements of a digital camera's lens, as opposed to *digital zoom,* which merely magnifies the captured pixels to simulate additional magnification. Optical zoom is always to be preferred over the digital variety.

orthochromatic: Sensitive primarily to blue and green light. Orthochromatic films tend to intensify reds in photographs.

overexposure: A condition in which too much light reaches the film or sensor, producing a dense negative or a very bright/light print, slide, or digital image.

panning: Moving the camera so that the image of a moving object remains in the same relative position in the viewfinder as you take a picture. The eventual effect creates a strong sense of movement.

panorama: A broad view, usually scenic. Some digital cameras also have a panorama mode used with software to stitch images together.

parallax compensation: An adjustment made by the camera or photographer to account for the difference in views between the taking lens and the viewfinder.

perspective: The rendition of apparent space in a photograph, such as how far the foreground and background appear to be separated from each other. Perspective is determined by the distance of the camera to the subject. Objects that are close appear large, and distant objects appear to be far away.

perspective control lens: A special lens that allows correcting distortion resulting from a high or low camera angle.

Photo CD: A special type of CD-ROM developed by Eastman Kodak Company that can store high quality photographic images in a proprietary space-saving format, along with music and other data.

Picture CD: A CD-ROM designed to hold digital images, often returned by photo finishers with a standard order of prints. The images are stored in JPEG format at sufficient size to use at home.

pixel: The smallest element of a digital image that can be assigned a color. The term is a contraction of *picture element.*

pixels per inch (ppi): The number of pixels that can be displayed per inch, usually used to refer to pixel resolution from a scanned image or on a monitor.

plug-in: A software module such as a filter that can be accessed from within an image editor to provide special functions.

portrait: The orientation of an image in which the longest dimension is vertical, also called *tall orientation*. In photography, a formal picture of an individual or sometimes a group.

positive: The opposite of a negative; an image with the same tonal relationships as those in the original scenes — for example, a finished print or a slide.

prepress: The stages of the reproduction process that precede printing, when halftones, color separations, and printing plates are created.

process color: The four color pigments used in color printing: cyan, magenta, yellow, and black (CMYK).

RAW: An image file format offered by many digital cameras that includes all the unprocessed information captured by the camera. RAW files are very large and must be processed by a special program, such as Adobe's Camera RAW plug-in or software provided by the camera vendor, after being downloaded from the camera.

rear-curtain sync: An optional kind of electronic flash synchronization technique, originally associated with focal plane shutters, which consist of a traveling set of curtains, including a front curtain (opens to reveal the film or sensor) and a rear curtain (follows at a distance determined by shutter speed to conceal the film or sensor at the conclusion of the exposure).

Rear-curtain sync causes the flash to fire at the *end* of the exposure, an instant before the second or rear curtain of the focal plane shutter begins to move, allowing background light to record when taking flash pictures under dim illumination. With slow shutter speeds, this feature can create a blur effect from the ambient light, showing as patterns that follow a moving subject with subject shown sharply frozen at the end of the blur trail. If you were shooting a photo of The Flash, the superhero would appear sharp, with a ghostly trail behind him. *See also* front-curtain sync.

red-eye: An effect from flash photography that appears to make a person or animal's eyes glow red (or among animals, yellow or green). Caused by light bouncing from the retina of the eye, red-eye is most pronounced in dim illumination (when the irises are wide open) and when the electronic flash is close to the lens and therefore prone to reflect directly back. Image editors can fix red-eye through cloning other pixels over the offending red or orange ones.

red-eye reduction: A way of reducing or eliminating the red-eye phenomenon. Some cameras offer a red-eye reduction mode that uses a *preflash* that causes the iris' of the subjects' eyes to close down just prior to a second, stronger flash used to take the picture.

reflection copy: Original artwork that is viewed by light reflected from its surface, rather than transmitted through it.

reflector: Any device used to reflect light onto a subject to improve balance of exposure (contrast). Another way is to use fill flash. *See also* fill flash.

register: To align images, usually for lining up color separations for making printing plates. *See also* registration mark.

registration mark: A mark that appears on a printed image, generally for color separations, to help in aligning the printing plates. Many applications, such as Photoshop, can add registration marks to your images when they are printed.

reproduction ratio: Used in macro photography to indicate the magnification of a subject.

resample: To change the size or resolution of an image. Resampling down discards pixel information in an image; resampling up adds pixel information through interpolation. *See also* interpolation.

resolution: In image editing, the number of pixels per inch, used to determine the size of the image when printed. That is, an 8 x 10" that is saved with 300 pixels per inch (ppi) resolution will print in an 8 x 10" size on a 300 dpi printer or 4 x 5" on a 600 dpi printer. In digital photography, resolution is the number of pixels that a camera or scanner can capture.

retouch: To edit an image, most often to remove flaws or to create a new effect.

RGB color mode: A color mode that represents the three colors (red, green, and blue) used by devices such as scanners or monitors to reproduce color. Photoshop works in RGB mode by default and even displays CMYK images by converting them to RGB.

saturation: The purity of color; the amount by which a pure color is diluted with white or gray.

scale: To change the size of some or all of an image. Rescaling affects file size.

scanner: A device that captures an image of a piece of artwork, slide, or negative and converts it to a digitized image or bitmap that the computer can handle.

Secure Data memory card: A flash memory card format that is gaining acceptance for use in digital cameras and other applications.

selection: In image editing, an area of an image chosen for manipulation, usually surrounded by a moving series of dots called a *selection border.*

selective focus: Choosing a lens opening that produces a shallow depth-of-field. Usually this is used to isolate a subject by causing most other elements in the scene to be blurred.

self-timer: Mechanism delaying the opening of the shutter for some seconds after the release has been operated.

sensitivity: A measure of the degree of response of a film or sensor to light, measured in digital cameras using ISO ratings.

sensor array: The grid-like arrangement of the red, green, and blue-sensitive elements of a digital camera's solid-state capture device. One vendor offers a sensor array that captures a fourth color, termed *emerald.*

shadow: The darkest part of an image, represented on a digital image by pixels with low numeric values or on a halftone by the smallest or absence of dots.

sharpening: Increasing the apparent sharpness of an image by boosting the contrast between adjacent pixels that form an edge.

shutter: In a conventional film camera, the mechanism consisting of blades, a curtain, plate, or some other movable cover that controls the time during which light reaches the film. Digital cameras can use actual shutters or simulate the action of a shutter electronically. Quite a few use a combination, employing a mechanical shutter for slow speeds and an electronic version for higher speeds. Many cameras include a reassuring shutter sound that mimics the noise a mechanical camera's shutter makes.

shutter-preferred: An exposure mode in which you set the shutter speed and the camera determines the appropriate f-stop. *See also* aperture-preferred.

sidelighting: Light striking the subject from the side relative to the position of the camera; produces shadows and highlights to create modeling on the subject.

single autofocus: The camera lens focused only when the shutter release button is partially depressed, just prior to taking the picture.

single lens reflex (SLR) camera: A type of camera, often with interchangeable lenses, that allows you to see through the camera's lens as you look in the camera's viewfinder. Other camera functions, such as light metering and flash control, also operate through the camera's lens. *See also* digital single lens reflex (dSLR).

slave unit: An accessory flash unit that supplements the main flash, usually triggered electronically when the slave senses the light output by the main unit.

slide: A photographic transparency mounted for projection.

slow-sync: An electronic flash technique for using the flash at a slow shutter speed, which allows background details to show more clearly.

SmartMedia: A type of memory card storage, generally outmoded today because its capacity is limited to 128MB, for digital cameras and other computer devices.

smoothing: To blur the boundaries between edges of an image, often to reduce a rough or jagged appearance.

soft focus: Produced by the use of a special lens that creates soft outlines.

soft lighting: Lighting that is low or moderate in contrast, such as on an overcast day.

solarization: In photography, an effect produced by exposing film to light partially through the developing process. Some of the tones are reversed, generating an interesting effect. In image editing, the same effect is produced by combining some positive areas of the image with some negative areas. Also called the *Sabattier effect,* to distinguish it from a different phenomenon called *overexposure solarization,* which is produced by exposing film to many, many times more light than is required to produce the image. With overexposure solarization, some of the very brightest tones, such as the sun, are reversed.

specular highlight: Bright spots in an image caused by reflection of light sources.

spot color: Ink used in a print job in addition to black or process colors.

spot metering: An exposure calculation system that emphasizes a small portion of the image area, usually in the center of the frame. Some cameras let you move the "spot" to other portions of the image area.

storage media: In the digital camera world, often refers to the flash memory cards used to retain images before they are transferred to your computer or another device. Nearly a dozen different types of media are used by digital cameras, and the number seems to grow monthly. The most common types include two sizes of CompactFlash cards (the main difference is in the thickness), *microdrives* (tiny hard disks), Sony Memory Sticks, Sony Memory Stick Duo, Secure Digital (SD) cards, SmartMedia Card (generally an obsolete format today), xD Picture Card, and Reduced Size MultiMedia Card.

subtractive primary colors: Cyan, magenta, and yellow, which are the printing inks that theoretically absorb all color and produce black. In practice, however, they generate a muddy brown, so black is added to preserve detail (especially in shadows). The combination of the three colors and black is CMYK. (K represents black, to differentiate it from blue in the RGB model, and is sometimes placed in parentheses to indicate that it's an optional part of the color model.) *See also* additive primary colors.

telephoto: A lens or lens setting that magnifies an image.

thermal wax transfer: A printing technology in which dots of wax from a ribbon are applied to paper when heated by thousands of tiny elements in a printhead.

threshold: A predefined level used by a device to determine whether a pixel will be represented as black or white.

thumbnail: A miniature copy of a page or image that provides a preview of the original.

TIFF (Tagged Image File Format): A standard graphics file format that can be used to store grayscale and color images plus selection masks. *See also* JPEG *and* GIF.

time exposure: A picture taken by leaving the lens open for a long period, usually more than one second. The camera is generally locked down with a tripod to prevent blur during the long exposure.

tint: A color with white added to it. In graphic arts, often refers to the percentage of one color added to another.

tolerance: The range of color or tonal values that will be selected, with a tool like an image editor's Magic Wand, or filled with paint, when using a tool like the Paint Bucket.

transparency: A positive photographic image on film, viewed or projected by light shining through film.

transparency scanner: A type of scanner that captures color slides or negatives.

tripod: A three-legged supporting stand used to hold the camera steady. Especially useful when using slow shutter speeds and/or telephoto lenses. *See also* unipod.

TTL: Through the lens. A system of providing viewing through the actual lens taking the picture (as with a camera with an electronic viewfinder, LCD display, or single lens reflex viewing), or calculation of exposure or focus based on the view through the lens.

tungsten light: Light from ordinary room lamps and ceiling fixtures, as opposed to fluorescent illumination.

underexposure: A condition in which too little light reaches the film or sensor, producing a *thin* negative (one with little density), a dark slide, a muddy-looking print, or a dark digital image.

unipod: A one-legged support, or monopod, used to steady the camera. *See also* tripod.

unsharp masking: The process for increasing the contrast between adjacent pixels in an image, increasing sharpness, especially around edges.

USB (Universal Serial Bus): A high-speed serial communication method commonly used to connect digital cameras and other devices to a computer.

viewfinder: The device in a camera used to frame the image. With an SLR camera, the viewfinder is also used to focus the image if focusing manually. You can also focus an image with the LCD display of a digital camera, which is a type of viewfinder.

vignetting: Dark corners of an image, often produced by using a lens hood that is too small for the field of view, or generated artificially by using image editing techniques.

white: The color formed by combining all the colors of light (in the additive color model) or by removing all colors (in the subtractive model). *See also* additive primary colors *and* subtractive primary colors.

white balance: The adjustment of a digital camera to the color temperature of the light source. Interior illumination is relatively red; outdoor light is relatively blue. Digital cameras often set correct white balance automatically or let you do it through menus. Image editors can often do some color correction of images that were exposed using the wrong white-balance setting.

white point: In image editing, the lightest pixel in the highlight area of an image.

wide-angle lens: A lens that has a shorter focal length and a wider field-of-view than a normal lens for a particular film or digital image format.

zoom: In image editing, to enlarge or reduce the size of an image on your monitor. In photography, to enlarge or reduce the size of an image using the magnification settings of a lens.

Index

F

S

U

FOR DUMMIES

The easy way to get more done and have more fun

PERSONAL FINANCE

0-7645-5231-7

0-7645-2431-3

0-7645-5331-3

Also available:

Estate Planning For Dummies
(0-7645-5501-4)

401(k)s For Dummies
(0-7645-5468-9)

Frugal Living For Dummies
(0-7645-5403-4)

Microsoft Money "X" For
Dummies
(0-7645-1689-2)

Mutual Funds For Dummies
(0-7645-5329-1)

Personal Bankruptcy For
Dummies
(0-7645-5498-0)

Quicken "X" For Dummies
(0-7645-1666-3)

Stock Investing For Dummies
(0-7645-5411-5)

Taxes For Dummies 2003
(0-7645-5475-1)

BUSINESS & CAREERS

0-7645-5314-3

0-7645-5307-0

0-7645-5471-9

Also available:

Business Plans Kit For
Dummies
(0-7645-5365-8)

Consulting For Dummies
(0-7645-5034-9)

Cool Careers For Dummies
(0-7645-5345-3)

Human Resources Kit For
Dummies
(0-7645-5131-0)

Managing For Dummies
(1-5688-4858-7)

QuickBooks All-in-One Desk
Reference For Dummies
(0-7645-1963-8)

Selling For Dummies
(0-7645-5363-1)

Small Business Kit For
Dummies
(0-7645-5093-4)

Starting an eBay Business For
Dummies
(0-7645-1547-0)

HEALTH, SPORTS & FITNESS

0-7645-5167-1

0-7645-5146-9

0-7645-5154-X

Also available:

Controlling Cholesterol For
Dummies
(0-7645-5440-9)

Dieting For Dummies
(0-7645-5126-4)

High Blood Pressure For
Dummies
(0-7645-5424-7)

Martial Arts For Dummies
(0-7645-5358-5)

Menopause For Dummies
(0-7645-5458-1)

Nutrition For Dummies
(0-7645-5180-9)

Power Yoga For Dummies
(0-7645-5342-9)

Thyroid For Dummies
(0-7645-5385-2)

Weight Training For Dummies
(0-7645-5168-X)

Yoga For Dummies
(0-7645-5117-5)

Available wherever books are sold.
Go to www.dummies.com or call 1-877-762-2974 to order direct.

FOR DUMMIES®

A world of resources to help you grow

HOME, GARDEN & HOBBIES

Feng Shui
0-7645-5295-3

Gardening
0-7645-5130-2

Guitar
0-7645-5106-X

Also available:

Auto Repair For Dummies
(0-7645-5089-6)

Chess For Dummies
(0-7645-5003-9)

Home Maintenance For
Dummies
(0-7645-5215-5)

Organizing For Dummies
(0-7645-5300-3)

Piano For Dummies
(0-7645-5105-1)

Poker For Dummies
(0-7645-5232-5)

Quilting For Dummies
(0-7645-5118-3)

Rock Guitar For Dummies
(0-7645-5356-9)

Roses For Dummies
(0-7645-5202-3)

Sewing For Dummies
(0-7645-5137-X)

FOOD & WINE

Cooking
0-7645-5250-3

Cookies
0-7645-5390-9

Wine
0-7645-5114-0

Also available:

Bartending For Dummies
(0-7645-5051-9)

Chinese Cooking For
Dummies
(0-7645-5247-3)

Christmas Cooking For
Dummies
(0-7645-5407-7)

Diabetes Cookbook For
Dummies
(0-7645-5230-9)

Grilling For Dummies
(0-7645-5076-4)

Low-Fat Cooking For
Dummies
(0-7645-5035-7)

Slow Cookers For Dummies
(0-7645-5240-6)

TRAVEL

Italy
0-7645-5453-0

Hawaii
0-7645-5438-7

Las Vegas
0-7645-5448-4

Also available:

America's National Parks For
Dummies
(0-7645-6204-5)

Caribbean For Dummies
(0-7645-5445-X)

Cruise Vacations For
Dummies 2003
(0-7645-5459-X)

Europe For Dummies
(0-7645-5456-5)

Ireland For Dummies
(0-7645-6199-5)

France For Dummies
(0-7645-6292-4)

London For Dummies
(0-7645-5416-6)

Mexico's Beach Resorts For
Dummies
(0-7645-6262-2)

Paris For Dummies
(0-7645-5494-8)

RV Vacations For Dummies
(0-7645-5443-3)

Walt Disney World & Orlando
For Dummies
(0-7645-5444-1)

Available wherever books are sold. Go to www.dummies.com or call 1-877-762-2974 to order direct.

FOR DUMMIES®

Helping you expand your horizons and realize your potential

INTERNET

0-7645-0894-6

0-7645-1659-0

0-7645-1642-6

Also available:

America Online 7.0 For Dummies
(0-7645-1624-8)

Genealogy Online For Dummies
(0-7645-0807-5)

The Internet All-in-One Desk Reference For Dummies
(0-7645-1659-0)

Internet Explorer 6 For Dummies
(0-7645-1344-3)

The Internet For Dummies Quick Reference
(0-7645-1645-0)

Internet Privacy For Dumm
(0-7645-0846-6)

Researching Online For Dummies
(0-7645-0546-7)

Starting an Online Busines For Dummies
(0-7645-1655-8)

DIGITAL MEDIA

0-7645-1664-7

0-7645-1675-2

0-7645-0806-7

Also available:

CD and DVD Recording For Dummies
(0-7645-1627-2)

Digital Photography All-in-One Desk Reference For Dummies
(0-7645-1800-3)

Digital Photography For Dummies Quick Reference
(0-7645-0750-8)

Home Recording for Musicians For Dummies
(0-7645-1634-5)

MP3 For Dummies
(0-7645-0858-X)

Paint Shop Pro "X" For Dummies
(0-7645-2440-2)

Photo Retouching & Restoration For Dummies
(0-7645-1662-0)

Scanners For Dummies
(0-7645-0783-4)

GRAPHICS

0-7645-0817-2

0-7645-1651-5

0-7645-0895-4

Also available:

Adobe Acrobat 5 PDF For Dummies
(0-7645-1652-3)

Fireworks 4 For Dummies
(0-7645-0804-0)

Illustrator 10 For Dummies
(0-7645-3636-2)

QuarkXPress 5 For Dummie
(0-7645-0643-9)

Visio 2000 For Dummies
(0-7645-0635-8)

Available wherever books are sold. Go to www.dummies.com or call 1-877-762-2974 to order direct.

FOR DUMMIES®

We take the mystery out of complicated subjects

Digital Photography All-in-One Desk Reference For Dummies, 2nd Edition

Cheat Sheet

File Format Guide

Here is a quick summary of the leading file formats used by image editors and digital cameras. The Cheatsheet descriptions are a bit terse; check out the Index to find definitions in the book of terms you don't understand.

File Extension	Name	Description
BMP	Microsoft Bitmap Format	The native format for Microsoft Paint, it supports up to 16.8 million different colors.
EPS	Encapsulated Postscript	Files created by programs such as Adobe Illustrator for vector-oriented (outline) artwork and text, although they can also incorporate pixel information.
EXIF	Extended File Format	An enhanced file format used by digital cameras to store image information along with other data. Similar to JPEG, it includes additional information from the camera, including exposure data.
GIF	Graphics Interchange Format	A format useful for Web pages because of the small file size. Supports transparent pixels, animation, and other features. Can display only 256 different colors, so it's good for line art but is not the best choice for photographs.
JPEG	Joint Photographic Experts Group	A format used by most digital cameras to store files, and used on Web pages to provide high compressed files of images with up to 16.8 million colors. Discards some image information to achieve small file size, but the user can select the quality level and amount of squeezing performed.
PCD	Kodak Photo CD	A format used on Photo CDs to provide full color images at several different resolution levels. Although programs like Photoshop can open these files, they cannot save in this format.
PCX	PC Paintbrush Format	An older image format that's capable of 16.8 million colors but is unable to save layers, alpha channels.
PDF	Portable Document Format	Adobe's format used by Adobe Acrobat Reader to display electronic documents for viewing onscreen on multiple platforms.
PICT	Macintosh Picture	The native Macintosh image format, capable of displaying 16.8 million colors.
PNG	Portable Network Graphic	Designed as a replacement for JPEG and GIF, PNG supports 16.8 million colors, has better transparency options than JPEG, and can be displayed by many (but not all) Web browsers. So far, this format has not caught on.
PSD	Photoshop Format	The native format used by Photoshop, capable of storing layers, selections, and other information used by the program. Many other applications support PSD, too.
RAW	Raw Format	As its name implies, this is an unadorned format used by some digital cameras to provide unenhanced transfer of basic image information.
TIFF	Tagged Image File Format	This is the standard format for image editing, capable of 16.8 million colors. In some variations, it can store selections and layers.

Digital Photography
All-in-One Desk Reference
For Dummies, 2nd Edition

Faker's Guide to Digital Photography Lingo

You don't have to be the only quiet one in the room when the topic turns to digital photography. Here are some hot topics and terms to toss out when you want to seem to reside on the bleeding edge of technology.

Term	What It Means
aperture priority	A camera control that lets you choose the lens opening while the camera's exposure meter determines the appropriate shutter speed.
calibration	Zeroing in components of your computer system (such as your monitor) to provide color that matches the original.
CCD, CMOS	Two kinds of computer chips used as sensors to capture images in digital cameras.
Compact Flash, Secure Digital, xD, Memory Stick	The four competing types of removable storage for digital cameras.
compression	A way of using software to squeeze an image down to a smaller, more manageable size. If you want to seem really cool, use the terms *lossless compression* (which doesn't discard any information during the squishing process) and *lossy compression* (which does throw away some image information, but makes smaller files).
depth-of-field	How much of your image is in focus at one time.
digicam	A cool term for a digital camera.
dye-sub	A kind of printer that produces extra-good hardcopies of digital images.
interpolation	A process by which software pulls pixels out of thin air to produce an image with higher resolution. (Actually, it calculates the pixels on those that already exist.)
ISO	Shorthand for the speed equivalent of a digital sensor when compared to traditional film sensitivity (from *International Standards Organization* rating, such as ISO 100, ISO 200).
JPEG	An image file format used by most digital cameras to make images really small, so more of them will fit in the camera. JPEG uses *lossy compression*.
megapixel	One million pixels; a measurement of the resolution of your camera's sensor.
ppi	Picture elements per inch; the more the better, especially when it comes time to make a print.
resample	To change the size of an image by recalculating the pixels.
resolution	How sharp your camera, monitor, or scanner is.
RGB	Red/green/blue: the primary colors of light, used by your digital camera to capture images.
shutter priority	A camera control that lets you set the length of the instant of time used to take the picture (the shorter, the better when it comes to freezing action) while the camera's exposure meter determines the proper lens setting.

Copyright © 2005 Wiley Publishing, Inc. All rights reserved.

Item 7328-4.

For more information about Wiley Publishing, call 1-800-762-2974.

For Dummies: Bestselling Book Series for Beginners